Precious Materials

THE ARTS OF METAL IN THE MEDIEVAL IRANIAN WORLD

This book is the first step in the completion of the ISLAMETAL research program, carried out by the Musée du Louvre and the Centre de Recherche et de Restauration des Musées de France (C2RMF) with the support of the Roshan Cultural Heritage Institute

Translation © Annabelle Collinet and Melanie Gibson

Photography copyright and credits on page 356

GINGKO
4 Molasses Row, London SW11 3UX
www.gingko.org.uk

© Musée du Louvre, Paris, 2023
www.louvre.fr

© Faton, Dijon, 2023
25, rue Berbisey – 21000 Dijon.
www.faton.fr

GINGKO 978-1-914983-12-2
Louvre 978-2-35031-788-5
Faton 978-2-87844-365-3

Project management:
Annabelle Collinet, researcher, curator, medieval Iranian world collection, Département des Arts de l'Islam, du Louvre, Paris
David Bourgarit, researcher, archaeometallurgist, Centre de Recherche et de Restauration des Musées de France.

Post-doctoral researchers:
Ziad el-Morr (2014–2015), Vana Orfanou (2015–2016) recruited by the Louvre with the support of the Roshan Cultural Heritage Institute in partnership with C2RMF.

Precious Materials

THE ARTS OF METAL IN THE MEDIEVAL IRANIAN WORLD

10TH–13TH CENTURIES

Edited and translated by Annabelle Collinet and Melanie Gibson

In loving memory of Marguerite Collinet (1921-2022)

Acknowledgements

Département des Arts de l'Islam,
Musée du Louvre

Precious Materials

*The Arts of Metal in the
Medieval Iranian World*

10th–13th centuries

Edited by:
Annabelle Collinet and Melanie Gibson

Authors:
Annabelle Collinet,
David Bourgarit

Contributors:
Ziad el-Morr,
Vana Orfanou
(archaeometallurgy)

Musée du Louvre

Laurence des Cars
President and CEO

Kim Pham
General Administrator

Francis Steinbock
Deputy Administrator

Souraya Noujaim
Director, Département des Arts de l'Islam

Aline François-Colin
Director of Exhibitions and Editions

Valérie Coudin
Deputy Director of Editions

The research undertaken for this book was made possible with the agreement of the former directors of the Musée du Louvre, Henri Loyrette and Jean-Luc Martinez, the former director of the Musée des Arts Decoratifs, Olivier Gabet, and the former directors of the Centre de recherche et de restauration des musées de France, Marie Lanvandier and Isabelle Pallot-Frossard, whom we thank for the support and confidence they showed the ISLAMETAL programme.

In the Département des Arts de l'Islam (DAI) our thanks go to its former director, Yannick Lintz, who supported this project right up to the publication of the French volume in 2021.

ISLAMETAL was made possible with the support of the Roshan Cultural Heritage Institute, which enabled the recruitment of two post-doctoral fellows for two consecutive years, Ziad el-Morr (2014–2015) and Vana Orfanou (2015–2016). Without their expertise, resourcefulness and unfailing enthusiasm, the analyses and observations carried out over three years on more than 150 objects would not have been completed and documented.

The Roshan Cultural Heritage Institute also enabled the presentation of the first results of the ISLAMETAL project in 2016 at the Medieval Iranian World study day organised, with sponsorship from the Roshan Cultural Heritage Institute, as part of the 'Object in Context', Louvre Museum Research Programme.

We would also like to thank Philippe Gaboriau.

The research carried out at C2RMF required the continuous input and support of many colleagues at the Centre. The Accélérateur Grand Louvre d'Analyses Elémentaires (AGLAE) team was always warmly collaborative and offered its many skills to the long sessions of analysis we were able to undertake. Our grateful thanks go to Claire Pacheco, Brice Moignard, Laurent Pichon and Quentin Lemasson. The magnificent X-rays in this book are the work of Jean Marsac and Elsa Lambert who always worked calmly and efficiently under often tense circumstances. Their enthusiasm and patience, not to mention their help in interpreting the images, were indispensable.

Observations under digital microscope of objects in the DAI reserves at the Louvre Museum were carried out using C2RMF equipment entrusted to us by Dominique Robcis. We thank him warmly for the HIROX© training he was patient enough to give us, and for his keen, expert eye on surface ornamentation and patinas. At C2RMF, we also benefited from the knowledge of Thomas Calligaro and Juliette Langlois, who helped us to identify non-metallic inlays on works of art. Finally, Benedicte Chantelart was responsible for the logistics of the conservation of the works at C2RMF throughout the analysis and examination phase of the research, conducted between 2013 and 2016.

The ISLAMETAL project involved moving the DAI objects works out of their display cases or storage areas and keeping them under scrutiny there for shorter or longer periods. This complex and delicate choreography could only have been managed by Isabelle Luche, Olivier Ségissement and Inès Cabane.

The ISLAMETAL project would not have been possible without my colleagues at DAI and their unfailing and generous support.

Well before the launch of ISLAMETAL, we began working with Helene Bendejacq on the photography required for this publication. This book owes a great deal to her perfectionist eye, to her photographic choices, and to her collaboration with photographers, both from the Réunion des Musées Nationaux and the Louvre's other service providers.

We salute here the memory of Jean-Gilles Berizzi, the first photographer on this project, who passed away in 2013.

We would also like to express special thanks to Mathieu Rabeau, Raphaël Chipault and to Benjamin Soligny and Hervé Lewandovski for the beautiful photographs that really allow us to see the objects.

We would also like to thank our curatorial colleagues, the collection managers and archaeologists at the Département des Arts de l'Islam who have always supported and encouraged my work on the collection of medieval Iranian art. Gwenaëlle Fellinger, Charlotte Maury, Delphine Miroudot and Rocco Rante have greatly assisted me with their ideas, their confidence and their bibliographic guidance. I would also like to extend my warmest thanks to my colleagues in the documentation team led by Marie Fradet, Monique Buresi, Carlos Fernandes, Elodie Pomet, Rosène Declementi and Nadège Picotin who, with characteristic enthusiasm, have always helped me in the documentary research that was required.

The reading of unpublished inscriptions, as well as their transcription and translation, were carried out by Viola Allegranzi who also reviewed inscriptions in the collection that had already been documented or published. This work was carried out as part of the 'Objets Inscrits' project directed by Carine Juvin, curator in charge of the medieval collections of the Middle East. I thank them both warmly for this vital contribution to the study of the collection and to this publication.

Finally, the ISLAMETAL project and the publication of DAI's medieval collection of Iranian metalwork are also the fruit of a collaboration between David Bourgarit and myself, with many other colleagues and friends who are archaeometallurgists, founders, chasers, engravers, restorers, historians, art historians, anthropologists and archaeologists.

I am grateful to the CAST:ING project team, at the Ecole Boulle, the Fonderie de Coubertin, the British Museum, the Victoria & Albert Museum, Museum für Islamische Kunst, Bamberg University, as well as Etienne Anheim, Christophe Berry, Moya Carey, Manon Castelle, Sophie Descamps, Patrick Donabedian, Jean Dubos, Guillaume Estrade, Finbarr Barry Flood, Ute Franke, Melanie Gibson, Lorenz Korn, Dickran Kouymjian, Susan La Niece, Benoit Mille, Peta Mothure, Agnes Ouzounian, Sepideh Parsapajouh, Emmanuel Plé, Marc Robert, Eric Thirier, Nicolas Thomas, Lise Saussus, Jeremy Warren and Lorenzo Morigi for their discussions, their enlightened opinions, their suggestions, their bibliographical contributions, their invitations—in other words, their invaluable help.

For the completion of this book, my deepest thanks go to Finbarr Barry Flood and Melanie Gibson who kindly agreed to carry out the external reviews. Patient, attentive and rigorous, they enabled me to add indispensable details and references and to revise certain theories. Finally, for the publication of this book, I would like to thank Violaine Bouvet-Lanselle at Éditions du Louvre and Jeanne Faton at Éditions Faton for their warm support and follow-up, to Élise Julienne Grosberg for the beautiful design of this book, and to Tina Maalouf for her precise and attentive proofreading of the Arabic inscriptions.

Musée du Louvre

Direction of Exhibitions and Editions
Violaine Bouvet-Lanselle
Head of Publications

Département des Arts de l'Islam
Helene Bendejacq
Iconography and Coordinator of Photography

Centre de Recherche et de Restauration des Musées du France (C2RMF)

Elsa Lambert
Radiography

Éditions Faton

Jeanne Faton
Director

Élise Julienne Grosberg
Graphic design, layout

Tina Maalouf, HallScript
Integration of Arabic texts

Gingko

Melanie Gibson
Head of the Art Series

Briony Hartley
Typesetting

Ally Oakes
Proofreading and correction

Contents

9 Preface
Yannick Lintz

10 Map of the Iranian World

13 Foreword

17 INTRODUCTION

17 The Collection

20 From Gaston Migeon to ISLAMETAL:
 Studies of the Collection

CHAPTER 1

28 THE ART OF METAL IN THE IRANIAN WORLD C. 900–1220

32 The Historical Background

33 The Material and Artistic Culture of Khurasan

40 Archaeological Data and Dating

43 The Context of Production

CHAPTER 2

50 MATERIALS, ALLOYS AND TECHNIQUES

David Bourgarit, Annabelle Collinet

53 Materials and Alloys in the Textual Sources

58 Alloys and Impurities

65 Metal Inlays

68 Shaping Techniques

77 The Surface

92 The Organisation of Production

CHAPTER 3

106 THE ART OF INLAID METAL IN HERAT

111 Masterpieces of Herat

126 Objects Attributable to Herat

CHAPTER 4

148 PRODUCTION IN GHAZNA AND KHURASAN

151 Production in Ghazna

178 Objects from Khurasan and their Regional Diffusion

CHAPTER 5

208 THE CONTEXT OF THE OBJECTS

213 Furnishings and their Uses

255 Serving Ware and Reception Practices

269 Care of the Body

277 Utensils from Shops

296 CONCLUSION

298 APPENDICES

David Bourgarit, Annabelle Collinet

300 Bibliography

312 Index

316 Archaeometallurgy

In this book, dates are generally given first in the Hegira calendar followed by the Romanised calendar.

The transliteration of Arabic inscriptions uses the simplified system used in Brill publications. The transliteration system of Persian inscriptions uses the Deutsche Morgenländische Gesellschaft (table DMG 1.0. Brill editions), except for ذ (transliterated ḏ) and ژ (transliterated j). In the body of the text, Arabic and Persian terms are similalry transliterated except for ذ (transliterated z), ش (transliterated sh) and غ (transliterated gh).

The publication of a museum's permanent collection is always significant. This catalogue of medieval Iranian metalwork from the tenth to thirteenth centuries represents an important milestone: the first volume in a series focusing on the collections of Islamic Art at the Louvre. In a department of European Art, this type of publication would be referred to as a 'catalogue raisonné', featuring detailed entries for each object, as is typical of the studies our museum colleagues have published over the decades.

Although still relatively young, the Louvre's Département des Arts de l'Islam has a rich and varied history. I enthusiastically supported Annabelle Collinet in her endeavour to produce a different kind of book, one which encompassed careful analysis and rigorous scholarship. Thanks to the Louvre's partnership with the Centre de Recherche et de Restauration des Musées de France, the objects in this study have been re-examined in the light of the most recent research. Working with the ISLAMETAL programme, it has been possible to study the metalwork collection both with the naked eye and also with digital imaging: methods of technical analysis that have revealed much information about the Louvre's metalwork corpus.

This volume includes hundreds of detailed photographs of exceptional quality, featuring every aspect of the objects: their surface appearance, internal structure and the traces of the craftsmen's tools. In addition to their inestimable research value, these images provoke an emotional response. Annabelle Collinet has combined a forensic study of these new images with a careful consideration of epigraphic, primary and secondary sources. The results of her exciting discoveries are contained in this book devoted to the first centuries of metalwork in the Iranian world. Her study offers fresh perspectives on important questions such as the conditions of workshop production, and the provenance and regional distribution of these objects, which often lack archaeological contexts. We can now better understand the artistic milieu of important centres of production such as Herat in Afghanistan, and other cities in the eastern Iranian world whose commercial activity was linked to the 'Silk Road'. The final chapter in the volume looks at the context and use of the objects.

I have no doubt that this book will serve as an essential reference for specialists and others interested in the subject, who will use it as a springboard for future analysis of Islamic metalwork in Western collections, as well as museums in Iran, Afghanistan and Central Asia. I am equally certain that readers will get the greatest pleasure from this book, while learning about the rich history of these works.

Yannick Lintz
Former director of the Département des Arts de l'Islam

Fig. 1

The Iranian World

Tabriz

TURKMENISTAN

Merv

Gurgan

Isfarā'in

Tus

Nishapur

Mashhad

Tehran

Rayy

Khurasan

Hamadan

Herat

Kashan

IRAN

Qa'en

Isfahan

Yazd

Sistan

Susa

Zarang

Kerman

Shiraz

Siraf

UZBEKISTAN

Bukhara

Penjikent

Afrasiab / Samarqand

TAJIKISTAN

Balkh

Bamiyan

Jam / Firuz-Koh

Kabul

Peshawar

Kashmir

AFGHANISTAN

Ghazna

Himachal Pradesh

PAKISTAN

Bust Qandahar

Lahore

Punjab

Sind

INDIA

0 250 km

Gold is the essence of the sun,
And silver the essence of the moon.[1]

'Omar Khayyam, The Book of Nowruz

For over a century, Persian art—synonymous with refinement and beauty—has occupied a prominent place in European culture. The art of the Iranian world remains at the core of the cultures of the Islamic world. From the second half of the nineteenth century onwards, the collections of the Louvre and the Musée des Arts Décoratifs were enriched by works on paper, carpets, textiles, ceramics and metalwork, mediums that featured the development of drawing, colour and calligraphy. Within this artistic production, metalwork is a vast topic that remains mysterious and misunderstood. This may be due to the complexity and variety of the metal wares, as well as the difficulty in attempting to read the objects. Indeed, while the dimensions of metal objects are often striking, the content of their surfaces often remains barely visible. The inscriptions, vegetal and geometric motifs and figural and zoomorphic scenes, can only be deciphered slowly, as the eye lingers on the miniscule elements etched into the metal. Often, one sees nothing. Above all else, this book aims to address the inscrutability of these objects: they are closely observed, and their details are carefully illustrated. Frequently, the ornament on the metal surface does not exceed two or three centimetres in height. Our scale of vision must thus be adjusted to apprehend these visual elements. The illustrations in this volume include standard photographs of the objects, as well as more detailed shots, but also X-rays and photographs taken with a digital microscope that reveal what the naked eye cannot see. The publication of these technical studies was one of the objectives of this catalogue. The previously unpublished archaeometallurgical analyses of objects in the Louvre collection have allowed us to study and show the techniques of metalwork production, contributing a great deal to our knowledge of these objects and answering important questions for a part of the collection regarding their geographic origin and the location of their centres of production: where are these objects from, and in which centres were they produced? Questions of provenance and production techniques led to another line of inquiry in the context of this study: what were the uses and significance of the objects, and what can they tell us about the individuals and societies who made and used them?

Medieval metalwork dating from the tenth to the fifteenth centuries is one of the artistic highlights of the Iranian world, as well as of the Département des Arts de l'Islam (henceforth DAI), whose collection holds over 150 objects from this period. Some examples

are well known by collectors and art historians, who have long been attracted by their varied forms and motifs, by their graphic stylisation or complex figural compositions. On the other hand, many objects are less known and have never been published. Until now, the collection has never been studied or published as an ensemble, although it is one of the most important collections in the world, with many representative works of metalwork from the medieval Iranian world. In this context, 'Iranian' refers to modern-day Iran, and also to Afghanistan, and parts of Central Asia, particularly Turkmenistan and Uzbekistan (fig. 1). The periodisation corresponds to two major phases in the cultural history of these vast regions, and for this reason the collection is being published in two parts. This volume is devoted to metalwork from the tenth to the beginning of the thirteenth centuries. The second will be dedicated to metalwork production from the thirteenth to the fifteenth centuries.

The decision to divide the material into two parts was also dictated by editorial concerns. The volumes were designed to be portable while respecting the components of the collection, and especially the importance of the Mongol invasions as a critical turning point in the medieval Islamic world. The material and artistic culture of the Persianate world of the period leading up to the invasions (ninth to thirteenth centuries) was one of the richest in the history of the Islamic world. Profound changes occurred in the thirteenth century, and these are visible in the art of metal as well as in the broader artistic and intellectual production. Metalwork datable after 1220 up to the end of the fifteenth and early sixteenth centuries, presents a range of very different production techniques, ornamentation and types, and forms the basis of the second volume. In the light of this future publication, certain choices were made relating to the content of the current volume: the objects that were selected are primarily domestic objects and furnishings. They do not include scientific instruments, or objects linked to the occult sciences by the content of their inscriptions and iconography. Indeed, these specific areas of study require

different research, and therefore, another publication. Objects directly linked to the occult sciences (alchemy, astrology, magic), as well as those associated with devotional practice,[2] constitute a diverse group within the DAI collection, one that merits a publication touching on a wide variety of materials, geographic spheres and chronologies. This group would include certain mirrors produced in the medieval Iranian world that were engraved with signs and texts linked to the occult at a later period, probably around the seventeenth century, in Iran or India. This book also excludes metalwork from Susa in western Iran as this material was found in an archaeological context and should therefore be considered alongside the ceramic and glass wares from the site in the DAI collection, together with the available excavation documents.

Studies of the DAI collection have long focused on style, iconography, dating, and geographic attributions. These approaches, which are at the heart of the study of a museum collection, are part and parcel of the identification process of a particular region or period. Such information allows one to develop and present further knowledge about these objects, both for specialists and the general public. As far as the metalwork in the Iranian world is concerned, questions of provenance, and of centres and systems of production, have never been examined from the perspective of materials, either at the Louvre or in other international collections. The ambitious project for archaeometallurgical research known as ISLAMETAL was thus established to deepen our understanding of systems of production and the circulation of metalwork in the Iranian world.[3] The project aimed to provide information on the processes, places and craftsmen linked to these major artistic traditions in Islamic art. Existing reference books and specialised articles on the art of medieval Islamic metalwork in the Iranian and Arab worlds offered diverse and fascinating approaches, but never from the angle of material study. ISLAMETAL allowed us to determine the compositions of the metal objects and to characterise the processes of their production and the techniques of ornamentation. Through these varied material traces, a picture

of the metalwork craftsmen emerges. Analyses of materials and visual examination (with the naked eye, under a digital microscope or with radiography) have led us to better define systems of production, and to attribute the provenance of some of the Louvre objects to Herat and Ghazna, two centres of medieval metalwork. Questions of regional provenance, and the centres of production, are at the heart of this volume. They have been determined with the support of textual and epigraphic sources, archaeological excavation and archaeometallurgical information. Thanks to the information drawn from these diverse sources, it has been possible to propose a new categorisation for some of the groups of DAI objects, based on their probable places of production and circulation in the medieval Iranian world.

Metalwork objects from pre-Mongol Khurasan—that is, from the pre-1220 eastern Iranian world—do not form a homogeneous ensemble. Object types that are most commonly found in museum collections are for the consumption and serving of liquids, the spraying of perfumed waters, and the use of water more generally in the form of vases, ewers, basins and buckets. They also include objects for the display and use of food and incense: bowls, plates and incense burners; and the making of pharmaceutical and other preparations such as pestles and mortars, cauldrons and scales. Other furnishings include mirrors and lighting devices, for instance lamps, lampstands and candlesticks. Finally, there are many inkwells and pen boxes. These objects were essentially destined for personal use, in private spaces, or for receptions and feasts. Some objects such as candlesticks may have nevertheless been displayed in public spaces. The DAI collection is characterised by the very diverse status of the objects, ranging from utensils produced in quantity to individual masterpieces, such as those inlaid with copper and silver by a 'painter-inlayer', sometimes created for a particular patron. All these objects are representative of the artistic and material culture of an urban and literate society of intellectual elites or merchants from across the pre-Mongol Iranian world. Metalwork objects, especially those made with a more or less golden yellow copper alloy, are part of the specific history of the period defined by the working of metal in sculptural forms; of relief, embossed or open work; of polychromy and surface effects produced by chasing and inlaying black bituminous material and red and white metals, copper and silver. The designs decorating these surfaces include calligraphy, vegetal ornaments and figural scenes where the cosmic figure of the ruler is juxtaposed with real and imaginary animals. The visual and written language that is in dialogue with the objects introduces us to a culture of sign and analogy. It is the histories of these objects that are discussed in this volume, where one or several interpretations of their cultural contexts, their functions, and their uses are proposed.

It is to be hoped that the research on this collection, begun in 2013 and culminating in this publication, will be found to be innovative and to throw new light both on the medieval Iranian world and the art of metal. The authors of *Precious Materials* hope it will be seen as a continuation of two of the most important studies of medieval Iranian metalwork: *Persian Metal Technology* by J.W. Allan (1979) and *Islamic Metalwork from the Iranian world, 8th–18th Centuries* by A.S. Melikian-Chirvani (1982). The pre-Mongol collection of metalwork in the Louvre is published not as a *catalogue raisonné* but as an analytical study that proposes a global perspective on medieval production (Chapter 1); the first complete technical analysis of the collection (Chapter 2); a presentation of the collection in light of the centres and regions of production that were revealed via archaeometallurgical studies (Chapters 3 and 4); and through the possible socio-cultural contexts of the objects' use and their significance (Chapter 5). The numerous photographs in this book are the images produced for the research project, a multidisciplinary study where art history and archaeological, archaeometallurgy and textual sources were used to present this important cultural heritage to the public, to specialists and to visitors to the Louvre.

1 Quotation from a poem attributed to Khayyam in Melikian-Chirvani 1996, 97. For the text in Persian, see pseudo-Khayyam, *Nowrūz-nāma*, ed. A. Hosuri, Tehran, 1978.
2 Flood, 2019.
3 Musée du Louvre/ Centre de Recherche et de Restauration des Musées de France (C2MRF) /Roshan Cultural Heritage Institute, 2013–17 .

THE COLLECTION

The Département des Arts de l'Islam (DAI) brings together the collections of the Louvre and the Musée des Arts Décoratifs (MAD).[1] The latter collection was displayed at the Louvre from 2006 as part of the reinstallation of the Islamic art collections in the Visconti wing, completed in 2012. As a result of their institutional histories, these two collections are both similar and complementary. As the Louvre holds a larger share of metalwork predating the thirteenth century, it supplements the metalwork collection of the MAD. All but four of the objects published in this volume are from the Louvre collection. In many respects, however, the collections are similar and contain objects dating from the fourteenth to the nineteenth centuries, often of the same type and acquired through the same channels.

Today's collection is the result of nearly 150 years of acquisitions. It is composed of purchases, donations and bequests, obtained primarily through commercial channels rather than archaeological excavations and surveys. It nevertheless constitutes a collection that is fairly consistent and representative of the material and artistic cultures of the Iranian world from the tenth century to the early 1220s. Amongst the objects included in this volume, two inkwells inlaid with precious metals are the first objects to have entered the collection (cat. nos. 5, 6). They were given to the museum in 1893 by the Parisian collectors Clothilde Duffeuty and Marie Arconati Visconti. From the 1890s onwards, the Louvre and Musée des Arts Décoratifs acquired large numbers of Persian artefacts that included metalwork.[2] Many of the objects that entered the Louvre between the end of the nineteenth century and the 1920s were acquired through the services of different connoisseurs, collectors and dealers. Yet more were acquired from networks established for the export of commercial excavation findings organised by, or for, dealers in Iran and Afghanistan. Raoul Duseigneur (1845-1916) acted as an adviser for several large Parisian collections that were eventually acquired by the Louvre (including that of his partner, the Marquise Arconati Visconti, and that of Clotilde Duffeuty).[3] Objects directly acquired from Raoul Duseigneur also entered the museum's collections. These include a group of nine objects that he sold to the Louvre which may have been part of a larger, more important corpus that, according to the inventory records, came from 'Sistan, in Oriental Persia' in 1908. This is one of the rare groups of objects for which we have a regional provenance, if not a precise geographical origin or archaeological context.

Ten objects from the Hackin archaeological missions in Afghanistan constitute a second group with a known provenance, and thus can also serve as a reference group. This group of

objects entered the Louvre's collections in the 1930s, directly transferred by Joseph Hackin (1886-1941), or arriving in 1937 as a donation from the Citroën Museum. The car company acted as sponsor for the 'Citroën Trans-Asiatic Expedition', also known in this period as the 'Croisière Jaune', headed in Afghanistan by the archaeologist Joseph Hackin. Besides acting as curator at the Musée Guimet from 1923, Hackin served as director of the French Archaeological Delegation in Afghanistan (DAFA) from 1934.[4] He travelled to Afghanistan in 1924 for the first season of the archaeological excavation, and returned for a second season in 1929. Hackin led the Citroën expedition from 1931 to 1932 and continued his archaeological work in Afghanistan until 1940.[5] Hackin's research took him to Bamiyan, Kabul and Sistan. Only the wider region of Afghanistan is known for certain objects Hackin brought back from his excavations. For other objects, the provenance is more precise as we know that they were uncovered in Ghazna, or in one case, Bamiyan.

Other objects from Afghanistan, such as those purchased in Kabul, entered the museum's collections later, following the sale of collections by diplomatic agents posted in Afghanistan (cat. nos. 2, 11, 23, 62, 63). For the most part, the provenance and history of the pre-Mongol objects in the DAI are unknown. They were bought on the art market, primarily in Paris, between the end of the nineteenth century and the end of the 2000s. Most of the objects in the pre-Mongol collection were acquired individually, or in small groups of two to five, over the decades. The largest ensemble of objects remain those acquired by Raoul Duseigneur and Joseph Hackin, respectively from Sistan and Afghanistan.[6]

Pieces of pre-Mongol metalwork that entered the Louvre before 1920 came via donations, bequests and purchases from important Parisian collectors and dealers whose names are familiar to connoisseurs of Persian or 'Muslim' art, as Islamic art was known in the early twentieth century. From 1890 to 1917, twenty-two objects were acquired either directly or indirectly on the market, from the above-named collectors as well as from Eugène Piot, Michel Boy, Comte Isaac de Camondo, Georges-Joseph Demotte and Georges Marteau.[7] The most remarkable objects acquired in the early twentieth century also came from the bequest of Charles Piet-Lataudrie (cat. nos. 3, 8).[8] Donations made in this same period to the MAD were from Jules Maciet,[9] except for one object formerly in the collection of Octave Homberg.

Besides the objects acquired from Hackin's missions, in the inter war period thirteen pre-Mongol metalwork objects were bought in Paris from collectors and dealers of Armenian origin (Hagop and Garbis Kalebdjian, Agop Indjoudjian) or with ties to the art market in Iran (Charles and Emile Vignier, Georges Joseph Demotte). The dealer Ayoub Rabenou, who was based between Tehran and Paris where he ran a gallery, also played an important role in collecting in this period through his connection to Arthur Upham Pope. In 1925, Roland de Mecquenem, who was excavating at Susa, purchased objects including metalwork while in Iran. It was also at this stage that the Louvre curators Gaston Migeon and David David-Weill donated objects, and pieces formerly in the Musée de Cluny were also added to the collection.

Over the course of the 1950s, the collection grew more slowly, with only a few purchases made in Paris, including one object from the Jacques Acheroff collection, and bequests from Félicité Ménard and Comte François Chandon de Briailles. In the 1960s, pieces of pre-Mongol metalwork began to be acquired through public auctions in Paris. The most significant object to enter the collection at this time, a ewer formerly in the Joanny Peytel collection, was sold at Drouot in 1965 (cat. no. 7). Purchases from the Parisian auction house Drouot, often through the Galerie Jean Soustiel, made up most of the acquisitions between the 1970s and 1990s, when the Islamic

section of the Département des Antiquités Orientales was directed by Marthe Bernus-Taylor. Their choice was driven by the wish to improve the collection through the acquisition of types of objects representative of pre-Mongol production in Khurasan. The opening of the Grand Louvre and the inauguration in 1993 of the Islamic Art galleries in the Richelieu wing was significant in that it motivated the growth of the collection through the purchase of objects available on the Parisian art market.

Few metalwork objects from the Iranian world have been acquired by the department since the late 1990s. Other parts of the DAI collection have been prioritised, and the acquisition of objects from heavily looted zones such as Afghanistan has been avoided unless they originated from ancient collections. Nevertheless, two objects were purchased on the Parisian art market in 2000 (cat. nos. 28, 37) and a donation, of which seven objects are included in this book, was accepted in 2009 (cat. nos. 18, 22, 26, 27, 75, 77, 78).[10] The most recent acquisition of medieval Iranian metalwork was an exceptional object with a known provenance, a pen box signed by an inlayer from Herat, acquired in 2010 at a public auction in Germany (cat. no. 2).

The Range of the Collection

A museum collection expands with the aim of becoming representative in a particular field. In the case of the Louvre, the museum's aims are informed by how best to exhibit the collection to the public, presenting what is known and defined as characteristic of a period in a given geographical area through knowledge accumulated in archaeology and research. From the 1970s to the present, this has been the prevailing logic behind the displays of Islamic art at the Louvre: objects are exhibited in historical and chronological sequence to illustrate changes and advances in the study of Islamic art and culture. This museological approach, as demonstrated by the major Paris exhibitions and the permanent displays of the Louvre, has changed considerably since the displays were installed before World War II.[11] Recently it has proved difficult to expand the medieval Iranian collections any further because of the doubtful provenance of many of the objects on the art market and the illegal trafficking and looting of objects, particularly in Afghanistan. Despite this, the department has sought to acquire objects that embody known types and characteristics of artistic production from a period in the pre-Mongol Iranian world that is sometimes referred to as 'Saljuq'. With regard to the art of metal, the material culture of this period was largely defined by Umberto Scerrato in the 1950s and 1960s, and by Asadullah Souren Melikian-Chirvani and James Allan in the 1970s and 1980s. The Louvre's choice of acquisitions and its exhibition strategy have been dominated by two questions: what do we know about this culture, and how best can we represent it in the DAI's collection of Islamic art?

The work of the scholars cited above, along with archaeological excavations, have informed much of what we know of medieval Iranian metalwork from the period preceding the Mongol invasions. Many of the objects were produced in Khurasan, a vast and historic region encompassing eastern Iran, as well as well as parts of Afghanistan and Central Asia (fig. 1). The material and artistic culture of this region constitutes the basis of what we presently know about the art of metal before the thirteenth century; little is known of any production from central and western Iran before the fourteenth century.

While the stratigraphy and precise dating of the metalwork uncovered in Susa is unknown, the material nevertheless constitutes an unparalleled (though largely unpublished) corpus of

copper alloy production from western Iran for the period between approximately the ninth and the eleventh centuries. Moreover, the study of astronomy and the manufacture of instruments related to its practical applications are well documented in Isfahan, as illustrated by astrolabes signed by astronomers or instrument makers from the city between 364/984 and 618/1221-22.[12] Melikian-Chirvani has been largely responsible for the definition of what he calls the 'Khurasan School' on the basis of the region's importance for the development of metalwork in the period from the tenth century to the Mongol invasions of the 1220s. He has identified this region as central to the formation of a distinctive medieval culture. Objects from Khurasan are frequently found in museums and private collections, as well as on the art market, and are also found in archaeological excavations. Indeed, objects found in an archaeological context have provided some of the best information on the material culture of the period. In Khurasan, the best-known sites remain Nishapur in eastern Iran and Ghazna in Afghanistan, and to these we can add material from Herat originating from the site or the region and presently in the city's museum.[13] The archaeological findings preserved in Afghanistan and Iran constitute reference collections. A portion of the material found in Nishapur is currently at the Metropolitan Museum of Art in New York. The site was excavated by American teams in the 1930s and the metalwork was published by Allan.[14] Metalwork objects with precious inlays and inscriptions documenting the names of the makers, as well as the date and place of manufacture, were added to this already large ensemble. These reference pieces are mainly held in large public collections, particularly the Hermitage Museum in Saint Petersburg.

The DAI holds one of the largest European collections of medieval Islamic metalwork, on a par with the collections in the Museum of Islamic Art in Berlin, the British Museum, and the Victoria and Albert Museum (V&A),[15] each of which is comparable to that of the DAI both in terms of the types of objects from the pre-Mongol period, and of the collection histories.[16] Each collection contains individual works that stand out from the mass-produced objects because of their exceptional size or their extremely luxurious materials (including precious metals) or because they include the signatures of their makers. These collections are unevenly published, however. The collection in the Berlin Museum of Islamic Art is accessible online and includes approximately one hundred objects from the pre-Mongol period; it was partially published in 1985.[17] The V&A's collection was fully published in Melikian-Chirvani's catalogue entitled *Islamic Metalwork from Iranian Lands: 8th-18th Centuries*; this book is still the main reference publication on the subject and features detailed studies of 175 objects.[18] In the United States, the largest collection of pre-Mongol metalwork is in the Metropolitan Museum of Art. Excluding the Nishapur material, this collection contains around one hundred exceptional objects, namely those with inlaid metalwork.[19]

FROM GASTON MIGEON TO ISLAMETAL: STUDIES OF THE COLLECTION
Published Objects

Between the end of the nineteenth and the beginning of the twenty-first centuries, two thirds of the DAI pre-Mongol metalwork collection was published, either individually or in small groups,

the majority of pieces only once; one third remained unpublished. Objects that were famous at the end of the nineteenth and the beginning of the twentieth centuries have remained so: the five most frequently published and illustrated metalwork objects are large and, most importantly, inlaid (cat. nos. 3, 4, 8, 52, 53); defined as 'masterpieces', they have overshadowed more modest objects. Indeed, the tendency is usually to focus on objects featuring complex ornamentation, often considered the most beautiful, not to mention the most decorative.[20]

From the nineteenth century to 1945, the Islamic art collection at the Louvre was held in the Département des Objets d'Art. Gaston Migeon (1861-1930), the eminent curator of the collection between 1902 and 1923, was the main author of publications on the collection. In 1899, he included two objects belonging to Charles Piet-Lataudrie (cat. nos. 3, 8) in two articles on inlaid metalwork published in la *Gazette des Beaux-Arts*.[21] Inlaid metals, at that point considered to have been produced in Mosul in Iraq, were placed under the category of 'Arab Art'. Metalwork from pre-Mongol Khurasan was not yet well identified, and the notion of 'Persian Art' was still in its infancy in Europe and the United States.[22] Migeon was one of the authors of the descriptive catalogue of the *Exposition d'Art musulman*, which he also entitled *Exposition des arts de l'Islam*, an exhibition held at the MAD in 1903. He also wrote several articles which allowed him to advance his research on certain groups of objects.[23] Organised by medium, the objects in *Exposition des arts de l'Islam* were loaned to the museum by prominent Parisian collectors. The candlestick with repoussé ducks (cat. no. 3) was subsequently featured in *Les Arts*.[24] Admired by Migeon and coveted by him for the Louvre, this masterpiece from Piet-Lataudrie's collection was bequeathed to the museum in 1909; it remains one of the most famous objects in the DAI.

In 1904, the great scholar Max Van Berchem (1863-1921) began to publish inscriptions in the *Journal Asiatique*.[25] These showed that inlaid metalwork dating from the end of the twelfth to the thirteenth centuries belonged to an 'Oriental group', and more specifically was produced in Khurasan. Van Berchem deduced this from an inscription on Piet-Lataudrie's ewer (cat. no. 8), and another on a bowl in the Peytel collection with the name of a dignitary from Khurasan;[26] these were the first inlaid objects to be identified as belonging to the Iranian world. The first major international exhibition of Islamic art, the largest to date, was held in Munich in 1910. A three-volume catalogue in large format was published in 1912, with one volume dedicated entirely to photographs of the objects. Featuring 500 works, this was the first catalogue of Islamic art.[27] The exhibition included 300 metalwork objects, loaned by the largest public and private European collections. This remarkable endeavour allowed for the better identification of metalwork from Khurasan, and the most noted example of pre-Mongol metalwork, the Bobrinsky bucket, astounded both scholars and collectors with its beauty and historical significance.[28] Migeon's article in *Les Arts* was nevertheless very critical of the exhibition, citing its 'incoherence and lack of taste', in a space that he likened to a 'hangar or a caravanserai'. The prominent collector and donor Raymond Kœchlin (1860-1931), who similarly disliked the aesthetic of the Munich Secession, referred to metalwork in his review. Migeon who co-signed Kœchlin's review with Hugues Krafft, wrote:[29]

'Amongst the copper objects, of which Paris can be proud to have the most beautiful collections, the most resplendent are those sent by M.M. Peytel, Paul Garnier, Edmond Guérin, Raymond Kœchlin, Baroness de Gléon and the Musée des Arts Décoratifs.'

Included among the medieval masterpieces of inlaid metalwork exhibited in Munich were

objects from Kœchlin's collection that were donated to the Louvre in 1932, along with a candle -stick signed by Dawud ibn Salama from Albert Goupil's collection that was bought by the MAD.[30] However, no metalwork from the Louvre was included. Only Peytel's ewer, acquired by the museum much later, was published in the catalogue (cat. no. 7);[31] it also appeared in Migeon's article in which he attributed the object to pre-Mongol Iran by comparing it to the Piet-Lataudrie's ewer which had entered the Louvre's collection in 1909 (cat. no. 8).[32]

In 1922, Migeon's two-volume publication, *L'Orient Musulman* catalogued, by medium, the collection of Islamic art in the Département des Objets d'Art. Most of the pre-Mongol metalwork from the collection was included and some pieces were illustrated.[33] However, as had been the case in the early 1900s, some were not linked to the Iranian world. Thus, Migeon labelled the 'incense burner in the shape of a parrot' (cat. no. 52), as 'Egyptian Art, 12th Century' both in the catalogue as well as in his 1905 article in the *Gazette des Beaux Arts*. In the same article, without illustrating the zodiac ewer (cat. no. 4), Migeon attributed it to thirteenth-century Mesopotamia.[34] In 1922, the ewer was published under the same label, as at that point Mosul dominated the attribution of inlaid copper alloy objects, which were always categorised as 'Arab'.[35]

In 1931, the *International Exhibition of Persian Art* was held in London, the first international exhibition of 'Persian Art' in Europe.[36] The exhibition was sponsored by King George V and Reza Shah Pahlavi, and conceived by Arthur Upham Pope (1881-1969), a noted figure in the field of Persian art who served the nationalist ideal constructed by the Iranian state.[37] The pre-Mongol objects in the exhibition were included in the section dedicated to Islamic art and labelled as originating from 'northeast Persia'.[38] The lamp with a figure leading two horses (cat. no. 44) was in the exhibition, and perhaps also the caracal (cat. no. 53) which was then in the possession of the Paris dealer Agop Indjoudjian and subsequently belonged to David David-Weill who donated it to the Louvre in 1933. The stand with griffins (cat. no. 45) was displayed in the same gallery.[39] Gallery III, where a plethora of pre-Mongol ceramics was exhibited, does not seem to have contained any inlaid metal pieces. Following the pivotal period of the early twentieth century, the monumental *Survey of Persian Art from the Prehistoric Times to the Present* (SPA), published in 1938–39 by A.U. Pope and P. Ackerman, testified to the establishment of the notion of 'Persian Art' and of works considered to belong to it.[40] Volume IX, with illustrations of metalwork, included ten pieces from the Louvre's pre-Mongol holdings, including amongst the objects without metal inlay: the stand with griffins (cat. no. 45), the lamp with a figure leading two horses (cat. no. 44), the caracal (cat. no. 53) and two mirrors (cat. nos. 68, 74). Inlaid objects included the already well-known ewers (cat. nos. 7 and 8), an inkwell (cat. no. 6), the tray with astrological decoration (cat. no. 10) and the zodiac ewer (cat. no. 4).[41] The types presented in the volume still dominate today's study of pre-Mongol metalwork, illustrating the fundamental and long-lasting influence of Pope's work on attitudes to the artistic production of the Iranian world. The main types of metal that were identified and acquired by important collectors and museums were catalogued in the *Survey*. The objects, in both the text and accompanying volume of images, were organised into two sections, with inlaid and non-inlaid copper alloys in one, and precious metals in another. Key dated and signed objects labelled as 'Persian Art' preceded the section on gold and silver vessels.[42] This catalogue reflected the progress that had been made in identifying metalwork from the Iranian world. Objects more within the scope of the Middle East were also included. Following Pope's dating scheme, until the end of the 1990s a ewer was exhibited in the Louvre in a display case dedicated to Iranian Saljuq art, when it is in fact more closely linked to thirteenth-century pro-

duction in the Middle East.[43] There was thus a reversal of primacy: the atemporal, and artistic genius of Persian Art, although subject to periods of apogee and decline, sometimes absorbed 'Arab art' and the works whose existence were owed to it, inspired by the 'innate Persian sense of beauty'.[44] Ralph Harari wrote a chapter on Persian Islamic metalwork and attributed the most famous piece of inlaid Mamluk metalwork—the Louvre basin known as the 'Baptistère de Saint Louis'—to the Mongol period and to an artist who was 'probably Iranian'.[45] This notion, long since revised, emerged in this period: in 1974, Marchal proposed the notion of 'Irano-Islamic' art, following Oleg Grabar's theory that Khurasan was the founding region of an 'Iranian Islamic Art'.[46]

Jean David-Weill (1898-1972) was curator of the Département des Antiquités Orientales in 1938, and again from 1945 until the late 1960s. As an Arabist who specialised in epigraphy, David-Weill focused very little on the metalwork of the Iranian world. Nevertheless, he published the most important acquisitions that took place under his direction: the incense burner stand with caracals (cat. no. 54) and two cauldrons (cat. nos. 82, 83).[47] In the 1970s, Melikian-Chirvani published the only existing studies on the metalwork collections at the Louvre and the MAD, which among others, included the pre-Mongol material. He discussed the objects and their inscriptions in two exhibition catalogues and a series of articles in *Studia Iranica* and argued for Khurasan as their place of production. In the following decade he developed and refined this idea. In *Arts de l'Islam, des origines à 1700 dans les collections publiques françaises*, Melikian-Chirvani discussed nine well-known objects in the section entitled 'Bronzes du Khorâssân'. Although the pieces had been previously published, he provided a great deal more information on them, as well as translations of unpublished inscriptions and an additional bibliography. His entries on two zoomorphic incense burners (cat. nos. 52, 53), the ewer formerly in the Peytel collection (cat. no. 7), whose central inscriptions he linked with a ewer dated 586/1190-91 (cat. no. 8), the candlestick with ducks in the round (cat. no. 3), the zodiac ewer (cat. no. 4) and the stand with griffins (cat. no. 45) enrich the previous publications of the objects.[48] He also revisited a recently acquired cauldron (cat. no. 83), previously published by David-Weill.[49] His exhibition, *Le bronze iranien* at the Musée des Arts Décoratifs, assembled inlaid and non-inlaid objects from the Louvre and the MAD in a section entitled 'Large workshop of Khurasan (eleventh to the beginning of the thirteenth century)'. Previously unseen objects from the two collections were exhibited with the well-known caracal (cat. no. 53).[50] His articles on the Khurasan bronzes referenced objects from the Louvre, thus one on repoussé decoration led him to republish an object from the Hackin mission (fig. 9).[51] In 1976, he published the inscriptions on one of the inlaid trays (cat. no. 11), formerly in the collection of André Nègre, and linked it to a group of similar objects.[52]

While Melikian-Chirvani was primarily concerned with metalwork from pre-Mongol Khurasan, Henri Marchal wrote the only article bringing together twelve of the sixteen unpublished metal objects from Sistan, acquired, on the one hand by Raoul Duseigneur, and on the other during Joseph Hackin's missions in Afghanistan.[53] He described the objects and transcribed and translated some of the inscriptions; most belong to well-known types and are described as such. With this article, Marchal contributes a rare study examining more 'modest' production, little studied by comparison with zoomorphic sculpture and masterpieces inlaid with precious metals.

Contributions by staff members of the Islamic department of the Louvre and then the DAI were published on the occasion of the opening of the Islamic Art galleries in the Richelieu wing in the Grand Louvre in 1993, and more recently for the opening of the galleries in the Visconti court in 2012. Exhibition and acquisition catalogues are obvious triggers for the publication of objects

from the collection. The first large exhibitions of Islamic art at the Louvre, under the direction of Marthe Bernus-Taylor, were entitled *Arabesques et Jardins de Paradis* (1989), and *L'Étrange et le Merveilleux en terres d'Islam* (2001). Their thematic approach, highlighting notions of ornament and iconography, led to the display of familiar examples of pre-Mongol metalwork,[54] but also of previously unpublished objects.[55] Under the direction of Sophie Makariou, the exhibition catalogue of *L'apparence des cieux. Astronomie et astrologie en terre d'Islam* (1998) focused on iconographic themes featured in the museum's collection of inlaid metalwork.[56] *Arts de l'Islam*, a catalogue which presents more than a decade of acquisitions by the DAI, includes the publication of eighteen pre-Mongol metal objects purchased between 1988 and 2001, most of which had never previously been displayed.[57] Finally, *Les Arts d'Islam au Musée du Louvre*, released on the occasion of the inauguration of the new galleries in the Visconti court, offered the opportunity to republish three masterpieces from the collection of the pre-Mongol metalwork, and to illustrate other well-known objects.[58]

Archaeometallurgy: the ISLAMETAL project

While two thirds of the pre-Mongol collection was published before 2013, only twenty-two metal objects were subjected to technical analysis. Research led by the Laboratoire de recherche des musées de France (now C2RMF) between 1974 and 1978 focused largely on alloy analysis. The study of metal inlays was impossible before the development of the AGLAE (Accélérateur Grand Louvre d'analyse élémentaire) particle accelerator, which performs analysis without sampling. Methods of shaping metal have been studied very little, with the exception of five X-rays completed between 1976 and 1978 on objects acquired on the art market. Most of the alloy analyses were performed at the request of James Allan while he was preparing the publication of his thesis, '*Persian Metal Technology 700-1300*'.[59] Only objects with a specific archaeological provenance were analysed at this juncture, such as the previously mentioned material from Sistan and Afghanistan. These analyses established the definition of certain alloys but followed a terminology that has since been modified both by the British Museum, and by ISLAMETAL, a subject discussed in Chapter 2.[60] Since the 1970s, the possibilities for technical analysis have significantly increased, particularly for the identification and tracing of impurities in copper. The characteristics of the alloys and their 'signatures', in other words the impurities in the metal, have been studied and interpreted thanks to machines developed by the C2RMF. This type of analysis has allowed materials to be grouped according to their similarities. Copper and silver inlays have been analysed for the first time and the results cross-referenced with the results of the alloy analyses; in certain cases, this has led to the identification of the same materials in both the alloy of the body and the inlay of the decoration. The new findings, impossible to establish by the naked eye, have led to a re-grouping of the objects. More generally, analysis of the material and its impurities has encouraged new hypotheses and areas of inquiry with regard to the organisation and production system of copper alloy objects.

These hypotheses have also benefited from a systematic and exhaustive examination of the objects with the naked eye, under a digital microscope and with X-rays. The interpretation of techniques for shaping and for applying surface ornament has led us to suggest ideas for the organisation of metalwork production. Casting metalworkers and coppersmiths used clearly distinct skills; the place and status of chasers and inlayers within the system was less easy to define.

The study of shaping techniques and of surface decoration has also led to technical comparisons with other products from the pre-Mongol Iranian world, particularly ceramic vessels and furniture, as well as stucco sculpture and reliefs.

The ISLAMETAL project (2013–17) was the result of a collaboration between the Louvre and the C2RMF, with the support of the Roshan Cultural Heritage Institute between 2014 and 2016. Its primary aim was to develop a new approach to the study of the metalwork collection, with its full publication as the first goal. The project participants: David Bourgarit (a researcher in archaeometallurgy from the C2RMF), Ziad el-Morr and Vana Orfanou (archaeometallurgy researchers, fellows of the Roshan Cultural Heritage Institute in the DAI), as well as the author of this volume, decided to focus first on metalwork datable to the pre-Mongol period, defined as the beginning of the tenth to the early thirteenth centuries, a collection of around one hundred objects representing nearly 43% of the DAI's collection of metalwork from the Iranian and Indian worlds spanning the tenth to the nineteenth centuries. The pre-Mongol corpus was defined according to well-known archaeological and art historical criteria, as well as the style of the objects and their associated inscriptions. It was subdivided into sixteen types established according to morphological and/or functional criteria and in the case of the high tin bronze objects, by the nature of the copper alloy. Several comparative objects were added to the study: some findings from Susa in western Iran, pieces from the Middle East with a documented local or regional provenance, and objects from the V&A catalogued by Melikian-Chirvani that were very close to examples from the DAI. The ISLAMETAL project benefited greatly from the expertise of Susan La Niece who, with Rachel Ward, examined a sizeable part of the British Museum's metalwork collection. Over the course of the research, nine of the DAI's objects were removed from the statistical analysis,[61] as they revealed themselves to be forgeries, of dubious authenticities, or too over-restored to be included in the investigation.[62] Other objects, such as a number of masterpieces of silver inlaid high tin bronze that were previously considered to form part of the pre-Mongol collection, will be published in the second volume of the catalogue of metalwork from the Iranian world, as their study led to a reappraisal of their dating. This re-evaluation of the objects underlines the importance of X-ray and microscope observation in the expertise of a collection.

In order to collect the archaeometallurgical data, the objects were subjected to a range of tests and analyses including X-rays, endoscopies, sampling, analysis by ICP-AES (Inductively Coupled Plasma–Atomic Emission Spectrometry) or by PIXE (Particle Induced X-Ray Emission), and observation under a microscope. The criteria for deciding on the correct method were determined by the ISLAMETAL partners, following the questions posed according to the criteria of the condition and integrity of the objects, particularly in light of analyses requiring sampling. Given the number of objects, their typological diversity and the wide scope of the collection, the team established three research principles on the basis of technical, archaeological, epigraphic, historical, and stylistic data with the aim of:

— Attempting to identify the geographical provenance of the objects, using newly established data on the composition of the alloy, the inlay, impurities in the copper and techniques of shaping and decoration.

— Attempting to characterise the centres of production. Certain objects with a known find site, with inscriptions, or with distinctive technical features permit the identification of centres of production such as Herat and Ghazna in Afghanistan.

— Comparing the materials and techniques of specially commissioned objects to mass-pro-

duced examples. The objective here was to determine if the status of the object was likely to influence techniques used for its production. We focused on investigating correlations between the shaping technique and the type of alloy used. More generally, the identification and characterisation of the three-sided relationship between the nature of the technical process, the type of alloy, and the quality of the object contributes greatly to the understanding of the functioning and organisation of methods of production. Thus, it is now possible to determine whether a particular type of object was made in one or more workshops and/or regions; or if there exists a direct correlation between a type of alloy and the function of an object.

The analysis of the materials, and the interpretation of the data obtained from the alloys, the inlays and the impurity of the copper, have allowed us to reconsider, or to specify, the attribution of certain pre-Mongol metalwork objects from the DAI. These proposals for new attributions are based on the grouping of objects around metalwork pieces that stand as key reference points, that are linked to a particular urban centre by a consensus of attribution as in the case of Herat, by archaeological data as with Ghazna, or by the hypothesis of the existence of a third group that is still poorly identified but merits a mention, as in the case of Bamiyan. We therefore propose that the use of certain identical materials that we have identified on various objects in the collection allows us to establish the 'signature' of a centre of production, or those of a group of objects from the same production system. This theory is open to debate: identical materials may have been used in different production centres relying on the same supply sources, while one centre may have relied on several sources or supply channels for raw materials or alloys, or various networks of primary material or alloy supply. The technical study of the shaping techniques and ornament of the objects, considered alongside material analyses and their interpretations, consolidated or qualified the evidence for the proposed groups. Traces of tools, and techniques associated with them such as hammering or casting, as well as cold worked decoration such as chasing, were found to be characteristic markers of groups of objects linked to two major production centres at Herat and Ghazna.

The results and hypotheses that emerged from this research are presented in this volume. Some add to our knowledge of the provenance, networks, and systems of production of pre-Mongol metalwork. Others are more of a starting point, requiring further study in other museum and archaeological collections. The research undertaken permitted us to propose new groupings for twenty-six objects and added new information on fifty-eight others. While the archaeometallurgical study did not reveal sufficient evidence to give the fifty-eight a specific 'signature', their technical study nevertheless considerably added to the data and possible interpretations. With the exception of certain well referenced archaeological objects, they are presented not by identified centres of production and circulation in Khurasan (Chapters 3 and 4), but by type, in thematic entries more related to the functions of the objects (Chapter 5).[63] In Chapter 5, they are categorised according to themes relating to their function: the objects are discussed according to their possible domestic or commercial uses, providing further information on their social context. Based on their shapes and decoration, furniture, vessels and utensils are grouped according to their potential meaning and significance, and their material and symbolic importance are discussed.

Notes

1 Located in the Palais du Louvre, pavillon de Marsan.

2 On the Islamic art collections in Paris, in the MAD and Louvre at this period see Labrusse, ed., 2007, 64–74, 310–22; Makariou ed., 2012, 11–19, 26–31.

3 Migeon et al, 1917, Baal 1981.

4 The Délégation Archéologique Française en Afghanistan (DAFA) was established in 1922.

5 Cambon et al., 2018, 26–31, 33–34, 42–43, 54–57.

6 The 2009 Pantanella-Signorini donation included thirteen objects from the pre-Mongol period; after examination or chemical analysis it was decided to remove six of them from this study.

7 To this collection can be added a group of gifts and purchases made thanks to the impetus of Gaston Migeon, curator of 'Muslim arts' at the Louvre between 1890 and 1923: a 1894 gift from Dr Fouquet in Cairo, a purchase made by Migeon in 1907 and a gift from the Société des Amis du Louvre in the name of Baroness Delort de Gléon in 1907, a purchase from M. Rosenberg in 1910.

8 Lucas, 2007.

9 See Day, 2007, for information on Jules Maciet (1846–1911) and his gifts to the MAD.

10 See note 6 above.

11 These displays were largely based on the grouping of objects by material in a concept derived from the decorative arts, but also on the distinctions between the categories that have defined 'Muslim Art' since the nineteenth century, in particular 'Arab Art' and 'Persian Art'. See note 22 and articles by Contenau, 1922 and 1923 on the new galleries of 'Muslim Art' at the Louvre; see also the catalogue by Migeon, 1922. On the history of the collection and its displays, see Labrusse, ed., 2007 and Makariou, ed., 2012.

12 Allan, 1979, 55; Allan and Kana'an, 2017, 453–56.

13 Tissot, 2006; Franke and Müller-Wiener, eds., 2016.

14 Allan, 1982A.

15 The collection of the Linden Museum in Stuttgart has a significant collection of pre-Mongol metalwork, but its acquisition is recent; assembled from the beginning of the 1970s, it has been largely bought in Afghanistan; Kalter and Pavaloi, 1987.

16 Roxburgh, 2000.

17 von Gladiss and Kröger, 1985, 1–63.

18 Melikian-Chirvani 1982A, 14; fewer than ten objects were omitted from his study. No objects have been added to the collection since this publication (2017 communication with Moya Carey, former curator of the Iranian world collections at the V&A).

19 The collection is accessible online and has been partly published; Canby et al, 2016, Ekhtiar et al, 2011.

20 On the concept of Islamic art as decoration, see Necipoğlu, 1995, 61–71, 2007 and 2016; Shalem, 2017.

21 Migeon, 1899 and 1900.

22 On the racial classification of art in nineteenth-century Europe, the notion of Semitic/Aryan art and its use in the early twentieth century by European scholars and the Iranian power, see Grigor, 2005 and 2009.

23 Migeon, 1903A and 1903B.

24 Migeon, 1903A, 15.

25 Van Berchem, 1904, 27.

26 Louvre, DAI, MAO 503, gift of Nicolas Landau, 1976, Van Berchem, 1904, 28.

27 On the exhibition and its historiographic importance, see Lermer and Shalem, eds., 2010.

28 Migeon, 1910, 20, although the manufacturing date was read by Van Berchem as 544/1150 and not 559/1163.

29 Migeon, 1910, 6, 20; Koechlin 1910, 256.

30 See the ewer signed Ibn Mawaliyya al-Mawsili from the Koechlin collection, Louvre, DAI, K3435 and the candlestick in the MAD, AD 4414; Collinet, 2001, 116–17. For the Albert Goupil collection, see Paris 1888.

31 Sarre and Martin, 1912, pl. 151, cat. no. 3036.

32 Migeon, 1910, 16, 21.

33 Migeon, 1922, no. 37, 14, pl. 15; no. 38, 14, pl. 17; no. 41, 15, pl. 14; nos. 42. 43 and 46, 15, pl. 16; no. 47, 15; no. 64, 20, pl. 21; no. 65, 20; no. 67 p. 20, pl. 23; no. 69, 20, pl. 24; no. 70, 21, pl. 23; no.75 p. 22. pl. 27; no. 80, 22, pl. 17.

34 Migeon, 1905, 451–52, 454–55.

35 Migeon, 1922, no. 70, 21, pl. 23.

36 London, 1931A and 1931B; Robinson, 2000; Wood, 2000. See Rizvi, 2007, 48, for the Philadelphia Exhibition in 1926.

37 Rizvi, 2007.

38 In Gallery II which exhibited objects from the Sasanian, early Islam and the Saljuq periods.

39 For the following three objects: London, 1931A, no. 74b, 48; no. 74e, 49 whose description corresponds to the incense burner: present cat. no. 53 'a lion with turquoise-inlaid eyes, height 28 cm'; and no. 77R, 54, where there is a reference to 'J.J. Marquet de Vasselot, Persian copper, Beaux-Arts, fig. 297.'

40 On this book, see Kadoi, ed., 2016 and Rizvi, 2007. On the trading and collections of Persian art, notably the cases of Marteau, Vignier and Demotte, see articles by J. Talbot, C. Maury and C. Vivet-Péclet in Maury, ed., 2019.

41 The caption for pl. 1284B was swapped with the one for pl. 1284C; pl. 1287A; pl. 1297; respectively pl. 1302A and B; respectively pl. 130A and D, this last belonging to the Peytel collection; pl. 1311F; pl. 1315A; pl. 1328.

42 Harari in *SPA*, 2489–91; 2519–21; 2526–28.

43 Inv. OA 7484, Pope, vol. IX/1, pl. 1282B.

44 Rizvi, 2007, especially 54–60. Harari, *SPA*, 2515, 2466. On the hierarchy of arts based on the racial theory of the superiority of Aryan/Iranians versus Semites/Arabs, see notes 11 and 22.

45 Pope, vol. VIB, 2466–529, especially 2477 and 2499. Harari also considered the bowl formerly in the Marquet de Vasselot collection (MAO 331), which is signed by Muhammad ibn al-Zain, the inlayer who signed the basin named as the 'Baptistère de Saint Louis', a Mamluk metal piece made in Egypt or Syria, c. 1320–40, to be related to Iran thanks to its depiction of princes of Mongol type (2480, fig. 808).

46 Marchal 1974, 7; Grabar 1987, 58–62.

47 David-Weill, 1959, 1962 and 1963.

48 Melikian-Chirvani, 1971, no. 127, 95; no. 135, 97–98; no. 128, 95–96; nos. 129 and 131, 96–97; no. 130, 96–97; no. 132, 97.

49 Melikian-Chirvani, 1971, no. 134, 97 and no. 133, 97.

50 Melikian-Chirvani, 1973, cat. 43, 14–15; cats. 49–50, 31, then considered a single object; the shield boss from the Hackin mission, 41, (present fig. 9); cat. 16, 20–21; cats. 69 and 73, 35–37.

51 The pieces were first published by Melikian-Chirvani in 1974B and 1977: a tray, OA 3369 and a lidded bowl MAO 1220, both in inlaid high tin bronze, will be published in vol. 2 of the DAI collection.

52 Melikian-Chirvani 1975A, for the shield boss (fig. 9) see 62, pl. XIV. For the tray see Melikian-Chirvani, 1976, 205–7, pl. II.

53 Marchal, 1974, 8–9 (lamp, cat. no. 34); 9–10 (incense burner, cat. no. 30); 10 (inkwell lid, cat. no. 12), 10–12 (scales tray, cat. no. 13); 12–13 (tray, OA 6155); 13–14 (small plates, cat. nos. 14, 25); 14 (tray, cat. no. 15); 15 (shield boss, fig. 9); 15–16 (sprinkler, cat. no. 31); 16–17 (ewers, cat. nos. 36,60).

54 Bernus-Taylor, ed., 1989, 147 and 150, (incense burners, cat. nos. 52 and 53); 152 (feline, cat. nos. 49–50); 270 (mirror with sphinx, cat. no. 71); 273 (lamp, cat no. 43), Bernus-Taylor ed., 2001, 23 (candlestick, cat. no. 3); 50–51 (tray cat. no. 10); 84–86 (ewer cat. no. 4); 141 (mirror with sphinx, cat. no. 70); 203 (lamp, cat. no. 43).

55 Bernus-Taylor, ed., 1989, 151 (feline, cat. no. 9); Bernus Taylor, ed. 2001, 76 (lamp, cat. no. 48.

56 The zodiac ewer (cat. no. 4); tray (cat. no. 10); scales tray (cat. no. 13).

57 See Makariou, ed., 2002, 50 (vase, cat no. 1); 51–52 (pouring vessel, cat. no. 37); 70–73 (lamps cat. nos. 21, 40, 48); 73–74 (ewer, cat. no. 19); 74–75 (lamp, cat. no. 29); 76–77 (lamp or incense burner, cat. no. 28).

58 Makariou, ed., 2012, incense burners, 111–13 (cat. nos. 52–53); candlestick, 154–56 (cat. no. 3).

59 Allan, 1976 and 1979.

60 La Niece et al., 2012.

61 Sprinkler MAO 763; ewer OA 7931; ewer neck and spout MAO 138; ewer MAO 624; high tin bronze bowls MAO 609 and MAO 2011; handle MAO 2226; lamp MAO 2227; bottle MAO 501.

62 The objects here described as 'forgeries' are modern and contemporary reproductions made to deceive the buyer as being medieval. The term 'doubtful' refers to objects of uncertain authenticity which may be contemporary productions, sold or donated to the museum as medieval works. Finally, 'over restored' objects are those which contain more than 50% resin or modern plaster fillings concealed by metallic paint, complementing objects that may well be old but cannot then be studied.

63 Especially those from Ghazna (cat. no. 13) or from Afghanistan (cat. no. 35) but with no archaeometallurgical data.

The Art of Metal in the Iranian World c. 900–1220

Medieval Khurasan was a flourishing intellectual and artistic centre in this period. In terms of cities, monuments and the manufacture of objects it was one of the richest regions of Islamic culture, as well as acting as a nexus for the production of historical and literary texts and for schools of philosophical and religious thought, and as the birthplace of the mystical practice of Sufism. The expansion of the region's cities and their populations, as well as regional and international commerce, contributed to the growth of mass production and the distribution of the 'arts of fire': particularly ceramics, glass and metalwork.

Before the Mongol period of the thirteenth to fourteenth centuries, metal ware originated largely in the eastern Iranian world. Objects made from copper alloys were used as furniture and food utensils, and as fixtures in palatial structures and public monuments. The latter category includes lighting devices for religious monuments such as mosques and shrines.[1] The large number of extant objects, along with textual and archaeological evidence, testify to the development of significant urban centres between the tenth and thirteenth centuries in the regions of Khurasan, Afghanistan, Sistan, and Transoxiana. Urban growth was accompanied by an increase in the population: by the end of the tenth century, the inhabitants of Nishapur numbered somewhere between 110,000 and 220,000, while Juzjani (1193-1260) recounts that nearly two million people perished in the Mongol invasions of Herat.[2] These objects also bear witness, as do the ceramic wares studied by Richard Bulliet in the context of Nishapur's pre-eleventh century social history, to a literate, Islamised society with a high standard of living, where intellectual and mercantile elites flourished.[3] Copper alloy objects thus constitute an important source of information on the urban, social and artistic practices of the pre-Mongol Iranian world.

The history of metalwork from this period is based on archaeological data, inscriptions and textual sources. It is above all the objects themselves, through their archaeological origins on the one hand and their documentary inscriptions on the other, that provide us with information on the conditions and contexts of their production. Discussions of the functions of objects, their social context or their methods of production are rarely found in the textual record. The main sources on the systems of material production are a number of legal treatises which have been recently studied by Ruba Kana'an: these texts regulating trade (*hisba*) deal with trading practices and production, but say little about manufacture.[4] Some information can also be gleaned from historical records, but this is often partial and inaccurate.[5] It seems likely that there is still much to uncover from the textual record, as many sources have yet to be examined.[6] Allan's study of the mineral deposits, mines and recipes of certain alloys remains the main reference for primary sources from the medieval Islamic Iranian world.[7]

THE HISTORICAL BACKGROUND

The toponym 'Khurasan' can be literally translated as 'the land of the rising sun', and indeed the region is situated to the east of the centres of power that contributed to its establishment by the Sasanians followed by the Arab conquerors.[8] Today, Khurasan is the administrative province of northeastern Iran. While its borders fluctuated in the medieval Islamic period, the region generally included northeastern Iran, Turkmenistan and the western and northern areas of Afghanistan (fig. 1).[9] Uzbekistan was not considered part of Khurasan, despite its inclusion in the region in certain medieval sources; nor was Ghazna in the district of Kabul although both were culturally linked to this vast region from the tenth century onwards.[10] Khurasan was first established as an administrative entity in the Sasanian period with capitals at Nishapur and Merv. After the Arab conquest in the seventh century, various other administratively divided regions were added to it, extending it well beyond its former Sasanian borders. This expansion included the regions of Herat and Balkh amongst others. The cities of Nishapur in northeastern Iran, Herat in western Afghanistan and Balkh in northern Afghanistan and Merv in southern Turkmenistan, each one situated in fertile agricultural land and on important commercial routes, remained the regional capitals of Khurasan until the Mongol conquest. In the Islamic period, Nishapur seems to have been the most developed capital.

To judge from the remains of the urban centres, great changes occurred in Khurasan during the ninth century: the Abbasid revolution, largely based in the region, overthrew the Umayyad caliphate in the middle of the eighth century, but Abbasid unity in the province of Khurasan was subsequently fragmented by regional powers. Powerful local dynasties, led by local governors, subsequently took control of the region: first the Taharids from Nishapur, then the Saffarids and finally the Samanids from Transoxiana who remained in power until the end of the tenth century. In the tenth century, the social and economic prosperity of Khurasan, largely based on the cultivation of cotton, was accompanied by significant urban expansion. Starting around the year 1000 CE, Turkish dynasties defeated the Samanids, and began to rule Transoxiana and Khurasan. Transoxiana was eventually conquered by the Qarakhanids, and Khurasan by the Ghaznavids and Saljuqs. From the twelfth century, the Khwarazm Shahs and the Ghurids dominated the region, which was then severely affected by the Mongol invasions of the 1220s, leaving in ruins the cities of Nishapur, Balkh, Herat and Merv.

The large urban centres of Khurasan, particularly the regional capitals, were linked to the production, circulation and use of metals sourced from the region and beyond. Objects of similar manufacture were produced and disseminated in other regional centres, in cultural spheres under the influence of Khurasan production. The objects became a canvas for calligraphy and figural decoration, with ornament on the alloy surface characterised by a great iconographic and epigraphic diversity: Arabic and Persian inscriptions adjoin figural images; geometric and epigraphic compositions form iconographic programmes that are at times too complex to decipher. From the twelfth century onwards, objects inlaid with precious metals became one of the most valued and luxurious productions in Khurasan. These objects represent the golden age of metalwork in the period before the 1220s, a time when eastern Iran was undergoing important political and economic changes. Indeed, these objects were being commissioned or acquired by wealthy and literate patrons, such as judges, important merchants, bureaucrats and religious figures.[11] The techniques of inlaid metalwork were being developed while Khurasan, Afghanistan

and the north-western regions of the Indian subcontinent were occupied by the Ghurids, all the while under threat from the Khwarazm Shahs. In Iran, the most luxurious ceramic wares featuring lustre or polychrome (*haft rang* or seven colour) decoration, are dated to this same period (1170-1220). As the Saljuq Empire was fragmenting, these new techniques of ceramic production were emerging in Iran, and in particular in Kashan, where they appear to have been linked with Shi'i circles.[12]

THE MATERIAL AND ARTISTIC CULTURE OF KHURASAN

A distinct culture started to emerge in the eastern Islamic world of present-day Khurasan and south Central Asia and the surrounding areas, reaching into western Iran and the Middle East. In the medieval period, this cultural efflorescence extended well beyond the borders of historic Khurasan; to the east it reached Central and South Asia, especially Punjab and Sindh where ceramic types typical of Khurasan are well attested in the pre-Mongol period.[13] Archaeological evidence has shown that the material culture of the ninth century, from the Samanid period onwards, was quite distinct from the one dating back to the sixth century. The emergence in eastern Iran and Khurasan of a material and artistic culture that was truly different from the pre-Islamic period can be observed in ceramic wares.[14] Metalwork in Eastern Iran and Khurasan also changed from the Samanid period onwards, with Sasanian models lasting into the ninth to early tenth centuries. The material culture of this period that is characteristic of Khurasan is largely known through the 'arts of fire', with ceramics and metalwork forming the majority of preserved objects.[15] In both mediums, a change can be observed in the types of objects, in the pursuit of polychromy and relief, and in a significant development in surface design. Calligraphy, vegetal and geometric motifs, and figural scenes decorate the surfaces of vessels, furnishings and ceramic and metal sculpture.[16] The chased and inlaid surfaces of metalwork are to some extent comparable to those of ceramics made in the Iranian world from the tenth century onwards, characterised by incised, champlevé and polychrome decoration made with glaze inlays and painted decorations over or under the glaze across Iran, Khurasan and Central and South Asia. [17]

Like ceramics, countless metal objects from the period remain: hundreds are held in public and private collections, and the market for illegally acquired works from Afghanistan has flourished. The region of Khurasan is the most likely source for medieval metalwork. Many cities were brutally destroyed and abandoned during periods of war and invasion in the second half of the twelfth and beginning of the thirteenth centuries. Caches of objects may have been hidden; many were later discovered by looters. It is clear that the number of objects reaching the commercial market through looting and trafficking is considerably greater than those uncovered in archaeological excavations.

As metal could be recycled and portable objects tend to be preserved in smaller numbers, the sheer volume of extant metal objects gives some indication of the original scale of the manufacture. While one explanation for this level of metalwork production rests with the availability of raw materials from the mines in the region, the size of the corpus also suggests that social changes were occurring, leading to new uses and functions for objects in both the private and

2a

Fig. 2

a) black material inlay on the alloy, detail
of the harpy head on the back (cat. no. 2)
b) and c) black material inlay under the
silver inlay, the tear in the inlay shows the
underlying black material (cat. no. 3).

public spheres. In addition, Khurasan metalwork was also being produced for export, with objects found across the Middle East clear evidence of this.[18]

Polychromy

Polychromy, which became a hallmark of ceramics and metalwork produced in the eastern Iranian world, evolved considerably in the tenth century. In the Iranian world, the history of inlay, and more generally the search for colour, began long before the twelfth century: vessels made of gold, gilded silver and nielloed silver from the Sasanian period are some of the best-known objects from pre-Islamic Iran. Techniques employed by craftsmen in gold and silver were essential for the production of copper alloy metalwork. Thus, niello was a well-known inlay in the tenth to thirteenth centuries and its techniques were described in the textual sources.[19] Polychromy in metalwork involves both inlay and overlay. In the case of precious metal inlay on copper alloys, the black material adds colour to the decoration, and it is also used between metal layers (fig. 2). Strictly speaking, the term 'inlay' for black and other coloured compounds, although convenient and commonly used, is in many cases inappropriate.

In the Islamic world, one of the first known copper alloy objects inlaid with precious metal dates to the eighth century.[20] This raises the question of the paucity of inlay before the twelfth century and has led to theories explaining its reintroduction in the specific context of Khurasan. The issue of polychromy and its resolution was not the sole preserve of metalworkers applying inlay, but was also found in goldsmiths' work, in ceramics and in books and in the illuminations and paintings added to manuscripts. Inlay was known on Indian sculpture and seems to have been in use from the eighth and ninth centuries to highlight facial traits, or jewels worn on the body: the copper alloy was enhanced with white and red. In northern India, mainly in Kashmir, in Himachal Pradesh and in Nepal and Tibet, Buddhist and Hindu statuary was produced from copper alloy inlaid with red copper, silver and black materials. The inlays were made with sheets and wires, and according to Rachel Ward and Barry Flood, were hammered into areas prepared with incision and chasing that are comparable with objects from Kashmir and Khurasan.[21] It appears that the use of the inlay technique with precious metals and black material was best known in Kashmir, and turquoises and rubies could also be added to the inlays of metal statuary. Kashmiri objects are known to have circulated in the eastern part of the Iranian world. The Bamiyan valley in Khurasan remained predominantly Buddhist long after the establishment of Islamic rule, and such objects are likely to have been found in temples. According to textual sources and archaeological finds, these objects were also brought as booty to the Afghan capitals of the Ghaznavid sultanate. Kashmir may therefore have been a key region for the development of inlaid metalwork in Khurasan because of the importance of its contacts with the Ghaznavid sultanate in the eleventh century.

The colours that characterise the metal objects in this book are the golden yellow of alloys

and the black of inlaid materials; more colourful objects add white or pale grey from silver, and red from pure copper (fig. 3). With the exception of light-absorbing black materials, the colours are metallic and reflective. The stones and precious metals were associated with colour symbolism, especially the most coveted such as rubies, gold and pearls, which, with their luminous, milky whiteness, were sometimes compared to silver. [22]

Pure copper is not a precious metal, but its malleability and colour may explain its recurrent use as an inlay. There may also be a link between the ruby—considered the most precious stone—the analogies associated with it, and the vivid red colour of the metal.[23] In the eleventh century, al-Biruni carefully described rubies, especially the deep red colour of stones from *Serendib* (Ceylon, present-day Sri Lanka), which were the most highly valued. Through its colour, the ruby was associated with wine, blood, pomegranate and saffron pistils dissolved in water, substances which had symbolic significance in the medieval Iranian world.[24] Al-Biruni adds that the statue of the Sun in the Brahamanabad/al-Mansurah temple in Sindh, seen by Muhammad ibn Qasim when he conquered the region in the early eighth century, was gilded and its eyes were inlaid with rubies.[25] Colour and light held many symbolic associations, with the former often postulated as a visual manifestation of the latter. Colour (Pers. *rang*) theory, its symbols and metaphors, are discussed in the textual sources but remain little studied in Islamic art history.[26] The three primary colours are white, black and red; the first two are contrasting, like night and day, but it is also argued by certain mystical movements that darkness can emit light. Yellow, according to certain poetic refe-

rences, has a more ambivalent meaning, but was nevertheless often associated with metal, and gold was linked to the sun and to Sunday. The symbolism of colours originated in cosmology, with each planet assigned its own colour and day, as explained in the Seven Portraits (*Haft Paykar*) of Nizami (c. 1128-1207): Saturn is black (Saturday), the moon is green (Monday), Mars is red (Tuesday), Mercury is blue (Wednesday), Jupiter is ochre/light brown (Thursday) and Venus is white (Friday).[27] In the oldest legal text on colours written in the Iranian world, dated 551/1156, a judge from Balkh, Hamid al-Din al-Balkhi, places white above all other colours, followed by black, green, red, yellow and finally indigo blue.[28] The symbolic significance of colours is at the centre of poetry in the medieval Iranian world, as shown by the late Chahryar Adle with reference to Nizami, and to Firdawsi in the eleventh-century *Shahnama*.[29]

In the Iranian world, copper alloy sculptures inlaid with glazed ceramic elements, probably made in the twelfth century, may be the earliest examples of inlay. The falcon and the caracal (cat. nos. 52, 53) feature this type of inlay which highlights the eyes: shards of turquoise blue-glazed fritware are inserted into the cavities of the eye sockets, evoking the coloured stones enhancing the features of Himalayan statues. They also recall ceramics from the same period, where drops of glaze contrast with the plain pale-coloured clay body. This type of decoration is

3a

3b

well attested in Iran, thanks to the excavations at Nishapur and Rayy.[30]

Vessels manufactured in precious metal also attest to this pursuit of colour. Thanks to inscriptions which include titles, and the calligraphy in which they are written, several extant objects can be dated to the eleventh and twelfth centuries. They are not inlaid with gold and silver, but are two-coloured, using a goldsmithing technique different from the one used for copper alloys; on nielloed objects, there is a contrast between white and black.[31] This colour juxtaposition which evokes the art of the book—with black ink applied to light-coloured paper—was widely used in the material culture of Khurasan and Central Asia from the tenth century onwards. The use of coloured clay slips contributed to an explosion of polychromy on earthenware ceramics. It appears that goldsmithing shapes and ornaments were close to the better-known ceramic wares.

Nearly one hundred vessels made of precious metals survive from the pre-Mongol period: a few have a documented provenance; many more are known only from textual sources. Caches of objects, such as the 'Harari hoard'[32] and the 'Hamadan treasure',[33] were respectively discovered in Iran and the Balkans but little information is available on the fortuitous circumstances of their discovery. The objects are likely to have been produced in the eastern Iranian world, probably in Khurasan, but might also have come from western Iran. They date from the end of the tenth to the end of the eleventh centuries. Thanks to a number of textual sources, we know of the use of gold and silver vessels during wine-drinking ceremonies (*bazm*) accompanied by music, poetry and songs. The texts also reveal that precious metal vessels were offered by rulers to their military leaders. Describing the court of Mahmud of Ghazna around the year 440/1048, Gardizi mentions the production of precious metal objects in the court workshop of the Sultan. He describes silver bowls, camel harnesses made of silver, and door handles for the Ka'ba.[34] These pieces did not survive but were melted down to mint coinage when the treasuries were

Fig. 5

Silver and copper inlays on copper alloys: a) detail of the wall with the zodiac sign of Aquarius represented by a jug (cat. no. 4) b) detail on the front of the feline (cat. no. 4).

empty. Other sources also testify to their disappearance: *Tarikh-e Sistan* (History of Sistan) describes the melting down of gold and silver vessels belonging to the Saffarid emirs around 900.[35] With their colour and decoration, the precious wares are comparable to beautiful but less expensive objects, particularly to slip-painted wares and inlaid copper alloys. The fact that the types are close or even similar, suggests that their uses were also similar—such objects were used for the consumption of food and drink, particularly during *bazm*.

Inscriptions

The recurring appearance of inscriptions on objects is characteristic of the medieval Iranian world. The art of writing and the significance of inscriptions, particularly on ceramics, have been the subject of numerous publications on topics ranging from the angular calligraphy known as Kufic, to the development of cursive writing, as well as on Arabic and Persian maxims, religious inscriptions and poetic texts found on all, or part of, objects made between the tenth and the thirteenth centuries.[36]

So-called 'documentary' inscriptions contained in signatures and providing information on the place of production, the date of manufacture, the name of the inlayer and so on, have served as the basis for the study of objects, generally of uncertain archaeological provenance. However, the nature of the most common texts, and their interpretation, have so far aroused little interest among scholars. Chased, cast or inlaid blessings or prayers on a corpus of objects of varying quality, type and status have not really been studied to allow them to be compared and contextualised.[37] Although often recorded and translated, such inscriptions have been neglected as they do not contain documentary information on the objects. Asadullah Souren Melikian-Chirvani, however, has used them as guides to the dating of objects, as their content changes over time. The functions of these inscriptions for the user or viewer of an object have recently begun to be interpreted. The majority of the inscriptions on pieces in the Louvre's collection, and more broadly on metalwork from the medieval Iranian world, are Arabic votive texts. The ubiquity of the formulas can also be observed on monumental inscriptions which contain similar texts to those found on metalwork from the same period. At Ghazna for example, sequences of blessings were found in the architectural decoration of the palace and at the site itself. In certain cases, the omission of the article 'al' within the sequence of words 'might reveal a Persian influence'.[38] These texts are similar to those found on metalwork from the same period.[39]

The best-documented corpus of calligraphy on monumental and portable objects is from the Ghaznavid period thanks to the discoveries made in Ghazna between the 1950s and the 1970s by Italian missions led by IsMEO (Associazione Internazionale di Studi sul Mediterraneo e l'Oriente) and recent research based on these findings. These inscriptions include epigraphy in Persian and Arabic, sometimes bilingual: some Arabic funerary inscriptions from the second half of the twelfth and the beginning of the thirteenth centuries integrate Persian invocations and expressions.[40] The same phenomenon can be found on inscriptions on portable objects, particularly those from Herat.[41] The other well-documented corpus of monumental inscriptions is from Bust/Lashkar-i Bazar in the Ghaznavid and Ghurid periods; their calligraphic repertoire is very similar to that of Ghazna.[42] Finally, the minaret of Jam/FiruzKoh has been the subject of several publications on the topic.[43]

As in the monumental epigraphy of Ghazna, portable metalwork objects feature both Kufic

4

5

and cursive calligraphy (figs. 4, 5). Most of the Ghazna inscriptions are in a 'bevelled', 'foliated' or 'floriated' Kufic, with florets and palmettes on top of the letters. The corpus of monumental epigraphy from the eastern Iranian world is datable from approximately 1050 to 1150.[44] The oldest preserved monumental cursive inscriptions in the Iranian and medieval Islamic worlds are the very homogeneous examples found in Ghazna that first appeared there in the first half of the eleventh century, their wider use dating from around 1050 onwards. Cursive Persian inscriptions date from the beginning of the eleventh to the beginning of the twelfth centuries;[45] the backgrounds of the monumental epigraphic bands are often decorated with vegetal motifs.[46] In metalwork, these vegetal scrolls, sometimes geometric and angular, sometimes more delicate and fluid, stand out from the yellow copper alloy, inlaid with a black material, with red copper or white silver (fig. 45). This type of polychromy is comparable to the painted and gilded marbles found in Ghazna: analysis of the paint has identified the use of gold, red from cinnabar and blue from lapis lazuli.[47]

Recent research has shown that modern Persian written with the Arabic alphabet became the common language of the Iranian and north Indian world from around 1050. The issue of the use of Persian has been studied in the context of Ghaznavid epigraphy, with reference to the marble sculptures from Ghazna, and more widely across the pre-Mongol Iranian world. Between the eleventh and the twelfth centuries, monumental Persian inscriptions mainly featured poetry.[48] Other types of inscriptions—historical, religious, votive—were more commonly written in Arabic.[49] The majority of inscriptions on objects, most frequently invocations to anonymous owners, are in Arabic, but bilingual inscriptions also appear. They testify to the bilingualism of the intellectual elites and of the court. Persian begins to appear on portable objects from the twelfth century, but Arabic inscriptions were more common until the fifteenth century. The distinction between the two languages is often not clear cut; the most apparent indication of Persian is the absence of the definite article, or the presence of connecting words with *ye*, and *e* endings.

Inscriptions on the DAI's pre-Mongol metalwork have been systematically recorded. Written in cursive or in Kufic script, they include mainly formulaic invocations and prayers in the form of blessings that are hollowed out, in relief or inlaid with silver or copper (figs. 4, 5). In several cases, the article is missing, which brings the Arabic invocations closer to Persian. Their identification and translation, sometimes previously unpublished, have made it possible, within the framework of this publication, to note common characteristics and variations in their order, mistakes and abbreviations. It seems that inscriptions on objects in the DAI do not demonstrate a direct link between their type and the function of the object.[50] The question of their relationship with what is unwritten, but uses a visual language, has been addressed in recent studies examining the relationship between the object and the inscription: how were these perceived by the beholder, the user or the owner of the object? The invocations inscribed on DAI metalwork pieces are either taken from the model used for casting—and therefore obtained by casting or by cold reworking—chased, or inlaid with silver or copper. Depending on the object, they can be clearly visible or hidden, as for example on the interior of an inkwell lid (cat. no. 12). The ins-

Fig. 4

Chased cursive calligraphy showing blessings, detail of bucket (cat. no. 16).

Fig. 5

Silver-inlaid Kufic calligraphy on a background that is chased, champlevé and inlaid with black material and in an oblong frame inlaid with copper (cat. no. 2); signature of Shazi of Herat, inlayer.

cription can dictate the type of interaction the beholder should have with the object: indicating whether it is to be turned from right to left, opened or brought to eye-level. Like the figural compositions, the inscriptions are often small and have to be read at close range to be deciphered, suggesting a haptic relationship between the object and its user. They are set in regularly spaced cartouches or interspersed with medallions or ornaments that allow the text to breathe. Words are sometimes abbreviated or cut into two different parts: certain letters can evoke a complete word by analogy or association. The formulas are repetitive, a characteristic perhaps related to the panegyric or *qasida*, the most important type of Persian lyrical poetry in this period. This poetic form makes extensive use of repetition, is recited in front of an audience during courtly ceremonies (in the Ghaznavid period, amongst others), and constitutes a ritual of affirmation of the royal institution. Above all, the poems conclude with a votive prayer (*du'a*) addressed to the patron (*sahibihi*).[51] They always begin in the same way: with the words: *al'izz wa-l-iqbal* (glory and prosperity) in Kufic inscriptions, and *bi-l-yumn wa-l-baraka* (with happiness and benediction) in cursive ones.[52] These same formulas introduce the succeeding invocations on the objects, which are lists of wishes, each linked by the word *wa* (and). These are found on ceramics and metalwork, and on less well-preserved materials such as textiles. The inscriptions on slip-painted earthenwares with dark calligraphy on a white ground are visually similar to the combination of niello on silver, and can be said to evoke the precious metal; there are supplications, *du'a* in Arabic, addressed to an anonymous owner, the phrases linked by *wa*, in sequences similar to those on metal.[53] However, ceramics show an important visual difference to metalwork: the inscriptions are on a large scale, occupying a prominent place on the surface of the object, and are clearly legible. Inscriptions on metalwork are less easily decipherable, making the visual impact of the inscriptions quite different from that of ceramics. Common expressions of piety take the form of a long or short address to the owner of the object (*li-sahibihi*), or are dedicated anonymously to whoever the beholder reading the inscription might be. Margaret Graves has shown the social implications of inscriptions emphasising 'good conduct'[54] to which the artisan may have subscribed: he was required to obey the rules and to behave virtuously, notions outlined in the code of *futuwwa* and associations of craftsmen. It is also possible that the invocations inscribed on objects contributed to keeping them pure, recommending them to God through the prayers.[55] The fact that they are always inscriptions in Arabic is also related to their function: without being religious in a Qur'anic sense, they activate the link with God and his presence through the written word that is intrinsically associated with him. Arabic votive inscriptions may also take the form of abbreviated formulas, or even isolated letters. Certain repeated letters on object inscriptions, or pseudo-calligraphy, have devotional and magical properties. *Baraka* (blessing), bestowing benediction on the owner, is the most common word, either alone or with other invocations, spelled out or in abbreviated form. For instance, on a large, slip-painted earthenware bowl, the formula 'blessing to the owner (*baraka li-sahibihi*) is associated with another inscription, a *hadith*, or saying of the Prophet,[56] transmitting an aura of blessing as *baraka* is also the prophetic benediction in religious talismanic practices.[57]

The talismanic nature of inscriptions is also suggested by their association with apotropaic elements such as the zodiac.[58] Many of the themes featured on objects are linked to cosmogony. Astrology was the most common practice of divination in the medieval Iranian world, as terrestrial events were believed to be governed by celestial forces.[59] The curative and protective effects of a talisman, an object such as a 'magic bowl' which was linked to astrological forces

would take place during the consumption of liquid from the vessel.[60] The most powerful esoteric science was that of letters, due to the power of the Arabic alphabet.[61] Thus the Arabic term *ʿayn* (and the corresponding letter) was thought to carry protection and guidance.[62] The apotropaic and prophylactic use of the Qurʾan was achieved through the reading of its verses, but also from the mysterious letters *kaf haʾya ʿayn sad* found in sura 19 of the Qurʾan and *haʾ mim ʿayn sin kaf* in sura 42. This practice also involved the deconstruction of verses and words into letters, each with a numerical value. Isolated letters (*muqattaʿat*) appear in twenty-nine suras of the Qurʾan.[63] The mystical symbolism of letters linked to suras came from the early period of Islam: they probably bore a protective function, similar to the words that were used, following the Tradition during the battles of the Prophet Muhammad.[64] The abbreviations, sometimes isolated letters, possessed a symbolic function from their association with a word: thus, the letter *kaf* (k) written in Kufic on ceramic vessels made in Nishapur, signified *baraka*, but also al-Kafi (the one that suffices), one of the ninety-nine names of God. Likewise, the presence of *alif-lam* (the definite article) was linked to the profession of faith. The benedictory aura could also emanate from pseudo-inscriptions.[65] The theme of devotional writing has been studied, above all, for so-called 'magico-therapeutic' objects. The divine presence linked to Arabic writing functioned through isolated letters or letters that did not form words. They could be seen or read as a symbolic vocabulary associated with divine presence and power. Thus, the 'magical' writing on bowls produced in the medieval Middle East or on amulets from Khurasan evoked the profession of faith.[66]

ARCHAEOLOGICAL DATA AND DATING

Similar types of objects, including both inlaid and non-inlaid metalwork, have been found in the main urban sites of the eastern Iranian world, in Iran, Afghanistan and Central Asia. Sites in Khurasan and within its cultural ambit were the main centres of production of the goods and of their diffusion. The main areas of provenance (in the archaeological sense of the term, and not necessarily related to the place of production) of metal and inlaid metal objects—if their history is known—are situated between eastern Iran and Central Asia. The large cities that have been the subject of extensive archaeological research and that have contributed most substantially to the published metalwork corpus are Nishapur, Herat, Ghazna and Samarqand, although no workshops for the production of copper alloy or furnaces have been found in excavations in Khurasan, Afghanistan or Transoxiana. However, a workshop probably dedicated to metal recycling has been identified in Budrach in Uzbekistan: a collection of mortars was discovered buried in pits in preparation for recycling, but is yet to be completely published.[67] To date, the only well-documented workshop for the medieval period, more precisely the eleventh century, was discovered at Tiberias. It has provided precious information on the practice of recycling cast copper alloys and on the circulation of metalwork from the Iranian world around the Mediterranean and the Caucasus.[68]

Nishapur and Shadiakh

The metal objects discovered in the oldest parts of Nishapur are not inlaid; uncovered during the American excavations in the 1930s, they were published by James Allan.[69] The American team excavated parts of the site (today no longer visible from the surface) that in the twelfth century were undergoing a phase of depopulation as the centre of the city of Nishapur gradually moved to the west of its former site. The site of Shadiakh lies to the south of the modern city of Nishapur, and to the west of the oldest parts of the site where the citadel and the lower city (*shahrestan*) are located. A suburb of Nishapur in the ninth century, Shadiakh increased in size from the twelfth century onwards, when a large portion of the city's population settled there. It was enlarged and fortified in the second half of the twelfth century, and the urban centre was located there after the Mongol invasions in 1221. At the end of the thirteenth century, the city shifted again, this time to its current location. One part of the site (extensively excavated under the direction of Rajab'ali Labbaf Khaniki) is dated approximately to a period from the twelfth to thirteenth centuries and has been identified as a palatial structure.[70] Some of the metal wares discovered at this site are inlaid.

Herat

In contrast to other Khurasan cities such as Nishapur, the location of Herat has never changed and the densely populated modern city covers the ancient city, with only the citadel accessible to archaeological excavations. Like most cities in the Iranian world, Herat had a citadel, a lower city and extensive suburbs. According to the historian Hamdallah Mustawfi (c. 1281-1344), Herat had a very busy commercial life with some 12,000 stores in the city's bazaars.[71] The city remained prosperous until the destruction of the Mongol invasions, after which it recovered fully only in the fifteenth century. Thanks to the impressive findings by Afghan and German teams working at the site until 2009, and their 2016 publication under the direction of Ute Franke, the wealth of metalwork material held in the Herat Museum has been fully revealed. Some objects that appeared in previous publications, especially those discussed by Melikian-Chirvani, have now disappeared. The objects in the Herat Museum, including wares with and without inlay produced around the tenth to thirteenth centuries, were found in the city itself, as well as elsewhere in Afghanistan.

Ghazna

Ghazna is in southeast Afghanistan, situated to the south of Kabul on the road between the centre of the country and the Indus. The city was the Ghaznavid capital in the eleventh century and was described as a large commercial centre connected to trade routes running between Iran, Central Asia, and India. It was looted and burned by the Ghurid Sultan 'Ala al-Din Husain in 1151, rebuilt, then destroyed again by the Mongols in 1221. The archaeological material, uncovered during excavations of the Ghaznavid and Ghurid palatial structures led by an Italian mission under the direction of Umberto Scerrato in the 1950s and 1960s, is presently in Kabul, divided

between the National Museum and the Rawza Islamic Museum. The latter was reopened in 2013, then destroyed in 2014. The remainder of the material is in Rome, held by Istituto Italiano per l'Africa e l'Oriente (IsIAO) and the Museo Nazionale d'Arte Orientale. Some material uncovered during excavations, surveys and collections in the 1930s led by the Délégation Archaéologique Française en Afghanistan (DAFA) and during the Citroën Expedition is conserved in the Louvre. Hundreds of metal objects are known to come from Ghazna, in a variety of types that include repoussé, chased, champlevé and inlaid with silver and/or red copper.

Samarqand

The Samanid, and later Qarakhanid, capital was first excavated by Russian teams and then by a Franco-Uzbek team. The metal wares from Afrasiab (the northern suburb and oldest part of Samarqand) are less frequently published than the ceramic wares. However, a wide variety of good quality metals have been found there that, like the material from Ghazna, show the presence in the city, from around the eleventh to the thirteenth centuries, of portable metal objects used in a domestic context. These include cast and openwork incense burners, plates with gadroons and engraved and inlaid decoration, a faceted basin and a tray stand with silver and red copper inlays.[72]

Metalwork Chronology

Many of the recovered objects did not form part of archaeological assemblages excavated with properly established stratigraphy, and most of the extant objects from the pre-Mongol Iranian world do not have a known provenance. In the absence of precise archaeological data, the question of correct dating remains an issue. The identification of metal wares made before the tenth century remains uncertain, except for those featuring inscriptions with a datable type of calligraphy. Additionally, some types of objects produced around the tenth century are likely to have remained in production until the 1220s. One dating clue is the presence of precious metal inlays that, according to the first known object of this type—a pen box dated 542/1148 in the Hermitage Museum[73]—would not have occurred before the mid-twelfth century. The question of dating objects from the pre-Mongol Iranian world has been discussed by Allan, who makes a distinction between objects from before 1100 and those datable to the twelfth to early thirteenth centuries.[74] Melikian-Chirvani has dated some portable objects similar to those in the DAI collection to the Samanid period, that is, before 1100. These are tripod incense burners with a half dome topped by a bird and polylobed arcades featuring inscriptions, approximately datable to the tenth century (cat. nos. 30, 58); lampstands with a tripod base with a convex profile and openwork decoration (similar to cat. no. 46), uncovered in the Maimana hoard in the east of Herat and whose foliated Kufic inscriptions suggest a Samanid period date.[75] Melikian-Chirvani has assigned early dates to the wine-pouring vessels with a bull head spout on the basis of their type of inscription (cat. nos. 60, 61). It is in this same period that he notes the first occurrence of blessings in Arabic beginning with the word *baraka* inscribed on the objects, followed by different formulas which later change and are therefore important dating markers. Melikian-Chirvani defines the later Khurasan production (c. 1150-1219) on the basis of inlaid objects with dates of manufacture; most of these are from Herat, Balkh and Ghazna in Afghanistan. He also includes objects, both

with and without inlay, that were used as lighting devices. The DAI holds comparable examples: for instance, a lampstand with concave petals (cat. no. 47). His dating of the production of the 'Late Khurasan School' is also based on the type of epigraphy inscribed on the objects, as on the stands and footed lamps dated c. 1150 onwards (cat. nos. 39, 46). Melikian-Chirvani attributes small plates or circular incense burners without feet or tripods (cat. nos. 14, 25, 59), as well as large, faceted basins (cat. no. 35), to the same period. A few rare, illustrated manuscripts predating the thirteenth century also offer certain dating clues for metalwork. An important example is the 595/1199 Book of Antidotes, probably made in the Jazira in northern Iraq;[76] in paintings of interiors, we can see domestic furnishing or medical accessories such as oblong pen boxes, inkwells with domed lids, ewers, jugs, and lamps on tall stands, types of objects that are readily identifiable and for which this manuscript provides a milestone date.[77]

THE CONTEXT OF PRODUCTION

Cities

Writing in the thirteenth century, al-Qazwini (1203–1283) notes that, before the Mongol invasions, the important centres of metalwork production were Herat, Nishapur and Merv, and that brass vessels inlaid with silver were made in Herat.[78] Except for Balkh, which he does not mention, al-Qazwini is therefore referring to three of the four capitals of Khurasan. Previous authors cite other urban centres in Central Asia (particularly in Uzbekistan) as important cities where copper vessels were produced and traded. In the tenth century, the geographer Ibn Hawqal describes the bazaars of Bukhara, where he notes that 'all sorts of objects in red and yellow copper, vases and various utensils that are commonly used by the local population are sold'.[79] The geographer al-Muqaddasi, also writing in the tenth century, adds that copper lamps were exported from Bukhara.[80] Ibn Hawqal mentions that Samarqand was an exporter of large copper vessels and that iron instruments produced from the Ferghana deposits were exported throughout Khurasan.[81] According to these sources therefore, certain metalwork objects were produced in the major cities of Transoxiana, while others such as hammered brasses with repoussé and inlaid decoration were perhaps more specific to Khurasan and were widely distributed, even in Central Asia. The similarities between objects discovered over a vast geographical area thus raise the question of the production, distribution and trade of these objects, as well as the raw materials necessary for their manufacture, such as alloys and precious metals. Signatures on Khurasan objects mention five urban centres in the region,[82] most frequently Merv,[83] Herat and Nishapur,[84] and more rarely Tus and Qaʿen in eastern Iran. There are no known signatures from Transoxiana on wares datable between the tenth and the beginning of the thirteenth centuries. No city of the *Mawarannahr*, that is the area beyond the Amu Darya river in Central Asia, is included in the *nisba*, the adjective in a signature indicating the place of origin. In the five groups of objects proposed as products of Transoxiana by Anatoli Ivanov, there are no inlaid metal wares; the objects are dated from the tenth to the eleventh centuries and predate the development of metalwork inlaid with silver and copper. These are particular types of bowls, trays, mortars and ewers (some of which are signed Ahmad).[85] To this day, their technical characteristics, which could perhaps help to differentiate them from Khurasan production, have not been published.

The only documented centre of inlaid metalwork production is Herat, as evidenced in textual sources and chased and inlaid inscriptions on the metal wares. In the second half of the twelfth and the beginning of the thirteenth centuries, certain objects included the phrase 'made in Herat', while others appear to have been made by inlayers using the *nisba al-Haravi*, 'from Herat'. This *nisba* is inscribed on several masterpieces from the second half of the twelfth century, including the Bobrinsky bucket dated Muharram 559/December 1163 and signed by Masud ibn Ahmad al-*naqqash* al-Haravi (the inlayer from Herat).[86] Another bucket in the Hermitage is signed Muhammad ibn Nasir ibn Muhammad al-Haravi,[87] and a ewer dated 1181 is signed Mahmud ibn Muhammad al-Haravi.[88]

Patrons, Bazaars and Craftsmen

Inlaid metal wares were precious objects; certain hammered examples could even be considered substitutes for gold and silver because of their colour. According to Allan, it was goldsmiths who initiated the production of hammered inlaid brass responding to a demand for luxury vessels despite the shortage of silver. He disagrees with Melikian-Chirvani who cites sources that refer to the continuous production of gold and silver vessels that could be used as monetary reserves and melted down when necessary. The latter scholar refutes a move away from silver and gold serving ware to explain the rise of inlaid metals.[89] Rather than considering brass wares inlaid with silver and copper as a substitute developed to compensate for a shortage of raw materials—for they are brass, as shown by the objects analysed at the DAI and the British Museum—it is perhaps more appropriate to consider them as entirely new products made for an emerging elite mercantile class,[90] part of an unprecedented shift to an art of polychromy, calligraphy and figural representation.

The patrons identified in inscriptions on inlaid wares are perhaps more socially diverse than those named on earlier vessels of precious metal. The paucity of both sources and objects does not allow us to arrive at this conclusion with absolute certainty, but it appears that gold and silver vessels belonged to dignitaries and statesmen, even if the individuals are not always mentioned in the textual sources. Certain copper alloy objects inlaid with precious metal feature the titles and names of emirs and statesmen, or scholars who were members of the sultan's court, as well as the names of religious figures and merchants.[91] The first inlaid metal object with an inscription that includes a date is linked to the practice of writing: the pen box dated 542/1148 features the name of a merchant, 'Umar ibn al-Fadl ibn Yusuf *al-bayya*'.[92] The Bobrinsky bucket was made for a merchant, Rashid or Rukn ad-Din 'Azizi ibn 'Abu'l Husain al-Zenjani. The zoomorphic sculpture made in Muharram 603/August-September 1206 was designed by the brother of the owner, the son of Afridun ibn Barzin, who was probably a merchant and a member of an urban, literate, wealthy elite.[93] The recipients of these objects linked to the courts of the Ghaznavids, Ghurids and Khwarazm Shahs were scholars with official positions: an inkwell with the name of a *mushrif*, or inspector of the court, is an example of this phenomenon.[94] A pen box signed by Shazi of Herat and dated 607/1210,[95] names Madj al-Mulk al-Muzaffar, *ṣadr* (first minister) of Khurasan who was posted to Merv where he established a library during the reign of 'Ala al-Din Muhammad Khwarazm Shah.[96] Finally, a pair of inscribed rectangular tabletops or trays dating to the beginning of the thirteenth century mention the name of a governor of Peshawar.[97]

Kana'an's study of legal texts offers precious information on the process of commercial

exchange and the commission of metalwork in Khurasan and Transoxiana at the end of the eleventh and the twelfth centuries.[98] The juridical texts discuss the use and possession of precious wares, as well as the design, commission, manufacture and sale of copper alloy objects. They also discuss their mercantile value, a complex matter since objects were manufactured with a mix of materials. The sources discuss both the production of objects for the general market as well as specific commissions, and list four types of commercial transactions.[99] Aside from the legal sources, the only information available on the complex organisation of metalwork production is provided by the few signatures inscribed on the most lavish objects. These offer some indication of the role of the craftsmen who were responsible for casting and inlaying. With regard to high-status commissioned objects, they demonstrate that there was a division of labour for the techniques of shaping and inlaying. The signatures, until recently interpreted as only belonging to the makers or the inlayers, are now understood to include patrons who belonged to a mercantile elite, or dignitaries in the case of objects linked to the practice of writing and thus inherently tied to political power. On the pen box dated 542/1148, the signature could refer to a merchant or a scholar. The inscription around the box reads: 'For the owner ʿAli ibn Yusuf ibn Uthman al-Hajj, ʿamal (work of) ʿUmar ibn al-Fadl ibn Yusuf al-Bayyaʾ or al-Nasidj/Nussadj, the scribe, the 20th dhu al-qaʾdh (sacred month of the Hajj) of the year 542'.[100] These could be the names of the owner and the patron/designer, but not the maker. The role of the bayyaʾ was linked to commerce and the production of metalwork. According to Kanaʾan, the signatory of the pen box of 1148, ʿUmar ibn al-Fadl ibn Yusuf al-Bayyaʾ, is perhaps the intermediary, or the merchant mentioned in legal texts. In the eleventh and beginning of the twelfth centuries, textual sources refer to the bayyaʾ as a member of the mercantile class. In the writings of Nasir-e Khusraw (1004-1088) the term appears in the description of the Isfahan bazaar: 'and in the street are fifty beautiful caravanserais and in each, are seated many bayyaʾ and merchants.' We also see the word used in the eleventh century by Nizam al-Mulk, and in the twelfth century by Ibn al-Balkhi. Bayyaʾ means a supplier, a courtier of high rank, a guarantor of quality, a figure who played an important role in the commerce of a city.[101] The Bobrinsky bucket is one of the only objects from this period to offer much information on the organisation of its manufacture. The inscriptions on the flat surface of the rim tell us about its shaping by casting or hammering (zarb) by Muhammad ibn ʿAbd al-Walid. It also specifies that it was: 'amal-e (work of) Hajib Masʿud ibn Ahmad al-naqqash (the inlayer, decorator) al-Haravi. The remainder of the inscription on the rim also mentions the patron, ʿAbd al-Rahman ibn ʿAbdallah al-Rashidi and its recipient, the glory of merchants, Hajji Rashid or Rukn ad-Din ʿAzizi ibn Abu'l Hussain al-Zenjani. Following Kanaʾan's hypothesis, this object was commissioned by a metalwork merchant, al-Zenjani, who owned one or several workshops managed by al-Rashidi, where the inlayer and the caster mentioned in the inscription worked. The sculpture of the zebu feeding its calf, possibly an automated pouring vessel,[102] is the other reference piece which indicates a division of labour between the inlayer and caster, and distinguishes the patron from the recipient. In this case, the makers and the recipient belonged to an elite mercantile class that was perhaps specifically linked to the metalwork market. Dated to the sacred month of Muharram 603/August-September 1206, the sculpture is signed ʿAli ibn Muhammad ibn Abu'-l Qasim al-naqqash. The design, commission and perhaps also the shaping, which the signature specifies was made in a single casting, may have been done by Ruzbeh ibn Afridun ibn Barzin. The recipient and owner is Shah Barzin ibn Afridun ibn Barzin, perhaps the brother of the designer/caster.

What emerges from the textual and material sources, as well as the technical analysis of objects in the DAI collection, points to a range of production systems. Objects available in the bazaar, whether off the shelf or made to commission, were regulated by the laws and rules of the *muhtasib*, an official who supervised the market,[103] and were administered by individuals who managed the craftsmen. It is possible that commissions from the court were not always subject to the rules of the bazaar. For instance, the historian Beyhaqi (995–1077) describes Ghaznavid commissions for sculpture which were made in the palace.[104] Nevertheless, with the exception of princely commissions, it seems that the main participants in the system of production and distribution were to be found in the bazaar, an open air or closed market place, the nexus of production and exchange at the heart of urban life.[105] In the Iranian world, up until the eleventh century, the bazaar was located in the walled lower city (*shahrestan*), usually near the congregational mosque; it seems it later moved to the suburbs (*rabad*). The role of the bazaar in the metalwork market is suggested by textual sources which describe its participants. The market was at the heart of production and transactions; different types of metallurgical expertise were located there, as well as places of production and points of sale. Craftsmen associations in the bazaars are well attested to, and were under the economic control of rich craftsmen and merchants.[106] Although there is no evidence for guilds in the pre-Mongol Iranian world, associations of craftsmen existed in the form of 'brotherhoods' defined by the moral code of *javanmardi/ futuwwa* or chivalry/virtue. These associations, which required both initiation and affiliation, developed from the eleventh century onwards for craftsmen working in the bazaar.[107] Similar organisations had already existed in the Sasanian period, and continued throughout the medieval period, each group occupying a specific part of the bazaar. The various specialisations listed in the Sasanian period include working with iron, with gold (*zarigar*) and with silver (*asemgar*, *asem paykar*).[108] For the later period, we know that in the major centres craftsmen working with silver (*noqrasaz*, *noqrakar*) and those working with gold (*zarigar*) constituted separate specialities: for example, Beyhaqi mentions a silversmiths' district in Balkh.[109] Craftsmen working with copper alloys were also grouped together within quarters of medieval bazaars. Local sources on Herat refer to the metalworkers working with iron or copper being divided into associations: in 602/1197, when the city was in Ghurid territory, a violent quarrel erupted between the bazaar of the blacksmiths (*haddadin*) and the bazaar of the coppersmiths (*saffarin*).[110] Medieval sources make it clear that specific craftsmen worked with copper alloys: those specialised in shaping objects are mentioned in the sources and on a few rare, signed objects. Most of the metalwork production in the pre-Mongol Iranian world involved casting, as demonstrated by the technical studies carried out on the DAI collection. The craftsmen were known as *saffarin* and the term *saffar* appears on signatures inscribed on cauldrons (cat. nos. 82, 83). Other more luxurious objects, also cast in copper alloy, were signed by specialised craftsmen who did not make utensils. Two other Persian terms are related to casting according to the shaping process that was employed. However, it is the term *zarb* (to hammer/strike) that was inscribed on the Bobrinsky bucket in 1163, indicating that the object was hammered into shape.[111] Hammering may have been used to finish the shape and to assemble the different parts, as buckets of this type were made by casting (see cat. no. 16). The inscription on the zoomorphic sculpture made in 1206 specifies that it was cast (*rikhteh shodeh*): from the verb *rikhtan* which literally means pouring, and refers to the pouring of the metal in the casting process.[112] Extrapolating from these rare material and textual sources, it seems that metal casters were a well-defined group of artisans in the bazaar, and that

craftsmen were subdivided according to their speciality, from making mass-produced utensils to individual artworks inlaid with precious metals.

One individual appears to be missing from both the pre-Mongol sources and the objects—the coppersmith. And yet, at this time, a very sophisticated production of hammered brass objects was emerging, using a range of techniques ranging from simple levelling to virtuoso repoussé. With one exception (cat. no. 14), all the brass objects in the DAI pre-Mongol collection were made by hammering. These objects were not the work of metal casters: they belong to a sphere of expertise that was very different and much closer to that of the goldsmith. Indeed, some of the rare precious metal vessels that survive are closer in shape to brass objects: a jug in nielloed silver is comparable to ewers with spouts in the shape of oil lamps (cat. nos. 7, 8).[113] It is therefore quite possible, as Allan suggested, that it was the goldsmiths mentioned in the textual sources who created the new brass wares, working with the hammer and with precious materials.[114] Moreover, the similarity of colour between gold and brass is the primary characteristic of this alloy, and this is duly specified in the sources. This similarity suggests that brass could be substituted for gold, and may explain its use.[115] The term *bereni*, Persian for brass, appears for the first time in a dictionary completed in 438/1046–47; only a few years earlier, al-Biruni had referred to it with the Arabic word *shabah*.

It is also likely that goldsmiths developed the art of inlaying precious metals on copper alloys. On signed cast and hammered objects, the most frequently mentioned craftsman is the inlayer (*naqqash*). This association between goldsmithing and the inlaying of precious metals was suggested by Sarakhsi (d. 1090), a jurist from Transoxiana who wrote that it is permissible to use *ajir* (a salaried contract) to make gold or silver vessels, to inlay gold and silver objects or to inlay gold and silver on brass or bronze objects.[116] It therefore seems that the tradition of inlaying precious metal on objects made from copper alloy can be dated before the first known object, the pen box dated 1148. Sarakhsi also suggested that the art of inlaying took place outside the foundry and that the design of the inlay could be planned before the casting phase.[117]

Notes

1 The 1.10 metre height of one lampstand suggests it was used in a large building. Now in Stuttgart, Linden Museum, Inv. no. A41251.

2 For Nishapur see Thomas, 2018, 274; for Herat see Franke and Urban, 2017, 1.

3 Bulliet, 1972.

4 See 45–48 in this volume; Milwright, 2017, 19.

5 Abū Saʿid ʿAbd al-Ḥayy Gardizī speaks of precious metal objects produced in Ghazna in the eleventh century, see 152 in this volume.

6 As well as local sources dealing with particular cities: for Herat see Paul, 2000.

7 Allan, 1979.

8 See Bosworth, 2011C, 2; Rante, ed., 2015.

9 The city of Rayy,, situated south of Tehran, is included in Khurasan in some Ghaznavid textual sources; in any case it connects the Iranian west to Khurasan. See Beyhaqi, 2011, vol. 1, 14, 84.

10 The valley of Bamiyan, and the regions of Ghur in the centre and Sistan in the southwest, in Afghanistan, do not form part of the Islamic and Persianised cultural ambit before the tenth century, with the Ghaznavids. See Bosworth, 1968, 34–35.

11 On commissions linked to the urban elites, often grouped under the term 'bourgeoisie' or 'upper middle class' see the essay by Anna Contadini, 2017. The steles discovered at the site of Bust (now Lashkar Gah in southern Afghanistan) suggest the existence of commissions from outside court circles, Flood 2009, 203.

12 Porter 2002, 2003, 2004 and 2011.

13 Collinet, 2010; Nabi Khan, 1990; Rajput 2009.

14 Rante and Collinet, 2013.

15 In the arts of fire, we also know of luxurious glass production; see Carboni and Whitehouse, 2001, 176–178.

16 For ceramics, see Pancaroğlu, 2016.

17 The interest in surface and colour effects can also be seen in the architecture of the medieval Iranian world with the use of stucco bas-reliefs, and brick facings as on the famous Samanid tomb built around 900 in Bukhara, Uzbekistan and from the twelfth century onwards with the use of glazed bricks on Ghurid monuments such as the equally famous Minaret of Jam in Afghanistan.

18 See the pouring vessels, cat nos. 36, 37.

19 Allan, 1979, 19–20.

20 Aquamanile in the form of an eagle, signed Sulayman, dated 180/796–97, Middle East or Iran, Saint Petersburg, Hermitage Museum, ИP-1567, Piotrovsky and Vrieze, 1999, no. 199, 226; for the first known inlaid objects in the Islamic World see Allan, 2022, 200–21.

21 Ward, 1993, 74; Flood, 2012, especially 133.

22 Schimmel and Soucek, 1992; al-Biruni, trans., 1989, 86–98.

23 Red also evokes the colour used in manuscripts to indicate sections of the text or to calligraphic titles.

24 Vesel, 1985; see 256 in this volume.

25 Al-Biruni, trans., 1989, 29–42; A similar story appears in Sachau, *Alberuni's India*, 1888, 79: the statue of the sun in Multan is made of gilded wood inlaid with rubies.

26 Bloom and Blair, eds., 2011, remains the only general study devoted to colour in the arts of Islam.

27 Schimmel and Soucek, 1992.

28 Adle, 2015, 88.

29 Adle, 2015, especially 89–106

30 Rante and Collinet, 2013, 195, fig. 107; Treptow, 2007, 27.

31 Niello is an inlay or overlay of black material with a grey to blue sheen that can be confused with black enamel. It is composed of one or more metallic sulphides (silver, copper or copper and lead) whose composition varies according to time and place.

32 The 'Harari hoard' is a collection of gilded silver and nielloed vessels unearthed in northern Iran and now in the LA Mayer Memorial Institute in Jerusalem. This set, purchased by the collector Harari, is of uncertain provenance and is poorly documented. It consists of 20 objects: 7 sprinklers or bottles, 4 incense burners with handles, 2 flat incense burners, 3 jugs, 1 bowl with a handle; 2 boxes; 1 spoon; and pieces of harness. According to Allan, 1986B, 57, the treasure is not homogeneous and contains some objects from Khurasan and others from northern Iran. The objects are not all from the same period and date from the end of the tenth and the end of the eleventh centuries.

33 The 'Hamadan treasure' is preserved in the National Museum of Tehran. It contains 11 nielloed silver objects. According to Melikian-Chirvani, 1986B, 99, it is a wine service (*majles khāne*) consisting of 3 bowls, 2 dishes, 1 tray, 1 ewer, 2 jugs, 1 bottle and 1 cup; 7 of the objects are inscribed in foliated Kufic with the name of an unidentified emir, Abu'l Abbas Valgin/Valgir b. Harun, client (*mawla*) of the Commander of the Faithful (ʿamir al-muʾminin). According to Melikian-Chirvani, 1986B,, the treasure

is datable to the first half of the eleventh century because the title 'mawla of the Commander of the Faithful' was given at that time to provincial governors appointed by the sultans.

34 Melikian-Chirvani, 1986B, 97.

35 Scott Meisami, 1999, 125.

36 See for instance Blair, 2014, 11–56 with bibliography; Ghouchani, 1986 and 1992.

37 Graves, 2018B.

38 See Rugiadi, 2007, for the epigraphic votive sequences from Ghazna.

39 Allegranzi, 2017, 149.

40 Laviola, 2016; Allegranzi, 2017, especially 148.

41 See for example, on the Bobrinsky bucket and the Tbilisi ewer, 110 in this volume.

42 Schlumberger and Sourdel-Thomine, 1978, vol. 1B.

43 Sourdel-Thomine, 2004.

44 Allegranzi, 2017, 151–52, table 1 and 309–17.

45 Allegranzi, 2017, 153–54, 455.

46 Allegranzi, 2017, 151–52, 321.

47 Cinnabar is a pigment derived from sulphur of mercury, see Rugiadi, 2012, 19.

48 O'Kane, 2009.

49 Allegranzi, 2017, 107, see 105–106 for a review of the research on the formation of modern Persian.

50 This is not the case with the poem inlaid on the Tbilisi ewer which refers to the ewer and its use; see 110 in this volume.

51 Scott Meisami, 1987, 42–43, 48–50.

52 Graves, 2018B, 324.

53 See Ghouchani, 1986 for the inscribed ceramics from Nishapur.

54 Graves, 2018B, 328.

55 On the notion of purity and restrictions against illicit contact, see Halevi, 2008.

56 Blair, 2014, 15.

57 Gruber, 2016, 34.

58 Graves, 2018B, 326.

59 Lory, 2016, 13.

60 Leoni, 2016, 60.

61 Lory, 2016, 31.

62 Gruber, 2016, 44.

63 Leoni, 2016, 64 and 92, note 45.

64 Jones, 1962.

65 Aanavi 1968, especially 355–56.

66 Flood, 2019, 103–40; Savage-Smith, 1997.

67 Jangar Ilyasov, 'The Budrach Hoard: Metalwork between Mawara al-Nahr and Khurasan. Heartland of Islamic Art and Culture: Khurasan from Early Islam to the Mongols and beyond'. International Conference, Linden-Museum, Stuttgart. 3-4/11/2016. The assemblage of 57 largely pre-Mongol metal objects unearthed at Robat-e Sharaf between Nishapur and Merv also suggests a set of objects prepared for recycling. See Kiani, ed., 1981; Fehervari and Kiani, 1982. I am grateful to Barry Flood and Lorenz Korn for these references.

68 See Khamis 2013 for an object exported from the Iranian world that was found in a workshop at Tiberias; see 199–200 in this volume.

69 Allan 1982A.

70 On the topography of Nishapur and the site of Shadiakh, see Rante and Collinet, 2013, 3–7.

71 Le Strange, 1966, cited by Thomas, 2018, 62.

72 Shishkina and Pavchinskaja, 1992, 26, 28–29, 119–21.

73 Saint Petersburg, Hermitage Museum, SA-12268; see note 92 below.

74 Allan, 1976–77, 6–13.

75 Scerrato, 1964.

76 Paris, Bibliothèque nationale de France, arabe 2964.

77 Menghini and Contin, eds., 2009.

78 Cited by Taragan, 2005, 29.

79 Ibn Hawqal, 1964, vol. 2, 470.

80 Blake, 1937, 306–307, citing Barthold, 1928, 235–36.

81 The Ferghana Valley in Central Asia overlaps with Uzbekistan and parts of Tajikistan and Kyrgyzstan; Ibn Hawqal, 1964, vol. 2, 485.

82 Ivanov in Piotrovsky and Pritula, eds., 2006, 38–39. For the cauldrons signed by an artisan from Merv, see 287 in this volume. For a recent survey of published signatures from Khurasan and Sistan and a bibliography, see Laviola, 2017B.

83 Ivanov, 1983.

84 Aga-Oglu, 1946.

85 Ivanov in Piotrovsky and Pritula, eds., 2006, 38 39.

86 Saint Petersburg, Hermitage Museum, IR-2268; cast copper alloy inlaid with silver and red copper (H. 18.5 cm; D. 22 cm). The Bobrinsky bucket was bought in Bukhara in 1885 by a Russian official and sold to Count Bobrinsky before entering the Hermitage in 1925; Loukonine and Ivanov, 1995, 134–35, no. 116.

87 Saint Petersburg, Hermitage Museum, ИР-1678.

88 Tbilisi, Georgian National Museum, MS. 135; Loukonine and Ivanov, 1995, 115–16, no. 117.

89 Allan 1976–77, 1986B, 60–65; Melikian-Chirvani, 1982B, 168 and 1986B, 89, 95.

90 See 127 in this volume.

91 Blair, 2014, 82–87.

92 Saint Petersburg, Hermitage Museum, SA-12268, copper alloy inlaid with silver and copper (L. 19 cm). The partly broken and restored object is decorated with an Arabic inscription on top of the lid and a poem in Persian on the sides where the name of the maker is also repeated. Other Persian verses on the base were engraved after the manufacture according to O'Kane, 2009, 42. The pen box was discovered in 1887 during the digging of an irrigation pit in Urumbai, Uzbekistan, near the southeastern part of the Aral Sea, in the area of an ancient fortress known as Karakalpak-kala and Orumbai-kala; see Giuzalian. 1968; Loukonine and Ivanov, 1995, no. 115, 134.

93 Saint Petersburg, Hermitage Museum, AZ-225; cast copper alloy with traces of silver inlay (W. 31 cm, H. 35 cm) The inscription on the head and collar is in Persian and Arabic; Ettinghausen, 2007, Allan and Kanaʾan, 2017, 462–66; Loukonine and Ivanov, 1995, no. 127, 144.

94 See 127 in this volume.

95 Washington DC, Freer Gallery of Art, 36.7. Atil, Chase, Jett, 1985, 102–110; see cat. no. 2 for a comparable example.

96 Herzfeld, 1936.

97 Mentioned by Allan, 1986B, 63.

98 Kanaʾan, 2009.

99 Kanaʾan, 2009, 188–95.

100 Muhammad al-Bayya, or the scribe, was read by the late Abdullah Ghouchani as the signature on the inkwell; New York, Metropolitan Museum of Art, 35.128a, b.

101 Giuzalian, 1968, 98–101.

102 See above, note 93.

103 Ghabin, 2009, 252–58.

104 Bosworth, 2011C, vol. 2, 169 and 216–17.

105 Floor, 1989; Allan and Kanaʾan, 2017, 474.

106 Floor, 1989; on the question of guilds which are not attested in Iran before the fourteenth century, see Floor, 1975, especially 99–105.

107 De Fouchecour, 2009, 210–11, 214; Zakeri, 2008; Milwright, 2017, 29. For a distinction between *futuwwa* and guild-like organisations particularly in Iran in the nineteenth century, see Floor, 1984. For the links between *futuwwa* and Sufism in the early thirteenth century, see Babayan, 2002, 168–69.

108 Daryaee, 2010, 403–4. For the Sasanian period see also Tazzafoli, 1974.

109 Allan, 1979, 21: Spink, 2015; Ross and Allan, 2001.

110 Ibn al-Athir, vol. XII, 207. The founder of the Saffarid dynasty (867–911) of Sistan, Yaʿqub ibn Layth, was a *saffar*, a craftsman working with copper. He was supported in his rise to power and his ambitions by the brotherhood of metal craftsmen; see Babayan, 2002, 171.

111 Kanaʾan, 2009, 176.

112 Foundry or *rikhteh-gari*; I thank Sepideh Parsapajouh (anthropologist, CNRS, CéSor-Centre d'études en sciences sociales du religieux) for the information on the technical terms encountered on these objects.

113 Pope, 1939, vol. IX/1, pl. 1345B.

114 Allan, 1976–77.

115 For the sources see Melikian-Chirvani and Allan, 1989.

116 Kanaʾan, 2009, 192.

117 It should be noted that the earliest preserved keys made for the Kaʿba with silver inlay date from the 1160s or earlier.

Materials, Alloys and Techniques

MATERIALS AND ALLOYS IN THE TEXTUAL SOURCES[1]

The seven metals repeatedly mentioned in the medieval sources and also listed by Abu'l Qasim of Kashan in the early fourteenth century are: gold, silver, copper, tin, iron, lead and *khar sini*, an alloy of copper and tin.[2]

Iran is rich in copper, lead and zinc ores. Metal deposits are present across the country, with the exception of the regions in the southeast and southwest which include the Zagros mountains and the province of Khuzistan. Copper mining is recorded in Iran from the sixth millennium onwards, and the reduction of ores into metal began in the fifth millennium.[3] The study of the Deh Hosein mine, located on the eastern side of the central Zagros range, has revealed the exploitation of ores rich in tin and copper in the second millennium. Archaeological excavations and surveys in Iran, as well as archaeometallurgical studies, have focused mainly on the earliest metal mining activity during the Prehistoric Era (Chalcolithic and Bronze Ages) but so far there has been little interest in mining in the medieval period. Outside Iran, geological surveys have revealed the existence of lead mineralisation in Central Asia, notably in Uzbekistan and Turkmenistan,[4] and in Afghanistan.[5] Copper ore deposits were found in Afghanistan in the provinces of Helmand, Herat, Kabul,[6] Ghazna and Kandahar[7] (Appendix 2). Tin deposits were also identified close to Herat.[8]

Information on deposits and the supply of raw materials in the tenth to twelfth centuries is mainly found in Arabic and Persian geographical texts, or more precisely, studies of local geographies or travel accounts. Technical data can be found in four important extant texts. The first is by al-Hamdani and was written in Yemen c. 331/942. The second is by al-Biruni and is likely to have been written in Ghazna before 1050; his text describes the extraction, production and use of metals. Nasir al-din Tusi (1201–74), an astronomer and scientist from Tus in Khurasan, wrote a general survey on minerals and precious stones which contains technical information about metals. Finally, Abu'l Qasim Kashani, in a text written in Tabriz in 1300–1 and partly based on that of al-Tusi, contributed the most important metallurgical treatise of the medieval Islamic world. It provides recipes for various alloys which were seemingly tested by Kashani himself.

The materials and fuels used for the production of copper alloys are in part similar to those used for the manufacture of ceramic glazes in the pre-Mongol period: copper, tin and lead were also frequently used for the production of glazed ceramics.[9] The same mineral ores were

employed in the medieval Iranian world for the 'arts of fire', in other words the production of ceramic, metal and glass wares. The region was also known for its manufacture of luxury coloured and opaque glass vessels.[10] Both the furnaces built for the processing of ores such as zinc oxide, as well as the high temperature kilns for processing minerals for ceramics, further illustrate the similarity of tools and processes in the manufacture of 'the arts of fire'.[11]

The Mines

Mines in ancient and pre-modern times—according to mining methods used until the early nineteenth century—largely contained iron, gold, copper, lead, zinc and silver, and were located in Iran, Afghanistan and Transoxiana. Geographical texts mention several mines that were known in the medieval period. In 889 al-Yaʻqubi names 'Mount Bamiyan' in Afghanistan, which contains copper, lead and mercury mines; he also describes the regions of Samarqand in Uzbekistan and Usrushana in Khurasan, and cites the alluvial gold of the Namiq river.[12] According to tenth-century texts by Ibn Hawqal as well as the *Hudud al-ʻAlam*, copper mining occurred in Transoxiana, Khurasan and in Iran, in the province of Kirman and the areas of Isfahan and Fars.[13] Ibn Hawqal refers to the Nuqan mountain in the region of Nishapur where there were copper, iron, silver and gold mines, although he specifies that the gold mining was not 'remunerative'. He describes, in Kuh on the road to Herat, a 'Mount Silver', where in his time a silver mine was closed due to a lack of wood—the fuel necessary for its exploitation. In his description of the region of Ghur in Afghanistan, Ibn Hawqal also mentions a mountain chain (that is, the Hindu Kush), where gold and silver ores were mined, and also describes abundant deposits of iron ore in Kabul. The mines in Transoxiana are also significant: Ibn Hawqal refers to iron ore deposits there, and the unmatched wealth of gold and silver mines (again in the Hindu Kush) in *Dar al-Islam* (the lands of Islam). Iron, copper, mercury, lead, gold, silver and tar were all mined in this region. In Samarqand, the Kuhak Hill (adjoining the foothills of the Hindu Kush) contains silver and gold ores, but these are difficult to extract; the Buttam mountains also contain silver and gold deposits. Gold and silver, as well as bitumen, copper and lead, are also mined in the mountains of Ferghana.[14]

Copper mines (Pers. *mis*) were widely exploited in Iran in the medieval period.[15] In the tenth century, Abu Dulaf is alone in mentioning a huge copper mine in Nishapur.[16] Both al-Istakhri and Ibn Hawqal refer to *nahas* or *ṣufr*, Arabic terms for copper, being produced in the region of Ferghana. Ibn Rustah also mentions *ṣufr* mines near Isfahan, and al-Mafarrukhi describes *ṣufr* mines in Kohistan (in the south of Iranian Khurasan). The word *ṣufr* can also refer to bronze or other copper alloys, but in these geographical texts Allan interprets the term to mean copper.[17]

Al-Muqaddasi, Abu'l Qasim Kashani and Marco Polo, writing in the tenth to thirteenth centuries, mention only Kirman as a zinc mining area.[18] Mining surveys show that zinc ores are associated with lead and copper (mineralisation of copper-lead-zinc) and are located in the regions cited in the ancient texts.[19] In addition, ceramic sticks used to collect zinc oxide during the treatment of this ore were also found in several sites in the region of Kirman, in Anarak as well as southeast of Mashhad in Khurasan, but with no information on their date.[20]

According to Allan, it is unlikely that tin (Ar. and Pers. *raṣaṣ*, or *qalʻi*) came from Iran and Khurasan in the medieval period although al-Biruni reports that tin deposits were known in Afghanistan to the south of Qandahar and in Sistan, up to the region of Herat. Towards the end

of the first century BCE, Strabo mentions that tin was being extracted from Sistan.[21] However, geographical sources and witnesses from between the ninth to thirteenth centuries mention mainly Kalah. Ibn Khordadbeh, al-Masʿudi, Abu Zayd (ninth century), Abu Dulaf and al-Biruni (eleventh century) cite Kalah as the source of tin in Iran. Its precise location varies: some authors identify Kalah with Kedah on the western coast of the Malacca peninsula in Malaysia, while others situate it in Kerah in the northeast of the same region. Wheatly locates it near the mouth of the Tenasserim River in Myanmar (Burma). However, Yaqut (c. 1179-1229) cites the poet Misʾar b. Muhlahal, who writes of his return to Kalah from China, specifying that it was the first city in India on the border with China, thus placing the mine in the Himalayan region. He also mentions that it was located inside a fortress (qalʿah) where sabres were struck. At the beginning of the fourteenth century, Abu'l Qasim Kashani also refers to China, Turkestan, Bolgar near the Volga River and Europe as sources of tin in addition to Kalah.[22] However, according to Yaqut, in the thirteenth century tin was brought to the Middle East from Spain, while Ibn Said writes that copper and tin were imported into Egypt from England, via Toulouse or Narbonne in France.

According to the sources, silver was processed from argentiferous lead.[23] Indeed, al-Hamdani describes the method of lead reduction as one stage in the making of silver. Likewise, Abu Dulaf mentions this process of cupellation, as well as the proportions of silver and litharge obtained from this method, (1 g of silver for 3 kg of litharge) in the region of Alaran. Silver was thus associated with the lead and zinc ore deposits which are plentiful in Iran,[24] especially in the centre, northwest and northeast in the provinces of Azerbaijan, Alborz, Isfahan, Yazd and southern Khurasan. The extraction of silver by the cupellation of lead ores has been documented in these regions since the fourth millennium. Archaeological excavations and surveys in Transoxiana indicate that silver mining took place until the tenth century in Ilaq in Uzbekistan, and until the eleventh and twelfth centuries in the Talus river valley in Kyrgyzstan, as well as in Pamir in Tajikistan.[25] According to tenth-century geographers, Khurasan and Transoxiana were well-known for their production of silver (Pers. sim). In Khurasan, the neighbouring mining towns of Panjhir and Jarbaya were the most important silver production sites and are mentioned—especially Panjhir—in all the geographical accounts.[26] In Iran, geographers mention other sites of silver mining in the provinces of Kirman, Jibal and Fars; also Mazandaran according to Ibn Isfandiyar, al-Taymara in the eighth century and Isfahan before the ninth century according to Ibn Rusta. One third of the silver that was extracted was due to the government, while the remaining two thirds could be used by private or local enterprises.[27] Lead (Pers. usrub) was thus a subproduct of silver processing. According to al-Biruni, lead was mined in Iraq and Khurasan.[28] Based on the sources for silver and lead mentioned in the texts, it would appear that lead mining was spread throughout the Iranian world, with the richest sources in Khurasan and Transoxiana. Silver mining was thus related to lead mining.[29] It seems that there were different qualities of lead, and that some originated from outside the Iranian world. Indeed, Abu'l Qasim Kashani refers to the mines of Kirman and Yazd, and to the excellent quality of lead from the Bulgars in contrast to the poor quality of Anatolian material.[30] Most precious metal vessels from the pre-Mongol Iranian world have disappeared, most probably melted down to mint coins. The famous silver mines in the Zarafshan valley in Central Asia operated in the Samanid period (until 975) and were still producing silver in 1937.[31] Allan has suggested that from around 1100, there was a shortage of silver in the entire Middle East which might have affected the production of silverware. He bases his theory on the lack of silver coins minted in the eastern Islamic world

between approximately 1000 and 1260, and the change in commercial routes that diverted silver from Turkestan.[32] In his analysis of the relationship between gold and silver dirham mints, Richard Bulliet indicated that silver coins had almost disappeared under the Saljuqs in order to accommodate gold dinars, not for lack of silver, but because of changes in financial policies and modes of consumption.[33] Melikian-Chirvani has also refuted Allan's hypothesis, maintaining that, according to sources contemporary to the periods of shortage identified by the latter, the production of silver vessels never stopped and silver was extracted from a number of small mines in the Iranian world. In addition, sources from the Mongol period mention the commerce of silver ingots from c. 1300 to 1320.[34]

Alloys

At least four and maybe six copper alloys can be identified in texts and extant objects. Much information is provided by al-Biruni in the eleventh century and Abu'l Qasim Kashani in 1301.

Tal or *batruy* is, according to al-Biruni, al-Tusi and Abu'l Qasim Kashani, an alloy of copper and lead used to make mortars, cauldrons and cooking pots.[35] This alloy might correspond to the high leaded copper with which cauldrons and almost all of the mortars from the DAI were made (Appendices 1, 6).

Brass (Pers. *berenj*; Pahlavi *bring*), used from the eleventh century onwards, is a mix of copper and zinc.[36] Brass known as *berenj* is hammered, but *shabah mufragh* is a type of brass that is cast, with different ratios and the addition of other metals to the alloy The oldest lexicographical mention of *berenj* is found in *Kitab al-Balaga* (438/1046–47), an Arabic-Persian dictionary by Adib Kordi Nishapuri, where it appears under the translation of the Arabic word *shabah* (similar to resembling) gold. This definition can already be found in al-Biruni, who explains that to obtain this yellow appearance, *tūtīyā*, which probably refers to zinc oxide, is added to copper.[37] Brass is described in the same manner by Nasir al-din Tusi and Abu'l Qasim Kashani and according to the lexicographical information, this alloy was specifically used for objects that were meant to ring, such as bells or bracelets. According to these sources, it was produced in Khurasan and Sistan in the twelfth and thirteenth centuries.

Shabah mufragh is, according to al-Biruni, an alloy of *batruy* and *berenj* and therefore a mix of copper, lead, zinc and tin. According to the same author, it is used for the manufacture of candlesticks, lampstands, basins for religious buildings and tools related to fire and the fireplace.[38] *Dararuy* is an alloy described by Abu'l Qasim Kashani as a mix containing *safidruy* (bronze rich in tin), *mis/mes* (copper) and *birinj/berenj* (brass).[39] This author does not mention for which objects this alloy was used, nor what the proportions of the ingredients might have been. We note that the analyses performed on the DAI's collection suggest that *shabah mufragh* without tin does not exist. Is it possible that *dararuy* and *shabah mufragh* are two different names for the same alloy? Al-Biruni may have omitted to mention the addition of bronze because its contribution to the recipe was minimal, possibly in a recycled alloy.

White bronze, or bronze with a high proportion of tin (around 20%), was well known in the Iranian world in the Sasanian period; it had been introduced in the Parthian era, probably imported from China. In the Islamic period, it is referred to in the sources as *asfidhruy* or *safidhruy*, literally 'white bronze'. In the eleventh century, al-Biruni is the first to describe it with the term *isfidru*.[40] He refers to contemporary objects in white bronze, particularly drinking vessels,

6

jugs and water basins that do not corrode and says that the production of *isfidru* is particularly well mastered in Sistan. He specifies that this alloy cannot be hammered, a point that, like its white colour, is later also mentioned by al-Tusi and Kashani. According to Allan, the term *khār sīnī* appears in the Arabic and Persian texts and is described as being used for the production of mirrors of the '*ṣīnī*/chinese type', that is circular in shape and with a suspension knop. This term could refer to a type of bronze with a relatively high proportion of tin, although less when compared to the real white bronzes. According to analyses conducted on the DAI collection, it is possible that this alloy was used in the mirror corpus (cat. nos. 70, 72, 73; Appendices 1 and 6). In the section devoted to *khār ṣīnī*, al-Biruni cites existing sources that speak to the material's rarity and its association with Chinese mirrors, its similarity to tin due to its colour and fusion and its lack of malleability and ductility.[41]

The different types of alloys used for the production of vessels and other portable objects were perhaps worked in workshops from ingots that were locally made or more distantly sourced. The hammering of copper ingots was observed in Iran at the end of the nineteenth century.[42] In the medieval period, it is very possible that alloys like brass and white bronze were worked like copper, that is, transformed into sheets by hammering, or melted in workshops after their purchase as ingots.

1
Small faceted vase

Khurasan, before 900
Hammered high tin bronze

H. 12.1 cm; W. max 9.4 cm; D. base 5 cm;
D. opening 5.9 cm; W. 0.284 kg

The surface of this object is marked by a complex stratigraphy of corrosion, which caused parts of it to rise. A gap filled with tin soldering is visible near the base and on the body. The porous surface suggests that the base was cleaned with an acidic solution.

Anonymous gift in memory of Bernard and Lucette Dauxerre, 1993; inv. no. MAO 900

Fig. 6

X-ray of the small faceted vase (cat. no. 1): the reliefs of the fluted neck and the facets of the body produced by hammering at high temperature are clearly visible.

ALLOYS AND IMPURITIES

The use of alloys in the medieval Iranian world has been the subject of very few studies. The only important publications on the subject by Allan include approximately sixty analyses on objects from the pre-Mongol Iranian world, largely from the collections of the Louvre, the Ashmolean and the British Museum.[43] Analyses were performed in the laboratory of the British Museum on over 300 objects dating from the tenth to the fifteenth centuries; these were from the museum's own collection, from the Ashmolean, the Courtauld Institute in London and the Archaeological Museum in Grenada.[44] To these can be added analyses on objects in the collection of the Freer Gallery of Art in Washington, and on eight objects from the Jordanian Heritage/Yarmouk University Museum at Irbid in Jordan.[45] Published analyses of medieval archaeological material focus mainly on the Middle East, including the wonderful research done by Matthew Ponting on 153 objects from a workshop hoard from Tiberias in Israel dating to the Fatimid period, the hoard discovered in Denia in Spain and the remains of a Byzantine ship found in southwest Turkey, near Serçe Limani.[46] For the same period, we can add the analysis of twenty-five objects from a hoard discovered in Caesarea in Israel.[47] Lastly, it is important to include analyses carried out on six objects uncovered in an Umayyad fortress in Umm al-Walid in Jordan.[48]

Investigations of shaping techniques are even rarer. The most complete studies on the subject remain those of Schweizer and the summary of objects in the collections of the British Museum. Here again, however, most of the works are from the Middle East and cover a much a broader period than the one with which we are dealing.[49]

Corpus and Methodology

Elementary analyses were carried out on eighty-one portable objects from the collection of the DAI.[50] These objects are from the eastern Iranian world and are datable c. 900-1220 (Appendix 1). Five comparative objects from western Iran and the Middle East were added to this corpus, as well as a shield boss from Ghazna (fig. 9). Some objects are composed of different parts, separately manufactured and these were analysed at different locations, bringing the total number of analyses to 102.

Two techniques of analysis were used for the study of bulk metal. When sampling was possible, measurements were completed by ICP-AES. In all other cases, PIXE was used.[51] Comparative tests confirmed the suitability of these two techniques.[52] The results and techniques can be found in Appendix 1.

Copper and/or silver inlays, found on sixteen objects in the corpus, were analysed by PIXE following a similar protocol to that used for the bulk metal. As a general rule, we tried to repeat the analyses for each type of inlay on each object in order to ensure that the results were representative.[53] In certain cases, we measured unusually high amounts of zinc, undoubtedly resulting from the underlying substrate in the case of a porous or very thin inlay. In such cases we systematically normalised the copper content accordingly.[54]

Copper Metallurgy Based on Five Types of Alloys

All the bulk metals in the analysed objects are copper-based alloys, the main alloying elements being zinc, tin and/or lead, with a wide variation in the contents of these three elements (Appendices 4, 5, 30). No pure copper was reported.[55]

It is quite complex to assess and/or define which values these elements should exceed so as to evaluate deliberate additions. To bypass this often unanswerable question, we prefer the notion of an 'element taken into account or not in the denomination of the alloy'. For example, even though 2% lead has an influence on the properties of the metal, we will refer to 'leaded alloy' only for amounts higher than 3%.[56]

Previous studies conducted in the very different contexts of Antiquity and Medieval Europe have shown how much the intentional or unintentional character of the presence of one of these elements can vary and, consequently, that a nomenclature of alloys specific to the period, or even to the corpus in question, is often the only way to make sense.[57] In order to establish this nomenclature, it is necessary to examine the distribution of the content of the three elements— lead, zinc and tin—as well as their relationships to each other. For the pre-Mongol collection at the DAI, a group of five types of alloy appears to be the most appropriate: high tin bronze (sometimes referred to as white bronze); leaded copper; brass, leaded brass and high leaded brass (Appendix 6).

High Tin Bronze indicates an alloy with over 13% tin and very little lead and zinc (less than 0.2%), except for one mirror with 3% (cat. no. 68). There are five high tin bronzes in the collection, including four mirrors. The small vase (cat. no. 1; fig. 6) is likely to be the oldest object in the corpus, and could be considered to be closer to pre-Islamic production as it is linked to types of Sasanian white bronzes that probably remained unchanged until the ninth century.[58] Remarkably, all the bronzes in the corpus are characterised by a high tin content (when compared to statuary bronze or bronze used for cannon making) and a very low zinc content.[59]

Brass is an alloy containing 11–25% zinc and less than 0.2% lead and tin, which distinguishes it from other alloys (with the exception of the small plate, cat. no. 14, that contains 1% lead). It has a very high ratio of zinc to tin (Zn/Sn) which exceeds 30. There are eleven brass objects in the collection, a fairly consistent group that includes very high quality objects (quality 5) and high quality objects (quality 4) with a relatively well-known provenance. The objects are inlaid with precious metals, with the exception of a tabletop or tray (cat. no. 15).

Leaded Brass is an alloy that contains 12–21% zinc,[60] 6–9% lead and 2–3% tin. There are seven leaded brass objects, and the group is fairly consistent in terms of quality and types (Appendix 6). The main characteristic of the leaded brass in this corpus is the intermediate lead content that is much higher than in high tin bronze and brass (more than 6%), but mostly lower than in high leaded copper and high leaded brass (less than 9%, compared to more than 15% for the majority, except for two objects, cat. nos. 54 and 64, which have 12–14% lead).

In addition to lead, the relatively high content of tin distinguishes leaded brass from brass (less than 0.6% for the latter). The zinc content is not consistently lower, which raises questions about hypotheses of dilution (see below, 93).

The distinction between leaded brass and high leaded brass is in the lead content, generally more than 15% for the latter. However, in the case of the two complete inkwells (cat. nos. 5, 6), we considered only the bases to be leaded brass (7–9%). The lids were classified as high leaded brass (16%). We noted that the inkwell lid (cat. no. 12) was also rich in lead (16%), but the inkwell base (cat. no. 17) was much richer in lead than the other bases (32%).

Although the distinction between leaded brasses and some high leaded coppers is not immediately apparent, one aspect remains clear: leaded brasses generally include a higher zinc content (more than 12% compared to less than 8%, except for cat. 9, which falls between the two categories of alloys). Furthermore, the ratio Zn/Sn is greater than or equal to 3.4 in leaded brass, but less than 1.8 in high leaded copper.

High Leaded Copper is an alloy that includes a wide range of compositions varying from what can be called high leaded copper with less than 1% tin and zinc, to the so-called leaded-red brasses (6–7% tin and zinc), to leaded brasses and the rare leaded bronzes. Given the impossibility of finding a satisfactory criterion (absolute tin and zinc content and/or tin/zinc ratio), we decided to group them into one type of alloy, that could also be called 'dirty copper' or 'dirty bronze'. Most of these alloys have a tin/zinc ratio of less than 3 and contain less than 4% tin, except in two objects, a padlock and a mortar, which are true leaded bronzes (cat. nos. 56, 26). The result is an alloy that consistently presents a high lead content (12–35%, with four objects at 7–10%) and with a variable tin content but generally lower than 5% (except for five objects with peaks of 8% or even 11% for the padlock, cat. no. 56) and above 2%, (except for the mortar, cat. no. 27, with 0.9% tin) and finally with very variable zinc contents (less than 0.05% to nearly 8%) but with a low proportion of zinc compared to tin (ratio of less than 1.8). These alloys resemble recycled materials, with likely additions of lead for those with higher contents of the latter. Objects in this group are of a heterogeneous type and quality. We thus find objects that were mass-produced, as well as less common ones: the incomplete ewer (cat. no. 36) and the lamp with a figure leading two horses (cat. no. 44); the lamp or incense burner with palmettes (cat. no. 28) and the suspension lamp (cat. no. 29).

High Leaded Brass includes alloys with 7–16% zinc (except for the falcon incense burner, cat. no. 52, with 5.4%), mostly with 14–30% lead and 2–4% tin. The distinction between leaded brasses is mainly in the lead content (more than 15% compared to less than 9%, with rare exceptions). Lead/zinc ratios are also generally two to three times higher (often more than 1.5 compared to less than 0.5).

Differences between high leaded brass and high leaded copper are much less clear than those between leaded brass and high leaded copper. First, high leaded brass and high leaded copper share a high lead content and an intermediate tin content. Second, the zinc content traces a continuum from less than 1% to 16% when considering both alloys. An arbitrary boundary has therefore been proposed around 6–8% zinc, based on the zinc/tin ratio (greater than or equal to 2 for brass, less than or equal to 1.8 for copper) with an overlap of the zinc contents around 6–8% (six objects have zinc contents between 6 and 8%). This is the most heterogeneous group. We find objects of varying types and qualities (qualities 2–4). Amongst these are the zoomorphic incense burners (cats. nos. 52, 53); the inkwell lid with figures (cat. no. 12) and the lamp with reclined felines (cat. no. 39). Considering the diffuse nature of the distinctions between certain groups of alloys, it is important to highlight the minor role of tin in their definition. With the

exception of the high tin bronzes that constitute a very distinct group, other alloy types have been defined mainly by their zinc and lead contents. We considered the notion of quaternary alloy (Cu-Zn-Sn-Pb) obsolete for the definition of alloys with relatively low tin and zinc contents as in high leaded copper:[61] Apart from the lead, the copper is not alloyed either with tin or zinc in the strict sense of the word.

Two objects avoid categorisation within any of the five types of alloys and are thus not included in the statistical analysis: a mirror (cat. no. 68) and a mortar (cat. no. 78).[62]

Two Principal Classes of Purity

In addition to the three potentially added elements (zinc, lead and tin), the metals contain a range of other chemical elements. Silver (Ag), arsenic (As) iron (Fe), nickel (Ni), sulphur (Sf), antimony (Sb), cobalt (Cb) and bismuth (Bi) are the main elements that were detected and quantified in our analyses. These are present in the ores from which copper is extracted and can also be found in the ores from which the alloying elements (zinc, lead and tin) are extracted but correlations have shown that they come mainly from copper. While these elements were not added intentionally, their presence is not necessarily random: they influence the purity of copper, and this purity could be controlled see 93–95. We will call these elements 'impurity elements' or 'impurities'.[63] For each object analysed, the accumulated impurity contents were plotted on a graph (Appendix 7).

Brasses differ greatly from other alloys because of their very low content of measured impurities, including silver and sulphur.[64] The total never exceeds 0.2%, whereas other alloys consistently reveal more than 1% accumulated impurities, with great variations, mainly in the case of arsenic and antimony.[65] Between these two extremes, high tin bronzes are less pure than brasses, but nevertheless have low amounts of impurities,[66] with generally less than 1% accumulated impurities (without counting lead or zinc, which would add about 0.1–5% impurities).

In order to identify possible groups of compositions based on the impurities contained in the alloys, a statistical analysis of the compositions by clustering was conducted on eighty objects, taking into account the eight impurities Ag, As, Fe, Ni, S, Sb, Co and Bi. Two atypical objects were not included in this analysis.[67] Two groups or classes could be distinguished (Classes 1 and 2; Appendix 8). Class 1 shows the same succession of impurities as Class 2 and in similar correlations, but with consistently higher contents of Ag, As, Sb, Ni and Bi when these were measured. We will return to the significance of these two classes for copper supply patterns. We note, however, that the separation between these two classes is not always clear, but follows a continuum of compositions. In addition, the brasses, by virtue of their high purity, were assigned to Class 2 by the statistical analysis.

Properties of Alloys

The choice of alloys and metals depends on several factors that can be classified in the corpus in order of predominance. The use of one of the five types of alloys is contingent first on the shaping technique (casting or hammering) and, for the cast object, on the typology. Cast objects are obtained by pouring a liquid alloy, whereas those shaped by hammering are cold worked from one or more solid metal sheets. The degree of sophistication in the ornament, whether chased or with metal inlay, has an impact on the preliminary choice of alloy.

Cast or Hammered Alloys

The shaping technique was the predominant aspect guiding the choice of a leaded alloy (casting), or an alloy without lead (hammering), regardless of the type or quality of the object. The choice of a high leaded alloy was systematically observed in the eleven openwork objects (lamps or incense burners) in the analysed corpus. This was probably the deliberate choice of a metal of high castability in order to better control the casting of the openwork.[68] On the other hand, pure metals were reserved for hammering.[69] This strategy for choosing alloys with lead and/or many impurities in the cast objects is common to the entire corpus except in the case of two cast objects which contain 3-5% lead, (mirror, cat. no. 68; mortar, cat. no. 78; Appendix 1). The corpus includes a single object made of cast brass (cat. no. 14). However, its lead content (here considered an impurity) and the impurities more generally are distinctly higher than in the hammered brasses (1% lead compared to less than 0.2% elsewhere). In addition, its zinc content is slightly lower than that of hammered brass (15% compared to an average 20%).

High tin bronzes, although marginal to the pre-Mongol corpus, deserve a mention. A vase (cat. no. 1) is the only hammered high tin bronze, although it is not cold worked like the brasses—it is necessary to exceed 500°C to overcome the brittleness of this material.[70] Previous work on metals from the medieval Islamic world show similar results for alloys (Appendix 9).[71] Brass without lead, or much more rarely, copper, were used in the manufacture of hammered objects. Cast objects were made from alloys with lead.

Cold Decorated Alloys

Most of the objects in the corpus, whatever the grade of their alloy, were cold worked on the surface, for the creation and/or reworking of the decoration by chasing, engraving, champlevé and inlays. This suggests, *a priori*, that this type of intervention had no influence on the choice of alloy, or on the purity of the metals. However, detailed examination suggests a more nuanced reading. On the one hand, it can be seen that none of the high tin bronzes (the mirrors, and the vase, cat. no. 1) were cold worked. On the other, it is the brasses and the leaded brasses, the alloys that are best suited for incision, that feature the most elaborate surface decoration. These were certainly the most expensive objects—we will see the precious character of the 'brass' material that was the preferred support for metal inlay. However, certain technical constraints cannot be ignored. Tin renders metal hard and brittle, while unalloyed copper or copper with too much lead is too soft: the addition of zinc in *ad hoc* proportions, with a little tin, leads to the ideal material for the chaser and the inlayer—that is brass—and this was precisely the formula chosen by the craftsmen.[72]

Alloys of Different Colours

The alloys in the pre-Mongol collection that were analysed and defined show varying shades of colour, quite distinct from their surface appearance which has often been transformed by corrosion or an artificial patina that turn them greenish, reddish or brown. Two alloys have a distinct colour: high tin bronzes are very light in colour with a tendency towards whitish-grey; brasses are of a yellow-gold colour which follows the definition of this alloy by al-Biruni. Few studies have been published on the precise aspects of the alloy colours that are discussed here, in particular on the effects of zinc and lead on the appearance of the metal.[73] However, the chart published by the Kupferinstitut provides some information: [74] red-gold (*Goldrot*) is achieved with 5% zinc, yellow-gold (*Goldgelb*) with 15% zinc and green-gold (*Grünlich gelb*) with 25% zinc to a saturated yellow with 37% zinc. An important limit would therefore be around 15% zinc.[75] The lower limit of brass and leaded brass in the corpus is above 15% zinc by mass (except for two inlaid objects, cat. no. 9 with 8% and cat. no. 4 with 12%). The objects are thus yellow in colour. On the other hand, high leaded brasses are more likely to contain around 8% zinc, with levels as low as 5 or even 4%; these objects tend to be pink in colour, with the high lead content tending to make the colours paler. Leaded coppers would have a more pronounced pink tone.

Other Properties of Alloys

The improved corrosion resistance of brass containing zinc is worth mentioning, especially for objects connected with food, drink or water. Both tin and arsenic, elements present in medieval alloys, may play an even greater role in resistance to corrosion. Indeed, they reduce the dezincification of brass caused by water (for alloys with more than 15% zinc). This is also found in modern metals: for example, drinking water pipes are made from an alloy called *Dezincification Resistant Brass* (DZR) or Brass C352.[76] Finally, let us recall the optical properties of alloys with high levels of tin: their reflective properties were exploited for the manufacture of mirrors.

Choice of Alloy, Quality and Type of Object

Quality

Independent of their type or of their technical aspects, objects in this corpus have been classified into groups 1–5 according to their quality (Appendices 10–12), with 5 being the highest and 1 the lowest. The quality of the shaping and the decoration, particularly the presence or absence of metal inlays, served as criteria for evaluation.[77] Links can be drawn between the quality of production and the materials employed (Appendix 12). The three objects of quality 5 (cat. nos. 2–4) were made with brass, a pure metal both in terms of its alloy elements (zinc alone) and its impurities.[78] The objects of quality 4 were made of brass, leaded brass and sometimes high leaded brass (cat. no. 12), that is alloys with a high zinc content. The highest quality of cast ewers (quality 4, leaded brass) contain less lead than lesser-quality ewers (high leaded brass). If leaded brass was often reserved for good quality objects (qualities 3 and 4), metals with a high zinc content, rather than lead content, determined the highest quality of objects (qualities 4 and 5). Nevertheless, some objects of lower quality (quality 2) are made with brass, such as two objects from Ghazna (cat. nos. 14, 15), as well as several brasses and leaded brasses of medium quality (quality 3) (Appendix 10). Low to medium quality objects (qualities 1–3) are made from all four types of alloy other than high tin bronze. Objects cast in high leaded copper, with a low

zinc content, confirm this ranking, as these are the only lower quality objects (qualities 1 and 2) such as mortars, most of the cauldrons and some lamps and incense burners. In this group, only one ewer (cat. no. 36) and a lamp (cat. no. 44) are of more careful manufacture (quality 3). It is therefore essentially the alloy, and particularly its zinc content, that is related to the quality of the object; the lead content does not have much impact on this ranking. The corpus does not allow for a systematic evaluation of the eventual role of the metal's purity. Analyses conducted on objects in other museum collections reveal similar links between the type of alloy used and the high quality of objects in the pre-Mongol Iranian world (Appendix 9).

Type

Comparisons between the pre-Mongol corpus of the DAI (Appendix 1) and other museum collections (Appendix 9) have led to certain hypotheses with respect to the links between the type of object and the choice of alloy. The mirrors are almost exclusively made of high tin bronze, as are the majority of the sphinx mirrors at the British Museum which are all made from the same alloy type.[79] The small plates or circular incense burners, the tabletops or trays and the ewers are all made from alloys with zinc, with or without lead, depending on the shaping technique, and regardless of the quality of the object (1–4), with the exception of one ewer (cat. no. 36) that has only 4% zinc. The sprinklers, the inkwells and one vase (cat. no. 63) are manufactured from another alloy—high leaded brass.[80]

Other types of objects (incense burners, feline carpet weights, lamps and lampstands, cauldrons and mortars, a flask and a shovel) do not seem to have been made from a specific alloy. While all contain high levels of lead, zinc levels trace a continuum from 0 to over 15%, without this variation being explicable on the basis of typology alone. It is likely that, at least in part, colour dictated the systematic use of brass for certain types of objects.

Alloy-Making Methods in Western Iran and the Middle East

Five DAI objects from Egypt (Antinopolis AF 1199), Lebanon (Sidon, MND 330 and MND 534) and western Iran (Susa, MAO S. 401 and MAO S.1753), datable from the eleventh to the twelfth centuries, were analysed for comparative purposes (Appendix 13).

One of the sprinklers found in Susa (MAO S.1753) and a lampstand from around Sidon (MND 330) fit into the same alloying pattern as those characterised for the eastern Iranian world. However, the three other objects reveal very different properties: the sprinkler from Antinopolis and a sprinkler from Susa (MAO S. 401) contain much less zinc: these are high leaded coppers, not leaded brasses. These isolated cases can nevertheless be considered in the context of larger archaeological assemblages.[81] In particular, the Tiberias hoard shows a relationship between alloys and typologies similar to those of the eastern Iranian world: most of the lampstands, sprinklers and lamps are made of high leaded brass with less than 12% zinc and more than 12% lead and the mortars are made of high leaded copper. More generally, the archaeological finds from Fatimid contexts at Tiberias, Denia and the Serçe Limani shipwreck[82] reveal a use of alloys similar to the one characteristic of the eastern Iranian world. Thus, the technique of shaping by casting or hammering determines if lead should or should not be used.[83] The five types of alloys defined for the pre-Mongol corpus differ relatively little from the four groups identified for the Middle Eastern objects.

METAL INLAYS

Sixteen objects in the pre-Mongol collections are inlaid (Appendix 14), most of them with copper and silver. Four are inlaid with copper alone (cat. nos. 9, 18, 19, 24), whereas the surface of cat. no. 10 is enhanced only with silver. No gold inlays were found, which accords with our knowledge of inlaid metalwork predating the Mongol period. Given their fragmentary and/or heavily eroded condition, it appears that the present inlays were those added during the objects' original manufacture, except in the case of one example (cat. no. 5).[84] While it is prudent to refrain from making generalisations from a limited corpus, one can nevertheless note that it is almost exclusively the brasses, with or without lead, that are inlaid.[85] In the case of cast objects, the lead content is not a determining factor for the presence or absence of inlay.[86] Whether shaped by hammering or by casting, the number of inlaid objects is almost equal. Concerning the purity of the copper (Class 1 or 2), no clear trend is apparent. Finally, the type of inlay does not seem to affect the type of metal that was inlaid: and the wires or sheets can be of copper and/or silver.

Silver Inlays

According to the analyses made on the inlays, four types of silver, in sheet or wire form, can be distinguished (Appendix 18): pure silver (96-99%), low-alloyed silver (94-96%), alloyed silver (89-90%) and high-alloyed silver (81-88%). If we list the major and minor elements that can sometimes be measured: copper (Cu), gold (Au), lead (Pb), bismuth (Bi) and tin (Sn), we find at least eight groups with the same composition. This variety removes any statistical significance in the corpus of thirteen objects: each one belonged to a specific group. Thus, the fact that all the objects of quality 4 are inlaid with the purest silvers, while those of qualities 3 and 5 show a great variability in the alloys of the inlaid silvers, is probably only a statistical bias. Nevertheless, analysis of silver inlays reveals a few recurrent phenomena. It is not possible to differentiate between silver wire or silver sheet compositions on any given object[87] which suggests a unique supply source, or even the shaping of the silver in the workshop rather than the purchase of prepared sheets and wires.

When silver is alloyed, whether naturally or artificially, the main alloy element is copper, ranging from 2 to 11%. However, other elements may also be present in substantial quantities, such as high quantities of lead (2–4%). This was only observed for the inlays of the inkwells (cat. nos. 5, 6, 17).[88] One example (cat. no. 5), as well as a ewer (cat. no. 4), present silver with a high tin content (2–3%). The gold contents are very homogeneous (around 1%) with two exceptions. The silver of one ewer (cat. no. 7) is characterised by a high gold content (almost 3%). Inversely, the silver inlay on another ewer (cat. no. 8) has less than 0.005% gold.[89] Finally, the quantities of bismuth are below the detection limit (less than 0.03%), with the exception of the inlaid silver (0.2%) of one object (cat. no. 23).

Copper Inlays

Analyses of the copper wires (linear inlay) and copper sheets (spatial inlay) on fifteen objects (Appendix 18) showed that these red inlays were made with an unalloyed metal that was more than 97% pure. The main impurity after lead (around 2%) is arsenic, whose content ranges

from 0.1 to nearly 0.4%, with peaks of more than 0.6% in some cases (cat. nos. 12, 17, 23). The other impurities detected in these inlays were nickel, antimony and silver (0.1% and above). An inkwell lid (cat. no. 12) is notable for its high antimony content (0.4%). Sulphur was not taken into account because surface analyses can sometimes be disturbed by corrosion. A clear correlation was observed between antimony and silver, and a possible correlation between nickel and silver in some copper. These correlations are different from those of the copper substrate (correlation As /Ni /Sb; Appendix 17) which would suggest that the copper inlays and the copper substrates generally did not have the same origin. The cluster analysis of five impurities: silver (Ag), arsenic (As), nickel (Ni), lead (Pb) and antimony (Sb) reveals four groups (Appendix 16). More precisely, the comparison between the copper used for inlay and the copper used in the substrate alloys leads to three possible cases (Appendix 17):

— The copper in the inlay is much purer than that in the substrate. We thus have two different supply sources of copper, one for the inlay and one for the substrate. This configuration was observed on three cast objects (base of cat. no. 6, cat. nos. 18, 19).

— The copper in the inlay is significantly less pure than the metal in the substrate. Again, there are two different sources of copper: one for the inlay and one for the substrate. This configuration characterises most of the hammered brass objects (cat. nos. 3, 4, 11, 23, 24).

— The copper in the inlays and substrates has the same impurities and at the same levels. Contrary to previous cases, this would indicate a single source of copper. This similarity was identified largely in the cast objects (cat. nos. 7, 8, 9, 12, 17), and in one hammered brass object (cat. no. 2). According to the statistical analysis, these cases correspond to two types of signatures in impurities which could be linked to two production centres:

— Two inkwells (cat. nos. 12, 17) form a duo characterised by high arsenic levels and are possibly linked to Ghazna where the inkwell cover (cat. no. 12) was found. The second inkwell (cat. no. 17) could also be linked to Herat by the type of silver used for its inlay. The copper impurities of two objects (cat. nos. 19, 23) are close to those of the two inkwells.

— Two reference objects are linked to Herat (cat. nos. 2, 3). The impurities in their copper (inlay and substrate) are very similar to those in three other objects (cat. nos. 7, 8, 9). The silver inlay on the two ewers (cat. nos. 7, 8), is, however, close to the inlay on the inkwell cover found in Ghazna (cat. no. 12).

Groups of Inlaid Objects

Combining the criteria of (a) the six groups of impurities in copper inlays, (b) the three cases of comparisons between the copper of the substrate and the inlays, and (c) the four types of silver, the following hypothetical groupings can be proposed:

8

red brasses are consistently thinner than those of cast metal objects (Appendix 22), and range from 0.8 to 1.2 mm, although one piece (cat. no. 2) has even thinner walls (0.4 mm). Hammered objects are also characterised by an almost identical match between the external and internal volumes.

Depending on the desired shape, several hammering techniques might be used, sometimes on the same object, in addition to possible folding, soldering or mechanical assembly.[93] Use of a lathe has not been identified on objects from the pre-Mongol period. The observable traces of hammering, and above all the width of the walls, are too thick to have been worked on a lathe and would seem to exclude this method from the shaping techniques used in the medieval Iranian world.[94]

To rough up the final shape, the plastic deformation of the metal was almost always carried out cold on one or more cast flat metal sheets known as blanks. A stamping phase carried out with a sledgehammer to deform the metal sheet into a hollow shape might precede the hammering to give the blank a concave form. The high tin bronze vase (cat. no. 1) was hot hammered at 500–700°C, the only method for working this alloy without breaking it. In the case of the brasses, all the identified hammering techniques were carried out cold, that is at ambient temperature, interspersed with periods of annealing.

Fig. 8

X-ray of a hammered brass object (cat. no. 35): the plastic deformation with a hammer is recognizable from the cloudy surface.

9

Simpler shapes were achieved by using one or several flat sheets of brass that were cut and folded. The U-shape of the pen box (cat. no. 2; fig. 61), for instance, was made by folding a metal sheet. For more complex shapes, the two available hammering techniques were biaxial stretching (also known as 'sinking') and uniaxial extension ('raising').[95] Repoussé was used primarily to make ornament in relief (fig. 9), sometimes raised very high and more or less in the round (cat. no. 3).

Certain hammered objects were not obtained from a single metal sheet, but rather by the assembly of several parts that were worked separately and then joined, either through hammering and crimping, folding or soldering. For example, two ewers in the collection (cat. nos. 4, 24) are made with four parts assembled together (figs. 10–11); the bottom is stamped and crimped and held by stapling on the dropped edge; the spout is made in two parts. The sheet above the spout of the zodiac ewer (cat. no. 4) is linked to the spout by a folded edge.

Sinking (Biaxial Stretching)

This process involves stretching the metal sheet from the inside in two directions, like a balloon being inflated.[96] The result is the thinning of the wall as the metal sheet expands. The rounded part of the large basin (cat. no. 35) was hammered in this way from a cast roughed-out shape on a flat anvil with an extended ball-peen hammer, as can be seen from the concentric traces visible on the X-ray (fig. 8). However, in the absence of metallographic sections, it is difficult, except in rare cases (cat. no. 35), to determine the thickness of the original sheet of metal.[97] The extra thicknesses of the central rosette (fig. 8) and the rim of the basin would correspond to the thickness of the cast blank (6.5 mm). The latter was thinned by hammering to a thickness of 1 mm, to shape the remaining part of the object.

Raising (Uniaxial Extension)

This method consists of compacting a shape on a hard surface serving as an anvil, with a rounded extended peen-hammer. The sheet is hammered in concentric circular movements, striking the metal outwards. In contrast to biaxial stretching, the metal sheet retains its approximate original thickness. Once the sheet is raised, it is hammered again in order to compact the metal and to unify and flatten it. This technique was documented in Iran in the twentieth century: coppersmiths in bazaars carried out raising on anvils of different shapes, set in the ground or resting on wooden supports.[98]

Raising was identified in the manufacture of brass pieces that are amongst the pre-Mongol masterpieces in the DAI. This technique was probably used to create the shape of the only square tabletop or tray in the collection (cat. no. 10; fig. 57). The centre of the tray is thicker than its sides which suggests that the cavities were created with biaxial stretching. After the cavities were made, the four sides of the object were folded to form the walls and the excess metal of the four corners was raised. The more complex hammered brasses (cat. nos. 3, 4, 24) were also shaped by raising. For the candlestick (cat. no. 3), the raising was carried out from a single sheet, to successively mount the base and then the socket.

No trace of hammering was observed on the ewers (cat. nos. 4, 24; figs. 10–11), but their shape

Fig. 9

Shield boss (?) in repoussé and chased brass; D. 20.4 cm; Thickness 0.2 cm; Ghazna, Afghanistan, twelfth century. It was found during the Joseph Hackin mission in Afghanistan and reached the Louvre in 1935; inv. no. AA 100.

70 MATERIALS, ALLOYS AND TECHNIQUES

Group A: Identical Copper and Silver Inlays

– Same group of Cu (high amounts of Ag and Sb) and Ag (rich in Cu and Sn):
cat. no. 4, ewer from Herat (quality 5, hammered brass, class 2 impurities);
cat. no. 5, cast inkwell base, no provenance (quality 3, leaded brass, class 2 impurities).
– Same group of Cu with high amounts of As (group Cu 5 and 6) and Ag poor in Cu:
cat. no. 12, inkwell lid from Ghazna (quality 4, high leaded brass, class 1 impurities);
cat. no. 17, inkwell (quality 4, high leaded brass, class 1 impurities).
The copper inlay in these two objects is similar to the copper of the substrate, and both have very similar substrates. The silver inlays are different: the silver on the inkwell lid is 'normal', while the silver on the base is high in lead (3%).
– cat. no. 23: tabletop or tray from Afghanistan (quality 4, hammered brass, class 2 impurities); variation: Ag high in Bi.
– cat. no. 19, ewer with no silver inlay, it presents the same copper inlay but purer (cat. no. 12 is nevertheless made from a copper that is higher in Sb content. and cat. no. 23 is made with copper that is slightly higher in Pb content).

Group B: Identical Copper Inlays (Cu2)

– cat. no. 24: ewer from Afghanistan (quality 3, hammered brass, class 2 impurities);
cat. no. 18: sprinkler with no provenance (quality 3, high leaded copper, class 1 impurities);
neither object is inlaid with silver.

Group C: Identical Copper Inlays (Cu3 and Cu4)

The most common copper group (Cu3 and Cu4) is found on seven objects. They have been grouped according to similarities in their silver inlay:
– cat. no. 3, candlestick from Herat (quality 5, hammered brass, class 2 impurities);
cat. no. 6, inkwell base (quality 3, leaded brass, class 1 impurities);
both have same Ag (high in copper; the silver of cat. no. 6 also has a high lead content compared to cat. no. 3 (2% compared to . 0.7%);
– cat. no. 2, pen box from Herat (quality 5, hammered brass, class 2 impurities);
cat. no. 11, tabletop or tray from Afghanistan (quality 4, hammered brass, class 2 impurities);
both have the same Ag with 'normal' copper;
– cat. no. 23, tabletop or tray from Afghanistan (quality 4, hammered brass, class 2 impurities); same Ag as cat. no. 11, (except for Bi);
cat. no. 2 and cat. no. 11 have the same substrate, but not the same copper for the inlay;
– cat. no. 7 and cat. no. 8 (dated 586/1190–91): ewers (quality 4, leaded brass, class 1 and class 2 impurities);
both have the same Ag (low levels of Cu);
– cat. no. 7 has silver with a higher gold content (2.6%);
– cat. no. 8 has the lowest gold content of any silver inlay in the corpus.
Cat. nos. 2, 7, 8, 9 have similar inlaid copper to that of the substrate; the inlay and substrate coppers of cat. no. 3 and of the tabletop or tray (cat. no. 11) are also comparable.

Group D: No Copper Inlay

– cat. no. 10: the tray is not in the previous groups (A–C) because it is inlaid only with silver. Its composition is not atypical but is nevertheless different from other silver in the pre-Mongol corpus.

SHAPING TECHNIQUES

Identification of the shaping processes is complex: it is a question of recognising any visible traces on an object in order to determine how its shape was achieved. Finishes applied after the shaping of the object, as well as its present state of conservation, often hide or indeed have erased all traces of its manufacture. Thus, observations made with the naked eye are inadequate for their detection and interpretation. For this reason, the collection presented in this volume, together with six comparative objects,[90] was examined under a digital microscope.[91] Thirty-seven objects from the corpus were X-rayed, particularly the complex shapes that were either made in several parts or are closed, thereby including areas that are not clearly visible or are indistinguishable. The two categories of shaping technique, casting and hammering, are unequally represented in the collection: only eleven of the eighty-four objects were produced using the hammering technique, leading to one of the important findings of this study: the prevalence of casting techniques in the metalwork of the pre-Mongol Iranian world. The development of hammering, and even the use of brass, probably increased in the Iranian world from the twelfth century onwards with the increased use of repoussé and inlaid ornament. These techniques are close to those used by goldsmiths and are fundamentally different from the much older casting processes used for copper alloys.

The typologies of cast objects are quite distinct from those of hammered objects and the relationship between these two production techniques and their makers seems tenuous. Presumably, casting workshops were distinct from those of coppersmiths where metal was hammered into shape. This is reflected in sources documenting the activity of craftsmen in bazaars, where the production of hammered objects is said to have taken place in workshops or stalls where casting was not practised.[92] It can be noted that the method of tin soldering was used for both cast and hammered objects.

Hammering

Objects in the DAI pre-Mongol corpus shaped by hammering—that is by the plastic deformation of a metal sheet with a hammer—are made from two types of lead-free alloys: high tin bronze (cat. no. 1) and brass (cat. nos. 2, 3, 4, 10, 11, 13, 15, 23, 24, 35). The former is an isolated example and is part of a production type inherited from the Sasanian period. On the other hand, judging from their typologies and inlays, hammered brasses can be firmly linked to the characteristic metalworking techniques of the Iranian world datable from the twelfth to the early thirteenth centuries, and belong to a very different metal culture.

Hammering can be identified by the naked eye if the hammer traces have not been erased by levelling and/or polishing (fig. 7). The surface is often bumpy, evidence of hammer blows struck during the final stages of the shaping process. These appear clearly in X-rays and have the mottled appearance of a cloudy sky (fig. 8). The thinness of the walls generally makes it possible to identify a hammered object. The high tin bronze vase (cat. no. 1; fig. 6) is quite thick at 2 mm, whereas the metal walls of hamme-

Fig. 7

Hammering traces on brass objects:
a) blows measuring 1 x 0.35 cm (back of cat. no. 23) b) oblong and very regular blows measuring 1 x 0.5 cm (interior of cat. no. 3).

7a 7b

suggests that they were formed by raising. Each ewer was probably raised upside down: the top part is at the beginning of the side and the base was made at the end of the raising. Once the shaping was complete, the neck opening was made by elongating the metal to receive the separately made spout. The facets of the zodiac ewer (cat. no. 4) were made once the circular shape was raised by flattening the curvature on a flat anvil placed inside the wall.

Repoussé

This is a process of hammering from the inside to create the relief visible on the exterior. It is mainly used for embossed ornament, not added separately to the surface of the substrate (cat. nos. 3, 4, 24; fig. 9). In the DAI collection, the rectangular table-tops or trays with very thin walls with mouldings and recessed parts were made with repoussé (cat. nos. 11, 15, 23), as were the gadroons on the body of a ewer (cat. no. 24). The most elaborate repoussé is used to shape the ornament in high relief and is characteristic of the finest and rarest objects that have come down to us from pre-Mongol Khurasan. One of these masterpieces is in the DAI collection (cat. no. 3): the ducks in the round and the relief ornament of the neck and body of the candlestick were all made with repoussé. The almost inaccessible ducks were probably shaped with a snarling iron, an elong-ated tool held in the area to be pushed out and operated by hammering. Regardless of the hammering process, the majority of X-rayed objects show similar oblong marks, suggesting the use of the same type of round peen-hammer. The tool marks have been measured and compared (cat. nos. 10, 15; fig. 7). These observations, along with the fact that an object could be the result of several associated

techniques (the shapes might be raised and then decorated with repoussé) suggest that the same craftsman mastered several hammering techniques and was in charge of both shaping and decorating the objects. It also seems clear that hammering, at least for objects shaped mainly by raising, was reserved for the manufacture of extremely high quality objects, as is suggested by the most elaborate pieces.[99] Less complex processes of hammering were observed for the manufacture of more commonly produced, but still good quality objects.

Figs. 10–11

Brass ewers shaped by hammering (raising and repoussé) assembled in four parts. Herat, Afghanistan, (cat. no. 4); Ghazna, Afghanistan, (cat. no. 24), late twelfth century.

12

13a

13b

Lost Wax Casting

A very large proportion of the DAI pre-Mongol collection is made up of cast objects.[100] Once this primary observation was made, our aim was to specify which types of technique were practised in the pre-Mongol Iranian world, basing our examination on this corpus. Rare textual and material sources attest to the processes of lost wax and sand casting. Thus, a poetic source mentions lost wax, and a metal frame used for sand casting has been found in Central Asia.[101] Only one object in the pre-Mongol collection was shaped by sand casting (cat. no. 55). The first major discovery resulting from the study of this corpus is that lost wax casting was the preferred casting technique, even for types which in other medieval archaeological contexts are shaped by other casting processes. Thus, the mirrors (cat. nos. 68–74) were made with lost wax and not sand casting, as evidenced by the wax-to-wax joint between the mirror knop and its surface, observed on all examples in the collection (fig. 13).[102] The cauldrons (cat. nos. 82–84; fig. 17, fig. 108) do not show any mould joints and were certainly produced with the lost wax technique, and not by core strickling as documented in other contexts.[103]

There are several techniques for lost wax casting, each defined according to the process of preparation of the wax model, although the model cannot always be identified. Determining the lost wax process from the finished object is often difficult since the traces of the casting pro-

cess are often erased when the object is finished; additionally, patinas or concretions may hide them or have made them disappear. However, the traces of tool marks printed in the wax and transposed onto the metal during the casting or the presence of core pins have often made it possible to establish almost all the objects that were shaped by lost wax casting. On the other hand, certain traces of manufacture, holes and protuberances on the bottom of most dishes and inkwells could not be interpreted (cat. nos. 6, 14, 59).[104] The small intentionally visible cavities inside and outside the bases are of uniform diameters (2–3 mm). Several hypotheses can be formulated for their function or origin: core strickling can be put aside as no mould joints have been identified but other possibilities include marks left by wax shaping on a lathe or by core pins, or the marks of a lathe used for cold working. Finally, one of the determining factors in lost wax production seems to be the control of the wall thickness. However, the three categories of thicknesses identified (Appendix 22) do not seem to correspond to distinct processes.

It is common for a first unfinished, or incomplete wax model to be produced: further steps related to the assembly and/or ornament made in the wax are often necessary. There are many examples of wax elements assembled for the addition of feet, handles and grips to the original form, but also to join several parts (cat. no. 54; fig. 12). Ornaments can also be added to a wax model in positive thus adding relief or elements in the round (cat. no. 44). Wax surface work is clearly visible in the facets adorning the necks and walls of several jugs, pitchers and a lamp or incense burner (cat. no. 28).[105] The frequent observation, through radiography, of a loss of thickness in the facet areas suggests a thinning of the wax model (fig. 14). Once the object was cast, the facets were highlighted with punching (cat. nos. 59, 60). Preparation on the surface of the wax model includes chasing, engraving or even preparation for the inlay. Finally, openwork was also made in the wax model (fig. 12).

The core pins observed in the interior of a large number of objects do not allow for the identification of the particular lost wax process; they are linked to the type of object to be cast and are not used for shapes where the bottom is assembled by soldering to the base. Thus, core pins are systematically, or almost always found in the walls of lamps and incense burners, but never in sprinklers and ewers. Nevertheless, a typology of these core pins seems to appear related to their morphology or the fact that they were added from the outer or inner side of the model (fig. 15).

14

Fig. 12

Lost wax casting: incense burner stand with caracals (cat. no. 54): the openwork and joins between the paws and the front bodies were made in the wax model.

Fig. 15

Lost wax casting: joins in the wax model between the knop and the mirror (cat. nos. 68–74).

Fig. 14

Lost wax casting. X-ray of the faceted vase with pendants (cat. no. 63): on the upper part the facets made in the wax model appear thinner and thus darker; the thicker metal appears white.

15a

15c

15b

15d

16a

16b

17

Lost Wax Casting Processes

The apparently technical uniformity of objects cast with the lost wax process conceals multiple variations, sometimes within the same object. In the case of the lamp with a figure leading two horses and its openwork stand (cat. no. 44), the wax model consists of different parts made using different processes. The stand was probably made by assembling wax slabs and therefore by a 'direct process', and the lamp by slush-moulding, that is using an 'indirect process'. These various parts were assembled to form the wax model for casting in two parts.

In the pre-Mongol Iranian world, there were at least three different ways of making a wax model.

Direct Wax-Slab Process

This technique consists of creating a wax model in positive, using wax slabs modelled by the craftsman. With this so-called direct process, the wax model is made without the use of a mould. The core of refractory material necessary to obtain a hollow shape during the casting is inserted afterwards. This process was described by the monk Theophilus for the manufacture of censers[106] and has been documented since Antiquity, notably for the creation of statuary.[107] In the pre-Mongol collection, the main clues leading to the identification of this technique were the consistent regularity and thinness of the objects' walls. This process could have been used for a number of objects, in particular inkwells and some incense burners (fig. 16). Parts of the lamps and openwork lampstands could have also been made in this way, as well as most ewers. This method can lead to thin or moderately thick object walls (Appendix 22). It is reminiscent of ceramic techniques where slabs of clay or siliceous fabric are modelled and then assembled.[108]

Fig. 15

Lost wax casting, core pins: a) on the interior of the lamp or incense burner with palmettes (cat. no. 28) b) on the incense burner with a lobed arched opening (cat. no. 30) c) close-up view of incense burner (cat. no. 30) d) on the exterior of the domed incense burner (cat. no. 57).

Fig. 16

Lost wax casting, direct process: a) and b) openwork of the falcon incense burner (cat. no. 52).

Fig. 17

Lost wax casting, direct process: X-ray of the cauldron signed Bu Bakr ibn Mahmud Saffar (cat. no. 83); the concentric bands of thickness on the upper section of the walls suggest the use of a lathe.

18a

18b

Wax Dipping Process

Another direct process consists of making the shape in a refractory material such as plaster or clay and dipping it in liquid wax. Once cooled and hardened, the rough wax shape is worked on a lathe.[109] This process also recalls a ceramic technique in which the making of a model or matrix is necessary for the manufacture of a mould: the shape of the object to be made in ceramic is prepared in clay or plaster in order to create a mould. No clue has been found on objects in the corpus to identify this practice as the associated evidence is difficult to distinguish from that left by the wax-slab process. However, certain objects such as the small plates or incense burners (cat. nos. 14, 25), the cauldrons (cat. nos. 82–84), the sprinklers and an inkwell (cat. no. 5) suggest the use of a lathe. This hypothesis is reinforced when observing the centring holes on the inkwells, as well as the thick concentric horizontal bands on a cauldron revealed by X-ray (fig. 17).[110]

Indirect Wax-Slab Process

Rather than working in the positive, a mould could be used to create the wax model. This is known as an indirect process. There are several ways of lining the inner surface of the mould with wax. One possibility is the application of wax slabs to the inner surface of a mould; a close variation of this process applies successive layers of liquid wax to the surface with a brush. The two techniques can be combined, with a first layer of wax applied with a brush, followed by further layers with slabs. A lamp (cat. no. 21), a sprinkler (cat. no. 18) and a feline carpet weight (cat. no. 9; fig. 18a) bear the marks of a bivalve mould and are very thin and uniform in thickness, suggesting the use of this method. The pitcher (cat. no. 62) also bears similar traces (fig. 18b). The partridge in the round (cat. no. 51; fig. 91) may also have been shaped with the same process. This technique also recalls the production process of a type of ceramic ware from the Iranian world that was shaped, often in several parts, by pressing the clay or siliceous fabric into a mould.[111]

Slush-Moulding Process

Another method of filling a mould with wax is described as 'slush-moulding' in which liquid wax is poured into a mould. There are no proven examples of this method in the corpus, but a ewer (cat. no. 7) and a lamp with a pedestal, the only one to have been X-rayed (cat. no. 39; fig. 82), contain certain clues that may indicate this process, particularly the interior contours that are less sharp than those on the exterior.

Fig. 18

Lost-wax casting, indirect process; objects with traces of a bivalve mould where the join is visible: a) interior of the feline carpet weight (cat. no. 9) b) X-ray of the faceted jug (cat. no. 62) showing the trace of vertical joint as a white line.

Fig. 19

Lost-wax casting, indirect process: X-ray of a ewer which may have been shaped with the slush-moulding process (cat. no. 7).

THE SURFACE

The majority of objects in the pre-Mongol collection are decorated with inlaid and incised compositions made with various processes, and with tools and techniques that shed light on the characteristics and systems of production that were in place in the Iranian sphere. More broadly, the study of tool traces is also aimed at identifying regional characteristics in one or more periods of production. The tools, and the ways in which they were used on metal surfaces, are indeed quite distinct according to the chronology of production. In particular, the treatment of chased backgrounds and the preparations of metal inlays were very different in objects from the pre-Mongol period, than for those made from 1220-30 up to the fourteenth century.

The study of identifiable tool traces was conducted in a systematic manner on the entire object corpus discussed in this volume. Each object was observed with the naked eye and if the condition of the surface permitted, the clearly visible traces were documented and measured under a digital microscope.[112] To this end, a chart describing and measuring surface treatments was drawn up prior to the observations.[113] The first distinction that was made was between traces on objects shaped by casting on the one hand, and by hammering on the other. On cast objects, the identification of decoration made with casting and that made with cold working was sometimes complex. The two processes were often used side by side and the state of conservation of the surfaces did not always allow for an identification of the techniques used. Cold work can be the reworking of reliefs and hollows made by casting and therefore occurred mainly in the wax model.

Surface ornament was carried out on both hammered and cast objects, using four main processes: chasing, engraving, champlevé and inlay, both metallic and with a black material. The chasing carried out on the wax model before casting was also the result of cold work which was transposed to the metal during casting.

Fettling and Finishing

Traces of the manufacturing process are always visible on objects shaped by casting in the form of flashings or metal infiltrations in the mould or core and seam lines or mould joints or gaps or irregularities on the surface. When visible on the outer surface, such traces were eliminated during the fettling phase immediately after the refractory mould has been removed, using a punch and a file (Appendix 19). These file marks are in turn usually erased during polishing but can sometimes be identified. They are associated more with the surface decoration than with fettling and appear on objects that are free of inlay grooves such as lamps with

19

20a

20b

Fig. 20

File incisions accentuating
a) reliefs on the head of a zoomorphic
lamp (cat. no. 48) b) the gadroons of an
inscribed flask (cat. no. 67).

Fig. 21

Chasing:
a) rectangular (cat. no. 23)
b) rectangular with a double blow
(cat. no. 23)
c) elliptical (cat. no. 2)
d) oblong (cat. no. 4)
e) triangular (cat. no. 9)
f) dome punched (cat. no. 4).

only relief surface decoration (thumb rest and spouts, cat. nos. 32, 33; champlevé decoration on lamps, cat. nos. 41, 48; fig. 20a). On other objects, the use of a file is similar to that of engraving over large areas (sprinkler, cat. no. 18; flask, fig. 20b, cat. no. 67; lamp, cat. no. 39). The marks of lathe polishing are more rarely visible: they leave regular striations on the surface after the moulding. Traces of this type have been identified on only one object (cat. no. 8): their absence around the handle shows that they postdate the casting, with the object, including the handle, having been cast in one piece.

Chasing

The incisions found on the DAI pre-Mongol metalwork are almost all chased. They are made with a punch struck with a hammer, and do not remove any metal but push it back on either side of the groove.[114] On objects from this period, incisions are used to rework or finish a cast design, to trace an ornament or an inscription, to draw the outline of an inlay, or to prepare the substrate for metal inlays.

The chasing that has been observed is generally made with a rectangular-headed punch. The marks of its impact are rectangular in shape when the tool was held vertically, and 'spike-shaped' when the blow was made twice, with the punch tilted (figs. 21a, 21b). Notching in the chasing is usually visible in the curved lines, where the rectangular head of the punch was held inclined and directed in an ellipse (fig. 21c).[115] Other punches making oblong traces have also been identified (fig. 21d); they were handled in the same way as rectangular-headed punches. On some objects, traces of triangular-headed punches have been identified (Appendices 20, 21). This type of tool, which is associated with other tracings made with rectangular-headed punches, was used in Herat (cat. nos. 13, 19; fig. 21e), in Ghazna and in other centres in the Iranian sphere (cat. nos. 37, 39, 61). Smaller triangular chasing lines have been observed on chased or inlaid ornament, for example on representations of animals, where it allows for greater detail on the bodies, on the substrate or the inlay (cat. nos. 7, 13, 24). These chasing lines are used to complement the tracings: they are superimposed on the chased drawing in continuous lines (cat. nos. 13, 39) or are clearly visible on a plain ground, in the motifs themselves. Triangular chasing lines have never been observed in inlay preparation. A final type of chasing that has been identified is made with a domed dot punch (fig. 21f): these punches print repetitive motifs that form the background to chased and/or inlaid designs (cat. no. 16; fig. 61), or of repoussé decoration (cat. nos. 3, 4).

These different types of chasing have been documented throughout the collection and are associated with reference objects linked to Herat and Ghazna, to date the best known centres of production. Thus, it appears that these types of chasing were common to all production and were diffused across the pre-Mongol Iranian world.

Chasing in Wax and Finishing

For many cast objects, the surface ornament, both in relief and hollowed out, was designed on the model and transposed to the metal by casting (Appendix 23). The most important part of the design phase was therefore the wax model. When the cast was of good quality, the degree of precision in the reliefs reproduced from the wax model could be so accurate that only a few cold working operations were necessary. Finishing by chasing or champlevé was not always required, but if the moulded impression was not sharp enough, it was used to add further detail to the

21a

21b

21c

21d

21e

21f

relief. For example, the shape and openwork of the incense burner base with felines (cat. no. 54) was modelled and worked in wax. The chasing around the openwork is thick and irregular: it is at the same level of filling of the mould as the other parts of the object and contains flashings linked to the casting (fig. 22a).[116] The condition of the objects' surface does not always allow for a clear distinction between the chasing designed in the wax and the cold working: concretions and corrosion hide the marks that would allow one to distinguish the traces of the casting—particularly the asperities—in the hollows, as well as the traces of cold work with sharper edges.[117] For example, the caracal (cat. no. 53) was made entirely in wax but had significant mould defects and had to be cold worked, even though these reworkings are not clearly identifiable.

On cast objects finished with chasing, few traces are measurable even if they are visible and, in some cases, allow one to discern incisions made with the same tool or with punches of varying widths. Two main types of rectangular-headed punches were used: flat-bottomed or V-shaped (Appendix 23). Their traces are very fine, and the width of the punch does not exceed 1 mm. However, the tool marks are rarely complete. Only one very thin rectangular-headed punch (0.55 x 0.85 mm) has been identified on the bull-headed jug from Afghanistan (cat. no. 60; fig. 22b). This type of rectangular-headed punch was identified on other objects of the same provenance, for instance a lamp (cat. no. 34).

It is not possible to interpret the measurements further; the widths and shapes of the punch marks are very homogeneous and do not allow us to refine the provenance or attribution of the objects. They do, however, provide information on the types of punch used on copper alloys in the foundry workshops of pre-Mongol Khurasan.

Cold Worked Chasing after Casting

The surface treatment of cast objects is clearly visible in many cases, as they were cold worked once the shaping was complete. These are not transpositions in metal of designs made in the wax model. The punch traces that were recorded and measured include at least four different types and suggest a greater variety of tools than those used for the simple reworking of decoration designed in wax (Appendix 21). The punches are of similar widths but some of the traces observed are narrower (0.3 mm) or wider (1.3 mm) than those generated by the reworking of designs made on the wax model. Their shape is rectangular, usually with a flat or rounded profile. In addition to these two types of punches, there are also oblong-shaped tools with a rounded profile, and others in a triangular shape with a V-shaped profile. Several punches might have been used on the same object, depending on the designs to be traced. The oblong punches are on average slightly thicker (1 x 1.5 mm). Triangular punches were similar in width to rectangular tracers (0.45 x 0.9 mm; 1 x 2 mm) and have been observed mainly on metalwork associated with Afghanistan. The thinnest measurable rectangular tracers were also used on objects produced in Afghanistan (0.3 x 1.5 mm; 0.5 x 1.5 mm; 0,6 x 1.2 mm). Other complete traces of rectangular punches were observed on objects with a less well-identified provenance (0.6 x 1.9 mm, Khurasan; 0.8 x 1.25 mm, Khurasan/Afghanistan). Finally, a distinctly thicker punch was used on a mortar probably made in Iran or Anatolia (1 x 2.75 mm).[118]

Some objects such as incense burners with quite complex shapes and surface treatment were clearly made in two distinct phases: the form and openwork were cast while the surface ornament was cold worked. This characteristic makes it possible to compare these objects, or conversely to distinguish them, from others of similar types. For example, the chasing on the incense

22a 22b

23a 23b

burner from Sistan (cat. no. 30) does not result from the reworking of decoration designed on the wax model and the tracings were cold worked. In this respect, it resembles a similar type of incense burner (cat. no. 58) where the shape and openwork were transposed in metal from the wax model and were probably entirely reworked by chasing with several rectangular tracers, and also by engraving and champlevé. Similarly, the falcon incense burner (cat. no. 52) has decoration that was probably made entirely with a tool on the cast and open worked object, but not on the wax model. It already featured the openwork around which the palmettes and the feathers were chased after the casting: this is suggested by the corrections of the tracings although the concretions, the remains of cleaning products and the black material preclude a precise identification of the incision techniques. The falcon incense burner thus appears to have been made with a series of different processes, whereas the caracal (cat. no. 53) seems to have been more complete at the wax sculpture phase. Changes in the movement of the tool and superimposed cold worked tracings are also visible on a sprinkler, possibly produced in Ghazna, decorated with imitations of stamped medallions (cat. no. 20). The lamp with a high faceted pedestal (cat. no. 39)

Fig. 22

Chasing in wax and finishing:
a) chasing transposed from the wax model with shrinkage porosities (cat. no. 54)
b) rectangular traces of cold worked chasing (cat. no. 60).

Fig. 23

Lamps with feline heads:
a) cold worked reworking (cat. no. 21)
b) cold worked chasing (cat. no. 40).

24

was shaped by lost wax casting but the recessed surface ornament was carried out with a tool and cold worked with very fine chasing (0.4–0.5 mm) and champlevé. In contrast, a lamp of the same type from Sistan (cat. no. 34) has both relief and recessed surface ornament, entirely prepared in wax except for a single, chased, cold worked motif. Similarly, a lamp that may have been produced in Ghazna (cat. no. 21) was designed in wax, the cold work being only the reworking of the wax decoration (Appendix 23), whereas a relatively similar lamp (cat. no. 40) was decorated with cold worked chasing on the sides and around the openwork encircling the opening (fig. 23; Appendix 21). Finally, two bull-headed pouring vessels (cat. nos. 60, 61) are also technically very distinct: the first, from Afghanistan, was almost entirely made in wax, and the chasing, with the exception of the bull's cheek, is a reworking of the cast (Appendix 23). The second has cold worked incised decoration worked with at least two punches (Appendix 21). These different methods of implementation demonstrate that in different places, or perhaps different periods, production processes for the same types of objects were varied. In the light of these technical studies therefore, it seems that groups of visually homogeneous objects were part of different manufacturing systems, and perhaps in the case of objects where the cold working phase exceeded that of the finishing, were more divided.

Observation of chasing made after casting has also made it possible to differentiate between types of work that stand out from those usually found on the pre-Mongol metalwork in the DAI collection. For example, a pitcher probably shaped by lost wax casting in a bivalve mould (cat. no. 62), features a frieze with double chasing and/or champlevé that was not found on other objects (fig. 24). By virtue of its type and technical characteristics, this object is quite different from other examples in the corpus. Other atypical methods of chasing have shed light on the modern refurbishments of objects. The pouring vessel with a pomegranate-shaped thumb rest (cat. no. 37) features two very different types of chasing (fig. 25). The rectangular chasing (0.6 x 1.9 mm) was made at the same time as the shaping, whereas the oblong chasing (0.9 x 1.3 mm), which is thicker and almost rounded and covers older and partly erased chasing on the neck, probably represents a recent repair of the surface.

Chasing on Hammered Objects

Allowing for the fact that the number of objects in this category is much smaller, the chasing on hammered objects appears more homogeneous than on cast objects. Visible as tracings framing the inlay, the chasing is either thinner, or made with the same tools as those used for the chasing of the inlay, and therefore of similar width (fig. 26). A single triangular-headed punch has been identified on a tabletop or tray from Ghazna (cat. no. 15). Almost all the tracings with distinct or partially distinct outlines were rectangular in shape (Appendix 24). The finest punches have been identified in the chasing of lines on hammered objects: the smallest tool to be measured produced an impact 0.25 mm in width and was used by Shazi of Herat (cat. no. 2). The largest punches, linked to metalwork production in Ghazna, measure 0.6 and 0.9 x 1.9 mm. Based on the study of objects in the DAI, it is possible to suggest that the punches used to chase brasses were thinner than those used for cast alloys, which, in objects associated with the east-ern Iranian world, were generally worked with larger punches with an impact of up to 1 x 2 mm.

Fig. 24

Atypical double chasing and/or champlevé on the faceted jug (cat. no. 62).

25a 25b

26a 26b

Matte Punching

On a small number of cast and hammered objects (in addition to a repoussé shield boss (fig. 9)[119] fine domed dot punching was observed, producing a matte surface (fig. 27; Appendix 25). Punching gives a visual play between the parts treated with line chasing or with inlays (cat. no. 2, fig. 38). In contrast to recessed decoration such as champlevé, these beaded surfaces do not seem to have been inlaid with black material; they were thus not intended to serve as an adhesive surface for the coloured material but rather to colour the metal substrate. The use of domed dot punches to obtain this colour effect is not very common in the DAI collection, whereas tracer punches are standard. Several types of matte surface have been identified. On hammered and repoussé brass objects, the domed dot punching serves to add detail and texture to certain parts of the animal representations, such as the repoussé manes of the lions found on objects from Herat (cat. nos. 3, 4). In contrast, the repoussé lions on the Ghazna ewer (cat. no. 24) do not seem to have a matte surface. However, the shield boss from the same site (fig. 9) features not only

27a

27b

28a

28b

Fig. 27

Domed dot punching (matte) on objects shaped by a) hammering (detail of the back, cat. no. 2) b) casting (inscription detail, cat. no. 57).

Fig. 28

Engraving: a) incision and tip tracing (cat. no. 25) b) compass engraving (cat no. 60).

a matte surface for the lion manes but also for the background of animal and epigraphic relief decoration. The Ghazna bucket (cat. no. 16), whose surface has been altered by a thick, dark patina, has an inscription under the rim and bird medallions on the body; these designs stand out on a uniformly matte surface made with a fine punch, the same size as one used on the sprinkler (cat. no. 18). The matte ground absorbs the light and contrasts with the smooth areas of chased design. The same treatment of the substrate is found in Herat, uniformly applied to the whole surface as on the pen box (cat. no. 2). Inlaid designs, as well as others that were simply chased on the back of the object, were applied to a matte surface. Additionally, rare circular and recessed patterns have also been observed; these occurred during the casting and came from the wax model (cat. no. 63) or they may have been cold worked, as indicated by the rotation traces of a gimlet (?) on two lamps from Sistan (cat. nos. 32, 33; D. 2 mm; 2.8 mm and 3.2 mm).

Engraving

Engraving is not always easily discernible on the worn surfaces of objects but it seems that this technique was used less systematically than chasing in the medieval Iranian world. The engraving tool incises the surface and, unlike chasing, removes material: metal shavings are cut away using appropriate tools. The motion is very different from that of chasing as it is continuous and made with different implements.[120] The burins used for surface engraving are pushed by hand, whereas those used for deeper engraving are hammered. Engraved lines are identifiable by the continuity of the strokes: unlike chasing they are uninterrupted and are often finer and more angular. The extremity of an engraved line is tapered, directed towards the surface of the substrate and marked by a clear stopping point (fig. 28). The shape of the tool is not always identifiable because the profile of the incision varies according to the angle of the cut: the cutting edges can be oblique, straight or concave.

Freehand and compass engravings were observed and measured on cast objects. None were recognised on hammered objects (Appendix 26). Engraving was identified in circular traces made with a compass (fig. 32b), or linked to chasing. The pre-Mongol collection has no objects entirely decorated with engraving. Compass tracings were made for the engraving of designs or layouts such as medallions (cat. no. 13), or concentric circles (cat. no. 25); they can be identified by the compass hole sometimes visible at the centre of the circles (cat. no. 13).

In addition to the eleven objects (Appendix 26) whose engraved incisions could be partially measured, engraving was also observed on two mortars (cat. nos. 26, 80). Centring holes and compass engravings were also found on objects with faceted necks (cat. nos. 37, 62; fig. 28) where the incisions accentuate the line of the facets. The use of a compass to trace ellipses and circular medallions seems to have been common practice. It was evidently a frequently used tool for the preparation of tracings, as on the base of a small plate with concentric registers (cat. no. 25), or for the rapid tracing of a medallion, even on a small scale (fig. 29).

Inlay

Observations made about inlay and its preparation are only conclusive if the objects are well preserved and the surfaces have not been excessively altered by rubbing or abrasion from cleaning. Three of the inlaid objects in the pre-Mongol collection of the DAI could not be studied, as two of them are corroded (cat. nos. 24, 47) and an artificial patina masks the decoration of a third (cat. no. 19).

Black Material Inlay

Based on the extant objects, inlays in black material are found on metal objects dating from as early as the tenth to eleventh centuries. Coloured material inlays are found concurrently on copper alloys with other metal inlays. In the twelfth and thirteenth centuries, the inlay mater-ials

Fig. 29

Compass engraving: the centre of the circle is marked by the tip of the compass (cat. no. 9).

30a

30b

were black and occasionally red, but are not easily datable.[121] After the beginning of the sixteenth century, particularly in the Iranian world, inlays were made of coloured material in white, green, red and black. Visually, the black inlay recalls the niello on silver and gilded silver of precious metal vessels in the Iranian world.[122] Black absorbs light and contrasts strongly with a white or gold metallic background. On brasses inlaid with metal sheet, black material was found consistently between the substrate and the silver or copper inlay (fig. 2b). Applied before the metal inlay, it appears to have secured it in place which implies that this material had adhesive properties.[123]

Analysis of black materials on objects in metalwork collections from the medieval Iranian world and the Middle East has identified their content as a resinous or bituminous material.[124] As part of the ISLAMETAL project, micro-samples were taken from test objects from the Mongol period to establish a protocol for the analysis of black materials in the medieval Iranian collection. The samples were analysed using gas chromatography with mass spectrometry, in order to identify the characteristic molecular constituents in the composition of the samples. The results were unsatisfactory as the black materials were found to be contaminated, mainly with protective waxes applied to the objects during restoration work.[125] The planned systematic analysis was therefore abandoned, but all the pastes in the collection were observed under digital microscope: they were found to be solid and applied cold to the chased or champlevé surfaces (fig. 30). No liquid hot-applied paste, which would have been identifiable by the presence of air bubbles, was noted.[126]

The black materials observed under the digital microscope were relatively homogeneous. Those that do not seem to have been remade are of a deep black colour, sometimes with a granular appearance (fig. 30a). On certain objects, the layering of the pastes suggests a partial repair to the inlays; with their diluted and brown appearance these resemble varnishes and are probably modern repairs or additions (fig. 30b).

Champlevé Preparation

Cast objects, like hammered brasses, usually have very pronounced flat or recessed areas. These champlevé areas were not intended to be visible: they served as preparation for the attachment of inlays in black material or metal. The surface of the substrate is in reserve and contrasts with these areas inlaid with colours and/or paste. The champlevé was made with a burin and removed material from the surface of the substrate to create rectangular or square sections deeper than

Fig. 30

Black material inlay on the surface of chased and champlevé substrates:
a) original black material (cat. no. 23)
b) heterogenous black material, partly replaced by a modern material or polish (cat. no. 7)

the incisions; when inlaid with black material these areas are flush with the surface. Two types of champlevé have been identified on the pre-Mongol metalwork of the DAI: these are flat or grooved, depending on whether they were made with one or more burin strokes (fig. 31a). The champlevé areas appear as more or less regular successions of squares or rectangles produced by the impact of the burin.

The champlevé areas are generally associated with ornament traced by chasing; the combination of the two techniques characterises most of the surface treatment of the objects studied. The flattened champlevé areas are made after the chased lines as indicated by the superimposition of champlevé areas over the chased lines (fig. 31b). This sequence suggests that the recessed areas of the metal surface were designed after the graphic composition.

On metalwork objects in the DAI collection where burin marks are clearly identifiable, it appears that the champlevé areas were made on hammered objects, on the wax model or on cast objects, after casting. The burins which could be identified were rectangular in shape (Appendix 27). Their dimensions vary considerably according to the object and its provenance. The finest burin marks that were measured were on objects from Herat inlaid with precious metals and black material (W. 0.8-1.2 mm). Objects linked to Ghazna had slightly wider burin marks (W. 1-1.5 mm). It was observed that tools of the same size were used on objects of the same type and were associated with the same production centres, such as two ewers (cat. nos. 7, 8) and two tabletops or trays (cat. nos. 10, 11) probably made in Herat. A cast object and a hammered one, both from Ghazna, (cat. nos. 13, 15), also bear traces of one or more burins of the same size. Similar tools were also used on the small dish or incense burner from Bamiyan (cat. no. 25) and on a fragmentary ewer from Afghanistan (cat. no. 36).

The use of champlevé as a preparation for inlay appears to be systematic in the collection, but one object that is atypical in its surface treatment qualifies this observation. The design of the body of a sprinkler (cat. no. 54) has chasing as well as champlevé. The pearls were made with a burin in order to make them appear in reserve. The geometric pattern of the wall was chased and the cruciform motifs drawn in a lattice were thinned out by champlevé (fig. 104b). One pearl was omitted and is flush with the surface; the rest are flat and do not reflect light like the surface of the substrate. No trace of the black paste inlay is preserved: it may have disappeared entirely. It is also possible that the visual contrast between the surface and the chased and champlevé areas was designed to produce this lighting contrast, using the alloy itself rather than inlay to add colour.

31a

31b

Metal Inlay

Types of Inlay

There are two types of metal inlay on copper alloys in the Iranian world, and more generally in the medieval Islamic world (from around the twelfth to the early sixteenth centuries). These

Fig. 31

Champlevé on cast and hammered objects, on a striated and flat surface (cat. no. 13): a) grooves made with a burin are inlaid with black material b) champlevé is applied after the tracing made by chasing.

32a

32b

Fig. 32

Silver and copper inlay:
a) linear. with wire (cat. no. 2
b) spatial, with sheet for the faces and
shafts of the animated script (cat. no. 4).

Fig. 33

Silver and copper inlay (cat. no. 4):
a) chasing preparation for wire b) chasing
and champlevé preparation for sheet.

33a

33b

are in wire (linear inlay) or sheet form (spatial inlay) (figs. 32a, 32b).[127] In the pre-Mongol period, this precious decoration was added to cast alloys, as well as to hammered brasses. The metal inlays were hammered into the substrate, into grooves and flattened areas prepared by chasing and champlevé. The inlays are either flush with the alloy or slightly raised from the surface. The subtle variations are visible when light is reflected on the inlaid areas.

Metal inlays made of silver or unalloyed copper are attested to in Khurasan from the middle of the twelfth century and up to the Mongol invasions. The white silver with a greyish tinge and the red copper stand out from the more or less yellow ground of the substrate, forming a contrast with the black material. Two-coloured designs are frequent on pre-Mongol objects: the same motifs may have both red and white inlays. For example, there is an animated inscription with silver-white vertical strokes and copper red heads (cat. no. 7), and an animal motif with a red body and silver legs and head (cat. no. 12). Based on the evidence of the DAI collection, it can be stated that in the pre-Mongol period, the inlays with the largest surface area were made of silver sheet, often chased on the surface to clarify the design and the details of the figures (fig. 32b). Gold inlays, which characterise the thirteenth- to fourteenth-century Mongol and Injuid periods

34a

34b

35a

35b

Fig. 34

Chasing (cat. no. 4): a) inlay preparation forming a hammered relief on the sheet b) outline and design of the motif, here the horse's front legs.

Fig. 35

Silver and copper inlay on cast objects: a) champlevé preparation for sheet inlay (cat. no. 8) b) chasing for wire inlay (cat. no. 9).

and continue into the fifteenth and early sixteenth centuries, do not seem to have been made in the Iranian world before that time.

Preparation of the Support

The support was prepared before the application of the inlays. The outline design of the area which was to receive the inlay was traced by chasing on a predetermined area of the object (figs. 33, 35). The design of the decoration therefore follows a pre-established composition, determined primarily by the shape of the object.

The likelihood of a model being made for the design of the inlay increases in line with the scale of the complexity and the surface coverage of the design. On circular objects, the composition tends to be concentric, depending on the horizontal and vertical surfaces, and the presence of facets on vertical forms. The layout and scale, and the size of the different components of the decoration were planned to fit the support perfectly. Such compositions require a model to lay out the tracing; they cannot be improvised directly on the object. Very precise iconographic programmes were observed in the most complex designs, including calligraphic inscriptions with

proportioned lettering. Although none have survived, the models may have been objects and/or drawings.[128] It is also possible that the craftsmen doing the chasing used stencils for the transfer of motifs to the metal surface.[129]

On pre-Mongol objects, inlaid designs are set within a wide chased outline, leaving a zone in reserve between the tracing and the inlay, as if the colours were only intended to fill part of the design (fig. 34). What characterises the twelfth- and early thirteenth-century inlay of the Iranian world is therefore a traced drawing that extends beyond the location of the inlay: thin chasing or engraving often surrounds the inlaid area. We thus have a doubly traced drawing, with one part left empty, in reserve, allowing the substrate to be visible. This creates a faint, subtle visual play between the inlaid and reserved areas that could be embellished with punched decoration or champlevé.

Phases in the Making of Inlaid Decoration
1. Preparation of the support with chasing for the outlines, with champlevé for the sheet; tooling and cold work preparation in the substrate or in the wax model.
2. Cold application of the black material to areas prepared with chasing and champlevé.
3. Preparation/cutting of the sheet to be inlaid.
4. Hammering of the wire and sheet inlay.
5. Surface chasing of the sheet inlay.

Inlay Processes

Once the preparatory tracing of the design was complete, areas to be filled with sheets of inlay were raised with champlevé to create irregularities on the surface so that the hammered sheet would grip the surface (figs. 33b, 35a). The champlevé was worked after the chasing was traced, and sometimes intersected with it (fig. 33a). On hammered objects, the chasing of the inlay is characterised by rectangular lines, double in most cases, creating a central relief where the metal is pushed towards the centre of the chasing (fig. 21c). On some cast objects, however, the preparation of the spatial inlay seems to have preceded the casting. On the two parts of the inkwells associated with Ghazna (cat. nos. 12, 17), the hollow tracing made by champlevé and chasing, partly intended to be inlaid, were prepared on the wax model (fig. 36). The preparation for the sheet inlay, recessed from the substrate to receive the inlay, shows flashings that appeared in the casting process and were not cold worked by champlevé. Moreover, the edges of the metal inserts prepared for inlay are rounded and resemble the edges of reliefs obtained by casting. On these two objects, the sheet inlays extend into several areas of the composition, and it is the surface chasing that establishes the final design (fig. 37). The treatment of the inlays in these cases is very different from that observed on other cast or hammered inlaid objects in the collection, even though this type of process has been documented on some inlays (cat. no. 4). On the lid (cat. no. 12), the traced outlines of the inlaid zones were cold worked after the inlay preparations in the wax model. The contour lines were made while the inlaid silhouette was in place: they are the same lines as the surface chasing of the sheet inserts. This very specific technique of inlaying

and making the finished design after the application of colour has not been observed so clearly on other inlaid objects in the pre-Mongol collection, except in the case of the zodiac ewer (cat. no. 4; fig. 34b). It may have been used for spatial inlaid decoration on fairly thick cast metalwork, and on hammered objects with complex designs. Other objects here attributed to Ghazna (cat. nos. 18, 19), show only cold worked surfaces; the filing, hammering, chasing and wire and sheet inlays were all done after the casting.

The punch marks and dimensions of the inlays are relatively homogeneous in the DAI collection. Based on their dimensions and shapes, the punches used for cast objects appear similar to those used on hammered brasses (Appendices 28, 29). The tools were very fine, and generally had rectangular heads. Only two triangular-headed punches were identified on the inlaid objects. The preparation of the wire inlay is more or less the same on both cast and hammered objects: the wires are inlaid in grooves made by a succession of double strokes with a rectangular-headed punch.

36a

36b

37a

37b

Securing the Inlay

The silver and copper sheets for the inlay were probably roughly cut prior to being hammered into place since a relatively precise shape was required to avoid the loss of precious material with an already calibrated thickness. The wires, on the other hand, were cut by the inlayer as they were being laid and hammered in, a technique still practised today. Smaller sheets were either made as wires and drawn by hammering, or pre-cut in the same way as the larger sheets (fig. 32b). The silver and copper sheet inlays were hammered into the flattened areas and incisions made in the substrate; wire inlays were hammered into chased lines.

The inlays were mechanically held in the substrate and pressed into the grooves and reliefs of the chasing; a thin layer of chased metal, forming a small bead, held down the inlaid plate (fig. 34a). As described above, observation under a microscope also showed the use of a black material as a background to the inlay, reinforcing its adhesion to the substrate (fig. 2b) therefore applied before the metal inlays. Once the inlays were in place, some were reworked with chasing, to add the details to the faces, for example (fig. 32b).

Fig. 56

Preparation of sheet inlay on cast objects: from the wax model: a) (cat no. 17) b) the base of the prepared area is not champlevé and casting asperities are visible (cat. no. 12).

Fig. 57

Metal inlays preparation on the wax models of cast objects: the silver sheets are chased to trace the design after the inlay is applied a) detail of a figure (cat. no. 12) b) close-up of another figure (cat. no. 12).

THE ORGANISATION OF PRODUCTION

The raw materials, the shaping techniques and the decorating methods provide valuable information on the organisational systems for the production of metal objects. The question of how the materials were obtained leads to the sources of the metals used in the alloys, but also to the practice of recycling. In terms of infrastructure and know-how, the processes of shaping by hammering or by casting, which involve alloys of differing properties and values, require different levels of organisation. Finally, the decorating methods observed in the pre-Mongol collection of the DAI, although partly shared by both hammering and casting, nevertheless reveal different phases of execution, organised according to different systems which suggests the participation of several individuals, or indeed several workshops or centres of production, in particular for cast objects.

Alloys and Recycling

The question of supply routes raises the question of the nature of the raw materials and how they circulated: were they pure metals—in this case copper, zinc, tin and/or lead—or pre-made alloys? The study of the production methods of the alloys that were analysed partially answers this question.

The Production of Copper Alloys

It would be inaccurate to point to a single method of alloy production, given the diversity of the typology and the social contexts of these objects, and probably also of their places of production. Analysis of objects in the pre-Mongol collection of the DAI showed that a minimum of four systems of production could be identified, based on three types of copper. The medieval textual sources suggest that at least two brasses of different origin were in use: a brass for casting (*shabah mufragh*), and a purer type used for hammering (*berenj*). These two types of brass were made from zinc with different origins: brass for casting was based on an iron-rich zinc ore, while brass for hammering contained very little iron.[130] On the other hand, leaded alloys, leaded brass, high leaded brass and high leaded copper were made by diluting brass with lead or a metal rich in lead. The initial alloy seems to be a brass with 20–24% zinc (Appendix 30A). This is also suggested by an inkwell (cat. no. 6), in which only the lead content allows for the differentiation between the two metals of the base and the lid. This method of production could correspond to the mix of brass and *batruy* (our definition of high-leaded copper),[131] which is referred to as *shabah mufragh* in the texts.[132] It remains to be seen what kind of brass this is, perhaps the one used for the manufacture of the small dish or incense burner (cat. no. 14) which contains relatively high levels of lead and arsenic (1% and 0.1%), although its composition is atypical when compared to the rest of the corpus.[133] A brass made with a lead-rich zinc ore could be another source for the composition of leaded brasses.[134] In the context of this study, the role of tin in alloys other than high tin bronzes, and also its origin, remain too complex to determine. Previous studies on medieval Islamic metal objects have shown that they contain a similar tin content (2–4%), always lower than the zinc content,[135] but their interpretation is unconvincing.[136] Allan and Ponting present tin as a deliberate addition, part of the recipe of a so-called quaternary alloy sometimes called gunmetal, without really specifying its role or its origin.[137] The only role that

we have so far identified for tin remains very hypothetical and could be linked to dezincification (see above 63. However, this cannot explain the systematic presence of tin in the alloys of the pre-Mongol collection. Craddock links the presence of tin to the recycling of tinned objects, of tin-lead alloy objects, and/or the recycling of brazings using this metal.[138] However, few if any objects made of tin-lead alloys are known from this period, and even fewer tin-plated objects. Mention of a soldering alloy, widely used for assembly, and identified in analyses of the DAI corpus, underlines the fact that tin that was not linked to copper did circulate in the medieval Iranian world.[139] Although tin remains in a minority overall when compared to zinc and lead, and plays no part in dilution, it is nevertheless possible that in high leaded copper, the high tin copper is situated on a line of dilution of high leaded brasses by tin, or even of dilution of leaded-brasses (Appendix 30B). These alloys would therefore belong to another system of production of leaded alloys, applying mainly to utilitarian objects such as taps and padlocks (cat. nos. 55, 56) and to mortars; in other words, a sphere of production other than vessels and domestic objects.

The corpus of high tin bronzes identified in the pre-Mongol collection is too small to allow for interpretations of the manufacture of this alloy. However, it is clear that the copper used was different from that of other alloys. Much purer than in leaded alloys, it nevertheless contains more impurities than the brasses (As, Fe, Ni, Sb).

Three types of copper were thus used for the production of objects in the pre-Mongol collection: a very pure copper for brasses, a slightly less pure copper for high tin bronzes and a much less pure copper for other alloys. According to Ponting, the impurities of the white bronzes, and particularly their high cobalt content, distinguishes these alloys from production linked to the Fatimid context, and indicates that they came from different centres.[140] Citing Melikian-Chirvani, he suggests distinct production centres for these vessels.[141] The different shaping techniques in certain cases such as cat. no. 1, provide a first element in favour of this hypothesis, as does the specificity of the copper.

Controlled Recycling

Dilution with lead, and sometimes tin, does not sufficiently explain the number of alloy varieties, since a number of compositions deviate from the dilution lines (Appendix 30). Only the practice of recycling, documented in archaeological research, can explain these variations.[142] This hypothesis is corroborated by the study of impurities in the DAI collection.

Two classes of copper purity were identified through statistical analysis (see above 59; Appendix 8). Class 1 contains copper with high levels of impurities and Class 2 is the purest copper, in addition to the brasses and the high tin bronzes which form two separate groups within these classes. At first sight, this suggests a dilution of the purer alloys (mainly brasses) by less pure alloys, leading from Class 2 to Class 1 metals. However, it has been shown that brasses are not involved in the production of the three leaded alloys: high leaded coppers, leaded brasses high leaded brasses. Furthermore, these three alloys are found in both classes of purity and with similar averages of alloying elements in their composition (Appendix 31).[143] The three leaded alloys were thus subject to the same degrees of dilution, regardless of their respective levels of impurity. The most likely hypothesis is that the two classes of impurity represent losses through repeated recycling:[144] Class 2 alloys would be the result of the recycling of Class 1 alloys. We observed that the volatile elements (As, Sb, Ni) decreased between Class 1 and Class 2 while maintaining the same correlations (Appendix 8),[145] a possible result of fusions and repeated recycling. This

decrease in impurities occurs on a continuum, wherein the compositions are represented by a Gaussian curve, rather than two distinct extremes. Most of the compositions that deviate from the lead dilution line, that is, those that are likely to be the result of recycling and therefore subject to the loss of impurities by volatilization, belong largely to Class 2 (Appendix 32).

The distance from the lead dilution line can also be a measure of the degree of recycling: the longer the distance, the more likely that the alloy was recycled. Conversely, compositions with no loss of impurities, that is mostly those in Class 1, are almost all on the lead dilution line and are therefore probably not recycled. Objects linked to the consumption or presentation of liquids and food can be found in this category. Class 2 objects made of recycled metal largely correspond to common types: simple mass-produced domestic objects such as lamps, or those used for the preparation of other products such as mortars and cauldrons. Objects resulting from repeated recycling, the furthest from the lead dilution line, include a tap (cat. no. 55), a cauldron (cat. no. 84), some mortars (cat. nos. 76, 79-81)[146] and two lamps (cat. nos. 32, 34). However, other more elaborate objects also made from recycled materials show that its use was not necessarily synonymous with common or low-quality production (cat. nos. 9, 44, 45, 52, 56).

Supply Routes and Metal Sources

Copper

The grouping of the objects into two main classes of impurity (1 and 2) has also revealed possible regional groups, at least for the southwestern and northeastern Iranian world. Class 2 includes objects attributed to the western region of the geographical area represented by the pre-Mongol collection (Appendix 1), as well as objects attributed to Iran and to Anatolia (cat. nos. 80, 81) and to Sistan. All the comparative objects from Susa in western Iran and from the Middle East are much closer to Class 2 than to Class 1 (Appendix 13).[147] Nineteen of the thirty-five objects in Class 1 can be attributed to eastern Khurasan and Afghanistan on the basis of their documented provenance, or by comparison with types excavated and/or held in Herat, in the Kabul area and in Ghazna.

The impurities in the copper would therefore indicate two supply routes, marking two areas of use with different chemical signatures: Class 2 encompasses the areas to the west and south of Khurasan, including Sistan, and Class 1 the regions of Khurasan and Afghanistan. The metal would have come from the same sources, but circulated along different routes with copper coming from the west being more recycled and containing lower volatile impurities (As, Sb, Ni) than copper coming from the east.

Three main supply systems for the pre-Mongol metalwork collection were identified through:
— Brass made for hammering, probably using fresh metal.
— High tin bronze, also using fresh copper but from a different supply route. The hammered brass and high tin bronze show all the signs of copper refining. The refining of copper for brass is the most advanced: the content of As, Sb, Fe, S decreases as they are eliminated by oxidation. Only the silver content remains the same, as it is impervious to oxidation (Appendix 33).
— All leaded alloys for casting are obtained by the dilution of a specific brass with lead or a high leaded alloy and are subject to controlled recycling. This copper is distinguished mainly by its antimony and arsenic content (0.5-1%) and silver and nickel (around 0.1%) with a relatively high content of bismuth (hundreds ppm; Appendix 33). This type of copper clearly suggests a

polymetallic ore of the fahlore type. This metal could have circulated westwards by controlled recycling.

At least two other copper circulation routes were identified. Leaded alloy production may also have included more marginal methods which are less represented in the DAI collection such as diluting leaded or high leaded brasses with tin to produce high leaded and high tin copper from approximately 5% tin (cat. nos. 26, 29, 55, 56, 80, 81; Appendices 30B, 1, 3). Finally, the unalloyed copper used as inlay on objects in the collection is in the majority of cases different from the copper of the substrate, and therefore suggests one or more additional supply routes.

The metals, particularly copper, that circulated along these routes originated primarily from the eastern Iranian world, and supplied the copper alloy market. The exploitation of copper from Khurasan to be alloyed and shaped by casting and hammering is consistent with medieval sources as well as contemporary geological data. Systematic analysis of the ores, as yet unavailable, would allow the precise determination of its sources.

Silver for inlay

Little analytical data is available for silver production. Many precious vessels from the pre-Mongol Iranian world have disappeared because the objects were melted down, most probably for the minting of coins. Extant vessels with a firm attribution have not been analysed, and no analysis of the silver inlay on medieval objects from Iran or the Middle East has to our knowledge been published.[148] The only available reference is the analysis of forty-six tenth-century coins from different parts of Afghanistan and Iran.[149] If we compare their gold and bismuth contents, supposedly less affected by the refining operations and therefore more characteristic of the original ores, we notice that the majority of the objects deviate from the signatures attributed to Panjhir. It was here that, according to the texts, the most important silver mine in the eastern part of the Iranian world was located in the pre-Mongol period.[150] The higher gold content and lower bismuth content in the inlays of the DAI corpus would indicate other origins, but these are found in coin workshops located in Transoxiana (Samarqand), southern Afghanistan (Sistan) and western Iran (Shiraz). Only the silver used for the inlay on one object (cat. no. 23), which contains 0.2% bismuth, could have come from Panjhir. Very similar silver was used on objects from Ghazna (cat. no. 12), and Herat (cat. no. 7) which suggests that several centres of production could be supplied by the same route.

Regional Characteristics and Centres of Production

From the evidence of the DAI collection, the alloying patterns appear to have been common to the entire Iranian world, although there were wide disparities in the metal compositions of both the objects and their inlays. It is possible that these variants were associated with different regions, or indeed centres of production. Within these divisions, specific compositions of substrates and inlays can be detected, revealing material fingerprints and alloying patterns. These groupings have been made on the basis of reference objects. The attribution to Herat of three objects (cat. nos. 2–4) is based on the signature of an inlayer, and on a broad consensus of the attribution of the prestigious inlaid metals, based on objects signed by Herat inlayers (see below 110-11). The urban centres from which some of the objects in the collection originate are Ghazna (cat. nos. 12–15) and a shield boss fig. 9) and Bamiyan (cat. no. 25). These are the sites excavated and surveyed by Joseph Hackin in the 1930s (see below 153, 179). Five objects in the collection

do not have an archaeological provenance but are documented as originating from Sistan at the very beginning of the twentieth century (see below 188-89).

No regional or local specificity could be identified on the basis of shaping techniques alone. Combined with research on the alloys and examination of the surfaces, it has been possible to distinguish types of production, or at least, various methods, or to bring together objects which, when measured, show identical toolmarks suggesting the same provenance. For example, objects from Sistan (cat. nos. 30-33) share common characteristics in the cold working of the cast objects, with a file, gimlet or by chasing, that are not found on other metal objects in the pre-Mongol collection. It is possible, particularly in the case of the lamps (cat. nos. 32, 33), that this type of ornament was typical of the region.

Tool marks and inlay dimensions are relatively homogeneous in the DAI collection. In some cases, however, it was possible to make classifications based on the similarity of the tools that were identified. Thus, the rectangular punch (0.55 x 0.85 mm) used on the wax model of the bull-headed jug from Afghanistan (cat. no. 60) is identical to one measured on other objects from Afghanistan (cat. no. 34). Different ways of organising the stages of the decoration were observed for similar types, demonstrating that production processes varied in different places, or perhaps at different times.

Groups of visually homogeneous objects are thus found, when seen in the light of technical studies, to come from different production systems. This relative divergence of processes can be observed at the two centres for which we have reference objects, Herat and Ghazna, where the technical specificities observed pertain more to the distribution of the tasks such as shaping, surface treatment and inlay, than to the techniques themselves.

Herat

The three masterpieces from Herat (cat. nos. 2, 3, 4) are hammered brasses and the brass does not have a specific composition.[151] The similarity of the composition of the copper inlay to the copper used for the hammered brass identified on two of these objects (cat. nos. 2, 3) suggests that the hammering and inlaying were done in the same workshop. However, the copper inlay and the hammered brass had to come from different sources, if only because the copper was transformed into brass. To find these two metals on the same object suggests that materials at different stages of production circulated across the same routes and even to the same centres of production, but not necessarily to a single place or workshop.

Although the composition of the substrates allow few groupings of hammered brasses to be established, the inlays suggest connections, even with cast objects. Based on the three reference objects from Herat, two distinct groups can be suggested, with two metal signatures other than the one from Ghazna. One group includes six objects that can be linked to the two reference objects (cat. nos. 2, 3); they are characterised by the same copper for the inlay (cat. no. 11) which is similar to the copper of the substrates of the cast objects, the feline carpet weight (cat. no. 9) and two ewers (cat. nos. 7, 8). The silver inlays in a tabletop or tray (cat. no. 10) are very close to those of the pen box (cat. no. 2), and of the tray (cat. no. 11). Finally, an inkwell (cat. no. 6) features the same copper and silver inlays as the candlestick with repoussé ducks (cat. no. 3). The zodiac ewer (cat. no. 4) could be a reference object for another group: the same copper and silver inlays (despite differences in lead and arsenic) were identified on an inkwell (cat. no. 5).

The practice of chasing in Herat does not reveal anything specific to this centre. The punches

used for cold worked decoration are relatively homogeneous, both for the tracing and chased inlay on cast and hammered objects. On cast objects, the chasing is rectangular, flat-bottomed, or U-shaped (0.25 x 0.8 mm; 0.4 x 1.2 mm; 0.5 x 1.3 mm) and triangular (0.4–0.45 x 0.9 mm). On hammered objects, tracing and inlay chasing are only rectangular, and often finer than on cast objects (0.1–0.2 x 0.4–0.6 mm; 0.25 x 0.5 0.6 mm; 0.3 x 1 mm; 0.4 x 0.9 mm; 0.4 x 1.1 mm; 0.75 x1.5 mm). The use of similar tools has also been identified on objects of the same type: on two ewers (cat. nos. 7, 8) and two tabletops or trays (cat. nos. 10, 11). The shapes of the punches are similar to those of the tools used in Ghazna, and their dimensions are relatively homogeneous. The tools may have been even finer in Herat, as suggested by the burin marks used for champlevé and measured on the objects linked to these two centres (Appendix 27). In Herat, the inlaying of precious metals on cast objects has so far only been well documented by the Bobrinsky bucket dated 1163 (above 44–46). The research carried out on the Louvre collection has added to our understanding of this production, which as far as the inlay methods are concerned, may be quite distinct from that of Ghazna. All of the spatial inlays observed on Herat objects, both cast and hammered, are inserted on champlevé surfaces that grip the metal sheets and have chased outlines. They were cold worked after the shaping phase, following a similar procedure to that for cast and hammered brasses. The materials used, copper and silver, show a great diversity that confirms the dynamism of this production centre, which probably developed from a network of complex exchanges, where the same materials could be used in several centres. Thus, the two ewers (cat. nos. 7, 8), are linked to the pen box of Shazi of Herat by the copper in the inlays and the substrates, but their silver inlays are similar to those of the Ghazna inkwell (cat. no. 12).

Ghazna

Two of the four objects from Joseph Hackin's archaeological research in Ghazna are hammered brasses (cat. nos. 13, 15); the third is cast brass (cat. no. 14). They represent only a minority of the alloys in the DAI pre-Mongol collection. Furthermore, as the brass contains very few homogeneous impurities, it remains difficult to characterise a brass type for hammering that is specific to Ghazna. However, it may be hypothesised that a particular type of copper refinement took place in this centre, or that a distinct supply of zinc was used in the Ghazna brasses.[152] The small dish (cat. no. 14), is, however, an atypical object in the collection, the only one made of cast brass, and the metal is itself unusual (high in Pb and As, low in Sb). It is possible that this object is specific to a particular type of production in this centre.

A cast object discovered in Ghazna (cat. no. 12) has the same composition of alloy elements and impurities as a bucket (cat. no. 16) with no archaeological provenance. These two objects, which were probably made in the same crucible, belong to Class 1 in terms of their impurities. The theory can be proposed therefore, that other objects in this group were also produced in Ghazna, in other words that this city may have been the main centre of production for cast objects in the eastern Iranian world. In the statistical group of impurities, several objects can indeed be linked to Ghazna either by their provenance in Afghanistan, or by comparison with similar examples found in Ghazna (Appendix 34). Some of them (cat. nos. 6, 17, 20, 21, 22) are very close in composition to two reference objects from Ghazna (cat. nos. 12, 16). An attribution to Ghazna for the other objects of Class 1 would not be inconsistent, particularly for objects close in the statistical graph to the reference objects of this centre whose signature is sketched out here.

The copper inlays on the lid of the inkwell found in Ghazna (cat. no. 12) are similar to those on

an inkwell with no documented provenance (cat. no. 17) made with an alloy with similar impurities. The copper inlays of a small ewer (cat. no. 19), whose substrate also links it to Ghazna, and a hammered brass tabletop or tray (cat. no. 23) can also be associated with these objects. In the case of decorative techniques, no specific dimensions or shapes of the tools used in the decoration could be proved from the two Ghazna reference objects, nor for other objects attributed to the city thanks to their alloy and inlay elements. At least seven punches were identified, but only four complete measurements could be taken. The punches used on cast objects had a rectangular flat-bottomed, U-shaped head (0.5 × 1.2 mm) or a triangular head (Appendix 21); on hammered objects, the head was rectangular (0.9 × 1.9 mm) and triangular (0.6 × 1.9 mm; 0.3 × 1.3 mm; Appendix 24). However, two aspects in the sequence of the decoration might characterise the art of inlay on cast objects from Ghazna. The preparation of sheet inlays in the wax model without any post-casting reworking has been observed only on the parts of two inkwells linked to this centre (cat. nos. 12, 17); the lid (cat. no. 12) features an almost unique inlay process in which outline tracings are not on the substrate surrounding the inlay, but on the inlay itself (fig. 37).

Bamiyan

The small dish or incense burner found in Bamiyan (cat. no. 25), is very atypical from the point of view of its impurities (high As, Ag, Sb, Ni; Appendix 3). Statistical analysis has clearly isolated this object, associating it with a mortar (cat. no. 26) due to its high content of tin as impurity. This high tin content is also found in a lamp of an atypical type (cat. no. 29), and a lamp or incense burner (cat. no. 28) belonging to Class 1 in terms of impurities (Appendices 7, 8). These four objects have atypical compositions when compared to other alloys in the pre-Mongol corpus and are therefore grouped together but a 'Bamiyan' chemical signature cannot be established from a single object from the site.

The Question of the Workshop

The organisation of metalwork production is one of the questions at the heart of this book. The reconstruction of supply routes for raw materials, alloys and pure metals is complex. Hypotheses of the centralisation of production are challenged by the diversity of regional mineral resources, the variety of supply routes and the materials available. Even once the materials had reached their destination, many other questions remain regarding the systems of production. The notion of the workshop as a centralised structure is challenged by divisions in the shaping processes (casting and hammering), and divisions between the shaping and the addition of surface decoration. A further question concerns the craftsmen involved in these different phases, given that the manufacture of an object could have taken place in various workshops or cities.

Several production systems were identified thanks to the technical study of pre-Mongol objects in the DAI collection. These systems are partly those described in the legal sources of the same period, which reveal various organisations, particularly in the case of objects that were commissioned outside the usual buying and selling—the commercial transactions in the bazaars.[153] The type of contract and the skills of the craftsmen determined the organisation of the production of an object. In these transactions, the commissioning of specific decoration for a previously purchased object was part of the contract made with a *naqqāsh*, or decorator. The commissioning of an object to be made and decorated according to the wishes of a patron was regulated by another type of contract. An intermediate agent would then organise the completion of the order

between the patron and the workshop(s) or craftsmen.

The measurements of the tool marks, combined with their stratigraphy, make it possible to determine the operating sequence and to distinguish the individuals at work on a metal object, such as the maker of the wax model and the caster who could be two distinct people, and the chaser and the inlayer.[154] Another major contribution of the technical study is the identification of the variety of materials and processes on the same object, which allow for the documentation of the relationships between those involved in metalwork. More broadly, these distinctions make it possible, in a modest way, to address the historical anthropology of the creation of these objects.

Wax and Casting

Several techniques can be employed in the manufacture of an object, and in particular several wax modelling and/or sculpting processes. This suggests that a certain polyvalence of skills operated within the same centre of production, or indeed in the hands of a single artisan. In the case of objects made up of several separately-cast parts that were assembled, interpreting the compositional homogeneity of the different elements in order to propose models of organisation for their manufacture has proved interesting.[155] There are sixteen objects of this type in the corpus and study of their variations suggested three modes of operation. With some objects, all the parts were cast in the same metal at the same time, presumably in the same workshop (cat. nos. 7, 37, 52, 56).[156] In the case of others, the various components were made from different pourings, possibly at different times, but probably in the same workshop. Slight variations in the composition of the metal are visible, although the zinc content seems to be deliberately kept at a constant level (cat. nos. 6, 38, 40, 44, 53, 65). Finally, two objects (cat. nos. 5, 21) are made up of several parts from different pourings, with variations in composition visible in many elements. These significant variations suggest that the parts were made at different times, and even in different locations.

The variety of casting processes seems to reflect the diversity of their types, and testifies to the breadth of skills around the working of wax that was shared throughout the medieval Iranian world. As the observation of the tool marks has indicated, some of the cast objects were fully or partly made in wax, with every element, including the surface ornament, conceived at the model phase and transposed onto the metal during the casting process. Objects made entirely on a wax model point to the craftsman in charge of the wax being primarily in charge of the design. The cold work by the chaser, made after the casting, was relatively minor and limited to the reworking—he did not participate in the creation of the surface design. This operating method can be observed on several types of objects (Appendix 23). As with the shaping process, the wax work was primarily a process of surface preparation: the play of the material, forming grooves and reliefs, would be transposed onto the metal during casting. Part of the inlay process might take place on the wax model, and therefore before the casting phase. If that was the case, the craftsman working with the wax was in charge of designing the areas of spatial inlay, which would then be filled by the inlayer. The majority of cast objects have decoration cold worked directly on the metal, with little or no preparation on the wax model. This type of decoration could have been entirely unrelated to the casting process, thereby suggesting the existence of another craftsman, or possibly another workshop outside the foundry, working exclusively with the surface ornamentation and not involved in the shaping process. The division of labour between the caster and chaser or chaser/inlayer is rarely documented on objects from the pre-Mongol Iranian

world. The signatures on the bucket made in Herat in 559/1163, and perhaps on the zoomorphic sculpture dated 603/1206, nevertheless prove the existence of this division of labour, at least for high quality objects.[157] The same system of organisation may have applied to the production of numerous extant objects made with lost wax casting, in which the caster was called upon to perform a task using skills unrelated to those of the chaser/inlayer. It is thus possible that once shaped, the object was chased by a different craftsman, in another workshop or even another city. In other words, the production of a finished object, including its shaping and surface treatment, did not necessarily take place in a single location. This is suggested by an inkwell in the collection with a substrate tied to Ghazna and inlays linked to Herat (cat. no. 6). This possible separation between the shaping and the decoration in two distinct, and possibly distant, centres, puts into perspective the notion of attribution and centre of production. This possibility might apply also to hammered objects from the same period, as well as to later Iranian metalwork.[158]

Hammering

Hammered brasses are precious productions of very high quality. The purity of the metal surpasses the technical requirements of its shaping by plastic deformation; it matches the high status of this type of production, and was realised by craftsmen of exceptional skill. These were probably goldsmiths who, around the turn of the twelfth century, had extended their activities to the production of inlaid brasses, in response to the growing number of commissions from members of the new urban elite.[159] These new techniques, or at least very specific skills, were thus developed through these new productions, driving an innovative metal culture in the Iranian world.

The zodiac ewer from Herat (cat. no. 4) is the only hammered object in the pre-Mongol collection for which all the individual components have been analysed. They are made of the same brass but with very different impurities. The ewer could therefore have been made with several different brasses, supplied by different sources. The neck has been broken and is not related to the body, an assembly that may have occurred during the object's circulation on the art market. Since the corpus is statistically limited, it did not allow us to associate a mode of production with a particular level of quality,[160] or to highlight regional technical particularities. However, cases of brasses made in several parts according to the terms of a predetermined contract are known in legal sources. The form of the finished object, with all its different parts, was assured by a prior contract. This suggests the possibility of the intervention of different craftsmen, if required, to ensure that the conditions of the contract were carried out.[161]

Was the coppersmith/goldsmith also the *naqqāsh*, the chaser-inlayer? Inlaid brasses combining the use of precious metals such as silver and hammering techniques including repoussé and chasing suggest the work of goldsmiths, craftsmen who were employed for the production of precious vessels and for the inlay of precious metals on copper alloys, but their role in the shaping of hammered brasses has yet to be clearly established.[162]

Chasers and Inlayers

In the case of cast and inlaid objects, it appears that the role of the inlayer was carried out separately, in the final stages of production. The object would have already been shaped, and perhaps also chased, when it reached the hands of the *naqqāsh*. Legal documents and technical studies attest to a separation between the production of the object and its inlaid decoration. In Herat, the

great centre of inlaid metalwork centre in pre-Mongol Khurasan (Chapter 3), the same copper was used both for the substrate of cast objects, and in certain cases for the inlay in hammered and cast objects. The production of the object and its inlaid decoration would have thus taken place in the same centre.

In the case of hammered objects, the same, extremely fine punch was certainly used by Shazi to chase and prepare the inlays (0.25 x 0.5–0.6 mm) on the pen box (cat. no. 2). The same hand and the same tool were probably also responsible for the tracing work (0.4 x 0.9–1.1 mm; 0.3 x 1 mm) and inlay chasing on two objects linked to Herat (cat. nos. 4, 11). On the cast objects from Herat, the punches used for tracing and inlay preparation are not always similar (cat. no. 8; tracing 0.5 x 1.3 mm; inlay 0.25 x 0.8 mm), but there is an almost identical tracing tool used for the inlay on another object (cat. no. 7; 0.4 x 1.2 mm). It is therefore possible that both objects were chased and inlaid in Herat, by the same craftsman. Other objects from Herat testify to the existence of another system, whereby the chaser and the inlayer were two distinct entities. On the cast objects, the inlay preparations were cold worked and were thus done after the casting process (cat. nos. 5, 6, 9). On these objects, the decoration was already prepared on the wax model, except for the inlay which was carried out in the second phase of the surface treatment (cat. no. 9; fig. 35b). This is suggested by the non-inlaid chasing decoration which is less sharp and somewhat different from the chasing around the inlays and was not made with the same tools (fig. 29). It seems likely that on this object, the inlay was completed during a second phase of work, by an inlayer who had received the object with its surface partially decorated. This division between shaping and the commission of a particular inlaid ornament is documented in the legal sources.[163] Other objects in the DAI collection suggest that objects shaped in one city were inlaid elsewhere. The sprinkler (cat. no. 18) and the inkwell (cat. no. 6) have substrates similar to the signatures of Ghazna compositions and inlays similar to those identified in Herat. This may mean that the inlay was carried out in a different centre from the shaping, but may also indicate the use of the same supply routes for the use of inlay metals in different centres, or, alternatively, that itinerant inlayers, working on a contract basis, decorated previously shaped objects.[164] On the sprinkler, the line and inlay chasing were made with the same rectangular tool with a U-shaped head (0.5–0.6 mm x 1.2 mm): the chaser and the inlayer were therefore the same craftsman. Analyses of the inlaid objects from Ghazna (cat. nos. 12, 17) also showed that the same copper was used in the substrate of the cast objects and in the inlay of the cast and hammered objects (cat. no. 23), indicating that the cast, hammered and inlaid metalwork was also produced in this city (see Chapter 4).

Eight systems of production of cast and hammered objects were possible:

Objects cast / chased in the same workshop—
three craftsmen: wax craftsman / caster / chaser for the reworking and finishing of the surface.

Objects cast / chased in one or two workshops—
three craftsmen: wax craftsman / caster / chaser for the making of surface designs.

Objects cast / chased in one or two workshops—
three or four craftsmen: wax craftsman / casting in several times or places/
chaser for the making of the surface designs.

Objects cast / chased/inlaid in two workshops—
three craftsmen: wax craftsman / caster / chaser-inlayer for the making of the surface designs.

Objects cast / chased / inlaid in two workshops—
three craftsmen: wax craftsman / caster / inlayer for the surface designs prepared on the wax model.

Objects cast / chased / inlaid in two or three workshops—
three or four craftsmen: wax craftsman / casting in several times or places /
chaser-inlayer for the making of the surface designs.

Objects cast / chased / inlaid in two or three workshops—
four craftsmen: wax craftsman / caster / chaser / chaser-inlayer.

Objects hammered / chased / inlaid in one or two workshops—
one or two craftsmen: coppersmith-goldsmith / chaser-inlayer.

Notes

1. We would like to sincerely thank Ziad el-Morr, who was a member of the ISLAMETAL project in 2014–15, for his wonderful contributions to this part of the text, namely the archaeological and textual sources.

2. Allan, 1973, 118, 120.

3. Nezafati et al, 2008; Momenzadeh, 2004.

4. Shimkin 1953, 126–27.

5. Collins, 1894; Tylecote, 1970, 286–87.

6. These include the famous Mes Aynak mine, which is still in use today. Mineral analyses were carried out on samples collected during the surveys, but are difficult to use today, see Berthoud, 1979.

7. Muhly, 1973, 234.

8. Berthoud, 1979, 32.

9. For the ceramic recipes of Abu'l Qasim Kashani, see Allan, 1973; Matin, 2020, 461–70.

10. Carboni and Whitehouse, 2001, 176–78.

11. See also the kiln and ceramics used for the manufacture of zinc oxide described by al-Jawbari around 1222, Allan, 1979, 41.

12. Ya'qubi, 1937, 103, 111.

13. Allan, 1976, 137.

14. For information on the sources cited in this paragraph, see Ibn Hawqal, 1964, vol. 2, 419–20, 426, 430, 436, 447, 468, 474–75, 483, 487, 492.

15. Al-Biruni, 1989, 210; Allan and Floor, 1993.

16. Bulliet, 1983, 271.

17. Allan, 1979, 25–26 and 53–54; Allan, 1976, vol. 1, 125. See also Aga-Oglu, 1944.

18. Allan, 1976, vol. 1, 150.

19. Abu'l Qasim Kashani, Abu Dulaf is cited by Yaqut, 1955–57, vol. 3, 456; al-Biruni, 1936, 245; al-Khwarizmi, 1895, 168.

20. Allan, 1976, vol. 1, 150.

21. Allan, 1976, vol. 1, 122, 127; Allan, 1979, 23–25, 27; Muhly, 1973, 260.

22. For information on Kalah and tin, see Allan, 1979, 27–28; Wheatly, 1961, 222–24; Wheeler, 2006, 30; Allan, 1973, 112 and 118; Melikian-Chirvani, 1982B, 169.

23. Allan, 1979, 17.

24. Nezafati et al, 2008.

25. Dekowna, 1971.

26. Allan, 1979, 13–14; al-Biruni, 1989, 208, Allan, 1976, vol. 1, 39–40.

27. Ibn Rustah, 1955, 156; Allan, 1979, 14–16.

28. al-Biruni, 1989, 221.

29. Allan, 1979, 17–18.

30. Abu'l Qasim Kashani, 1966, 340–341; Allan 1973, 112, 118.

31. Blake, 1937, 309.

32. Allan, 1986B, 58, 60; Blake, 1937, 291.

33. Bulliet, 2009, 122–23. I would like to sincerely thank Melanie Gibson for this reference on the numismatic data and the question of the discontinuation of silver coins.

34. Melikian-Chirvani, 1982B, 155–72; Melikian-Chirvani 1986B, 103–104.

35. Allan, 1979, 52.

36. Melikian-Chirvani and Allan, 1989.

37. Allan, 1979, 39–45.

38. Allan, 1979, 52; al-Biruni, 1989, 226.

39. Allan, 1979, 52.

40. Allan, 1979, 46–48; al-Biruni, 1989, 225–26.

41. Allan 1979, 48–51; al-Biruni, 1989, 223.

42. Allan 1979, 38–39.

43. Allan, 1976 (thesis).

44. Craddock et al, 1998, for a first compilation of data, as well as the synthesis published in La Niece, 2003 and La Niece et al, 2012.

45. Atil, Chase and Jett, 1985; Al-Sa'ad, 2000 whose later attributions (approximately to the fourteenth century) are still to be determined.

46. Ponting, 2003 and 2008; Brill, 2003.

47. Shalev and Freund, 2002. In addition, we would like to mention the analysis of ten objects from Umm al-Qays, Jordan, although these are not from the period we are discussing, Arafat et al, 2003; and the portable household objects from Jerash, Jordan, which include objects from the Roman period to the middle of the eighth century, Orfanou et al, 2020. Likewise, five objects discovered in a Sasanian palace in western Iran, Oudbashi et al, 2017.

48. Bujard and Schweizer, 1994.

49. In addition to Bujard and Schweizer, 1994, and La Niece, 2003, there is the work of Ponting, 2003 and 2008; and the short but interesting study on portable household objects from the Umayyad period found during the excavations of in Mafraq, Jordan, Garenne-Marot et al, 1998.

50. From the initial corpus of 103 objects, 17 were removed: 4 pestles arbitrarily associated with mortars by the art market (Pantanella-Signorini donation, 2009), modern forgeries, and objects of doubtful authenticity (1 lamp MAO 2227, 1 tripod MAO 2226, 1 ewer neck MAO 138, 1 ewer MAO 624, 1 bottle MAO 501, 2 high tin bronze bowls MAO 609 and MAO 2011). Following technical analysis other objects were subsequently dated to later periods. These include 3 high tin bronzes (MAO 503, MAO 1220, OA 3369) and 1 plate, OA 6155, all attributed to the early Mongol period. Some of them were already dated after 1220 by Melikian-Chirvani, 1973, 38–39; 1974B, 31–42 and figs. 1–7; Melikian-Chirvani, 1977, 193–95 and 200–10, pls. X–XII for the lidded bowl acquired by the Louvre in 1997 (MAO 1220). The lid OA 8180 is datable to the Safavid period due to a nastaliq inscription in a cartouche. Finally, a bowl, MAO 1279, remains undatable. Four objects were not analysed due to the impossibility of extracting samples and the difficulty of studying the very corroded surfaces.

51. PIXE (Particle Induced X-Ray Emission): particles (here, protons) with high energy are generated by the AGLAE particle accelerator and sent to the metal object. The metal in question reacts by emitting X-rays that are characteristic of its composition. ICP-AES (Inductively Coupled Plasma-Atomic Emission Spectrometry) reacts with metal in a different way: shavings are taken from the object and dissolved in acid, then heated to very high temperatures in a plasma, resulting in the emission of ultraviolet rays, which are also characteristic of the metal's composition.

52. See the details of ICP-AES protocols in Bourgarit and Mille, 2003, and for PIXE, Bourgarit and Thomas, 2012. For more details on the elements analysed and comparison tests in the current study, see Orfanou et al, 2018.

53. Thus, when an object had copper and silver inlays in both wires and sheets, i.e. four types of inlay, eight analyses were carried out, see Orfanou et al, 2018.

54. See the details of for ICP-AES protocols in Bourgarit and Mille, 2003, and for PIXE, Bourgarit and Thomas, 2012. For more details on the elements analysed and comparison tests in the current study, see Orfanou et al, 2018.

55. The two pure or almost pure coppers that were considered pre-Mongol before the technical study of the collection were removed: one is likely a fake or is in any case doubtful (MAO 624), and the other is dated to a later period (OA 8180).

56. Throughout the text, the sign '%' will be used to refer to 'wt%'.

57. See especially, Bayley, 1991; Bourgarit and Thomas, 2012; as well as Boust and Bourgarit, 2023. For example, the terms 'red brass' and 'gunmetal' are often used.

58. Melikian-Chirvani, 1974A with bibliography; Srinivasan and Glover, 1998. For the vase cat. no. 1, see Makariou, ed., 2002, 50.

59. Except for the padlock (cat. no. 56), and a mortar (cat. no. 26), which were classified as high-leaded coppers (Appendices 1, 6).

60. Except for the feline carpet weight (cat. no. 9) with 8% zinc.

61. We thus removed 'red brass' and 'gunmetal', terms which have been much discussed and debated in the literature, Bourgarit and Thomas, 2012.

62. The mirror (cat. no. 68) could be categorised in the brass group, but the Zn/Sn ratio is 4, whereas for the brass group the ratio is above 30. Moreover, it contains nearly 3% Pb (all other brasses have less than 1%). It does not relate well to the leaded coppers as it does not contain enough lead. Finally, all of the other mirrors are high tin bronzes. The mortar (cat. no. 78) could be classified in the leaded copper group but its Zn/Sn ratio is very high (6.5 / 1.8 for leaded copper). In addition, it has a relatively low lead content (5 / more than 12%) and tin (0.9 / more than 2%). It is too weak in Zn to be classified within the group of leaded brasses (6 / more than 12% for the leaded brasses).

63. When zinc, tin and / or lead were not considered as alloy elements, they were added to the list of impurities.

64. When identifying the impurities, lead and tin were not considered. They are present (0.2–1%) in the brasses.

65. Alloys other than brasses are rarely very pure: the leaded copper of a cauldron (cat. no. 84), which is low in As, Fe, Ni, and Zn, and the leaded brass of an ewer (cat. no. 37), which is low in As and Sb.

66. Except the high tin bronze of a mirror (cat. no. 71), with high As and S contents

67. The mirror (cat. no. 68) and the mortar

(cat. no. 78); other atypical compositions (Appendix 1) were included in the statistical analysis.

68 For the castability of copper-based alloys, see Mille, 2017.

69 However, the ewer (cat. no. 4) is distinguished by a slightly higher sulphur content (0.3 / less than 0.1%) than the other hammered objects and is also characterised by a low zinc content (12 / 20% on average).

70 Pillai et al, 1994.

71 Allan, 1979; Atil, Chase and Jett, 1985; Craddock, 1979 and 1998; La Niece at al, 2012; Ponting, 2003 and 2008.

72 The ideal alloy contains between 15–30 % zinc, with a little tin (around 1%). See the remarkable experiment led by d'Arcet in 1818 (Table 1 at the end of the book) in his search for the ideal alloy for gilded bronze, and our analyses of bronze mounts on French furniture from the seventeenth to eighteenth centuries. Heavily chased, these mounts contain 1–2% tin in brasses with 20% zinc, Bourgarit and Pons, 2020. The experiments led by the conservators Emmanuel Plé and Dominique Robcis (C2RMF) suggest the same conclusion.

73 On this subject, see Fang and McDonnell, 2011; Boust and Bourgarit, 2023.

74 https://www.kupferinstitut.de/de/ werkstoffe.eigenschaften/kupfer-zink-messing.html#c8619

75 For the alloy known as 'tombac', (which is not the *tombak* known by Islamic art historians, which in the Ottoman world designates copper gilded with mercury) which is used today in goldsmithing and which includes 5–20% zinc; the colours vary greatly at 10–15% zinc. These alloys are also considered to be suitable for cold shaping, pressing, hammering or embossing. The addition of lead, tin, and/ or arsenic would modify these colours. Thus, white tombac would include 10% zinc, and 'traces' of arsenic.

76 Tin (1%) is also found in in the composition of 'amiral brass'.

77 Thus, eight analysed objects in the corpus that are not cold decorated are quality 1 and 2.

78 The shaping technique known as hammering determines the choice of this alloy and adds to the quality of the

object.

79 La Niece et al, 2012, 251–52 and Table 1, 251.

80 Except for the vase (cat. no. 1) which is high tin bronze.

81 Only five objects in the British Museum with published analyses were catalogued as coming from the Middle East between the tenth and twelfth centuries, Craddock et al, 1998, Tables 2 and 3. We find similar alloys to those characterised here: brass, high lead brass and high lead copper. Three objects found at Siraf in Iran have also been analysed at the British Museum: they are very heterogenous, and their results indicate a high tin bronze, a bronze and an inconclusive analysis (more than 40% lead), Allan, 1979, Table 21, nos. 46, 47, 49.

82 Khamis, 2013; Ponting, 2003 and 2008. Cauldrons from Tiberias, Denia and Serçe Limani are made of copper and three lampstands from Denia are made of either copper or brass; this may reflect a regional difference. For example, the lampstand found in Sidon, Lebanon (MND 534) is also made of brass (Appendix 13).

83 See Ponting, 2003, where the cast objects almost all contain more than 5% lead. For objects from Caesarea, the limit is less clear and is around 2%, Shalev and Freund, 2002, 86.

84 These silver inlays were partially redone, and indeed some feature atypical compositions.

85 Only one sprinkler (cat. no. 18) is an exception to this rule (quality 3, high lead copper) but with an alloy on the borderline between copper and brass (6.5% zinc, with a lower fixed limit at 7% for brasses).

86 About as many leaded brasses as high leaded brasses.

87 This explains why the wire and sheet compositions on a single object have been grouped into a single average value.

88 It is clear that the lead that was analysed was not from the underlying substrate.

89 A low gold content cannot, by itself, constitute a criterion for the age of the silver. Ogden, 1999, 32 notes that there are silver ores poor in gold, and indicates that there were gold-poor objects from Greece and Sasanian Iran, but does

not provide a reference. In addition, the gold content never exceeds 0.4% in the analysis of 46 silver coins from tenth, century Afghanistan and Iran, Cowell and Lowick, 1988.

90 In addition to five objects from western Iran and the Middle East (Appendix 13), the shield boss from Ghazna (fig. 9) was studied for its hammering techniques, especially the repoussé.

91 HIROX KH7700.

92 See Wulff, 1966, 20–28.

93 Many thanks to Jean Dubos, founder and former director of the Fonderie de Coubertin, for his help in the identification of the hammering techniques on objects from the DAI.

94 According to La Niece, 2003, in modern treatises by Crawshaw, 1909 and Johnson, 1960, the recommended thicknesses are 0.4–0.8 mm for machining brasses.

95 See Saussus, 2019, 120. A great deal of lexicographical confusion remains concerning biaxial expansion, sometimes referred to as stamping, Gendron, 1924, 9.

96 Pernot, 2015, 67.

97 A thickness of 5–6 mm is considered reasonable by a contemporary cauldron-maker (communication with Jean Dubos).

98 Wulff, 1966, 24–25, fig. 20. This is the only ethnographic study of metalwork published for Iran, and is based on fieldwork conducted between 1937 and 1941.

99 See also Atil, Chase and Jett 1985, 95–101; Ward, 1993, fig. 52 and fig. 56; Blair, 2014.

100 Some were observed with Jean Dubos and Benoît Mille (archaeometallurgist, head of the 'Arts of Fire' department, C2RMF).

101 Giuzalian, 1968, 97; Baypakov, Pidaev and Khamikov, eds., 2012, 106.

102 An example of a mirror made with lost wax casting was noted by Murakami et al, 2003.

103 Thomas and Bourgarit, 2014.

104 Also on a lamp (cat. no. 29), a lampstand (cat. no. 47), a bucket (cat. no. 16) and a bowl (cat. no. 66).

105 These include 5 pouring vessels and ewers (cat. nos. 60, 61, 7, 19, 37), 2 sprinklers (cat. no. 20 and comparative object from Susa, MAO S. 1753, 2 vases

(cat. nos. 1, 63) and the pitcher (cat. no. 62). We will also mention the sprinkler from Egypt (comparative object AF 1199).

106 Theophilus, 1979, 132–38.

107 For Ancient Greece, see also Mattusch, 1990; for contemporary Nepal, see Craddock, 2015.

108 See the lanterns discovered in Nishapur, Wilkinson, 1973, nos. 52–53, 307 and 343; also the architectural models in Graves, 2008 and 2012.

109 In a personal communication, Ziad el-Morr and Meas Sreyneath note that this type of process is still used in the Middle East and Southeast Asia.

110 This is not achieved by core strickling which would have produced a surface of uniform thickness, see Thomas and Bourgarit, 2014, 56, 58.

111 Moulds with recessed patterns used for the manufacture of siliceous ceramics have been found at Nishapur, Wilkinson, 1973, 272–73, 284. This technique is also well known in South Asia: moulds and moulded clayey ceramics using the same process were, for instance, discovered in Sindh, see Collinet, 2010, vol. 2, figs. 20, 91–92 and 177.

112 The surface condition is of course a determining factor in these observations and measurements. Layers of corrosion, as well as abrasive cleaning or concealed repairs, contribute to the disappearance of these traces. Some objects are only partially observable; others do not reveal any tool traces.

113 Chart drawn up by Ziad al-Morr in 2014.

114 For a general survey of chasing techniques, see Untracht, 1982, 118–146 and De Bois, 1999. We would also like to warmly thank Guillaume Estrade, chaser and teacher at the Ecole Boulle, for his observations on the pre-Mongol objects in storage at the DAI and his theoretical and practical applications at the Ecole Boulle in 2015. We would also like to thank Eric Thiriet, art bronze maker, for his observations on the DAI objects in 2015.

115 It does not seem that curved punches with a slightly concave shape were used for these tracings.

116 Small asperities on the outer or inner surface of the cast object resulting from small asperities on the surface of the mould or core. The smaller the asperity,

the better the castability of the metal, and therefore the success of the casting.

117 A cauldron (cat. no. 82), incense burners (cat. nos. 53, 58), a lamp or incense burner with palmettes (cat. no. 28), an incense burner plate with three felines (cat. no. 59), a horse-shaped padlock (cat. no. 56), a flask (cat. no. 67).

118 Cat. no. 80; for the attribution of this type of mortar, see below 283.

119 Louvre, DAI, AA 100, fig. 9, in hammered and chased brass, which was compared to this object as it served as a 'reference' object, since it has a known provenance, being part of the findings of the Joseph Hackin archaeological mission at Ghazna.

120 Our warmest thanks to Marc Robert, engraver and teacher at the Ecole Boulle, for his theoretical and practical demonstrations of engraving techniques in the workshops of the school in 2015.

121 See the inkwell inscribed with the name of Uthman ibn Abu Bakr of Zanjan, Iran, thirteenth century, L. 28 cm, cast copper alloy, inlaid with copper, silver, and red and black coloured pastes, Copenhagen, David Collection, 11/1982, von Folsach, 2001, cat no. 484.

122 See 44–47 in this volume.

123 As has been well known since Antiquity, see Maish and Collinet, in press.

124 Atil, Chase and Jett, 1985, 39; Ward, 1993, 35.

125 Unpublished report by Juliette Langlois, C2RMF, 2015.

126 Orfanou et al, 2018, especially Table 7, 27.

127 For an introduction to the art of inlay, particularly for metal sculptures, see Maish and Collinet, in press. On the art of inlaid metalwork in the arts of Islam, especially for the technical aspects, see Allan, 1979; Atil, Chase and Jett, 1985; Ward, 1993.

128 However, the use of a design model for metal inlay is attested to in Iran from the fourteenth century; see Komaroff and Carboni, 2002, 187–94; see also Ward ed, 2014, especially 10–12, 32–33, 122–29, 133–35 for the relationship between inlaid metal and the Iranian drawings conserved in the Diez albums in the Staatsbibliothek, Berlin.

129 This practice was not clearly observed on pre-Mongol metal objects in the DAI, but traces of stencils for the transfer

of drawings have been identified on Iranian metal objects of the thirteenth to fourteenth centuries.

130 Iron (Fe) is only correlated with zinc (Zn) for zinc contents below 16%; for most other contents above 16%, especially for brass, the iron level is very low. The hypothesis of the same zinc ore but a different smelting process that would have removed the iron is unlikely, see Bourgarit and Thomas, 2015. The high levels of iron measured on the ewer, cat. no. 36, (1.7%) are probably due to surface pollution.

131 We also note that there is no mention of tin in these recipes. It must therefore probably be the case that any tin content lower than 4%, often present in this and other alloys used for the production of cast objects analysed by the C2RMF, entered the metal through recycling. These additions may have been made with small quantities of tin-rich bronze, or with large quantities of tin-poor bronze that the craftsmen did not distinguish from copper, either by adding solderings or objects of tin-lead alloy, Allan, 1979, 164; Craddock, 1979.

132 Allan, 1979, 45–55.

133 If the brass of this object was the source of the dilutions, it would have a mixture of impurities typical of lead alloys, and more particularly those of class 1 (not or only slightly recycled). On the other hand, it would have high antimony levels (more than 5%), an element that is known to come from copper and not from lead added to the alloy (no Pb/Sb correlation). However, the small dish (cat. no. 14) contains 100 times less antimony (0.005%).

134 The results of experimental laboratory simulations, confirmed during fieldwork with furnaces and crucibles inspired by medieval models and on the same scale, have shown that it is possible to reach more than 5% lead in brass, Bourgarit and Thomas, 2011.

135 Allan, 1976; Atil, Chase and Jett, 1985; Craddock, 1979; Le Niece et al, 2012; Ponting, 2003 and 2008.

136 The production of a Parisian workshop from the beginning of the fourteenth century is also characterised by the same consistent presence of tin in the same type of alloy. This observation

remains unexplained, Bourgarit and Thomas, 2012.

137 Allan, 1976; Ponting, 2003.

138 Craddock, 1979.

139 However, the tin in the objects analysed here cannot have come from the recycling of the solderings alone, for reasons of quantity but also because tin is not related to lead.

140 Ponting, 2003.

141 Melikian-Chirvani, 1974A, 124.

142 The Budrach hoard in Uzbekistan, as well as the Tiberias workshop, the latter outside the scope of our study, were mentioned on page 40 in this volume.

143 Except perhaps for lead, whose content is somewhat higher in Class 1 alloys.

144 Ponting and Levene, 2015.

145 Silver (Ag), and bismuth (Bi) are not volatile but also decrease. There is a slight correlation with lead, which is often accompanied by these two impurities and which is, on average, lower in Class 2.

146 The mortar (cat. no. 26) is very far from the dilution line but belongs to a class that is atypical. The only two Class 1 objects far from the dilution line, a mortar (cat. no. 27) and a cauldron (cat. no. 82) are also of common manufacture.

147 See above, 64–65.

148 Objects with a known provenance that have yet to be analysed are in the Museum for Islamic Art, Jerusalem, and the Iran Bastan Museum, Tehran, see above 48, notes 32 and 33; see also Spink 2015.

149 Cowell and Lowick, 1988.

150 See above, 55.

151 The relatively low zinc content of the Zodiac ewer (cat. no. 4; 12%, compared with more than 15% for other brasses, including those from Herat), and possibly high sulphur levels, cannot be interpreted as a marker for this centre, nor excluded. The zinc content could be part of the variability of alloy compositions from the same centre.

152 Ghazna brasses contain slightly less lead (Pb) and tin (Sn) than those of Herat: this could indicate a different zinc origin and/or different brass making processes, but this difference is very tenuous and observed on a restricted sampling of objects, Thomas and Bourgarit, 2014.

153 Kana'an, 2009; see also 44–47 in this

volume.

154 The superimposition of the traces also makes it possible to distinguish modern retracings of the decoration, sometimes 'refreshed', probably before the objects' arrival on the art market.

155 This approach has made it possible, particularly in the very specific context of small Angkor votive statues, to distinguish between mass-productions and individual commissions, Bourgarit et al, 2003.

156 One cauldron (cat. no. 82) was subject to two analyses: the foot and the casting gate at the bottom of the wall. The similarity in the compositions shows that the foot and wall were cast simultaneously. This also allows us to appreciate the overall accuracy of the measurement (around 10%). The same applies to the handles and the body of a bucket (cat. no. 16).

157 Saint Petersburg, Hermitage ИР-2268 and AZ-225; Loukonine and Ivanov, 1995, no. 116, 134, no. 127, 144; Ettinghausen, 2007.

158 Thus, mass-produced bowls from Fars, particularly those dating to the first half of the fourteenth century with similar alloys and the same shaping processes, but different styles of inlay, suggest that inlay workshops were more numerous than shaping workshops, see Collinet, ed., forthcoming. The hypothesis that metal objects were shaped, left blank and then decorated in different workshops has already been suggested by historians of metalwork such as Rachel Ward, 1993, 92.

159 see above, 44–47.

160 The variations in the lead content of the inkwell lids are discussed above, 60, 66.

161 Kana'an, 2009, 191.

162 Kana'an, 2009, 192.

163 Kana'an, 2009, 192.

164 Kana'an, 2009, 193.

The Art of Inlaid Metal in Herat

I rrigated by the Hari Rud, surrounded by fertile lands, situated at the crossroads of commercial routes to central Asia, Sistan and Iran, Herat was one of the most prosperous cities in the medieval Iranian world.[1] One of the capitals of the Sasanian empire, then one of the four capitals of medieval Khurasan, Herat remained a flourishing metropolis until the Mongol invasions. From the tenth century onwards, it is often mentioned in Arab historical and geographical sources, as well as in local sources. Recent archaeological and historical research on the site, as well as objects preserved in the city's museum, have led to the publication of two impressive volumes under the aegis of Ute Franke, to date the most complete compendium of knowledge on the city and its history.[2] After the Arab conquest in 31/651-52, Herat and the region remained more or less under the control of caliphal governors sent first by the Umayyads (661-750), and then by the Abbasids. In the ninth century, Herat, like a large part of Khurasan, was in the hands of the Taharids and the Saffarids before the Samanid conquest. In the tenth century, the city, surrounded by walls and dominated by a citadel, contained many bazaars distributed between its centre and residential quarters. At the dawn of the second millennium, Herat was incorporated into Ghaznavid territories before its conquest by the Saljuqs in 1040; it then became the capital of eastern Khurasan until its occupation by Ghurid military troops in the mid-twelfth century. In 571/1175-76 Herat was conquered by the Ghurids but was rapidly subjected to attacks led by the Khwarazm Shahs who finally took over the region, chasing out the Ghurids who installed themselves in northern India at the beginning of the thirteenth century. In 1221-22 Herat was destroyed by Mongol armies and its population of over 1.5 million inhabitants was decimated. The city only regained international importance in the fifteenth century under the Timurids.

Herat and the First 'Painters on Metal'

Herat is the only centre of production of inlaid metalwork in Khurasan to be documented by textual sources[3] and by extant objects. The works linked to this centre are inlaid with silver, copper and black material. Their inscriptions include the phrase 'made in Herat' and are signed by inlayers (*naqqash*, a word that also means painter) who use the *nisba*, an adjective indicating the person's origin, thus al-Haravi has the meaning 'from Herat'. This *nisba* is documented from the second half of the twelfth century to the beginning of the thirteenth century. Al-Haravi inlayers who are known by their signatures include Muhammad ibn Abu Sahl,[4] Muhammad ibn Asir and Shazi.

The first object featuring a 'made in Herat' inscription is the Bobrinsky bucket, made in 559/1163;[5] a second undated bucket with notable similarities to it is signed Muhammad ibn Nasir ibn Muhammad al-Haravi;[6] both pieces are cast. The oldest hammered object with repoussé and inlaid decoration dates from 557/1181–82; Mahmud ibn Muhammad al-Haravi is the maker of the decoration of a tall, elegant ewer with a poem in cursive Arabic script on twelve of the fourteen flutes on the walls.[7] The inscription mentions Herat as the place of production and concludes with the signature of the inlayer and the date of its manufacture. The inscription also confirms the function of the object as an *aftaba*, or ewer, its prophylactic role linked to the zodiac figures on the object's shoulder and the planets evoked in the inscription.

The iconography of the zodiac and astronomy is recurrent both on inlaid and non-inlaid metals from Khurasan and is very accomplished on objects produced in Herat. Astronomy and astrology were inseparable in the medieval period: this was the science of the stars. These two closely related sciences were based on a knowledge of Greek astronomy which was being translated into Arabic from the ninth century and was enriched in the Iranian world from the tenth century onwards by famous astronomers and mathematicians such as 'Abd al-Rahman al-Sufi (903–986), al-Biruni (d. 1048) and Nasir al-Din al-Tusi (d. 1274). The recurrent astral figures on metal furniture and objects show that this important science had become a visual trope, thereby conferring cosmological and talismanic powers to the objects.[8] These images are also found in other mediums, especially ceramics. Representations of the stars derived from scientific treatises, especially the planets and the zodiac constellations, appeared on objects in the twelfth century. The forty-eight constellations, including the stars of the northern hemisphere, the zodiac which is 'the path of the sun, moon, and planets', and the southern hemisphere were located in the celestial vault by the great Persian astronomer 'Abd al-Rahman al-Sufi. His *Kitab Suwar al-kawakib al-thabitah*, or Book of Fixed Stars, followed on from Ptolemy's *Almagest* which he translated into Arabic, and whose calculations were enhanced by his own observations.[9] The constellations were represented by figures, animals and objects that can be found on many objects such as furniture and devices related to lighting which refer to the light of the heavens.[10]

Many other themes are depicted on inlaid objects, some of which appear for the first time in Herat. Thus, on the Bobrinsky bucket, we find two backgammon players and guests at a banquet. Feasting and hunting scenes and astrological figures are recurrent themes, topoi of a refined and learned visual culture. They allude to cosmogonic knowledge, poetic visions, literary references and mystical practices. They are linked to an episteme and to representations of terrestrial and celestial powers that largely characterise the art of this period. On the Bobrinsky bucket, we find for the first time in the art of Islam a type of calligraphy known as 'animated script', in which the

uprights of the letters feature human faces. Like the figural scenes, the inscriptions decorate a metal art that had become a medium for the pictorial and the calligraphic, where the figure occupied a central place, and whose development clearly took place in Herat in the twelfth century. Animated inscriptions are unique to the art of metal and are not found in other mediums.[11] In the Khurasan region and in Central Asia, a precedent can be seen in the ornithomorphic inscriptions on metalwork, on precious vessels and on slip-painted ceramic wares of the tenth to eleventh centuries where letters in Kufic script were used to form the contours of birds, in part or entirely.

A consensus has now been reached on the attribution of metals to Herat from about 1150, in the Ghurid period,[12] especially brass with high quality repoussé and/or inlaid decoration. Melikian-Chirvani compares repoussé metalwork, with its surface relief and monumental decoration, to the production of moulded ceramics in Khurasan.[13] The well-documented 'Khurasan' repoussé metalwork has a provenance in Afghanistan: it is characterised by the extreme thinness of the walls, a background often adorned with domed dot punching and inscriptions although some objects are without inscriptions. In this group, Melikian-Chirvani compares the DAI shield boss from Ghazna (fig. 9) with a similar object conserved in the Herat museum. He adds to this group of repoussé-decorated objects a wine cup from the Kabul museum, a candlestick and two rosewater flasks in Herat and a jug from the Kabul museum.[14] Two complete jugs of the same type are also in the Herat museum.[15] Melikian-Chirvani has also published trays and candlesticks with inlaid decoration produced in Khurasan, according to their provenance from Afghanistan and sold in Paris in 1976.[16] While the art of repoussé brass was one of the signature techniques of Herat, it was probably also practised in other centres, particularly in Ghazna.

MASTERPIECES FROM HERAT

Three objects from the DAI are inlaid masterpieces in the pre-Mongol collection and are some of the most luxurious and famous metalwork production of Herat. They include a pen box signed by Shazi al-Haravi (cat. no. 2), a candlestick with entirely repoussé decoration with ducks in the round (cat. no. 3) and the zodiac ewer (cat. no. 4). The richly inlaid decoration of the ewer makes it one of the finest examples of a well-documented group similar to the one made in Herat in 577/1181-82. A comparison of the materials, especially the inlays, as well as aspects of the chasing and inlay techniques of these three works, reveal a coherence and similarity between the hammered objects whose sumptuous decoration and, most importantly one signature, link them to Herat.

2
Pen box signed by Shazi Naqqash

Afghanistan, Herat, c. 1210

Hammered brass, chased decoration, inlaid with copper, silver and black material

L. 21 cm; W. max. 3.8 cm; W. min. 1.5 cm; H. 0.6–1.7 cm; Thickness 0.6–0.8 mm; Thickness min. 0.4 mm; Weight 0.272 kg

Chasing W. 0.25 mm

Copper wire W. 0.6 mm; silver wire: W. 0.5 mm

Rectangular-headed punch 0.5–0.6 x 0.25 mm

The metal is yellow, with a thin brownish patina. The object is incomplete: the lid is no longer removable because the lower hinge is missing, and the ink receptacle has disappeared. The pen box was shaped from three sheets of brass, perhaps originally soldered but now held together with glued fabric. Small tears in the very thin sheets are visible, especially at the top edge and near the circular opening. Another small tear is visible in the decoration of the reverse.

Bought at auction in 2010; acquired in the Kabul bazaar by its former owners, German scholars in Kabul in the 1960s; inv. no. MAO 2228

INSCRIPTIONS[17]

Cartouche on the front of the pen box signature, Kufic script (fig. 5)

عمل شاذي نقاش

ʿamal Shazi Naqqāsh/Work of Shazi the painter/inlayer
Top and centre of the reverse: votive formula in Arabic, *thuluth* script

العز و الاقبال و الدو[لة] ا

al-ʿizz wa al-iqbā/l wa al-daw[la] alif (or al-dawā[la/ma] ?)
glory, good fortu/ne, pros[perity] *alif* (or succ[ess]/lon[g life](?))

Votive formula in Arabic on both sides: in *thuluth* script

العز و الاقبال و الدولة و السلامة و السعاد[ة] و العافية و التاييد
و التامة و الزيادة/ة و الر[ا]حة و الرحمة و التاييد و الشكر
و الشاكر و القناعة و الشفاعة و البقا

al-ʿizz wa al-iqbāl wa al-dawla wa al-salāma wa al-saʿād[a] wa al-ʿāfiya wa al-taʾyyid wa al-tāmma wa al-zyād (or ziyāda)
/a wa al-r[ā]ḥa wa al-raḥma wa al-taʾyyid wa al-šukr wa al-šākir wa al-qānaʿa wa al-šafāʿa wa al-baqā
glory, good fortune, prosperity, peace, happiness, health, soundness, abundan[ce] (or vision of God) / tranquillity, clemency, soundness, thanks, gratitude, contentment, intercession, longevity

The pen box is trapezoidal with tapering walls. This is the writing case of a literate man or a statesman, used for storing sharpened reeds for writing. The circular opening in the widest part suggests the place of a now missing inkwell. The pen box was opened by a hinge, the lid sliding to the side. The brass sheets, which are very thin, measure less than 1 mm in thickness (fig. 39). This object is very delicate, both in its shape and in the fineness of its ornament which evokes a fantastic garden with plants inhabited by hares, and on the reverse a single harpy. These creatures are associated with good wishes and with the divine invocations that are inscribed on the vegetal ground that occupies a large part of the composition. The top face is decorated with an animated foliate scroll on both sides of the signature which is framed by a rectangular cartouche. Inlaid with silver and copper on the front, and silver on the sides, the decoration is highlighted with black material that also accentuates the finely chased motifs on the reverse; this has a compartmented and airy composition with the background left partly blank. The upper part is decorated with two votive inscriptions and a harpy (fig. 2a), the lower part with almond-shaped medallion and dense foliage with large plants.

The background of the chased and inlaid decoration is entirely punched (fig. 38). The inlaid decoration is two-coloured, a characteristic that is not systematic on copper- and silver-inlaid objects but is found on other objects in the collection here attributed to Herat (cat. nos. 7, 8, 11). The heads of the hares are also two-coloured, and their features are defined by fine chasing on the surface of the small sheets (fig. 40). The decoration is also characterised by inlays that leave part of the outline in reserve; they provide a contrast to the inlaid decoration, which appears to emerge from the chased background, creating a visual overlay of the outlines and the inlaid areas.

The chasing grooves (W. 0.25 mm) are the finest of any

38

observed in the Louvre pre-Mongol corpus and indicate the use of a tool with a thinner tip than those used on other objects in the collection. The inlaid decoration is made with wires and small sheets of copper inlaid flush with the substrate. However, the silver wire and sheet inlays are convex and in relief, creating a decoration that is polychromatic and that plays on the different visual effects of the two types of inlay (fig. 40). The background of the copper and small silver sheets is prepared with champlevé. The wires are inserted into grooves chased with two strikes of a rectangular-headed punch, giving the line a linear or notched appearance (fig. 41).

Shazi is one of the only Herat inlayers who can be identified by several surviving objects. Melikian-Chirvani, who devoted a monograph article to him,[18] considers him to have been a *naqqash* of manuscripts, or at any rate to have been trained in the arts of the book. Shazi is known today for four inlaid objects, including a pen box dated 607/1210-11 that provides an indication of his period of activity. This masterpiece of inlaid metal is a reference object because it is signed and dated and bears the name of a great vizier of Khurasan.[19] Its signature is identical to the one on the Louvre pen box and its decoration is very similar, particularly in the animated scrolls, suggesting that the two pen boxes can be dated to the same period. Observation and analysis of the alloy conducted at the Freer Gallery of Art showed that the object was cast. The chasing for the silver wire inlay was made with a square-ended tool in double rows of punches. The copper-wire inlay shows three parallel chasing grooves which are found on the Louvre object. However, on the Freer pen box there are domed dot punches between the inlaid areas that, according to these observations, were added after the inlay.

Another pen box very similar to the DAI example was seen in 1968 by Melikian-Chirvani in Herat. It 'was discovered in the Badqis/Baghis of Herat', that is, in the region to the northeast of the city, according to its then owner ʿAta Mohammad Naqshbandi (Naqshbandi Foundation). The fourth object is a fragmentary cosmetic flask with an ornithomorphic shape.[20] The only object made by Shazi that contains his *nisba*, it is

Fig. 38

Back of the pen box (cat. no. 2): inscription chased on a punched ground (domed dot punch).

Fig. 39

X-ray of the pen box (cat. no. 2).

39

inscribed, 'Shazi al-naqqash al-Haravi'. Also in private hands, it was acquired on the market in Kabul as originating from Herat according to the information provided by its owner; it was seen by Melikian-Chirvani in the 1970s.[21]

Of the four objects decorated by Shazi, two were cast and two were hammered. The objects demonstrate that he used silver and red copper inlays, that he punched the background of the decoration and that he alternated decorated areas with others left in reserve, even in the traced motifs. The signatures on the three pen boxes have the same content but different styles. The types of inscriptions found on the objects show a great variety. Although no animated inscription is visible on the Louvre pen box, this type of calligraphy is prominent on two more writing-related objects inlaid by Shazi.

The two pen boxes in the Louvre and the former Naqshbandi foundation are very similar in form, almost identical in size and very close in decoration, in particular the animated scrolls that are of similar composition and placed under the identically formulated signature on the top face of the objects.[22] The same iconography can be found on the Freer pen box lid and on the ornithomorphic flask. The objects are also characterised by the treatment of the ground with a domed dot punch and use of red copper inlay to outline the designs; they also share the two-colour compositions. The reproduction and note by James Allan on the Naqshbandi pen box[23] show a use of copper in the animated scrolls. The distribution of silver and copper is identical or almost identical to that of the Louvre: red copper for the necks, and silver for the heads and the scrolls. However, the treatment of the inlays is distinctive: on the Louvre pen box we see reserved spaces between the inlay and the traced line, whereas on the Naqshbandi pen box there is an unreserved outline that enhances the inlay, and on the 1210 pen box something in between the two. In addition, the choice of non-inlaid decoration is only found on the reverse of the DAI pen box. Decoration chased on a punched ground is not found on other known objects by Shazi; these were planned without metal inlay. The reverse of the Naqshbandi pen box is instead inlaid with silver and decorated with votive inscriptions and birds in a foliate interlace. It is very different when compared to the reverse of the Louvre object which is characterised by large blank spaces and motifs spaced out in superimposed registers.

On the other hand, the same eulogies are found on all three objects, including the use of a rare term noted by Melikian-Chirvani, *ziyada* (vision of God). There are twenty invocations on the Louvre pen box, with the same number on the Naqshbandi pen box according to Allan, but twenty-four according to Melikian-Chirvani. It is possible that the formulas were abbreviated on the Louvre object: such shortened forms were indeed observed by Melikian-Chirvani on the other two objects, leading him to conclude that there were twenty-four inscriptions on the Naqshbandi pen box.

Fig. 40

Front of the pen box (cat. no. 2): animated scroll inlaid with silver and copper.

Fig. 41

Front of the pen box (cat. no. 2): animated scroll inlaid with silver and copper showing the preparation of the wire and sheet inlays.

3
Candlestick with ducks in the round

Afghanistan, Herat, second half of the twelfth century

Hammered brass, repoussé, chased and champlevé decoration, inlaid with silver, copper and black material

H. 34 cm; D. 35.5 cm; Thickness max. (base) 0.45–0.5 mm; Thickness average 1 mm; Weight 2.688 kg

Oblong hammer marks (U-shaped): 1 x 0.5 mm

Chasing W. 0.4 x 0.5 mm

Champlevé W. 1.2 mm

Copper and silver wires W. 0.5 mm

Rectangular punch 0.6 x 0.4 mm

The original golden yellow colour has faded and been altered by the ageing of old varnishes and waxes that have caused the surface to corrode to a dark red. On the edge of the socket, a large tear has been repaired by the addition of a yellow metal plate held in place by five rivets. Inside the candlestick the patina is thick, of a brown, almost black colour. There are a few breaks in the material due to its thinness: seven small gaps are in the very thin areas of the lion friezes or around their edges but only one break was found in one of the ducks in the round.

Bequest of Charles Piet-Lataudrie, 1909; inv. no. OA 6315

INSCRIPTIONS[24]

In the upper band, the text in three cartouches is preserved, five other cartouches have been deliberately removed: blessings in Arabic, in *thuluth* script

[...] / السلامة و السعادة / و الزيادة و العافية و العـ/ـناية
[...] / و الكرامة و الشكرة

/ al-salāma wa al-saʿāda / wa al-ziyāda wa al-ʿāfiya wa al-ʿi/nāya wa al-karāma wa al-šukra / [...]
[...] / health, happiness / abundance, well-being, sol/icitude, consideration, recognition / [...]

In the lower band, divided into seven cartouches: blessings in Arabic, in Kufic script

باليمن و البركة و الكامة ؟ و الد / و السلامة و السرور و التامة /
و السعادة و التامة و العمة (النعمة ؟) و /
العافية و الشكرة و الشاكر/ة و الكرامة و الشفاعة و (ا) ا/
لبركة و الدو[ا]مة و الدولة و ا(ل)/ لسلامة و السعادة و التامة /
و العمة و العافية و البقا لصاحبه

bi-l-yumn wa al-baraka wa al-kāma? wa al-d (sic) / wa al-salāma wa al- surūr wa al-tāmma / wa al-saʿāda wa al-tāmma wa al-ʿ-m-a (niʿma?) wa /
al-ʿāfiya (sic) wa al-šukra wa al-šākir/a wa al-karāma wa al-šafāʿa wa alif a/l-baraka wa al-da[w]āma wa al-dawla wa a
/ l-salāma wa al-saʿāda wa al-tāmma / wa al-ʿ-m-a (sic) al-ʿāfiya (sic) wa al-baqā li-ṣāḥibihi
/ with happiness, blessing (...)(?) pros/[perity] /, health joy, plenitude/, happiness, abundance and well-being(?), / health (sic), recognition, gratitud/e, consideration, intercession *alif* / blessing, long life, prosperity, / health, happiness, plenitude /, well-being (?), health (sic) and longevity to its owner.

The candlestick with ducks in the round is one of the highlights of the DAI collection and was already well known before its arrival at the Louvre in 1909.[25] In 1903 it was exhibited at the MAD in the *Exposition des Arts Musulmans* and was described by Migeon:

'It is impossible to forget, even after a single viewing, this extraordinary candlestick of squat form, with on the shoulder a crown of birds in the round, all facing outwards as if ready to take flight, and these circular friezes on the body of seated lions, hieratic, separated by a wide band of bosses. Overall, the piece is both rugged and has an incredible majesty.'[26]

At the time of the bequest, Migeon mentions that Piet-Lataudrie, who stopped buying before 1894, did not acquire anything during his travels in Egypt and Asia Minor.[27] His objects were 'largely acquired in Paris, from Armenians who traded with merchants in the bazaar of Constantinople'. This information echoes the Armenian inscription below the shoulder, set against foliate scrolls inlaid with silver, similar to those found below the socket. This inscription is engraved over the original decoration, and it dates from the end of the seventeenth century, postdating the candlestick by five centuries. The inscription states that in 1699, the candlestick was given to the church of Saint Mary of God, in a town in western Armenia, in the region of Bitlis, between northwest Iran and eastern Anatolia, in western Armenia. It reads:[28]

ՅԻՇԱՏԱԿ Է ՇԱՄԷՏՐԷՆՑՍ ՅՈՎԱՆԷՍԻ ՈՐԴԻ Մ[Ա]ԴՏԵՍԻ
ՊԱ[Ղ]ՏԱՍԱՐԻՆ Է Ի ԴՈԻՌՆ Ս[ՈԻՐ]Բ Ա[ՍՏՈԻԱ]ԾԱԾԻՆ
ԹՎ[ԻՆ] ՌՃԽԸ
ՍԱՍԷՆՑԻ

Fig. 42

Candlestick (cat. no. 3): abraded inscription.

42

Fig. 43

X-ray of the candlestick
with ducks (cat. no. 3).

yIŠATAK Ē ŠAMĒTRĒNƏS yOVANESI ORDI M[A]ŁTESI
PA[Ł]TASARIN Ē I DUŘN S[UR]B A[STUA]CACIN T'V[IN] ŘČXƏ
SASĒNC'I

In memory of Yovanēs Samêtrēn, son of the pilgrim [M[a]ltesi
(Mahtesi borrowed from Arabic, a faithful believer who made
the pilgrimage to Jerusalem) Pa[l]tasar (Balthasar). [This] is for
the [church] of Saint Mary of God. In the year 1148 (551/1699).
From Sasenc

This object is one of the rare surviving candlesticks of this
type. It does not have a signature or a date, nor a name of the
commissioner or the place of production. It is possible that the
inscriptions that originally ran along the top of the wall were
abraded because they contained this information (fig. 42). The
candlestick was shaped by hammering a sheet of brass. Its
ornament is complex and features both chased and repoussé
decoration as well as the addition of other material, since the
work is inlaid with silver, copper and black material. Ten deco-
rative planes have been counted on the object: the recessed
decoration is champlevé, incised and chased; some is chased
obliquely to create a relief accentuating a slight repoussé
from the inside. There is also an inlay plane, and five planes
of repoussé culminating in elements in the round.

A masterpiece of metalwork in its shaping and relief deco-
ration, the candlestick is a veritable tour de force. Its imposing
size suggests a substantial weight and yet it is surprisingly light.
It was made with one circular metal sheet entirely worked with
hammers. The metal sheet is very thin, and the object has no
base. The thickness of the metal decreases as it reaches the top

of the object with the base having the thickest section (5 mm)
and the walls and repoussé decoration being extremely thin
(1 mm). This candlestick shows how the material was work-
ed to the limits of its plasticity. The single-sheet construction
as well as the thinness and regularity of the metal wall are
clearly visible on the X-ray (fig. 43), which also shows that no
element, not even the intricate sculptural ducks on the shoul-
der were made separately.

Repoussé, a process that uses the plastic deformation
capacity of the material in its metallic state, is very complex,
and requires a perfect understanding of the resistance of the
metal. This technique is here seen at its peak.[29] This object is
very fragile: the thin metal has not in any way been consoli-
dated, with no reinforcing cement visible inside the elements
in the round. Here, the craftsman had to make the shape
thicker to keep enough material to stretch it. On the flat part
of the shoulder, traces of the tools used to shape the metal
during the hammering are clearly visible (fig. 7b). Looked at
from inside of the wall, the material is so thin that in some
parts it appears almost translucent. In the centre of the wall,
the preparation for the inlay of the solar pattern is clearly
visible from the inside. This indicates that the metal is in
some parts perhaps even thinner and therefore slightly irre-
gular, or that the chasing is deeper and also slightly irregular.
The incised and repoussé decoration of the lower band where
the lions and the hares are located is also clearly visible from
the inside.

Ten bosses inlaid with silver wire surround the central part
of the socket; its slightly sloping bottom edge has a vegetal
frieze inlaid in silver. The shoulder has eighteen facets like
concave petals, each with a solar motif inlaid in silver and cop-
per. On the edge of the shoulder, eighteen birds face outwards;
each one sits in a mandorla shape, incised and highlighted
with copper wire, in a foliate interlace with traces of silver
and black material. The gaps between the birds, incised and
inlaid with black material, are irregularly spaced. On the
candlestick wall, the upper band has a frieze of thirty-three
lions executed in low to high relief (fig. 44a). They are similar
without being identical: small details betray their individual
workmanship, reworked from the exterior with incisions.
The bodies are arranged in profile and oriented towards the
left, with the heads shown frontally. One paw and the tail are
incised, while the rest of the body is made with repoussé on
four planes of depth. Below the lions there is a band of cursive
inscription divided into eight cartouches framed by copper
wire and interspersed with eight solar motifs identical to those
on the shoulder, with a copper heart and eight silver petals.
Two cartouches are intact (fig. 45a), five are totally abraded
and a sixth is partially abraded. No legible traces were detected
in the erased areas under the microscope or by X-ray (fig. 42).
This silver-inlaid inscription was set against a vegetal back-
ground inlaid with black material. The centre of the wall is
decorated with a wide band of forty-one bosses arranged in
a staggered pattern in three rows. These solar motifs, simi-
lar to those already described, have silver-inlaid petals and a
red copper core. Below, a band of inscription in Kufic script is

divided into eight cartouches framed with copper wire (fig. 45b). These cartouches, like those in cursive script on the upper part of the wall, are interspersed with eight solar motifs inlaid with copper and silver. The inscriptions are inlaid with silver and stand out from the foliate background inlaid with black material. The bottom of the wall, the widest part of the candlestick, is decorated with a frieze of thirty-one felines, with thirty-one hares incised between them (fig. 44b). This decoration is slightly different from the frieze of lions at the top of the wall: the lions have only one paw incised, and their tails are replaced by the heads of the hares. Finally, the edge of the base is decorated with a guilloche frieze.

The inlays of small sheets and wires are hammered flush with the substrate. One part of the tracing of the decoration and the inscriptions is left blank around the inlays (fig. 2b, fig. 46). The wires are inserted into chased grooves with straight or slanted sides made with a rectangular-headed punch with a succession of double strokes (fig. 47). The recesses for the sheets are made by champlevé and surrounded by a deeper chased groove (fig. 47). Observation of the area of the solar-patterned bosses under the microscope clearly identified the inlay preparation in the slanting grooves: it was made using chasing for the outlines and champlevé for the centre. At the top of the wall, the vegetal frieze running along the junction with the shoulder is inlaid with silver sheets that form the largest inlays on the candlestick. The sheets are convex and in

slight relief from the walls; they are chased to give more detail to the tracing of the split palmettes. The additional adhesion provided by the black material under the inlays was observed in this part of the decoration as in the other inlaid areas (fig. 2b).

The candlestick has several symbols linked to the stars. The solar motifs of the rosettes, the lions, the ducks and the hares can all be seen as related to this theme. The lion (Leo) is one of the constellations of the zodiac, an astrological sign linked with the sun and by analogy to power and the sovereign. The constellation of the hare, which according to astronomy is ascendant at the same time as that of the lion, is situated in the southern hemisphere.[30] Birds are often represented in the round on lighting devices (cat. no. 42) and bird-shaped lamps were also produced in medieval Khurasan. Birds can reach the sky and can therefore approach the divine light.[31] In the northern hemisphere, several constellations are represented by birds: the lyre or the goose, the pigeon and the hen which are located close to each other, the eagle and the flying vulture; and in the southern hemisphere, the constellation of the crow. Visually, these representations are linked to the invocations inscribed on the candlestick, are related to the symbolism of light, astral and divine, and also recall the lighting function of the candlestick. Given its size and quality, the candlestick may have been a commission for a prestigious monument. It was made by a craftsman whose identity is not known, but who

44a

44b

Fig. 44

Candlestick (cat. no. 3): a) body of a lion in profile showing the repoussé in high relief b) head of a hare incised on the base.

45a

45b

46

was manifestly one of the few capable of executing an object with such prowess, and surpassing even the few candlesticks whose form, bird decoration and feline reliefs are comparable, but which do not have elements in the round.[32]

Two candlesticks can be compared to the Louvre example since they also feature friezes of ducks in the round on the edge of the shoulder. Their inscriptions are formulas of blessing. One in the Dar Al-Athar al-Islamiyya in Kuwait does not have entirely repoussé decoration since the ducks were made separately.[33] It seems only one other candlestick, in the Museum of Islamic Art in Cairo, is closely similar to the Louvre example: it was made from a single circular metal sheet worked in repoussé with dimensions and decoration that are very similar except for the intact inscribed cartouches containing blessings. Although it does not have a documentary inscription, it seems possible that it formed a pair with the DAI candlestick.[34] Another candlestick in Kuwait, also devoid of a documentary inscription, was worked in repoussé and may have come from the same workshop.[35] It has very similar dimensions (H. 31 cm; D. max. 35 cm) and was also made with

47

a single sheet of metal. The base is octagonal, but the neck and socket are similar to those of the Louvre candlestick; copper is used for the framing and silver inlay for the motifs and inscriptions. This object is characterised by the inlaid ground on which the reliefs of the repoussé motifs, also inlaid, stand out. The motifs are repetitive and monumental: lions sitting in profile surrounding a harpy and eight felines attacking a bull are representations related to the stars and the cosmic battle. The contents of the votive inscriptions, published by Melikian-Chirvani,[36] are close to those of the Louvre object. The formulas begin with the term *bi'l yumm* (might it be given, possessed) and include the term *ziyada*.

In the absence of any documentary inscriptions on the extant candlesticks with ducks, other objects presenting similar characteristics can be cited in order to suggest the context in which the objects were commissioned, perhaps by a dignitary from the Ghurid dynasty which ruled Afghanistan between 1150 and 1215 before conquering northern India. A tray[37] and a ewer[38] seem to be the only other surviving objects with repoussé motifs and friezes of birds in the round. These may be ducks as on the Louvre candlestick, symbolic creatures related to an Indian context, and in this case to the Ghurids.[39] On the upper part of the ewer, there is a partially erased inscription, an incomplete title in a formula used by Ghurid dignitaries.[40] It begins with two titles of authority 'al-Sayyed al-Ajall.' According to records of the Ghurid sultans known from numismatic, as well as textual and epigraphic sources, the most complex and elaborate titles date from the twelfth century. Those of the Ghurid dignitaries have never been systematically researched, but titles found on metal objects are close to this ewer with ducks in the round. The commission of objects by Ghurid dignitaries is also attested by a candlestick currently in the Linden Museum in Stuttgart which has entirely repoussé decoration.[41] On the shoulder, an inlaid inscription gives the date 561/1166 and mentions a Ghurid high dignitary who has yet to be identified in the textual sources: al-Sahib al-Ajall (...) Abi'l Fath Muhammad ibn Abi Sa'd. This object, the only medieval candlestick with repoussé decoration that bears a date, is thus a rare example of a commission by a Ghurid dignitary.

4
Zodiac ewer

Afghanistan, Herat, end of the twelfth century

Hammered brass, repoussé, chased and champlevé decoration, inlaid with silver, copper and black material

H. 39.3 cm; D. max. 17.6 cm; D. (base) 10.7 cm; D. (opening) 5.8 cm; Thickness (spout and wall) 1 mm; Weight 1.53 kg

Repoussé decoration straight chasing W. 1 mm; curved chasing W. 1.3 mm

Rectangular punch (U-shaped) 1.1 x 0.4 mm

Matte punching D. 1.3 mm

Inlaid decoration: rectangular punch 0.9 x 0.4 mm

The handle (now missing) was attached with solder, traces of which can be seen on the neck and body. The spout and neck are detached from the ewer and attached to the shoulder by a modern assembly. The spout has gaps on the rim and on the head of the recumbent lion. The substrate is torn near a seated lion. The shoulder also has gaps and three mechanical deformations next to the attachment of the handle. The gaps and tears mark the junction between the body and the foot. The object has been cleaned with an acidic solution that has rendered the substrate porous.

Acquired from Michel Boy, Paris, 1902; inv. no. OA 5548

INSCRIPTIONS[42]

On the neck, in two vertical bands divided in two cartouches on either side of the collar: blessings in Arabic, in *thuluth* script on one line,

العز و الاقبال و الـ/ لعافية و العناية و الدوامة و ا /
والعافية و العناية و الكربه ؟ / والعافية و العناية

*al-ʿizz wa al-iqbāl wa al-/l-ʿāfiya wa al-ʿināya wa al-dawāma wa alif /
wa al-ʿāfiya wa al-ʿināya wa al-k-r-b-h ? / wa al-ʿāfiya wa al-ʿināya*
glory, fortune, / health, solicitude, long life, *alif*/health, solicitude (...) health and solicitude

Shoulder, in one line, in a circular band: blessings in Arabic, in *naskh* animated script

العز و الاقبال و الدولة و السعادة و العافية و الكر[ا]مة و الدوامة
و الديانة و العناية و الرفعة و الشاكرة ا

*al-ʿizz wa al-iqbāl wa al-dawla wa al-saʿāda wa al-ʿāfiya wa al-kar[ā]ma
wa al-dawāma wa al-dyāna wa al-ʿināya wa al-rafaʿa wa
al-šākira alif*
glory, fortune, prosperity, felicity, health consi [de] ration, long life, faith, solicitude, elevation, and gratitude *alif*

Top of the body: blessings in Arabic, one line of *naskh* animated script

بالبر و البر/كة و التا/مة و البر/كة و النا/صرة و الد/ و العافية (sic) و ا/
لدوامة و ا/لنعمة و ا/لرفعة و ا/لتما و الـ[...]/مة و الماى ؟ / مة

*bi-/l-birr wa al-bara/ka wa al-tā/mma wa al-bara/ka wa al-nā/ṣira wa al-
d/ wa al-ʿāfiya (sic) wa a/l-dawāma wa a/
l-niʿma wa a/l-rafaʿa wa a/l-tamma wa al-[...]/ma wa al-(...)? /ma*
with/piety, benediction, pleni/tude, benedic/tion, as/sistance, health / long life / well-being, elevation, / plenitude [..]/ (...) and (...) (...)(?)

Bottom of the body: blessings in Arabic in one line of *naskh* animated script

العز و الا/قبال و ا/لدوالة / و السعا/دة و الـ/
ا / و العنا/ية و العا[في]ة] / (sic) بلامة
و القناعة / و الدوا/مة و العا/مة ؟ و ا دائم ؟

*al-ʿizz wa al-i/qbāl wa a/al-dawāla / wa al-saʿâ/da wa al-/(sa ?)lāma (sic)
alif / al-ʿinā/ya wa al-ʿā[fiya] / wa al-qānaʿa /
wa al-dawā/ma wa al-ʿā/ma ? wa alif dāʾim ?*
glory, for/tune, success/, felici/ty/, [he]alth *alif*/solici/tude, he [alth[/, contentment/, long/life, (...)/(...) and *alif* perpetually(?)

In terms of its composition and iconography, this zodiac ewer has the most complex and elaborate inlaid decoration of any object in the pre-Mongol collection. Very well conserved, the inlays are all in silver with the exception of a single sheet of red copper on the back of the neck which has two reclining lions, their heads in the round and facing frontally and the bodies in high relief and in profile; a third lion lies on the spout. These are worked in repoussé and over the surface, with chasing to refine the contours and to define details such as the fur (figs. 21d, 21f). The felines add to the imposing aspect of this object: their scale is eye-catching, and they are immediately visible, whereas the abundant and miniscule inlaid decoration demands close observation in order to be deciphered. The decoration is on eight planes, ranging from high relief to recession, with five planes in repoussé and three flush with the substrate—with inlay chasing and champlevé. The subtlety of the reliefs alone illustrates the high degree of refinement that went towards the making of the ewer.

The neck with a tall spout rests on a shoulder with a star-shaped projection, a twelve-faceted body and a high foot. The base is made of a sheet ornamented with a large radiating and probably solar composition made by stamping, folded onto the object by hammering (fig. 10). The object was shaped by raising and consists of four assembled parts: the spout in two parts, the body, and the base (see above, 70–71). The spout was made with two sheets of brass: the upper part of the reclining lion is folded into the lower part of the spout and on the upper portion of the neck. The spout has a longitudinal seam line around the length of the wall opposite the neck. This seam line, which is porous and barely visible in the X-ray, is very

likely a solder that joins the two sides of the sheet used to make the spout. The hammering is very regular, as shown by the homogeneous thicknesses of the spout and the walls (1 mm).

The neck is decorated with votive inscriptions, with vegetal decoration and representations of the moon (fig. 48a), in a closed crescent shape, which is the most common symbol on pre-Mongol metalwork.[43] On the base of the neck and between the star-shaped protrusions on the shoulder is a frieze of animals, a foliated frieze, another consisting of knots and pecking birds. The animated script, its faces looking unhappy, unfurls against a vegetal background also inlaid with silver (fig. 32b). The upper part of the body has a star motif marking the transition between the shoulder and the body; it is decorated with a frieze of horsemen converging on an enthroned figure, who is equidistant from the missing handle and thus centred on the front of the object. Framed by two inscriptions of blessings and horsemen, this figure is a personification of the pseudo-planet Jawzahr which represents the intersection of the orbit of the moon with the ecliptic: this is the planet of eclipses. Its representation is associated with the crescent moon and its personification as an enthroned prince is well known on inlaid metalwork of this period.[44] Here, its association with galloping horsemen suggests that this is a representation of the cosmic struggle that generates eclipses. On the back of the body, the decoration is interrupted by a large vertical band which marks the location of the now-vanished handle. The body has representation of the twelve signs of the zodiac between two inscriptions in animated script. Each facet is decorated with a sign of the zodiac inside a medallion which contrasts with the vegetal background (fig. 49). The bottom of the wall is decorated on each facet with a crescent moon. Finally, the foot has a frieze of animals facing towards the left, in the same direction

as the inscriptions. All the motifs are on a champlevé ground of vegetal scrolls inlaid with silver.

The ewer is entirely decorated with compositions relating to the heavenly world. The formulas of good wishes, the celestial motifs and the representation of a cosmic battle are associated with this subject. Representations of the zodiac and the planets are linked to the cosmic depiction of the world and the prince, both of which have powers of protection and are related to the formulas of blessings, which themselves also invoke divine benediction. The whole composition, figural and epigraphic, confers a talismanic power on this magnificent object. Thus, the depiction of horsemen converging on Jawzahr evokes combat, or *razm*. Associated with feasting, *bazm*—in the theme of *bazm o razm*, feasting and fighting—often relates to benedictory formulas, and is their visual equivalent.[45] Combat is often represented by armed horsemen, sometimes shown as hunters. *Bazm o razm* is a hallmark of medieval Persian poetry and is often associated with astronomy, with the representation of the dimension and with the cosmic symbolism of the sovereign. The same is true for mythical winged creatures such as griffins, harpies, sphinxes and dragons that are often associated with hunts symbolising the princely hunt, a cosmological symbol of the power of the prince. These creatures, like the representations of astronomical motifs belong to what, in Persian texts, is called the feast of the heavens, *bazm-e falak*.

The ewer is inlaid with silver wires and sheets. The flattened wires, like the convex sheets, are inlaid in relief from the substrate and catch the light. The sheets are chased on the surface in order to outline all the details of the motifs, as well as the figures of the animated script (fig. 34). The wires were hammered into single or double chasing grooves with

Fig. 48

Representations of the moon on the neck of the zodiac ewer (cat. no. 4): a) inlaid with silver b) the missing silver inlay reveals the preparation for the attachment of the sheet by champlevé; the copper inlay on top of the moon is partially visible.

48a

48b

rectangular-headed punches (fig. 33). The preparation with one or two grooves allowed for smaller or larger wires. The same type of inlay preparation is visible on the candlestick with ducks (cat. no. 3), and on the tabletops or trays (cat. nos. 11, 23). The vegetal motifs are inlaid with silver sheets with chased outlines and champlevé on the surface. The same type of inlay can be seen in other decoration where sheets were used: the method for applying inlay was thus very consistent on the whole object (fig. 68b). On the neck, the only copper inlay is on a very worn area and the sheet remains flush with the substrate: the copper is more hammered and has a flatter surface than the silver. The largest area of flat spatial inlay (L. 1.7 cm; H. 0.8 cm), in the form of a crescent moon (fig. 48b), is under the handle. The chasing of the outlines around the inlays is thinner than for the inlay preparations and is always on lines that follow precise and regular tracings (figs. 3a, 33). As on other Herat objects, the line is far removed from the wires and spatial inlay and leaves a space where the alloy is visible. These lines were apparently made after the inlays, as shown by the superimposition of the contour chasing on the inlaid sheets that sometimes protrudes beyond the lines (fig. 34).

The zodiac ewer belongs to a very well-known type of object, for which the reference object inlaid with silver and copper (H. 38 cm) was made in Herat in 577/1181–82 and was signed by Mahmud ibn Muhammad al-Haravi.[46] Also hammered and decorated with repoussé decoration, this ewer has the twelve signs of the zodiac on the shoulder. The poem on the body refers to the prophylactic role of the object in relation to the planets evoked in the couplets. Many ewers of this shape are preserved, characterised by large dimensions, a gadrooned or faceted body, and decoration that combines areas of repoussé and rich inlays. They were used to pour water into basins and were part of the luxury serving ware used for handwashing during receptions.[47] The *tasht-dār* (ewer-carrier) or *āb-dār* (water-carrier) was a high-level dignitary in the service of the sultan, generally a Turkish soldier of high rank.[48] However, ewers of this type vary in quality. It has been suggested that the same centre in Khurasan could have produced, in the same period, luxurious ewers and others of lesser quality.[49] It is possible that these objects did not all come from the same centre, with some from Herat, and others from centres such as Ghazna. The archaeological provenance and the material analysis can be interpreted according to this hypothesis. Among the most elaborate examples of these ewers is one of the largest in the Galleria Estense in Modena.[50] It is inlaid with silver and repoussé decoration and its quality is reminiscent of the candlestick with ducks (cat. no. 3); on the neck a falconer on horseback surmounts a frieze of harpies with heads in the round projecting from the shoulder. Another brass ewer of comparable quality, shaped with the same process and with similar inlays of silver and black material, is in the British Museum (H. 40 cm).[51] The ornament with knotted and animated Kufic inscriptions and signs of the zodiac is also similar. A fragmentary object conserved in the Golestan Museum is also of comparable in quality and has a

49

similar composition with animated script and representations of the zodiac in the centre of the faceted body.[52] One final ewer is almost identical to the one in the Louvre. It has the same dimensions, is of the same type and was shaped with the same process. The handle, which was cast separately, is extant and shows the original height of the ewer (38 cm), a measurement identical to the DAI. Recently acquired by the Louvre Abu Dhabi and originating from the Aron collection,[53] this ewer was certainly inlaid in the same workshop. In any case, the same compositional model was used for both objects. Only a few variants, such as the wording of the invocations, distinguish them, but both objects seem to have been made by the same hands. Perhaps they belonged to a set or service intended for the same patron. They may have been part of an anonymous but very luxurious market where the same models or even the same patterns were used on several objects.

Fig. 49

Body of the Zodiac ewer (cat. no. 4): detail of Capricorn inlaid with chased silver.

OBJECTS ATTRIBUTABLE TO HERAT

Comparisons of materials, especially inlays, allows other objects with an undocumented provenance to be linked to Herat. One of these objects (cat. no. 8) is dated 586/1190–91 and offers an additional marker to the group of cast and inlaid objects from this city. The metal objects that are here proposed as coming from the centre are cast and hammered and inlaid with silver or with silver and copper, and with black material. The alloys used for the making of these cast objects are varied and their impurities heterogeneous. This begs the question of their shaping, which may have taken place in centres other than Herat, where perhaps only the decoration was completed.

The object types are varied: they include inkwells, ewers, tabletops or trays, and a small zoomorphic sculpture that may have been used as a carpet weight. These are pieces of good quality, but if we exclude the tray (cat. no. 10), are not exceptional achievements when compared to the masterpieces produced in that city. Their attribution to Herat therefore reveals that objects from this centre were not always made for specific commissions, but also for the market. One of the objects, here attributed to Herat, is a ewer bearing the signature of an inlay maker from al-Isfaraʾin in eastern Iran, documented only by this object (cat. no. 7). As this signature is fake, or at least, modern, the very existence of this *nisba* for metalwork can no longer be considered.

Inkwells with figural and inscribed decoration (cat. nos. 5, 6)

Two inkwells shaped by lost wax casting and inlaid with silver and copper have been linked, on the basis of their inlays, to the zodiac ewer (cat. no. 4) and the candlestick with ducks (cat. no. 3). The same silver and copper were used on the one hand for the ewer and an inkwell with figural decoration and inscriptions (cat. no. 5)[54] and on the other for the candlestick and an inkwell with inscriptions (cat. no. 6).[55] In these two inkwells, the only complete ones in the collection, the lead content is systematically much higher in the lid (over 16%) than the base (less than 9%), while the zinc content is relatively stable. No constraint related to casting (castability) or the elaboration of the decoration seems to justify this difference. Although the higher weight may appear to be a relevant property for the lids, the gain from this variation in the lead content appears negligible. Other objects that were analysed contradict the hypothesis of the addition of lead being specific to the lids. An inkwell base (cat. no. 17) is also very rich in lead (32%). Similarly, an inkwell in the British Museum has the same lead content in the lid and the base (13-14%).[56] Inkwells, like pen boxes, were state objects, badges of office; they signified sovereign power and ministerial office.[57] Ibn al-Athir writes that in

Iran the state inkwell (*davāt-e dawlat*) served as an insignia for viziers.[58] The inkwells were kept in the *davatkhane*, where from the Ghaznavid period all government inkwells were stored, in the custody of the *amir davātdar*, or master of inkwells.[59] The *davātdar* appears to have also been in charge of preserving the archives,[60] and moreover, these high dignitaries may have been entrusted with regional government offices.[61] Two inkwells were found in the palace of Masʾud III in Ghazna, during Umberto Scerrato's excavations in 1957-58. They were located in an area near the throne room that was thought to be private apartments.[62]

Inkwells are the most numerous surviving writing utensils from the pre-Mongol Iranian world. The most common shape in Khurasan before the Mongol period has a cylindrical base with three short feet, or a flat base.[63] It is closed by a rounded lid evoking a dome with gadroons and fitted with a spherical knop, a cosmic symbol linked to this shape.[64] The base has three suspension rings that allow the object to be hung from a belt or wrist. The cast objects are usually small (H. 10-13 cm; D. 8-10 cm). The two parts are held together by links between the lid hinges and rings at the base. Many of the objects are today in a fragmentary state with only the lid or the base preserved. It is possible that many of the 'complete' objects were assembled after their original production; they have often lost their suspension rings or attachments, which in many cases have been remade. It is possible that the ink was not in direct contact with the metal but was in a glass container held by the inner rim of the receptacle. According to the textual sources, a round shape was preferable to an angular one to avoid an accumulation of dirt and dust in the corners, and for ease of cleaning.[65]

The inlaid decoration generally unfurls in superimposed registers on the inkwell base, and in circular bands on the rim and the flat part of the lid. Examples are signed by an inlayer from Herat, Muhammad ibn Abu-Sahl al-Haravi,[66] and by two inlayers from Nishapur. The inkwells frequently feature calligraphic decoration. The sides are often decorated with superimposed bands or arcades framing figural scenes. Recurrent themes, alongside votive, or more rarely documentary, inscriptions are figural scenes linked to the court, to astrology/astronomy or to the function of the calligrapher/literary man.[67] A small group of four objects decorated with inscriptions and figures of calligraphers offer some contextual information on the inkwells. Some bear dedications to their owners: one is dedicated to Shaykh (...) ʿAli ibn Muhammad ibn ʿAli *al-mushrif*, that is, the inspector of the court treasury.[68] Another in the Eretz Israel Museum has the name of Mahmud ibn Muhammad *jawahir-zāda* (the descendant of jewels).[69] The inscription on the lid contains the word *davāt* and a metaphor about ink being the water of life for which the inkwell is the source.[70] Finally Melikian-Chirvani identified a dedication to a *muʾallim* or master on one example in the Victoria and Albert Museum in London (henceforth V&A).[71]

5

Inkwell with figures and votive inscriptions

Afghanistan, Herat, c. 1150–1220

Lid: cast high leaded brass, traces of chased decoration

H. 41 cm; D. 7.6 cm; Thickness average 2–2.5 mm; Weight 0.315 kg

Base: cast leaded brass, chased decoration, inlaid with silver and copper

H. 8 cm; D. 5.5 cm; Thickness average 2 mm; Weight 0.428 kg

Copper and silver wires W. 0.3 mm

Two suspension rings are missing on the lid and three on the base; these were attached to the substrate by rivets and tin soldering. The two parts are tarnished by a dark brown patina. The surface of the lid is very worn, and its decoration is illegible. The base has an altered and heterogeneous surface, with significant concretions of corrosion which make legibility difficult. It is possible that some inlays were remade in the modern period, especially the silver wires in the inscriptions. The interior surfaces have homogeneous concretions.

Gift, Clothilde Duffeuty, 1893; inv. no. OA 3354

INSCRIPTIONS[72]

Band above the base: blessings in Arabic in Kufic script, interrupted by medallions

اليمن و البـ / ـركة و الد / ولة و التـ ا / يد و الق د / رة و السعاد[ة] / و البق صا]حبه]

/ al-yumn wa al-b a/ raka wa al-da/wla wa al-taʾ / yyid wa al-qud/ra wa al-saʿād[a] / wa al-baqā li-ṣā[ḥibihi]

happiness, bene/diction, pros/perity, sup/port, power, felicit[y] / and long life to [its] own[er]

Band below the base: blessings in Arabic in *naskh* calligraphy, interrupted by medallions

لعز و الاقبال / و الـ[ـد]ولة و / السعاد[ة] و / و الكرامة و/ القدرة و الـ(...)/(...) و البقا لصـ[ـاحبه]

al-ʿizz wa al-iqbāl / wa al-[da]wla wa / al-saʿād[a] wa / wa al-karāma wa / al-qudra wa al-(...) / (...) wa al-baqā li-ṣ[āḥibihi]

glory, fortune / prosperity/felicit[y] / consideration, / strength (...) / (...) and long life to its owner

50

It is possible that the two parts do not belong to the same original object but were put together long before their arrival in Paris in the nineteenth century. Indeed, the very worn lid bears no trace of inlaid decoration and is in a very different state of preservation from the base. It is marked by three holes that are more recent than its inscribed decoration, and may therefore have been replaced on the current base, with a suspension system later than the original. The base of the inkwell also has a repair at the junction with the wall which could be contemporary with the making of the object, or postdate it. The base is inlaid with silver and copper wires and sheets. The copper inlays are very corroded and appear blackish. The silver inlays are much more legible and must have been partly redone in the modern period. The copper wires are flat and flush with the surface, whereas the silver wires are convex and raised from the substrate. The wires are inserted into grooves chased with a rectangular-headed tool. The silver wires identified as modern are found on a thinner underlying inscription with scrolls. A palmette in the centre of the wall has original copper inlay, hammered flush with the substrate, and silver inlay in higher relief that is possibly modern. The heterogeneous appearance of the spatial inlays and the very corroded appearance of the preparation for the missing inlays also suggest that the inlays were reworked. A marked contrast is visible between the body of an original figure and its head, inlaid in silver, that was probably remade (fig. 50), and another figure that has not been repaired with silver inlay and whose copper inlay is very corroded. Finally, a third figure certainly has a modern silver head on original copper inlay: the silver alters the rest of the copper visible under a microscope on the neck. Some areas of preparation for the copper sheet inlay are well enough preserved to reveal the champlevé background, creating a cross-hatched and convex surface lower than the substrate. The edges have been deepened with chasing to improve the hold of the inlay. Chasing with a domed dot punch is visible in some areas of the decoration near the suspension brackets.

The figural themes are similar to those on another inkwell in the David Collection, with a signature on the lid that reads: *ʿamal-i Shah Malik*.[73] The base of this object is decorated with a banquet scene, and we can also distinguish a bearded figure, shown in profile, who has been identified as a dervish.[74] On the DAI inkwell, the figures with heavily altered inlays hold objects that are mostly unidentifiable. The dancing dervish, his beard and conical headgear similar to those on the Copenhagen inkwell,[75] is perhaps the oldest surviving representation of a Sufi on inlaid metalwork, particularly on an example attributable to Herat.

Fig. 50

Figure on the inkwell (cat. no. 5): the inlaid silver face, possibly a modern repair, extends onto the heavily corroded copper inlay used for the clothing.

6
Inkwell with votive inscriptions

Afghanistan, Herat, c. 1150–1220

Lid: high leaded cast brass, engraved and champlevé decoration, inlaid with silver, copper and black material

H. 4.8 cm; D. 8.2 cm; Thickness max. (knop) 1.4 cm; Thickness (rim) 1.6 mm; (lip) 3 mm; Weight 0.190 kg

Base: cast brass, engraved decoration, champlevé, inlaid with silver, copper and black material H. 6.5 cm; D. 8 cm; Thickness 5 mm; Thickness max. (inside the base) 6 mm; (edge/walls) 2 mm; Weight 0.423 kg

Silver wire W. 0.4 mm

Copper wire W. 0.5 mm

Chased tracings W. 0.4–0.5 mm

Preparatory chasing for copper inlay W. 0.6 mm

Preparatory chasing for silver inlay W. 0.4 mm

Champlevé W. 1.2 mm

A dark brown artificial patina covers the two parts of the object. In some areas, this thick patina hides the copper decoration. Certain parts of the inkwell such as the lid are altered by areas of red corrosion. With the exception of some missing locking components, the object is in relatively good condition and no inlay has disappeared. The object has only one casting defect: the interior of the container is very irregular at the opening and becomes thicker towards the wall which indicates an infiltration of the metal during the casting process.

Gift, Marquise Arconati-Visconti, 1893; inv. no. OA 3372

INSCRIPTIONS[76]

On the cover plate in a circular band: blessings in Arabic in *thuluth* script:

<div dir="rtl">العز و الاقبال و الدولة و السعادة و السلامة و الشفاعة و البقا لصاحبه</div>

al-ʿizz wa al-iqbāl wa al-dawla wa al-saʿāda wa al-salāma wa al-šafāʿa wa al-baqā li-ṣāḥibihi
glory, good fortune, prosperity, happiness, health, intercession, and long life to its owner

On the lid in three cartouches: blessings in Arabic in Kufic script, repeated three times

<div dir="rtl">باليمن و البركة و الد / باليمن و البركة و الد / باليمن و البركة و الد</div>

bi-l-yumn wa al-baraka wa al-d(...)
with happiness, benediction/blessing, and prosperity

Upper register of the base: blessings in Arabic in *thuluth* script, in three cartouches, repeated three times, two of them abbreviated

<div dir="rtl">العز و الاقبال و الد / العز و الاقبال و ا / العز و الاقبال و ا</div>

al-ʿizz wa al-iqbāl wa al-d / al-ʿizz wa al-iqbāl wa alif / al-ʿizz wa al-iqbāl wa alif /
glory, good fortune and [prosperity]/glory, good fortune and *alif*/ glory, good fortune and *alif*

Lower register of the base: blessings in Arabic in Kufic script in three cartouches, repeated three times, two of them abbreviated

<div dir="rtl">باليمن و البركة و الدولة / باليمن و البركة و الد/ باليمن و البركة و الد</div>

bi-l-yumn wa al-baraka wa al-dawla / bi-l-yumn wa al-baraka wa al-d / bi-l-yumn wa al-baraka wa al-d /
happiness, blessing and prosperity / happiness, blessing and p[roperty] / happiness, blessing and p[roperty] /

51

This inkwell is of very good quality and has partially retained its six separately made suspension elements (rings and attachments) which were assembled on the object with copper rivets and soldering. The lid was cast in one piece with lost wax, possibly in a direct process. The knop is solid and has concentric striations on its interior surface. As with the other inkwell (cat. no. 5), it is impossible to explain the process with which the protuberance visible in the centre occurred in the shaping process (fig. 51).

The two parts are consistent and belong to the same original inkwell. They are decorated with vegetal motifs and inscriptions, and are chased and inlaid with black material, silver wires and copper wires and sheets. They have a flat surface and are hammered so as to be flush with the substrate. The chased decoration and the well-preserved champlevé areas have deep tracings with sharp edges. The silver wire inlays, which are very thin, are hammered into rectangular chasings or engravings with a clean and regular line. On the base and the lid, each composition is enclosed in a band or cartouche outlined with copper wire. The lid under the gadrooned grip is decorated with petals with foliate decoration and two elegant inscriptions that contrast with the fine detailed tracing of the foliate background. The inner plate of the base, only visible when the inkwell is open, is also decorated with a chased vegetal frieze. On the wall, two bands of inscriptions in the same script as those on the lid surround a vegetal scroll. The outlines of the letters and those of the leafy stems are larger in the inlaid zones and thus leave a part of the decoration blank. The foliate scroll is two-coloured: the copper centres of the florets contrast with the silver stems (fig. 52). This decoration is similar to the plant scrolls, also two-coloured, that decorate the tabletops or trays (cat. nos. 11, 23) here associated with Herat and Ghazna by their inlay materials. The copper inlays are treated as a malleable paste, an aspect also observed on other two-colour decorations in the pre-Mongol collection.

52

Ewers with documentary inscriptions (cat. nos. 7, 8)

These two ewers shaped by lost wax casting are among the best-known objects in the DAI collection of inlaid metalwork, and were published as early as the 1900s.[77] They come from prestigious collections: cat. no. 7 belonged to Joanny Peytel who in 1910 lent it to Munich on the occasion of the largest exhibition of Islamic art ever organised; cat. no. 8 belonged to the Piet-Lataudrie collection and came into the Louvre with the candlestick with ducks (cat. no. 3). Within the group of 'ewers with oil lamp-shaped spouts', as this type of object is often known, the two Louvre examples are perhaps the best known of a type which is well represented in Islamic art collections. Both are decorated with Arabic inscriptions that feature, on one, a *nisba* long considered a sign of a Khurasan production centre (cat. no. 7);[78] and on the other, the name of the owner and the date of production, 1190–91 (cat. no. 8). They are linked here to production from Herat on the basis of the impurities in their copper inlays. The same copper was used for the production of brasses used for the pen box of Shazi al-Haravi and for the candlestick with ducks (cat. nos. 2, 3). Moreover, the method of preparation of the surface to be inlaid with both wires and sheets is similar to the one observed on the zodiac ewer (cat. no. 4).

The shape of the ewers recalls a group of nielloed silver vessels, including a jug from the Hamadan treasure (H. 26 cm) that once belonged to a wine serving set (*majles khane*) datable to the eleventh century according to the titles inscribed on seven of the objects.[79] The inscription, in floriated Kufic, names an unidentified emir, Abu'l Abbas Valgin (or Valgir) ibn Harun.

The pear-shaped ewers form a heterogeneous group of variable quality. The best preserved ones, with careful decoration inlaid with silver or silver and copper, have one distinguishing feature: they bear inscriptions inlaid with silver that name an owner and stand out from the bare ground of the body. On two ewers in the Metropolitan Museum, the owners have a *nisba* from Sistan.[80] Were these inscriptions commissioned at the same time as the decoration or were they additions, marks of ownership made after the objects were purchased? On the DAI ewer (cat. no. 8), the original tool marks of the ownership inscription are the same as those in other sections of the decoration, which suggests that the same inlayer made them and that it was therefore a commissioned object.

53a 53b 54a 54b

7

Ewer 'of 'Ali ibn 'Umar (?) al-Isfara'ini'

Afghanistan, Herat, end of the twelfth century

Cast leaded brass, chased, incised and champlevé decoration, inlaid with silver, copper and black material

H. 14.5 cm; W. (spout-handle) 9 cm; D. (base) 5.8 cm; Max D. 8 cm; Weight 0.624 kg

Outline chasing 0.4–0.5 x 0.9 mm

Inlay chasing 0.4 x 1.2 mm

Rectangular punch (U-shaped)

Engraving (V-shaped) W. 0.1 mm; W. 0.4–0.5 mm

Copper wire W. 0.8 mm

Silver wire W. 0.6 mm

The bottom of the ewer is a modern repair. The spout has lost its small lid. Originally the handle may have had a thumb rest. The base is irregular and has a small hole. The surface has been cleaned with an acidic solution and is porous. The decoration is partially abraded, and some areas are worn. The object has two superimposed layers of black material; the one covering the subjacent layer is a modern refurbishment (fig. 30).

Purchase, Paris, Drouot auction 1965, former collection Joanny Peytel; inv. no. MAO 428

INSCRIPTIONS[81]

Modern signature on the body on either side of the handle in Arabic in cursive script. It is chased and inlaid with black material in the abraded scratches and mechanical deformations that postdate the manufacture of the object (fig. 53).

<div dir="rtl">

عمل علي بن عمر/ موف ؟ الاسفرائني
</div>

'amal (work of) 'Ali ibn 'Umar / M-u-f(?) al-Isfara'ini

Upper band on the body: blessings in Arabic, animated Kufic script

<div dir="rtl">

العز و الاقبال و الدولة و السعادة و السلامة لصاحبه
</div>

al-'izz wa al-iqbāl wa al-dawla wa al-sa'āda wa al-salāma li-ṣāḥibihi
glory, fortune, prosperity, happiness, and health to its owner

Lower band on the body: blessings in Arabic, Kufic script

<div dir="rtl">

باليمن و البركة و الدولة و السعادة و السلامة
و التأييد و النصرة
و الرا[ا]حة و البقا لصاحبه
</div>

bi-l-yumn wa al-baraka wa al-dawla wa al-sa'āda wa al-salāma wa al-tā'iyyd wa al-nuṣra wa al-r[ā]ḥa wa al-baqā li-ṣāḥibihi /
With happiness, blessings, prosperity, happiness, health, solidity, victory, tranquillity, and long life to its owner

Cartouche on the handle of the ewer. The text in the five other cartouches is abraded: blessings in Arabic, Kufic script

<div dir="rtl">

[الدو]/لة ؟ و السعادة
</div>

[al-daw]/la ? wa al-sa'āda [prospe]/rité ?, félicité
[prospe]rity(?), felicity

This ewer has been known to collectors since the beginning of the twentieth century, when it belonged to Joanny Peytel, a banker, patron and friend of Auguste Rodin. Much later it was bought at auction by the Louvre and has been published and exhibited several times.[82] It has been considered a reference object because the signature features the *nisba* of the city of Isfara'in in northwest Khurasan, considered by geographers of the tenth century to be one of the rural districts of Nishapur.[83] Unlike other inscriptions on the ewer, this one is not inlaid with metal and is in a very simple script. Melikian-Chirvani noted that the signature may have been contemporary with the original date of production, or may have been added afterwards, as in the case of attributions in the arts of the book.[84] Observations made under a microscope have shown that the inscription significantly postdates the production of the ewer. It sits above traces of wear on the body and thus appears to be relatively recent, perhaps contemporary with the repair to the bottom of the object (fig. 53). The ewer was cast in one piece with the handle; the only element that was added was the now missing lid (fig. 19). Traces of tool marks transposed from the wax model are visible around the handle; they are also visible at the top of the handle and at each junction of the body. The airy decoration occupies all parts of the object but leaves a large space for the bare substrate. The two inlaid inscriptions frame animal and flower vase motifs treated with silver wires in relief and with copper wires flush with the substrate. The animated inscription decorating the top of the body is two-coloured: small copper sheets were used for the now abraded heads, and silver wires for the shafts of the letters. The cartouches and medallions with animals are also two-coloured and have chased and engraved backgrounds. The animals, like the inscriptions, have a chased outline not covered by precious inlay and thus partially left in reserve. The larger spatial inlays are in copper and are always convex. The areas with no abrasion show that chasing and engraving were used to detail the mouths and bodies of the animals. A very similar small ewer in the Metropolitan Museum of Art may have come from the same workshop since it has the same composition with two-coloured copper and silver decoration.[85] It also has an inscription added after the manufacture of the object: on the bottom of the ewer body, an owner's mark includes the name Ahmad ibn Muhammad Isfahani (from Isfahan). Its possible original owner has his name inlaid with silver in *naskh* as *Shaykh al-Faqih* (Doctor of Religious Law) Ahmad ibn 'Ali al-Sijizi or al-Sistani (from Sistan). His name is followed by a signature, variously read by Yasser Tabbaa as *'amal Bandar* and by Melikian-Chirvani and Abdullah Gouchani as *'amal Payedar*. The ewer also contains votive inscriptions in Kufic and *naskh* scripts, with the same formula, or very similar, to the one in the Louvre. On another ewer of the same type, also in the Metropolitan Museum,[86] the body has the name of 'Ali ibn 'Abd al-Rahman ibn Tahir al-Adib al-Sijizi (that is Sijistani, from Sistan ?).

Ewer with the name of ʿUthman ibn Sulayman al-Nahghavani

Afghanistan, Herat, 586/1190–91

Cast leaded brass, chased and champlevé decoration, inlaid with glass, black material, copper and silver

H. 22.2 cm; D. max. 12.9 cm; D. (base) 10.4 cm; Thickness 0.2–0.5 mm; Weight 1.004 kg

Outline chasing 0.5 x 1.3 mm

Inlay chasing 0.25 x 0.8 mm

Copper wires W. 0.8 mm

Silver wires W. 0.6 mm

This object shows small casting defects, cavities caused by air bubbles and shrinkage porosities at the base of the handle. A small gap is visible at the edge of the spout. The metal was probably cleaned with an acidic solution, since the epidermis is porous. Much of the inlay is missing. The modern surface is very different from the original substrate. Two other repairs have been identified, one a very fine solder on the foot, and a second at the junction between the spout and the neck, concealed by a ring. The object has been broken and reassembled without soldering; this relatively modern repair is not functional as the ewer would have leaked. Certain areas of the chased decoration are also modern, such as the motifs visible on the front of the spout.

Bequest of Charles Piet-Lataudrie, 1909; inv. no. OA 6314

INSCRIPTIONS

Centre of the body: in Arabic, *thuluth* script

بركة لصاحبه عثمان / بن سليمان النخجواني /
عمل ڤ شعبان سعد ؟ سنة /
ست و ثمانين و خمس مائة

baraka li-ṣāḥibihi ʿUṯmān / ibn Sulaymān al-Naḫǧavānī / ʿumila fī Shaʿbān saʿd ? sana / sitta wa ṯamānīn wa ẖams māʾia
blessings to its owner Uthman / ibn Sulayman a-Nahghavani / made in Shaʾban saʾd(?) in the year / five hundred eighty-six.

The name of the owner and the date of production of the ewer are inscribed on either side of the handle. Viewed under a microscop,e it seems that the inscription was partially modified. The legible date is the one that was originally chased on the object at its date of production, but the part with the name of the owner specifying the *nisba* al-Nahghavani is not entirely legible. The inscription has been restored but the original inscription, which is very faint in some areas, cannot be read (fig. 54).

Upper band of the body: blessings in Arabic, *thuluth* script[87]

العز و الاقبال و الدولة و العناية و القناعة و الزياد[ة] و الدوامة
و الرلسة (الرئاسة ؟) و البقا لصاحبه

al-ʿizz wa al-iqbāl wa al-dawla wa al-ʿināya wa al-qānaʿa wa al ziyād[a] wa al-dawāma wa (...) (al-ryāsa ?) wa al-baqā li-ṣāḥibihi
glory, good fortune, prosperity, solicitude, contentment, abundance and long life to its owner

Lower band of the handle: blessings in Arabic, Kufic script

باليمن و البركة و الدولة و السلامة و السعادة و (...) و العافية و الطاعة و الفراغة
و الك(...)اعة ؟ (sic) و البكة ؟ و الكفاية و النصرة و الكرامة و الكرامة
و العناية و الكتابة و العلا و البقا لصاحبه

bi-l-yumn wa al-baraka wa al-dawla wa al-salāma wa al-saʿāda wa (...) wa al-ʿāfiya wa al-ṭāʿa wa al-farāġa wa al-baka ? wa al-kifāya wa al-nuṣra wa al-karāma wa al-karāma (sic) wa al-k(...)āʿa ? wa al-ʿināya wa al-kitāba wa al-ʿalā wa al-baqā li-ṣāḥibihi
with happiness, blessings, prosperity, health, felicity (...) health, obedience, no worry (...)
sufficiency, victory, consideration (sic), solicitude, inscription(?) greatness and long life to its owner

The ewer was cast in one piece with the same shaping process as the previous one (fig. 55). Tool marks, transposed during the casting of the wax model, are visible around the attachments of the handle. The only added element is the small lid, which is solid and decorated with a turquoise blue glass bead.[88] The object is, however, much thinner than the previous ewer (cat. no. 7) and its surface is covered with horizontal striations which suggest that it was machined with a lathe after shaping as the striations are interrupted near the handle. On the inside of the handle, polishing marks are clearly visible. The object is decorated with elegant inlaid and chased decoration, leaving large areas of the golden alloy bare. On either side of the spout, two sphinxes represent the good omens promised

in the silver-inlaid inscriptions of blessings arranged around the body. On the neck, medallions decorated with foliate interlacing are placed above the votive inscription in cursive script, set on a ground of chased and champlevé plant spirals inlaid with black material. The centre of the body is decorated with a silver-inlaid dedicatory inscription and medallions enclosing birds. The inscriptions are inlaid with silver on black material and the small sheets have champlevé and chased preparation. The part with the signature was poorly prepared for the inlay and its stratigraphy is complex. The part corresponding to the name of the owner shows different tool marks which were engraved without any systematic traces of inlay preparation. The tracing of the outline of the inscription does not always

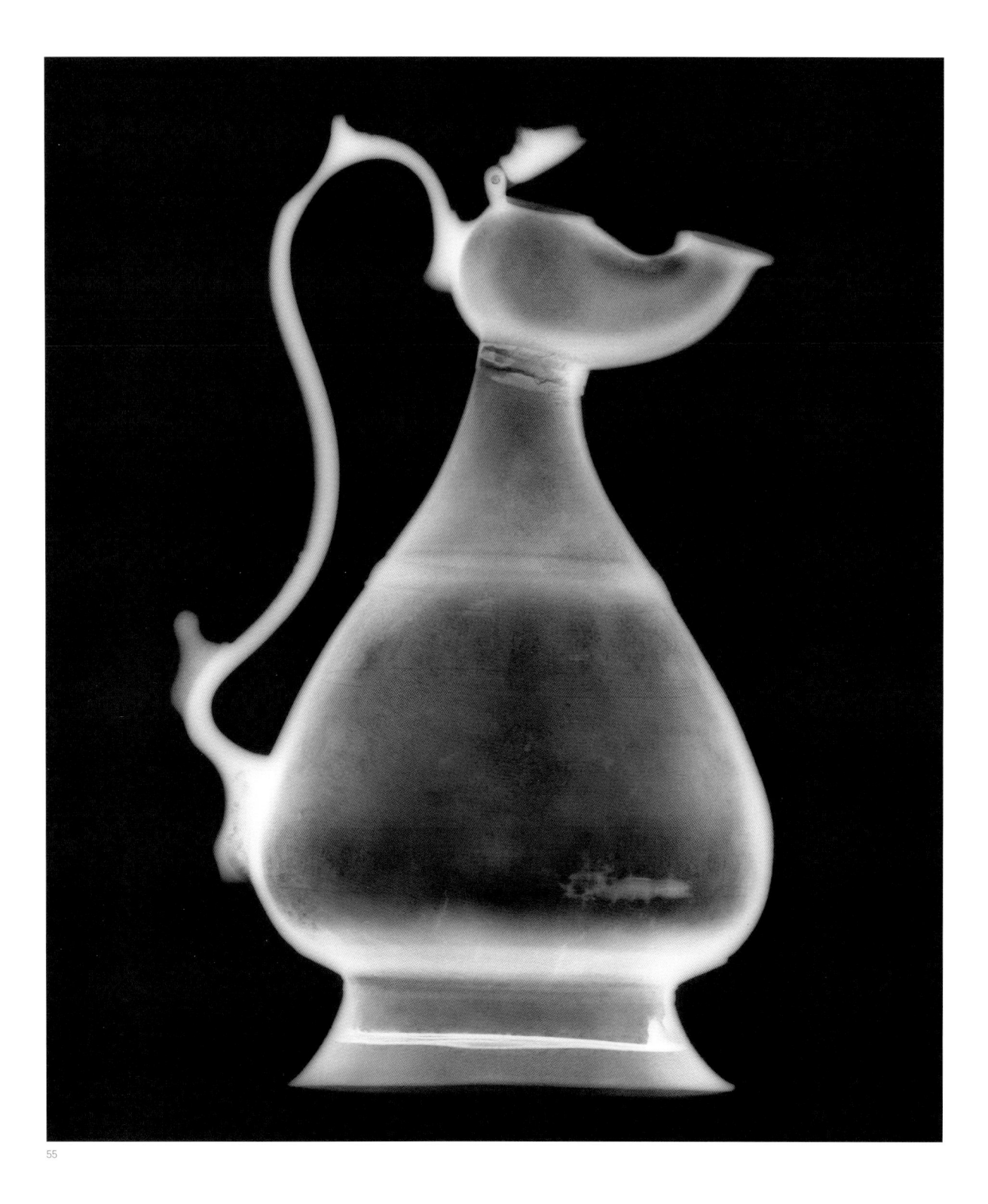

55

correspond with the outline of the inlays and therefore indicates that the inscription was remade. However, one part of the inscription was illegible, and was therefore poorly redone. In this repair of the inscription, we observe the same traces as those of the modern incisions (fig. 54).

The two-colour motifs are framed with red copper wires. The use of both copper and silver is visible, but little inlay has survived. On the right side of the spout, the sphinx with missing inlay shows the preparation of the sheet which is champlevé and inlaid with black material but seems flush with the substrate. The deep chasing of the outline suggests that the inlays were convex and thus fragile, and this may have facilitated their removal. The copper wires are inlaid with a double notched chasing and have a flat surface. They are hammered flush with the substrate. The silver wires were prepared in the same way but are more in relief, as are the sheets. Like the other ewer (cat. no. 7), this object has three planes of decoration. The small silver sheets were chased to give more detail to the design.

Fig. 55

X-ray of ewer (cat. no. 8): the modern repair of the neck with a ring hiding the point of breakage is clearly visible.

9
Feline carpet weight

Afghanistan, Herat, c. 1150–1220

Cast leaded brass, openwork, filed and chased decoration, inlaid with copper and black material

L. 15.9 cm; W. 6.4 cm; Thickness 1.3–3 mm; Weight 0.663 kg

The surface is homogeneous and does not show any corrosion, except for a few brown spots. The object is incomplete: a tear on the hindquarters suggests the former location of the tail. The worn areas are clearly visible in the reliefs and in the cast and chased decoration. The surface of the metal is porous, probably the result of cleaning with an acidic solution. The black material inlays seem to have been remade and the object shows traces of a former varnish.

Bequest of Lucien Demotte, 1938; inv. no. AA 269

INSCRIPTION[89]

Cartouche on the right side: blessings in Arabic, Kufic script

باليمن و البركة

bi-l-yumn wa al-baraka / with happiness and blessings

This small zoomorphic sculpture is here associated with objects from Herat as the copper used for the inlays is the same as one used for the manufacture of the brass of the Shazi pen box (cat. no. 2) and the candlestick with ducks (cat. no. 3).

The small feline has dorsal and ventral openings, and its ears, snout, eyes and mouth are open. These openings raise the question of the function of such objects which have been interpreted both as pumice stone holders for the bath and as carpet weights to hold down the edges of carpets. In this case, the sculptures evoke the presence of real cats alongside their representations in houses. No carpet from the twelfth to thirteenth centuries has come down to us, except perhaps from Anatolia. However, their use is well documented in Islamic manuscript paintings datable around 1220-30 which show floor rugs and carpets laid out on platforms, as well as seat and saddle rugs.[90]

The object was cast in one piece. Traces of the model joints are visible on the exterior and interior of the small feline and suggest that the casting was done using a bivalve mould (fig. 18a). On the surface, decoration of latticework and guilloche patterns made with a file are visible and the paws also seem to have been filed. The inlays framing the dorsal opening have been cut away which suggests that this hole is not original. The inlays are in copper wire with no surviving spatial inlays (fig. 3b, fig. 35b). The motifs include plants on the chest, vases on the flanks, birds on the neck and small compass-drawn medall-

ions on the hindquarters (fig. 29). On the side of the cat's legs there are figures that evoke *bazm* or feasting. These figures reinforce the interpretation of these sculptures as objects associated with carpets on which one might find seated—as on this feline—a tambourine player, a harpist, two cross-legged figures shown frontally with *tiraz* bands on their robes of honour on a ground of foliage and scrolling plants. On the back of the cat, the decoration is erased but may have contained an inscribed cartouche.

Tabletops or trays (cat. nos. 10, 11)

Two trays of hammered brass are associated with the centre of Herat. One (cat. no. 11) has the same silver and copper inlays as the pen box signed by Shazi of Herat (cat. no. 2).[91] The square tray (cat. no. 10) also has the same silver inlays as these objects.

Tabletop or tray with astrological decoration

Herat, Afghanistan, c.1150-1220

Hammered brass, repoussé, chased and champlevé decoration, inlaid with silver and black material

L. 22 cm; W. 21.8 cm; H. 4.7 cm; Thickness 0.8–1.2 mm; Weight 0.980 kg

Oblong hammer marks (U-shaped section) 0.4 x 1.1–1.2 cm

Chasing W. 0.6 mm

Rectangular champlevé W. 0.9 mm

Silver wires W. 0.75, 1.5 mm

Large wires and small sheets with rectangular punch 0.75 x 1.5 mm

The object is in very good condition, with one gap in the lower corner and a tear. At the centre of the back there is a chased number, either ∧ or ∨

Gift, Count Isaac de Camondo, 1913; inv. no. OA 6479

INSCRIPTIONS[92]

Circular band in the cavity: blessings in Arabic, Kufic script

باليمن و البركة و الدولة و السلامة و السعادة و النعمة

و العافية و الدوامة

(...)و الشكرة و الشاكرة و الـ

bi-l-yumn wa al-baraka wa al-dawla wa al-salāma wa al-saʿāda wa al-niʿma wa al-ʿāfiya wa al-dawāma wa al-šukra wa al-šākira wa al-(...)

with happiness, blessings, prosperity, salvation, felicity, well-being, health, long life, reconnaissance, gratitude, and (...)

Inner border: blessings in Arabic, Kufic script. The text is interrupted in the centre of each side and at the corners

العز و الاقبال و الدولة و السلا/مة و السعادة و النعمة و الد/

و العافية و الكرامة و العناية / و الشكرة و الشاكرة و النصرة /

و التامة و القدرة و القـ/ـوة (sic) و الناصرة و الكفاية و الدوا/امة

دائم لصاحبه (sic) و الرحمة و الراحة و التا/مة و البقا ا

al-ʿizz wa al-iqbāl wa al-dawla wa al-salā/ma wa al-saʿāda wa al-niʿma wa al-d/ wa al-ʿāfiya wa al-karāma wa al-ʿināya / wa al-šukra wa al-šākira wa al-nuṣra / wa al-nāṣira wa al-kifāya wa al-dawā/āma (sic) wa al-tāmma wa al-qudra wa al-qu/wwa wa al-raḥma wa al-rāḥa wa al-tā/mma wa al-baqā alif dāʾim li-ṣāḥibihi/

glory, fortune, prosperity, heal/th, happiness, well-being (...)/ health, consideration, solicitude/ reconnaissance, gratitude, victory/ assistance, sufficiency, long/life, plenitude, str/ength clemency, tranquillity, pleni/tude, long-life, *alif*, perpetuity to its owner.

On all four sides, with two cartouches separated by a medallion: blessings in Arabic, Kufic script

باليمن و البركة و الد/والة و السلامة و السعـ/ـادة و النعمة و العافية /

و الشكرة و الشاكرة و / [النصر]ة ؟ و الناصرة و الد/والة و التامة و التاييد /

و الشفاعة و العناية / و القوة و القدرة و الد

bi-l-yumn wa al-baraka wa al-d/awāla wa al-salāma wa al-saʿ/āda wa al-niʿma wa al-ʿāfiya / wa al-šukra wa al-šākira wa / [al-al-nuṣr]a ? wa al-nāṣira wa al-da/wāla wa al-tāmma wa al-taʾiyyd / wa al-šafāʿa wa al-ʿināya / wa al-quwwa wa l-qudra wa al-d/

With happiness, blessing, su/ccess, salvation, happi/ness, wellbeing, health / reconnaissance, gratitude, / [victor]y(?), assistance, su/ccess, plenitude, solidity /, intercession / strength, power and (...)/

The shaping, decoration and inlay of this tray are of exceptional quality.[93] The hammering is very regular: the object is of a homogeneous thickness and the large central polylobed medallion is symmetrical (fig. 57). The carefully composed decoration is of beautiful draughtsmanship, and the inlays are carefully drawn in an expressive and vivacious style. The inlays are almost completely intact; made only in silver, they had tarnished and sulphured and have been completely cleaned. The contrasting effect is because the reddish substrate has a layer of stable corrosion.[94] One area on the back was previously cleaned, uncovering the yellow epidermis of the brass. Preparation for the wire inlay is barely visible: smaller and larger silver sheets were hammered into double chasing lines; they are slightly in relief, with a flat surface and hammered on a champlevé ground (fig. 56).

The decoration includes harpies, hares, birds, knots and foliate interlaces; in the centre, a duck and a fish are framed by eight moons. These motifs are linked to astronomy and constellations such as that of the hare. Jawzahr is shown as the pseudo-planetary node of the lunar orbit.[95] The head and the tail of a dragon or snake are considered to be nodes responsible for eclipses during their conjunction with the sun or the moon. Jawzahr is shown as an enthroned sovereign at the centre of the four sides of the object, connected to the motifs in the cavity of the tray where eight moons extend out from the central star or sun. With the exception of one of the sovereigns who is shown drinking, the three other enthroned figures are shown holding one or both throne posts, as in some other representations where the upright is shown as a snake, thus associating this princely iconography with astronomy, and more specifically with Jawzahr. The presence of the moons at the centre of the tray reinforces this analogy with the figures. Most hammered and repoussé trays are rectangular. The square type (sides 21-23 cm) is less common and constitutes a small group with few examples. One inlaid with silver is inscribed with the name of the emir Ikhtiyar al-Dawlah Muhammad ibn ʿAli Kharpust who was the Ghurid governor of Peshawar and of Khurasan under the Khwarazm Shahs before the Mongol invasions.[96] The function of the square tray, like that of the rectangular version, remains unclear. The thinness

56a

56b

Fig. 56

Representation of
Jawzahr (cat. no. 10):
a) inlay with silver sheet
(face) b) preparation of
the spatial inlay (throne).

of the metal sides (thickness 1 mm), as well as the very pronounced form of the cavetto makes it implausible that they functioned as trays. It may be that they were receptacles or display trays for small, light products that were placed within the cavities. It has often been suggested that these objects could have been the tops of small pieces of furniture, assuming the presence of some kind of reinforcement such as a wooden frame.[97] If this was the case, we only have a partial understanding of the objects. The Louvre tray has a counterpart in the Metropolitan Museum of Art; the two objects may have formed a pair and were certainly made in the same workshop or by the same craftsman or craftsmen. They both previously belonged to Parisian collections: the Metropolitan piece was in the Eugène Mutiaux Collection and was sold at Drouot in 1952.[98] The objects are nearly identical: they have the same dimensions, the same chased silver inlays and the same surprisingly complete state of preservation of the inlays. The treatment of the monochrome inlaid decoration on the example in the Metropolitan, with outline chasing around the silver motifs, is similar to that on the DAI tray. Additionally, and in a manner that is also similar to the DAI object, the few areas that have observable wire inlay preparation were made with regular double chasing forming a central relief. Finally, there are only a few variations in the formulas of blessings and in the decoration of the two objects, for example in the treatment of the animals in the cavetto. On the Metropolitan tray, the hare's

ears are not upright while on the sides it has vegetal ornament rather than birds flanking Jawzahr and foliate decoration in the moons. The feathers of the creatures bordering the knots are rendered differently on the two objects. The inlaid square trays are characterised by an eight-lobed medallion in the cavity and their decoration is linked to themes of good omens by inscriptions of blessings and astrological motifs. The pair of objects at the Louvre and the Metropolitan feature Jawzahr, harpies, the moon and knots evoking the eclipse. We find the same themes of votive inscriptions, solar motifs and knots on an example at the Ashmolean Museum,[99] and another in the Keir collection.[100] The latter, made of brass and inlaid only with silver, has the same shape with an octagonal cavity, the same dimensions (L. 22.5 cm; H. 4 cm), and is decorated with vegetal motifs, animated inscriptions and signs of the sun and the moon, represented as flowers and a crescent moon. Its inscription of blessings, however, is much shorter than the inscription on the Louvre object. Two slightly smaller trays (19 x 19 cm) were published by Melikian-Chirvani.[101] They have chased decoration of a lower quality and a less elegant style, with an octagonal cavity and triangular cut-outs. This links them more closely to the rectangular trays, but they are also decorated with votive formulas around the rim and the centre and mythical animals linked to astronomy, possibly a griffin and a harpy, which evoke the iconographic programmes of the silver-inlaid square trays.

57

Fig. 57

X-ray of the tray with
astrological decoration
(cat. no. 10).

11
Tabletop or tray with rosette and inscriptions

Afghanistan, Herat, c. 1150–1220

Hammered brass, chased and champlevé decoration, inlaid with silver, copper and black material

L. 31 cm; W. 20.3 cm; H. 3.5 cm; Thickness max. 0.8 mm; Thickness min. 0.5 mm; Weight 0.602 kg

Hammering marks (U-shaped section) 0.8 x 0.4 cm

Chasing W. 0.3 mm

Champlevé W. 0.9 mm

Silver and copper wires W. 0.4–0.5 mm

Rectangular-headed punch 0.3 x 1 mm

The brown patina has been removed from the inlaid decoration. The object is altered by a large gap on one side, and a tear and indentations on the widths. The walls have been restored with glued fabric.

Purchase, Drouot auction 1976, former collection André Nègre;[102] inv. no. MAO 498

INSCRIPTIONS

Rim: blessings in Arabic, *thuluth* script

العز و الاقبال و ا/لدوالة و السعادة / و السلامة و ا/لنعمة و العافية /
و التائيد و التا/مة و الشاكرة و ا/لنعمة و الراحة و السا /
و الشفاعة و ا/لشكر و الشاكرة / و البقا دائمًا

al-ʿizz wa al-iqbāl wa a / l-dawāla wa al-saʿāda / wa al-salāma wa a/l-niʿma wa al-ʿāfiya / wa al-taʾiyyd wa al-tā/mma wa al-šākira wa a/l-niʿma wa al-rāḥa wa al-sā (al-šā[kira] ?) / wa al-šafāʿa wa a/l-šukr wa al-šākira / wa al-baqā dāʾiman /

glory, fortune, / success, felicity / health, / well-being, health /, solidity, pleni/tude, gratitude, / well-being, tranquillity (...) (gra[titude](?)/, intercession, / gratitude, thankfulness / and long-life, perpetuity

Cavity: blessings in Arabic, Kufic script

باليمن و البركة و الد ؟ / بالدوالة و السعادة

bi-l-yumn wa al-baraka wa al-d ? / bi-l-dawāla wa al-saʿāda /

with happiness, blessing, (...) / with success, felicity /

This type of rectangular object is shaped by hammering and repoussé. The rectangular rim surmounts a cavity made by deforming the metal sheet, forming a surface with a geometric cut-out, cut sides and a polylobed shape. The thin and fragile metal sheet suggests that a wooden frame reinforced the back, or that this type of object had no functional use.[103] It is possible that these metal objects, typically considered as trays, might have formed part of furniture of which the wooden supports have disappeared. James Allan has suggested that they are the tops of small tables. Furthermore, the often misshapen and incomplete sides are undecorated; perhaps only the horizontal part was visible, and the vertical sides were inserted into the furniture frame. The same form, but without the vertical sides, exists in ceramics at the same period; these trays are much more solid and could have been used to display foodstuffs.[104]

This very common type, of which there are many surviving examples, can be divided into three groups by decoration: these are repoussé, inlaid or chased without inlays. The inlaid 'trays' often have similar compositions to those in the Louvre. A group of seven repoussé examples coming from the Ghazna region and that were in the Kabul, Ghazna and Herat Museums were published by Melikian-Chirvani and are similar in shape to this example and to cat. no. 23. Made without inlay, those with specified dimensions measure around 29 x 18 cm; the invocations to the anonymous owners placed around the rims are more or less similar and use recurring terms.[105] One of the reference objects for this type, inscribed with the name of the Khwarazm Shah Abu Ibrahim, is in silver and is datable to around 1040. It was discovered near Tobolsk in Siberia, east of the Urals, along with a silver bottle with the name of a Balkh vizier who died around 1060, Abu ʿAli Ahmad ibn Shazan.[106] The same type, made of copper alloy with silver and copper-inlaid decoration, is dated to the twelfth century and was produced in Khurasan, or more precisely in Afghanistan, before 1220. Some of these objects were made for high-ranking dignitaries, as attested by one inlaid in silver and inscribed with the name of an emir in charge of justice, Husam al-Dawlah (or Husam al-Din) Shir Malik bin Zayd, who is not identified in the sources.[107]

Around the rim and in the cavity, there are cartouches inscribed in Arabic containing a series of invocations inlaid with silver on a chased and champlevé vegetal background and with copper wire on the rim (fig. 58b).[108] On the rim, the ten cartouches in *thuluth* script are interspersed with six medallions enclosing crescent moons; a further six crescent moons are in the cavetto.

Like the invocations around the rim, those around the large roundel with a star composition in the cavity are in dialogue with the astronomical evocations. The lanceolate rosettes with copper centres recall the many rosettes on the candlestick with ducks (cat. no. 3) which are probably allusions to the sun (fig. 58a). The Solomon's knots above the cartouches and the Solomon's seal formed by a six-pointed star in the geometric interlaces of the central roundel are also linked to these cos-

58a

58b

mogonic representations.[109] The use of copper and silver on the same motif evoke the two-coloured decorations of three other objects in the collection that, by virtue of their inlay materials, can be linked to Herat (cat. nos. 6, 7, 8). The chasing lines are very regular; the silver and copper wires are inlaid in double chased oblique lines. The copper wires are hammered flush with the substrate, while the small copper sheets are in slight relief and chased.

This object seems to form a pair with one acquired at the auction of the André Nègre collection (cat. no. 23). Despite a few differences, the dimensions and inlay design are very similar. Suns instead of moons are scattered along the rim and the cavetto of the object; the central roundel is larger, and the inscribed cartouches on the interior are rectangular rather than curved. The same two-coloured treatment of the copper and silver is visible in the inlay of both objects. However, the alloy, the weight and the tool marks of the two trays are diffe-

rent, as well as the sequence of application of the inlay and chasing which was carried out after the inlay on the second object (cat. no. 23). Furthermore, this tray here proposed as originating from Ghazna due to the impurities of the copper (see above, 174), does not have the same hammering traces. In addition, the tools used for the chasing and the champlevé are, according to the measurements of the traces on both objects, thinner in the example attributed to Herat. Nevertheless, a rectangular-headed punch of the same dimension was used on both objects. Here, it is the analyses of the materials and the study of the tool traces that has led to a distinction being made between the two objects, whose type and decoration are otherwise very similar. It seems possible that the two major centres of Herat and Ghazna manufactured similar objects inlaid with precious metals.

Notes

1. Szuppe, 2003A and 2003B; Paul, 2000 and 2003.

2. Franke and Müller-Wiener, eds., 2016; Franke and Urban, eds., 2017.

3. See al-Qazwini (d. 1283) cited by Contadini, 2017, 439. Herat was also known for its production of iron for the forging of weapons in India and Punjab as mentioned by al-Biruni in the eleventh century, 1989, 216, 218.

4. Melikian-Chirvani, 1986A, 75.

5. See above 44–47..

6. Saint Petersburg, Hermitage Museum, ИР-166, cast copper alloy, inlaid with silver and copper; H. 18.8 cm; D. 21.5 cm; modern gilding and repairs; on the rim, a word meaning 'merchant' *li-tajir*, but it may be a later ownership mark; see Loukonine and Ivanov, 1995, no. 126, 144–45.

7. Tbilisi, Museum of History of Georgia, MC 135; hammered and repoussé, inlaid with silver and copper, H. 38 cm; the base is later than the object and traces of old repairs are visible on the neck, Loukonine and Ivanov, 1995, no. 117, 136–37.

8. Carboni, 1997.

9. Al-Sufi, 1874, 40.

10. The oldest preserved manuscripts are located in Oxford, at the Bodleian Library. See a copy made in Mosul, north Iraq, dated 566/1170, MS Huntington 212, accessible online https://digital.bodleian.ox.ac.uk.

11. See Grohmann, 1958 on animated script.

12. Blair, 2014, 57–111.

13. Melikian-Chirvani, 1975A, 52.

14. Melikian-Chirvani, 1975A, 61–69, the shield boss or lamp base, and flasks are missing and do not appear in the catalogue of the Herat Museum published by Franke and Müller-Wiener, eds, 2016.

15. In the collection of the Herat Museum, a shield boss, close to the one in the DAI (see above, 70, fig. 9) is interpreted as a lamp base. The complete jugs have lids, see Franke and Müller-Wiener, eds., 2016, 136–37.

16. Melikian-Chirvani, 1976; including cat. no. 11 in this volume and a candlestick in the al-Sabah collection, Kuwait, LNS 81M.

17. Stuttgart, 2010, 312–13; reviewed by Viola Allegranzi in 2016.

18. Melikian-Chirvani, 1979. Another decorator/inlayer for whom we have three signed works is Hasan Ba Sahl, also discussed by Melikian-Chirvani in the article.

19. Washington, D.C., Freer Gallery of Art, Herzfeld collection, F1936.7, bought in Bukhara, Uzbekistan, Herzfeld, 1936; Atil, Chase and Jett, 1985, 107–10; Allan and Kanaʾan, 2017, 466–68. The pen box names Madj al-Mulk al-Muzaffar, *ṣadr* (principal) and *nizam* (order) of Khurasan, probably the ṣadr of ʿAla al-Din Muhammd Khwarazm Shah, who was posted in Merv; cast brass (copper 69.6%, zinc, 13.3%, lead 15.2%, tin 1.4%) inlaid with silver and copper (L. 31 cm; H. 5 cm); on the lid, the signature in foliated and animated Kufic reads *ʿamal Shazi al-naqqash*.

20. The head that formed the lid, and perhaps the application stick, are missing.

21. Melikian-Chirvani, 1979, 224.

22. Melikian-Chirvani, 1974B, pl. IX, fig. 9 and Melikian-Chirvani, 1982A, 70, fig. 40.

23. Melikian-Chirvani, 1982A, 70; Falk, ed., 1985, no. 265, 258–59.

24. Melikian-Chirvani, 1971, no. 131, 97; reviewed by Viola Allegranzi in 2016.

25. See above, 21..The candlestick appears at the beginning of *The Thousand and One Nights*, in one of Léon Carré's illustrations for Henri Piazza's edition of Joseph-Charles Mardrus' translation, published in twelve volumes between 1926 and 1932. Carré shows the candlestick in volume 1, before the first story told by Sheherazade to King Shahriyar. He adds a tall candle and does not give a precise representation. The picture does, however, illustrate the use of the object and the fact that it was well known to orientalists and collectors.

26. Migeon, Van Berchem and Huart, 1903, no. 72, 17.

27. Migeon, 1909.

28. I owe many thanks to Patrick Donabedian, who, with the help of Agnès Ouzounian and Dickran Kouymjian, completed in 2014 the reading of the inscription, the transcription, the translation and the interpretation.

29. The realisation of this object was recognised as an incredible feat both by contemporary coppersmiths and other metalworkers, as well as by the archaeometallurgists who studied it. For the technical observations, and the hammering processes used to shape the candlestick, see above, 68–71..

30. al-Sufi, 1874, 215–17.

31. For the symbolic meanings of birds, and their link to the heavens, see above, 215 and cat. nos. 42, 43.

32. Atil, Chase and Jett, 1985, 95–101.

33. Kuwait, Dar Al-Athar al-Islamiyya, Al-Sabah Collection, Jenkins, ed., 1983, 71.

34. Pope, 1939, vol. IX/1, pl. 1321; O'Kane et al, 2012, 222.

35. Canby et al, 2016, cat. no. 142, 227–28; Atil, ed., 1990, no. 39, 138–39.

36. Melikian-Chirvani, 1976, 210–11, Paris, 1976, lot. 71.

37. Saint Petersburg, Hermitage Museum, Pope, 1935, 63.

38. Former collection Friedrich Sarre, Berlin, Sarre, 1906, 10–11. The ewer is missing a handle and base, which, however, completed the object exhibited in Munich in 1910, see Sarre and Martin, eds., 1912, pl. 141, cat. no. 3045; Berlin, Museum für Islamische Kunst, I.3567 http://www.smb-digital.de/eMuseumPlus?service=Externalinterface&module=collection&objectID=1910845&viewType=detailView

39. Flood, 2009, 170.

40. Giunta and Bresc, 2004.

41. See Forkl et al, 1993, pl. 83; for the inscription see http://hdl.library.upenn.edu/1017/d/fisher/n2005051257.

42. Melikian-Chirvani, 1971, no. 130, 96–97; reviewed by V. Allegranzi in 2016.

43. The moon is represented by a woman holding a joined crescent moon in paintings in manuscripts of the same period. See the double frontispiece of

the *Kitab al-Diryaq* (Book of Antidotes), Pseudo-Galen, dated 1198–99, Paris, Bibliothèque nationale de France, arabe 2964, Menghini and Contin, eds., 2009.

44 See above, cat. no. 10.

45 On this theme, see also 44–47 in this volume.

46 Tbilisi, Georgia History Museum, MC135. See above, 110.

47 See the poem on the Tbilisi ewer, Loukonine and Ivanov, 1995, 136–37.

48 Beyhaqi, 2011, vol. 1, LVX, vol. 3, 72–73, note 303.

49 Bernardini, in Curatola ed., 1993, 236–37.

50 Modena, Galleria Estense, 6921, H: 44.8 cm; Curatola, ed., 1993, no. 125, 234–37; Canby et al, 2016, no. 73, 143.

51 London, British Museum, 1848,0805; studied by Susan La Niece whom I thank warmly for sending X-ray and microscope observation images, and whose material analyses are published in Craddock et al, 1998, Table 2, 90.

52 Hartner, 1938, fig. 1.

53 See London, 2011B, lot 24.

54 Group Λ, see above, 67.

55 Group C, see above, 67.

56 London, British Museum 1939-6-20,1, see Craddock et al, 1998, table 3, 99.

57 Melikian-Chirvani, 1986A.

58 Barthold, 1928, 229, completed by Taragan, 2005, 39.

59 Melikian-Chirvani, 1986A, 72.

60 Beyhaqi, 2011, vol. 1, 57, and references.

61 See Simjūr for a *davātdār* named in the governorate of Sistan, at the beginning of the tenth century, in Bosworth, 2011C, 56.

62 Laviola, 2017A. The inkwell in Rome has been analysed, see the table in Laviola, 2017A, 120.

63 See Graves, 2018A, 106–40, with references. An inkwell of the same type, analysed at the Getty Museum, has shown that the cast alloy was composed of copper 65%, zinc 20%, lead 10% and tin 5%, Scott 1991, 87.

64 Melikian-Chirvani, 1986A, 74.

65 Baer, 1972, 199.

66 Baltimore, Walters Art Gallery, 54-514. Melikian-Chirvani, 1986A, 75.

67 Taragan, 2005.

68 Toronto, Royal Ontario Museum, 972.10. Taragan, 2005, 31, 34.

69 Tel Aviv, Eretz Israel Museum, MHM 193.

70 Taragan 2005, 31–32.

71 London, V&A, 1175-1903, Melikian-Chirvani, 1982A, 124–25.

72 Unpublished; reading and translation by V. Allegranzi in 2016.

73 Copenhagen, David Collection, 32/1970; H. 9.5 cm; D. 7.5 cm, Falk, ed., 1985, no. 183, 172; von Folsach, 2001, no. 481.

74 Graves 2018A, 130–31.

75 Identified by Graves, 2018A, 136.

76 Read by C. Naffah; reviewed by V. Allegranzi in 2016.

77 See above, 22..

78 Allan, 1986A, 126.

79 Tehran, Golestan Museum, Pope, 1939, vol. IX/1, pl. 1345B.

80 New York, MMA, 54.64 and 33.96.

81 Melikian-Chirvani, 1971, 96, reviewed by V. Allegranzi in 2016.

82 Sarre and Martin, eds., 1912, pl. 151, cat. 3036; Paris, 1965, lot. 111.

83 Bosworth, 1998.

84 Melikian-Chirvani, 1971, 97.

85 New York, MMA, 54.64, H. 15.2 cm. For a recent publication of the inscriptions and the production of the object, see Contadini 2017, 434.

86 New York, MMA, 33.96, H. 18.4 cm, Dimand, 1934; Dimand 1945, 91.

87 The inscriptions were read by Melikian-Chirvani, 1971, no. 129, 96.

88 The material was identified with X-Ray Fluorescence Spectrometry (XRF). I warmly thank Thomas Calligaro, C2RMF, who completed this examination in 2015.

89 Read by Viola Allegranzi in 2016.

90 See also the page in the *De Materia Medica* of Dioscorides, 621/1224, Dallas Museum of Art, Keir Collection, K.1.2014.2.

91 Group C.

92 Reviewed and translated by V. Allegranzi in 2016.

93 Vitry et al, 1922, no. 19; Migeon, 1922, no. 22, 75, pl. 27; reproduced in Pope, 1939, vol. IX/1, pl. 1315A

94 The surface corrosion type is similar to the candlestick with ducks (cat. no. 3).

95 Hartner, 1938; Azarpay, 1978.

96 I warmly thank Melanie Gibson who alerted me to the existence of this object and the study of its inscription, in Spink et al, 2020, 332–33. It was probably one of a pair of trays, formerly in the Mahboubian collection, on which the name of the governor was identified by James Allan (personal communication with Barry Flood).

97 Canby et al, 2016, no. 44, 116.

98 New York, MMA, 56.144. The famous collection belonging to the godfather of Marcel Proust was dispersed at different auctions (Paris, 1952). The tray (lot. 51, pl. III) was described as a bezel and was attributed to Mosul, thirteenth century. It was sold to the Metropolitan Museum of Art in 1956.

99 Oxford, Ashmolean Museum, EA1974.9.

100 See Canby et al, 2016, 116.

101 Melikian-Chirvani, 1982A, nos. 28–29, 99–100.

102 Melikian-Chirvani, 1976, 206, published the inscription of the tray shortly after its appearance on the art market. For objects from the André Nègre collection, see also cat. nos. 23, 39, 62.

103 Melikian-Chirvani, 1975A, 51.

104 Tokyo, 2008, no. 144, 65 and 90.

105 Melikian-Chirvani, 1975A, 54–61.

106 Saint Petersburg, Hermitage Museum; see Allan, 1986B, 57; Melikian-Chirvani, 1982B, 161–63.

107 Nasser D. Khalili Collection, MTW 136. I am grateful to Melanie Gibson for having shared the most recent publication of these objects, Gibson, 2022, 350–63.

108 Melikian-Chirvani, 1976; reviewed by V. Allegranzi in 2016.

109 Milstein, ed, 1994.

CHAPTER 4

Production in Ghazna and Khurasan

PRODUCTION IN GHAZNA

The metal culture of Ghazna is well known relative to that of other capitals in the medieval Iranian world. Due to the disappearance and destruction of objects from the early 1980s onwards, this knowledge is now largely based on the IsMEO photographic archive, compiled between the 1950s and 1970s, and on research carried out within the framework of the Islamic Ghazni project, begun in 2004.[1] Based on these archives, the PhD thesis by Valentina Laviola has brought to light a series of previously unknown objects and has contributed greatly to our knowledge of the types present in Ghazna, and more widely in Afghanistan.[2]

The largest number of archaeologically documented metalwork objects from the pre-Mongol Iranian world were found in Ghazna, in Nishapur, and in Herat and its region. Unlike Herat, Ghazna is not mentioned in the sources as a centre of inlaid metalwork production. However, in the eleventh century Beyhaqi, in the context of the new palace of Ghazna, describes vessels and utensils for feasts and wine banquets, a throne, a crown made of precious metal and brass statues made by the goldsmiths and gilders of Ghazna in the city's citadel between 1035 and 1037.[3]

Few historical texts mention Ghazna before it became the capital of the Ghaznavids during the eleventh and twelfth centuries. A royal residence, Ghazna was at that time the cultural centre of the eastern Islamic world.[4] Lying between Khurasan and India, the city is located in the Zabulistan region of southeastern Afghanistan.[5] Ghazna was rarely mentioned in the Arabic sources from the seventh to tenth centuries, except in the Samanid and Saffarid periods of the ninth to tenth centuries.[6] For ibn Hawqal, writing at the end of the tenth century, Ghazna was in Sistan, but in his chapter on Khurasan he refers to the city as belonging to the district of Bamiyan, then in the province of Balkh.[7] Even before it became the capital of the Ghaznavids, the city was the heart of their empire and the starting point for lucrative expeditions to Sindh and India,[8] an important commercial node linking Iran and Central Asia to the Indian subcontinent. Ibn Hawqal specifies that it served as a commercial warehouse for the Hindus.[9] This nexus of routes linking the Iranian and Indian worlds reached its peak in the eleventh and twelfth centuries, when it became the prosperous summer capital of the Ghaznavids, located at the heart of a road network serving Khurasan, Central Asia, Sistan and the Indian subcontinent.[10]

According to Gardizi, the *shahrestan*, or heart of the city of Ghazna, was destroyed by Ya'qub ibn al-Layth Saffari around 256/870 and was rebuilt with the citadel by his brother, Amr ibn

al-Layth.[11] Al-Muqaddasi describes the city at the end of the tenth century, built according to a model that was characteristic of the Iranian world, with a citadel housing a palace, a fortified city where the markets were located and a suburb that also included markets.[12] The urban organisation described by Beyhaqi suggests that it was an extensive city at the beginning of the eleventh century. In his chronicle of the year 421/1030, he mentions the burial of Sultan Mahmud in the *Bagh-i Piruzi* garden in Ghazna, and also the citadel of the city several times. In the reign of Mas'ud I (1031–41), the new palatial complex as well as the fortress were mentioned by Beyhaqi from 422/1031. The gardens of Ghazna are described as locations for wine banquets and places for festivities and encampments.[13] Gardizi also describes the bazaars being decorated for the sultan's arrival, the troops based in Ghazna, and in 427/1035–36, the completion of a new palace for which a golden throne was created, inlaid with jewels and surmounted by a golden crown and precious stones.[14] This prosperity was largely due to booty brought from India and Sind, much of it from temple lootings.[15] The Ghaznavid treasury that was so amply supplied by these expeditions was kept in Ghazna which had the status of a capital and royal residence.[16]

During the second half of the eleventh century, when the capitals in Khurasan became part of the Saljuq territories, Ghaznavid centres of power moved eastwards to the Indian world. Ghazna retained its status, but Lahore in the Punjab emerged as the other capital of a reduced empire. Lahore was the last city to remain in Ghaznavid hands, until 1186.[17] Juzjani describes a fire caused by lightning strikes that destroyed the city's bazaars during the reign of Sultan Arslan Shah (1115–1118).[18] Ghazna was sacked by the Saljuq army of Sultan Sanjar in 510/1117 when he took a large part of the treasure, including precious stones, thrones, crowns and hundreds of gold and silver vessels. The city was once again occupied by the Saljuqs in 530/1135–36 and was finally devastated in 1150 by the Ghurid emir 'Ala al-Din Husain, 'the arsonist of the world'. It would not properly recover from this destruction.[19] Although never regaining its former splendour, Ghazna became one of the centres of Ghurid power during the reign of Mu'izz al-Din Muhammad (1173–1206), the ruler who probably occupied and renovated the Ghaznavid palace excavated by the IsMEO.[20] Along with Bamiyan and Firuz-Koh, Ghazna was one of the Ghurid capitals and the seat of an important garrison. After a brief period in the hands of the Khwarazm Shahs, Ghazna was destroyed by the Mongol armies in 618/1221, and according to Juzjani remained under Mongol stewardship until 639/1241.[21]

Objects Discovered at the Site

The first archaeological excavations in Ghazna were conducted under the direction of the French Archaeological Delegation in Afghanistan (DAFA) from 1920 to 1930. It was during the missions of Joseph Hackin that the first pre-Mongol metal objects, now preserved in the Louvre, were found there. However, it was the IsMEO missions that launched extensive excavations from 1956, particularly in the Ghaznavid architectural complex of Mas'ud III, later published by Alessio Bombaci in 1966.[22] The palatial structures, and more broadly the city of Ghazna, yielded an abundance of architectural, ceramic and metallic material from the Ghaznavid and Ghurid periods. The precise context of their discovery is generally unknown and the only information available is that the objects were discovered or bought in Ghazna. Some are more precisely documented as coming from the palace of Mas'ud III, excavated from 1957 by the IsMEO. These include two inkwells, part of a lampstand, a handle with an ornithomorphic thumb rest, miniature vessels and a fragment of a spoon. The fortuitous discovery of a hundred or so buckets, uncovered during work at the foot of the Ghazna citadel, and of which sixteen were transferred to the Kabul Museum, has also enabled the recent study of those that were preserved.[23]

The DAI holds a small group of four objects, both with inlay and without, that were discovered in Ghazna by Joseph Hackin in the early 1930s and were donated to the Louvre in 1934.[24] These objects include an inkwell lid inlaid with silver and red copper (cat. no. 12), a plate with chased decoration from a set of scales (cat. no. 13), a small plate of cast brass (cat. no. 14) and a rectangular tabletop or tray in hammered and chased brass (cat. no. 15). It is possible to postulate that these objects were made in Ghazna, given the numerous comparable examples that were found there which have largely permitted the definition of a metal culture in the Ghaznavid, then Ghurid capital, from 1150.[25] Materials analysis corroborated this hypothesis for the cast objects, which also indicated an attribution to Ghazna for the production of other objects in the collection.

12
Inkwell lid with figures

Afghanistan, Ghazna, late twelfth to early thirteenth century

Cast high leaded brass, chased and champlevé decoration, inlaid with black material, silver and copper

H. 4.7 cm; D. 8.1 cm; Thickness 3–3.4 mm; Weight 0.260 kg

The lid is in good condition. One of the three suspension loops is missing; the two surviving loops may still have their original rivets and a broken copper fragment from the missing loop suggests that it was repaired before being lost. The yellow epidermis is slightly tarnished on the exterior and is covered with a very brown patina inside the dome of the lid. A small bump is visible on the edge as well as some irregularities and a superficial hole inside the rim. The inlay is only missing in a few places, particularly the stems of the letters on the exterior inscription and the copper wire on the outer rim of the lid at the base of the inscription. Overall, the black material is well conserved except on the vertical sides where it shows heavy traces of wear.

Joseph Hackin mission 1933, acquired 1934; inv. no. AA 65

INSCRIPTIONS[26]

On the exterior of the lid in a circular band: blessings in Arabic, *thuluth* script

العز و الاقبال و الدولة و السلامة و السعاد[ة] و الطاعة و العناية
و القناعة و البقا دائم لصاحبه

al-ʿizz wa al-iqbāl wa al-dawla wa al-salāma wa al-saʿād[a] wa al-ṭāʿa wa al-ʿināya wa al-qānāʿa wa al-baqā dāʾim li-ṣāḥibihi
glory, fortune, prosperity, wellbeing, felicit[y], obedience, solicitude, contentment and lasting long life to its owner.

On the interior of the lid, in a circular band divided into three cartouches with medallions: blessings in Arabic, Kufic script

باليمن و البركة و / الدولة و التا/مة و النصرة و

bi-l-yumn wa al-baraka wa / al-dawla wa al-tā/mma wa al-nuṣra wa /
with happiness, blessing / prosperity, pleni/tude, victory and /

This lid covered a now missing base: the whole formed an inkwell of the same type as two other DAI objects (cat. nos. 5, 6). Its superb quality is indicative of the original object, the base of which must also have been covered with silver decoration enhanced by copper wire. It is the only inlaid metal object brought back from Ghazna by Hackin, one of the few objects in the pre-Mongol collection to have been cast and inlaid with silver and copper, along with two ewers here attributed to Herat (cat. nos. 7, 8) and an inkwell base attributed to Ghazna (cat. no. 17). It was cast, as indicated by the thickness of the walls and the porosity of the material that is clearly visible in X-rays. Cast in one piece, the lid was probably made with direct lost wax casting, as suggested by the irregular inner surface which shows traces of the wax model. Traces of a joint made directly in the model between the flanged section and the flat side of the lid are visible. The object is heavy as the metal is thick and the knop is solid. The latter is marked by a circular hole at the centre, possibly the mark of a compass used in the model before casting, to ensure the circular shape and dimensions of the lid.

The decoration of the domed lid has six figures seated in the gadroons, with a copper and silver interlace marking the base. These are princes and dignitaries of high rank: they are wearing robes of honour with *tiraz* bands (embroidery on the sleeves) and fur hats known as *sharbush* which here symbolise the insignia of power (fig. 37). Some are holding cups, others possibly a mace, perhaps illustrating an audience. The flat surface of the lid has a beautiful inscription with tall letters on a foliate ground framed with a copper wire. The side is decorated with a frieze of dogs and hares pursuing each other towards the left and separated by the suspension handles (fig. 59). On the interior of the inkwell, the flat surface is decorated with three inscriptions in Kufic script against a floriated background, interspersed with three blank medallions and scrolling copper wire. The composition, the treatment of the decoration and its quality, like the figures on the dome and the content of the votive inscriptions, link the lid with one of the most beautiful inkwells, now in the Doha Museum of Islamic

Fig. 59

Side of the inkwell lid (cat. no. 12): detail of the animal frieze inlaid with chased silver and framed by copper wire; the background with a vegetal scroll is inlaid with black

Art.[27] Its formulas of blessings are similarly positioned to those of the DAI lid: in Kufic on the interior and in animated *naskh* on the exterior. On the base, two friezes of hares recall the animal chase on the Ghazna lid. The DAI lid with its gadroons framing the figures is also comparable to an inkwell of similar exceptional quality covered with silver sheet,[28] as well as one of the inkwells discovered in the palace of Ghazna.[29]

The inlays, which are very worn and flush with the substrate in certain parts of the decoration, are hammered in the areas of chasing and champlevé. Around them, the champlevé accentuates the relief of the coloured compositions. The silver inlays are narrower than the surrounding outline chasing, forming the tracing of the letters and the figures on the lid. These outlines were made after the inlays, as can be seen in the superimposition of chasing on the large silver inlays of the figures and the sectioning of the silver wires by the chasing of the letter outlines. Thus, it seems that the colour was applied to the object before the final drawing. The hammered silver sheets and wires colouring the heads, busts, arms and legs are set in grooves and a flat or champlevé base. They were probably made on the wax model, as shown by the asperities and the reliefs with rounded outlines which are without sharp edges (figs. 36b, 37). As described earlier in this book (see above, 91), this lid illustrates an inlay process that, on objects from the DAI collection, has only been identified on this lid, and on an inkwell base also linked to Ghazna (cat. no. 17). These inlay preparations were made on the wax model and transferred to the metal during casting. However, the outline chasings of the inlays are more likely to have been cold worked after the casting process and thus were probably made by the inlayer in order to complete a composition originally conceived on the wax model. The chasing on the sheets adds detail, such as the draping of the textiles, the bodies of the animals, the traits of the human faces and the animal snouts. The inlays of the animal friezes are in relief on the substrate; the inlays of small sheets are more in relief and thicker than the large sheets used for the figures. They also have different processes of preparation, especially in the cursive inscription: in striated champlevé, chased without champlevé, in relief in an inverted V-shape made with two chasings, and lastly with flat chasing.

13
Plate from a set of scales inscribed Mahmud ibn Uthman

Afghanistan, Ghazna, twelfth century

Hammered brass, chased and champlevé decoration, inlaid with black material

H. 6.5 cm; D. 23.4 cm; Thickness (edge) 1.8–2.5 mm; Thickness (wall) 0.5–0.7 mm; Weight 0.324 kg

The edge has small mechanical deformations. The epidermis is yellow and porous and has been treated with micro sandblasting and polishing that has homogenised the slightly granular surface marked with brown spots.[30]

Joseph Hackin mission, 1933, acquired 1934; inv. no. AA 64

INSCRIPTIONS[31]

On the inner edge: blessings in Arabic in *thuluth* script

العز و الاقبال و الدولة و السعادة و السلامة و الشفاعة و الشاكرة و الشكرة و الكرامة

و النعما و العاوا (العلواء ؟) و الراحة و الرحمة و الـ[...] و الناصر و القادرة و الـ

al-ʿizz wa al-iqbāl wa al-dawla wa al-saʿāda wa al-salāma wa al-šafāʿa wa al-šākira wa al-šukra wa al-karāma wa al-naʿmā wa al-ʿalwā ? wa al-nāṣir wa al-qādira wa al-

glory, fortune, prosperity, felicity, wellbeing, intercession, gratitude, thankfulness, consideration, grace, noble action(?) help, predestination, [illegible word], victory, strength and *alif-lam*

Ownership mark on the reverse: with fine chasing in a V-shape, possibly contemporary with the manufacture of the object

لصاحبه محمود بن عثمان

li-ṣāḥibihi Maḥmūd ibn ʿUṯman / To its owner Mahmud ibn Uthman

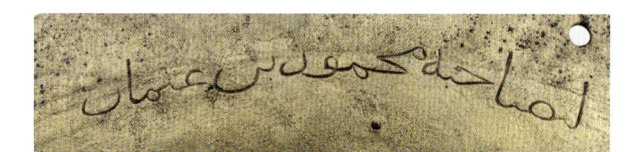

The second plate from this set of scales, with the same dimensions and decoration, was also found in Ghazna and is kept in the Kabul Museum where it was first documented by the IsMEO in 1958.[32] Three equidistant suspension holes and the axis of the decoration, as well as the flattened shape, allow us to interpret the function of these objects. The scale mechanism has disappeared, but the extant plates indicate that it was a beam scale, similar to the one depicted on the object in the astrological sign of Libra. The central post is shown with the beak and the neck of a bird: it supports a horizontal strut with two round trays hanging at the ends. This type of scale, of Roman origin, is preserved in the name of the astrological sign Libra,[33] and is represented in manuscript paintings produced in the medieval Middle East during the first half of the thirteenth century. A painting in the *Kitab al-Diryaq* (Book of Antidotes), Pseudo-Galen, copied in 1199, and another in the Arabic translation of *De Materia Medica* of Dioscorides copied in 1224, show such scales being used by apothecaries in the context of medicinal preparations. In the manuscripts of the *Maqamat* (Assemblies), such as the one made in Baghdad in 1237, two merchants are shown in the slave market stall, weighing products on a beam scale.[34]

The thickness of the hammered object is irregular, as shown under X-ray by the 'cloudy' aspect of the metal. The edge is slightly thicker towards the interior. The suspension holes do not show any trace of the metal having been pushed and seem to be contemporaneous with the shaping of the object: it was probably not a replacement for scales, but a plate designed as such. The decoration is organised in concentric circles: below the rim there is a band of cursive inscription, then a knotted ribbon forms twelve circular medallions, each housing a sign of the zodiac on a foliate background, like the inscription. The medallions were traced with a compass, as shown by the central holes which are sometimes visible. The chasing lines in the figural decoration are homogeneous and either rectangular or triangular in shape. The elliptical chasing is notched. A band of animals going towards the left frame the central medallion, where there is a sphinx, its face shown frontally, also moving to the left, emerging from a background of spiral scrolls, its tail curling to form an animal. Numerous residues of black material are clearly visible in the champlevé and chased decoration (fig. 31). This material was therefore largely intended to conceal the hollows of the decor with its rather rough and dry tracing.

From observation of the object under the microscope, it appears that the same hand traced all the decoration, and the inscription which is on three planes: the surface, the chased plane and the most recessed plane in champlevé. The process of making the inscription began with the chasing of the outline in two thicknesses, one much thinner and in a V-shape, the other thicker. This tracing is cut by the champlevé which is sometimes superimposed over the tracing of the letters.

14
Small tray or incense burner

Afghanistan, Ghazna, c. 1150–1220

Cast brass, chased and champlevé decoration

D. 19.8 cm; H. 3.7 cm; Thickness min. (wall) 3 mm; Thickness max (lip) 5 mm; Weight 0.770 kg

Chasing W. 0.75 mm

Covered with an artificial patina of a reddish-brown to greenish colour, the irregular surface has a heterogeneous aspect despite the addition of tinted microcrystalline wax. This object has been restored with treatment of the concretions and the thick and/or active corrosion. Stable areas of red corrosion are visible, and others where the epidermis has been worn by rubbing.

Joseph Hackin mission, 1933, acquired 1934; inv. no. AA 63

INSCRIPTION[35]

On the exterior: blessings in Arabic, floriated Kufic

البركة و الدولة / و السلامة ال(...) و الك(...) / ؟
و السعاد[ة] و سكة ؟ / و البقا له ؟ و الب و الك ؟

al-baraka wa al-dawla / wa al-salāma al-(...) wa al-k(...) ? / wa al-saʿād[a] wa b-b-k-a ? / wa al-baqā la-hu ? wa al-b wa al-k ? (...)
blessing, prosperity/, wellbeing(...), (...)/, felicit[y]/ long life to him(?), *al-ba, al-ka*(?)

This object does not have a flat rim, in contrast to other small circular and flat-bottomed dishes or incense burners of similar dimensions produced in the same period, of which many examples have been preserved (see for instance the one from Bamiyan, cat. no. 25). This example from Ghazna has a much narrower flat lip and is thus of a slightly different type which is not documented in material from the site.[36] Catalogued in 1976 by Allan who considered it to be an incense burner, the object is the only one listed with this very atypical shape,[37] and it does not appear that other examples have been published. Its manufacture is also atypical, as it is the only brass object in the DAI pre-Mongol collection which was cast; all the others were hammered. There are few clues to how the object was cast. The presence of a cavity in the interior and the exterior of the base is linked to the shaping, but might have also been used for the compass tracing of the concentric bands of the decoration. The latter is not easy to observe as it has been very abraded by rubbing. The decoration was cold worked with a rectangular-headed tool and probably with champlevé. On the wall, there are four cartouches inscribed in floriated Kufic interspersed with four medallions with birds. On the bottom, three very abraded inscribed cartouches alternate with three medallions with vegetal motifs.

15
Tabletop or tray with birds

Afghanistan, Ghazna, late twelfth to early thirteenth century

Hammered brass, chased and champlevé decoration, inlaid with black material

L. 29.5 cm; W. 18.2 cm; H. 2.2 cm; Thickness max. (edge) 1.4 mm; Thickness min. (wall) 1.2 mm; Weight 0.608 kg

Hammering marks (oblong, U-shaped section) 0.4 x 1.5 cm; (rounded, rectangular section) D. 0.8 cm[38]

Triangular chasing 0.6 x 1.9 mm

Champlevé W. 1.5 mm

The surface of the brown-green colour is corroded on the front and is largely covered with thick concretions on the back. The tray has tears, three holes and cracks. A repair or an older restoration with a metallic staple at the edge is visible on the back. The decoration is filled with dirt.

Joseph Hackin mission, 1933, acquired 1934; inv. no. AA 61

INSCRIPTIONS[39]

On the edge of the tray, a pseudo-inscription, or an abbreviated Arabic blessing in Kufic script, is divided into six cartouches separated by medallions; the six repeated inscriptions can be deciphered as

الكا و البر و ال(...)

al-kā wa al-birr wa al-(...) / [bénédic]tion et piété? et (...) / ...

[bless]ing and piety(?) and (...) / ...

This object is of medium quality but should be imagined with its original colours, the beautiful golden yellow of the brass contrasting with the black inlaid decoration. The tray is decorated with rather crude votive inscriptions and bird motifs (fig. 60) and was hammered with one oblong and one rounded tool. The decoration on three planes is both champlevé and chased. Two punches were identified, one making a large V-shape and the other a finer U-shape. The reliefs created form hollows which give a matte background into which the black material was inlaid.

The function or context of these 'trays', a very common type in pre-Mongol Khurasan, remains uncertain. The objects have been interpreted as tabletops that could be fitted to small pieces of furniture to serve foodstuffs.[40] If this was the case, the fragility and thinness of the hammered surface suggest the presence of a more solid support. No object of this type has been discovered within a wooden frame, and indeed no equivalent shape is known in modern furniture to confirm this interpretation of the shape.

The largest number of examples come from Ghazna: around twenty are documented in the archives of IsMEO. These objects, some discovered at that site and others of unknown provenance, are perhaps still conserved there and in Kabul. Five examples are also currently in Herat.[41] This type is also well documented in Central Asia. Three trays with repoussé decoration belong to the 'treasure of Kalaibaland' and a fourth was found in Penjikent (Tajikistan). Finally, some rare examples made in precious metals are in the Hermitage Museum: one in silver with niello and gold (?) is perhaps in the name of a Khwarazm Shah, and another also in silver with niello and gold with the name of a high dignitary from Khurasan.[42]

All these objects have similar dimensions (L. 30-35 cm), a wide flat rim and a recessed polygonal surface with right angles or curves. The decoration is either repoussé, chased or inlaid with silver and red copper. The decoration of this tray made in a fairly rough style with birds enclosed in a knotted medallion recurs in much of the metalwork of the pre-Mongol Iranian world, especially in the context of Ghazna,[43] as for instance on a bucket in the MAD collection (cat. no. 16).

60

Fig. 60

X-ray of a tabletop or tray (cat. no. 15): the thinness of the hammered brass sheet and the chased and champlevé decoration are clearly visible.

Metals Attributable to Ghazna

Material analysis has permitted some DAI objects without a documented provenance to be attributed to Ghazna. Made of cast copper alloy and hammered brass, they have inlays of precious metals or chased decoration. The production type and tool marks are in many cases similar to those of the objects discovered in Ghazna that were donated to the Louvre by Joseph Hackin. These were commercial pieces, of medium to very good quality, belonging to common types of pre-Mongol metalwork production. Similar examples were found on the site or were conserved in the Ghazna museums.[44]

The inkwell lid (cat. no. 12), the only inlaid object from Ghazna in the DAI with an archaeological provenance, is made of the same alloy as an unprovenanced bucket in the MAD collection (cat. no. 16). These two objects with identical alloys came from the same crucible (Appendix 6). The bucket is one of multiple examples of this type that has been identified as being from Ghazna. The impurities in the copper used to make the lid and the bucket are similar to those identified in the copper of an unprovenanced inkwell base (cat. no. 17) and demonstrate that these alloys originated from the same copper distribution circuit which, moreover, differed from the copper that was used for Herat objects.[45] Since other alloy compositions used in the manufacture of a wide variety of objects are similar to those of the lid and bucket (cat. nos. 12, 16), an attribution to Ghazna is here proposed for the two sprinklers (cat. nos. 18, 20), a lamp (cat. no. 21) and a mortar (cat. no. 22). The copper inlays of the sprinkler with red floral ornament (cat. no. 18) are similar to those on a ewer brought by Joseph Hackin from Afghanistan (cat. no. 24) so this object is also linked to the metalwork production of the city. Furthermore, the same copper as one used in alloys from Ghazna was also used for the lid inlay (cat. no. 12), the base of an inkwell (cat. no. 17) and a ewer (cat. no. 19). These objects are therefore probable evidence of inlay with precious metals on cast objects that were produced in Ghazna. Inlaid decoration on hammered brasses is attributable to Ghazna thanks to another object in the collection: a tray inlaid with the same copper (cat. no. 23) as objects known to be from this centre. Some pieces may have been made with elements that can be identified with raw materials supplied to Ghazna but were inlaid in Herat. This is perhaps the case of an inkwell (cat. no. 6), which, on the basis of its inlaid decoration, is discussed with other objects from Herat.

16
Bucket with a votive inscription

Afghanistan, Ghazna, late twelfth to early thirteenth century

Cast high leaded brass, chased decoration

H. 15.5 cm; D. max. 17.3 cm; Thickness min. (wall): 0.6 mm;
Thickness max. (lip): 8 mm; Weight 0.951 kg

This object is fragmentary: a trace of solder on the base suggests that
there may have been a foot that has now disappeared; the handle is
also missing. Several holes and tears have altered the sides and some
have traces of earlier tin solder repairs. The bucket is entirely covered
by an artificial patina of a blackish colour. Areas of red and green stable
corrosion are visible on the exterior and the interior.

On long-term loan from the Musée des Arts Décoratifs; gift,
Jean Linzeler, 1928; inv. no. AD 26749

INSCRIPTIONS

Circular band below the rim: blessings in Arabic, *naskh* script

باليمن و البركة و الدولة و السلامة و السعادة و ا لصاحبه

*bi-l-yumn wa al-baraka wa al-dawla wa al-salāma wa al-saʿâda wa alif
li-ṣāḥibihi*

with happiness, blessing, prosperity, wellbeing, felicity, *alif* to its owner

61

Fig. 61

Bucket (cat. no. 16): detail
of a vegetal motif, the
domed dot punch creating
a matte ground and
chasing with a rectangular
punch.

Fig. 62

Bucket (cat. no. 16): bird
medallion on the body.

62

This bucket is one the few metalwork objects from the
pre-Mongol Iranian world to have been acquired by the
MAD. Unpublished before Melikian-Chirvani transcribed and
translated the cursive inscriptions, giving an indication of
its high quality (fig. 4),[46] it has not been the object of a new
study for over fifty years. It is perhaps one of the first metal
objects from Ghazna to have entered a French collection. Jean
Linzeler, who donated two objects to the MAD in 1928, was not
known as a collector of 'Persian art', as it was known at that
time.[47] However, he belonged to a family of famous Parisian
goldsmiths and jewellers, and in the 1920s his brother Robert
Linzeler created small boxes inspired by Persian miniatures.[48]

Analysis of the alloy has shown that it is identical to one
of the inkwell lids (cat. no. 12). These two objects were cer-
tainly made during the same casting session using the lost wax
method. They suggest that diverse objects could be produced
in the same casting workshop at the same time. The centre of
the bottom has a protuberance that could have been where a
sprue was located. The missing foot would have been attached
with tin solder and was thus made separately, like the missing
handle. The thick patina that covers the object obscures the
chased decoration: traces made by a domed dot punch and
a rectangular-headed punch are nevertheless visible (fig. 61).
The wide band below the rim has a votive inscription address-
ing an anonymous owner; it is on a foliate background that
contrasts with the punch-dotted ground (fig. 62). The largely
undecorated sides are adorned with four birds in circular and
almond-shaped medallions in a design that resembles one
chased on the hammered brass tabletop or tray from Ghazna
(cat. no. 15). The ground is decorated with punch-dotting and
foliage (fig. 62).

Many buckets of a similar type were discovered at the site.
These objects, probably produced in Ghazna on the evidence
of a group that was fortuitously discovered at the base of the
citadel but has now largely disappeared, show some variations
but have broadly similar dimensions (approx. H. 15 cm, D. 17
cm).[49] One is very close to the example in the MAD but has
three small feet. The handles, the rim and the rounded profile
of the exterior are all close, and so is the treatment and com-
position of the chased surface. A wide band below the rim
has a fluid cursive inscription with blessings in Arabic. The
centre is decorated with an animal frieze, and the bottom of
the sides with a pseudo-inscription or abbreviated blessings.[50]
Three more similar buckets in this group, but retaining a foot
and silver inlay, have several votive inscriptions in Arabic,
including four with the same sequence as those identified on
the MAD bucket.[51]

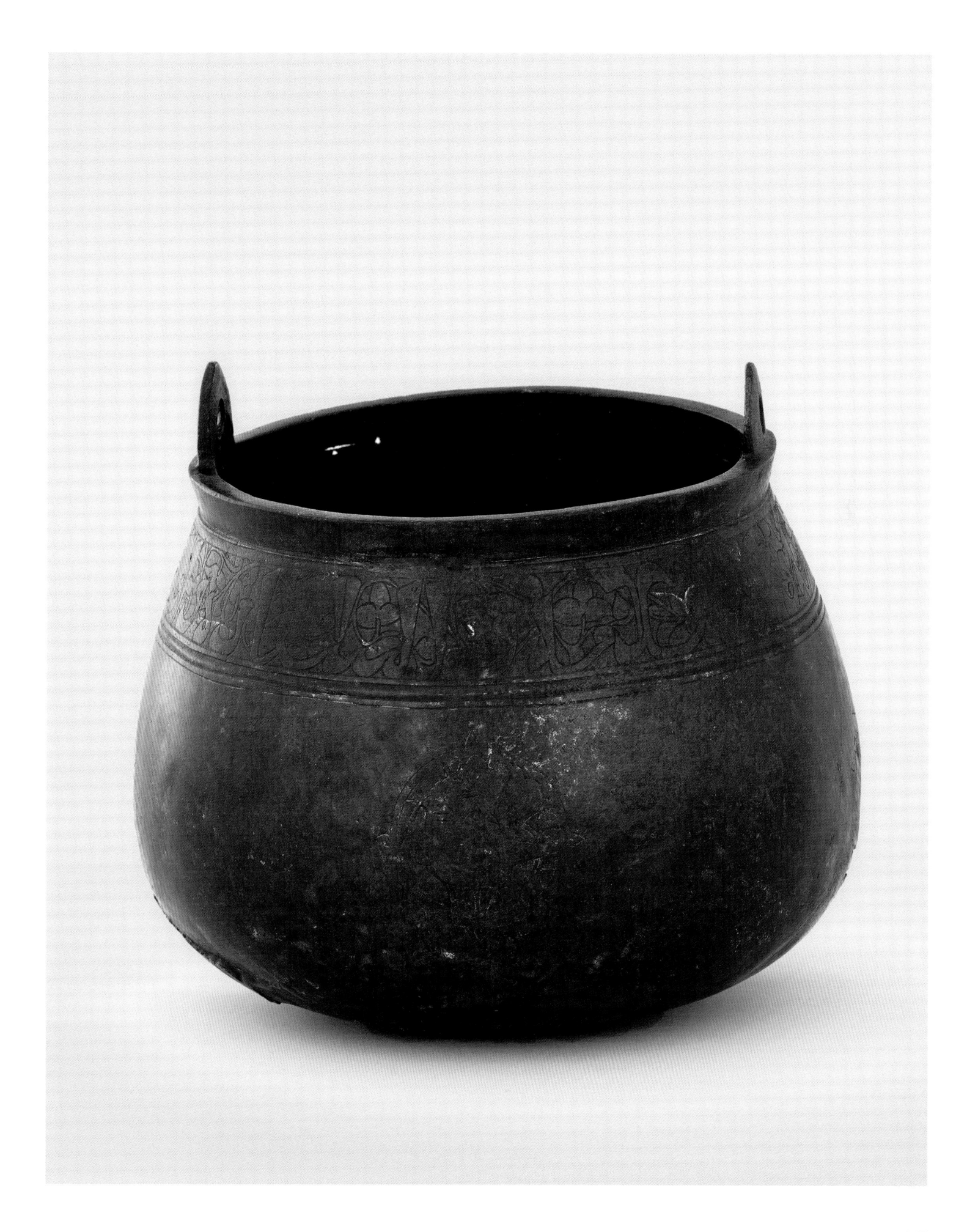

17
Inkwell base with scenes of a banquet

Afghanistan, Ghazna, late twelfth to early thirteenth century

Cast high leaded brass, chased and champlevé decoration, inlaid with silver, copper and black material

D. base 8.2 cm; H. 6.1 cm; Thickness 1.7–3 mm; Weight 0.360 kg

The lid is missing, as well as the suspension rings on the base. The interior is of a very black-brown colour, with a granular surface. The object is covered with a brown patina and areas of red and green corrosion. The base has been cleaned, revealing a golden substrate. The inlays are well preserved.

Gift, Mr and Mrs Nicolas Landau, 1977; inv. no. MAO 605

INSCRIPTION[52]

In the central register: blessings in Arabic, *thuluth* script

العز و الاقبال و الد؟/ لدولة و السلامة / و السعاد[ة] و العناية (sic) ؟

al-ʿizz wa al-iqbāl wa al- d/ l-dawla wa al-salāma / wa al-saʿād[a] wa al-ʿināya (sic)?

glory, fortune, (...) / prosperity, wellbein g/, felicit[y] and solicitude (sic) (?) /

The inlaid decoration, arranged in three superimposed registers, has two bands with banquet scenes framing a votive inscription. In the two friezes, seated drinkers are shown gesticulating or declaiming with wide arm gestures, probably a depiction of the festive consumption of wine. This theme is recurrent in medieval Persian texts, both historical and poetic, that evoke wine ceremonies linked to the court or to learned circles of the tenth and eleventh centuries,[53] and frequently also found on objects. This *bazm* theme can be considered the visual counterpart of the blessings expressed in the elegant central band of epigraphy. In the light of its distinctive decorative scheme, it might also allude to the career of a cupbearer who has become a dignitary.[54] The ground of the inscription is decorated with scrolling foliage. Knots are inlaid on either side of the missing suspension rings. The inlays are applied with silver wires and sheets but the framing lines are made with copper wires.

The opening and the top of the inkwell are irregular and not flat, probably the result of a casting defect. The inlaid decoration has the same characteristics and treatment as an inkwell lid from Ghazna (cat. no. 12). First conceived on the wax model and then transposed onto the metal, the spatial inlay preparations are in champlevé and have the same characteristics as those of the Ghazna inkwell lid (fig. 36a). These preparations are very different, particularly in the case of the spatial inlays,

63a

63b

Fig. 63

Inkwell base with scenes of a banquet (cat. no. 17): a) seated figure being offered a cup b) details of the inscription in *thuluth* script.

from those of the cast and hammered objects in the DAI collection that were cold worked. They have asperities and are in lower relief than was the case with cold worked chasing. The inlaid areas are placed within traced outlines that are much wider and leave a large portion of the decoration blank (fig. 63). The chasing of the outlines was probably cold worked and made by the inlayer and thus with the same process as the one observed for the making of the lid from Ghazna. Furthermore, the incisions in the sheet inlay detailing the figures have schematic contours in the treatment of the inlay and are perhaps characteristic of inlays on cast objects made in Ghazna. A very similar inkwell is currently in Berlin.[55] It is not, however, inlaid

with copper and musicians are shown beside the drinkers, music being inseparable from princely celebrations.[56] We find the same knots on the walls, inserted between the suspension rings and on the base. As on the Louvre inkwell, the evocation of banquet scenes on the exterior is suggested by the foliage between the feasting guests, which contrasts with the blank ground of the alloy. The votive inscription, like the one on the DAI, is placed on a ground of palmettes in a similar style.

18
Sprinkler with red floral ornament

Afghanistan, Ghazna, twelfth century

Cast high leaded brass, filed and chased decoration, inlaid with copper

H. 17.4 cm; D. max. 9.2 cm; Thickness max. 3.4 mm; Weight 0.554 kg

File (V-shaped section) W. 2 mm

Punch (rectangular, U-shaped base, straight profile) 0.6 x 1.2 mm

Punch for inlay (rectangular) 0.4–0.6 x 1.2 mm

Domed dot punch D. 0.7 mm

The much altered surface of the object has been rendered partially illegible by layers of red and green corrosion and areas that have probably been restored. The decoration, which was filed or chased, is encrusted with the residue of white concretions. The surface has also been altered by multiple scratches caused by an abrasive.

Donation Pantanella-Signorini, 2009; inv. no. MAO 2103

This type of rosewater sprinkler,[57] with a flared neck above an almost cylindrical body and a flat base, is attested to by two examples from Nishapur.[58] One of these, with a filter and an opening similar to the DAI example, is from Qanat Tepe. The ceramic types found in this part of the site, according to Wilkinson who excavated it in 1938, suggest that it was occupied until the twelfth century.[59] This dating is corroborated by a recent survey of the *shahrestan*, the lower city of Nishapur situated beside Qanat Tepe. The surface material found on the site suggests that it was no longer inhabited after c. 1170, but was used for the manufacture of ceramics and/or glass.[60] Furthermore, another sprinkler of the same type was signed by 'Abd al-Razzaq al-Nishapuri (from Nishapur),[61] and objects of the same shape made in glass might have been produced before those in copper alloy.[62] This type was also present elsewhere in the Middle East: datable examples from the eleventh century were discovered in Tiberias,[63] and another sprinkler in the DAI, similar to those from Tiberias, was found at Antinopolis in Egypt.[64] These sprinklers, like those from the Iranian world, were cast but with a different process: the base, formed from a disc, was soldered to the wall of the object and the neck, made in two parts, was also joined by soldering. In addition, they were made with lids attached by a hinge to the edge of the neck.

Given the difference in the appearance of the metal and of the decoration, it is not certain that the neck and the body were originally part of the same object. In addition, when compared to similar objects, the neck seems disproportionate to the body. The sprinkler is composed of four parts: the filter, the neck, the body and the cast disc of the base (fig. 65).[65] These four cast parts were joined by soldering. Examination by X-ray shows traces of a joint between the filter and the neck; along the length of the body there is a metal infiltration or a mould seam. Small casting defects are visible on the neck, marked by a puncture and a surface cavity caused by an air bubble.

The sprinkler has two recessed decorative planes. Those on the neck, like the filter, cannot be seen easily as they are encrusted with a white-green corrosion. It is possible that the decorative motifs were engraved. The copper wire inlay is flush with the surface (fig. 64); the wire is not very thick and has the appearance of sheet inlay. Areas where the inlay is missing indicate how it was prepared: the chasing has a vertical profile of the same type as the non-inlaid chasing made with the same rectangular-headed tool. Another tool that marked the surface more deeply in a V-shape was used for the geometric outlines of the body decoration, such as the frieze, the frames and the diamond pattern; this could have been a larger punch or a file. The ground was matte punched with a fine domed dot punch of similar dimensions to one used for the bucket (cat. no. 16).

64

Fig. 64

Sprinkler (cat. no. 18): copper inlay.

Fig. 65

X-ray of the sprinkler (cat. no. 18).

65

167

19

Ewer with moon ornament

Afghanistan, Ghazna, late twelfth century

Cast high leaded brass, chased, engraved and champlevé decoration, inlaid with copper

H. 15.4 cm; D. max. 8.5 cm; Thickness min. (foot)1 mm; Thickness max. (spout) 2 mm; Weight 0.318 kg

Rectangular chasing: 0.5 x 0.9 mm

Triangular chasing W. 0.6 mm

Engraving W. 0.4 mm

Champlevé W. 0.8–0.9 mm

Copper wire inlay W. 1.3 mm

The spout has a hole and the hinge attaching the lid appears to have been recently filed. The surface is entirely covered with a brownish substance similar to Judea bitumen that partially conceals concretions and green corrosion, as well as chased and inlaid decoration. The object has received some modern repairs, probably before its arrival on the art market. The neck has been reattached to the body with solder and mastic but is out of alignment: the back of the neck should be above the missing handle which is marked only by traces of solder. The edge of the foot has been broken and repaired, and the base has been roughly attached with solder.

Purchase, Galerie Jean Soustiel, Paris, 1990; inv. no. MAO 855

INSCRIPTION[66]

On the top part of the body: Arabic blessings in Kufic script in two cartouches

باليمن و البركة و الس[ر]/ور ؟ و السعاد[ة](...) و (...)ا ؟ لصاحبه

bi-l-yumn wa al-baraka wa al-s(...) / ūr [= al-surūr ?] wa al-saʿāda[a] (...) wa (...) alif ? li-ṣāḥibihi
with happiness, blessing, (...) / (...) [joy (?)], felicit[y] (...) and (...) *alif* (?) to his owner

This small ewer originally had a handle and a lid. Its manufacture is of lower quality, but it is of the same type as two objects attributed to Herat (cat. nos. 7, 8). Two other ewers of almost similar quality are in the Herat Museum.[67] According to the IsMEO archives, no ewer of this type was recorded by the Italian team from the Ghazna site.[68] These objects, a variant of the pear-shaped wine jug type from the same period (cat. nos. 60, 61), are, according to certain researchers, thought to be lamps, and indeed the spout and pedestal-like neck does resemble the shape of an oil lamp (cat. nos. 34, 39). But the analogy may instead refer to a connection between water and light—itself associated with the source of life—that was well known in the medieval Middle East and Iranian world and is a metaphor that can be found for lamps as well as drinking vessels.[69] This type of small ewer seems to aptly represent this analogy of form and meaning.

This ewer with a crescent moon can be attributed to Ghazna on the basis of analysis of its material, especially the copper impurities. The copper found in Ghazna alloys was used for the inlays of the lid found at the site (cat. no. 12) as well as on this ewer. Furthermore, the rough and sometimes imprecise chasing is reminiscent of the tabletop or tray from Ghazna (cat. no. 15); both objects have triangular chasing of the same width (0.6 mm). Shaped by lost wax casting, as suggested by the tool marks in the wax on the joint between the spout and the neck, it was realised in a very different way to ewers of the same type associated with Herat. The casting was not made in one piece: three or even four parts were assembled in wax—the spout, the neck and perhaps the foot—and the junction between the neck and the body was soldered, probably having been cast separately and badly reassembled much later.

The sides of the spout have a champlevé vegetal frieze with fine engraving identifiable by V-shaped sections and shallow, tapering ends (fig. 66) that recall the treatment of a wine jug spout (cat. no. 61); the petals on the neck and the foot are also reminiscent of this object as well as a second one of the same type (cat. no. 60) The traces of matte punching and square chasing on the spout are also found on both of these objects. The bull heads and the facets of the necks are punched in stripes or squares, an effect that is perhaps more closely linked to the work of the caster than that of the chaser.

On the upper part of the body, the votive Arabic inscription in Kufic script is chased in two cartouches; below them there are four cartouches containing animals moving two by two towards the moon that occupies the front of the ewer. On the opposite side, the missing handle was placed inside an arch. Two vases with engraved and chased floral bouquets complete this composition. The inlays are at the base of the neck, set with a copper wire, and in the representation of the moon, highlighted by a large, curved copper sheet (fig. 67). The inlaid areas cover the surface poorly and stand out against the golden background of the alloy: this characteristic is found on other pre-Mongol metalwork objects, particularly on a ewer which is here attributed to Ghazna production (cat. no. 24). The copper inlays are very fine and comparable to those observed on the sprinkler with red floral ornament (cat. no. 18). The decoration of the body, particularly the chasing of the bird, is close to the chased motifs on the tray and the bucket from Ghazna (cat. nos. 15, 16).

66

67a

67b

Fig. 66

Ewer with moon ornament
(cat. no. 19): engraved
decoration and champlevé
on the spout.

Fig. 67

Copper inlay on the ewer
with moon ornament (cat.
no. 19) a) representation
of the moon on the body
b) wire marking the base
of the neck.

20
Sprinkler with lotuses and medallions

68a

68b

Afghanistan, Ghazna, twelfth century

Cast leaded brass, chased and champlevé decoration, inlaid with black material

H. 14.7 cm; D. max. 8.8 cm; D. (opening) 3 cm; Thickness (rim) 1 mm; D. (boss on the neck) 8.6 mm; Thickness (base) 0.5 x 1.5 mm; Weight 0.250 kg

The surface is entirely covered with a brown patina that is probably artificial and recent. The object seems to have been rubbed and then a patina applied the subjacent epidermis of the yellow metal appears in some areas. The lower part of the body is altered by two holes and a mechanical deformation causing a cavity.

Purchase, Galerie Jean Soustiel, Paris, 1985; inv. no. MAO 761

Allan has identified objects of this type as bottles, and on the basis of their decoration has attributed them to twelfth century Khurasan.[70] According to him, the type with lotus buds in relief has existed since the tenth to eleventh centuries. The documented locations of comparable sprinklers with lotus buds are Ghazna, Takht-e Bazar in Turkmenistan and also Tal-i Zohak in the region of Fars.[71] According to Melikian-Chirvani, these provenances suggest that the objects were made in Khurasan workshops, as well as in other regions. This type of object, with a pear-shaped body, projecting bosses and lotuses, might have copied silver prototypes that were made in Tabaristan in the Sasanian period.[72] Allan suggests that forms derived from this model were still being produced in the ninth century.[73] The object was shaped by lost wax casting, as suggested by the tool marks in the wax visible on the lotus buds that were transposed onto the metal during the casting process. The thickness of the base is irregular, perhaps due to a defect in the model or the displacement of the mould core during casting. The object has no bottom, and the base has a sloping profile over which a metal sheet must have been folded by hammering in order to close it. The round opening has five projecting bosses above a faceted neck. On the body, fifteen lotus buds in relief are arranged in three rows in staggered groups of five. Medallions of different sizes (D. 0.86, 1.2, 1.5 cm) enclose confronted birds (?), confronted griffins (?) and addorsed goats or hares (fig. 68a). These medallions appear to have stamped decoration, but this is deceptive as they are slightly different and follow the curvature of the body. They have traces of chasing in a straight section with a flat surface and ground and champlevé areas. Remnants of black material are also visible.

Below the neck and above the foot, framing the whole composition of the body, are two chased friezes with an unread votive inscription in champlevé inlaid with black material and interspersed with medallions enclosing a crescent moon (fig. 68b). The association between representations of the moon and invocative formulas is recurrent on metalwork from the pre-Mongol Iranian world, as on two copper inlaid ewers also associated with Ghazna (cat. nos. 19, 24) and on a large, faceted basin from Afghanistan (cat. no. 35).

Fig. 68

Sprinkler with lotuses and medallions (cat. no. 20): a) goat-like animal in a medallion on the body b) detail of the inscription interspersed with crescent moons.

21
Lamp with the head of a feline

Afghanistan, Ghazna, twelfth century

Cast high leaded brass, chased and openwork decoration, inlaid with black material

L. 15 cm; W. max. 9.6 cm; H. (with lid) 7.5 cm; H. (without lid) 6.5 cm; D. (opening) 4 cm; Thickness min. 0.5 mm; max. 4 mm; Average thickness 2 mm; Weight 0.284 kg

Chasing W. 0.7 mm

The surface of the lamp is entirely covered with a brown patina. White concretions, probably the residue of cleaning products, are visible in the chasing grooves and in areas in relief. The object has holes, tears and dents on the spout and the container. A missing foot was attached to the base and traces of tin from a circular solder are visible. A square hole on the bottom suggests an old repair of the foot, or a double fastening system. The lid is made of a different alloy from the container,[74] and was probably not originally part of the lamp as it seems too small for the opening and the hinge connecting the two parts is missing. The sides of the interior of the object are covered with concretions.

Purchase, Galerie Jean Soustiel, Paris, 1990; inv. no. MAO 854

INSCRIPTION[75]

On the sides of the spout: repeated Arabic blessings in *thuluth* script

ا/ البركة ؟ و الد / ا[ل]البركة و ؟ الدولة / ا

[a]l-baraka ? wa al-da[wla] / [a]l-baraka wa ? al-dawla / alif

Blessing (?) and pros[perity] / blessing and (?) prosperity / *alif*

This lamp differs from another one with the head of a feline, acquired at the same time, which is pear-shaped and circular in cross-section and has a longer spout (cat. no. 40). Lamps of similar types were discovered in Afghanistan, some coming from Ghazna. Only two have openwork next to the spout and not around the opening.[76] This shape of lamp with a bulbous body and a long oblique spout is equally well documented in Central Asia. One, complete but with an imprecise archaeological provenance, sits on a high foot and is closed by a lid with a feline head and a palmette-shaped thumb rest.[77] Published lamps from sites in Khurasan and Central Asia are all devoid of openwork. They demonstrate the very wide diffusion of this type of object between Turkmenistan, Tajikistan (Shakhristan, Zolisard treasure) and in the southwest of Kazakhstan (Talgar).[78]

The shaping and execution of the decoration of this lamp are of medium quality. The thickness is irregular with the sides and spout thinner than the rim and the openwork. There are casting defects, in particular infiltrations in the mould joints or in the core that suggest the shaping was done by the indirect lost wax casting process with a bivalve mould.[79] The decoration of the looped openwork band below the rim of the lamp, as well as the inscription and the medallions with birds on the spout and the walls, were made by casting (fig. 23a). The lamp has two planes of decoration, moulded and chased. The birds and the vegetal composition on the flat part of the spout were cold worked by chasing, while the inscriptions were not chased. Remains of the black material inlay are clearly visible in the chasing and in the moulded composition.

Mortar with lotus buds

Afghanistan, Ghazna, twelfth century

Cast high leaded copper

Mortar: H. 14.5 cm; D. max. 15.5 cm; Thickness min. (rim): 1.45 cm; Weight 5.614 kg

Lotus buds: H. 2.75, 2.8, 2.95 cm; W. 1.95, 1.8 cm

The greenish brown surface of the mortar has been crudely made with bronze and green paint and is also partially covered with concretions. Tool marks, some of which appear to be modern, are visible on the surface.

Donation, Pantanella-Signorini, 2009; inv. no. MAO 2105

The two staggered rows of ten lotus buds in groups of five on the walls were modelled separately in wax, as suggested by the tool marks around their edges. These indicate the smoothing of the joints in the wax model, between the wall and the lotus buds, and thus a lost wax casting. Cavities caused by air bubbles on the wall and base, as well as defects in the model or in the mould imprint, are visible in the nearly erased frieze near the base. The bottom of the mortar is concave, which could indicate that the object was cast vertically, and its bulging shape may have been due to the pressure of the metal mass.

The decoration is very abraded and only partially visible. Like another mortar in the collection (cat. no. 76), it originally had repeated inscriptions below the edge, one of which is mirrored and thus reversed and a vegetal frieze at the base of the wall. The Arabic inscription in Kufic script repeats the word *al-mulk* (sovereignty) six times.[80] The inscription and the frieze seem to have been made in the casting and not by cold worked chasing. The condition of the object does not allow one to determine whether the palmettes attached to the lotus buds were moulded or cold worked. Likewise, the vegetal frieze at the base of the wall is not clearly visible because it is too worn.

A similar mortar has a possible mark of ownership with the name of al-Shaykh al-Faqih Abu al-Fadl Muhammad ibn Ishaq.[81] Seven mortars of the same type, including four with very similar decoration, are documented in museums in Afghanistan according to the archives of the IsMEO. One was found in Ghazna.[82] Two published examples come from Uzbekistan. One found in the site of Dashlyalang (Turkmenistan) is datable to the eleventh to twelfth centuries.[83]

Tabletop or tray with a rosette and inscriptions

Afghanistan, Ghazna, c. 1150–1220

Hammered brass, chased and champlevé decoration, inlaid with silver, copper and black material

L. 30.6 cm; W. 20.5 cm; H. 3.9 cm; Thickness 0.6–1.5 mm; Weight 0.499 kg

Hammering (oblong, U-shaped section) 0.4 x 1.5 cm

Champlevé W. 1 mm

Chasing: l. 0.4–0.6 mm

Chasing inlay (punch with rectangular head) silver wire 0.3 x 1 mm; copper wire 0.6 x 2 mm

Silver wire W. 0.4 mm

Copper wire W. 1 mm

Covered with a brown patina, the brass is nevertheless visible in parts of the decoration. One side is missing; a significant mechanical deformation marks its length. A crack has been restored on one side and the object has been consolidated with glued fabric.

Gift, André Nègre 1976; inv. no. MAO 499

INSCRIPTIONS[84]

Along the rim, votive formulas in Arabic, in *thuluth* script:

العز و الا/قبال و الد/ولة و ال / لسعادة / و النعمة / و العافية /
و الكرامة و ا / لرافعة و ا/لتمة و ا / لبقا لصاحبه

al-ʿizz wa al-i / qbāl wa al-da / wla wa al- / l-saʿāda / wa al-niʿma / wa al-ʿāfiya / wa al-karāma wa a / l-rāfiʿa wa a / l-tāmma wa a/l-baqā li-ṣāḥibihi / glory f/ortune, pro/sperity, / felicity/, wellbeing/, health/, consideration, / elevation, / plenitude and /longevity to its owner
On the recessed interior: two repetitions of a votive formula, in Arabic and in Kufic script

باليمن و البر(...) ؟ / باليمن و البر و

bi-l-yumn wa al-b-r-(...) / bi-l-yumn wa al-birr wa /
with happiness, b-r-(...) / with happiness, piety(?) and /

This object is very close to another tabletop or tray, here associated with Herat (cat. no. 11), acquired during a public auction;[85] both were originally from the collection of André Nègre, assembled in Afghanistan. Nevertheless, they have different archaeometallurgical characteristics and are linked to two distinct centres of production which suggests that this type of high-quality commercial product, of which many examples survive, was made in different centres in the medieval Iranian world.

The impurities in the copper inlay are the same as those contained in the copper used to make objects from Ghazna (cat. nos. 12, 17). Furthermore, the hammering marks observed on the object (fig. 7a) are similar to those measured on the tabletop or tray (cat. no. 15) also from the site. So, in addition to the use of the same material on one object serving as a reference point for Ghazna, can be added use of the same hammering tool on a second reference object from this centre. Finally, it is possible that this object has a characteristic specific to Ghazna in the application of the inlaid decoration. On the decorative background of the object, knots and floriated motifs were inlaid first and the outline chasing around the rim was made later. This process has been identified on a different part of the tray, where an inlaid area is under the chased tracing (fig. 69). This same sequence, with the colour inlaid before the tracing, was observed on two cast and inlaid objects from Ghazna (cat. nos. 12, 17). On other inlaid objects from the DAI, the inlays were made after the outline tracing, except in certain sections of the zodiac ewer (cat. no. 4).

The object has inscriptions and geometric designs that follow the shape of the rim and the cut sides. On the rim, ten inscribed cartouches are interspersed with six rosettes or solar motifs. Six other suns are on the cut sides. The cartouches inlaid with copper wire enclose votive inscriptions in *thuluth*

69

70

Fig. 69

Tabletop or tray (cat. no. 23): inlays with two coloured floriated motifs intersecting with the outline tracing.

Fig. 70

Tabletop or tray (cat. no. 23): inscription inlaid with silver wire on a champlevé vegetal ground and inlaid with black material.

script on a vegetal background (fig. 70). Their wording differs from that of the tray attributed to Herat (cat. no. 11). As on this tray, the background is occupied by two Arabic invocations in Kufic script. The rounded cartouches flank a medallion enclosing a geometric design forming a six-pointed star or seal of Solomon.

Numerous traces of black material inlay (fig. 30a) were observed on this object in the chased and champlevé areas of the inscriptions and the large star-shaped rosette. The chasing, inlaid with black material rather than metal, is wider and has a flat base. (figs. 21a and 21b). The double chasing for the preparation of the metal inlay, where traces of rectangular punches are clearly visible, are regular, forming a central relief that serves to fit the wires (fig. 70). The copper wires are inlaid flush with the substrate. In the case of the silver wires that widen into small sheets, as in the stems of the letters in the inscriptions, the chaser simply enlarged his tracing. The inlay is not interrupted to change from a wire to a small sheet and

this suggests that the silver wire was thick enough to allow for the hammering to cover the surface. Conversely, the inlays on the solar rosettes are applied with small circular sheets and double chasing, leaving a thick metal area in the centre (fig. 21a). These inlays are hammered onto the centre circle in reserve and at the same level as the surface of the substrate. Observation of the tool marks has allowed the identification of at least two different punches, chosen according to the width of the desired chasing and the width of the wire to be inlaid.

24
Gadrooned ewer with felines and moons

Afghanistan, Ghazna, late twelfth century

Hammered brass, repoussé and chased decoration, inlaid with copper

H. 32.5 cm; D. max. 19 cm; Thickness min. (wall and neck) 0.8 mm; Thickness max. (base and lip) 4 mm; Weight 1.1 kg

Punch (rectangular-headed, flat bottom) 0.9 x 1.9 mm

Champlevé W, 2 mm

The surface is covered with a brown patina and a stable layer of green corrosion making the decoration partially illegible. There are some areas of flaking on the walls showing the yellow epidermis. The ewer is broken; its handle is missing and the neck that held the handle is detached from the shoulder (fig. 11). Part of the neck is missing, and the reassembled object is probably less slender than the original. Cracks and holes are visible on the shoulder and the walls. Three old plugs made with cast metal are not visible to the naked eye; X-rays revealed that these are probably modern and were made after the discovery of the object.

Gift, Citroën Museum, 1937; inv. no. AA 176

INSCRIPTION[86]

On the shoulder: repeated blessings and isolated letters in Arabic in *thuluth* script

العناية و ا / لعناية و الر/ لعناية و الب./ لعناية و العه / لعناية و ا / لعناية و ا

al-ʿināya wa a / l-ʿināya wa al-r? / l-ʿināya wa al-b? / l-ʿināya wa al-ʿa? / l-ʿināya wa a / l-ʿināya wa

alif / solicitude, / solicitude, (...) / solicitude, (...) /solicitude, (...) / solicitude, / solicitude and *alif* /

71

This ewer comes from Afghanistan from where it was certainly brought back by Joseph Hackin after the Citroën company's expedition to Asia in the early 1930s. It has the same shape as the zodiac ewer linked to Herat (cat. no. 4). Like other objects of the same period, it represents a less luxurious version of prestigious Herat productions. The copper inlays of the sprinkler (cat. no. 18) are similar to those analysed on this ewer, thus suggesting that it can be linked to Ghazna. The alloy contains very few impurities, fewer than in the brass used to make the zodiac ewer (Appendix 6). The shaping process of

these two objects was similar. The ewers were made in four hammered parts, assembled by crimping and folding sheets of brass (figs. 10, 11). The four parts were the same for both objects: two sheets for the spout and neck, one for the body and one for the base. A handle, moulded in the same way as for comparable ewers, was soldered to the back of the neck and body. Clearly visible in the layout of the inlaid composition of the zodiac ewer (cat. no. 4), the placing of the handle on the present ewer is similar. Due to the poor condition of the surface of this ewer, it was not possible to measure and compare the hammering marks on both objects. If both had been shaped in the same way and therefore possibly in the same centre, the treatment of the surface—that is the impurities of the copper used for the inlays and the measurements of the tracings—would show, beyond the difference in quality of the two objects, quite distinctive characteristics. The punch used for the tracings is much thinner on the zodiac ewer. The two ewers raise the possibility of a system of production where the shaping took place in one centre and the decoration in another.

The neck is decorated with two felines in relief made with repoussé and with additional chasing detailing the fur. The ewer does not seem to have been inlaid with silver. The copper inlays, not easily visible because of the corrosion, seem to cover only the shoulder and are used exclusively for the inlay of the moon (figs. 71, 72). They were first observed under a magnifying glass and were then revealed by emissiography and observation under a digital microscope. The walls, with alternating inscriptions and vegetal friezes on the gadroons, are worked with chasing and champlevé.

Only two fragments of a ewer of the same type are documented as coming from Ghazna, but several examples were, or are currently, held in the main collections in Afghanistan.[87] This type of ewer was also produced in Iran in ceramics, moulded with a siliceous fabric. One example with a gadrooned body and lustre decoration has alternating vegetal decoration and inscriptions and recalls the composition of this ewer attributed to Ghazna.[88]

The inscriptions and the pseudo-inscriptions are placed in different cartouches: on the shoulder, there is a repeated blessing in *thuluth* script enclosed in six cartouches separated by medallions with vegetal grounds. The same word is repeated at the beginning of the cartouche, followed by a conjunction and the definite article and sometimes isolated letters. Only pseudo-inscriptions were identified on the gadroons: one, in Kufic script, is placed at the top of the wall in ten horizontal cartouches, one of which is incomplete. The others are in *thuluth* script in the vertical bands of the larger gadroons. The pseudo-inscriptions are distributed in two cartouches of different sizes, interspersed with medallions. The same sequence of letters as those identified on a lamp (cat. no. 34) and on a large basin (cat. no. 35) were deciphered.[89]

Fig. 71

Gadrooned ewer (cat. no. 24): crescent moon inlaid with copper.

Fig. 72

Gadrooned ewer (cat. no. 24): emissiography of the shoulder revealing the chased inscription on the champlevé background interspersed with crescent moons inlaid with copper.

OBJECTS FROM KHURASAN AND THEIR REGIONAL DIFFUSION

The production of Herat and Ghazna can be characterised by the materials employed, especially the copper. Other objects in the collection whose local or regional provenances are documented by the history of their acquisition either have different characteristics defined by the impurities of their materials, or do not have any determining features and cannot be linked to identified centres of production. Here they are classified according to these criteria. All seem to be from Afghanistan. Certain types uncovered in well-documented archaeological contexts such as Tiberias testify to the wide diffusion of metal objects from Khurasan, reaching as far as the Middle East.

Shahr-e Gholghola/Bamiyan

'In a high valley of the Hindu-Kush, in Afghanistan, at the confluence of two streams, stand two famous giant statues of the Buddha sculpted out of the cliff. They watch over the modern village of Bamiyan and beyond that, on the southern bank of the river, a conical hill, covered with old walls and ruined towers. It is amongst the ruins of this citadel, known as 'Shahr-e Gholghola', that the pottery presented here was found over the last twenty years, either by chance during commercial research expeditions, or in simple tourist visits.'[90]

The famous site of Bamiyan, here poetically described by Gardin, is now disfigured by the Taliban destruction of the monumental Buddhas in 2001, and is threatened by erosion. It is located in the large intra-mountainous basin of the same name in central Afghanistan. In medieval times, Bamiyan was a commercial hub in Khurasan,[91] situated on important commercial routes linking it to India. A famous Buddhist centre, the city was only conquered by Islamic forces in the Ghaznavid period: according to Juzjani, Sebuktigin took over the city in 355/977. It became the centre of a rich and important territory in the twelfth century, encompassing the ancient regional capital of Balkh, and was governed by a line of Ghurid sultans. Bamiyan is one of the three capitals of the sultans of the dynasty, together with Ghazna and Firuz-Koh. The region was famous for its gold and silver mines, but also for rubies, crystal and jade. After the conquest of 1214-15 by the Khwarazm Shahs,[92] the city was destroyed by the Mongol armies in the early 1220s. The site of Shahr-e Gholghola, where objects datable from the eleventh to the thirteenth centuries have been discovered, was not reoccupied after its destruction.

Shahr-e Gholghola (city of tumult) was the site of archaeological missions by the Délégation archéologique française en Afghanistan (DAFA) in the years 1920–30. The work of the DAFA must have contributed greatly to the development of commercial excavations and later visits to the site, mentioned by Gardin in his 1957 article on the ceramics of Bamiyan. Over the course of DAFA's work, dedicated mainly to the impressive Buddhist remains, some archaeological

research was also devoted to Shahr-e Gholghola. In 1930, Joseph Hackin launched soundings on the 'Muslim citadel'.[93] The site was also prospected, and soundings made by British teams in the 1950s and 1970s.[94] It is especially known for its architectural remains and its ceramic material from the medieval Islamic period,

A small group of ceramic wares from the site itself or from other sites in Afghanistan and labelled as 'from Bamiyan' was given to the Louvre by Joseph Hackin following his missions. In 1934, a glazed bowl came into the collection with the only metalwork object in the DAI that has been documented as originating from Shahr-e Gholghola.[95] This small plate or incense burner (cat. no. 25) was probably discovered during the 1930 Bamiyan mission. It is a cast object with chased decoration and belongs to a very common type of object from Afghanistan. Its decoration, a chased and champlevé sphinx at the centre of the plate, recalls the only other metalwork object of the same period known to have come from Shahr-e Gholghola.[96] The characteristics of the alloy do not allow for the definition of a metal signature. However, this unique object is considered a reference piece and other alloys in the collection have been compared to it.

Four objects resemble the small plate or incense burner from Shahr-e Gholghola (cat. no. 25). Their materials show very atypical characteristics compared to the rest of the collection and they are therefore considered as their own group. The five objects are comparable because of the impurities contained within their alloys. Following a statistical analysis of the impurities, the closest example to the plate is a mortar (cat. no. 26). The objects are cast and not inlaid, and they are of medium quality. Although they do not have a documented history, they nevertheless belong to well-identified groups and include two mortars (cat. nos. 26, 27) and a lamp or incense burner (cat. no. 28). The fourth, a lamp (cat. no. 29) is less usual, and seems to have no equivalent in the published corpus of pre-Mongol metalwork.

Presented here with the small plate from Shahr-e Gholghola, these objects are not thought to have the same provenance as their decorative characteristics do not permit a confirmation of this attribution. The similar impurities in their contents, without which it would be impossible to associate them, nevertheless illustrate the similarity of their source material. It is thus proposed that they were all probably produced in Khurasan, more specifically in Afghanistan. This supports the hypothesis of the production of these objects, generally associated with this region on the basis of the locations where they were discovered or where comparable objects are preserved.

Moreover, in addition to the impurity in their contents, they also have comparable characteristics, such as their use of engraving. This manner of incising the surface is not found systematically in the collection of pre-Mongol metalwork and thus constitutes a largely atypical element that should be highlighted. Nevertheless, the traces of tool marks and the measurements of better conserved surfaces have shown that the burins and punches used for engraving and chasing these objects were different. This aspect is not entirely conclusive since this could have been the consequence of different workshops being responsible for the decoration, perhaps even at different periods; the variety of tools does not allow us to further connect this small group.

25
Small plate with a sphinx

Afghanistan, Bamiyan (?) c. 1150–1220

Cast high leaded brass, chased, engraved and champlevé decoration, inlaid with black material

Base D. 14.3 cm; D. max. 15.7 cm; H. 2.6 cm; Thickness min. (wall) 1.5 mm; Thickness max. (junction between the wall and the rim) 4.5 mm; Thickness average 2 mm; Weight 0.374 kg

Chasing W. 0.7 mm

Compass engraving W. 0.5 mm

Champlevé (rectangular, V-shaped section) W. 1.3 mm

In relatively good condition despite some abrasion of the decoration, the object has a heterogeneous surface and colour. The yellow epidermis has areas of stable red corrosion and brown spots.

Joseph Hackin mission, acquired in 1934; inv. no. AA 62

INSCRIPTION[97]

On the rim:, in Arabic in *thuluth* script

العز و الاقبال

al-ʿizz wa al-iqbāl / glory and fortune

73

On the rim of this small plate, there is a vegetal frieze, almost entirely erased, interspersed with small medallions with very worn illegible decoration. The sides are decorated with chased and champlevé inscriptions in cartouches that alternate with circular medallions. The decoration is on two planes inlaid with black material: the first is engraved and chased (fig. 73), the second deeper plane is in champlevé. The engraving was made with a compass and some longer tracings and details of the sphinx in the central medallion were made freehand (fig. 28a, fig. 73). The compass-made circular tracing frames the circular composition and was thus made before the rest of the decoration, hence the chased outlines of the sphinx overlap the compass lines. On the body of the animal, the details are formed with small, chased triangles that recall the treatment of other zoomorphic decorative motifs in the collection and are recurrent in the chasing of pre-Mongol metalwork (cat. nos. 7, 34). On the reverse, the centre of the object is also decorated with a vegetal medallion, framed by concentric bands traced with a compass, the largest of which encloses a vegetal frieze. Probably cast with the lost wax process, the body of the object thins out towards the rim and has flaws on the exterior. In the centre, on both the interior and the exterior, a cavity can be associated with the centring of the compass used for tracing the concentric bands of the decoration. Alternatively, it was made with a lathe used to work the shape after the casting phase; no striations linked to such lathe work are visible, but that could be the result of polishing.[98]

Such small plates (D. 15–18 cm) may have been used as incense burners. This was the most common type of object observed by Melikian-Chirvani in museums and bazaars in Afghanistan, as well as in Iranian Khurasan;[99] such objects were largely used in the eastern Iranian world. With a flat base and a wide rim, they are sometimes supported on three feet, occasionally in zoomorphic shapes (cat. no. 59). In 1976, Allan identified them as incense burners and listed sixteen, with or without feet, including the two DAI examples.[100] In addition to the one from Bamiyan, those with an archaeological origin or a documented geographic provenance are from Samarqand, Ghazna, Bukhara and perhaps Hamadan. The decoration of these small plates is mostly made with chasing and engraving highlighted with black material. Certain examples inlaid with copper and silver are thus datable between 1150 and 1220.[101]

The surface of these plates is usually decorated with cartouches containing invocations, as with this example. The decorative compositions, organised in circular bands around a central medallion, are often linked to astronomy—these were solar symbols with rays, sphinxes and hares with knotted ears—or lunar symbols with crescents, as on the plate in the Samarqand Museum. Other plates decorated with a sphinx in profile, moving towards the left and facing forwards, are also extant.[102] The tracing of the mythical creature was made quickly, and the drawing is more or less precise, and the details of the fur are chased. Like the example from Bamiyan and those in London, one in the Muzim-i Rawza in Ghazna[103] has decoration on the reverse and the same compass-made tracings with cavities at the centre of the front and back of the object.[104] It thus seems that most of these small plates were shaped and decorated according to the same processes.

Fig. 73

Small plate or incense burner (cat. no. 25): head of the sphinx, traced with chasing and engraving.

181

26
Mortar with animals

Khurasan, eleventh to twelfth century

Cast high leaded copper, engraved decoration

H. 13.3 cm; D. (opening) 16.4 cm; D. (base) 15.7 cm; Thickness min. (wall) 3.5 mm; Thickness (upper wall) 6.7 mm; Weight 4.942 kg

This object has a significant hole and open cracks. The hole is in the bulging lower part of the wall and there is a horizontal crack opposite it, at the same height. Deformations such as the sagging wall, the concave bottom and the bulging base are perhaps linked to casting defects; more recent deformations have led to the deterioration of the junction between the wall and the bottom, the ridge of which is marked by dents.

Donation Pantanella-Signorini 2009; inv. no. MAO 2104

The decoration, skilfully composed in superimposed registers, occupies almost the entire height of the wall. It has three decorative planes: one engraved on the surface and two that are chased and champlevé with deeper grooves in the wax model. The decoration was almost entirely made in the casting, as indicated by the asperities visible in the background of the champlevé motifs from the wax model (fig. 74a). Some areas of decoration, such as the lines around the medallions and the details of the animal representations (fig. 74b), were cold worked. No trace of black material or precious metal inlay could be observed. The execution of the decoration is of good quality and only small casting defects are visible: shrinkage porosities at the base, pitting and cavities caused by air bubbles on the whole surface of the mortar.

Below the rim, an undeciphered formula of blessing in Arabic is inscribed in Kufic script on the vegetal background. It is arranged in seven cartouches punctuated by seven medallions with birds shown in profile facing towards the right. This frieze surmounts a large, interlaced motif that has been traced in a relatively careless way compared to the rest of the decoration. Below, seven trilobed arches enclose addorsed and confronted animals on either side of the arches: these are hares sitting on their hind legs, or goat-like creatures. Each arch has a medallion at the top, decorated with a griffin or hare against a dense vegetal background that contrasts with the smooth surfaces of the animal decoration. On the lower, blank part of the wall, rectangular cartouches enclose vegetal scrolls. Near the base and in a large vegetal band, there are geometric scrolls with circular cores. There is no comparable mortar with a documented provenance from the region between eastern Iran and Central Asia that has the same characteristics as this elegant, although damaged, example, with a concave profile and no ornamental or functional protuberances. The delicate and complex rendering of the decoration also has no equivalent. Nevertheless, there are similarities with a type of object with a concave profile that was first established by James Allan and then by Emilie Savage-Smith,[105] a shape associated with Khurasan. Allan cites cylindrical mortars with oblique sides decorated with lotus buds from Ghazna, Bukhara, Mazar-e Sharif and Herat. This mortar with animals can be linked by its decoration with arches to Afghanistan, where lobed arcades feature in the architectural decoration of the Ghaznavid period. The epigraphy used in the inscription at the top of the mortar wall is also reminiscent of those found in Ghaznavid contexts.[106]

Fig. 74

Mortar with animals (cat. no. 26): a) champlevé and chased decoration in the wax model b) cold worked areas with engraving.

74a

74b

27
Mortar with lotus buds

Khurasan, eleventh to twelfth century

Cast high-leaded copper, chased, engraved and champlevé decoration

Mortar: H. 11.3 cm; D. max. 14 cm; Thickness min. 0.2 cm; Thickness max. (base) 2.25 cm; Lotus buds: H. 2.1–2.2 cm; width: 1.7–1.8 cm; Weight 3.434 kg

Punches: 0.5 x 1 mm; W. 0.8 mm; (rounded profile) W. 0.8–0.9 mm

Champlevé W. 2.2 mm

Engraving (?) W. 0.8–0.9 mm

The surface of the mortar is heterogeneous, altered by large areas of green and red corrosion and burial concretions around the lotuses. The object has been filed recently and areas of decoration rubbed off by aggressive cleaning. It also has two gaps. Some of the decoration has recently been refreshed, especially on the upper and lower friezes of the wall.

Donation, Pantanella-Signorini, 2009; inv. no. MAO 2107

INSCRIPTIONS[107]

On the wall: blessings in Arabic in Kufic script
In the upper half: ... / الكا و الكا
al-kā wa al-kā / [benedic]tion and [benedic]tion(?).

Near the base: ... / الكا و البر ؟
..(?) *al-kā wa al-birr ?* / ... [benedic]tion and piety

Mortars of this type are considered by Emily Savage-Smith to have been produced in the Middle East in the eleventh to twelfth centuries,[108] but it seems that their places of discovery and current location link them more closely to the Iranian world. In addition to two very similar examples, linked to Afghanistan but without archaeological provenance, there is a mortar with a deeper concave profile and more careful decoration. It was discovered in Dashlyalang, a medieval site in Turkmenistan where many metal objects have been found.[109]

This mortar is decorated with eight lotus buds arranged in a staggered pattern on the cylindrical wall, which is slightly flared under the rim and has a stocky profile. Judging from the visible tool marks at the junction between the wall and the buds, evidence of the smoothing of the wax joins between the wax models of the motifs and the wall, the object was made by lost wax casting. The shaping and decoration demonstrate the low quality of the craftsmanship. The wall sags slightly and is of very irregular thickness: a gap created by a casting defect is also visible in a very thin section of the wall. Another casting defect can be seen at the base, which is also irregular. Finally, an infiltration of the metal, visible on the base, is probably due to the cracking of the mould. Based on the clearly visible corrosion in the background of the decoration, the engraved and chased decoration appears contemporary to the shaping but has recent areas of reworking. The inscriptions are chased and the geometric and vegetal motifs seem to be engraved. The tracing of the decoration is irregular and no line is straight. The inscription friezes, on a vegetal ground, have no trace of inlay. They consist of repeated abbreviated invocations. The epigraphy is arranged across a line of four cartouches, at the top and the bottom of the wall with the word blessing (*baraka*) repeated.

Lamp or incense burner with palmettes

Khurasan, tenth to eleventh century

Cast high leaded copper, openwork, chased and champlevé decoration, inlaid with black material (traces)

H. 14.5 cm; D. max. 20.6 cm; D. (opening) 10.8 cm; D. (base) 10 cm; Thickness max. (upper part of the openwork wall) 2.5–4 mm; Thickness min. (edge) 1–2.5 mm; Weight 1.169 kg

Part of the base is missing, and the edge is partially torn. No trace of a bottom attachment is visible on the complete section. The alloy is in a poor state of preservation and has a thick layer of green and red stabilised corrosion, altering the surface.[110] Observation of the decoration is limited by these layers of corrosion and by the protective wax on the exterior surface.

Purchase, Galerie Kevorkian, Paris, 2000; inv. no. MAO 1255

INSCRIPTION[111]

Under the pearl border on the rim: blessings in Arabic in floriated Kufic script

بالنور و البرك/ـة التامة و السرور الـ/ـكاملة و السلامة الكافية و السـ/(...)ـة ؟/(...) لصاحبه

bi-l-nūr wa al-barak / a al-tāmma wa al-surūr al- / kāmila wa al-salāma al-kāfiya wa al-s / (...)a ? / (...) li-ṣāḥibihi

with light, full benedic/tion, joy / perfection, satisfactory wellbeing, (...) / (...)(?) / (...) to its owner

75a

75b

The function of this object remains unclear. It forms an almost entirely reticulated casing that may have enclosed a container for incense, or another substance whose combustion released a perfume. It could also have served as an oil container and could therefore be a lamp casing. This is suggested by the votive inscription located under the pearl band of the rim that begins with the word *nūr* (light). Many examples of this type have been published, after a first study by Melikian-Chirvani in 1975 of an object he observed in the Herat museum and dated to the tenth century on the basis of its epigraphy and openwork decoration.[112] Another example found in Khulbuk in southwest Tajikistan can be dated to before 1050 according to the occupation of the site.[113] It seems, however, that the majority of the documented objects are from Khurasan: the Hermitage example was discovered in Sarakhs on the border between Iran and Turkmenistan.[114] These objects (H. approx. 15 cm) all have a flattened, round shape, with a lower section often decorated with petals. The flared lower section varies in width and apparently has no base. The flat beaded rim is above an Arabic votive inscription in Kufic script and an openwork wall with a continuous design, or one punctuated by medallions. A very similar object to the DAI example is currently in the Herat Museum: it has the same profile and rests on a flared base, as well as having a floriated Kufic inscription, continuous openwork vegetal decoration and petals on the lower section of the wall.[115]

This lamp container or incense burner was shaped by lost wax casting. This is indicated by the two remnants of core pins visible near the rim inside the wall (fig. 15a), by the asperities visible on the interior and by the metal pushed inwards from the exterior into the openwork decoration. Finally, near the base, a break in the model or mould has been repaired. Few casting defects are visible on this fine object. However, metal infiltrations in the mould can be seen inside the wall. The pearl band and vegetal openwork decoration were largely made by the casting of a wax model and were cold worked with chasing and champlevé. The design is made up of a network of palmettes and florets set into a foliated arcade, punctuated with medallions enclosing of the seal of Solomon (fig. 75a). The composition, in two superimposed rows, is on a larger scale in the upper band that takes up the rounded part of the wall. On the lower band, the petal decorations are reminiscent of those on bull's head vessels (cat. nos. 60, 61). On the shoulder, the epigraphy seems to have been made by chasing and champlevé (fig. 75b). The inscription, partly erased by wear and corrosion, is very irregular or was badly conceived for the space, since some parts of it are more spaced out than others. The text is divided into four parts separated by interlaced motifs and runs around the whole circumference below the pearl border.

Fig. 75

Lamp or incense burner with palmettes (cat. no. 28): a) chased and champlevé decoration on the body b) Kufic inscription.

29

Suspension lamp

Khurasan, tenth to eleventh centuries

Cast high leaded copper, openwork and chased decoration

H. 11.5 cm; D. (rim) 13.5 cm; D. (opening) 7.7 cm; D. (base) 6.2 cm; Thickness (lip) 0.8–1.1 mm; Average thickness (wall) 1 mm; Thickness (base) 5 mm; Weight 0.420 kg

The exterior of the object is covered with a thick grainy patina, dark brown-green in colour with areas of red-orange corrosion. The interior has been painted with bronzine. The epidermis is brittle, and the edge of the rim is marked by numerous scars. Three suspension handles were once attached: their traces, in almond and circular shapes, as well as remains of the solder are visible. These handles were thus made separately and soldered to the wall along the almond-shaped and circular lines.

Purchase, Kvanja Zanko, Paris, 1993; inv. no. MAO 908

INSCRIPTION[116]

In the centre of the wall, repeated abbreviated blessings in Kufic floriated script, containing the words *yumn* (felicity) and *bikr* (pure, new)

بكر و يمن و بكر و يمن و / و بكر و بلار ؟ و يمن و يمن و بلار ؟ /

و بكر و يمن و يمن و بلار ؟ و

This small lamp with a pear-shaped body has a tall, flared openwork rim and sits on a flat and slightly flared base. The rim has an openwork pattern of four rows of circles in an interlaced design; the centre of the rounded body has a floriated Kufic inscription divided into three cartouches containing the word *yumn*. The absence of the definite article suggests that this inscription is Persian, or more specifically that it was made in a Persian-speaking context.

No comparable metal objects have been published as coming from the Iranian world, although glass lamps of a very similar shape and size are known from Khurasan and Iran, with one discovered in Nishapur dating from the tenth to eleventh centuries.[117] The same type thus existed in both materials, but the manner of lighting was different: the transparency and reflectivity of a glass lamp meant that the light it emitted was stronger than the light coming from a metal lamp that relied entirely on reflection. Suspension lamps made of copper alloy without openwork are known in the Islamic world but are better documented in the Mamluk period in the medieval Middle East.[118] The porosity of the alloy, clearly discernible on X-rays, indicate that this object was cast in one

76

Fig. 76

Suspension lamp (cat. no. 29): detail of the inscription in floriated Kufic.

Fig. 77

X-ray of the suspension lamp (cat. no. 29): the casting defect of the base and the protuberance on the bottom are visible, as well as the thickness of the metal in this part of the object.

77

piece. The shape is regular, and the casting, polishing and decoration are all of good quality. The lamp is very delicate, but its thickness varies: the join between the rim and the container is thicker than the wall which is itself of irregular thickness. A tear in the body and a hole on the base may have been caused by the brittleness of the casting in this area. There are a few defects: two small holes in the body, small dents on the surface visible on the inside of the rim and superficial flaws on the inside of the upper part of the wall. The openwork decoration was probably made in the casting of the wax model. The protuberance under the base and the additional thickening on the bottom (fig. 77), are probably linked to the shaping of the wax model used for casting.

On the high flared rim, the decorative band of openwork circles is regular except for one small extra circle in the composition. This decoration is framed by an interlaced band with very delicate and regular chasing with a V-shaped profile. The inscriptions, like the openwork decoration, were moulded, as indicated by their very rounded relief and small defects of the moulding in the tracing of the letters. They were probably cold worked with a tool, chased with a V-shaped profile (fig. 76). The background of the inscriptions seems to have been cold worked with champlevé to accentuate the relief of the moulding. Only the contour lines of the cartouches were entirely cold worked and not made in the wax model. The large chasing resembles the interlace motif on the rim.

Objects from Sistan

This regional provenance for a small group of DAI metal objects is documented only in the inventories of the Département des Objets d'Art, as well as in copies of these inventories in the Département des Arts de l'Islam. According to these documents, 'this piece and the eight following ones were brought from Séistan (eastern Persia) in 1908' and acquired by the Louvre from the Paris dealer Raoul Duseigneur.[119] Eight are from the medieval Iranian world, including six portable objects and two that are most probably parts of shields.[120] The objects from the pre-Mongol period presented here are very similar to well-documented metalwork from Khurasan. Their type, the choice of alloys and the decoration link them to the metal culture of the region. They illustrate a parallel production and/or the diffusion of material culture from Khurasan to the border region of Sistan.

The historical region of Sistan (fig. 1), or Nimruz, is today divided between eastern Iran and Afghanistan. Ibn Hawqal in the tenth century devoted a chapter to Sistan in his *Kitab surat al-ard* (Configuration of the Earth) where he specified that Khurasan bordered Sistan and India in the east. [121] He included Sistan in 'all of Ghur up to India'. The region was linked by road networks to the large cities of the eastern Iranian world, Herat and Ghazna, but also westwards towards Kerman and Fars.[122] Administratively linked to Khurasan by the Abbasids, Sistan was conquered in the ninth century, as well as briefly becoming a part of Khurasan, by the coppersmith (*saffar*) Ya'qub ibn al-Layth who practised this craft in Zarang, where metalwork made with copper alloys was produced.[123] The dynasty of the Saffarid emirs (861-1003), centred in Sistan, was defeated by the Ghaznavid conquests and the capital Zarang was sacked. Despite the troubled years of the middle of the eleventh century, the region remained under Ghaznavid control until the twelfth century, when it passed into Ghurid hands.[124] Sistan is frequently mentioned in medieval Persian sources,[125] as well as its capital Zarang/Shahr-i Sistan.[126] Archaeological research carried out by Hackin and Ghirshman in the region in 1936, during which ceramics were collected and later studied by Gardin, revealed similarities with the ceramic medieval material from Afghanistan.[127] However, the only site that has been extensively excavated, in the east of the region, remains Bust/Lashkar-i Bazar. The winter capital of the sultan, Mahmud of Ghazna, it formed an immense urban and palatial ensemble dominated by a citadel. According to Juzjani,

it remained a Ghurid residence, after the vengeful destruction of the incomparable Ghaznavid palaces and buildings by 'Ala al-Din Husayn (r. 1149-61). After the destruction of Ghazna in 1150, the Ghurid sultan marched on Sistan and destroyed the palace and public monuments of Bust/Lashkar-i Bazar.[128] The 'soldier market' was incorporated into the city of Bust and has been partially excavated.[129] Material found during excavations of the bazaar and the larger site consisted mainly of ceramics—no metal objects seem to have been discovered. The ceramics can be dated to between the tenth and thirteenth centuries and include underglaze slip-painted wares comparable to those produced and distributed around Khurasan, Central Asia and the Indian subcontinent in the same period. The production of metalwork in Sistan was therefore not attested to in the archaeological excavations. However, two inscribed objects referring to individuals originally from Sijistan/Sistan were catalogued by L.A. Mayer: a silver-inlaid ewer with an inscription names the owner from Sistan (*al-Sidjzi*) and a bowl that once belonged to F.R. Martin and appeared in the 1931 'Exhibition of Persian Art' in London has the name of a maker with a *nisba* from Sistan, Muhammad ibn Ahmad al-Sidjizi.[130] The region is also mentioned by al-Biruni in the eleventh century as having a reputation for the fabrication of *asfidhruy* (high tin bronze).[131]

Of medium quality and mainly cast, the DAI objects acquired in Sistan have no surface ornament or have chased decoration. They are domestic objects of relatively simple manufacture. The two characteristic alloys of high leaded copper and high leaded brass were made with materials from different sources, without a signature that would allow these objects to be linked to the centres of Herat and Ghazna which have been more conclusively defined by the study of the DAI collection. On the contrary, the impurities of the alloys suggest diverse origins—a regional provenance from Sistan is therefore not a defining characteristic of this small group of objects. The impurities in the alloys nevertheless allow three groups to be identified within the analysed metals. The incense burner (cat. no. 30) linked to class 1 impurities (see above 61, 93-94) is discernible from other metals bought in Sistan that do not contain bismuth or cobalt and are thus linked to class 2 (see above 94-95). In the second group, a lamp (cat. no. 33) contains significantly more nickel and more arsenic than the two others (cat. nos. 32, 34) and the sprinkler (cat. no. 31).

30
Incense burner with a lobed arched opening

Khurasan or Sistan, tenth to eleventh century

Cast high leaded copper, openwork and chased decoration, inlaid with black material.

H. 14 cm; W. max. 8 cm; Thickness min. 4 mm; Weight 0.422 kg

Chasing (flat bottom) W. 0.9 mm

Modern punch (V or U-shaped section) W. 1.3 mm

The surface is irregular, heterogeneous and of a brown colour with red and green corrosion. There are visible concretions in the grooves of the cast decoration and inside the wall. A break is visible on the open part of the container, at the right junction of the arch which is cracked.

Purchase, Raoul Duseigneur, Paris, 1908; inv. no. OA 6156

The three-legged object is made with a cylindrical container in which coals and substances for burning were placed. The perfumed smoke would escape through the openwork semi-dome with four gadroons and a lobed arched opening at the front. The object is unbalanced by its front right front foot which is shorter and 2 mm wider: it may be an old repair or a casting defect. Only the polygonal knop joint has been added on the wax model and the object seems to have been cast in one piece. On the interior of the incense burner, there are three core pins (fig. 15b). The presence of flashings and metal infiltrations inside the wall point to the shaping of the piece by lost wax casting. Traces of core infiltrations on the inside of the openwork signify that the decoration was made in the wax model. The perforations were probably made with a hot tool directly in the wax. The openwork was made by the casting of the wax model, reworked cold after the infiltration of metal during casting. Other defects such as holes and blisters are visible on the object.

The form and the openwork are highlighted by chased decoration inlaid with black material which probably includes areas of modern remaking: some of the chasing seems newer and slightly wider and has a concave or V-shape. The irregular openwork of the ribbed dome is outlined with sinuous lines drawing an interlace pattern. On the base, three medallions alternate with three vertical bands decorated with palmettes and flowers. The edges of the base and the arch are decorated with floral scrolls. The lobed opening recalls an ornament that was widespread in sculpted stone in the Ghaznavid period: there are lobed arches on the cenotaph of Mahmud of Ghazna.[132] The medallions with four terminal nodes decorating the base are like those enclosing birds on the brass tabletop or tray from Ghazna (cat. no. 15).

This form of incense burner is well known and is associated with Khurasan. Eva Baer published the Louvre example as the oldest identified object and compared it to a copper-inlaid censer from Jerusalem. This type of object was probably specific to eastern Iran and would have been produced up to the early Mongol period.[133] Fifteen examples including this one were recorded by Allan who described an inlaid example in Boston bearing the signature of Abu'l Munif ibn Mas'ud.[134] However, few similar examples found in documented contexts have been published. An example found in an excavation in Ghazna and preserved in Kabul is from an undocumented context;[135] likewise an object discovered in Turkmenistan.[136] These small censers (H. 14–20 cm) are supported on three or more rarely four legs. They are often surmounted by a bird in the round on top of the dome, here replaced by a polygonal knop. According to Melikian-Chirvani, the objects that are not inlaid with precious metals form one of the groups datable to the tenth century, or in any case before 1100 according to their inscriptions,[137] that contain auspicious wishes in Arabic.[138]

The example from the V&A published by Melikian-Chirvani is very similar to this object. However, it is supported on four feet and its lobed arched opening is framed by two small wings with the dome surmounted by a bird in the round.[139] The two objects were shaped following the same method: three or four core pins are visible on the interior of the wall. The exterior surface corresponds to the interior one. The openwork decoration made in the casting of the wax model is very asymmetrical. No joint was observed on the incense burner from the V&A: the object was undoubtedly cast in one piece with direct lost wax casting. Another incense burner of a similar type inlaid with black material and copper has also been examined and analysed: it was cast in one piece and has now lost its knop.[140] Its shaping was somewhat different, with openwork that was probably cold worked and not cast.

31
Sprinkler with a globular body

Khurasan or Sistan, tenth to eleventh century

Cast high leaded brass, chased decoration

H. 20.7 cm; D. max. 10. 7 cm; Thickness min. (body) 0.5 mm;
Thickness (neck and pedestal) 3 mm; Weight 0.504 kg

Punch W. 0.3 x 1.5 mm

Chasing W. 0.6, 0.9 mm

The object is in a relatively poor state of preservation. The greenish
surface is covered with concretions that make it difficult to see the
decoration clearly. There is an old filling on the body, invisible to the eye
but clearly identifiable by X-ray: it is a repair made during the shaping
to fill a casting defect, or one that was made more recently, but in any
case prior to burial. One area of the wall has been very visibly rubbed;
the whole surface is very scratched. There are gaps in the lower part
of the body. The bottom is missing and a nodule on the neck has been
pushed in.

Purchase, Raoul Duseigneur, Paris 1908; inv. no. OA 6160

INSCRIPTION[141]

On the upper part of the body: blessings in Arabic, in *naskh* script

اليمن ؟ و الر(...) ؟ و الس[... و ال] ـسلامة و البقا لـ[ـصا] ؟

bi-l-yumn ? wa al-(...) wa al-s[... wa al-] salāma wa al-baqā li-[ṣā] ?

with happiness, (...), [...] wellbeing, longevity to [...](?)

This type of container, which seems to have been used
throughout the Iranian world,[142] has a neck with projecting
nodules, a rounded body and a high pedestal. Several variants
exist: the foot can be more or less elongated and the body can
have a rounded or flatter profile. At least three comparable exa-
mples with no openwork on the neck were found in Ghazna,
which according to present knowledge seems to be the site
where the majority of these documented objects originated.
One with similar chased decoration with a votive inscription
at the top of the body and medallions enclosing birds was in
Kabul, as well as others whose archaeological provenance was
unknown.[143] Based on the example discovered in Samarqand,
these sprinklers are datable from the ninth to tenth centu-
ries.[144] Since no published examples have metal inlays, it is
possible that this shape was no longer produced in the twelfth
and thirteenth centuries.

No trace of a join to the base is visible: a sheet of metal was
originally folded over the pedestal to close the object, which
was cast in one piece. The openwork of the neck was made
by casting, as well as the nodules. The thickness of the foot is
irregular, probably because of a defect in the model or a dis-
placement of the mould core. The repair of the body, if it was
indeed made during a secondary cast, was probably due to a
poor filling of the mould and the extreme thinness of the wall.

The cursive inscription on the upper part of the body is
largely illegible due to the corrosion and abraded surface. The
inscribed blessing is addressed to an anonymous owner, but
the word *sahibihi* is not clear.[145] The inscription is chased and/
or engraved on a ground of small spirals similar to the grounds
of the four medallions with partridges positioned around the
centre of the body. An interlace motif, traced in varying widths,
links the medallions; another is chased at the base of the wall.
This poor-quality decoration was judged to be suspicious by
Henri Marchal who thought that it had been applied later than
the shaping of the object;[146] recent examination suggests that
this was not the case.

The chased decoration has straight and notched grooves in
the curved traces. The punch had horizontal, vertical or slan-
ting edges of varying widths, suggesting that a single rather
than multiple tools was oriented at different angles.

Oil lamps (cat. nos. 32–34)

These lamps were shaped with lost wax casting. The double-spouted lamp with a palmette thumb rest (cat. no. 32) has toolmarks at the junction of the handle and the container, probably due to the reworking of the wax model. The handles and thumb rests of the two lamps (cat. nos. 32, 33), as well as the spouts and containers, were probably modelled in wax and added to the wax model. The decoration of the thumb rests was made with a file. The beaded grooved motifs were perhaps cold worked with a gimlet. These objects are made with two different alloys, a high leaded copper and a high leaded brass, and, judging from the impurities of the alloys, have different provenances, but may nevertheless have come from the same production centre on the basis of their similar shaping and decoration.

A lamp that compares with the example with a palmette thumb rest (cat. no. 32) was discovered in Nishapur.[147] With a single spout, it has a thumb rest and a circular handle similar to the lamp bought in Sistan and was found in the excavation of Village Tepe, an area where dwellings were found, as well as wells and pits subsequent to its occupation, which according to the ceramic sherds found on the surface of the site lasted until the Mongol invasions.[148] Another lamp, also discovered in Nishapur but without any archaeological documentation, is very similar to the second lamp (cat. no. 33). It is slightly smaller but of the same shape, the profile of the spout having the same projections and the wings on the sides no serrations.[149] Two more similar lamps of unknown archaeological provenance are in the Kabul Museum.[150] This type was also found in Turkmenistan,[151] illustrating a fairly well-documented distribution in the eastern Iranian world, but without any archaeological dating. According to Allan, this type of oil lamp is datable to before 1100 by comparison with the ceramic lamps discovered in Nishapur and published by Wilkinson.[152]

32
Double-spouted lamp with a palmette thumb rest

Khurasan or Sistan, tenth to eleventh century

Cast high leaded copper, filed decoration

L. 16.2 cm; W. 8.4 cm; H. 5.3 cm; D. (opening) 4.9 cm; Thickness min. (wall) 0.5 mm; Thickness (wall) 1–1.5 mm; Weight 0.186 kg

File marks W. 1.8 mm

The surface of the object is reddish brown. The epidermis is altered and irregular; it has been rubbed and then patinated and waxed. There are four holes in the sides of the container.[153]

Purchase, Raoul Duseigneur, Paris, 1908; inv. no. OA 6158

This double-spouted lamp previously had a separately made foot or base which was soldered to the container: the circular traces of this assembly are clearly visible, even if the area was concealed during the restoration. The object as it is preserved was cast in one piece. The shaping is of good quality but there are a few irregularities, including the handle which is mis-aligned. The elegant palmette on top of the handle, as well as the projecting spouts, were made by casting. The grooves of the vegetal thumb rest were cold worked with a file and it is possible that the small concentric grooves on the spout were cold worked with a gimlet; they could also be the result of tool marks in the wax model.

33
Lamp with scalloped handles

Khurasan or Sistan, tenth to eleventh century

Cast high leaded brass, filed decoration

L. 13.2 cm; W. 8.6 cm; H. 4.1 cm; D. (opening) 4.5 cm; Thickness min. (wall): 1.2 mm; Weight 0.122 kg

File marks W. 1.35 mm

Purchase, Raoul Duseigneur, Paris, 1908; inv. no. OA 6159

The object is in a poor condition. Its irregular brown-green surface is covered with concretions and corrosion. The metal is not rubbed except under the spout. The thumb rest is broken and a hole is visible on the spout; the break to the thumb rest probably occurred before the object's burial or is very old. A repair to the vessel wall, probably modern, is visible from the three fillings of the base. The lamp has several casting defects including the incorrect centering of the handle and the irregularity of the spout rim. A small hole has been drilled in the spout near the junction with the wall. No traces of soldering are visible on the base which may have rested on its flattened bottom. Like the previous lamp (cat. no. 32), this example has decoration made with a file and hollow beads made in wax and cold worked using a gimlet.

34
Lamp with a harpy

Khurasan or Sistan, twelfth century

Cast high leaded copper, champlevé and chased decoration, inlaid with black material

H. max. 15.5 cm; H. (without handle) 8.9 cm; L. max. 14.5 cm; W. max. 7.9 cm; W. (base) 7.7 cm; Thickness min. (foot) 1.5 mm; W. max. (handle junction) 10 mm; Thickness average 2–2.5 mm; Weight 0.376 kg

Chasing W. 0.6 mm

The object is covered with a reddish-brown patina, with older green corrosion that has accumulated in the grooves of the decoration. Two small holes are visible in the container and the foot, as well as a small hole on the wall.

Purchase, Raoul Duseigneur, Paris, 1908; inv. OA 6157

This lamp with a pear-shaped container rests on a high faceted foot with a hexagonal base. It has a spout and a handle with a thumb rest in the shape of a harpy. The container would have been closed by a now missing lid, made separately and held by a hinge. According to Allan, this type of lamp dates from after 1100 on the basis of comparison with ceramic models.[154] He identified twenty-one examples in metal including the one in the DAI, and noted that three lamps were from Ghazna and one from Swat in northwest Pakistan.[155] Nineteen examples in Kabul were listed more recently, including one very similar to the DAI example.[156] A complete lamp with an extant thumb rest and lid was found at Takht-e Bazar in Turkmenistan.[157] These lamps, of a type well identified and common to the rest of the Iranian world, have decoration made by casting and are incised and often inlaid with silver or red copper, which, like the type of writing used in their inscriptions, tends to place their dating to around 1100 to 1220.[158]

The oil container and the foot were probably made in a single piece by lost wax casting as the two parts do not seem to have been soldered together. Visible marks at the junction of the handle and the container were possibly made by a tool used to work the wax model while hot, the results of which are transposed onto the metal. Inside the foot, remains of clay may have come from the mould core. The curved parts of the handle and the thumb rest were made separately and attached with solder. The raised areas were made during the casting phase. The animals, heads in the round and bodies engraved, that are positioned on either side of the container are common on oil lamps of this period. The projections formed by the heads may have been functional and supported a suspension handle, as on a lamp in the V&A.[159] This decoration, which plays on the visual contrast of the flat and relief surfaces, is close to the better preserved ornament of another lamp (cat. no. 39). The flat surface of the lamp and its support are decorated with fluid floriated scrolls made by champlevé and chasing with traces of inlaid black material. On either side of the container, there are two rectangular bands with letters in *thuluth* script against a floriated vegetal background. Henri Marchal believed that the votive inscription was legible.[160] However, it appears to be composed with a sequence of letters found on two other objects from Afghanistan in the collection.[161] Traced by chasing and champlevé, these designs were inlaid with black material of which only traces remain, rendered invisible by the surface corrosion. Another V&A lamp with the same form and a handle surmounted by a harpy was shaped in a similar manner.[162] Like the DAI example, the lamp rests on a high faceted foot and has lost the lid that was attached with a hinge and thus made separately. It has champlevé and chased decoration and silver and black material inlays that are visible on the harpy, the foot and the edge of the lamp.

From Samarqand to Tiberias: the diffusion of metalwork in the Iranian world

Portable metalwork objects produced in historical Khurasan, an area that includes present-day eastern Iran, Afghanistan and Turkmenistan, are also known from Central Asia, Asia Minor and the Middle East. This wide distribution of certain types raises the question of where and when they were made, but also of their systems of distribution. The discovery of the same types of objects in very distant sites is a sign of their extensive circulation. This may have been the result of similar production in various centres through the diffusion of models whose form and decoration were copied; it may also have been the result of commerce, with objects exported from the cities of production to the cities of consumption.

The wide distribution of similar types throughout the entire region of Khurasan and beyond is also well documented in other mediums, especially ceramics, still forming the most common and best-known archaeological evidence. Thematic and stylistic similarities across these vast geographical areas are also apparent in less frequently discovered works of art such as wall paintings intended for the princely elite,[163] evidence that suggests a widely shared material, visual and artistic culture. In the Louvre collection of pre-Mongol metalwork, several objects illustrate this phenomenon because they belong to types that are relatively well documented archaeologically, and their areas of distribution are fairly well known. Their archaeometallurgical study has also opened up new avenues of research on the question of the diffusion of models and on the trade in alloys and metal objects.

A large, faceted basin (cat. no. 35) was found during the expedition organised by the Citroën company in Asia in the early 1930s, led by Joseph Hackin in Afghanistan in 1931–32. The basin belongs to a type that is datable to before 1220 and is among the largest surviving portable metal objects from the pre-Mongol period. The shape remained common until the fourteenth century in Iran.[164] These basins have low, star-shaped sides with twelve to eighteen facets, a slightly curved profile and a large opening (32–46 cm) on a large, flat base. They are cast, with chased or copper- and silver-inlaid decoration; the exterior walls are left blank. The inscriptions and other designs are chased in friezes below the rim and in concentric bands on the interior around a radiating central motif. These basins probably accompanied ewers and were used to hold water for handwashing. In his account of the year 421/1029, the Ghaznavid historian Beyhaqi refers to the office of *tasht-dar* or guardian of the royal ablution basins, who was close to the sultan and a high-ranking soldier attached to the palace and its equipment.[165] According to the archaeological data, the circulation of these basins before the 1220s illustrates their widespread diffusion in the Iranian and Afghan parts of Khurasan, as well as in Transoxiana, and similar objects have been found in Nishapur and Samarqand.[166] The Nishapur basin, which has chased decoration, was discovered during excavations in Shadiakh, in a part of the site occupied in the twelfth and early thirteenth centuries. The basin discovered in Afrasiab/Samarqand is of a smaller size (D. 34 cm); with eighteen facets, it is inlaid with silver and the central rosette is framed by a frieze of fish. Most of the known basins of this type seem to have come from present-day Afghanistan. Many are documented as being from there or are in museum collections, without archaeological provenance in most cases. According to Allan, they were a product specific to Sistan or Ghazna.[167] Twenty-eight complete or fragmentary basins were found in Afghanistan, five at the Ghazna site.

They were probably all made using the same process which included casting as well as hammering of the base and the facets since almost all of them have a rosette in relief in the centre.[168] Melikian-Chirvani studied several examples in the museums of Kabul, Herat and Ghazna. The piece he published from the Muzim-i Rawza in Ghazna has sixteen facets and a central rosette on a chased ground, and he dated it to the second half of the twelfth century.[169] As with other hammered brass objects from the pre-Mongol period, we find the same forms, produced with the same process, with decoration that may or may not include precious metal inlays. Thus, the faceted or gadrooned ewers that may have been paired with this type of basin (cat. nos. 4, 24) also have more or less inlay. The two metal-inspired forms were also used for fine ceramic wares made of a siliceous fabric glazed with metallic lustre.[170]

Other types of metal vessels circulated even more widely: the shape of the large pouring vessels with pomegranate-shaped thumb rests (cat. nos. 36, 37) may be one of the most widespread in the pre-Mongol period. Numerous examples datable from the tenth to thirteenth centuries are extant from Khurasan, Central Asia and the Middle East. With relatively large dimensions (H. 30-35 cm), these pouring vessels have tall, faceted tubular necks and round, ovoid or pear-shaped bodies. It is the volume of these objects that catches the eye, particularly the beaded handle surmounted by a fruit in the round that is their highest and most visible element. These vessels were possibly linked to wine-drinking, as the pomegranate is one of the autumn fruits linked to *bazm* (wine banquet), especially the one celebrated during Mehregan (autumn festival), where wine would be served, its red colour referring to the drink and sometimes also to the drinker.[171] The neck and the body are generally chased and inlaid with black material, more rarely with metal. A pouring vessel inlaid with copper, its handle missing but of the same type, is signed *ʿamal Naṣir* with copper inlay. It seems to be the only published example of this type with a signature.[172] One object in the DAI was found during Joseph Hackin's archaeological mission in Afghanistan in 1933 (cat. no. 36) and is similar to an unprovenanced object which entered the collection much more recently (cat. no. 37). The two objects have the same characteristics in their shaping, as does a similar third ewer in the V&A.[173] They seem to have been made in one piece by lost wax casting. The general shape, without the pomegranate or the beading on the handle, has its origins in the Middle East and would have spread eastwards during the Islamic period. In the Roman period of the fifth to sixth centuries, this shape was found in glass and also in silver.[174] Vessels of the same shape with high, tubular necks above rounded or pear-shaped bodies and straight handles with thumb rests were also found in Raqqa in Syria. Three published examples, in glass, ceramic and copper alloy, are from the Abbasid palace complex built by Harun al-Rashid in the ninth century.[175] Pouring vessels of the same shape, but with a beaded straight handle surmounted by a pomegranate, appear to be made of copper alloy and are later in date according to the known archaeological contexts. They come mainly from the Iranian world but also from the Middle East.

More examples were uncovered in the Iranian world and in Central Asia than in the Middle East, and these were probably imported, such as one discovered in Baghdad.[176] Another vessel was found in Tiberias, in a context that can be dated to the eleventh century. It was discovered in a workshop for the repair and recycling of copper alloys, the only one of its kind in a group of around one thousand metal objects and fragments. It was intact and filled with metal pieces, put into a storage jar containing metals awaiting recycling. According to Elias Khamis, this pouring vessel had been cast in one piece.[177] The alloy is different from those of the two DAI

examples, but is similar to a high leaded brass, one of the five types of alloys identified in the Louvre pre-Mongol collection.[178] Its impurities, and in particular its cobalt content, distinguish it from other Tiberias alloys that were analysed. According to Matthew Ponting, it is possible that the object came from the Iranian world.[179] Pouring vessels with pomegranates are linked to the eastern Iranian world as the majority of documented objects were found or are held there.[180] Some are from Khurasan; one of the earliest might be the object discovered at Tepe Madraseh in Nishapur, in a large complex organised around a courtyard and mainly occupied between the ninth to the tenth centuries.[181] This pouring vessel with an ovoid body (H. 33.5 cm) has votive formulas that are common to pre-Mongol Khurasan and are inscribed in Kufic and *naskh*.[182] One was discovered at Sultan Qala in Merv[183] and two others were found at the twelfth- to thirteenth-century site of Yasydepe, also in Turkmenistan[184]. In Afghanistan, a pouring vessel with no archaeological provenance was referenced in the Kabul Museum; another from Ghazna is of a slightly different type.[185] At least fifteen pouring vessels with pomegranates came from sites in Mawarannahr or were purchased there. It is likely that they were produced in these different regions between Khurasan and Central Asia, as proposed by Marshak on the basis of a vessel bought in Samarqand in 1888 and other examples also in the Hermitage Museum, includ-ing two discovered at Toy-Tubé in Tajikistan.[186] Hoards from Kalaibaland and Zoli Zard, also in Tajikistan, included five pomegranate pouring vessels.[187] Finally, one discovered in Talgar testifies to the dif-fusion of this type as far as southeast Kazakhstan.[188]

35
Large faceted basin

Afghanistan, c. 1150–1220

Cast and hammered brass, chased and champlevé decoration

D. (opening) 46.3 cm; H. 11.4 cm; Thickness (wall) 1 mm; Thickness min. (base) 0.6 mm; Thickness max. (edge) 6.5 mm; Weight 2.225 kg

Chasing W. 0.5 mm

Champlevé (rectangular) W. 1.75 mm

The object is incomplete and in very poor condition. The surface is greenish-brown and covered with corrosion and burial concretions. The very thin wall has broken away around the base. Part of the wall and the base are missing, and this area may have been consolidated shortly after the discovery of the object, with metal armatures welded to the substrate to hold together the torn, cracked and split metal.

Gift, Citroën Museum, 1937; inv. no. AA 175

INSCRIPTION[189]

On the base: in six cartouches, blessings in Arabic, *naskh* script

باليمن و البركة و / الدولة و السلامة / و السعادة و الحا/مة ؟

و / النعمة و [...] / (...)[...] السـعادة ؟ (sic) و الشكرامة

bi-l-yumn wa al-baraka wa / al-dawla wa al-salāma / wa al-saʿāda wa al-ḥ-ā / m-a ? wa al-šukarāma (sic: al-šukr + al-karāma ?)
wa / al-niʿma wa [...] / (...) [...] al-saʿāda ?
with happiness, blessing, / prosperity, wellbeing, / felicity, (...)/(...), (sic: gratitude + consideration(?)) /, well-being [...] / (...) [...] felicity(?)

This large basin with fourteen facets was shaped by hammering from a cast blank (see above, 69). The rosette in the centre of the base is in fairly high relief with tool marks in the wax model. The centre is thicker than the rest of the bottom of the basin, the density of the metal in this area appearing white on the X-ray (fig. 8). The rough shape of the basin was cast and the form raised by hammering, a process identifiable on X-ray by the cloudy appearance of the metal sheet. The exterior is plain, and the decoration is instead concentrated on the interior surface, at the top and bottom of the sides. The geometric design is of two superimposed six-pointed stars and the inscriptions are chased and champlevé. The tracings are more visible under X-ray as the corrosion and concretions render them almost invisible to the naked eye. The same star-shaped composition with the points of the stars alternating with inscribed cartouches can be identified on the base of a large, chased plate or basin in the Herat Museum.[190] The bless-

ings in the inscriptions have similar formulations, including a relatively rare invocation: *al-shukr* (gratitude). Finally, at the centre of the star there is a sphinx similar to the one on the scale tray found in Ghazna (cat. no. 13).

Around the central rosette a first band inscribed in *naskh* script is interspersed with three representations of the moon. It is a pseudo-inscription, or rather a formula of abbreviated invocations, like the formula also in *naskh* in the cartouches under the rim. This large circular inscription separated by the twelve points of the star is also in cursive script: it consists of a series of eulogies in Arabic, distributed in six cartouches separated by medallions containing palmettes. The final part of the inscription has gaps from the damage to the object and some words are incorrectly written.

Pouring vessels with pomegranate-shaped thumb rests (cat. nos. 36, 37)

On the basis of X-rays and close observation, it seems that these two objects were probably cast in one piece (figs. 79, 81). There are no joins between the bodies and the handles and in both cases the handles, the most fragile elements, have broken off, as on other published examples. They were fixed with solder, repairs probably made after the burial of the objects. This is suggested by the filed and partly cleaned surface at the base of the handle of the pouring vessel, that came from Joseph Hackin's mission, to which the tin solder was later added (cat. no. 36). However, it is also possible that these pouring vessels, or at least some examples in this group, were cast in two parts. The handles would then not have been attached by soldering, but cast separately with the pomegranate and then joined to the neck and body with tin solder, which was repaired after the discovery of the objects. The two Louvre pouring vessels appear to have been shaped in the same way, with one important difference: the facets of the neck were made by casting the wax model, which in one case was faceted (cat. no. 36); on the other, the neck has different longitudinal thicknesses, and the facets have traces of hammering made by plastic deformation (cat. no. 37). Thus, two methods of working the shape differentiate the processes: one used only the wax model and the other used hammering after the casting. The bottoms of the objects are missing and they must have been closed by a metal sheet folded around the base by hammering. The bottom of the pouring vessel with a drinker and flower vases (cat. no. 37) is a modern repair, roughly attached with mastic (?) inside the base.

Both vessels have the same frontal composition: on the side opposite the handle, there are lobed medallions topped with a finial. The surfaces were cold worked with chasing and champlevé, but the two objects were clearly not worked with the same tools: the punch used on the Hackin pouring vessel is much finer (cat. no. 36) and on the other the burin used for the champlevé is much wider (cat. no. 37, fig. 142).

36
Incomplete pouring vessel

Afghanistan, eleventh to twelfth century

Cast high leaded copper, chased and champlevé decoration

H. 24 cm; D. max. 15.1 cm; Thickness (neck) 0.5–2.5 mm; Thickness (body) 1.5–3 mm; Thickness (edge) 3 mm; Weight 0.832 kg

Punch (triangular or rectangular) 0.4 x 0.8 mm

Burin 1.3 x 3.5 mm

The vessel is very incomplete: part of the neck is missing and was reattached to the body with a Plexiglas rod that is incorrectly aligned with the position of the handle. The neck was originally taller and the junction with the base of the neck is missing. Analysis of the material has shown that the two parts come from the same object. The handle and base are missing. The altered brown surface allows one to see areas of red and green corrosion. The interior of the walls is greenish, corroded and partially covered with concretions. The very yellow epidermis has been rubbed from the body at the point where the handle is broken. An area of decoration opposite the handle was certainly rubbed clean in the past; the rest of the wall does not seem to have been cleaned and the corrosion is perhaps concealed by an artificial brown patina. Certain chased areas have been refreshed as shown by where the epidermis is visible in tracing on the rim, the neck, the body and the base.

Joseph Hackin mission, 1933; acquired in 1934; inv. no. AA 59

The upper section has a band of Arabic inscription, partly erased, written in Kufic script, repeating الدو that can probably be read as *al-daw[la]* (prospe[rity]).[191]

Of medium quality, the vessel has defects. On the interior of the body, a flashing or vertical infiltration of the metal suggests that there were cracks in the wax model or the mould, which additionally was poorly filled with metal, as indicated by the small gaps in the upper part of the body. These defects, together with the tool marks around the base of the handle on the body, indicate that the vessel was shaped by lost wax casting. The irregular and discontinuous facets of the neck, which appear white or very dark on the X-rays (fig. 79), also indicate

78

79

a variable thickness. The filed striations on the inside of the base and the body may be evidence of machining.

The position of the handle, at the edge of the neck and the body, does not show a join with the walls which suggests that the ewer was cast in a single piece. Similarly, the raised ring at the base of the neck does not cover the connection between the neck and the body. The base of the handle shows traces of filing and possibly soldering, probably due to a repair or the assembly of another part of the handle. Another repair was made to a dent in the wall. Thus, despite its barely functional use due to the casting defects that caused gaps in the wall, this object was judged to be worth repairing. Some of the repairs may have been carried out after its discovery, but the presence of cold worked decoration shows that it was completed after its shaping.

Only some parts of the chased and champlevé decoration remain visible (fig. 78). The relief of the tracing must have been quite pronounced and was probably inlaid with black material. The champlevé areas are deeper than the chasing. Under the handle, a vegetal motif can be seen around a symmetrical axis: it forms a knotted arch with a palmette scroll. Vegetal decoration is also visible at the base of the neck.

Fig. 78

Incomplete pouring vessel (cat. no. 36): detail of the chased and champlevé motifs.

Fig. 79

X-ray of the incomplete pouring vessel (cat. no. 36).

37
Pouring vessel with a drinking figure and flower vases

Afghanistan, c. 1150–1220

Cast leaded brass, chased and champlevé decoration, inlaid with black material

H. 33 cm; D. max. 17.5 cm; D. (base) 8.3 cm;; Thickness min. (neck) 1.2 mm; Thickness max. (edge) 7 mm; Thickness (base) 2–3 mm; Weight 1.570 kg

Hammering marks L. 1 cm

Punch 0.6 x 1.9 mm

Burin 1 x 1.9 mm

The yellow metal has been rubbed down to the epidermis. The soldered repairs to the handle were reattached during the restoration of the vessel and a circular area of tin solder is visible by X-ray. Like the repair on the handle, it was covered up during the restoration of the object in 2012. Other holes and tears, much more irregular and probably the result of impacts, are also visible on the surface. They were filled from inside the wall before the addition of the modern base and/or made up on the surface. On the interior, large areas of a beige mastic (?) filler were observed by endoscopy.[192] The body has dents caused by impacts. The surface is very scratched due to the removal of layers of corrosion; the removal affected all the surface, and it was homogenised by a reddish-brown paint which was taken off during the restoration.

Purchase, Galerie Kevorkian, 2000; inv. no. MAO 1256

INSCRIPTION[193]

On the shoulder: blessings in Arabic in *thuluth* script

<div dir="rtl">

العز و الاقبال و الدولة و السلامة و التا / مة و الكرامة
و العافية و البقا لصاحبه

</div>

al-ʿizz wa al-iqbāl wa al-dawla wa al-salāma wa al-tā/mma wa al-karāma wa al-ʿāfiya wa al-baqā li-ṣāḥibihi
glory, fortune, prosperity, wellbeing, pleni/tude, consideration and long life to its owner.

80a

80b

Fig. 80

Pouring vessel with a drinking figure and flower vases (cat. no. 37), details: a) the drinker's head b) the cup he is holding.

Fig. 81

X-ray of the ewer with drinking figure and flower vases (cat. no. 37).

81

The vessel retains its original handle, as shown by the leaded brass that was used for the body and handle. The straight shaft of the handle is embellished with six pearls and topped with a pomegranate in the round that was cast from the same wax model. Traces of the junction between the base of the fruit and the top of the handle are clearly visible on the vessel which has traces of the modelling transposed onto the metal during casting. The X-ray shows that the two parts of the handle were cast at one time, with no visible joint in the metal (fig. 81).

The casting has some defects: the body of the ewer is marked by several cavities caused by air bubbles. Gaps in the centre of the wall, repaired with tin solder and forming very regular circular patches, are clearly visible on X-rays. These repairs may hide casting holes that were filled at the time of the manufacture of the object, in order to make it functional as a container for liquid. The slight fold in the base, visible on X-rays, probably served to fix the metal sheet that was folded by hammering and closed the bottom.

The traces of chasing visible on the neck and body have different features: the large-scale vegetal decoration flanking the facets of the neck is modern (fig. 25) and conceals the original chasing, now almost erased, that previously highlighted the tracing of the facets. On the edge, a frieze of pearls, also almost erased, was part of the original decoration that had two planes, one chased and one champlevé. There is no trace of metal inlay on the ewer, but the inlay of black material has been reworked and completed, probably during the recent chasing. The modern decoration of the neck, which originally consisted of only very faint chasing around the facets, is made up of vegetal friezes with large petals. The tool marks and the scale of the motifs are very different from those on the body. On the neck, the chasing traces are circular, oval or oblong (1.3 x 0.9 mm). A stencil or preparatory drawing under these thick tracings shows thinner chasing in a V-shaped section (W. 0.3 mm). On the shoulder, an inscription addressing the anonymous owner contrasts with a ground of vegetal scrolls in champlevé inlaid with black material. On the body, where a large part of the surface was left plain, there are medallions with vegetal friezes and vases holding sprays of flowers framing a large pointed lobed arch on the front that encloses a drinking figure (fig. 80). This image corroborates the association of this type of vessel with the consumption of wine. The tracing of the chasing is rough and jittery, even imprecise. Areas can be noted where the composition appears to overlap parts of the figure, such as on the hand and the beaker of the drinker, or the inscription where the vegetal traces overlay the letters. Designs combining flower vases and figures participating in a banquet with votive invocations belong to the very widespread visual repertoire of *bazm*. Here represented on a pouring vessel, they associate the function of the object with the context of its use. The same representations can be found on other objects in the collection, such as the feline carpet weight inlaid with copper (cat. no. 9), here linked to Herat production.

Notes

1 For a presentation of the project, see Giunta, 2005 and http/ghazni.bradypus.net
2 Laviola, 2016.
3 Bosworth, 2011C, vol. 2, 169 and 216–17.
4 Bosworth, 1977A, 115.
5 Beyhaqi, 2011, vol. 1, 6; Barbier de Meynard, 1861, 406.
6 Bosworth, 1977B. 1073.
7 Ibn Hawqal, 1964, vol. 2, 402, 432, 435.
8 Beyhaqi, 2011, vol. 1, 95; Bosworth, 2011C, 96–98, 107–108.
9 Ibn Hawqal, 1964, vol. 2, 410, 435–36; De Planhol and Giunta, 2000.
10 Inaba, 2013, 80–83.
11 Bosworth, 2011C, 47; Allegranzi, 2017, 135.
12 Bosworth, 1977B, 1073.
13 Beyhaqi, 2011, vol. 1, 94, 176, 236, 303, 452–53; vol. 2, 194, 237.
14 Bosworth, 2011C, vol. 2, 169, 216–17. Beyhaqi also mentions the new palace of Mas'ud in his chronicle of the year 428/1036, see Beyhaqi, 2011, vol. 2, 194.
15 Bosworth, 1977A, 4.
16 Inaba, 2013, 86.
17 Bosworth, 1977A, 8, 62, 64, 76, 124–25.
18 Juzjani, 1995, vol. 1, 108. For the topography of Ghazna from the ninth to twelfth centuries according to the medieval sources, see Allegranzi, 2017, 133–39, 246–50.
19 Bosworth, 1977A, 97, 101; Beyhaqi, 2011, vol. 1, 23–24; Juzjani, 1995, vol. 1, 111.
20 Allegranzi, 2017, 54.
21 Bosworth, 1977A, 118; Juzjani 1995, vol. 1, 378–79; vol. 2, 100, 1013, 1042–43, 1126–28, 1132.
22 For a synthesis of the archaeological research in Ghazna, see Allegranzi, 2017, 33–40.
23 Laviola, 2016, vol. 1, 56.
24 Marchal, 1974, 18; see 96–98 in this volume.
25 Laviola, 2017A.
26 Marchal, 1974, 10; reviewed by V. Allegranzi in 2016.
27 Formerly in the Nuhad Es-Said collection, Allan, 1982B, no. 2, 36–39, attributed the inkwell to Herat and dated it to the beginning of the thirteenth century.
28 Falk, ed., 1985, no. 262, 257.
29 Rome, Museo Nazionale d'Arte Orientale Giuseppe Tucci; see Laviola, 2016, vol. 1, 182–87.
30 Intervention made in 1993.
31 Marchal, 1974, 10–12, reviewed by V. Allegranzi in 2016 and M. Buresi in 2018.
32 Laviola, 2016, vol. 1, 85, vol. 2, no. 70, 415.

33 Carboni, 1997, 36–37.
34 Paris, Bibliothèque nationale de France, arabe 5847, f. 105r.
35 Read and translated by V. Allegranzi in 2016.
36 No example of either type appears in the archives of the Italian mission in Ghazna, Laviola, 2016.
37 Allan, 1976, vol. 2, 763, fig. 58.
38 According to Ziad el-Morr, these traces suggest the use of a sinking hammer in the first case and a levelling hammer in the second.
39 Marchal, 1974, 14; reviewed by V. Allegranzi in 2016.
40 Allan, 1976, vol. 1, 317–19.
41 Franke and Müller-Wiener, eds., 2016, 133–34.
42 Baypakov, Pidaev and Khakimov, eds., 2012, 94, 123–26, 220–21; Piotovski and Pitrula, eds., 2006, no. 14, 21; and for the title inscribed on the tray, Shaykh al-Amid al-Sayyid, see the title of a mid-eleventh century vizier from Balkh cited by Allan, 1982A, 17.
43 See the same decoration on trays from the region of Ghazna/Kabul in Laviola, 2016, vol. 1, 93–94.
44 Laviola, 2016; Tissot, 2006, 481–87.
45 See above, 94–98.
46 Melikian-Chirvani, 1973, 21.
47 See above, 21–23, for more on this idea. Jean Linzeler gave two objects to the MAD in 1928, this bucket and a folding chair (inv. no. 26497) made in France at the end of the eighteenth century.
48 I would like to thank Isabelle Foumel, in charge of documentation at the MAD, for information on gifts from Jean Linzeler to the MAD and his family relationship with Robert Linzeler.
49 Laviola, 2016, vol. 1, 196–319 for a chapter on the Ghazna buckets transferred in Kabul.
50 Laviola, 2016, vol. 1, no. 213, 205–208.
51 Laviola, 2016, vol. 1, no. 215, 213–21, inscription B, 216, inscription D, 217; no. 216, 222–28, inscription C, 225; no. 218, 234–39, inscription C, 237.
52 Read by M. Bernus-Taylor in 1977; reviewed by V. Allegranzi in 2016.
53 Yarshater, 1960; Beyhaqi, 2011, vol. 1, 453–54; vol. 2, 275–82; Juzjani, 1995, vol. 1, 387.
54 Yarshater, 1960, 49.
55 Museum für Islamische Kunst, IK, I.46/23, H. 6 cm; D. 8 cm; Weight 0.396 kg; von Gladiss and Kröger, 1985, 61–62.

56 Yarshater, 1960, 47.
57 On the use of perfumed water, see Chapter 5, cat. nos. 64, 67.
58 Allan, 1976, vol. 1, 178–80; Allan, 1982A, nos. 90–91, 76–77.
59 Kröger, 1995, 16–17.
60 Collinet, 2015, 132–38.
61 Berlin, Museum für Islamische Kunst, I. 3565, Pope, 1939, vol. IX/1, pl. 1311E.
62 See the bottle with birds, Copenhagen, David Collection, 3/1971, described as being from 'Western Asia or Egypt, ninth-tenth centuries', in Carboni and Whitehouse, 2001, no. 89, 183.
63 Khamis, 2013, 60–62, 306–13; Ponting, 2003 and 2008 for analyses of the materials.
64 DAI, AF 1199, see Appendix 13.
65 One of the sprinklers discovered in Nishapur has the same type of cast base, see Allan, 1982A, no. 90, 76–77.
66 Read and translated by V. Allegranzi in 2016.
67 Franke and Müller-Wiener, eds., 2016, M44 and M45, 122, figs. 30–31, 104.
68 Laviola, 2016, vol. 2, 375–79.
69 Shalem, 1994, 7–8.
70 Allan, 1976, vol. 1, 175–78.
71 Laviola, 2016, vol. 2, 647–49; Ainy, 1980, no. 185; Stein, 1936, pl. XXIX.
72 South and southeast of the Caspian Sea, Melikian-Chirvani, 1982A, 29.
73 Allan, 1976, vol. 1, 176.
74 Lamp: 13% zinc, 3% tin and 20% lead; lid: 8% zinc, 4% tin and 24% lead.
75 Read and translated by V. Allegranzi in 2016.
76 Laviola, 2016, vol. 2, 500–508; however, no lamp of this type has been published that is linked with the site and the Herat Museum.
77 Abdullayev, Fakhretdinova and Khakimov, 1986, no. 6, 47.
78 Baypakov, Pidaev and Khakimov, eds., 2012, 144; fig. 11, 155; 165, pls. III.XIV; figs. 7–15, 163–68, 78–80. The site of Talgar also led to the discovery of metal objects from the pre-Mongol period that are comparable to DAI objects: lamps and tripod stands (cat. no. 46), mirrors (cat. nos. 68, 69), pouring vessels (cat. nos. 36, 37).
79 Three longitudinal infiltrations are visible on the interior of the object with the largest running along the centre of the container and extending to the edge of the spout. On the other hand, no trace of

the mould can be seen on the lamp (cat. no. 40).
80 Read by V. Allegranzi in 2016.
81 Khalili Collection, MTW 626, H. 16.5 cm; D. 16.4 cm; Weight 7.6 kg; the cylindrical mortar has a sloping rim, a flat lip, eight lotus buds, engraved interlaced decoration and an Arabic inscription in Kufic script, see Maddison and Savage-Smith, 1997, 301, no. 176.
82 Laviola, 2016, vol. 2, 603–6.
83 Baypakov, Pidaev and Khakimov, eds., 2012, 179–180, 256–57, III.IV, III.V, 211, III. XXI. For another similar mortar lacking an archaeological provenance, see Berlin, Museum für Islamische Kunst, (H. 16.8 cm), Pope, 1939, vol. IX/1, pl. 1280B; Munich, Kuhnke Collection, Launert, 1990, 95, pl. 50. For the date of this type of mortar see Chapter 5, 277–78.
84 Read by V. Allegranzi in 2016.
85 Paris, 1976, lot no. 82; Melikian-Chirvani, 1976.
86 Read by T. Bittar (no date); reviewed by V. Allegranzi in 2016.
87 Laviola, 2016, vol. 2, 398–401; Franke and Müller-Wiener, eds., 2016, cat. M106, 123.
88 Cambridge, Fitzwilliam Museum, C.61-2019, former Ades Family Collection, H. 34.5 cm; Watson, 1985, fig. 82, 103.
89 Read by V. Allegranzi in 2016.
90 Gardin, 1957, 227.
91 De Planhol and Tarzi, 1988, 658.
92 Juzjani, 1995, vol. 1, 74, 248–49, 260, 267, 421–37, 502–503.
93 Hackin, 1933, 1. On Hackin and Bamiyan, see also Cambon et al, 2018, 64–65.
94 Ball and Gardin, 1982, 244.
95 Louvre, DAI, AA 66. In 1937, Hackin donated to the DAI four ceramic pieces of a type associated with Bamiyan (AA 206–AA 209), but these are also found in other regions in Afghanistan, such as Sistan, and in the Ghur at Firuz-Koh, the summer capital of the Ghurids; see Gascoigne, 2010, 118–24.
96 Rowland and Rice, 1971, pl. 173.
97 Read and translated by V. Allegranzi in 2016.
98 Melikian-Chirvani, 1982A, nos. 36–38, 105–107, presumes shaping by casting and with a lathe.
99 Melikian-Chirvani, 1982A, 60–61.
100 Allan, 1976, vol. 2, 759–62; the dish (Louvre, DAI, AA 62) was published by Marchal, 1974, 13.
101 London, V&A, 768-1889 and 537-1876,

101 Melikian-Chirvani, 1982A, nos. 37–38, 106–107; Herat Museum, Franke and Müller-Wiener, eds., 2016, cat. M83, 128; Samarqand Museum, Baypakov, Pidaev and Khakimov, eds., 2012, 225; Khakimov, ed., 2004, no. 249, 142.

102 Herat Museum, Franke and Müller-Wiener, eds., 2016, cat. M73, 127, and detail 88; London, V&A, M.32-1954, Melikian-Chirvani, 1982A, no. 36, 105–106.

103 Laviola, 2016, vol. 2, 440–45, for eleven examples in Ghazna and Kabul.

104 Melikian-Chirvani, 1982A, figs. 21–22, 61.

105 Allan, 1976 vol. 1, 235; vol. 2, 651, type C/1/a/1, represented by the only example from the Metropolitan Museum 27.13.12; Maddison and Savage-Smith, 1997, 291–93.

106 One of the most famous examples of architectural Ghaznavid epigraphy is the inscription sculpted in marble from the palace of Mas'ud III (r. 1099–1115) in Ghazna. See the Persian poem sculpted on plaques mounted around the palace court; Bombaci, 1966; Allegranzi, 2017, especially vol. 1, 43–58, 159–72, vol. 2, 7–147.

107 Reading, interpretation and translation by V. Allegranzi in 2016.

108 Maddison and Savage-Smith, 1997, 291, 300–2.

109 Laviola, 2016, 605; Melikian-Chirvani, 1982A, fig. 34, 66–67; Baypakov, Pidaev and Khakimov eds., 2012, 141, 170.

110 2009 restoration, reducing the concretions and corrosion, and making the corrosion stable.

111 Read and translated by V. Allegranzi in 2016.

112 Melikian-Chirvani, 1975B, 194–95, pls. IX and X.

113 Franke and Müller-Wiener, eds., 2016, 99; Siméon, 2012.

114 Loukonine and Ivanov, 1995, no. 99, 121.

115 Franke and Müller-Wiener, eds., 2016, fig. 23, 99 and cat. M41, 122.

116 Read and translated by V. Allegranzi in 2016.

117 Kröger, 1995, no. 235, 182–83.

118 Rice, 1955, 227 and fig. 14.

119 Louvre, DAI, OA 6155 to OA 6163. Inventory of the DOA, OA 6000–OA 7847 (9DD7) 29–33; Inventory of the DAI, general inventory 1, MR 194–MAO147, 76–80.

120 Louvre, DAI, OA 6155 is a dish inlaid with silver of the Mongol period. The

elements of shields, OA 6161 and OA 6162, were not analysed for the ISLAMETAL project because a thick layer of corrosion on the substrate prevented accurate sampling. See however, the analysis published by Allan, 1979, Table 21, 143.

121 Sijistan in Arabic. Ibn Hawqal, 1964, vol. 2, 391, 401; Bosworth, 2000, 31–32; Bosworth, 2011A and 2011B.

122 Ibn Hawqal, 1964, vol. 2, 401–13.

123 Scott Meisami, 1999, 109, 115, 117; Bosworth, 2002, Bosworth, 2011C, 46.

124 Bosworth, 2010; Scott Meisami, 1999, 131; Bosworth, 1977A, 30, 44.

125 Beyhaqi 2011, vol. 1, 53

126 Scott Meisami, 1999, 109, 111; Bosworth, 2000, 31.

127 Hackin, 1936; Gardin, 1959.

128 Juzjani, 1995, vol. 1, 355, 392, 422; Bosworth, 1977A, 118.

129 Ball, 2008, 240–46; Ball and Gardin, 1982, 63, 176–77; Schlumberger and Sourdel-Thomine, 1978; Fischer and de Planhol, 1989; Gardin, 1963.

130 New York, MMA, 33.96, Mayer, 1959, 37, 65, Wiet, 1931, 160; Wiet 1933, 17–18, pl. IV; the object might have modern decoration.

131 Allan, 1979, 53.

132 Giunta, 2001, figs. 6–8, 115–18.

133 Baer, 1983, 52–55.

134 Boston, Museum of Fine Arts. 46.1135; Allan, 1976, vol. 2, 745–49.

135 Tissot, 2006, 481; Laviola, 2016, vol. 1, 127, vol. 2, 597.

136 Baypakov, Pidaev and Khakimov eds., 2012, 140, 197, 214, III. XXXIII and III. XXXIIIa.

137 See above, 43, see also the V&A incense burner, M.78-1957, H. 19.5; D. (base) 9.2 cm; Thickness 1.5–2.5 mm, Melikian-Chirvani, 1982A, 42–43.

138 See also the incense burner in Saint Petersburg, Hermitage Museum, ИР 1669, Loukonine and Ivanov, 1995, no. 102, 125.

139 Observation made by Bourgarit and Collinet, November 2017. The bird seems to be an addition or repair as its scale is bigger in relation to the object and it does not have the same patina.

140 Washington, Freer Gallery of Art, 77.5, Atil, Chase and Jett, 1985, no. 12, 92–94.

141 Identified by Marchal, 1974, 15; reviewed and translated by V. Allegranzi in 2016.

142 Allan, 1986A, 120–121.

143 Kabul, National Museum of Afghanistan, 58-2-26, H. 17.2 cm, Tissot, 2006, 482; Allan, 1976, vol. 2, 598; Laviola, 2016, 653. For other objects of the same type, see Melikian-Chirvani, 1982A, 29–31; Allan, 1976, vol. 2, fig. 22 and 598–99; Laviola, 2016, vol. 2, 651–58.

144 Melikian-Chirvani, 1982A, 29.

145 Identified by Marchal, 1974, 15; reviewed and translated by V. Allegranzi in 2016.

146 Marchal, 1974, 15.

147 New York, MMA, 38.40.133, L. 15.2 cm; H. 5.3 cm, Allan, 1982A, no. 106, 88–89.

148 Kröger, 1995, 18.

149 Tehran, National Museum of Iran, L. 11.3 cm, Allan, 1982A, no. 109, 88–89.

150 Laviola, 2016, vol. 2, 503.

151 Baypakov, Pidaev and Khamikov, eds. 2012, 144, 212, no. XVIIa.

152 Allan, 1982A, 48.

153 Two older fillings were removed during restoration of the object in 2011.

154 Allan, 1976, vol. 1, 270–72.

155 Allan, 1976, vol. 2, 696–700.

156 Laviola, 2016, vol. 2, 514–23, especially 522.

157 Achkhabad, Academy of Sciences of Turkmenistan, Institute of History, Archives of the Department of Archaeology, Ainy, 1980, no. 190.

158 Melikian-Chirvani, 1982A, 57, 60, nos. 32–34; 102–104.

159 Melikian-Chirvani, 1982A, no. 35, 104–105.

160 Marchal, 1974, 8–9.

161 Read by V. Allegranzi in 2016. These are the basin (cat. no. 35) and the ewer (cat no. 24).

162 London, V&A, 1532.1903, H. 15 cm; W. 9.5 cm; D. (base) 7 cm, Melikian-Chirvani, 1973, 30; Melikian-Chirvani, 1982A, no. 32, 102. Observation made by Bourgarit and Collinet, November 2017.

163 See the paintings at Lashkar-i Bazar, Schlumberger, 1959; Schlumberger and Sourdel-Thomine, 1978. See also the paintings at Samarqand, Karev, 2005 and 2013.

164 Melikian-Chirvani, 1982A, no. 86, 190–192; Komaroff and Carboni, eds., 2002, fig. 211, 179 and cat. no. 169, 280.

165 Beyhaqi, 2011, vol. 1, 153 and vol. 3, 71–72, note 303.

166 Basin from Nishapur/Shadiakh: excavations led by R. Labbaf Khaniki, University of Mashhad, ICHTO, 2001–2005, unpublished; basin from Samarqand, Museum of History of Art

and Culture of Uzbekistan, A 176-61, chased decoration and silver inlay, H. 8 cm; D. 34 cm, Shishkina and Pavchinskaja, 1992, no. 334, 121.

167 Allan, 1982A, 20.

168 Laviola, 2016, vol. 2, 466–79; Franke and Müller-Wiener, eds., 2016, 134–35.

169 Melikian-Chirvani, 1982A, 63.

170 Watson, 1986, 206–207.

171 Melikian-Chirvani, 1992, 108–9; De Fouchécour, 1969, 60–61, 193.

172 Saint Petersburg, Hermitage Museum, CA-12680, Loukonine and Ivanov, 1995, no. 124, 142–43,

173 London, V&A, 758-1889, Melikian-Chirvani, 1982A, no. 19, 85–86. Observation by Collinet and Bourgarit, November 2017.

174 Allan, 1982A, 19; Khamis, 2013, 53.

175 Al-Ush, 1976, figs. 74–76, 173–75; Salibi, 2004; inv. no. 6, 87 and pl. 44a; inv. no. 37, 88 and pl. 52b.

176 Hameed, 1967, fig. 1–4, 146–47; Khamis, 2013, 54.

177 Khamis, 2013, 2–7, 53–55, no. 190, 158, 296, 53.

178 Pb 11.5%; Zn 16.4%, Sn 1.5%; Ponting, 2003, Table 2, 102, no. 575:85.

179 Ponting, 2003, 90; Ponting, 2008, 44.

180 Allan, 1976, vol. 2, 622–24, fig. 28; Melikian-Chirvani, 1982A, 85–86.

181 Kröger, 1995, 14.

182 New York, MMA, 38.40.240, Allan, 1982A, no. 100, 82–83.

183 Merv Museum, archives of the DAI, photography by Th. Bittar, 1995.

184 Baypakov, Pidaev and Khakimov, eds., 2012, 207, pl. III.X–XI, 135–36.

185 Laviola, 2016, vol. 2, 369, 371.

186 Marshak, 1972.

187 Baypakov, Pidaev and Khakimov, eds., 2012, pl. III.II and IV, 162, 93, fig. 6, 145.

188 Baypakov, Pidaev and Khakimov, eds., 2012, 79.

189 Read and translated by V. Allegranzi in 2016. The pseudo-inscriptions have the same sequence of letters as cat. nos. 24 and 34.

190 HNM 04;05;86, D. 53 cm, Franke and Müller-Wiener, eds., 2016, no. M117, 135.

191 Read by V. Allegranzi in 2016.

192 Completed by Farhad Kazémi and Nicolas Mélard, curators, Musée du Louvre and C2RMF, whom I thank for this opportunity.

193 Read by Th. Bittar in 2001, reviewed by V. Allegranzi in 2016.

The Context of the Objects

T

he metal objects—with a status that ranges from utensil to work of art—raise the question of their functions. When considered in terms of sociology and meaning, that is to say their more abstract roles, the metalwork pieces provide insights into the links between their use and their contexts, both material and symbolic.

The Urban and Social Context

The large number of copper alloy objects that survive from the pre-Mongol period demonstrate that this material was widely used in the manufacture of furnishings, vessels and utensils. They illustrate both the diversity of medieval types and the variety of their status—ranging from modest serial production to works of art inlaid with precious metals. These variable qualities suggest equally distinct contexts of use that that are more or less known. Thanks to textual references, to find sites and to a few known signatures, it has been convincingly established that the extant metal objects were produced, sold and used in cities. As referred to in Chapter 1, the development of cities played a significant role in the production of portable metal objects that circulated widely in bazaars. The dense urban network was connected by roads across medieval Khurasan and many cities with thriving markets are cited in the sources.[1] As with other artefacts, copper alloy wares circulated from city to city, sometimes across huge distances, as shown by certain types of objects that are evidence of the material, visual and artistic culture of the pre-Mongol Iranian world (Chapter 4). Many types of metal wares are also known in ceramics, as attested by the numerous comparable objects preserved in both materials. The metal models[2] thus circulated in the Iranian world through the production and commercial exchange of copper alloys but also of siliceous and clay-bodied ceramic wares.

The question of the context of the object relates to its social function, understood from its purpose and the circumstances of its practical as well as symbolic use. In this sense, the objects are both anthropological and social markers. The most commonly preserved metal wares are related particularly to food, to care of the body and to medical practices, and were used in domestic

contexts as well as in bazaars. Other types were used in more affluent domestic contexts, in structures linked to elites or in public monuments. Objects bought in the market, as well as commissioned works, represent a rich visual culture in which figural and calligraphic compositions were used. Artefacts with figurative and graphic compositions refer to a vast literary and poetic culture, largely Persian. They belong to a visual culture of allusion and can thus be considered, beyond their material function, as carriers of a visual language relating to other images that could be pictorial or intellectual, poetic or even devotional. Indeed, the chased or inlaid inscriptions on the metal objects are often divine invocations: they also constitute a visual language which can be considered a form of intercession. The frequent use of epigraphy on metalwork in the medieval Iranian world forms part of a global context of artistic production in this vast geographic expanse, beginning in approximately the tenth century.[3] Texts found on architecture and objects thus characterise the visual and literary culture of the Iranian world. Especially in the case of metalwork, glass and ceramics, or 'the arts of fire', the repertoire of texts on furnishings and portable objects used in domestic and reception contexts is relatively well documented.[4]

Knowledge of the contexts of use can come from archaeology, particularly when objects have been uncovered during horizontal excavations in which structures are extensively excavated. The interpretation of the distribution of objects within an archaeological structure, or in terms of the scale of a site, helps to identify their function and status. Although it is exceptional to uncover metal objects, two inkwells can be cited that were found in a palace in Ghazna,[5] and the Tiberias metalwork that was found in a workshop where copper alloys were repaired and recycled.[6] The social context of metal objects can also be identified when they are represented in illustrated manu-scripts: cauldrons and mortars are depicted in medical treatises; lamps, lampstands and other furnishings are shown in interiors. Such objects, whether excavated or illustrated, constitute the traces of social and domestic practices. Vessels and furnishings give an indication of ways of living in a domestic or public structure such as the bazaar or the mosque.[7]

Material and Symbolic Functions

The material function of an isolated object, or one belonging to an archaeological assemblage, is identified by its typology, with its form pointing to one or more functions. Pouring vessels are easy to identify, but understanding whether they were used for drinking, for washing or for care of the body is often more difficult. Certain practical functions are also recognisable by their traces on the objects: those used to cook food or to prepare products with heat are likely to show traces of smoke and/or combustion. However, identifying what was presented or consumed in the vessels, as well as the social contexts in which they were employed, requires the use of sources other than the objects themselves. Written texts allow us to understand the material and symbolic contexts of certain categories of object. The visual culture of the elites of the medieval period can, in effect, be approached through texts involving the imagination, such as poetry, a literary form that between the tenth and eleventh centuries was both witness and protagonist in the shaping of the intellectual and cultural context. Poetic thought and language developed analogy as a mode of perception and conceptualisation. Descriptions are expressed symbolically: a subject is visually referenced by a sign, or a set of signs, rather than by a direct representation. The identification of particular vessel types in the poetic or lexicographic sources has been well established in key studies by Melikian-Chirvani, notably in the case of objects linked to wine rituals in the

Iranian world. These vessels, which include zoomorphic elements, had a symbolic function and were linked to specific uses. Other objects, such as zoomorphic sculptures, might further illustrate the link between material and symbolic use, between artefact and mental image.

Objects whose original contexts are not known are nevertheless vectors of meaning: it is a question then of considering the objects themselves as indicators of their context, be it material or symbolic. Such interpretations can be made from what the objects themselves express through their types, their inscriptions and their status, all of which are often related to the quality of their materials. In this analysis, the role of the material dominates. As Avinoam Shalem has shown, establishing links between the shape, the function, the material and the ornament that formed the aesthetic and the appeal of an object was a practice that existed in medieval society, and appeared in the writing of al-Biruni.[8] It was this very author who remarked on brass having the appearance of gold (see above, 56). In the art of metal, the substitution of materials appears to have been a key idea. The illusion of, or allusion to, gold through the use of copper alloys, particularly brass, together with the form and surface decoration, could produce a very attractive object at a lower cost than one made with gold.

FURNISHINGS AND THEIR USES

The objects in the collection that can be understood as coming from domestic contexts were no doubt part of the furnishings of wealthy homes. Indeed, these are objects of average to good quality, particularly in terms of their shaping, as shown by observations made for the ISLAMETAL project. However, these metalwork objects do not constitute a homogeneous group, and some are of more modest quality than others. They were all cast, largely with the lost wax method. Some have only a little cold work: these are objects for which the working of the material—in the round, in relief, with openwork—took precedence over the surface decoration. Only a lampstand and a padlock (cat. nos. 47, 56) are decorated with metal inlays. Most of the objects are inlaid with black material and certain sculptures with glazed ceramic. They are mainly attributable to Khurasan, although some types such as a jug (cat. no. 62) may have been produced in Mawarannahr, an attribution based on its similarities to other objects found in Central Asia.

The largest group consists of objects linked to lighting, such as oil lamps and lampstands, and to the burning of odorous substances. Some of the incense burners are zoomorphic sculptures, as are other types of objects with a more enigmatic function (cat. nos. 49-51). Some objects are serving ware, categorised here according to their use during receptions: these are mainly bottles and jugs, a group that is well documented in the medieval Iranian world. Another object in this category is a shovel, perhaps used for serving rice, of which the DAI holds one of the few known examples (cat. no. 65). Objects linked to bodily care include mirrors, with only one piece that might be a perfume flask featuring in the pre-Mongol collection (cat. no. 67).[9]

The uses of the objects grouped here are not always well defined. However, they testify in some cases to a complex visual culture, where the symbolic functions of objects were closely tied to their functional uses. This link undoubtedly operated within a system of analogies that was well known in the episteme of the medieval period. It can be found in poetic works and in treatises on the occult sciences.[10] Most of these metal objects have zoomorphic shapes or representations of animals on the surface. This bestiary refers to the cosmography, literature and poetry that

was being produced in the medieval Iranian world, a material visualisation of scholarly texts and writings. Thus, *bazm o razm* (feast and battle) is commonplace in medieval Persian poetry and is linked to the figure of the prince.[11] The latter is frequently associated with astronomy, which includes representations of the ruler in his cosmic and symbolic dimensions. Creatures such as griffins, harpies, sphinxes and dragons were also often linked to the princely hunt, within the cosmic symbolism of the sovereign's power. These creatures, together with astronomical motifs, belong to what is known in Persian texts as *bazm-e falak* (feast of the heavens).

Lighting Devices: Lamps and Lampstands

The lighting of residential and public buildings is relatively well known thanks to depictions of lamps and lampstands in paintings. Historical sources also mention exterior lighting in princely contexts. For instance, Beyhaqi refers to torches and candles being used for lighting in Ghazna.[12] Lanterns were also used, probably outdoors as the flame is protected: a type of openwork lamp known in ceramic does not seem to have been produced in metal.[13] Candlesticks and especially oil lamps and tall cylindrical stands are common in both materials. The combination of a tripod support and a lamp is known from manuscript paintings: in the famous manuscript of the *Kitab al-Diryaq* (Book of Antidotes), Pseudo-Galen, dated 595/1198–99,[14] a doctor reads in front of a lampstand resting on the ground. However, the two objects were not always linked as lamps could also be placed in wall niches—and thus elevated, they were more effective as the light was reflected off the walls. Such a display is attested to in a domestic building identified in the Ghurid capital of Jam/Firuz-Koh, where a ceramic lamp was found placed in an alcove in the corner of a room (height approx. 40 cm).[15]

Oil lamps and their stands are among the most numerous metalwork objects to have been preserved from the medieval Iranian world.[16] Objects and furnishings related to lighting are very common types since every domestic structure required lighting. More than the nature of the objects, it is their quality, their dimensions and the complexity of their shapes and decoration that allow their status to be determined. One of the notable characteristics of oil lamps from the pre-Mongol period is their wide variety. They range from small single-spouted lamps of very simple manufacture to large objects with zoomorphic elements—the lid, feet and/or handle—making these objects look like animal sculptures.[17] Their function as lighting devices is then doubled by their symbolic function as emitters of divine light. This is suggested by lamps evoking birds or with birds in the round, including the Simurgh, as well as those with parts reminiscent of

felines. These creatures are linked to ascension towards the heavenly throne or its light, and the lamps are often inscribed with divine invocations that reinforce or substitute this association. The oils used in the lamps could have been perfumed and sometimes involved in occult practices.[18] The DAI collection contains lamps of different types as well as tripod stands designed to hold a single lamp. The majority of these objects are fragmentary: the lamps were largely supported on one or more feet, had a lid, a handle or a thumb rest, one or all of which have frequently disappeared. They form a group of fine quality, with examples ranging from more common types to exceptional ones. Lamps with figural scenes and in one case, a high openwork stand, illustrate the refinement of some types of manufacture (cat. nos. 43, 44). They also have visual references to cosmography and to the poetry of the medieval Iranian world. The lampstands in the collection are incomplete and one with a tray (cat. no. 47) is the result of an older repair or a modern reconstruction. They are similar to the most common types from the pre-Mongol period and like the lamps, the decoration on some examples contains allusions to cosmic and divine light.

Lamps on a faceted foot (cat. nos. 38, 39)

Although fragmentary, these two lamps resemble an example from Sistan (cat. no. 34). Their original handles and lids are missing, and one has lost its foot. The lids were hinged; the handle and the high foot were soldered to the back of the container and to the base. These one- or two-spouted lamps have the same almond-shaped opening as the lamp with a harpy (cat. no. 34). This type of lamp, which appeared around 1150, comes from Afghanistan according to the archaeological and commercial history of the majority of documented examples from Mazar-i Sharif, Kabul and Ghazna,[19] or were acquired in Afghanistan, particularly in Kabul.[20] Those resting on the base of the container have traces of solder and of a missing foot: if we reconstruct their original form, all are probably of a similar type; only the handle and the single or double spouts show variations.

38
Lamp with two spouts

Khurasan, Afghanistan or Iran (Rayy?), twelfth century

Cast high leaded brass, champlevé, chased and engraved decoration, inlaid with black material

L. 8.6 cm; W. 6.7 cm; H. max. 6.4 cm; H. (without lid) 3.2 cm; Thickness min. (wall) 1 mm; Average thickness 3 mm; Thickness max. (lid knop) 5.5 mm; Weight 0.172 kg

Compass engraving W. 0.5 mm

Chasing W. 0.5 mm

This small lamp has a brown patina, with stable corrosion. The lid is not original: it is of a different composition and does not fit the shape of the opening of the container. On the base, the scar where the foot was torn off is clearly visible. It has been filed so as to flatten it and stabilise the object. On the back of the container, a trace of solder suggests the presence of a handle, now disappeared.

Transferred by the Département des Antiquités Orientales in 1925; inv. OA.7871/34

According to information in the inventory, this lamp was bought by the archaeologist Roland de Mecquenem in Iran in 1925 and would have come from the site of Rayy, south of Tehran. It might therefore be an object that was not produced in Khurasan. The alloy that was used for this lamp and the copper impurities (Appendix 1) do not distinguish it from alloys in the DAI pre-Mongol collection, which are largely associated with the eastern Iranian world. The cold worked tracing on the surface resembles that found on the rest of the collection. Two compass-engraved circles on a vegetal background decor-ate the flat surfaces of the spouts, while the sides show birds. One line of text, an unread votive pseudo-inscription in Kufic script, is located in a cartouche at the back of the container. This decoration too is not very different from that of objects produced in Khurasan. However, the method of shaping is very different from two other lamps with the same type of container and opening (cat. nos. 34, 39): the flat top and the container were soldered rather than cast in one piece. This lamp is unique in the collection for being shaped with this method.

39
Lamp with reclining felines

Khurasan, Afghanistan, twelfth century

Cast high leaded brass, champlevé and chased decoration, inlaid with black material

L. 12.6 cm; W. 9.9 cm; H. 11.5 cm; Width (base) 8.5 cm; Thickness min. (base) 1.3 mm; Thickness max. (handle) 10 mm; Average thickness 2–4 mm; Weight 0.536 kg

Chasing (U-shaped section) W. 0.4–0.5 mm

Champlevé W. 1.2 mm

File W. 1.2 mm

The yellow surface, which is rubbed down to the epidermis, has areas of stable corrosion and red colour. The metal has been abraded and probably cleaned with an acid solution, as suggested by the porous surface and the alteration of the reliefs. The object has lost its handle, as shown by traces of tin solder on the back, and its lid, of which part of the hinge remains. Small holes are also visible on the edge of the spout, which is broken. The base is chipped, and the flat side of the container is dented.

Purchase, Joseph Soustiel, Paris, 1976; inv. MAO 502

INSCRIPTION[21]

On the flat top in two cartouches: blessings in Arabic in *thuluth* script

العز و الاقبال و الدوال/ـة ؟ و الدوامة و ا(...)

al-ʿizz wa al-iqbāl wa al-dawāl/a ? wa al-dawāma wa alif (...) / glory, fortune, success, long life, *alif* (...)

This object belonged to the collection of André Nègre which was assembled in Afghanistan and sold in Paris in 1976. Other metalwork objects in the DAI collection were also formerly in his collection.[22] The lamp was cast, as shown by the small defects resulting from irregularities in the wax model or in the filling of the mould, as well as by the flashings and cavities caused by air bubbles in the wall of the container and the foot. On the base of the container, a plug may conceal where the foot was soldered; it is therefore not certain that the casting was completed in one piece (fig. 82). The lamp has an octagonal base and a faceted foot. On the sides, two reclining cats with bodies in relief and heads in the round form the handles. On the foot and the sides of the container are birds and vegetal friezes, rendered by casting and cold worked after shaping with chasing and champlevé.

Fig. 82

X-ray of the lamp with reclining felines (cat. no. 39).

82

217

Lamps with feline-headed lids (cat. nos. 40, 41)

Lids with the flattened head of a feline emerging from the circular surface give an almost zoomorphic appearance to these lamps and resemble the example attributed here to Ghazna (cat. no. 21). Several forms of lamp with one or more spouts and resting on a foot or flat base have this type of lid. They circulated largely in Khurasan and Central Asia before the end of the twelfth century.[23] The association between felines and light evokes astrological representations that were common in medieval visual culture in which the lion was associated with the sun. This connection also had protective properties, perhaps an evocation of the constellation of Leo as described by Yaqut in the 1220s. He mentions that the door of the Iranian city of Hamadan bore the image of a lion in relief made by a magician which served as a talisman to temper the extreme winter conditions to which the city was often subjected and for which it had an unfortunate reputation.[24]

Khurasan, Afghanistan, twelfth century

Cast high leaded brass, openwork, chased and engraved decoration, inlaid with black material

L. 11.5 cm; W. 8.6 cm; H. 7 cm; D. (opening) 4 cm; Thickness min. (wall) 1 mm; Thickness max. (handle) 9 mm; Weight 0.244 kg

Chasing (rectangular) W. 0.6 mm

The surface has a light brown patina with areas of stable green-brown corrosion. The handle and foot are missing, and traces of these parts are visible in the remains of tin solder under the foot and at the back of the container. A square area in relief seems to have been cut or filed down to flatten the broken handle. The object is altered by two gaps and a transversal crack, a deformation at the edge of the spout and a dent in the openwork decoration.

Purchase, Galerie Jean Soustiel, Paris, 1990; inv. no. MAO 853.

This lamp, which is of fine workmanship, was shaped by lost wax casting, as indicated by the traces of smoothing of the model on the base of the handles, and the flashings and metal infiltrations inside the lid, the spout and the container. A core pin remains in the wall; its presence suggests that the shaping method was different from the one observed on the lamp with a feline head attributed to Ghazna (cat. no. 21), which has a seam along the mould joint. The openwork around the opening and all the areas in relief were made by casting: these include the openwork band which has defects, the feline head on the lid which was cast separately and attached to the lamp by a hinge, the scrolls on the sides of the container, the button-shaped handles and the band around the spout. The lid is original: analysis has shown that it was made of the same alloy as the body of the object, the dimensions correspond and the hinge system is preserved. The vegetal decoration was completed during the casting of the wax model and cold worked by chasing with clean and regular traces (fig. 23b).

41
Lamp with six spouts

Khurasan, twelfth century

Cast high leaded brass, champlevé, engraved and filed decoration

D. 24 cm; H. max. 8 cm; Thickness min. (spout) 1.5 mm; Thickness max. (handle) 8 mm; Average thickness 2–3 mm; Weight 0.684 kg

Engraving W. 0.5 mm

Champlevé W. 1.6 mm

File W. 1.2 mm

The surface is covered with a brown homogeneous patina, with areas of stable red and green corrosion. The thumb rest of the handle is broken. The object has two cracks and small gaps, particularly at the edge of the spouts. At the bottom of the container, the surface is partially covered by a layer of varnish or yellow wax, with shiny drips on the corrosion layer that may be linked to the application of the exterior patina.

Purchase, Ayoub Rabenou, Paris, 1928; inv. no. OA 7958

Circular marks on the base suggest that the lamp was not intended to lie flat but was originally soldered to a pedestal. The thumb rest on the handle is now broken and missing; it would have added extra height to an object that must have been quite imposing. By reconstructing the shape in this way, this object resembles several large lamps in Iranian collections that have multiple spouts, a flat-bottomed container raised on a high foot and a handle surmounted by a large thumb rest or, in some cases, a vertical post.[25] The lid is attached to the body by a hinge that seems original. It was cast separately from the lamp which was cast in one piece with the lost wax process as indicated by tool marks in the wax model visible on the edge of the opening of the container and by a core pin still in the bottom of the object. Casting defects and shrinkage porosities are clearly visible on the wall, on the handle and on the base near the handle. The fragmentary spout cannot be seen in the photograph: it has not been broken but is the result of a major casting defect in the manufacturing process. It is possible that the lamp was repaired so that it could become functional and that the filling of the spout later disappeared. The lid has an empty cavity at the top which might have previously housed glass or glazed ceramic inlay comparable to other objects in the collection (cat. nos. 8, 52, 53). No trace of metallic inlay or black material was observed. The container is decorated with champlevé, a vegetal frieze and flowers running down each spout; the florets on the edge of the spouts were made with a file.

42
Lamp with a bird on the lid

Khurasan, eleventh to twelfth century

Cast high leaded copper

L. 15 cm; W. 6.6 cm; H. 13 cm; D. (opening) 3.1 cm; D. (lid) 3.8 cm; Thickness min. (spout) 1 mm; Thickness max. (foot) 9.8 mm;| Average thickness 1–2 mm; Weight 0.384 kg

The lamp is in good condition. Its dark brown surface results from an artificial patina. The thumb rest on the handle, broken at an unknown date, has been repaired. A repair visible on the back that is perhaps contemporary with the object's arrival on the art market is covered by patina; metal plates have probably been soldered on to reconnect the handle and the container. A metal plate possibly made of copper that was fixed to the interior of the right-hand spout was observed with endoscopy.[26] A repair with a plug is visible on the outside of the wall and dates to the manufacture of the object. In effect it would have been unusable without this plugging of the casting defect.

Purchase, Galerie Jean Soustiel, Paris, 1985; inv. no. MAO 760

The lamp rests on three slender feet that recall bird's legs. It is complete, having retained its original lid and hinge, as well as its handle. The lamp consists of two separately cast parts with the container, the feet and probably the handle made in one casting, and the lid in the other. The rounded lid is surmounted by a bird in the round that serves as a thumb rest. The little bird is visibly joined with the surface of the lid: this is the metal transposition of the join between the two parts of the wax model. The two-spouted container is connected to the three feet in the same way. The lamp was thus made with the lost wax method, as suggested by the tool marks on the intersections, some with poor joins due to casting defects such as flashings in the bottom of the container and a casting repair in the wall. There is no decoration other than the three-petalled florets on the rim of the spouts, or it is completely hidden by the patina. These florets are similar to those on the six-spouted lamp (cat. no. 41).

Like many other lamps produced in Khurasan during this period, the overall appearance of this object suggests a bird. Those with two or more aligned spouts usually rest on three angled legs. The spouts have a flat edge, often finished with a vegetal pattern. The almond-shaped thumb rest on the handle recalls a wing. Today, these objects appear as more or less abstract sculptures, devoid, or almost devoid, of surface ornament, operating visually only through their shape. Several incomplete examples very similar to the Louvre lamp are extant, but their provenance is poorly documented.[27] The link between the function of these objects and the symbolic meaning of light is suggested by the presence of the bird on the lid and the overall ornithomorphic appearance of the lamp.

43

Lamp with Zal and the Simurgh

Khurasan, eleventh to twelfth century

Cast high leaded brass, openwork, chased and filed (?) decoration

D. 19.3 cm; H. 13.8 cm; Thickness max. (foot) 9 mm; Average thickness 2–3 mm; Weight 1.010 kg

Several parts of this lamp are missing: the separately cast lid, the bent section of the left front foot, two florets at the end of the spouts, two small rings under the spouts and the thumb rest of the handle. The two openwork knops on the sides of the lamp are also fragmentary. A few casting defects such as cracks and a gap near the back foot are visible. The interior is covered with concretions; the exterior has been rubbed and is very worn. The yellow alloy appears in places under the brown-coloured artificial patina. Areas of green and red corrosion are visible over and under the patina.

On long term loan from the Musée de Cluny (Musée national du Moyen Âge), 1928; inv. no. OA 7958/2 (former no. CL 13561)

Unpublished before 1973, this high-quality lamp remains one of the highlights of the pre-Mongol collection,[28] particularly given its theme of ascension which is of poetic and mystical inspiration. The character clinging to the monumental bird with outstretched wings can be identified as Zal, who was taken into the skies by the mythical Simurgh. In the *Shahnama* (Book of Kings), the epic Persian poem sent to sultan Mahmud of Ghazna by the poet Ferdowsi c. 409/1018 and still recited in Iran, the story of this ascension takes place early in the reign of King Manuchihr. Zal, son of Sam, was born with black eyes and the white hair of an old man. To conceal his ill-starred fate from the world, Sam has the child brought to the Alborz, a mountain close to the sun and far from people, where the Simurgh lives.[29] The bird descends from the sky to save Zal and brings him to his nest, where he grows to manhood. In Persian literature, the theme of ascension is also widely associated with the mythical figures of the kings Kay Kavus and Alexander the Great.[30] The latter appears repeatedly in the Book of Kings and entire texts are dedicated to him, such as the *Iskandarnama* (Book of Alexander) by Nizami, completed around 599/1202. His ascension, which also appears in most versions of the *Romance of Alexander* that circulated around the medieval Mediterranean world, recalls that of Kay Kavus where the king flies away in a cradle or throne carried by birds of prey.[31]

83

Although larger, in many respects this lamp has the same morphology as the previous example: it has a similarly shaped container with a circular opening, a flat bottom and an identical handle, originally topped with a now-missing thumb rest. The three angled legs, in a shape that echoes the three spouts, are also similar to the lamp with a bird (cat. no. 42). On the sides, the openwork projections were used to attach a handle or a suspension chain; they are incomplete but would have included hinges and probably rings. The lamp might have thus rested on a support or could have been hung—a possibility that recalls the figurative theme of Zal's ascension into the heavens. The method of shaping the two lamps was also similar, using a two-part lost wax casting: the lid in one casting and the lamp, with the feet and the figures, in the other. Inside the wall, two core pins can be seen in the front, on either side of the eagle. Traces of tool marks in the wax model which were transposed into the metal during casting can be seen in the join above the handle, which therefore included a thumb rest, but also on the fragmentary suspension knops. Zal and the Simurgh were modelled in wax and then connected to the container.

As with the lamp with a bird (cat. no. 42), the visual impact is entirely based on the shape and volume of the lamp, in this case including knops projecting from the sides, but above all the bird and the figure which are treated more as reliefs than in the round but stand out clearly from the wall and the spouts (fig. 83). On the feet and under the hooves, as well as around the openwork of the knops and at the end of the floriated spouts, the only patterns that mark the surface of the metal are those made by chasing and/or filing, perhaps cold worked after the casting.

Fig. 83

Lamp with Zal and the Simurgh (cat. no. 44): details of the faces modelled in wax.

44
Lamp with a figure leading two horses

Khurasan, eleventh to twelfth century

Cast high leaded copper, openwork and chased decoration, inlaid with black material

H. max. 21 cm; W. max. 17.8 cm; Weight 0.908kg

Lamp: H. 5.7 cm; W. max. 9.4 cm; Thickness (edge) 2.5 mm; Thickness (wall) 1.5 mm; Weight 0.370 kg

Stand: H. 11.3 cm; W. 9.3 cm; Thickness 2.2–2.4 mm; Weight 0.538 kg

Thumb rest: Thickness 2.5 mm

The lid of the lamp is missing and only a fragment of its attachment to the hinge remains. Originally the object consisted of three separate parts. The stand is slightly unstable as one of the legs is a little shorter than the others. A repair is visible on the back of the thumb rest. The object may have been coated with an artificial patina that has homogenised the appearance of the lamp and the base. It seems that the surface tracing has been refreshed quite recently.

Purchase, Indjoudjian (Gallery?), Paris, 1927; inv. no. OA 7890

INSCRIPTION[32]

In four cartouches at the top of each side of the stand: in Arabic, in plaited and floriated Kufic script, the term الملك, *al-mulk* (royalty)

84

Several lamps that are similar to this example have been published, but none are known from an archaeological context. Two were offered for sale at an auction in Paris:[33] both have lids and the one that most resembles this one has a feline-headed lid similar to the DAI lamps (cat. nos. 21, 40, 41). By virtue of its type and the sculptural and openwork elements that characterise it, the present example was associated, as soon it was acquired and later in its publication by Pope and Ackerman, with the production of the pre-Mongol Iranian world.[34]

This object has two striking features: the first is that it cannot function without its stand because the base of the lamp was designed to fit into it, and the second is that the very imposing thumb rest is a figurative element made from a wax model. It is a small, complete, portable piece, made in two parts, and judging from the small number of surviving examples, this type of object was much less common than the more usual tall tripod lampstands (cat. nos. 45–47). Much shorter than the tripod stands, this type of medium-sized object was intended to be placed in a niche or raised on a piece of furniture. It was designed to be seen from the front: the scene represented on the thumb rest has a full-length frontal figure with an incised body and a head in the round. He is dressed in some kind of tunic and holds the reins or halters of each horse in each hand; their heads are shown in profile with their chests concealed, perhaps by their caparisons. This image of a horse driver is known from comparable thumb rests and others that have become detached. It may be a representation of the constellation of the charioteer known as Auriga, *mumsik al-ainna* (the one who holds the reins), or *al-inaz* (the goats), represented in al-Sufi's *Kitab suwar al-kawakib al-thabita* (Book of Fixed Stars)

as a figure of a standing man.[35] In Ptolemy's Almagest and in Greek mythology, the charioteer is known as Erichthonios, the hero associated with the invention of the terrestrial *quadriga*. The constellation of the charioteer is linked to the equinox and therefore to the advent of spring and New Year (*nowruz*) in Iran.

The lamp and the support with a cylindrical shaft are held together by a bracket that inserts and twists into the top of the stand. This system of assembly is well known in the pre-Mongol Iranian world: it is similar to two lampstands (cat. nos. 45, 47) and also to the two removable parts of the caracal (cat. no. 53). The present lamp and its stand are made of high leaded copper, but their composition differs which indicates that they did not emerge from the same crucible. The stand contains more lead, zinc and tin than the lamp (Appendix 1). Both parts were shaped by lost wax casting. Two core pins remain in the lamp wall and there are traces of work in the wax, at the neck/shoulder junction of the stand and on the thumb rest. The openwork of the thumb rest has solid areas that were filled with metal infiltrations during pouring. On the stand, the openwork vegetal composition includes metal clusters inside the wall. The reliefs made in the wax model were cold worked after shaping by chasing, as shown by the tracing with a V-shaped profile, observed in several areas. This tracing cannot be clearly seen or measured because of the surface condition of the object and the presence of a black material, perhaps remade, in the grooves. It appears, however, that the same cold working tools were used on both parts of the object (fig. 84).

Tripod stands (cat. nos. 45–47)

Stands for oil lamps are metal furnishings which, according to the complete objects that have been preserved, measure between 50 centimetres and more than one metre in height. They were made by casting and assembled from at least three parts: the base, the shaft and the tray. On the basis of a number of extant examples, the two most common types had a base that was either convex or polygonal.[36] The most imposing examples have a convex base and a cylindrical or polygonal shaft, as illustrated by the large stand in the Linden-Museum in Stuttgart (H. 1.10 m).[37] It is possible that furnishings of this size were produced for public buildings or for palace structures. Furthermore, they were designed to accommodate similarly large lamps: this implies that large oil lamps would also have been intended for buildings other than domestic structures. Tripod lampstand bases with a convex shape and openwork decoration are from Khurasan and Mawarannahr; they are datable from the tenth to the beginning of the thirteenth centuries on the basis of their archaeological contexts and their inscriptions. The example discovered in the Maimana hoard, east of Herat in Afghanistan, has inscriptions in floriated Kufic that allow it to be dated to the Samanid period (ninth to tenth centuries).[38] Openwork and solid bases, as well as cylindrical openwork shafts are preserved in Herat[39] and Ghazna.[40] Copper-inlaid fragments have also been discovered in Turkmenistan. Published material of this type from Central Asia comes from the eleventh- to thirteenth-century sites of Taraz, Talgar and Otrar in Kazakhstan, from Kyrgyzstan and from the Zoli Zard (Uzun) treasure in Tajikistan.[41]

Lampstands with a polylobed base of concave petals and a shaft with superimposed rounded elements, here referred to as balusters, appeared in the twelfth century, as shown by the frequent presence of inlays on these objects. The balusters have a rounded or faceted profile. Incomplete examples, some of which are inlaid with copper wire, were preserved in Herat,[42] Kabul and especially Ghazna, where many shaft fragments were found.[43] The same type of

object probably circulated and/or was produced in Central Asia as suggested by an example discovered at Afrasiab/Samarqand, of which only the base remains,[44] and a fragmentary tripod stand purchased in Bukhara, now in the British Museum.[45] In addition to these objects with a documented provenance, there is one example with a silver-inlaid signature bearing the name of Paydar ibn Marzban al-Qayni. Giuzalian links this name to pre-Islamic Iran; like other Iranian names, it remained in use in the medieval period, particularly for metalworkers. As for the *nisba*, it connects the maker or patron of the object to the city of Qayin (Qa'en) in southern Khurasan.[46]

These two types of stands, with a convex or a polylobed base, were also produced in the Middle East during the same period, although of different shapes and significantly without openwork or inlay. Many were discovered in the eleventh-century Tiberias hoard in which lampstands formed the largest group of objects.[47] According to Elias Khamis, the shafts, composed of two balusters either side of a cylinder, were made by sand casting as the core is preserved in most cases and consists of sand, lime and earth. The tripod supports would have also been shaped by sand casting. The curved rods inside the legs, which, according to the ISLAMETAL observations, are sprues that were left in place and served as reinforcements, are according to Khamis, reinforcing armatures not related to the casting of the objects.[48] Tripods from the Iranian world were shaped in at least two different ways; some have sprues at the back of the feet and suggest lost wax casting. This method seems to have been systematically used for polylobed tripods. Others were made in the same way, or possibly with another lost wax casting process if they have seam lines under the feet instead of sprues or armatures (cat. no. 46). The convex bases preserved in Afghanistan have an interesting feature: unlike the solid bases, the ones with openwork have sprues behind the feet.[49] They therefore seem to be associated with the lost wax casting method favoured for making openwork walls.

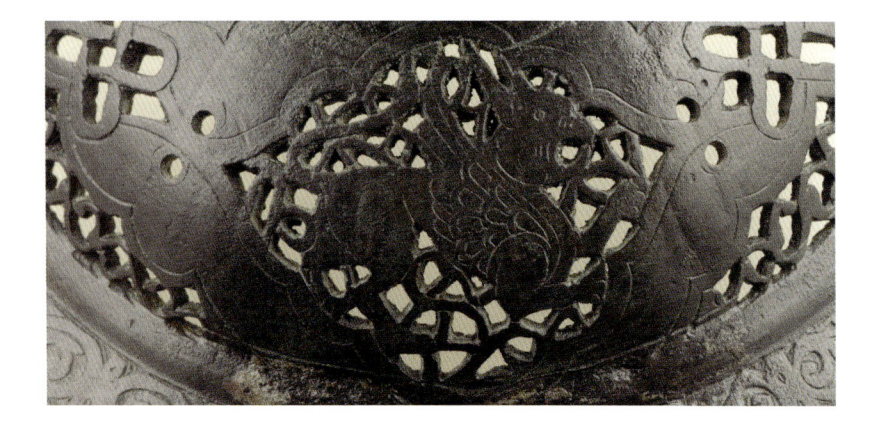

45
Stand with griffins

Khurasan, twelfth to early thirteenth century

Cast high leaded copper, openwork and chased decoration

H. 51.2 cm; D. max. 25.7 cm; Thickness (wall and shaft) 4 mm; Weight 2.852 kg

Chasing W. 0.5 mm

In a good state of preservation, the assembly of the stand has been reinforced by a modern mount, the stem of which is visible in X-rays. The object has a homogeneous brown patina. There is stable green corrosion in many of the chased lines. A gap in the lower baluster shows the residue of powdery soil from the burial of the object.

Purchase, Ayoub Rabenou, Paris, 1928; inv. no. OA 7957

This tripod stand, although missing the tray on which a lamp would have rested, is one of the oldest published stands from the pre-Mongol Iranian world. Of very fine quality and imposing size, it was exhibited in 1931 in London and reproduced by Pope and Ackerman in the late 1930s.[50] The object was shaped in two parts by lost wax casting (fig. 85). The trace of a join transposed from the wax during casting is visible on the top of the base. All the openwork surfaces were designed on the wax model. The chasing was cold worked to clearly delineate the openwork and to add detail to the tracing of the solid surfaces. Traces of file marks from the machining remain on the upper section of one of the feet. The two parts, which were probably originally soldered together, are composed of a support with a convex profile under a circular neck. The shaft is formed of two rounded balusters framing a high cylindrical section. The stand rests on three feet in a shape that recalls hooves or dragon heads. The convex part of the base and the entire shaft are decorated with openwork. On the two parts, there are five griffins framed by polylobed cloud-like medallions. The griffin, a creature with the body of a feline and the wings and head of an eagle, is a mythical bird that was probably assimilated with the Simurgh in the Iranian world during the Islamic period.[51] It is often associated with the harpy, a winged creature with a female head linked to astrological, or more broadly cosmogonic, representations.[52] Another lampstand, entirely made with openwork and very similar to this one, is decorated with harpies within the interlaced motifs.[53] Undeciphered votive inscriptions in cursive script mark the top and bottom of the shaft. On the base, the seal of the prophet Solomon can be seen. These themes, combined on an object that serves to support a light source, can be interpreted as apotropaic signs and representations.

Fig. 85

X-ray of the stand with griffins (cat. no. 45): the rod running through the object belongs to a modern assembly.

85

46
Lampstand base

Khurasan, Afghanistan, twelfth to early thirteenth century

Cast high leaded brass, openwork, chased and engraved decoration, inlaid with black material(?)

D. max. 30 cm; H. 16.4 cm; Thickness min. (edge) 3 mm; Thickness max. (neck) 6 mm; Weight 2.314 kg

Engraving (U-shaped section) W. 0.6 mm

The object is partly covered by a brown patina, probably artificial, that conceals areas of red corrosion and homogenises the surface. Some areas of this patina have been removed by rubbing and the surface is very striated, revealing a golden yellow substrate. The backs of the walls are stained with yellowish-white paint. Two gaps (breaks) are visible around the base and at the edge of the neck.

Purchase, Galerie Jean Soustiel, Paris 1987; former collection Jules Jeuniette;[54] inv. no. MAO 771

86

Fig. 86

Lampstand base (cat. no. 46): detail of the cold reworked openwork.

The object, which has a convex profile, rests on three hooves, a recurring animal allusion on this type of object. The lower part of the base has an inscription in *thuluth* script distributed into three cartouches, probably repeating the Arabic invocation العلا al-ʿalā (greatness).[55] The openwork part of the stand is decorated with vegetal interlacing of palmettes alternating with solid medallions with incised geometric patterns. The neck is decorated with a large, incised interlaced band. All the openwork and relief surfaces were made in the casting, and the designs were cold worked with chasing and engraving (fig. 86). The height of the reliefs has been reduced by the erosion of the surface although the imprecise and loose forms are also the result of the medium quality of the casting.

The object was cast in one part using the lost wax technique. Sprues are clearly visible on the reverse, at the junction of the feet and base. The mould junctions were not removed from the back of the feet, but on the visible side the seams were removed by file machining. The junctions between the base and the three feet are different due to a defect in the wax model. Other defects show that this type of object belonged to a medium-quality manufacture: gaps in the impression or poor filling of the mould during pouring are visible, as well as metal infiltration in the openwork. Some areas were cold worked with square and circular tools to enhance the perforations (fig. 86). In contrast, the flat areas of the object were decorated with incisions: the decoration of the medallions between the openwork and the interlace band on the collar were cold worked after casting and did not originate in the wax model.

47
Stand with balusters

Khurasan, Afghanistan, c. 1150–1220

Cast high leaded copper,[56] copper inlay

H. max. 49.9 cm; D. max. (tray) 15 cm; D. (base) 16.1 cm; Thickness 1 mm; Thickness (foot) 2–3 mm; Weight 1.409 kg

The object has a greenish appearance and is covered with a layer of corrosion but also a green patina that was applied to homogenise the surface. The base has been covered with a fake layer of green corrosion attached with a coloured glue varnish which has beaded into large drops under the feet. The back of the feet are covered with a brown patina. Part of the edge of the tray is misshaped and its lower edge has small gaps.

Purchase, Galerie Jean Soustiel, Paris, 1987; inv. no. MAO 772

This stand is very similar to one decorated with birds which has a tray with a scalloped edge and an oblique rim with a votive inscription. Its substrate reveals the epidermis which is yellow in colour, making it possible to imagine the former appearance of the DAI example.[57] The object is complete, but examination and analysis of the individual parts suggest that it was assembled, probably quite recently and with commercial intent, from several lampstands of the same type. The object could not be examined with the naked eye or by microscope and was studied by means of X-rays taken from several angles in order to observe the joins (fig. 87). The X-rays also enabled the identification of large copper wire inlays on the base and the shaft. Each faceted baluster is inlaid with a copper wire, and chased circles on the balusters also appeared in the X-ray.

The stand consists of five parts: the base, the three parts of the shaft and the tray. The centre of the base is too wide to accommodate the shaft and a modern repair is visible at the base of the neck; the support is tilted and the tray is not correctly screwed into the shaft because these two parts were not designed to fit together. Additionally, the baluster inserted into the tray is joined to the shaft with non-metallic soldering, as are the two lower balusters. The different parts of the support were probably made by lost wax casting. For the base, this is suggested by the presence of leg reinforcements with sprues (fig. 87).

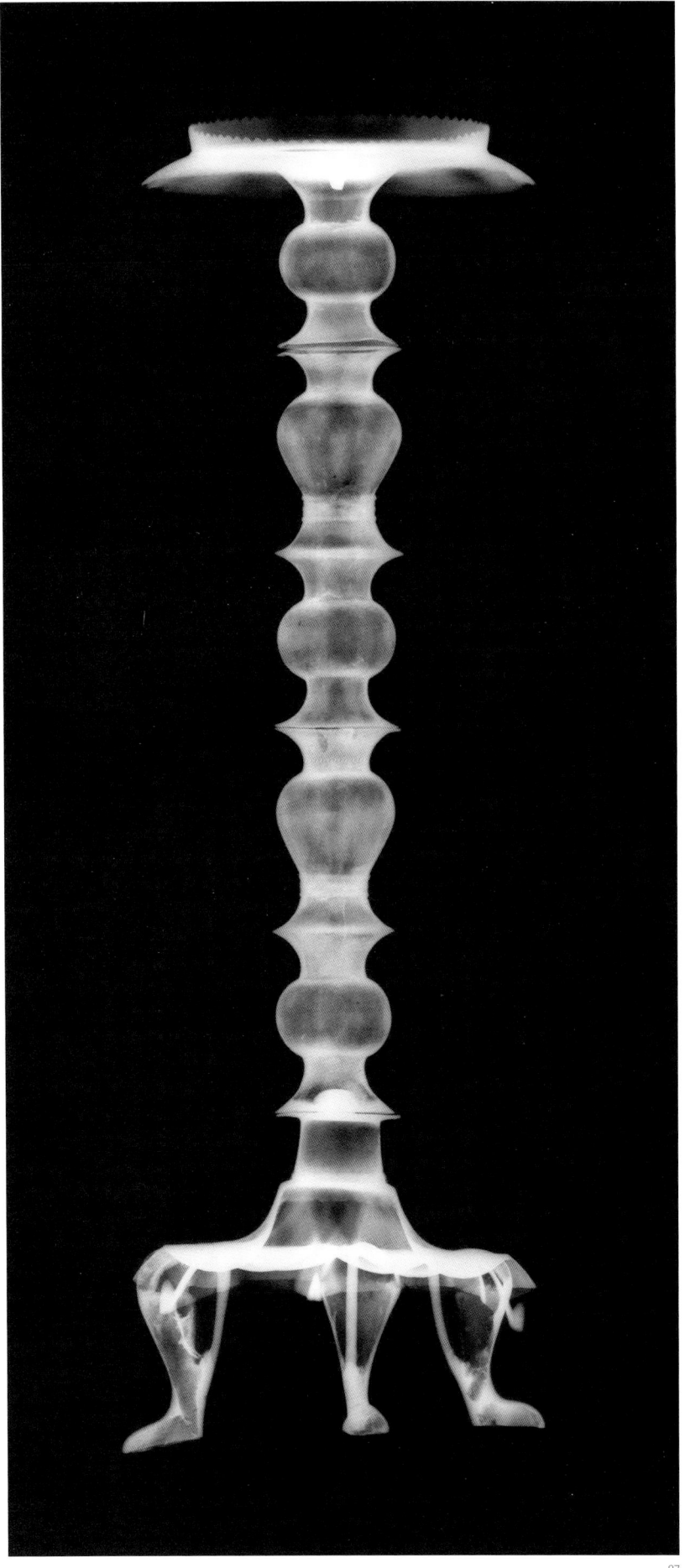

Inside the shaft, a continuous vertical flashing is visible in one of the two pairs of balusters, demonstrating that it came from a single mould. The shaft has five balusters, three rounded and two faceted, that were assembled together in the wax model. As the diameters and thicknesses, are identical, it is likely that the shaft comes from the same original set. The X-ray showed no trace of tin soldering, except perhaps for one dense mass. Each baluster is made of three parts assembled in the wax: these are not of the same thickness and the joints and thickened areas are visible on the X-ray. The tray was cast in one piece with the assembly key; its very irregular flange seems to have been cut cold but it is possible that its appearance is the result of the irregular cutting of the wax model, transposed during casting. The centre of the tray has a cavity with concentric circles around it, probably incised with a compass.

Fig. 87

X-ray of the stand with balusters (cat. no. 47).

87

Zoomorphic objects: utensils and sculptures

Zoomorphic metal objects were well known in the medieval period and included several types whose functions have been more or less clearly identified. These good-quality pieces demonstrate the use of copper alloys across a wide range of metalwork production, the common thread being their representation of animals. The metal objects, which can be considered sculptures, are the expressions of a visual culture linked to a literate society for which poetry doubtless served as the major source of inspiration. It is possible to link this production to Khurasan and to Iran, especially in the light of the hundreds of extant ceramic statuettes resembling zoomorphic and ornithomorphic metal examples.[58] Thus, in its pose and its beak, a lustre-glazed ceramic falcon[59] resembles a falcon incense burner in the Louvre (cat no. 52), that also recalls a turquoise blue-glazed falcon, especially its eyes.[60] Ceramic sculpture existed in the pre-Mongol period, especially glazed in metallic lustre, datable c. 1150-75.[61] Glazed ceramic sculptures produced in the Iranian world measure between 15 and 40 centimetres in height which is close in size to those made in metal. From the beginning of the eleventh century, a radical change took place in the ceramic arts with the development of a new fabric, a very white, thin, hard material composed mainly of siliceous elements, that was shaped by modelling or by moulding. Such manufacturing techniques are similar to those used in metalwork: when shaped by moulding, they are comparable to the processes used for metal sculptures made from a wax model. The function of these ceramic objects is easily identifiable in the case of pouring vessels, thanks to the presence of a spout. Figurines shaped as animals or humans without openings are generally considered to be purely decorative. Zoomorphic metal objects from the Iranian world include incense burners, identifiable by their openwork decoration, and also small ewers or even parts of automata.[62] Ceramic sculptures represent male and female figures, animals, birds and mythical creatures. The lion and the bull are the most represented animals or signs of the zodiac. Other species that can be identified include camels, elephants, monkeys, sheep and goats, as well as birds such as raptors, roosters, pigeons, hoopoes, peacocks, sphinxes and harpies. Metalwork objects include felines, birds of prey, roosters and partridges.[63] The pre-Mongol period, from the eleventh century onwards, was the most important period for sculpture in the medieval Islamic world. The period was distinguished by a marked development of colour and of two- and three-dimensional figures. Areas from which statuary and objects can be provenanced are mainly in Khurasan and central Iran (Rayy, Kashan). Countless figurative scenes are inlaid and chased on metals, or painted and moulded on ceramics, but also moulded or carved in stucco. Sculpture, both in relief and in the round, seems to have disappeared during the Mongol period. The relationship between medieval elites and visual culture can be understood through textual sources such as poetry. Alongside the historical sources, the poetic texts show that the 'the conditions of possibility' of this visual culture were very present in medieval Khurasan. During the eleventh and twelfth centuries, the lyric poetry of the Ghaznavid and later Seljuq courts in Afghanistan, as well as the panegyric genre (qaṣida), contain mentions of 'paintings' in palatial complexes, whose descriptions reflect their symbolic status as microcosm and cosmos. Visual and symbolic metaphors of an earthly paradise are common in medieval lyric poetry. They do not describe real palaces, but paintings representing palaces.[64] They are therefore representations, figurations of the subjects described—themselves images—cited in poetic contexts. Lyric poetry shows that in the medieval period, representation as a visualisation of a mental image was a literary topos. Poetic descriptions, or vaṣf, of palaces,

also used poetic images and references to fantastic trees with female fruits, lions, elephants, cattle, birds such as peacocks, pheasants and falcons; but also, calligraphic wall paintings (*taṣavir*), *bazm o razm* with musicians, cupbearers, friezes of statues and sculpted reliefs,[65] or pavilions in gardens (*bustan-saray*) and precious substances such as musk and amber. The beings, subjects and objects cited in the poems can be found in the sculptures and the objects, all of which belonged to this literary and visual culture. It is this world of still lives, of figures 'forever fixed in calm and repose' as found in the poetic descriptions of paintings and sculptures representing palaces, that is suggested in the preserved objects.

Some sources give information on life-size or almost life-size sculpture, in the context of Ghaznavid Afghanistan. The historian Beyhaqi records a celebration that took place in 1038. He describes the throne of sultan Mas'ud surmounted by four bronze statues with arms raised so as to hold the crown over the head of the ruler.[66] Metal and stone sculptures were well known, and the techniques of casting and carving widespread in contemporary Afghanistan and north India. However, surviving sculptures and reliefs from palatial contexts are mainly in stucco (*gachbori*). They come from Khurasan—a few heads and reliefs have recently been discovered in northeastern Iran—but the most famous are from Rayy near Tehran, or are assumed to have this provenance. During the same period, architectural models and ceramic and metal statuettes formed the corpus of portable sculptures. The relationship between certain objects, literary sources and dictionaries is well established, particularly for objects related to wine rituals.[67] Lexicographic references define the *takuk* as a wine vessel in the shape of a bull or a lion made of gold, silver or clay. Thanks to these sources, bull or lion-shaped vessels can be interpreted as playing a role in a wine-drinking ritual at the dawning of the new year. Other animals, especially roosters and different birds, are also linked to wine and many ceramic and metal vessels can be considered wine containers. The poet Manuchihr wrote at the court of Sultan Mas'ud in Ghazna during the first half of the eleventh century. According to Hanaway, his works, like many other poems written at the same time, are linked to the very important and famous festival of *mihragan*, the beginning of autumn which is the season of the harvest.

48
Small zoomorphic lamp

Khurasan, eleventh to twelfth century

Cast high leaded copper, chased and filed decoration, inlaid with black material (?)

L. max. 11.3 cm; W. max. 6.1 cm; H. max. 9.8 cm; Thickness max. (tail) 12 mm; Average thickness 2–3 mm; Weight 0.362 kg

The surface is fairly homogeneous and has a reddish-brown colour with areas of stable corrosion. Some parts, especially the belly of the animal, are more heterogeneous with an altered, grainy surface and parts that have lifted. Areas of green corrosion are also visible on the surface. Small holes and cracks are visible on the back of the animal, near one rear paw and under the mouth serving as a spout. Another crack which has lifted the metal is located between one of the hind legs and the side of the animal. The inside of the container is covered with concretions and homogeneous green layer of corrosion.

Purchase, Galerie Jean Soustiel, Paris, 1988; inv. no. MAO 830

The lamp is complete and has retained its flat lid which supports a small creature in the round that appears to be standing on the back of this lamp shaped as an animal. It is very worn like other reliefs on this object, for example the zoomorphic end of the thumb rest which is the tail of the animal. The lamp is reminiscent of a feline with two mouths, the widest of which forms the spout of the oil lamp. The piece was shaped by lost wax casting; three core pins, identified by touch and by endoscopy, have remained in the wall on either side of the spout and above the left leg.[68] The object was made in two parts: the lamp, with the legs and the thumb rest in one, and the lid in the other. The surface was cold worked with a file to further define the eyes, the snout and forehead (fig. 20a) as well as the side knops. The chasing demarcates the various parts of the animal's body. Inscriptions or sequences of letters on the sides, now very worn and illegible, were also chased. These recessed areas may contain remnants of black material. Other small oil lamps survive in the shape of composite animals similar to this one;[69] one of the closest in shape belongs to the Keir Collection.[70] No published example has a documented archaeological provenance.

Feline carpet weights (cat. nos. 49, 50)

A sculpture of a small animal in the form of a recumbent feline with a turned head was recorded in the collection as a complete object and was published as such half a century later.[71] Considered complete until recently, the feline was in fact the modern assembly (reversible and mechanical) of two object halves with different dimensions which prevented them from fitting precisely.[72] As a consequence of this finding, two distinct and separate objects are being presented here. Although both halves come from the same type of object as the other small feline in the collection (cat. no. 9), their method of shaping was very different, with the latter being cast in one piece as is the case with all other published examples.

The two closely related reliefs that were acquired as one sculpture consist of the front (cat. no. 49) and the back (cat. no. 50) of felines, mounted lengthwise by soldering as shown by the traces of tin observed on the edges of the two fragments. The two alloys are very similar and contain the same impurities, but the lead content differs markedly between the front (13%) and the back (28%) parts of the felines. The method of shaping the two felines was similar but the tools used were not the same.

Comparable sculptural objects have no archaeological provenance and their contexts of use remain unknown. They are generally referred to as 'pumice stone holders' and are therefore associated with bath utensils (see cat. no. 9). This use was mentioned in Pope and Ackerman's volume,[73] but has not been documented in any text or manuscript painting. The average size of the objects (L. 13-15 cm) and the narrowness of the belly opening seem to contradict this hypothesis. These objects are much larger than any known ceramic pumice stones and because of their weight would be impractical to handle. Furthermore, the sometimes complex cut-outs of the openings make the insertion of a pumice stone improbable. The objects might instead have served as weights to anchor carpets to the ground, although this suggestion is equally undocumented. These sculptures have openings, especially pierced ears: this suggests that something might have hung from them but it is unknown if this was jewellery or other items. The pierced ears recall Hindu metal sculptures produced in South Asia in the medieval period, for instance in Kashmir.

Fig. 88

Face of feline (cat. no. 49): detail of chased vegetal motifs.

Fig. 89

Back of feline (cat. no. 50): detail of the palm leaf motif on the front paw.

88

89

49
Front of a feline

Khurasan, Afghanistan or eastern Iran, eleventh to twelfth century

Cast high leaded brass, openwork, champlevé and chased decoration

L. max. 15.8 cm; H. 10.7 cm; W. max. 3.4 cm; Thickness min. (wall) 1 mm; Thickness max. (base of ear) 7.6 mm; Average thickness 1–4 mm; Weight 0.541 kg

Chasing (rectangular section) W. 1 mm

The reddish colour, in places mottled black, is due to a stable corrosion layer that disturbs the clarity of the surface and alters the appearance of the decoration. The base of the object is misshapen around the rectangular opening. The very thin wall is fragile: gaps, tears and cracks are visible in the chest, the back and one of the legs. A tear follows the shape of the tail. Inside, the metal is reddish-brown in appearance and altered by areas of green corrosion, including one streak running from the upper back down to the back paw. Earthy concretions, possibly from burial, are visible along the width of the legs.

Purchase, Indjoudjian (Gallery?), 1923; inv. no. OA 7800-1

Both the casting and the surface finishing are of medium quality. The interior and exterior of the wall are different: the inside of the head does not reproduce the details of the outside and is quite thick. The openwork and deeply recessed decoration made with champlevé, and in the case of the palmette by chasing, suggest that the ornament was made in wax and cold worked after shaping. The object could therefore have been shaped by lost wax casting in a direct process. The entire surface is incised so as to detail the features of the animal: the legs, the moustache, the mouth and snout and the fur below the eyes; the entire surface also has designs of plants and birds. On the chest, there is a composition with a large bird, which extends along the rear part of the sculpture. A spiralling plant is chased on top of the front leg (fig. 88). The flank is incised with scrolling stems with buds and two flowers. The base has a sequence of six characters in floriated Kufic in a rectangular cartouche, either a pseudo or a series of letters referring to the profession of faith.[74] The hindquarters are decorated with a medallion enclosing a bird, which, like the one on the chest, is shown in profile and looks toward the front of the cat. The back is also chased with a vegetal composition in which a bird can be distinguished; it is cut and continues on the back. These compositions suggest that the tooling was carried out after the two parts of the sculpture had been soldered together.

51
Partridge (part of an automaton?)

Khurasan, eastern Iran, twelfth century

Cast leaded brass, chased and champlevé decoration, inlaid with black material

H. 14.8 cm; L. 14 cm; W. 6.6 cm; Thickness min. (belly) 2.5 mm; Thickness max. (leg) 11 mm; Weight 0.471 kg

Chasing W. 0. 7 mm

The upper part of the beak has disappeared: it was removable and attached by a hinge. The surface is very heterogeneous and grainy, with stable green and red corrosion. The screws of the former mounting of the object, now unremovable, are attached to the legs of the bird (fig. 91). A significant mechanical deformation has dented one of the flanks.

Purchase, Charles Vignier, 1924; inv. no. OA 7819

50
Back of a feline

Khurasan, Afghanistan or eastern Iran, eleventh to twelfth century

Cast high leaded brass, chased and engraved (?) decoration

L. max. 15.5 cm; H. 9.3 cm; W. max. 3.4 cm; Thickness min. (edge) 0.5 mm; Thickness max. (edge) 3 mm; Average thickness 1–2 mm; Weight 0.381 kg

Chasing (V-shaped section) W. 0.9 mm

The surface condition is similar to cat. no. 49 and is similarly altered by corrosion. Three tears and gaps are visible on the chest, the hindquarters and at the junction between the base and the back leg. A trace of soldering remains in the centre of the upper edge.

Purchase, (Galerie?) Indjoudjian, 1923; inv. no. OA 7800-2

Fig. 90

Partridge (cat. no. 51): detail of the chased and champlevé vegetal frieze surrounding one of the medallions; the recessed decoration has traces of black material inlay.

90

The relief was probably shaped with lost wax casting, in a direct process. During the casting, an infiltration of the core may have occurred and is visible in the upper portion of the interior.

Like the front half, this relief was made by casting and the chasing was probably cold worked after shaping. The treatment is rudimentary and there are no areas of champlevé. The top of the back has a very eroded design, including a vegetal frieze. The hindquarters bear a medallion with a cruciform or knotted decoration and the back leg has an interlace motif. A palm leaf on the front back paw is incised to show the claws (fig. 89). On the flank there is a cartouche with a very worn inscription or a series of letters in floriated Kufic.

The sculpture was cast in one piece with the lost wax process. The thickness of the metal is relatively regular and consistent with the exterior layout, with the exception of the beak and wings where it is thinner (fig. 91). The underside of the tail is very flat and forms right angles with the edges, which suggests that a wax plate was used for this part of the bird when the model was made. X-rays of the interior of the body revealed three metal pins holding the core, the remains of which may still be found inside the bird, near the tail. The core was probably connected to the mould by a fired clay cylinder which would have left an opening in the belly. large enough for its extraction after casting. Traces of joints in the wax are visible at the junction between the upper legs and the body and on

91

the left leg. The claws may have been added to the legs of the wax model. The casting resulted in irregular thickness of the metal, with small gaps and cavities caused by air bubbles on the head and at the junction of the neck. Projecting areas such as the eyes and wings were moulded; the rest of the decoration was chased on two planes, with chasing and champlevé (fig. 90). On the wings and tail, the feathers were chased. The decoration of the chest with vegetal frieze medallions is misaligned. On the back, a medallion contains a knot motif. This small object may have been a bird-shaped wine vessel but the opening in its belly makes this an unsatisfactory interpretation (fig 91). All of the extant objects have this opening, which seems unsuitable for its use as a wine vessel. Another inter-

pretation suggests that these small sculptures were sprinklers for scented water, which would have flowed out of the beak.[75] Allan identified them as incense holders because of their similarity to zoomorphic incense burners.[76] They may be elements of larger sculptures, such as automata. Other examples are known, some of which have retained their complete beak. They have the same characteristics, and one has eyes inlaid with turquoise glaze.[77] Openwork sculptures of the same shape and size are also extant. Their function as incense burners is easily identifiable thanks to their openwork and an opening in the chest that allowed access to the interior of the bird where coals and other burning substances could be placed.[78]

Fig. 91

X-ray of partridge (cat. no. 51).

Openwork sculptures (cat. nos. 52–54)

The best-known animal sculptures from medieval Iran, especially Khurasan, are incense burners. The protective function of incense is visually associated with objects depicting auspicious animals—in medieval Persian poetry the prince can appear as a falcon.[79] The turquoise blue inlaid into the eye sockets left empty during the shaping of the objects was as beneficial as the burning substances this colour symbolised the heavens. It alluded also to the turquoise stone that warded off the evil eye and whose most famous mines were at Nishapur.[80] The turquoise-glazed ceramic eyes are sometimes preserved, as on two openwork sculptures in the DAI, as well as on other examples, particularly in Iranian collections.[81]

The largest number of zoomorphic incense burners, of which there are several dozen, are felines, more precisely caracals, a species that belongs to the family of cats. Easily domesticated, these animals could be trained for hunting. Their representations in metal form a very heterogeneous group. The largest known example (H. 85 cm) is in the Metropolitan Museum in New York. Discovered in Iran, in Taybad in eastern Khurasan, it was signed by Ja'far ibn Muhammad ibn 'Ali and dated 577/1181–82; another inscription gives the name of the emir who commissioned the object.[82] A fragmentary and much smaller example (H. 20 cm) was also discovered in Nishapur.[83] These sculptures circulated throughout Central Asia: a feline incense burner was unearthed north of the *shahrestan* of Khulbuk in Tajikistan, a city destroyed in the eleventh century.[84] This object, signed by 'Ali ibn Abu Nasr, attests to a production earlier than those examples with copper and silver inlay dating to around the twelfth century. Here again, the existence of signed sculptures, for instance by 'Ali ibn Muhammad al-Tadji (?), illustrates the high status of these objects.[85] Most of the inscriptions on these sculptures are votive formulas which are forms of incantation; much more rarely, they are Qur'anic extracts as on the incense burner in the Cleveland Museum of Art.[86]

Bird-shaped incense burners are less common; only a few are known, and none seem to have a documented archaeological provenance.[87] Ceramic falcons without openwork have also survived.[88] The falcon was trained to hunt birds such as partridges.[89] As recounted by Gardizi, trained falcons and eagles were part of princely gifts in the Ghaznavid period.[90]

52
Falcon

Khurasan, eastern Iran, c. 1180–1220

Cast high leaded brass with openwork, chased and champlevé (?) decoration, inlaid with turquoise-glazed siliceous ceramic and black material

H. max. 22.5 cm; W. max. 8.7 cm; Thickness (upper part) 1–2 mm; (lower part) 2–2.5 mm; (legs) 3.5–6 mm; Weight 0.974 kg

The supporting tail has broken off and the bird is no longer balanced; it cannot stand without a mount to hold its legs to a base (not shown in the photograph reproduced here). The object is misshapen and fragile, and can only be handled with difficulty. There is an old repair plate on the tail and the clasp has been reattached by soldering (?) on the lower part. This part of the body is misshapen and no longer connects with the upper part. A thick layer of concretions and corrosion covers the interior walls. The exterior is homogeneous in colour with a brownish patina. In areas of wear and tear, the yellow epidermis is clearly visible. Greenish traces of paint (?) can be seen on the surface. There are also concretions and residues of whitish cleaning products in the incised decoration, the bottom of which is therefore not clearly visible. Traces of recent chasing in the lower back of the bird suggest a refreshing of this part of the design.

Purchase, Raoul Duseigneur, 1896; inv. no. OA 4044 bis

INSCRIPTION[91]

On the back of the head: in *naskh* script, blessings in Arabic

العز الدائم الدولة

al-ʿizz al-dāʾim al-dawla / perpetual glory and pros[perity]

The eyes are inlaid into the openwork, probably with turquoise-glazed ceramic on both sides (fig 92a). The sculpture, which retains its original hinge, opens in the centre: this allowed odorous substances and burning coals to be deposited in the body (fig. 93). The bird was closed by inserting the clasp into the hole provided for this purpose, the dimensions of which are consistent with this. Inside the object, no trace of a core pin is visible. Several casting asperities and the jagged edges suggest that the interiors of the walls were not machined. Inside the legs, asperities are visible and perhaps also traces of work in the wax model.

It is very likely that this sculpture, cast in two parts, was the result of a direct lost wax casting after the cutting of the wax model. The openwork was made in the wax model and does not appear to have been reworked from the outside after casting; it provides eye and beak openings for the falcon and forms palmette patterns on its back and stars on top of the head and chest. The openwork is framed by chased tracings, detailing the openwork palmettes on the back (fig. 16). The pearls adorning the feathers chased on the surface were perhaps originally intended to be openwork (fig. 92c). These

92a

92b

92c

Fig. 92

Falcon incense burner (cat. no. 52):
a) eye inlay of turquoise, blue-glazed siliceous ceramic b) detail of a chased palmette inlaid with black material c) detail of the openwork feathers that were not made by casting (?).

fine patterns designed in the wax (D. 1.5 mm) may have disappeared with the accumulation of concretions, or may have been partly filled with metal during casting. The interior is in any case solid, covered with a thick layer of concretions and corrosion. The casting is of good quality although the upper part of the body is thinner than the lower part. However, a mould defect is visible on the back of the head and the undecorated interior of the leg has superficial defects.

Except for the openwork, the decoration was entirely cold worked on the cast form. The surface of the bird is covered with chased patterns: the entire body is decorated with palmette friezes, including the sides of the wings and the tops of the legs (fig. 92b). The plumage on the centre, breast and neck is rendered as scales. This style of the pattern is very different to that of the caracal (cat. no. 53). The inscription in cursive script around the head, the more monumental openwork and the large palmettes closely resemble the decoration of lustre ceramics produced in Iran c. 1180–1220. The decoration is all-encompassing: no surface is bare except for the lower part of the legs and the claws, and it is characterised by an interplay between the openwork and chased surfaces. Three planes of relief can be discerned, not counting the areas made by casting, to form parts of the bird such as the beak, the wings and the beginning of the tail which also has chased decoration.

Fig. 93

X-ray of the falcon incense burner (cat. no. 52).

93

94a

94b

94c

53
Caracal

Khurasan, eastern Iran, twelfth century

Cast high leaded brass, openwork and incised decoration, inlaid with turquoise blue-glazed siliceous ceramic

Body: H. max. 16 cm; L. 32.5 cm; W. max. 10. 2 cm; Thickness (back): 3 mm; Thickness (legs) 13–15 mm; Weight 1.51 kg

Head: H. 14.6 cm; W. max. 9.8cm; Thickness 0.5–3 mm; Thickness (ears) 5–8.3 mm; Weight 0.532 kg

The incense burner may be incomplete, as suggested by an opening in the chest that once had a handle or a plate closing off access to the interior of the body. The greenish appearance is due to a partly artificial patina. Areas of stable reddish corrosion also mark the surface. The patina is homogeneous on the two parts, the head and neck on the one hand, and the body on the other (fig. 95). The tail is not original and has been inserted and secured to the body with surface-painted mastic. Other feline incense burners do not have this type of tail, which fits awkwardly into the style of the sculpture. It may be the modern reuse of a medieval handle, added to replace the missing part of the sculpture.[92] The entire object is altered by corrosion and a patina which conceals the incisions. Areas of wear and tear on the head and body reveal the yellow substrate. The head and neck are better preserved than the body, with only one crack and two gaps visible on the neck. The body has suffered from mechanical shocks and has several deformations. The opening that forms part of the neck support system is broken. The front legs are not aligned with the chest and one leg is not flat. The right flank is depressed and probably made up; one repair in the centre of the body, under the back and on the right side, is visible by X-ray. Multiple cracks and gaps are either filled or concealed across the belly and the body. Some have been filled with solder. The belly openings, three rectangular and one square, remain unexplained. Inside the rump, in the depressed area, is a layer of metal with tears, tucked into the side. This object has obviously undergone ancient repairs, some of which date to its manufacture.

Gift David David-Weill, 1933; inv. no. AA 19

INSCRIPTION[93]

On the chest: blessings in Arabic, in floriated and knotted Kufic

البركة و اليمن و العز و البقا

al-baraka wa al-yumn wa al-ʿizz wa al-baqā / blessings, happiness, glory and longevity

Fig. 94

Caracal (cat. no. 53):
a) eye inlay of turquoise blue-glazed siliceous ceramic
b) detail of the openwork
c) detail of the inscription on the chest.

The two pieces of this object were part of its original form: the dimensions of the neck and the fastenings correspond to each other, and the openwork designs on the head and the body of the animal are identical. The alloys are very similar in both parts and have identical impurities. However, the lead content is higher in the alloy of the body (26%) than in the head (19%).

The whole sculpture, modelling and openwork, was made

95

in wax and both parts were cast with the lost wax process. The eyes have glazed ceramic inlays inserted into openings made in the metal for this purpose: these are reused ceramic pieces, cut to the size of the openings (fig. 94a). The inscription band on the chest was made in the casting (fig. 94c). On the interior, a wall separates the chest from the rest of the body. Three core pins remain and possibly the remnants of the refractory earthen core in the solid upper part of the legs (fig. 95). Significant defects in the casting are visible in the partly solid geometric decoration. The X-ray reveals a gap in the openwork decoration at the base of the back and an area of non-metallic filling. However, the moulding of the head was successful with only small superficial casting defects visible around the snout. The openwork was partially reworked with a tool: certain areas appear to be pushed from the outside towards the inside.

Three core pins can be felt on the inside of the head, one at the junction of the head and neck, and two in the neck. The openwork decoration of the neck, which is much more clearly rendered than on the body, is of an identical design; it is complemented by two palmettes. However, the surface incisions are very worn or concealed by the patina: the eye outlines, for instance, were formerly extended by palmettes that are now largely invisible. Given the condition of the surface, the thickness of the corrosion and the artificial patina, it is difficult to determine whether the surface incisions were cold worked or resulted from the transposition of the wax model (fig. 94b).

Fig. 95

Caracal (cat. no. 53): X-ray of the two separately cast parts.

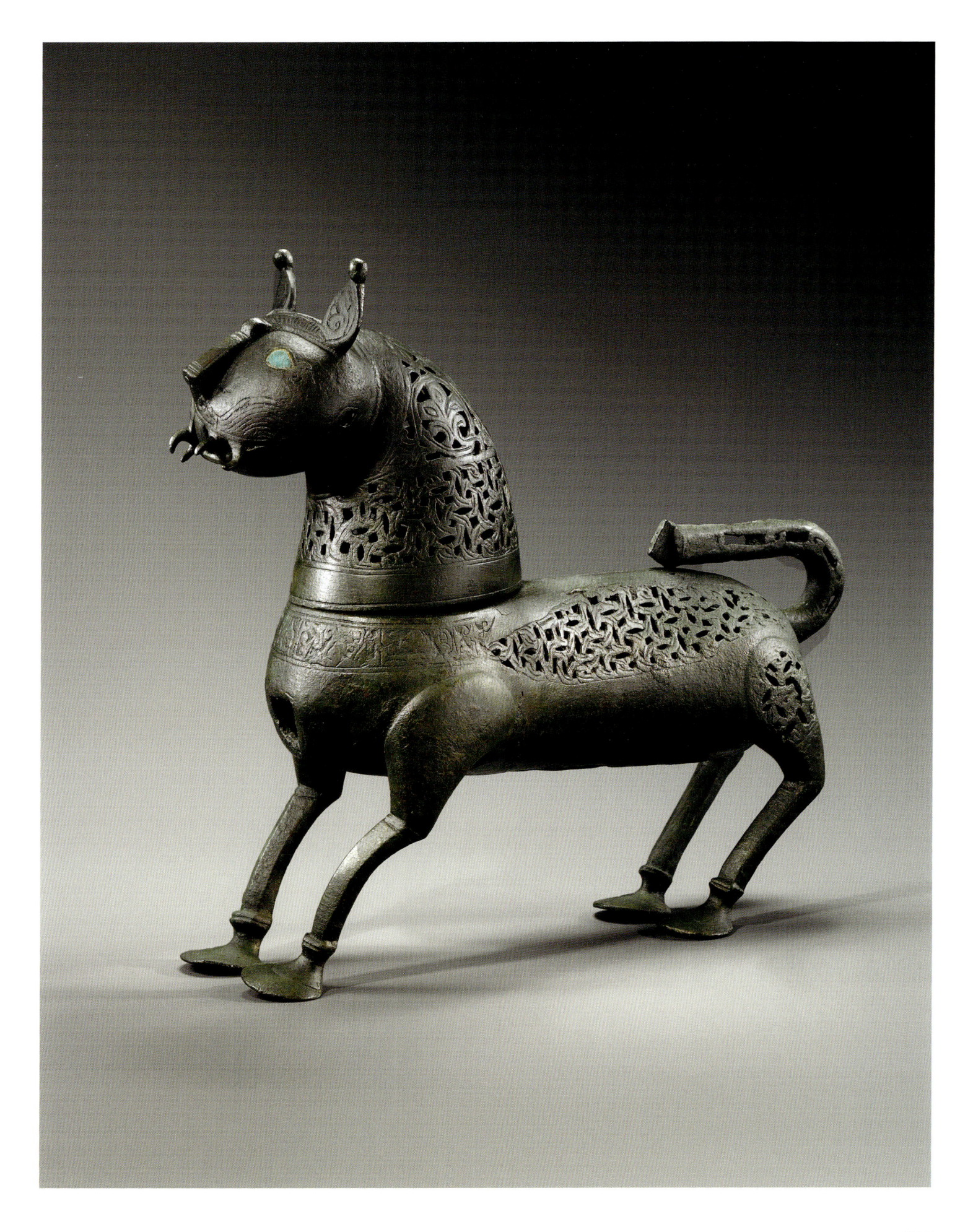

54
Incense burner stand with caracals

Khurasan, eastern Iran, twelfth century

Cast high leaded brass, openwork and chased decoration

L. max. 17.6 cm; H. max. 22.5 cm; Thickness min. (wall) 1–2.5 mm; Thickness (heads) 3 mm; Thickness max. (snout) 9 mm; Weight 1.120 kg

Chasing with irregular tracing (U-shaped, V-shaped and flat bottomed) W. 0.5–1.6 mm

The surface is brown in colour, with areas of green corrosion. The figures are incomplete: one has a broken ear; three other ears are also broken and have been filed down. A transversal slit is visible on the head of the caracal with both its ears. There are small gaps around the central opening.

Purchase, Jacques Acheroff, Paris, 1958; inv. no. MAO 357

The forequarters of three caracals, their legs forming a tripod, surround the circular base. Fairly coarse irregular chasing frames the openings. Palmettes arranged in a geometric network decorate the chests and the necks of the felines, whose features and ears are detailed with incised tracings. The sides of the base have three birds within frames. A very similar object is in the Cincinnati Museum of Art: it is identical in shape, the openings are in the same places and the surface chasing is large and very irregular.[94] However, no openings have been made in the back of the necks and heads of the caracals, all the openings show birds and there is only one palmette on the neck of the felines. With the exception of these two examples, few comparable objects are known and none with a documented provenance. However, a protome of a feline (H. 6.1 cm), was found at the site of Gurgan, located east of the Caspian Sea and west of Khurasan.[95] The DAI stand was acquired from Jacques Acheroff, an antiquities dealer who is said to have bought it in Egypt as an object from Gurgan.[96] Two other very similar stands were exhibited by Oleg Grabar in 1959, one of which is surmounted in the centre by a three-dimensional bird on a large openwork baluster. The consistency of the dimensions of the two parts, as well as the similarity in their openings, suggest that this is a complete object, an incense burner with its original mount.[97]

It seems likely, therefore, that this caracal base once formed part of an incense burner.[98] It was in any case designed to fit a section that was inserted into the central circular-shaped opening and possibly also into the diamond and triangular shapes cut into the backs of the necks and the heads of the caracals. Like all the openwork objects in the collection, the caracal stand was entirely made in wax and then cast (fig. 12). A core pin remains in the body of one of the felines and probable remnants of the clay core were found inside their heads. The rectangular openings under each protome may have been designed as passages for the core. Some shrinkage porosities and cavities caused by air bubbles in the casting are visible in the angular areas on the exterior and multiple shrinkage porosities are visible on the interior of the walls. The joints made in the wax model between the legs and the forequarters are visible. The openwork was cold worked after shaping in order to perfect it in areas where metal had infiltrated during the casting. The rather coarse and imprecise chasing was also cold worked (fig. 22a) and some reworking is visible. The eyes of the felines do not show any trace of ceramic inlay, but it is highly possible that the eye sockets were intended for this purpose, like those of the caracal and the falcon incense burners (cat. nos. 52, 53).

55
Fountain spout and tap

Khurasan, eastern Iran, twelfth century

Cast high leaded copper, chased decoration

Spout: L. 44.5 cm; H. max. 10.5 cm; D. max. 8.1–8.3 cm; D. min. 4.6–5 cm; Thickness (edge) 6–9.8 mm; Weight 5.337 kg

Tap: L. max. 9.9 cm; H. max. 23.6 cm; D. (upper) 6.4 cm, (lower) 2.8cm; Weight 2.658 kg

The pipe is brownish in appearance and the spout has a lighter yellow colour; both show significant signs of wear and areas of stable green corrosion. The head of the feline in particular is worn at the front and its features are almost erased; the ears show traces of recent file marks. The bird tap is incomplete: its broken tail and crest have been filed off; wear on the back and where it has been handled are evidence of repeated use. Traces of shocks and bumps are visible on both parts.

Purchase 1973, former collection Jacques Acheroff; inv. no. MAO 486

This fountain spout with a feline head and a bird-shaped tap resembles one published object and another rare example that appeared in a public auction.[99] The bird tap published by Grabar in 1959 is in better condition and a peacock can be identified. As none of these objects have an archaeological provenance, their architectural context is unknown; nor can it be determined whether they distributed water in domestic or public structures. Judging from the less damaged appearance of the pipe, this was inserted into the masonry with only the zoomorphic elements protruding from the structure, perhaps up to the moulded ring behind the tap. The conical tip of the tap had two openings: the larger of these allowed water to flow when it was aligned with the fountain duct, while the second smaller one, located on the lower part of the cone, served to block the valve and the water supply. The tap was attached to a vertical structure, the water probably spilling into a basin. The system of water conduits feeding into basins is attested by rare finds in the pre-Mongol Iranian world, as at Lashkar-i Bazar in Afghanistan.[100]

The spout and the tap are of consistent dimensions and therefore seem to have been part of the original object. Their alloys, although of the same family, have different compositions: the spout contains more lead (18%) than the tap (7%). Each part was cast in one piece, probably by sand casting as suggested by the two longitudinal seams on the pipe. Multiple casting defects are clearly visible on all the surfaces, in particular large cavities caused by air bubbles. The objects were only partially machined, and the tap is irregularly polished. Some areas remain very grainy, especially between the bird and the conical end. The features of the feline and its fur were chased, probably directly on the model and perhaps partially cold worked.

Horse-shaped padlock

Khurasan, eastern Iran, twelfth to early thirteenth century

Cast high leaded copper, chased and champlevé decoration, traces of silver inlay

L. 8.3 cm; H. 5 cm; W. 1.6 cm; Weight 0.100 kg

The greenish surface is altered by stable corrosion which prevents a clear reading of the surface because the reliefs are very shallow. The object has been filled and painted: the opening on the chest is invisible to the naked eye.

Gift, Jacques Coiffard, 1963; inv. no. MAO 415

The identification of this small object was confirmed by X-rays that revealed the original mechanism of the padlock in the hollow body of the horse (fig. 96). Many zoomorphic padlocks have survived, and many can be dated to the pre-Mongol period.[101] A padlock of this type was discovered in excavations at Gurgan in western Khurasan.[102] The DAI example is datable by the traces of silver inlay in rectangular sheets on the back and sides prepared with champlevé (fig. 97). Zoomorphic padlocks were made in steel from the fifteenth to the seventeenth centuries and continued to be produced in Qajar, Iran in the nineteenth and twentieth centuries, when parts of the bazaar were devoted to the manufacture and sale of these objects. Padlocks were used for a variety of purposes: the largest (L. up to 40 cm) to secure the doors of public and private structures; smaller ones to lock furniture and boxes.[103] Their role in a Shi'i devotional context is also frequent; even today votive padlocks are hung on the gates of shrines, especially around the tombs of holy figures.

The padlock was cast in three parts. Two form the profile of the horse, as indicated by the seam line on the back and the belly. A third part consists of the tail and an articulated hinge at the back of the horse that was opened with a key inserted in the chest, as also revealed by the X-ray. The two side parts are fairly symmetrical and fit together well, although surface corrosion prevented identification of their exact method of assembly. The patterns on the sides were cast and then cold worked with champlevé and chasing; they may be different on the two sides but are not clearly visible. Interlaced motifs and vegetal scrolls can, however, be seen (fig. 98). It is possible that one of the legs, like the back and the sides, was inlaid with silver.

Fig. 96

X-ray of the horse-shaped padlock (cat. no. 56).

Fig. 97

Horse-shaped padlock (cat. no. 56): fragments of silver inlay in rectangular sheet on the back.

Fig. 98

Horse-shaped padlock (cat. no. 56): chased and champlevé motif on a back leg.

96

97

98

Incense burners

Non-zoomorphic incense burners sometimes evoke architectural forms, particularly domed structures (cat. nos. 57, 58). These objects, which are either closed or with an arched opening, have openwork in the rounded section. They also have feet that recall animal paws. Small dishes resting on sculptural zoomorphic legs are perhaps incense burners (cat. no. 59). They are of the same type as objects resting on their base, of which two in the DAI collection are from Ghazna and Bamiyan (cat. nos. 14, 25). The use of these objects is not documented and while it is possible that they were intended for the presentation of food, they could also be interpreted as incense holders. This is how they are identified by Allan, who groups the two types of bases as flat or tripod-shaped. Examples in silver and gilded silver have also survived.[104]

The use of incense in the medieval period is best known from textual sources. This was a domestic, palatial and devotional practice and is therefore found in a variety of contexts. The use of odorous substances is naturally linked to fragrances, a recent topic in anthropological history that focuses on the social and symbolic significance of fumigation.[105] Perfumes used for burning consisted of organic materials such as musk and ambergris that are secreted by animals; or vegetable matter such as wood, gum-resin, bark and dried flowers, used individually or combined, depending on the properties that were required.[106] They were used in bodily care, perfuming hair and clothes, in medical and prophylactic fumigations, especially for air purification, and in occult and talismanic practices for their links to spirits and their astral analogies.[107] Descriptive poetry, or *vaṣf*, of the eleventh to twelfth centuries, uses images of substances such as amber, Tibetan musk, sandalwood and so on, to describe the materials and colours of palace paintings as they are associated with paradise. The poems also evoke soft and fragrant winds laden with scents of musk, aloe and rose—spring breezes whose perfume was replaced by incense burners.[108] Amber, musk and sandalwood were burned and used with other substances such as camphor and ambergris in many medicinal and medical contexts, as well as in rites of passage from birth to death.[109] For instance, incense burners were prepared in anticipation of childbirth. In some medieval sources, certain sculptures were considered to have talismanic functions. The medical properties of certain burning substances such as ambergris or camphor might have also been linked to these protective qualities. Fumigations were also practised during devotional, particularly mystical, rituals.[110] The controversial use of incense burners during funeral processions is attested to by sources from the early and medieval periods.[111] Finally, fumigations are often found in the context of private and princely receptions. The substances used to diffuse the fragrant smoke were highly prized and the object of princely gifts when coming from distant lands: aloe wood 'from Khmer' or Cambodia, yellow sandalwood and speckled ambergris are listed among the lavish presents offered in 1025–26 by Mahmud of Ghazna to ʿAlitigin, the Qarakhanid ruler of Transoxiana.[112]

57
Domed incense burner

Khurasan, Afghanistan. eleventh century

Cast high leaded brass, openwork, chased and engraved decoration

H. 11.3 cm; D. max. 9.2 cm; Thickness (lid) 1 mm; (container) 0.7–2 mm; (foot) 9–9.2 mm; Weight 0.537 kg

Cold worked with a file

Chasing (V-shaped section)

Domed dot punch D. 1 mm

The object, in good condition, has a stable greenish-brown patina. The very yellow epidermis shows through in areas that have been rubbed or filed. Several parts have been filed, probably before reaching the art market, in order to lighten the concretions and corrosion and to further emphasise the decoration. The very thin wall has a small gap at the bottom of the container with a painted area above, concealing a crack which may have resulted from a casting defect.

Purchase, Galerie Jean Soustiel, Paris, 1980;[113] inv. no. MAO 622

INSCRIPTION[114]

On the container wall:

باليمن و البركة و السرو(ا)ر(sic) و السعادة و السلامة ؟

bi-l-yumn wa al-baraka wa al-surū(alif)r (sic) wa al-saʿāda wa al-salāma?
with happiness, blessing, joy, felicity and wellbeing (?)

The cylindrical incense burner with a rounded dome rests on three flat feet in the shape of palmettes. It was fitted with a removable handle that was inserted into the wall. The object has a hinge for opening the dome. The openwork design that occupies the rounded part of the incense burner is made up of a network of palmettes in bevelled relief (fig. 99). It resembles the openwork of the lamp or incense burner with palmettes (cat. no. 28), presented here as one of the groups with alloys close to those documented at Bamiyan, and is similar to other openwork designs on lamp containers and stands now in the Herat Museum.[115] The present incense burner has an inscription in floriated and knotted Kufic in a rectangular cartouche on the otherwise bare wall. This good-quality object was made with lost wax casting. Inside the container, small metal hooks and a fragment of casting slag are visible, as are core pins which can also be seen in the lid (fig. 15c). Small casting defects in the form of cavities caused by air bubbles are visible on the exterior and in the openwork decoration, which has clearly been pushed inwards. The wax model was probably designed as a closed form, then cut and connected to a two-part hinge before casting. This method of shaping seems comparable to that of the falcon incense burner (cat. no. 52). The hinge between the lid and the object is flat and

uneven on the interior. The rather irregular openwork design, with asymmetrical holes made in the casting, was cold worked after shaping, probably with a file. The inscription was cold worked and therefore did not appear on the wax model. It is engraved and chased and stands out against the matte background made with a domed dot punch (fig. 27a). As the superimposed tracings demonstrate, this background was made after the inscription.

99

Fig. 99

Domed incense burner (cat. no. 57): openwork with bevelled palmettes.

58

Incense burner with a four-lobed arch

Khurasan, Afghanistan, tenth to eleventh century

Cast high leaded copper, openwork, chased, compass-engraved and champlevé decoration, inlaid with black material

H. max. 15.2 cm; D 7.6 cm; Thickness (wall) 1–2 mm; Weight 0.319 kg

Chasing (V- and U-shaped section), rectangular with a flat bottom

The patinated surface is brown, with stable areas of red and green corrosion. It is worn and the reliefs have been flattened, especially in the solid areas. The object has been repaired and some areas painted; the top of the dome was probably broken and in order to conceal this, a bronzine-painted support was welded onto it, topped with a bird in the round. This ridge is slightly off centre and attached by a fairly rough tin solder.

Purchase, Galerie Jean Soustiel, Paris, 1985; inv. no. MAO 762

100

This object is of the same type as the incense burner acquired in Sistan (cat. no. 30), a type that was common in the eastern regions of the Iranian world. The openwork half-dome surmounts a cylindrical tripod base with legs on palmette-shaped feet; one is under the open part of the object and not at the back of the container. Both objects were shaped using the same lost wax casting process, as shown by a core pin inside the dome and flashings inside the container due to metal infiltration during the casting. The very thin wall shows casting defects and was probably fractured during manufacture around the arch, one side of which is not perforated, and at the junction with the base. In addition, some of the openwork was not fully pierced, perhaps because of the fragility of the wall which is too thin in certain areas. In any case, many cracks are visible on the object, which also has an irregular base.

This form of incense burner, which is much more common than the closed-dome type of the previous object, is also characterised by the absence of a handle. In addition, the openwork is not very elaborate: it has a simple pierced design unlike the complex networks of palmettes in the dome (cat. no. 57) or the walls of the lamp or incense burner with palmettes (cat. no. 28) and the caracal (cat. no. 53). This openwork decoration was often, as in this case, reworked with a tool, following the infiltration of metal into the model during casting,

and then it seems was cold worked to make geometric and vegetal motifs (fig. 100). The surface designs on the present object are quite worn and altered by corrosion, particularly on the base where three compass-drawn medallions form rosettes. The half-dome is decorated with interlaced vegetal scrolls framing a geometric design of squares alternating with crosses around the openwork. Beaded petals are chased under the ridge of the finial; they recall the plumage of the falcon incense burner (cat. no. 52). On incense burners of this type, the ornithomorphic handle is frequently repaired or remade, as on a previously mentioned example in the V&A (see cat. no. 30). The bird, symbol of the soul, was associated, as on oil lamps, with smoke rising into the air and evoked the use of censers in prophylactic and occult practices.[116] It was probably this analogy of the bird with the soul which explains its recurring presence on objects related to light and fumigation, in which substances rise towards heavens while being burnt.

Fig. 100

Incense burner with a four-lobed arch (cat. no. 58): cold worked chasing around the openwork decoration.

59
Incense dish with three felines

Khurasan, eastern Iran or Afghanistan, late twelfth to early thirteenth century

Cast high leaded brass, chased or engraved decoration

H. max. 10.8 cm; H. (dish) 3.35 cm; D. max. 21.3 cm; Thickness max. (feline head) 2.85 cm; Thickness min. (rim) 2 mm; Weight 1.732 kg

The greenish-looking object has been altered by thick concretions and stable corrosion, both of which have created thickened layers on the substrate, particularly inside the wall of the dish. The chipped edge has lost some material and some areas have recently been reattached. The condition of the surface which has altered the relief has prevented identification of the tools used to create the recessed decoration.

Purchase, Georges-Joseph Demotte, 1917; inv. no. OA 7187

INSCRIPTION[117]

On the wall, in six cartouches: blessings in Arabic in *naskh* script

العز الدا / العز الدا[ئم ؟] و/ و الاقبال / الاقبال و / [و] الدو / الدولت و ال

al-ʿizz al-dā / al-ʿizz al-dā[ʾim ?] wa / wa al-iqbāl / al-iqbāl wa /
(wa) al-daw / al-dawlat wa al- /
per[petual] glory/per(petual(?)) glory and / and fortune / fortune /
and pro[sperity] / prosperity and *alif-lam* /

Allan has linked this object to similar small dishes without feet.[118] He identified them as incense burners, while Melikian-Chirvani considered them as dishes with a flat base or on baluster feet comparable to an example formerly held in Ghazna.[119] Several tripod dishes have been published, one of which is believed to have come from Hamadan in western Iran.[120] Other zoomorphic supports for these objects include harpies, elephants or even—in the case of a six-footed object—lions alternating with bulls.[121] A lustre-glazed ceramic dish with sphinx-shaped feet dated 611/1215 offers a reference object for this type, and illustrates the similarity of ceramic and metal production in the pre-Mongol Iranian world.[122] This form continued to be produced in metal well into the fourteenth century, as illustrated by an object supported on feline feet dated 725/1325 that is signed *Ustad Husayn Isfahani* (Master Husayn of Isfahan).[123]

The dish has three legs made as tubular posts terminating in a feline in the round. The animals were modelled in wax and are similar to the felines or feline heads commonly found in the metalwork and ceramic production of the medieval Iranian world that were modelled and moulded in siliceous fabric, as supports for house models,[124] or shaped in the round

as wine vessels (*takuk*).[125] The lion is associated with gold and the sun. Here, the felines support a dish, the interior of which is decorated with the six planets—the Moon, Mercury, Venus, Mars, Jupiter and Saturn—rotating around the sun. This very simplified composition recalls figural representations of this theme on inlaid metalwork as well as on ceramics.[126] A frieze of animals revolves around the stars on the interior, and on the exterior repeated incantations fill six cartouches interspersed with medallions.

The incense burner was shaped with the lost wax method, following a process that is too complex to identify. It is possible that the assembly in wax of the feet and the dish was cast in one pouring. Or it could have been cast in two phases: first the feet in lost wax, followed by the dish, its convex profile possibly indicating a secondary and reverse casting. Only one foot lies flat the other two are tilted, indicating that they were not set flat during casting and were probably positioned upside down. Casting defects and cracks from the mould are visible, particularly in the thickness of one foot. The relief patterns on the dish were transposed from the wax model. They were probably partly cold worked with a tool after casting, either by chasing or engraving.

SERVING WARE AND RECEPTION PRACTICES

The uses of vessels and utensils are linked to the private receptions of guests and perhaps, in certain cases, to ceremonial occasions. Metalwork from the DAI collection can be interpreted as having been used in both these contexts. In descriptions or allusions to festivities in textual sources, there are frequent mentions of wine, of the music that accompanied libation rituals and of fragrances such as musk and ambergris perfuming the air that was already heady with the smell of wine.[127] The incense burners discussed above could have been used in festive contexts. Other perfumes in liquid form, such as rose water, were used and diffused from sprinklers. There are also wine vessels and utensils for serving food in the DAI collection.

The most important festivals of the Persian calendar during the medieval period are known mainly from poetic sources.[128] One of the main court rituals in the Iranian world was the wine banquet (*bazm-e mey*, *bazm-e sharab*). The festivals were gatherings for libation (*majles-e sharab*) which played a great role in the exercise of power. Wine was the prerogative of princely circles and was linked to the cosmic symbolism of the sovereign who was enthroned during these highly ritualised ceremonies. The royal wine was red, or the colour of the precious ruby.[129] The *bazm* lasted several hours or days during which the wine was consumed after a meal and with music.[130] It took place during the three major annual celebrations, *nowruz* (spring), *mihragan* (autumn) and *sade* (a fire celebration in winter) and was linked to the conjunction of the sun and the moon. The poems evoke receptions organised for the New Year celebrations at *nowruz* and for the harvest and grape collection at *mihragan*, celebrated on the first day of autumn, during which libations would take place.[131] The context of *bazm*, as analysed in the textual sources by Melikian-Chirvani, makes it possible to interpret figurative representations on the objects and even the objects themselves.

Wine vessels with bull heads (cat. nos. 60, 61)

Zoomorphic and bull-headed vessels have been identified as wine pouring vessels by Melikian-Chirvani and Melanie Gibson, based on lexicographic and poetic sources.[132] They highlight conjunctions between the sun, sovereign and wine, and between the moon, bull and drinking vessels and horns, allowing the meaning of these vessels to be interpreted. In medieval dictionaries, *takuk* (vessel) which was used for wine drinking, refers mainly to the bull but also to other animals such as the lion made as vessels.[133] The generic term refers to a zoomorphic drinking vessel, while *gavi* refers to its specific shape, that of a cow or bull. This is explained in the *Farhang Lughat-i Fars*, the oldest extant Persian lexicographic dictionary written around 457/1065 by Abu Mansur ʿAli ibn Ahmad Asadi Tusi, who compiled it to explain the many rare and archaic words found in the new Persian poetry. The entry for *takuk gavi* describes a bull-shaped vessel for wine, made of ceramics, gold or other materials.[134]

The bull's head recalls the drinking horn, made of a hollowed-out horn, or the shape of a horn with a spout like a bull head, for example in silver. Horns with animal protomes feature in eleventh-century Persian poetry. Some poems also exalt the link between wine and the stars, and of the zodiac sign of the bull in relation to the wine container. The bull is associated with the moon, and the consumption of wine from a container evoking the celestial body (the horn, or by extension the protome) is based on the disposition and cosmic meaning of the wine banquet. Celebration of Mithra continued into the Islamic period. After *nowruz*, *mihragan* was the most important feast in the Iranian world, at least until the twelfth century, and these vessels may have been used in this context—a distant echo of sacrificial rituals in which wine libations replaced blood.[135]

This fairly common type of vessel was produced in both ceramic and metal. Bull-headed jugs in siliceous ceramic are very similar to those made of metal.[136] Two distinct groups have been established in metalwork, on the basis of their dimensions:[137] examples in the Louvre and the V&A[138] were produced with lost wax casting and belong to the first group (H. 15–20 cm); the second group includes larger jugs (H. 25–38 cm). All were made by casting and none are inlaid with precious metals, suggesting that the production of this type preceded the development of inlays in the twelfth century. Ceramic and metal zoomorphic- and bull-headed vessels come from Iran and Afghanistan. One example in the DAI collection (cat. no. 60), according to its entry in the inventory, comes from Joseph Hackin's mission in Afghanistan, but with no further details. A few have been found in Central Asia, in the valley of the Talas River in Kazakhstan; or in Kyrgyzstan.[139] On the basis of the inscriptions, Melikian-Chirvani established a date around the tenth to eleventh centuries for these types of wine vessels.[140]

The two examples in the Louvre are very similar, visually connected by the pear-shaped profile, the bull's head, the interlace and the calligraphy on the belly. They were made with the same type of alloy and using a similar process, first by lost wax casting and then by hammering. The treatment of the bull's heads as well as their openings are very similar. Moreover, the parts of these vessels which are now lost, such as the handle or the base plate, were mounted on the objects in the same way. Finally, the cold working techniques are comparable. Nevertheless, the impurities of the two alloys are very different; the quality of the casting and the surface ornaments are not the same and the tools used, especially for the chasing and champlevé, are different. The casting of the first (cat. no. 60) is of better quality and the cold worked designs are precise, made with finer tools than those used on the second (cat. no. 61).

60
Pouring vessel with a votive inscription

Afghanistan, tenth to eleventh century

Cast high leaded brass, hammered, chased, engraved and champlevé decoration, inlaid with black material.

H. 15.2 cm; D. max. 8.2 cm; Thickness min. (body) 1.3 mm; Thickness max. (spout) 15 mm; Weight 0.274 kg
Engraving W. 0.4 mm

Punch 0.55 x 0.85 mm

Chasing (U-shaped and flat bottomed) suggesting the use of two separate tools

The yellow alloy is largely covered with a brown patina, probably artificial. Some areas such as the bull's head have been altered by corrosion. The object has large holes, dents and filled-in repairs on the body and neck. The head of the bull has lost a horn and an ear, and where they were originally placed, it has been filed down. The jug was fitted with a handle; this is visible from the remains of tin solder on the wall. The back of the bull's head has been torn off. No traces of solder or gaps are visible on the base which was probably closed by a sheet of metal, folded over the foot by hammering.

Missio,n Joseph Hackin in Afghanistan, 1933; inv. no. AA 60

INSCRIPTION[141]

On the widest part of the body: blessings in Arabic in floriated Kufic, completed by pseudo-epigraphy

بركة و يمن و سرور و [س]ـعادة

baraka wa yumn wa surūr wa [sa]ʿāda
blessings, happiness, joy, [fel]icity

The fine quality of this object, which has been much altered, remains apparent. The pouring spout with a diamond-shaped opening surmounts a faceted neck and a pear-shaped body. The wall surfaces are largely left bare, elegantly decorated with an interlace in relief and a floriated inscription, where the absence of the definite article suggests the Persian usage of Arabic terms.

The surfaces have designs in relief and in recess, the two planes enhanced by inlays of black material of which traces remain. The palmette on the bull's head, the interlace on the body and the inscription were made by casting (fig. 101) These reliefs were cold worked with a tool after casting and completed with chasing and champlevé (fig 22b). The animal's head is further detailed and decorated with cold worked chasing. The vessel was shaped by lost wax casting, as indicated by toolmarks in the model visible near the horns and at the junction between the neck and the head of the bull. The fine quality of the casting is also identifiable by surface pitting and shrinkage porosities. The facets of the neck were made with horizontal hammering, traces of which are clearly visible. Evidence of file machining is preserved on the raised wires near the interlace and under the inscription. Each facet has an engraving, the outline of which forms a petal (fig. 28b), a motif similar to other objects in the collection (cat. nos. 28, 37, 62).

101

Fig. 101

Pouring vessel (cat. no. 60): cast and cold worked chased palmette motif on the bull's head.

61
Faceted pouring vessel

Afghanistan, tenth to eleventh century

Cast high leaded brass, hammered, champlevé, engraved and chased decoration, inlaid with black material

H. 20.2 cm; D. max. 9.8 cm; Thickness min. (body) 0.7 mm; Thickness max. (horn) 11 mm; Base thickness 2 mm; Weight 0.450 kg

Triangular punch (V-shaped section) 1.1 x 2 mm

Rectangular punch (flat bottomed) 0.8 x 1.25 mm

A brown patina and a layer of stable reddish corrosion cover the vessel which has numerous gaps and unfilled cracks. The preserved surface is altered by corrosion and significant wear of the reliefs due to very abrasive cleaning and possibly also the poor impression of the reliefs during casting. The handle is missing; traces of tears are visible at the back of the head and at the bottom of the body. The base, originally probably closed by a hammered sheet that was folded over it, has also disappeared.

Acquired in Cairo by Gaston Migeon, 1907; inv. no. OA 6101

As with the previous pouring vessel (cat. no. 60), signs of lost wax casting are visible on the back of the head and on the horns, where traces remain of the tool. The wax join is visible at the base of the head and near the ring on the neck. The two ears are not identical, one being larger. Casting defects, and especially the poor filling of the mould during pouring, are visible in the structural gap at the back of the head and in the shrinkage porosities on the lower part of the spout and on the joint between the head and the neck. The facets of the vessel were made by hammering it in three wide bands on the neck, the body and on both sides of the 'inscribed' band. The facets are also marked by vertical incisions. The hammer marks are more elongated than on the previous pouring vessel and were not made with the same tool. What the two objects have in common are the cold working of the reliefs made in the casting of the wax model, such as the bull's head and the projections from the wall. The same motifs, here with rougher tracing, adorn the sides of the head and the horns, although on this vessel the palmettes on the head were entirely cold worked (fig. 102) and the muzzle was dome punched to give detail to its shape. A pseudo-inscription in floriated Kufic, which seems to have been traced or emphasised with champlevé framed by chasing, appears on the widest part of the body.

102

Fig. 102

Pouring vessel (cat. no. 61): cold worked chased palmette motif on the bull's head.

62
Faceted jug

Khurasan or Afghanistan, eleventh century

Cast high leaded brass, chased and engraved decoration, inlaid with black material (?)

H. max. 20.3 cm; H. (neck and body) 15.2 cm; D. (opening) 7.8 cm; D. max. 9.7 cm; Thickness 0.9–1.8 mm; Weight 0.566 kg

The body and the neck of the jug are on a modern base;[142] the handle and the thumb rest are probably from the medieval period, but have been reused from other objects and were mounted on the jug in preparation for its eventual sale on the art market. The handle is made of high tin bronze. The small feline that has been reused as a thumb rest might have been a foot as suggested by the cut along the back; it was roughly soldered onto the spherical curve of the handle which in turn was attached to the jug with a thick and visible tin solder. Traces of the original handle, larger and wider than the present one, are visible on the neck and the wall of the jug which is reddish in appearance, with a thick layer of stable and lightened corrosion. It is partly covered with bronzine which homogenised the appearance of the surface and conceals the cracks. The chased lines at the bottom of the wall are very altered but consistent with those observed on the other parts of the jug.

Purchase, Galerie Jean Soustiel, Paris, 1978; former collection of André Nègre; inv. no. MAO 615

This object, acquired in Afghanistan by André Nègre while he was ambassador there, has certainly been repaired and reworked.[143] Observation and analysis of the materials made it possible to identify the various parts of the object and its different alloys. This type of jug, with a cylindrical and faceted body and neck, recalls, through the outline of the petals on the facets, other objects such as the wine pouring vessels and the openwork lamp or incense burner (cat. nos. 60, 61, 28). A jug very similar to this one (H. 20 cm) was unearthed in Uzbekistan—it appears to be the only published comparable object with an archaeological provenance. It comes from the citadel of Eski-Akhsi, the surviving remains of Akhsiket, capital of Ferghana in the ninth- to tenth-century Samanid period and a prosperous city until its destruction by the Mongol armies.[144] A comparable object in high tin bronze, although smaller (H. 12 cm) and of a slightly different type, has also been published by Melikian-Chirvani.[145]

The thickness of the neck and of the wall, both at the top and the bottom, are very regular. The jug was cast but the neck and the body have a different appearance in X-rays (fig. 18b). The neck, which protrudes from the body and forms an acute angle with it, is more homogeneous and without flashing which suggests that the two parts were mounted together. The X-ray image shows two vertical lines of high density in the body, diametrically opposed to each other. Given their stringy appearance, these may be flashings, and thus traces of a two-part core and of a bivalve mould used for shaping the object with indirect lost wax casting. The surface of the jug was cold worked with compass engravings for the petals of the facets and with chasing for the vegetal friezes (fig. 24). The chasing with flat-bottomed toolmarks is wide and shows traces of modern reworking.

63
Faceted vase with pendants

Khurasan, eleventh to twelfth century

Vase: cast leaded brass, chased and champlevé decoration

Foot: cast high leaded brass

H. max. 22.8 cm; D. max. 12.6 cm; D. (opening) 14 cm; D. (base) 12.6 cm;
Thickness (edge) 1.5–2 mm; Weight 1.22 kg

The vessel is covered with a fairly thick, homogeneous and stable
greenish-brown patina. Residues of burial concretions are visible in the
hollow parts of the substrate and decoration. The worn areas of the
patina reveal the light-yellow epidermis of the metal. The vase has been
repaired and two gaps have been filled at the edge of the rim and at
the bottom of the wall which has bumps and dents and a repair of fine
tin solder. The vase rests on a foot that is in a very different state of
preservation: the surface is reddish-brown and painted over, the metal
has many small gaps caused by casting defects and the surface is very
worn. It has an inscription in a wide band that has been made illegible
by abrasion.

Purchase, Hussain Afsar, Paris, 1978; inv. no. MAO 614

INSCRIPTION[146]

Inside the border: blessings in Arabic in knotted floriated Kufic script

برَكة و يمن / و سرُور و / سعادة / لصاحبه

bara/ka wa yumn / wa sur/ūr wa / saʿāda / li-ṣāḥibihi
bless/ing and happiness / and jo/y and/ and felicity / to its owner

Vases of similar shape with a high flared neck, a pear-shaped
body and a high foot are represented on metal objects of the
pre-Mongol period (as on the sides of cat. no. 9). The flowers
placed in vases that decorate the surface of this object demons-
trate the use of this type of vessel in Khurasan; such images
of vases holding flowers that are perfuming the interior are
perhaps allusions to the banquet. On the feline carpet weight
(cat. no. 9), representations of these vases are juxtaposed with
images of musicians, components of the wine banquet which
was always associated with music and perfumes such as wine
and incense. The shape of these vases is also that of incense
burners of the same dimensions and with openwork walls.[147]
Vases of the same type were also produced in siliceous cera-
mic, in Iran as elsewhere in the Middle East, decorated with
with metallic lustre or simply glazed.[148] Published examples
in metal demonstrate the wide diffusion of this shape, found
in Khurasan and Afghanistan and beyond in the Iranian wor-
ld.[149] An example with a smooth body, found at Budrach in

Uzbekistan in a probable recycling workshop, would attest
to the production of this vase shape before the eleventh cen-
tury.[150] Vase bases of this type in Afghan museums, some
coming from Ghazna,[151] confirm the method of shaping for
these objects: they were assembled by soldering or riveting
a rounded base to a pedestal and have smooth, gadrooned or
faceted walls. Some have an openwork base; examples inlaid
with precious metals are rarer and their ornament is usually
in relief or hollowed out of the alloy itself. At least two other
vases of the same type with jewel-like motifs are known.[152]
In the pre-Mongol Iranian world, decoration of hanging ele-
ments, as well as other types of jewellery, is better known from
moulded ceramics with jewel-like ornaments, where the golds-
mith's precious mater-ials have been substituted with clay or
copper alloy.[153]

Purchased by the Louvre after it was offered for public
sale in Paris,[154] this vase may have been repaired before it was
put on the market. The foot was attached with a fine layer of
solder that is invisible to the eye but is clearly identifiable on
X-rays (fig 14). It was cast in high leaded brass and two distinct
alloys were used for the two parts of the object. This may be a
modern assembly of two medieval objects, given the different
state of preservation of the vase and its base. The porosity of
the substrate and its cloudy appearance in X-rays indicate that
the object was cast. The casting is of very good quality and the
reliefs are sharply rendered. The thickest areas are the junction
between the neck and the wall, and the pendants on the body.
A few defects are visible: two small gaps in the neck and body
and inside the wall there are flashings from metal infiltration in
the mould. The vase was probably shaped by lost wax casting
and the relief ornaments transposed from the wax model were
systematically cold worked with chasing and champlevé (fig.
103).

Each facet of the flared rim has a cartouche enclosing an
inscription (fig. 103a) with champlevé work that is close to the
Kufic inscription of a lamp in the collection (cat. no. 29). It
has two planes of depth in certain areas and the chasing has
redefined the rounded parts made in the casting. Distributed
across six rectangular cartouches, the absence of the definite
article in the inscription suggests a Persian context.

The exterior of the flared neck is left plain and the nar-
rowest part of the curve has a wide interlace: the way it is ren-
dered and the tools employed are identical to those observed
for the inscription. The interlace surmounts the pendant-like
ornaments, the chains encircling an additional facet cut into
the petals on the body. The reliefs are consistent on both the
interior and exterior of the wall. The identical circular medal-
lions are framed by interlace bands and enclose a cruciform
shape (fig. 103b). Between each petal on the wall, the rounded
pear-shaped body is decorated with a flat wide palmette; their
relief made in the casting is accentuated with champlevé out-
lines.

103a

103b

Fig. 105

Faceted vase with
pendants (cat. no. 63):
a) detail of the Kufic
inscription
b) detail of a pendant,
cold worked with
champlevé and chasing.

64
Sprinkler for scented water

Khurasan, eastern Iran, twelfth to early thirteenth century

Cast high leaded brass, champlevé, chased and engraved decoration

H. 19.9 cm; D. max. 10.1 cm; D. (opening) 7.1 cm; Thickness (body) 1–3 mm: Thickness max. (rim) 5 mm; Weight 0.594 kg

The base is missing: the shoulder has two gaps and an open crack in the thinnest and more fragile part of the wall. The edge is chipped. The surface is brown and the patina is altered by thick, earthy, light-coloured concretions on the inside and outside of the wall and by stable greenish and reddish corrosion.

Gift, Octave Homberg, acquired from (Agop?) Kalebdjian, Paris, 1921. inv. no. OA 7485

INSCRIPTION[155]

On the shoulder: blessings in Arabic, in Kufic script

البركة و اليمن و السرور و السر و السعادة و ال

al-baraka wa al-yumn wa al-surūr wa al-sarr al-saʿāda wa al blessing, happiness, joy, rejoicing, felicity and (…)

The size and narrowness of the neck suggest that this object is more likely to be a sprinkler than a bottle. Written sources in the medieval Iranian world refer to multiple uses for scented liquids both for entertaining guests and for personal use, for example, in perfuming clothing. Rosewater in particular, seems to have been used frequently in festive and ritual contexts: the poet Manuchihr (c. 982–1040) metaphorically evokes the rosewater poured over the head of the bride during wedding ceremonies.[156] Rosewater, was the most prized perfumed water and was produced in Iran, as attested to in sources dating from the ninth to tenth centuries.[157] According to al-Ansari (1006–89), this perfume was made by distilling the flowers in a container placed over a fire. The distillation of rosewater, a long-standing tradition in Iran, is described by al-Kindi in the ninth century, who also mentions the manufacture of other scented waters made from saffron, musk and sandalwood, using the same process.[158] In poetry rosewater also features as the natural rainwater that exalts the rose's perfume that is the scent of spring. The rose is a topos in Persian poetry, with multiple metaphors and meanings evoking its appearance, its perfume or its colour—inseparable from spring, the nightingale and the beloved. For Farrokhi (c. 980–1037), the scent of the rose was associated with musk to define the very perfume of the garden and of paradise, while for al-Ansari the perfume was musk itself.[159]

This very fine sprinkler has rarely been reproduced since its publication by Migeon shortly after its acquisition.[160] It is of the same shape as an example that, on the basis of its copper inlay, can be attributed to Ghazna (cat. no. 18). This type with a flat base, cylindrical body and flared neck is well known in the Iranian world, particularly in Khurasan. This example is not inlaid with metal. The decoration, which is of very fine workmanship, was cold worked and made partly in reserve with champlevé. This method of producing ornament both in recess and in relief closely resembles a manufacturing method for siliceous and earthenware ceramics that was used in the medieval Iranian world. However, this is an atypical object within the DAI metalwork collection. It was cast in one piece but was originally made in two parts, the separate base soldered on to the body. The shaping by casting is identifiable by the metal infiltrations that caused oblique, perpendicular and straight flashings and a network of cracks visible inside the walls. In addition, the rather irregular filling generated slightly variable thicknesses. No mould seams were visible on the X-rays, and it is likely that the sprinkler was made by lost wax casting from a wax model assembled at the junction of the neck and the wall. The surface design at the top of the neck and on the walls seem to have been cold worked. There is a vegetal frieze on the flaring neck, and the shoulder and walls are decorated with superimposed registers featuring, from top to bottom: an inscription, an animal frieze, a wide geometric band of interlacing quatrefoils and finally, a frieze of palmettes. The depiction of animals chasing each other on a ground of vegetal scrolls perhaps evokes the hunt, and by association, the cosmic hunt. This theme, well known in the medieval Iranian world, recurs in literature and on objects. In lustre ceramics, for instance, there is an animal frieze on a fragmentary bottle dated 575/1179.[161] It is associated with certain verses and invocations, as well as with representation of an assembly (*majlis*). The reliefs and recesses on the sprinkler made by chasing and champlevé are clear and well preserved; they have convex and flat surfaces, and flat and V-shaped recesses (fig. 104a). The entire wall is decorated with chasing, engraving and champlevé, with a very particular use of champlevé in the central area where the cruciform motifs are created with champlevé (fig 104b). The interlaced design and the pattern in reserve also recall luxurious lustre wares, as does the layout of the palmettes at the bottom of the wall. Indeed, a lustre bowl dated 607/1210 juxtaposes the same combination of a geometric interlace, verses of Persian poetry, blessings in Arabic and dragons.[162]

104a

104b

Fig. 104

Sprinkler (cat. no. 54):
a) chased motif
b) champlevé motif
making a quadrilobed
ornament in reserve.

65
Rice shovel (?)

Iran, Khurasan, twelfth to early thirteenth century

Cast high leaded brass, chased and champlevé decoration

L. max. 60 cm; Weight 1.309 kg

Original handle L. 28.8 cm

Shovel L. 25 cm; W. 17.4 cm; Thickness max. 1.4 cm; Thickness min. 2 mm

The object consists of two parts assembled during a recent repair of the handle by the insertion of a tube. The two original parts are therefore not in contact. The surface of the shovel is altered by burial concretions, especially in the corner; it has a brown patina and stable green and red corrosion. The reliefs are very worn or even erased. A gap is visible in the upper left section. The handle does not show the same traces of burial and corrosion but has a uniform brown patina.

Bequest of Georges Marteau, 1916, former Georges-Joseph Demotte collection; inv. no. OA 7083

INSCRIPTIONS[163]

On the front: blessings in Arabic in *thuluth* script

الد [... مة] و السلا [...] (...) ؟ر (...)
(...) râ ? (...) wa al-salā[ma ...] al-d / [āʾim ?]
(...) and well[being](perpetual(?))

On the reverse: blessings in Arabic in *thuluth* script

والعز و البقا لصاحبه و العز الد[ائم ؟]
wa al-ʿizz wa al-baqā li-ṣāḥibihi wa al-ʿizz al-d[āʾim ?]
and glory and longevity to its owner and per [petual] glory

105

Fig. 105

Rice shovel (cat. no. 65): detail of chased and champlevé motifs.

CAT. NO. 69

Cast copper alloy

D. 14.3 cm; H. (edge) 0.75 cm; Thickness 1.5–8 mm; Thickness (edge) 3.5 mm; D. (knop) 2.3 cm; Weight 0.362kg

The mirror has a green-brown surface with green concretions and areas of corrosion. Two gaps, one extended by two cracks, have altered the appearance of the object.

Long-term loan from the Musée des Arts Décoratifs; former collection Octave Homberg; gift of Jules Maciet, 1908; inv. no. AD 14919

INSCRIPTION[184]

Around the edge of both mirrors: blessings in Arabic, in floriated Kufic script

بركة و يمن و سرور و سعادة [و] سلامة
و غبطة و بقاء لصاحبه

baraka wa yumn wa surūr wa saʿāda [wa] salāma wa ġibṭa wa baqāʾ li-ṣāḥibihi

glory, happiness, joy, felicity, wellbeing, salvation and longevity to its owner

These two objects are almost identical with undecorated front sides. Of medium quality, they have the same defects from the wax model, or from the impression of the mould during casting; the only variations are the two holes drilled into the suspension knops. It can therefore be assumed that both mirrors were made from the same model or the same mould. It is equally possible that the same mould was used to produce two identical wax models, but with different holes in the suspension knops. The wax models would have included all the elements for the mirrors: the circular body, the edges and the knops.

The composition in two concentric bands separated by pearl bands was made by casting, probably without any later cold working. The decoration is on two planes with the animals and the inscription in higher relief than the pearl bands. In the centre, the knop is framed by a six-petalled flower. A frieze of animals moving to the left against a scrolling ground fills the inner band: two felines, possibly cheetahs, pursue two hares which look back at them. The airy scrolls have trilobed and serrated palmettes as well as florets. This repetitive iconography corresponds with the inscription that encircles the frieze which is also repetitive. Inscribed in floriated Kufic, the

votive formula is repeated twice in a single line; the use of Arabic without the definite article suggests a Persian context.

There are at least two other types of mirror with comparable compositions: one has a longer, non-repetitive inscription and an animal frieze of a hare probably chased by a dog, and a goat chased by a feline.[185] An example found in Donsk in Ukraine would be the only mirror of this type with a documented place of discovery.[186] The second type has the same animal decoration but with different inscriptions.[187] A third type, one example of which is in New York, is larger (D. 19.2 cm) and has a different decoration and a longer inscription.[188] Finally, a mirror in Berlin[189] is considered identical to the one in the Louvre (cat. no. 68) but was made from a different model: the decoration is not identical and the votive inscription around the rim is in cursive script.[190] The models for these mirrors are thus more varied, it seems, than those for the mirrors with sphinxes (cat. nos. 70–73): it was not the same model that was circulating, but variants with the same type of decorations and inscription.

70–73
Mirrors with sphinxes

Khurasan or Anatolia, twelfth to thirteenth century

Cast high tin bronze

INSCRIPTION[191]

Around the edge of the mirrors:: blessings in Arabic, in floriated Kufic script

العز و البقا و الدولة و البها و الرفعة و الثنا و الغبطة
و العلا و الملك و النما
و القدرة و الآلا لصاحبه أبدًا

al-ʿizz wa al-baqā wa al-dawla wa al-bahā wa al-rifaʿa wa al-ṯanā wa al-ġibṭa wa al-ʿalā wa al-mulk wa al-namā wa al-qudra wa al-ālā li-ṣāḥibihi abadan.
glory, longevity, prosperity, splendour, high rank, praise, salvation, greatness, royalty, greatness, power and blessings to its owner, forever

CAT. NO. 70

D. 11.1 cm; H. (edge) 0.5 cm; Thickness 1.7–4.5 mm; Thickness (edge) 2 mm; D. (knop) 1.2 cm; Weight 0.162 kg

The mirror has a brown patina and is in good condition. The casting is of good quality, with almost no casting defects. A small infiltration of metal is visible between the head of the left-hand sphinx and the vegetal decoration.

Purchase, 1896. inv. no. OA 3945

CAT. NO. 71

D. 11.3 cm; H. (edge) 0.68 cm; Thickness 2–6 mm; Thickness (edge) 4.1 mm; D. (knop) 1.6 cm; Weight 0.250 kg

The mirror has a brown patina and is in good condition. The casting is of medium quality as the impression is imprecise and excess metal is visible in the reliefs. There are flashings at the end of the tail of the right-hand sphinx and on the lower edge of the inscription.

Purchase, Roland de Mecquenem in Iran, 1925; transferred by the Département des Antiquités Orientales in 1925; inv. no. OA 7871/72

Cat. no. 70

The fronts of all four mirrors are undecorated. Two (cat. nos. 70, 71) have a pronounced edge (H. 5–6.8 cm) and are slightly larger (D. 11 cm approx.) than the other two (D. 10 cm approx.) with flat edges (cat. nos. 72, 73). On the back, the mirrors have identical decorative compositions on three planes of relief of two addorsed sphinxes either side of a flowered branch. The heads are depicted frontally, the bodies in profile and in motion; between the paws of each sphinx, there is another plant. Framing the two sphinxes is the same votive inscription in floriated Kufic dedicated to an anonymous owner. Observation of these four mirrors,[192] and a review of other published types of sphinx mirrors, suggests that such objects were always shaped by lost wax casting. Examination under the microscope showed that the decoration on three planes was not cold worked after shaping and was thus entirely cast from the wax model, including the chasing of the inscription, and the bodies and the heads of the sphinxes. The recurring motifs are the figures of the sphinxes and the inscriptions in Kufic which are always identical. This model was systematically reproduced, sometimes with defects in the impression. On one mirror there is a small gap in the left leg of the right-hand sphinx (cat. no. 73); on another the addition of the knop has erased the wing and the back of the sphinx (cat. no. 72). The decoration of the two mirrors is exactly the same, although the knop of the second is larger and has altered the composition. The knops, which are of different shapes and sizes, were added separately with the wax model of each knop attached to the wax model of the mirror (fig. 13). This process can be seen in the tool marks left around the knops, and in the alteration of some of the decoration, particularly the wings.

D. 10.5 cm; H. (edge) 0.23 cm; Thickness 0.6–3.5 mm; Thickness (edge) 2 mm; D. (knop) 1.7 cm; Weight 0.088 kg

The mirror is broken and more than half is missing. The surface is reddish-brown with a stable layer of corrosion. The surface has been rubbed and the decoration is very worn. The casting is of medium quality, particularly in the irregular filling of the metal, which has infiltrated several parts of the design: between a flower and the sphinx, near the edge of the inscription and between the inscription and the edge.

A label on the front reads: 'Gift of Mme Duffeuty'; 1893, the year of Clothilde Duffeuty's gifts, as recorded in the inventories of the Département des Objets d'Art; no. AFI 1343

CAT. NO. 73

D. 10.6 cm; H. (edge) 0.41 cm; Thickness 3.2–5 mm; Thickness (edge) 2 mm; D. (knop) 9.7 mm; Weight 0.240 kg

The object has a brown patina and is in very good condition. Its manufacture was of good quality with few casting defects. Some pitting on the front of the mirror and a cavity caused by air bubbles on the base of the knop are visible. There is a small gap in the left leg of the right-hand sphinx. The wing of the left-hand sphinx is erased, probably due to work on the wax during the application of the wax model of the knop. Finally, a metal infiltration during the casting filled the space between the edge of the inscription and the lower right leg of the left-hand sphinx.

Long term loan from the Musée des Arts Décoratifs; gift, Jules Maciet, 1908; inv. no. AD 14918

Cat. no. 72

The same model was used for moulds with a sloping or flat rim, and on one mirror (cat. no. 71) the connection with the rim is clearly visible. The impressions were more or less precise according to the state of wear of the mould.

Mirrors with sphinxes are preserved in the greatest number and are the type most frequently found in public collections, as well as on the art market, with many examples published.[193] The same design of sphinxes framed by the same votive inscription in floriated Kufic is also known from ceramic lids.[194] There are, however, some variants of the sphinx mirrors that suggest their more limited circulation, given the scarcity of extant examples and of other moulds or models. Nevertheless, the majority can be linked to the same original model, as described above, to which, for example, an additional border has been added. Another type of mirror with sphinxes is smaller in diameter (8.7 cm) and has no inscription.[195] Most of these variants have been recorded and published by Umberto Scerrato.[196] One mirror in a private collection in Rome is strikingly different since the faces of the sphinxes were replaced by palmettes.[197] According to Melikian-Chirvani, these mirrors with sphinxes are associated with Khurasan production because of their frequent presence in the markets in eastern Iran and the discovery of two specimens in Termez[198] and one in Mawarannahr. Furthermore, an identical mirror is in the Dushanbe Museum, and another is in Tashkent.[199] Examples in Turkey suggest that their distribution extended all the way to Anatolia.[200] They do not appear to have circulated in Afghanistan since no object of this type appears in the archives of the IsMEO, nor in the corpus of objects recorded in Herat.

Some mirrors with sphinxes were used or reused as 'magic mirrors'. One example has a representation of the pseudo-planet of eclipses, Jawzahr and a text engraved on the front side.[201] It may never have served as a true reflective mirror—the central knop is not drilled so it could not be hung. One example in the Khalili collection was reused as a talismanic plaque.[202] Another sphinx mirror of a different type has a scalloped edge and is larger (D. 12.7 cm); a magic square and inscriptions can be seen on the front.[203]

Cat. no. 73

74
Mirror with a hunter

Iran or Anatolia, twelfth to thirteenth century

Cast high tin bronze

D. 13.7 cm; H. (edge) 0.38 cm; Thickness 1.5–6.5 mm; Thickness (edge) 6 mm; D. (knop) 2 cm; Weight 0.408 kg

The mirror is in good condition: the front, which is light yellow in colour, is smooth and the surface has been rubbed. The back is covered with a brown patina, with areas where the metal epidermis is visible; these are the most worn areas on the hunter's body and face.

Gift, Doctor Fouquet, Cairo, 1894; inv. no. OA 6020

The lost wax casting is of medium quality. The suspension knop shows traces of the wax joints for its connection with the wax model of the mirror. This was located on the horse and has probably obscured traces of the rider's leg, as well as the animal's flank and rump. Metal infiltration due to a defective impression is visible on the outer edge. The decoration is imprecise and irregular, and the outlines are not sharp. There is evidence of shrinkage porosities near the horseman's head. There is no epigraphy and the mirror has a pierced knop obliquely placed in relation to the vertical axis of the hunter occupying the centre of the design. If the mirror was hung, it was not suspended on the axis of its decoration, which has two planes in relief and a flat surface. Turning on his mount, the rider pierces a feline with his spear. To the left, another feline attacks the horse's chest. The border is decorated with nine flying birds; their elongated heads and necks, like the shape of their wings, are reminiscent of wading birds, or cranes. According to Allan, these are phoenixes, whose depiction dates the object to the Ilkhanid period (thirteenth to fourteenth centuries).[204] However, the type of mirror, its alloy and the way it was made are similar to mirrors of the twelfth to thirteenth centuries. The image of a horseman chasing a feline is commonly found in the medieval Iranian world and is associated with images of the ruler or the hero hunting lions, an allegory of the cosmic hunt. This scene may thus evoke some of the most famous stories in the *Shahnama*, such as King Bahram Gur or the hero Isfandiyar slaying lions. The birds in flight filling the band along the edge replace the votive formulas found in that position on most circular mirrors: their association with the soul and their link with the heavens visually evoke these votive inscriptions.

UTENSILS FROM SHOPS

Many metal utensils in collections of Islamic art consist of mortars and cauldrons. Mortars are especially common and hundreds of examples have survived. They are generally of unknown provenance or from poorly documented archaeological contexts. Several examples are held in the DAI collection. Of variable quality, these utilitarian objects are perhaps more associated with commercial than domestic contexts, as they are mainly linked to the medical and pharmaceutical professions. A few rare, illustrated manuscripts dating from the end of the twelfth and the beginning of the thirteenth centuries are one of the sources that allow us to contextualise their uses. Mortars and cauldrons are depicted in manuscripts from Baghdad and the Jazira, a region in northern Iraq, and include medieval and pharmaceutical treatises with scenes depicting pharmacists in their shops and doctors preparing treatments.

Mortars

From the tenth century onwards, several textual sources mention the use of mortars in the Islamic world: the physician Abu Bakr Muhammad ibn Zakariya al-Razi (d. 925) calls them *mihras* in Arabic and *havan* in Persian. Medieval sources on the use of metal mortars, whose cylindrical shape may have derived from stone mortars, have been collected by Allan.[205] Their use in the preparation of pharmaceutical products is documented, for example, in the representation of the making of aromatic wine for coughs in the 1224 Arabic manuscript of *De Materia Medica* of Dioscorides attributed to Baghdad, which illustrates a figure pounding an ingredient in a mortar placed on the ground.[206] Mortars were also used by alchemists and craftsmen. In addition, they were in domestic use for the preparation of spices, herbs or even the grinding of sugar.[207]

Almost all the mortars in the DAI are made of high leaded copper, which is probably the alloy known as *tal* or *batruy* and which, according to al-Biruni, al-Tusi and Abu'l-Qasim Kashani, was used for the production of utensils such as mortars, cooking pots and cauldrons.[208] Others, as illustrated by a mortar in the collection (cat. no. 78) were made of leaded brass, which would correspond to al-Biruni's *shabah mufragh*.[209] The proportion of lead is high in these alloys, which would have facilitated the casting, increased the weight and contributed to the stability of the objects.[210] Some have more or less collapsed walls and tears and/or bulging bases, sometimes with cracks or gaps.[211] These defects may have been caused by use, but almost no trace of pestle impact is visible inside the objects. These deformations seem to be structural and were caused by the sagging of the mould walls under the pressure of the pouring metal and its solidification, with a weight of between three to more than twelve kilograms. All the mortars have casting defects such as cavities caused by air bubbles and shrinkage porosities, sometimes repaired by being cast-on.[212] These include flashings (cat. no. 80), excessive filling of the reliefs (cat. no. 76) or metal infiltration probably due to the cracking of the mould (cat. no. 27). Through material analysis, three of the ten mortars in the DAI have been linked to eleventh- and twelfth-century production in Khurasan, based on comparisons with a reference object from Bamiyan (cat. nos. 26, 27) and to twelfth-century Ghazna productions (cat. no. 22). The other seven are cylindrical with a concave profile (cat. nos. 75, 76), or are octagonal (cat. nos. 77, 78), cylindrical with a wide flat rim (cat. no. 79) or of a very different type, which is octagonal with animal heads (cat. nos. 80, 81).

None of the mortars have a documented provenance but they belong to common and fairly

well-published types of objects attributed to the Iranian world, as well as to Anatolia. They are decorated with moulded, engraved, chased and champlevé decoration, inlaid with black material. No metal inlay has been found on these objects.

Numerous examples of mortars were preserved in Afghanistan where Melikian-Chirvani observed four recurring types.[213] The earliest has a cylindrical shape with a slightly flared rim and lip, which was used at least until the end of the twelfth century (cat. nos. 22, 25, 75, 76).[214] One variant has a concave profile, decorated with a lotus and one inlaid example of this type has an indecipherable signature.[215] These mortars are also associated with the medieval Iranian world[216] based on documented examples from Ghazna, Bukhara, Mazar-e Sharif and Herat.[217] Another recurring type is an octagonal mortar with a very pronounced base and rim (cat. no. 77): a copper-inlaid example is in the Herat Museum. According to Allan, mortars with a flat rim and a flat base (cat. no. 79) also came from eastern Iran, based on comparable examples found at Maimana and Ghazna in Afghanistan.[218] Animal-headed mortars (cat. nos. 80, 81) are associated with Anatolia and the Jazira.[219] They are similar to specimens found in shipwrecks containing Mamluk coins, the earliest of which were minted in 1404.

75–76
Cylindrical mortars

CAT. NO. 75

Khurasan, twelfth century

Cast high leaded copper

H. 10.5 cm; D. 13.5 cm; Thickness max. 1.5 cm; Weight 2.936 kg

The surface has a grainy texture which is covered with a reddish-brown patina and green corrosion. The mortar has some burial concretions in the irregularities of the base and in the top and bottom friezes.

Donation, Pantanella-Signorini, 2009; inv. no. MAO 2218

CAT. NO. 76

Khurasan, end of the twelfth century

Cast high leaded copper

H. 13.1 cm; D. max. 15 cm; Thickness max. 1.5 cm; Weight 4.758 kg

The object is in good condition and is covered with a brown patina, probably artificial. Burial concretions are visible in the casting defects of the base and in the floral friezes around the base of the wall. Traces of tool impacts may be due to the use of the mortar: numerous blows causing small dents are visible on the wall.

On long-term loan from the Musée des Arts Décoratifs; gift, Jules Maciet, 1904; inv. no. AD 11287

Mortars of this type are generally attributed to Khurasan and dated between the eleventh and thirteenth centuries.[220] An example from Ghazna that was preserved in Kabul is decorated with lotus buds and engraved ornament,[221] and resembles the DAI mortars.

The mortar has a flat rim and a slightly convex wall with a flared base and rim. The object is of poor quality and has casting defects: the base is cracked and rounded. There are defects in the wall, which is uneven, sags at the centre and has a gap. The cast decoration consists of six lotus buds with irregular tracing and relief, arranged in two staggered rows. There are rough asperities around the rim and the object seems to have received little machining after it was shaped. Traces of toolmarks around the lotus buds, transposed from the wax model, are evidence of lost wax casting. The two interlace bands around the rim and base are characterised by a rough tracing and a flat relief. They have been chased and were probably recently refreshed, as suggested by areas where the metal epidermis is visible. The frieze below the rim evokes an inscription in floriated Kufic.

The attribution to Khurasan and dating to the end of the twelfth century proposed by Melikian-Chirvani are based on the style of epigraphy in knotted and floriated Kufic in a wide band below the rim. The inscribed frieze is a repetition of the same alternating and mirrored formula: an inscription which repeats الملك (royalty) seven times and a square or with a *mim* (m) from which emerge ibexes in profile.[222]

All the decoration was made by casting without being cold worked afterwards. It is on two planes, with the lotus buds in high relief and the friezes in low relief with a flat surface. Several examples of similar mortars from Afghanistan have been published.[223] This good-quality object was shaped with lost wax and traces of toolmarks transposed from the model are visible around the almond-shaped lotus buds, placed regularly in staggered rows on the wall. Defects in the moulding can be found in the inscribed frieze where letters are present or, alternatively, are missing. A recurring defect is the pronounced indent above the right-hand floret in the inscription. Other small defects related to the mould impression were noted, such as the overfilling of the decoration details.

77–78
Octagonal mortars

CAT. NO. 77

Khurasan, twelfth to early thirteenth century

Cast high leaded copper, engraved and chased decoration

H. 12.5 cm; D. 18 cm; Thickness max. 2.15 cm; Weight 5.094 kg

Punch (U-shaped section) 1.1 mm

Domed dot punch D. 1 mm

Engraving (U-shaped section) W. 0.9 mm

The surface of the object is greenish-brown and covered with layers of corrosion, bronzine, painting and concretions. It shows traces of use and the possible marks of modern tools.

Donation, Pantanella-Signorini, 2009; inv. no. MAO 2224

CAT. NO. 78

Khurasan, twelfth to early thirteenth century

Cast leaded brass, engraved and chased decoration

H. 15.5 cm; D. 19.5 cm; Thickness max. 3 cm; D. (ring) 9.25 cm; Weight 11.3 kg

The object has a yellowish-brown surface and is in good condition. The earthy concretions are evidence of its burial but the surface is uniform and close to the epidermis, under a fine patina that is probably artificial. Toolmarks and traces of shocks, both from use and more recent, are visible on the wall and the rim. The bottom is very scratched; under the base there are visible traces of a black and whitish material, possibly paint.

Donation, Pantanella-Signorini 2009. inv. no. MAO 2106

Similar mortars are preserved in Herat.[224] This object is of medium quality, with a heavy flared base and rim and a bulging base that became misshapen during casting. The wall has partly sagged, a defect that occurred during the manufacture. The base of the mortar has been painted with bronzine and black and green paint, possibly concealing a plaster filling; a repair has also been painted over. The rim is decorated with a chased interlace and vegetal frieze, and the base with cartouches with pseudo-inscriptions in floriated Kufic and vegetal friezes. The wall is punctuated by spandrels forming medallions with centres containing vegetal motifs surmounted by a palmette. The chasing and engraving are regular, similar and of the same depth; the surface has matte punching. With the exception of the inscriptions, most of the motifs seem to have been refreshed through the concretions.

This octagonal mortar stands out for its distinctive alloy and type, which are unusual amongst surviving mortars. It has a single suspension ring, threaded through the head of a feline. The wall, with a slightly flared rim, is decorated with lotus buds, one on each facet, except where the ring is placed where there are two buds, unevenly arranged and lower on the wall. With the exception of the incisions detailing the features of the feline, there are no chased designs on the mortar. A fairly similar published object is in Turkey.[225] Another comparable piece of smaller dimensions, is in the Metropolitan Museum.[226] Like the DAI mortar, it has no documented provenance. However, the alloy, the faceted shape, the lotus buds and the feline head connect the mortar more closely with the metalwork production of pre-Mongol Khurasan.

As with other mortars in the collection, this object was shaped by lost wax casting. The casting is of medium quality: the bottom is curved, the sides sag slightly and cracks are visible on both the exterior and the interior of the object. Since the cracks were only superficial, without making any break in the object, they did not impede its use and were not filled or consolidated. The base, on the other hand, has a repair by cast-on of a structural gap that is clearly visible. The lotus buds were made in the same wax as the mortar and are all of slightly different sizes. The feline handle was probably made in wax and joined to the wax model, but the junction with the wall is not clearly visible. The head of the feline seems to have been recently refreshed with a file in order to enhance features that had been erased by wear, whereas the cold working of the angles with a file probably dates back to the machining of the object. A pouring hole is visible in the handle, in the feline's mouth.

79
Mortar with a flat rim

Khurasan or Afghanistan, twelfth to early thirteenth century (?)

Cast high leaded copper, chased and engraved decoration

H. 16.5 cm; D. max. 25 cm; Thickness max. 1.4 cm; Weight 7.338 kg

Punch (U-shaped bottom) 1 x 1.5 mm

Engraving W. 1 mm

With a brown patina, the object has areas of stable corrosion, red on the interior surface and mainly green on the base. Traces of burial concretions are also visible.

Purchase, M. Rosenberg, Paris, 1910; inv. no. OA 6438

The attribution and dating of this type of mortar remain uncertain, although it was probably produced throughout the eleventh to fourteenth centuries.[227] A mortar of similar shape but with suspension knops and three moulded lotus buds on the wall was discovered during the excavations of the *shahrestan* or lower city of Budrach in Uzbekistan.[228] An example from the cache of metalwork discovered at Maimana in Afghanistan, a cache that predates the Mongol invasions of 1220-21, was in the Kabul Museum.[229] Nevertheless, Allan assumed a later date for the Louvre mortar on the basis of its curious style of epigraphy which he did not identify.[230] It is reminiscent, especially in the style of the *alif-lam*, of an inscription, also undeciphered, on a carved stone from Afghanistan in the DAI.[231] Finally, another mortar of the same type with inlaid decoration was also in the Kabul Museum.[232]

A gap in the domed part of the base is certainly due to the cracking of this area during casting when the plugging by cast-on did not hold. This is suggested by a rough repair filling another hole near the base. A gap on the edge of the rim and numerous cavities caused by air bubbles inside the wall are also structural and not linked to the altered state of the mortar. The external appearance is partly that of a rough cast object. The wall has three parallel moulded ridges. There are two undeciphered inscriptions on the wide bands on the rim and the base: on the rim, the inscription is divided by six moulded lotus buds, and on the base by rosettes in medallions. Both inscriptions are rendered in flat relief and contrast with a vegetal ground. A section of the inscription on the base has an irregular surface which seems to have flaked off as a result of a casting defect and was therefore chased and engraved after shaping.

Mortars with animal heads (cat. nos. 80, 81)

Mortars of this type may have been produced in Iran, in Anatolia and in Iraq between the twelfth and fourteenth centuries.[233] Certain inscriptions, as well as where the objects are preserved or were discovered, provide clues to these attributions. One mortar is inlaid with silver and black material; along the edge, votive formulas in Arabic give the name of its owner Abu Bakr ʿAli Malik Zad al-Tabrizi, his *nisba* referring to the city of Tabriz in northwest Iran.[234] Another from Rayy near Tehran, according to Pope, is also close to this type.[235] In Istanbul, two octagonal mortars with bovine heads attaching the rings are attributed to Diyarbakir and dated to the twelfth to thirteenth centuries.[236] Finally, ten octagonal mortars with nine pestles were discovered in a shipwreck off the Carmel Coast in Israel; they have one or two attachments with felines.[237] These mortars also resemble examples discovered in shipwrecks containing Mamluk coins, the most recent of which was minted in 1404.[238]

Two octagonal mortars without archaeological provenance in the Metropolitan Museum are close to those in the Louvre. One with bull's head handles is of similar dimensions to the DAI example (cat. no. 81).[239] The rim is decorated with a repeated votive inscription in Arabic in Kufic script. The second has a handle with a bovine head; the top and bottom are inscribed with a repetition of the wish 'prosperity' in *naskh*, as read by Abdullah Ghouchani.[240]

80
Mortar with felines

Iran or Anatolia, thirteenth century (?)

Cast high leaded copper, chased, champlevé and engraved (?) decoration

H. 13.5 cm; D. max. 19.9 cm; Thickness max. 3.6 cm; Weight 8.310 kg

Engraving (?) 0.8–1.3 mm

Burin L. 2.8 mm

Punch 0.5 x 2.75 mm

The mortar is covered with a very brown patina, areas of stable green corrosion and traces of burial: remains of concretions are visible in the handles with feline heads.

Bequest of Gaston Migeon, 1931; inv. no. OA 8181

INSCRIPTIONS

Below the rim:

العمر المر ا/لعمر المر ا/لمر العمر ا/المر العمر

al-ʿumr al-marʾ a / 1-ʿumr al-marʾ a / l-marʾ al-ʿumr a / l- marʾ al-ʿumr
healthy life / healthy life / healthy life / healthy life /(?)

Above the base:

العمر المر ال /العمر المر ال/العمر المر ال / العمر المر ال

al-ʿumr al-marʾ al-la / -ʿumr al-ʿumr al- / al-ʿumr al-marʾ al- / al-ʿumr al-marʾ al-
healthy life *alif-lam* / healthy life *alif-lam* / healthy life *alif-lam* / healthy life *alif-lam* / (?)

The inscriptions repeat blessings for good health which suggest that this mortar was used in the preparation of medicinal substances. In four cartouches below the rim, the two words ʿumr and marʾ are repeated with an inversion in their order: marʾ probably derives from the root *m-r-ʾ* 'to be healthy'.[241] We find the same litany alternating with the article al at the bottom of the mortar wall, with a similar arrangement in the cartouches. Several upright letters are fitted into the background of the inscriptions: these may be isolated letters corresponding to votive invocations.

The object is of irregular shape: each side has variations, and the handles are misaligned. It was shaped by lost wax cast-ing as suggested by the toolmarks visible in the connections between the handles and the wall. The four double loop handles are each made as feline heads that may have been modelled separately and added. The casting quality is mediocre. The composition has two vertical variants which are similar but have slight differences in the patterns. One variant has, from top: an inscription on the rim, a handle with a feline head set in an arch with vegetal decoration and a scroll with half-palmettes. The second variant has the same vertical arrangement, but contains a half-palmette vegetal scroll, a rosette with vegetal decoration and an inscription. Each corner of the facets is marked by a palmette. The decoration from the wax model seen in the inscriptions and vegetal bands was partly reworked by chasing, champlevé and probably with engraving. The relief, on a single plane, has a flat base and flat or rounded surfaces.

81
Mortar with bulls and felines

Iran or Anatolia, thirteenth century (?)

Cast high leaded copper, chased, champlevé and engraved (?) decoration, inlaid with black material

H. 14.6 cm; D. (base) 19.5 cm; D. (opening) 20.5 cm; Thickness max. 3.6 cm; Weight 12.3 kg

The porous appearance of the metal is due to its cleaning with an acid solution or other abrasive product. The surface has a tarnished yellow patina, in good condition, with areas of stable red corrosion. The black material was probably remade.

Bequest of Comte François Chandon de Briailles, 1955; formerly in the Bustros collection; acquired in Beirut in 1936 as from Aleppo; inv. no. MAO 316

INSCRIPTIONS²⁴²

Blessings in Arabic in *thuluth* and Kufic scripts are located on the rim (1–2); around the edge (3); alternating with four anepigraphic cartouches and at the bottom of the wall (4–5):

1. Four cartouches with *thuluth* script alternating with cartouches containing text 2

العز/ [...] / الد/ [...] /اثم / الا/ [...] / [...] / قبال
al-ʿizz a/ [...] / l-dāʾim / [...] / wa al-i / [...] / [...] / qbāl alif /
glory/ [...] /perpetual / [...] / fo r/ [...] / tune *alif /*

2. Four cartouches in Kufic script alternating with cartouches containing text 1

[...] / [...] / العز ا / لد [...]/اثم / [...] / و الا / [قبال ا
[...] / [...] / al-ʿizz / [...] / al-d/ [...] / āʾim / al-i[qbāl] / [...] /
[...] glory / [...] / per / [...] petual / for[tune] / [...] / [...] /

3. In *thuluth* script

العز الدا/ثم و الاقبال / الزائد و ا/لعمر السالم
al-ʿizz al-dā / ʾim wa al-iqbāl / al-zāʾid wa a / l-ʿumr al-sālim /
perpetual glory, fortune / growing an d/ healthy life

4. In *thuluth* script

العز الدائم / [...] / و الاقبال ا/ [...] /الزائد العمر ا/ [...] /السالم و الجد
al-ʿizz al-dāʾim / [...] / wa al-iqbāl a / [...] / l-zāʾid al-ʿumr a/ [...] / l-sālim wa al-ǧadd /
perpetual glory / [...] /. fortune / growing life / [...] / health and luck

5. In four cartouches alternating with cartouches containing text 2, a votive formula in Kufic script

العز الد/ [...] / اثم و الا ؟ / [...] / ـة ؟ الخالد(sic) و/ [...] / السلامة
al-ʿizz al-d/ [...] / āʾim wa al-alif ? / [...] / a ? al-ḫālid wa / [...] / al-salāma /
per / [petual] [...]glory[...] / [...]eternal and / wellbeing

As on the previous object (cat. no. 80), the vow 'healthy life' appears twice, suggesting the use of this mortar for medicinal purposes. It is of good quality, especially when compared to other mortars in the collection. There are few deformations and no large cracks in the sides. However, some shaping defects are visible such as small cracks at the bottom of the wall and a slight sagging of the body, as well as pittings and cavities caused by air bubbles on the base. The faceted sides are punctuated by lotus buds that alternate with the double loop handles of the suspension rings adorned with bull's heads surmounting feline heads. The wax models of the handles were roughly joined to the wax model of the mortar. These reliefs are out of alignment and, when assembled in wax, caused the support to sink. The rings hanging from the handles are of different sizes; as can be seen from their openings, they were soldered onto the handles while hot and may in fact be repairs.

Like the previous mortar (cat. no. 80), the decoration of the sides is made up of two similar alternating designs. One has the ring suspension handles, the other a lotus bud. The first design, from top to bottom has a vegetal scroll intersected by a triangle which supports the top of the bull's horns, the place-ment of the animal head loops and an inscription in cursive calligraphy. The second design includes an inscription band in cursive script, a lobed arch decorated with vegetal scrolls fra-ming a central projecting lotus bud and an inscription in Kufic script. Each projecting angle on the rim and base is decor-ated with a palmette. On the flat top of the rim, the angles are marked with vegetal ornament dividing up a Kufic inscription.

The mortar has three planes of decoration: one in relief made by the casting of the wax model, with champlevé and chasing. Toolmarks are visible in the vegetal compositions. In certain areas where the decoration is rather blunt-edged, the champlevé decoration is clearly visible. The border of the vegetal arches was also cold worked. Tracing lines can also be seen in other parts of the composition which were probably largely made and cold worked after the shaping. The presence of bubbles in the black material suggests that it was applied hot. This characteristic, not seen on any other piece in the entire DAI collection of metalwork from the pre-Mongol and Mongol periods, suggests a late repair to this inlay. If the object was originally inlaid with black material, it would be the only inlaid mortar in the collection.

Cauldrons

These utensils, which were sometimes very large, were used in the medieval period for the preparation of medicinal products. For example, a pharmacy is depicted in the richly illustrated copy of the dispersed *De Materia Medica* produced in Baghdad in 621/1224.[243] On the ground floor, a pharmacist is heating a medical preparation in a cauldron over a fire; the medicine, made of honey and water, is being prescribed for weakness. On the first floor of the dispensary, a row of storage jars that are either being filled or protected from the air suggest that medicines were prepared in pharmacies inside bazaars. Cauldrons were also used as domestic utensils and for outdoor banquets in Central Asia.[244] Many representations of cauldrons can be seen in paintings and drawings from the Iranian world in which outdoor meals or encampments are shown. Although dated to the later period of the sixteenth and seventeenth centuries, these depictions nevertheless suggest the probable use of such cauldrons as cooking pots in earlier contexts. Many cauldrons similar to those in the DAI have been found in Central Asia, as well as in Afghanistan.[245] One discovered at Shahr-e Arman in northwestern Afghanistan near Turkmenistan suggests that their production dates from before the 1220s as the site was destroyed during the Mongol invasions and remained unoccupied thereafter.[246]

The three large cauldrons in the collection (cat. nos. 82, 83, 84; figs. 17, 108) are of very similar types: the almost hemispherical body rests on three conical feet and has a flat rim with four projecting sections, one of which has a flat pouring spout. They were therefore designed for liquid substances, for pouring rather than sampling, and were meant to be picked up by the curved handles or the rim. On the underside, projecting pouring holes are visible. Two cauldrons with handles are signed by craftsmen who call themselves *ṣaffār*, or 'cauldron maker' (cat. nos. 82, 83). These are the only objects that document a profession that is specific to the production of metalwork. The use of this term suggests a particular link with cauldron production, a process that involved casting and thus a skill related to the handling of molten metal.[247] The third cauldron (cat. no. 84) is distinguished only by its lack of handles and signature. All three were made with a high leaded copper, the same type of alloy as the mortars. Two cauldrons (cat. nos. 82, 84) are made with a similar alloy; the third (cat. no. 83) is characterised by a higher zinc content (Appendix 1). All are fire-blackened and were used to prepare products with heating: the outside of the walls, otherwise covered with a blackish-brown patina, is blackened, weathered and blistered.

The cauldrons were made with lost wax casting, although the exact processes of manufacture are difficult to reconstruct. Those with handles (cat. nos. 82, 83) may have had them cast as a first step; then the object was cast upside down onto the existing handles included in the mould.[248] The embedding of the curved grips into the molten metal can be identified on one example on which one handle has broken off (cat. no. 82). The same method may have been used for the feet.

The two cauldrons with handles belong to a group which includes approximately thirty signed and unsigned published examples (see the opposite page).[249] Some have votive inscriptions in *naskh* script instead of signatures.[250] Several other similar cauldrons are preserved, and Melikian-Chirvani cited examples he saw in Afghanistan in Kabul, Mazar-e Sharif, Herat and in the markets of Khurasan, on both the Iranian and Afghan sides. He also mentions the names of Khurasani bronze makers on these objects, using *nisbas* from Merv and Tus.[251] In the absence

of precise archaeological contexts and inscribed examples, the dating of the cauldrons varies. Melikian-Chirvani included this type in the category of metals predating 1100, probably on the basis of what he considered to be the model for this type of object, a cauldron made in steatite and discovered in Nishapur.[252] According to David-Weill, all signed cauldrons with two handles originated from the same centre of production and are datable from the twelfth to thirteenth centuries.[253] A cauldron signed by Muhammad ibn al-Husayn al-Salar (?) was attributed by Melikian-Chirvani to Transoxiana or Khurasan and dated c. 1250-1300.[254] The most recent publications, based on objects in Herat and particularly from excavations in Central Asia, tend to date these productions to the pre-Mongol period.

Recorded Cauldrons

Signatures with the *nisba* of cities in Khurasan

***Nisba* of Merv**
Seven identical cauldrons signed by Abu Bakr ibn Ahmad Marwazi / Abu Bakr ibn Ahmad-e Marvazi.[255]
According to Loukonine and Ivanov, there are cauldrons of the same shape cast by other foundry workers with the same *nisba*.[256]
***Nisba* of Tus**
One cauldron signed Hajaki Tusi / Khadjaki-e Tusi.[257]

Families of cauldron makers

Abu Bakr Ibn Mahmud Saffar and his son (?) Mahmud ibn Abi Bakr
One cauldron signed Abu Bakr ibn Mahmud Ṣaffar (possibly cat. no. 82)[258]
One cauldron signed Bu Bakr Mahmud Ṣaffar[259]
One cauldron signed Bu Bakr[260]
Four cauldrons signed Mahmud ibn Abi Bakr[261]

Hasan ibn ʿAli, his son (?) al-Husayn ibn al-Hasan al-Ṣaffar and his son (?)
Muhammad ibn al-Husayn al-Salar (Ṣaffar?)
One cauldron signed Hasan ibn ʿAli[262]
One cauldron signed al-Husayn ibn al-Hasan al-Saffar[263]
One cauldron signed Muhammad ibn al-Husayn al-Salar.[264]

Locations where cauldrons have been found

Shahr-e Arman (Afghanistan), a cauldron signed by Ali ibn Haidar[265]

Takht-e Bazar (Turkmenistan)[266]

Samarqand (Uzbekistan)[267]

82

Cauldron signed Ibrahim ibn Ahmad Saffar

Khurasan, twelfth to thirteenth century

Cast high leaded copper

D. max. 47.8 cm; D. (rim) 40.8–41.3 cm; D. (inside rim) 36.5–37 cm; H. max. 25.8 cm; H. (without handles) 17.5–18 cm; Thickness max. (handle) 3.2 cm; Thickness min. (rim and handles) 6–8 mm; Weight 7.745 kg

The object, one handle of which is broken, is covered with a brown patina. The underside is blackened from repeated heating and also has whitish concretions. The soft and eroded angles of the metal edges show wear.

Purchase, Mme Jean Goudchaux, Paris, 1960; inv. no. MAO 366[268]

INSCRIPTION[269]

On the flat handle opposite the spout: a signature in *naskh* script

<div dir="rtl">عمل ابرهيم بن أحمد صفّار</div>

'amal (work of) Ibrāhīm ibn Aḥmad Ṣaffar

The bottom of the cauldron has been repaired where the pouring hole was located and consolidated with a section held in place by rivets or copper staples under a brown patina (fig. 108); two are now missing. The sides are of regular thickness. However, manufacturing and casting defects are visible on both the interior and exterior. An infiltration in the mould formed a slight mass on the outside of the rim, at the junction between the flat handle and the wall; cavities caused by air bubbles are visible in the top of the body and the complete handle has a crack at its junction with the rim. Two of the flat handles are undecorated; the others have inscriptions and a vegetal motif. This decoration, which was made in wax, was probably not cold worked. The baseline of the inscriptions faces the inside of the cauldron. The signature reveals a Persian-speaking context as suggested by the absence of the article, and contrasts with the vegetal ground. This section of the cauldron did not cast properly, and the flat handle is incomplete. The inscription appears to be on a whitish background, multiple traces of which are visible to the naked eye. These traces, which do not appear elsewhere on the object, are located under corrosion or blackish concretions and may be the remains of an inlaid white material. However, in certain parts of the cauldron this material appears in single points which make its identification uncertain. On either side of the spout and in two cartouches, there is a votive formula in Arabic in Kufic script, reading *a/-'izz / al-dā'im* (glory/lasting).[270] The first part of the inscription is very worn and partially erased. The spout has a flat bottom and a rectangular profile and is decorated with a palmette and florets.

108

Fig. 108

X-ray of the cauldron signed Ibrahim ibn Ahmad Saffar (cat. no. 82).

Fig. 109

Signature of Ibrahim ibn Ahmad Saffar (cat. no. 82).

109

289

83
Cauldron signed Bu Bakr ibn Mahmud Saffar

Khurasan, twelfth to thirteenth century

Cast high leaded copper

D. max. 53.4 cm; D. (rim) 44.5 cm; D. (inside rim) 39.5 cm; H. max. 28.3 cm; H. (without handles) 18.5 cm; Thickness max. (handle) 1.5–1.7 cm; Thickness min. (handle and rim) 2.5–7 mm; Weight 8.904 kg

The object is covered with a blackish brown patina and black spots are visible on the interior and exterior of the body. Traces of earthy concretions are caught in the granular areas, under the flat handles and the rim. The underside is blackened where the cauldron was exposed to fire. The conical feet, which must have measured 5–6 cm in height, were probably cut before the object was sold, as it must not have been stable enough and required balancing. The surface of the pink epidermis is visible on this section. Large areas of wear are visible under the handles, perhaps because the cauldron was carried on a horizontal shaft inserted into its suspension handles. The surface of the object is worn by rubbing and brushing.

Purchase, Mme Jean Goudchaux, Paris, 1960; formerly Demotte collection; inv. no. MAO 362

INSCRIPTION[271]

On the handle opposite the spout: a signature in floriated Kufic script

عمل بو بكر بن محمود صقّار

'*amal* (work of) Bu Bakr ibn Mahmud Ṣaffar

The cauldron is signed in Persian as suggested by the absence of a definite article before the term ṣ*affar*. For David-Weill, the variations in the readings of the signatures explain the divergence between the names and he suggests that this was the same cauldron maker as Mahmud ibn Abi Bakr and Abu Bakr ibn Mahmud (see Table, 287).[272]

The object is larger than the cauldron signed by Ibrahim ibn Ahmad Saffar (cat. no. 81) and the scale of the decoration is also greater, but the two objects are very similar. This cauldron has two curved grips and four flat handles, one of which has a flat spout. Each handle is decorated: the one bearing the signature is in very good condition, the one with the spout has two medallions with a geometric interlace and vegetal decoration on the flat of the spout. The two curved grips are decorated with very worn medallions surrounded by palmettes within almond-shaped frames topped with finials. On the rim, interlaces similar to those adorning the rim of the cauldron with animals (cat. no. 84) alternate with two vegetal scrolls.

The casting is of good quality with few defects. No crack or hole is visible, except on one of the flat handles and on the edge. Some defects in the impression of the wax model are visible in the vegetal motifs, which are sometimes incomplete or irregular. The surface is slightly uneven to the touch. Some superficial defects such as cavities caused by air bubbles are visible on the interior. The shaping process was similar to that used for the other cauldron (cat. no. 82): the pouring hole is clearly visible on the underside of the wall. Ridges underneath the flat handles, probably used as pouring channels, distinguish this cauldron from the other two in the collection. These channels may have been added because this object is larger. All the motifs, including the inscription, seem to have been made by casting the model and do not appear to have been cold worked after shaping. Many casting asperities are visible in the bottoms of the ornaments. The decoration is on two planes, with a flat surface and slightly rounded angles.

110

Fig. 110

Signature of Bu Bakr ibn
Mahmud Saffar (cat. no. 83)

84
Cauldron with animals

Khurasan, twelfth to thirteenth century

Cast high leaded copper, chased decoration

H. 18 cm; D. max. 43.4–43.8 cm; D. (rim) 37.8–38.1 cm; D. (inside rim) 33–33.8 cm; Thickness max. (foot) 2.3–2.7 cm; Thickness min. (rim and handle) 7–8 mm; Weight 6.578 kg

The cauldron is in relatively good condition, with no gaps or breaks in its body. The outer surface is very blackened probably as a result of its repeated use over a fire. The three feet are partly flaking and very brittle. They have probably been slightly shortened recently as the epidermis is visible along the bottom. The interior of the wall is altered by corrosion and green streaks, as, before entering the museum, the cauldron must have been used as a planter or for some other purpose that involved water or wet materials. Traces of black paint are visible in the spout handle. The surface has been cleared down to the epidermis in some areas and it is marked with brush strokes revealing the pink-coloured alloy. The general wear of the decoration is also clearly visible as the reliefs are not very marked.

Bequest Mme Ménard, 1969; acquired from the dealer and collector Claude Anet; inv. no. MAO 436

The tripod shape is the same as that of the other two cauldrons in the collection, with a hemispherical body and four flat handles, one formed as a flat spout; this type is slightly different because it does not have curving grips.

The lack of grips suggests that the cauldron was shaped in one casting. As on the other cauldrons, the pouring hole is clearly visible on the underside, in the centre of the wall. The shaping is of medium quality: the object is symmetrical and well balanced. The thickness of the metal is fairly regular, although the wall is thicker at the bottom, near the pouring hole. Some defects are clearly visible: one of the flat handles, decorated with moving animals, came out poorly with a faulty impression, while on the other an excess of metal was also the result of a defect in the mould. Finally, the rim and flat handles have quite significant cavities caused by air bubbles and two handles appear to sag slightly. Traces of machining are identifiable on the flat handles whose edges have been refined. All four have decoration made in the casting that is now difficult to read as it is very worn. The flat handle with the spout may have had vegetal decoration on either side of the spout. The other handles have animal decoration, always including a goat or other caprid (fig. 111). All the animals face to the right. On the rim, there is an interlace band with an irregular pattern. The decoration seems to have been only slightly cold worked: rare traces of punching were observed, detailing the tracings of moulded patterns and smoothing the roughness of the casting.

Fig. 111

Flat handle decorated with moving animals, with a faulty impression (cat. no. 84)

111

Notes

1 See Le Strange, 1905, 382–432; Ibn Hawqal, 1964, vol. 2: on Sistan 401–12; on Khurasan 413–41; on Transoxiana 443–99.

2 Tabbaa, 1987.

3 See Blair, 1998, 97–99, 106–19 and Blair, 2014, 2–3, 11–56, 57–111.

4 See Ghouchani, 1986.

5 Laviola, 2016, vol. 1, 182–87.

6 Khamis, 2013.

7 As in two famous manuscripts in Paris, Bibliothèque nationale de France, arabe 2964, *Kitab al-Diryaq* (Book of Antidotes), Pseudo-Galen, 1198–99; and Paris, Bibliothèque nationale de France, arabe 5847, *Maqamat* (Assemblies) of Hariri, 1236–37.

8 Shalem, 1994, 3–4; al-Biruni, 1989.

9 In the DAI, metalwork of the Iranian world linked to bodily care, including medical instruments, is mainly represented by the objects excavated at Susa in Iran.

10 Coulon, 2015. Analogy (*qiyās*) is a system of reasoning that is one of the bases of law and jurisprudence in Islam. On systems of thought based on similarities, including analogy, which were inherited from Antiquity and continued into the sixteenth century in Europe, see Foucault, 1966, Chapter 2, especially 36–38.

11 On this theme, see also 124 and 214 in this volume.

12 Beyhaqi, 2011, vol. 1, 354.

13 Particularly in Nishapur; Wilkinson, 1973 published two complete unglazed clay lanterns, nos. 52–53, pages 307, 343.

14 Paris, Bibliothèque nationale de France, arabe 2964.

15 Thomas, 2018, 198, 205–8.

16 Allan, 1982A, 45–49; Dahncke, 1992.

17 See also the unpublished lamps in Tehran, Reza-e Abbasi Museum.

18 Coulon, 2015, 184.

19 See cat. no. 34.

20 Dahncke, 1992, 128–44.

21 Read by M. Bernus-Taylor in 1976; reviewed by V. Allegranzi in 2016.

22 Paris, 1976; see cat. nos. 11, 23.

23 For the archaeological information on these types of lamps and their regional diffusion, see cat. no. 21. For examples without archaeological provenance that were purchased in Kabul, see Dahncke, 1992, 100, 103–105.

24 Yaqut 1955–57, vol. 5, 476, 479; see also Barbier de Meynard, 1861, 606. I sincerely thank Barry Flood for having shared this reference with me.

25 For instance, some unpublished examples in Tehran, Reza-e Abbasi Museum.

26 Completed by Farhad Kazémi and Nicolas Mélard, curators, Musée du Louvre and C2RMF, whom I thank for this opportunity.

27 See especially the lamp in Berlin, Museum für Islamische Kunst, I. 4315.

28 Melikian-Chirvani, 1973, 14–15.

29 Ferdowsi, 1976, vol. 1, 219–21.

30 For multiple appearances of Alexander in Persian literature, see references in Feuillebois-Pierunek, 2012 and Manteghi, 2018.

31 Konstantakos, 2020. For a representation of the Simurgh and the association between it and Garuda, the vehicle of Vishnu, represented ascending on a seventh-century Bactrian silver gilt plaque in Saint Petersburg, Hermitage Museum, S-217, see Compareti, 2015, fig. 8, 39. I sincerely thank Melanie Gibson for this reference.

32 Read by V. Allegranzi in 2016.

33 Paris, 1994, lot 36; Paris, 2002, lot 305; the second is now in the Nasser D. Khalili Collection, MTW 73, Spink et al, 2022, vol. 2, no. 429, 562.

34 The attribution 'Persia, XIIIth centuries' is in the DAI inventory, vol. 1, 214–15. Pope, 1939, vol. IX/1, pl. 1287A.

35 Al-Sufi, 1874, 91–95.

36 Allan, 1976, vol. 2, 705–12, fig. 48.

37 Dressen, Minkenberg and Oellers, eds., 2003, vol. 1, 111.

38 Melikian-Chirvani, 1975B, 193; Melikian-Chirvani 1982A, 34.

39 Franke and Müller-Wiener, eds., 2016, figs. 36–37, 106–107; cat. M58–M61,

124–125, cat. M80, 128.

40 Laviola, 2016, vol. 2, 534–41, 550–52.

41 Baypakov, Pidaev and Khamikov, eds., 2012, respectively 138–39, 212–13; 158, 162, 166, 49, 60–61, 64, 67, 78, 70, 119.

42 Franke and Müller-Wiener, eds., 2016. fig. 38, 107 and cat. no. M63-M68, 125–126; fig. 33, 105, cat. no. M81, 128.

43 Laviola, 2016, vol 2, 541–49, 553–69; Melikian-Chirvani, 1982A, 56–58.

44 Shishkina and Pavchinskaja, 1992, no. 326, 119.

45 London, British Museum, 1905. 1110. 10, Pope, 1939, vol. IX/1, pl. 1283D.

46 Saint Petersburg, Hermitage Museum, see Loukonine and Ivanov, 1995, no. 122, 141; Giuzalian, 1968, 107–108, figs. 7-8.

47 Khamis, 2013, 27–39, 131–50, 232–72.

48 Khamis, 2013, 32, 35–36.

49 Laviola, 2016, vol. 1, 234–41.

50 London, 1931A, no. 77R, 54; Pope, 1939, vol. IX/1, pl 1284B.

51 Pellat, 1991.

52 See also the representations on the tray, cat. no. 10.

53 Detroit Museum of Art, 29.362. Published alongside the Louvre lampstand, Pope, 1939, vol. IX/1, pl. 1284A.

54 A label on the base reads 'Jeuniette 189', a reference to the lot number of the object that was sold at auction in Paris when the collection was dispersed, see Paris, 1919, 36. The collector added to the collection of the future DAI by making a donation in January 1919 in memory of his brother Fernand (ceramics and carpets, OA 7251–7257).

55 Rereading by V. Allegranzi in 2016.

56 Only the base could be analysed by sampling; the shaft and tray are too thin to be sampled and the corrosion of the surfaces prevented their analysis by PIXE.

57 Falk, ed., 1985, no. 261, 257.

58 For metal and ceramic figurines in the pre-Mongol Iranian world, see also the essay by Gibson, 2022, 350–63.

59 Cambridge, Fitzwilliam Museum, C1-1967, 47 x 25 cm, see Canby et al, 2016, no. 131,

214–15.

60 Former Lewisohn collection, published in Pope, 1939, vol. VI/2, pl. 6765 and in Koechlin and Migeon, 1928, pl. 16.

61 Gibson, 2008–2009, 40.

62 See also the rooster in Saint Petersburg, Hermitage Museum, Ka 2323, Piotrovsky and Pritula, eds., 2006, no. 16, 24–25. See also Hill, 1974.

63 Gibson 2008–2009, 42, note 16.

64 See Foucault, 1966; Scott-Meisami, 2001; Seyed-Gohrab, 2012.

65 The term *tamathil/tamthil*, used to designate these sculptures, signifies 'analogy', exemplification, in eleventh-century literary theory.

66 Beyhaqi, 2011, vol. 2, 216–17.

67 Melikian-Chirvani, 1982C, 1991, 1995 and 1996; Hanaway, 1988. For the stucco, see Riefstahl, 1931; Duggan, 2012 and Heidemann et al, 2014.

68 Endoscopy carried out by F. Kazemi and N. Mélard, curators, Musée du Louvre and C2RMF.

69 Allan, 1976, vol. 1, 378; vol.2, 703, fig. 47.

70 For the list of published examples of this type of lamp and one in the Keir Collection, see the publication of lamp MAO 830, in Makariou, ed., 2002, no. 36, 70–71. See also the lamp in the Nasser D. Khalili Collection, MTW33. Spink et al, 2022, vol. 2, no. 443, 571.

71 DAI Inventory, vol. I, 192: 'Crouched tiger, body shown in profile and the head from the front, the legs folded. The body of the beast is cut lengthwise, and is shaped by two parts of hollowed metal (…)'. Melikian-Chirvani 1973, 31.

72 The modern assembly was dismantled by the author in 2013, following observation with the naked eye. Although undocumented, this assembly probably dated from the beginning of the 1990s, ahead of the 1993 exhibition of the feline in the permanent exhibition space devoted to the Arts of Islam in the Richelieu wing in the Louvre.

73 Pope, 1939, vol. IX/1, pl. 1306B, 1306C.

74 Melikian-Chirvani, 1973, 31; reviewed by V. Allegranzi in 2016.

75 Meyer, 2015, no. 20, 56–57.

76 Allan, 1976, vol. 1, 315; vol. 2, 765, fig. 59.

77 Cleveland Museum of Art, 1948, 458.

78 Partridge incense burner, Saint Louis, City Art Museum, 245:1952, Pope, 1939, vol. IX/1, pl. 1298B; Grabar, 1959, no. 47, 56.

79 De Fouchécour, 1969, 146.

80 Al-Biruni, 1989, 147.

81 As seen on two unpublished caracal incense burners in Tehran, Reza-e Abbasi Museum.

82 New York, MMA, 1972.87, Ekhtiar, Soucek et al, 2011, no. 86, 129–130.

83 Allan, 1982A, no. 175, 100–101.

84 Loukonine and Ivanov, 1995, no. 100; Siméon, 2012, fig. 25b.

85 Loukonine and Ivanov, 1995, no. 101.

86 Cleveland Museum of Art, 1948.301, Sheperd, 1957, cover and 117.

87 A falcon with broken feet but an intact tail once belonged to the Harari collection. It features a removable dorsal opening that is visible in photographs in the DAI documentary archives. Another very similar example (H. 24.5 cm) was sold at auction, London, 2006, lot 95.

88 For a complete ceramic example from Iran, with metallic lustre, c. 1180–1220, see Pope, 1939, vol. VI/1, pl. 647.

89 De Fouchécour, 1969, 146.

90 Bosworth, 2011C, 95.

91 Melikian-Chirvani, 1971, no. 135, 97–98.

92 A single published caracal in the National Museum of Iran, see Tehran, 1948, 52, fig. 9, has, it seems, the same tail as the example from the Louvre. A similar handle is visible on a jug discovered in Akhsiket, Uzbekistan, see Baypakov, Pidaev, Khamikov eds., 2012, 223.

93 Melikian-Chirvani, 1971, no. 127, 95.

94 Reported and photographed by D.S. Rice, see David-Weill, 1962. One of the caracal heads is very different and was mounted on the stand to replace a broken head.

95 Kiani, 1984, no. 47.2, pl. 47. For recent archaeological research in the area of Gurgan but focused on earlier dates, especially the Sasanian period, see Sauer et al, 2013.

96 David-Weill, 1959.

97 Grabar, 1959, no. 24, 26, 53, then the Rabenou collection, acquired by the Israel Museum, Jerusalem, on loan to the Eretz Israel Museum, Jerusalem, M 3692.9.64, see Ziffer, 1996, 77; see also Grabar, 1959, nos. 52, 31, 58, Saint Louis, Art Museum, 17:1954.

98 See also the ceramic incense burner with caracal protomes in the DAI with a siliceous body and turquoise glaze, MAO 407, also acquired by the Louvre from Acheroff, in 1962.

99 Grabar, 1959, no. 45, 30 and 56; one example sold at auction in London, 1992, lot 218.

100 Schlumberger, 1959, 260–61.

101 Melikian-Chirvani, 1982A, no. 18, 54; for horse-shaped padlocks, see Rashidi 2011, 47–91.

102 Kiani, 1984, no. 482–82, pl. 48.

103 Allan and Gilmour, 2000, 402–405, 419.

104 Allan, 1976, vol. 2, fig. 58, 567 and 758–64.

105 Bonnéric, 2015; see also Meyer, 2015.

106 Ducène, 2015, 163–65.

107 Coulon, 2015.

108 De Fouchécour, 1969, 97, 99.

109 Halevi, 2007, 53–54. The use of zoomorphic incense burners in the shape of falcons and other living beings during funerary ceremonies in cemeteries and mosques is attested to by a medieval legal source which castigates its practice; see Flood, forthcoming, who generously communicated this information and its interpretation, both unpublished, as well as the passage of *Nisab al-ihtisab*, ed. 1986, 178–79 and its translation by M. Izzi Dien, 1997, 75.

110 Bonnéric, 2015, 31–35; Coulon, 2015, 201; Ducène, 2015, 166–73.

111 Halevi, 2004, 16; Halevi, 2007, 145. I sincerely thank Barry Flood who alerted me to these references on the funerary use of incense burners.

112 Bosworth, 2011C, 95.

113 Purchased at auction by Jean Soustiel, Paris, 1978, lot 303.

114 Uncredited reading in the DAI inventory, reviewed by V. Allegranzi in 2016.

115 Franke and Müller-Wiener, eds., 2016, 98–99, 121–22, figs. 37, 107, 124.

116 Coulon, 2015.

117 Read by V. Allegranzi in 2016.

118 Allan, 1976, vol. 2, no. 6, 760.

119 Melikian-Chirvani, 1982A, 61.

120 Allan, 1976, vol. 2, no. 7, 761; Pope 1939, vol. IX/1, pl. 1287B.

121 Allan, 1976, vol. 2, no. 4, 760, no. 7, 761 and no. 2, 763.

122 Canby et al, 2016, 224.

123 Pope, 1939, vol. IX/1, pl. 1283C, D. 19.5 cm; Moser Collection, Historisches Museum, Bern.

124 As seen on a house model from Gurgan (?) in the Tehran, Glass and Ceramic Museum; see also Kiani, 2001, 55. For a study of these architectural models, see Graves, 2008.

125 Gibson, 2008–2009.

126 Carboni, 1997, especially no. 7, 20.

127 See in the *Shahnama* (Book of Kings): Melikian-Chirvani, 1992, 99–100, 102, 106.

128 De Fouchécour, 1969.

129 Melikian-Chirvani, 1992, 95, 100; Melikian-Chirvani, 1996, 94.

130 On *bazm*, see also 124, 214, 255 in this volume.

131 Melikian-Chirvani, 1991; Melikian-Chirvani, 1992, 107–109.

132 Melikian-Chirvani, 1991. For examples of zoomorphic ceramics, see Canby et al, 2016, 217–218.

133 Melikian-Chirvani, 1982C and 1991.

134 Gibson, 2010.

135 Melikian-Chirvani, 1996, 85–90, 92, 94, 97.

136 Kiani, 1978, no. 92, 108–109.

137 Allan, 1976, vol. 2, 627–28.

138 Melikian-Chirvani, 1982A, no. 16, 52–53.

139 Baypakov, Pidaev, Khakimov eds., 2012, Ill. XVI, 76 and 89.

140 See above, 43.

141 Partial translation by Henri Marchal, 1974, 16; read and translated by V. Allegranzi in 2016.

142 This machine-cut base (visible from the striations) is more yellow and without cracks; it is glued to the bottom of the original walls.

143 Collection dispersed in Paris, 1976; see cat. nos. 11, 23, 63 for the same provenance.

144 Baypakov, Pidaev, Khakimov eds., 2012, 223; Abdullayev, Rtveladze, Shishkina eds., 1991, vol. 2, 191 and no. 744, 193.

145 Melikian-Chirvani, 1974A, 131–32; sold at auction in Paris, 1960, lot 131.

146 Read by M. Bernus-Taylor in 1978; reviewed by V. Allegranzi in 2016.

147 Allan, 1976, vol. 2, 751, fig. 56; Kalter and Pavaloi, eds., 1987, 128.

148 Bahrami, 1949, pl. XCV, H. 30 cm; Matossian Collection, then Keir Collection, see Tabbaa, 1987, 109; Louvre, DAI, MAO 252, H. 20.3 cm, from Tripoli.

149 Franke and Müller-Wiener, eds., 2016, 123, cat. no. M51-M54; Melikian-Chirvani, 1975B, 202–204, pls. XVII–XVIII; Laviola 2016, vol. 2, 638–40.

150 Baypakov, Pidaev, Khakimov eds., 2012, 184 and 222–23.

151 Laviola, 2016, vol. 2, nos. 453–54, 628–29 (catalogued as lids).

152 Fehérvári, 1976, no. 57, 64, pl. 17, H. 20.3 cm, acquired in Iran in 1967; London, 2013, lot 64.

153 Baer, 1989.

154 Paris, 1978, lot 279.

155 Read and translated by Th. Bittar in 1987.

156 De Fouchécour, 1969, 71.

157 Aʿlam, 2003.

158 Meyer, 2015, 7.

159 De Fouchécour, 1969, 35, 68–73.

160 Migeon, 1922, no. 64, 20, pl. 21; see also Paris, 1977, no. 326, 158.

161 London, British Museum, 1920.0326.1, Watson, 1985, fig. 37.

162 New York, MMA, 61.40, Canby et al, 2016, no. 144, 230–31.

163 Reading and translation not credited, archives of the DAI, reviewed by V. Allegranzi in 2016.

164 New York, MMA, 1975, 266.

165 Ettinghausen, 1978, 29–30, quoted in the online catalogue of the Metropolitan Museum of Art.

166 Oral communication with Mrs. Afkari, University of Tehran, 2006.

167 Excavation of the Acropolis, Jacques de Morgan, 1899–1902. Louvre, Département des Antiquités Orientales, SB 3736/A.S. 7815. Described on the paper index card as a 'slightly curved plate (shovel?) with

long concave sides. On either side of the handle (? and incomplete), the side has two inclined concavities topped by hooks'; H. 26.3 cm, L. 12.7 cm.

168 Read by J. David-Weill, 1969; reviewed by V. Allegranzi in 2016.

169 Ploug et al, 1969, 33, 8.

170 Read by V. Allegranzi in 2016.

171 Allan, 1976, vol. 2, 813.

172 Allan, 1982A, 39 and no. 85, 76.

173 Saint Petersburg, Hermitage Museum, UP 1496; Bumiller, 1993, 109–14.

174 These types of objects are well represented in the metalwork coming from the Susa excavations in western Iran which is mostly unpublished, although a selection of objects is exhibited in the DAI galleries in the Louvre. For the Nishapur material, see Allan, 1982A; for the catalogue of cosmetic crucibles and other objects linked to grooming found in Iran, see Allan, 1976, vol. 2, 798–99, 802–805.

175 Omidsalar, 2011.

176 The two mirrors in the MAD could not be analysed as the samplings were not authorised and the layers of corrosion and concretions that cover them did not allow for a surface analysis by PIXE.

177 See above, 57.

178 De Fouchécour, 1969, 126–27.

179 Melikian-Chirvani, 1992, 116.

180 Carboni, 2006.

181 Mirror dated 548/1153, Cairo, Museum of Islamic Art, from the Harari coll. no. 113; mirror dated 675/1276, Cairo, Museum of Islamic Art, from the Harari coll. no. 112. See Rice, 1961, 289.

182 Rice, 1961, 289.

183 Melikian-Chirvani, 1973, 37; Melikian-Chirvani, 1982A, 130–131.

184 Melikian-Chirvani, 1973, 35; reviewed by V. Allegranzi in 2016.

185 Examples are in the Detroit Institute of Arts, 30431, D. 14 cm; British Museum, 1866, 1229.75, 166.12–29.75; Baghdad, Iraq Museum, A 820, D. 14.7 cm, Jones and Michell eds, 1976, no. 184, 173, as well as one sold at auction, London, 2008, lot. 65, incorrectly described as from the same mould as cat. no. 68.

186 Krachkovskaya, 1960, D. 14 cm, four different animals linked to the hunt, pearl bands, votive inscription; Allan, 1976, vol. 2, no. 1, 807, suggests that it could have been from the same mould.

187 Lyon, Musée des Beaux-Arts; see Melikian-Chirvani, 1973, 35.

188 New York, MMA, 42.136; see Carboni, 2006, 165 with references to published mirrors.

189 Berlin, Museum für Islamische Kunst, I. 1615, D. 9 cm; von Gladiss and Krogers, 1985, 55.

190 Allan, 1976, vol. 2, 807.

191 Inscriptions read by Melikian-Chirvani, 1973, 37; by Th. Bittar in 1987; reviewed by V. Allegranzi in 2016.

192 A mirror in London, V&A, 928-1886, D. 10.5 cm, Melikian-Chirvani, 1982A, no. 58, 130–31, was purchased in 1886 in Tehran.

It has a flat rim, very worn reliefs, imprecise decoration and a knop with a vertical handle. Traces of where the knop was added on the wax model are visible near the wings of the sphinx.

193 Scerrato, 1980, 88–94; Carboni, 2006, 164. Melikian-Chirvani, 1973, 37, notes the appearance of fake objects on the art market.

194 See also Louvre, DAI, moulded clay ceramic lid, MAO 936/412.

195 New York, MMA, 08.208.1, D. 8.7 cm; H. 7 mm.

196 Scerrato, 1980, 67–72. I sincerely thank Barry Flood for sharing this article.

197 Scerrato, 1980, 67–68.

198 Baypakov, Pidaev, Khakimov eds, 2012, 227; see also 121 for another example, found in Kyrgyzstan.

199 Photography by Roland Bezenval, DAI documentary archives.

200 Istanbul, Museum of Turkish and Islamic Art, 2972, 2590 and Huseyin Kocabaş Collection, 909, 905, Istanbul, 1983, nos. 131–34, 72–73.

201 London, V&A, 928–1886, Melikian-Chirvani, 1982A, no. 58, 131–32.

202 Maddison and Savage-Smith, 1997, no. 52, 128.

203 Riyad, 1985, no. 83.

204 Allan, 1982A, 34.

205 Allan, 1976, vol. 1, 237–39.

206 Page in New York, MMA, 13.152.6, see Paris, 1996, 85.

207 Maddison and Savage-Smith, 1997, 290.

208 Fifteen mortars analysed before 1997 were cited by Savage-Smith. All have a high lead content: six are from Al-Andalus (leaded tin brass, 5.2– 13.05% lead, 1.8–2.82% tin; leaded bronze and leaded zinc bronze, with a different lead content 3.38–9.31%). Nine other mortars from other regions of the Islamic world that were analysed contain a substantial quantity of lead, varying from 10 to 34%. Five of them are leaded tin brasses, (tin 2.7–3.6%, zinc 5.8–8.6%). The other four mortars are leaded bronzes (tin 3.2–6.1%, zinc 0,04- 1.7 %). London, British Museum 1939.10-18.1; 1907.11-9.1; 1907.11-9.4; 1907.11-9.7; see Craddock et al, 1998, 110.

209 Allan, 1976, vol. 1, 234–35, 237.

210 According to Savage-Smith, mortars with grips were made in a single casting with no secondary casting. The rings that are sometimes looped through these grips were produced separately, or 'from twisted, heavy-gauge wire', Maddison and Savage-Smith, 1997, 290. The mortars were cast like the bells: the casting hole is at the top of the mould which is at the base of the mortar, so they are cast base to top.

211 Cat. nos. 27, 75, 77–80.

212 Cat. nos. 76–79.

213 Melikian-Chirvani, 1982A, 67–69.

214 Melikian-Chirvani, 1982A, fig. 34, 66.

215 Melikian-Chirvani, 1982A, Mazar-i Sharif, Muzim-i Bakhtar, fig. 35, 67.

216 Resembles type 5 which is characterised by a concave profile in Allan and Savage-Smith.

217 Maddison and Savage-Smith, 1997, 291–93; Allan, 1976, vol. 1, 235.

218 Type 7 in Allan, 1976, vol. 1, 236; and Maddison and Savage-Smith, 1997, 292–94.

219 Similar to type 3 in Allan and later Savage-Smith; see also their type 2, Maddison and Savage-Smith, 1997, 291–293. These are attributed to the Syro-Egyptian region.

220 See an attribution Syria-Egypt, eleventh to twelfth centuries, Maddison and Savage-Smith, 1997, 300.

221 Kabul, National Museum of Afghanistan, 58-2-4, H. 12 cm; cylindrical wall, oblique edge, flat rim, Tissot, 2006, 486.

222 Melikian-Chirvani, 1973, 18–19.

223 Afghanistan, Mazar-i Sharif Museum; Lausanne, Coll. Marmillod, acquired in Herat; Melikian-Chirvani, 1973, 19; Berlin, Museum für Islamische Kunst, I. 1289, H. 15 cm, D. 16.8 cm, unprovenanced, Pope. 1939, vol. IX/1, pl. 1280B; Kabul Museum, 58.2.42, from Ghazna; former collection Martin, from Bukhara; for the latter two, see Allan, 1976, vol. 2, nos. 2 and 6, 650.

224 One published by Melikian-Chirvani, 1982A, figs. 38, 68 and notes 47 and 81 as being from Khurasan, second half of the twelfth to early thirteenth-centuries, H. 12.5 cm; D. opening 18 cm. It has a single grip with a very fine ring, engraved and champlevé decoration and copper inlay, with blessings in naskh and Kufic scripts.

225 Istanbul, Museum of Turkish and Islamic Arts, 1512. Istanbul, 1983, no. D110, 65.

226 New York, MMA, 41.160.199, H. 10.8 cm; D. 14.3 cm; the mortar has seven lotus buds and a feline-headed handle. It is attributed to fourteenth-century Iran in the online catalogue entry.

227 Melikian-Chirvani, 1982A, 68–69 and no. 40, 109, Khurasan, twelfth century; Maddison and Savage-Smith, 1997, 316, Khurasan, fourteenth to fifteenth centuries.

228 Tashkent, Academy of Sciences, Institute of Fine Arts, FASI 0890, 20 x 23.5 cm; cylindrical wall, large flat rim and flat base. No stratigraphic context but attributed to the twelfth century, see Abdullayev, Rtevladze, Shishkina eds., 1991, vol. 2, no. 547, 113.

229 Kabul, National Museum of Afghanistan, H. 12 cm; D. 16.8 cm; undecorated; see Scerrato, 1964, 686, fig. 16.

230 Allan 1976, vol. 2, 662.

231 Louvre, DAI, MAO 852. See Makariou, ed., 2002, no. 24, 58.

232 Kabul, National Museum of Afghanistan, champlevé decoration (?) inlaid with copper, cartouches with inscriptions of blessing in Arabic, see Melikian-Chirvani, 1982A, note 46, 81.

233 Attributions to this type of mortar: western Iran, thirteenth century, Melikian-Chirvani, 1982A, 160–62; Anatolia, thirteenth to fourteenth centuries, Falk, ed., 1985, no. 278, 270; Anatolia/Jazira, twelfth to fourteenth centuries, Maddison and Savage-Smith, 1997, 304.

234 New York, MMA, 91.1.527a, H. 11.4 cm; D. 14.6 cm.

235 London, V&A, 466-76, Pope, 1939, vol. IX/1, pl. 1281; Melikian-Chirvani, 1982A, 160–161.

236 Istanbul, TIEM, 1509 and 1510, H 12.5 cm, D. 16 cm; H. 13.5 cm, D. 18 cm.

237 Jerusalem, Israel Museum; the mortars measure D. 14.5–19.5 cm; H. 9–13.5 cm.

238 Maddison and Savage-Smith, 1997, 291, 304.

239 New York, MMA, 07.208, H. 14.6 cm, W. max: 23.7 cm, D. 18.1 cm; unknown history, before 1907 in the collection of A. Filippo, London.

240 New York, MMA, 13.81, H. 11.4 cm, D. 17.1 cm, gift of Emile Tabbagh, 1913.

241 These are not pseudo-inscriptions as Allan suggested, 1976, vol. 2, no. 2, 660. Reading and translation not credited, archives of the DAI, reviewed and interpreted by V. Allegranzi in 2016.

242 Read by V. Allegranzi in 2016.

243 Dispersed page, New York, MMA, 57.51.21.

244 Piotrovsky and Vrieze, 1999, no. 120, 165.

245 Baypakov, Pidaev and Khakimov, eds., 2012; Franke and Müller-Wiener, eds., 2016, M.31–M35, 97, 120–121. An example which was on loan in Kabul, National Museum of Afghanistan was also published by Melikian-Chirvani, 1973, 42 (H. 14.5–15.7 cm; D. 41.7 cm).

246 Wannell, 2002, 242–43.

247 It thus appears inappropriate to translate ṣaffar as 'coppersmith' which is a more general term for the working of metal by hammering.

248 Hypothesis communicated by Jean Dubos and David Bourgarit during observation of the objects in 2015.

249 See also Laviola, 2017C.

250 Samarqand Museum, Khakimov, ed., 2004, no. 246, 141.

251 Melikian-Chirvani, 1973, 43.

252 Melikian-Chirvani, 1982A, 48–49.

253 David-Weill, 1963, 31.

254 London, V&A, 1953-1899, Melikian-Chirvani, 1982A, no. 80, 180.

255 Mayer, 1959, 24; Ivanov, 1983; Loukonine and Ivanov, 1995, no. 119, 139. Another is in the Georgia Museum, Tbilisi, no. 1; H. 20 cm; D. 52.4–53.5 cm; a handle is broken. A cauldron sold at auction, London, 2011A, lot 26, once belonged to S.C. Welch and is one of the seven cauldrons catalogued by Mayer in 1959, D. 52.5 cm, flat rim handle with a steeply angled spout.

256 Loukonine and Ivanov, 1995, 139.

257 Melikian-Chirvani, 1973, 43.

258 Formerly in the Demotte Collection, Mayer, 1959, 25.

259 Saint Petersburg, Hermitage, TP-207, Piotrovsky and Vrieze, 1999, no. 120, 165.

260 London, V&A, M.37-1959, H. 17.5–19.5 cm; D. max. 45.8 cm; the two handles are broken. According to the online catalogue, the lead brass cauldron has champlevé decoration and was shaped in two parts and joined by soldering, Melikian-Chirvani, 1982A, 48–49.

261 Three cauldrons in Saint Petersburg; one in Kiev, Mayer, 1959, 55.

262 Location unknown. The signature in floriated Kufic seems to have been incised, D. 31.8 cm, sold at auction, Paris 2010, lot 17.

263 Herat Museum, Melikian-Chirvani, 1982A, 180.

264 London, V&A, 1953-1899, bought in Samarqand, H. 19.7 cm (without handles); H. 28 cm (with handles); D. max. 46.7 cm; according to the online catalogue entry, which has engraved decoration is made of leaded brass and would have been shaped in two parts. It is datable to the Mongol period by the Arabic inscription in naskh script on a vegetal ground; Melikian-Chirvani, 1982A, no. 80, 180; Melikian-Chirvani, 1973, 42–43.

265 Wannell, 2002, 242–43.

266 Ashkabad, History Museum of Turkmenistan, Pougatchenkova and Khakimov, 1988, no 184.

267 Samarqand, Museum, A-176-60, D. 34 cm, H. 15.5 cm; the object is complete and decorated on the flat handle with a blessing in naskh script, Shishkina and Pavchinskaja, 1992, no. 329, 120.

268 A second number is inscribed on the object: 72.33.1.

269 David-Weill, 1963, 30; reviewed by C. Juvin in 2006.

270 David-Weill, 1963, 30.

271 David-Weill, 1963; Melikian-Chirvani, 1971, no. 134, 97.

272 David-Weill, 1963, 30.

Conclusion

'For example, in photography, process reproduction can bring out those aspects of the original that are unattainable to the naked eye yet accessible to the lens, which is adjustable and chooses its angle at will. And photographic reproduction, with the aid of certain processes, such as enlargement or slow motion, can capture images which escape natural vision.'

Walter Benjamin, 1935[1]

This book has adopted an innovative methodology rarely used in the study of major museum collections of the arts of Islam—it has sought to enrich our knowledge of the objects through archaeo-metallurgy and its imagery. The aim was to identify, through the study of a collection of sufficient size to be representative, the characteristics of metalwork production in the eastern Iranian world, particularly Khurasan, and to attempt to further characterise the metalwork culture of this region and its spheres of diffusion in the pre-Mongol period. By investigating the materials and their applications, the objective was to reconsider the collection and the methods of study that had previously been applied to it. The archaeometallurgical approach has also shown how much in-depth observation of objects is necessary for the expert appraisal and evaluation of a single object, and more widely to the entire collection. Visual observation and systematic use of the digital microscope and X-rays as necessary have been invaluable in detecting concealments, repairs and refurbishments carried out in preparation of the sale of the objects. Analyses and examinations of the materials and processes used in the production of the objects and their decoration have shown—when applied to the collection of the Louvre—that metalwork in the Iranian world was, until the 1220s, characterised by a broad variety of alloys of which five different types have been established. Their impurities, as well as those detected in the metal inlays, especially copper, reveal several supply routes for materials and distinct metallurgical signatures, from which emerge regional variations and different centres of production. This data reinforces our existing knowledge of production systems, as well as of alloy formulas and recycling practices. Combined with the study of shaping and decoration, the archaeometallurgical research applied to the DAI collection has also brought to light agents that were hitherto little known in the art of metal. One of the results of the technical studies carried out on the collection is the highlighting of the importance of lost wax casting and the major role of wax craftsmen and foundry workers. The link with other types of production, such as objects that were hammered and related to the work of the goldsmith, show that craftsmen specialising in chasing and inlay were both versatile and probably mobile because they were able to work on different metals, shaped in very different workshops.

The primary characteristic of a museum collection is that it is assembled over considerable time and contains objects whose precise origins are usually unknown. Only in exceptional cases can the histories of the objects be traced. The question of provenance is therefore at the heart of the study of these collections. One object-

ive of the research carried out on the DAI metalwork was to refine the attributions of objects or groups of objects, based on reference objects whose provenance was fairly well established by scientific consensus or known from the history of their archaeological provenance. Developing knowledge on questions of provenance also allowed for the characterisation of production and its attribution to identifiable regions or centres, in order to better define the hallmarks of their respective production, but also to understand them in a broader regional context. Thus, alongside the well-identified inlaid production of Herat, both for cast and hammered objects, there is evidence of production in Ghazna. We find similar types of objects in both centres, but can also distinguish production techniques that can be very different from those observed on objects from Herat and elsewhere in Khurasan. Other centres of production still remain to be identified and characterised. Above all, the region of Khurasan is distinguished by its immense treasure, comprising countless pieces of cast and hammered metal, vessels and utensils decorated with chasing and precious metals that were disseminated throughout the Iranian world and beyond.

By the diversity of its forms and decoration, the metalwork of pre-Mongol Khurasan introduces us to a vast visual culture. This is also one of the topics discussed in this book. From modest artefacts to precious masterpieces, the objects in the DAI collection are presented in the last chapter in terms of their possible uses in an attempt to interpret them in their historical sense, in order to understand their function in their urban contexts—in other words, to see them not as museum objects, frozen and immobile in their display cases and storerooms. When they are exhibited, the objects on view, long considered to be decorative works, are not always easy to understand. Their previous lives and their significance cannot be deciphered without introducing possible interpretations. The relationship of form to function, or iconography to symbolic meaning, is not self-evident. The aim was therefore to show them, as much as possible, as objects that were handled, looked at, read and sometimes admired by owners belonging to very different social groups in the cities of the Iranian world, who lived with these objects in their homes, or used them in public settings such as the bazaar.

1 *In Illuminations*, ed. Hannah Arendt, trans. Harry Zohn, New York, 1969, 3–4

Appendices

Bibliography

PRIMARY SOURCES

Abu Dulaf, Misar ibn al-Muhalhil, 1955. *al-Risalat al-thaniyya*, text, translation and commentary by V. MInorsky, Cairo.

Abu'l Qasim, 'Abd Allah Kashani, 1345/1966. *'Arayis al-jawahir wa nafayis al-atayib*, Tehran.

Abu Zayd, 1845. *Akhbar al-sin wa'l-hind*, Joseph Toussaint Reinaud, *Relation des voyages faits par les Arabes et les Persans dans l'Inde et à la Chine dans le IXᵉ siècle de l'ère chrétienne, texte arabe, imprimé en 1811 par les soins de feu Langlès, publié avec des corrections et additions et accompagné d'une traduction française et d'éclaircissements*, vol. II, Paris, Imprimerie royale, Paris, Imprimerie royale.

Beyhaqi, Abu 'l-Fazl, 2011. *The History of Beyhaqi (The History of Sultan Mas'ud of Ghazna, 1030-1041)*, translated with a historical, geographic, linguistic and cultural commentary and notes by C.E. Bosworth. Completely revised with additional commentary by Mohsen Ashtiany. Vol. I, *Introduction and Translation of Years 421-423 A.H = 1030-1032 A.D*; vol. II, *Translation of Years 424-432 A.H. = 1032-1041 A.D. and the History of Khwarazm*; vol. III, *Commentary, Bibliography and Index*, Boston / Washington, Ilex Foundation / Center for Hellenic Studies.

Al-Biruni, Muhammad ibn Ahmad, 1888. *Alberuni's India, An Account of the Religion, Philosophy, Literature, Geography, Chronology, Astronomy, Customs, Laws and Astrology of India about AD 1030*, edited with notes and index by E.C. Sachau, vols. I and II, new edition, New Delhi, Indialog Publications Pvt. Ltd.

Al-Biruni, Muhammad ibn Ahmad, 1936 /2001. *Kitab al-jamahir fi marifat al-jawahir*, Hyderabad, edited by F. Krenkow, reprint, Frankfurt,, F. Sezgin, 2001.

Al-Biruni, Muhammad ibn Ahmad, 1989. *al-Beruni's Book on Mineralogy, The Book Most Comprehensive in Knowledge on Precious Stones*, Hakim edition, translated by Mohammad Said, Islamabad, Pakistan Hijra Council.

Ferdowsi, 1976. *Le Shah Nameh ou le Livre des Rois*, published with translation and commentary by J. Mohl. Persian text with a French translation, 7 volumes, Paris, Imprimerie royale, reprint, Paris, Maisonneuve editions, 1976.

Al-Hamdani, al-Hasan ibn Ahmad, 1968. *Kitab al-jawharatain al-'atiqatain*, edition and translation by C. Toll, Uppsala.

Ibn al-Athir, 1965-1967. *al-Kamil fi'l-ta'rikh*, edition by C.J. Tornberg, 13 volumes, Beirut. Ṣādir.

Ibn 'Awad Sanami, Muhammad, 1986. *Niṣāb al-ihtisāb*, edition by Murayzin Sa'id Murayzin 'Asiri, Mecca, Maktabat al-Talib al-Jami'.

Ibn Hawqal, Muhammad Abu'l Qasim, 1964. *Kitab surat al-ard. Configuration de la terre*, introduction and translation with index by J.H. Kramers and G. Wiet, 2 volumes, Beirut, Maisonneuve and Larose Editions.

Ibn Isfandiyar, Muhammad ibn al-Hasan, 1905. *Tarikh-i Tabaristan*, abridged translation by E.C. Browne, Leiden/London, Brill / Quar.

Al-Istakhri, Ibrahim ibn Muhammad, 1870 /2014. *Kitab masalik al-mamalik*, revised edition by M.J. de Goeje, Leiden, Brill.

Ibn Khurdadhba, 'Ubaid Allah ibn 'Abd Allah, 1889 /1992. *Kitab al-masalik wa'l-mamalik*, M.J. de Goeje edition, Leiden, Brill, facsimile edition, Frankfurt, Institute for the history of Arabic - Islamic science, 1992.

Ibn Rustah, Ahmad ibn 'Umar, 1955. *Kitab al-a'laq al-nafisa, Les atours précieux*, translation G. Wiet, Cairo, IFAO.

Juzjani, Menhaj al-Din, 1995. *Ṭabaḳāt-i-Nāṣirī: A General History of the Muhammadan Dynasties of Asia, including Hindustan; from A.H. 194 (810 A.D.) to A.H. 658 (1260 A.D.) and the Irruption of the Infidel Mughals into Islam*, translation H.H. Raverty, 2 volumes, Calcutta, The Asiatic Society, new edition.

Al-Khwarizmi, Abu Bakr, 1895. *Kitab Mafatiḥ al-'Ulum*, edited by G. van Volten, Leiden.

Al-Mafarrukhi, Mufaddal ibn Sa'd, 1352/1933. *Kitab mahasin Isfahan*, Tehran, J.D al-Yusaini.

Al-Mas'udi, 'Ali ibn Husain, 1861-77/1962-1997. *Kitab muruj al-dhahab wa ma'adin al-jawhar, Les prairies d'or*, edited and translated by C. Barbier de Meynard and A. Pavet de Courteille, 9 volumes, Paris, Imprimerie nationale; translation revised by Ch. Pellat, 5 volumes, Paris, Société asiatique, 1962-1997.

Al-Muqaddasi, Muhammad ibn Ahmad, 1877/2014. *Ahsan al-taqasim fi marifat al-aqalim*, M.J. de Goeje edition, revised, Leiden, Brill.

Al-Muqaddasi, Muhammad ibn Ahmad, 1963. *Aḥsan at-taqāsīm fi ma'rifat al-aqālīm. La meilleure répartition pour la connaissance des provinces*, partial translation by André Miquel, Damascus Institut français de Damas.

Polo, Marco, 1929 / 1958. *The book of Sir Marco Polo*, translated and edited by H. Yule, 2 volumes, London; translation by R. Latham, Harmondsworth, UK.

Al-Sufi, 'Abd al-Rahman, 1874. *Description of the fixed stars in the mid-tenth century of our era by the Persian astronomer Abd al-Rahman al-Sufi*, translated by H.C.F.C. Schjellerup, Saint-Petersburg, Commissioner of the Imperial Academy of.

Theophilus, c. 1122/1979. *On divers arts*, translated by J.G. Hawthorne and C.S. Smith, New York, Dover Publications.

Al-Tusi, Nasir al-Din, 1348/1969. *Tansukh namayi Ilkhani*, Tehran.

al-Ya'qubi, Ahmad ibn Abi Ya'qub, 1937. *Kitāb al-buldān, Les Pays*, French translation by G. Wiet, Cairo, IFAO.

Yaqut, ibn 'Abd Allah al-Rumi al- Hamawi, 1957. *Mu'jam al-buldān*, 20 volumes, Beirut, Dār Sâdir.

STUDIES AND EXHIBITIONS

Aanavi D., 1968. « Devotional Writing: "Pseudoinscriptions" in Islamic Art », *The Metropolitan Museum of Art Bulletin*, 26/9, 353-358.

Abdullayev T., Fakhretdinova D., Khakimov A., 1986. *A Song in Metal, Folk Art of Uzbekistan*, Tashkent, Gafur Gulyam Art and Literature Publishers.

Abdullayev K.A., Rtveladze E.V., Shishkina G.V., eds., 1991. *Culture and Art of Ancient Uzbekistan*, exhibition catalogue, Moscow, Vneshtorgizdat.

Adle Ch., 2015. « Signification et symbolisme des couleurs dans le monde iranien à l'époque islamique », *Voir et concevoir la couleur en Asie*, P-S. Filliozat and M. Zink, eds., actes du colloque

international organisé par l'Académie des Inscriptions et Belles-Lettres, la Société asiatique et l'INALCO, 12-13 January 2013, Paris, Académie des Inscriptions et Belles-Lettres, 85-159.

Aga-Oglu M., 1944. « A Brief Note on Islamic Terminology for Bronze and Brass », *Journal of the American Oriental Society,* 64/4, 218-223.

Aga-Oglu M., 1946. « A Preliminary Note on Two Artists From Nishapur », *Bulletin of the Iranian Institute,* 6-7, 121–124.

Ainy L., 1980. *The Central Asian Art of Avicenna Epoch,* Dushanbe, Tajikistan, Irfon.

Al-Saa'd Z., 2000. « Technology and Provenance of a Collection of Islamic Copper-Based Objects as Found by Chemical and Lead Isotope Analysis », *Archaeometry,* 42/2, 385-397.

Al-'Ush A.F., 1976. *Musée national de Damas. Département des Antiquités arabes islamiques,* Damascus, Direction générale des antiquités et des musées.

A'lam H., 2003. « Golāb », *Encyclopædia Iranica,* XI/1-2, 5–21.

Allan J.W., 1973. « Abū'l-Qāsim's Treatise on Ceramics », *Iran,* 11, 11-120.

Allan J.W., 1976. *The Metalworking Industry in Iran in the Early Islamic Period,* PhD thesis, 2 volumes, Oxford, University of Oxford, Faculty of Oriental Studies.

Allan J.W., 1976-1977. « Silver: the Key to Bronze in Early Islamic Iran », *Kunst Des Orients,* 11/1-2, 5-21.

Allan J.W., 1979. *Persian Metal Technology 700-1300 AD,* « Oriental Institute Monographs 2 », London, Ithaca Press.

Allan J.W., 1982A. *Nishapur: Metalwork of the Early Islamic Period,* New York, The Metropolitan Museum of Art.

Allan J.W., 1982B. *Islamic Metalwork: the Nuhad es-Said Collection,* London, Philip Wilson Publishers.

Allan J.W., 1986A. *Metalwork of the Islamic World, the Aron Collection,* London, Sotheby's.

Allan J.W., 1986B. « The Survival of Precious and Base Metal Objects from the Medieval Islamic World », in *Pots & Pans. A Colloquium on Precious Metals and Ceramics in the Muslim, Chinese and Graeco-Roman Worlds. Oxford 1985,* M. Vickers, ed., « Oxford Studies in Islamic Art, III », Oxford, Oxford University Press, 57-70.

Allan, J.W., 2022. « Syrian Nilotics and the History of Silver Inlay in the Near East », *Fruit of Knowledge, Wheel of Learning: Essays in Honour of Robert Hillenbrand,* Melanie Gibson, ed., London: Gingko, 200–21.

Allan J.W., Floor W., 1993. « COPPER i. Islamic Persia », *Encyclopædia Iranica,* vol. VI, fasc. 3, 558-560.

Allan J.W., Gilmour B., 2000. *Persian Steel. The Tanavoli Collection,* « Oxford Studies in Islamic Art, XV », Oxford, Oxford University Press.

Allan J.W., Kana'an R., 2017. « The Social and Economic Life of Metalwork, in *A Companion to Islamic Art and Architecture. Volume 1, From the Prophet to the Mongols,* F.B. Flood and G. Necipoğlu, eds., Hoboken, Wiley-Blackwell / John Wiley & Sons, 453-477.

Allegranzi V., 2017. *Les inscriptions persanes de Ghazni, Afghanistan. Nouvelles sources pour l'étude de l'histoire culturelle et de la tradition épigraphique ghaznavide (Vᵉ-VIᵉ / XIᵉ-XIIᵉ siècles),* PhD thesis, Paris, université Sorbonne Paris Cité.

Arafat A., Na'es M., Kantarelou V., Haddad N., Giakoumaki A., Argyropoulos V., Anglos D., Karydas A.-G., 2013. « Combined in Situ Micro-XRF, LIBS and SEM-EDS Analysis of Base Metal and Corrosion Products for Islamic Copper Alloyed Artefacts from Umm Qais Museum, Jordan », *Journal of Cultural Heritage,* 14, nᵒ 3, 261-269.

Arcet J.P.-J. d', 1818. *Mémoire sur l'art de dorer le bronze. Ouvrage qui a remporté le prix fondé par M. Ravrio et proposé par l'Académie royale des sciences,* Paris, Imprimerie de veuve Agasse.

Atil E., ed., 1990. *Art islamique et mécénat.Trésors d'art du Koweït,* exposition de la collection al-Sabah, prêt du musée national du Koweït, Paris, Institut du Monde Arabe.

Atil E., Chase W.T., Jett P., 1985. *Islamic Metalwork in the Freer Gallery of Art,* Washington D.C., The Smithsonian Institution.

Azarpay G., 1978. « The Eclipse Dragon on an Arabic Frontispiece-Miniature », *Journal of the American Oriental Society,* 98/4, 363–374.

Baal G., 1981. « Un salon dreyfusard, des lendemains de l'affaire à la Grande Guerre : la marquise Arconati-Visconti et ses amis », *Revue d'histoire moderne & contemporaine,* 28-3, 433-463.

Babayan K., 2002. *Mystics, Monarchs, and Messiahs. Cultural Landscapes of Early Modern Iran,* Cambridge / London, Harvard University Press.

Baer E., 1972. « An Islamic Inkwell in the Metropolitan Museum of Art », in *Islamic Art in the Metropolitan Museum of Art,* R. Ettinghausen, ed., New York, Metropolitan Museum of Art, 199–211.

Baer E., 1983. *Metalwork in Medieval Islamic Art,* Albany, State University of New York Press.

Baer E., 1989. « Jeweled Ceramics from Medieval Islam: A Note on the Ambiguity of Islamic Ornament », *Muqarnas,* 6, 83-97.

Baer E., 2004. *The Human Figure in Islamic Art. Inheritances and Islamic Tansformations,* Costa Mesa, California, Mazda Publishers.

Bahrami M., 1949. *Gurgan Faiences,* Cairo, Le Scribe égyptien.

Ball W., 2008. *The Monuments of Aghanistan. History, Archaeology and Architecture,* London / New York, I.B. Tauris.

Ball W., Gardin J.-C., 1982. *Archaeological Gazetteer of Afghanistan. Catalogue des sites archéologiques d'Afghanistan,* 2 volumes, Paris, Éditions Recherche sur les civilisations.

Barbier de Meynard C., 1861. *Dictionnaire géographique, historique et littéraire de la Perse et des contrées adjacentes,* extrait du *Mo'djem el-Bouldan* de Yaqout, Paris, Imprimerie imperiale.

Barthold W., 1928. *Turkestan Down to the Mongol Invasion,* second edition, translated from the Russian original and revised by the author with H.A.R. Gibb, « Gibb Memorial Series, New Series, V, 9 », London, Luzac and Co.

Bayley J., 1991. « Alloy Nomenclature », in *Medieval Finds from Excavations in London: 3. Dress Accessories c.1150-c.1450,* G. Egan and F. Pritchard, eds., London, HMSO, 13–17.

Baypakov K., Pidaev Sh., Khakimov A. eds., 2012. *The Artistic Culture of Central Asia and Azerbaijan in the 9th–15th centuries,* vol. III, *Toreutics,* Samarqand/Tashkent, IICAS.

Benjamin W., 1939. *L'œuvre d'art à l'époque de sa reproductibilité technique,* translated from German by Maurice de Gandillac, revised by Rainer Rochlitz, Paris, Allia, 2009.

Bernus-Taylor M., ed., 1989. *Arabesques et jardins de paradis. Collections françaises d'art islamique,* exhibition catalogue, Paris, Musée du Louvre, 16 October 1989–15 January 1990, Paris, Éditions de la Réunion des musées nationaux.

Bernus-Taylor M., ed., 2001. *L'Étrangeet le Merveilleux en terres d'Islam,* exhibition catalogue, Paris, Musée du Louvre, 23 April-23 July 2001, Paris, Éditions de la Réunion des musées nationaux.

Berthoud T., 1979. *Étude par l'analyse de traces et la modélisation de la filiation entre minerai de cuivre et objets archéologiques du Moyen-Orient, PhD thesis,* Paris-VI, université Pierre et Marie Curie.

Berthoud T., Cleuziou S., Hurtel L.P., Menu M., Volfovsky C., 1982. «Cuivre et alliages en Iran, Afghanistan, Oman au cours des IVe et IIIe millénaires», *Paléorient,* 8/2, 39-54.

Blair S., 1998. *Islamic Inscriptions,* Edinburgh, Edinburgh University Press.

Blair S., 2014. *Text and Image in Medieval Persian Art,* Edinburgh, Edinburgh University Press.

Blake R.P., 1937. «The Circulation of Silver in the Moslem East Down to the Mongol Epoch», *Harvard Journal of Asiatic Studies,* 2/3-4, 201–328.

Bloom J., Blair S., eds., 2011. *And Diverse Are Their Hues. Color in Islamic Art and Culture,* New Haven / London, Yale University Press.

Bombaci A., 1966. *The Kufic Inscription in Persian Verses in the Court of the Royal Palace of Mas'ud III at Ghazni,* «Reports and Memoirs, vol. V», Rome, IsMEO, Centro Studi e Scavi Archeologici in Asia.

Bonnéric J., 2015. «Entre fragrances et pestilences, étudier les odeurs en terre d'Islam au Moyen Âge», *Bulletin d'études orientales, LXIV, Histoire et anthropologie des odeurs en terre d'Islam à l'époque médiévale,* 21-42.

Bosworth C.E., 1968. «The Development of Persian Culture under the Early Ghaznavids», *Iran,* 6, 33-44.

Bosworth C.E., 1977A. *The Later Ghaznavids: Splendour and Decay. The Dynasty in Afghanistan and Northern India 1040-1186,* Edinburgh, Edinburgh University Press.

Bosworth C.E., 1977B «Ghazna», *Encyclopedia of Islam,* second edition, vol. II, Leiden, Brill, 1073-1074.

Bosworth C.E., 1998. «Esfarãyen», *Encyclopædia Iranica,* vol. VIII , fasc. 6, 595.

Bosworth C.E., 2000. «Sistan and its Local Histories», *Iranian Studies,* 33/1-2, 31–43.

Bosworth C.E., 2002. «Ya'qub b. Layt b. Mo'addal», *Encyclopædia Iranica,* online edition.

Bosworth C.E., 2010. «Saffarids», *Encyclopædia Iranica,* online edition.

Bosworth C.E., 2011A. «Sistãn ii. In the Islamic period», *Encyclopædia Iranica,* online edition.

Bosworth C.E., 2011B. «Târiḵ-e Sistãn», *Encyclopædia Iranica,* online edition.

Bosworth C.E., 2011C. *The Ornament of Histories. A History of the Eastern Islamic Lands AD 650-1041. The Persian Text of Abū Sa'id 'Abd al-Ḥayy Gardīzī,* London / New York, I.B. Tauris & BIPS Persian Studies Series.

Bourgarit D., 2023. «Metals», in *Guidelines for the technical Study of Cast Bronze Sculpture,* D. Bourgarit, J. Bassett, F. Bewer, A. Heginbotham, A. Lacey and P. Motture, eds., vol. 1, chap. 2, Los Angeles, Getty Publications.

Bourgarit D., Mille B., 2003. «The Elemental Analysis of Ancient Copper-Based Artefacts by Inductively-Coupled-Plasma Atomic-Emission-Spectrometry (ICP-AES): An Optimized Methodology Reveals Some Secrets of the Vix Crater», *Measurement Science and Technology,* 14, 1538-1555.

Bourgarit D., Mille B., Borel T., Baptiste P., Zéphir T., 2003. «A Millennium of Khmer Bronze Metallurgy: A Technical Study of Seventy-five Bronze Artefacts from the Musée Guimet and the Phnom Penh National Museum», in *Scientific Research in the Field of Asian Art. Proceedings of the First Forbes Symposium at the Freer Gallery of Art,* P. Jett, J.G. Douglas, B. McCarthy and J. Winter, eds., Washington D.C., 27-29 September 2001, London, Archetype Publications, 103-126.

Bourgarit D., Pons E., 2020. «Composition des bronzes dorés dans les meubles Boulle et contemporains», *Techné,* 49, 68-79.

Bourgarit D., Thomas N., 2011. «From Laboratory to Field Experiments: Shared Experience in Brass Cementation», *Historical Metallurgy,* 45/1, 8-16.

Bourgarit D., Thomas N., 2012. «Late Medieval Copper Alloying Practices: A View From a Parisian Workshop of the 14th Century AD», *Journal of Archaeological Science,* 39, 3052-3070.

Bourgarit D., Thomas N., 2015. «Ancient brasses: misconceptions and new insights», in *Archaeometallurgy in Europe III. Proceedings of the 3rd International Conference,* Hauptmann A. and Modarressi-Tehrani D., eds., 29 June–1 July 2011, «Der Anschnitt, 26», Bochum, Deutsches Bergbau-Museum, 255-261.

Boust C., Bourgarit D., 2023 «Photography and Other Imaging Techniques for the Visualization of a Sculpture», in *Guidelines for the Technical Study of Cast Bronze Sculpture,* D. Bourgarit, J. Bassett, F.G. Bewer, A. Heginbotham and P. Motture, eds., vol. 2, chap. 2, Los Angeles, Getty Publications.

Brill R.H., 2003. «Chemical Analyses of Some Metal Finds», in *Serçe Liman: An Eleventh Century Shipwreck,* G. Bass, J.W. Allan and W. Peel, eds, «Nautical Archaeology Series 4»; College Station, Texas A & M University Press.

Bujard J., Schweizer F., 1994. «Aspect métallurgique de quelques objets byzantins et omeyyades découverts récemment en Jordanie», in *L'œuvre d'art sous le regard des sciences,* A. Rinuy et F. Schweizer, eds., exhibition catalogue, Geneva, musée d'Art et d'Histoire, 17 March–15 May 1994, Geneva, Slatkine, 191–208.

Bulliet R.W., 1972. *The Patricians of Nishapur: a Study in Medieval Islamic Social History,* «Harvard Middle Eastern Studies, 16», Cambridge, Harvard University Press.

Bulliet R.W., 1983. «Abū Dolaf al-Yanbū'ī», *Encyclopædia Iranica,* vol. I, fasc. 3, 271-272.

Bulliet R.W., 2009. *Cotton, Climate and Camels in Early Islamic Iran: A Moment in World History,* New York, Columbia University Press.

Bumiller M., 1993. *Typologie Frühislamischer Bronzen. Flügelschalen und Flakons. Bumiller-Collection,* «Schriften zur Islamischen Kunst-und Kulturgeschichte Band 3», Panicale, Italy, Bumiller.

Cambon P., Giraudier V., Trouplin V., eds., 2018. *De l'Asie à la France libre. Joseph & Marie Hackin,*

archéologues et compagnons de la libération, exhibition catalogue, Paris, Musée de l'Ordre de la Libération, 15 June-16 September 2018, Paris, Lienart.

Campanella L., Alessandri O.C., Ferretti M., Plattner S.H., 2009. « The Effect of Tin on Dezincification of Archaeological Copper Alloys », *Corrosion Science*, 51/9, 218–2191.

Canby S.R., Beyazit D., Rugiadi M., Peacock A.C.S., eds., 2016. *Court and Cosmos, the Great Age of the Seljuqs*, exhibition catalogue, The Metropolitan Museum of Art, 27 April-24 July 2016, New York, Metropolitan Museum of Art.

Carboni S., 1997. *Following the Stars: Images of the Zodiac in Islamic Art*, New York, Metropolitan Museum of Art.

Carboni S., 2006. « Narcissism or Catoptromancy ? Mirrors from the Medieval Eastern Islamic World », in *Sifting Sands, Reading Signs, Studies in honour of Professor Géza Fehérvari*, P. Baker and B. Brend, eds., London, Furnace Publishing, 161–170.

Carboni S., Whitehouse D., 2001. *Glass of the Sultans*, with contributions by R.H. Brill and W. Gudenrath, exhibition catalogue, New York, The Metropolitan Museum of Art. 2 October 2001–13 January 2002, New York, The Metropolitan Museum of Art.

Collinet A., 2001. « Le métal ayyoubide », in *L'Orient de Saladin. L'art des Ayyoubides*, S. Makariou, ed., exhibition catalogue, Paris, Institut du Monde Arabe, 23 October 2001-10 March 2002, Gallimard / Institut du Monde Arabe, 127-130.

Collinet A., 2010. *Au prisme de la céramique : le Sind et l'Islam. Culture matérielle du sud du Pakistan, VIII^e-XVIII^e siècles, PhD thesis*, Paris, université de Paris-I Panthéon-Sorbonne.

Collinet A., 2015. « Nouvelles recherches sur la céramique de Nishapur : la prospection du shahrestan », in *Greater Khorasan. History, Geography, Archaeology and Material Culture*, R. Rante, ed., Berlin / Munich / Boston, De Gruyter, 125-139.

Collinet A. ed., forthcoming, A Collinet, D. Bourgarit, with contributions by Z. el Morr and V. Orfanou. *Le dessin et la couleur. L'art de l'incrustation dans le monde iranien médiéval. XIII^e-XV^e siècles*, département des Arts de l'Islam, collections du Musée du Louvre et du Musée des Arts Décoratifs, Paris, Musée du Louvre éditions.

Collins A.L., 1894. « The Ghorband Lead Mines, Afghanistan », *Transactions of the Federated Institution of Mining Engineers*, VI/III, 449–456.

Compareti M., 2015. « Ancient Iranian Decorative Textiles: New Evidence from Archaeological Investigations and Private Collections », *The Silk Road*, 13, 36-44.

Contadini A., 2017. « Patronage and the Idea of an Urban Bourgeoisie », in *A Companion to Islamic Art and Architecture. Volume I, From the Prophet to the Mongols*, F.B. Flood and G. Necipoğlu, eds., Hoboken, Wiley-Blackwell / John Wiley & Sons, 431-452.

Contenau G., 1922. « Les nouvelles salles d'art musulman au Musée du Louvre », *Syria*, 3/3, 251–260.

Contenau G., 1923. « Les nouvelles salles d'art musulman au Musée du Louvre », *Syria*, 4/1, 66–75.

Coulon J.-Ch., 2015. « Fumigations et rituels magiques. Le rôle des encens et fumigations dans la magie arabe médiévale », *Bulletin d'études orientales*, LXIV, *Histoire et anthropologie des odeurs en terre d'Islam à l'époque médiévale*, 179-248.

Cowell M.R., Lowick N.M., 1988. « Silver from the Panjhir Mines », in *Metallurgy in Numismatics 2*, A. Oddy, ed., London, Royal Numismatic Society, 65-74.

Craddock P.T., 1979. « The Copper Alloys of the Medieval Islamic World - Inheritors of the Classical Tradition », *World Archaeology*, 11/1, 69–79.

Craddock P.T., 2015. « The Metal Casting Traditions of South Asia: Continuity and Innovation », *Indian Journal of History of Science*, 50/1, 55–82.

Craddock P.T., Eckstein K., 2003. « Production of Brass in Antiquity by Direct Reduction », in *Mining and Metal Production Through the Ages*, P.T. Craddock and J. Lang, eds., London, British Museum Press, 216-30.

Craddock P.T., La Nicce S., Hook D., 1998. « Brass in the Medieval Islamic World », in *2000 Years of Zinc and Brass*, P.T. Craddock, ed, London, British Museum, 73-114.

Crawshaw F.D., 1909. *Metal Spinning*, « Popular Mechanics Twenty-Five Cent Handbook Series Number Two », Chicago, Popular Mechanics Co.

Cretu C., Van der Lingen E., 1999. « Colored Gold Alloys », *Gold Bulletin*, 32/4, 115-126.

Curatola G., ed., 1993. *Eredità dell'Islam, Arte Islamica in Italia*, Venice, Palazzo Ducale, 30 October 1993 – 30 April 1994, Cinisello Balsamo, Silvana.

Dahncke M., 1992. *Frühislamische Bronze. Öllampen und ihre Typologie. Bumiller-Collection*, « Schriften zur Islamischen Kunst und Kulturgeschichte Band 2 », Panicale, Italy, Bumiller.

Daryaee T., 2010. « Bazaars, Merchants, and Trade in Late Antique Iran », *Comparative Studies of South Asia, Africa and the Middle East*, 30/3, 401-409.

David-Weill J., 1959. « Nouvelles acquisitions, musée du Louvre, département des Antiquités orientales et des Arts musulmans », *La Revue des Arts*, 41.

David-Weill J., 1962. « Addenda », *La Revue du Louvre et des musées de France*, 2, 143.

David-Weill J., 1963. « Bronzes du Daghestan », *Eretz-Israel*, vol. 7, 29-3, pl. VIII.

Day S., 2007. « Jules Maciet et le goût du tapis islamique », in *Purs décors ? Arts de l'Islam, regards du XIX^e siècle*, R. Labrusse, ed., exhibition catalogue, Paris, Musée des Arts Décoratifs, 11 October 2007-13 January 2008, Paris, Les Arts Décoratifs / Musée du Louvre éditions, 302-309.

De Bois G., 1999. *La ciselure et ses techniques : le bronze, l'orfèvrerie, la bijouterie*, Dourdan, Éditions Vial.

De Fouchécour C.-H., 1969. *La description de la nature dans la poésie lyrique persane du XI^e siècle. Inventaire et analyse des thèmes*, Paris, Klincksieck.

De Fouchécour C.-H., 2009. *Le sage et le prince en Iran médiéval. Morale et politique dans les textes littéraires persans, X^e-XIII^e siècles*, Paris, L'Harmattan ; new edition of Éditions Recherche sur les civilisations, A.D.P.F., 1986.

Dekowna M., 1971. « Stan Radari nad Cornictwen Srebra i tzw. Kryzysem Srebra w Azji Srodkowej », *Archeologia Polski*, 16, 483-502.

De Planhol X., Giunta R., 2000. « Ḡaznī », *Encyclopædia Iranica*, vol. X, fasc. 4, 384-388.

De Planhol X., Tarzi Z., 1988. « Bāmīān », *Encyclopædia Iranica*, vol. III, fasc. 6, 657-661.

Dimand M.S., 1934. « A Persian Bronze Ewer of

the Twelfth Century», *The Metropolitan Museum of Art Bulletin*, 29, 25-26.

Dimand M.S., 1945. «Saljuk Bronzes from Khurasan», *The Metropolitan Museum of Art Bulletin*, 4, 87-92.

Dressen W., Minkenberg G., Oellers A.C., eds., 2003. *Ex Oriente. Isaak und der Weisse Elefant: Bagdad-Jerusalem-Aachen, eine Reise durch drei Kulturen um 800 und Heute. Band I: Die reise des Isaak - Bagdad,* exhibition catalogue, Aix-la-Chapelle, 30 June–28 September 2003, Mainz, Philipp von Zabern.

Ducène J.-Ch., 2015. «Des parfums et des fumées: les parfums à brûler en Islam médiéval»„ *Bulletin d'études orientales*, LXIV, *Histoire et anthropologie des odeurs en terre d'Islam à l'époque médiévale*, 159-178.

Duggan T.M.P., 2012. «On the Tradition of Islamic Figural Sculpture to 1300», *Mediterranean Journal of Humanities*, II/1, 61-86.

Ekhtiar M., Soucek P.P., Canby Sh.R., Najat Haidar N., 2011. *Masterpieces from the Department of Islamic Art in the Metropolitan Museum of Art*, New York / New Haven / London, Metropolitan Museum of Art / Yale University Press.

El Morr Z., Pernot M., 2011. «Middle Bronze Age Metallurgy in the Levant: Evidence from the Weapons of Byblos», *Journal of Archaeological Science*, 38/10, 2613-2624.

Ettinghausen R., 1978. «Medieval Islamic Metal Objects of Unusual Shapes and Decorations in the Metropolitan Museum of Art», *Islamic Archaeological Studies*, 1, 29-30.

Ettinghausen E.S., 2007. «Analysing a Pictorial Narrative. The Aquamanile in the Hermitage Museum in St. Petersburg», in *Facts and Artefacts. Art in the Islamic World, Festschrift for Jens Kröger on his 65th Birthday*, A. Hagedorn and A. Shalem, eds., Boston/Leiden, Brill,

Falk T., ed., 1985. *Trésors de l'Islam,* exhibition catalogue, Geneva, musée d'Art d'Histoire, 25 June-27 October 1985, Geneva, musée d'Art et d'Histoire.

Fang J.-L., McDonnell G., 2011. «The Color of Copper Alloys», *Historical Mertallurgy*, 45/1, 52-61.

Fehérvári G., 1976. *Islamic Metalwork of the Eighth To The Fifteenth Century in the Keir Collection*, London, Faber & Faber.

Fehérvári G., Kiany M., 1982. «Discoveries from Robat-e Sharaf. The Metalwork», *Archaeologische Mitteilungen aus Iran*, 15, published by the Tehran department of the German Archaeological Institute, 329-346.

Feuillebois-Pierunek E., 2012. «Les figures d'Alexandre dans la littérature persane. Entre assimilation, moralisation et ironie», in *Épopées du monde. Pour un panorama (presque) général*, Paris, Classiques Garnier, 181-202.

Fischer K., de Planhol X., 1989. «Bost», *Encyclopædia Iranica*, vol. IV, fasc. 4, 383-386.

Flood F.B., 2009. *Objects of Translation, Material Culture and Medieval "Hindu-Muslim" Encounter*, Princeton, Princeton University Press.

Flood F.B., 2012. «Gilding, Inlay and the Mobility of Metallurgy: a Case of Fraud in Medieval Kashmir», in *Metalwork and Material Culture in the Islamic World. Art, Craft and Text*, V. Porter & M. Rosser-Owen, eds., essays presented to James Allan, London, I.B. Tauris, 131-142.

Flood F.B., 2019. *Technologies de dévotion dans les arts de l'Islam. Pèlerins, reliques et copies*, «La Chaire du Louvre», Paris, Musée du Louvre éditions / Hazan.

Flood F.B., 2022. «Islam and Image: Paradoxical Histories», *In the Name of the Image: Figurative Representation in Islamic and Christian Cultures*, Axel Langer ed., Zurich, Hatje Cantz Verlageds, 301-318.

Floor W., 1975. «The Guilds in Iran – an Overview from the Earliest Beginnings till 1972», *Zeitschrift der Deutschen Morgenländischen Gesellschaft*, 125/1, 99-116.

Floor W., 1984. «Guilds and Futuvvat in Iran», *Zeitschrift der Deutschen Morgenländischen Gesellschaft*, 134/1, 106-114.

Floor W., 1989. «Bāzār, ii. Organization and Function», *Encyclopædia Iranica*, vol. IV, fasc. 1, 25-30.

Folsach K. von, 2001. *Art from the World of Islam in the David Collection*, Copenhagen, The David Collection.

Forkl H., Kalter J., Leisten T., Pavaloi M., 1993. *Die Garten des Islam*, Stuttgart, Hansjorg Mayer / Linden-Museum.

Foucault M., 1966. *Les mots et les choses*.

Une archéologie des sciences humaines, Paris, Gallimard; new edition 2005.

Franke U., Müller-Wiener M., eds., 2016. *Herat Through Time. The Collections of the Herat Museum and Archive,* «Ancient Herat 3», Berlin, Staatliche Museen zu Berlin / Preußischer Kulturbesitz.

Franke U., Urban T., eds., 2017. *Excavations and Explorations in Herat City*, «Ancient Herat 2», Berlin, Staatliche Museen zu Berlin / Preußischer Kulturbesitz.

Gardin J.-C., 1957. «Poteries de Bamiyan», *Ars Orientalis*, 2, 227-245.

Gardin J.-C., 1959. «Tessons de poterie musulmane provenant du Seistan afghan», in *Diverses recherches archéologiques en Afghanistan, 1933-1940*, J. Hackin, J. Carl and J. Meunié, «Mémoires de la DAFA, 8», Paris, PUF, 29-37.

Gardin J.-C., 1963. *Lashkari bazar, une résidence royale ghaznévide,* vol. II, *Les trouvailles, céramiques et monnaies de Lashkari Bazar et de Bust*, «Mémoires de la DAFA, 18», Paris, Klincksieck.

Garenne-Marot L., Bertholon R., Bell B., Lacoudre N., 1998. «Métal et techniques de fabrication d'un lot d'objets en alliage base-cuivre de l'époque omeyyade (VIIIe siècle)», in *Les Métaux Antiques. Travail et Restauration,* actes du colloque de Poitiers, 28-30 September 1995, G. Nicolini and N. Dieudonné-Glad, eds., «Monographies Instrumentum nᵒ 6», Montagnac, Monique Mergoil, 29-38.

Gascoigne A., 2010. «Pottery from Jām: A Medieval Ceramic Corpus from Afghanistan», *Iran*, 48, 107-151.

Gendron L., 1924. *Le chaudronnier en cuivre*, «Le Livre de la Profession», Paris, Librairie de l'enseignement technique.

Ghabin A., 2009. *Ḥisba, Arts and Craft in Islam*, Wiesbaden, Harrassowitz Verlag.

Ghouchani A., 1986. *Inscriptions on Nishabur Pottery*, Tehran, Reza Abbasi Museum.

Ghouchani A., 1992. *Persian Poetry on the Tiles of Takht-i Sulaymān (13th Century)*, Tehran, Iran University Press.

Gibson M., 2008-2009. «The Enigmatic Figure: Ceramic Sculpture from Iran and Syria c. 1150-

1250 », *Transactions of the Oriental Ceramic Society*, 73, 39-50.

Gibson M., 2010. *Takūk and Timthāl: A study of glazed ceramic sculpture from Iran and Syria circa 1150-1250*, PhD thesis, London University, School of Oriental and African Studies.

Gibson M., 2012. « A Symbolic Khassakiyya: Representations of the Palace Guard in Murals and Stucco Sculpture », in *Islamic Art, Architecture and Material Culture. New perspectives*, M.S. Graves, ed., « BAR International Series 2436 », Oxford, BAR Publishing, 81-91.

Gibson M., 2022. « A Menagerie in Metal », in *Brasses, Bronze and Silver of the Islamic Lands*, M. Spink, ed., with D. Behrens-Abouseif and M. Gibson, « The Nasser D. Khalili Collection of Islamic Art », vol. XI, part. 1, The Nour Foundation, 350-363.

Giunta R., 2001. « The Tomb of Muḥammad al-Harawī (447/1055) at Ġaznī (Afghanistan) and Some New Observations on the Tomb of Maḥmūd the Ġaznavid », *East and West*, 51/1, 109-126.

Giunta R., 2005. « Islamic Ghazni, An IsIAO Archaeological Project in Afghanistan: A Preliminary Report (July 2004-June 2005) », *East and West*, 55/1473–484.

Giunta R., Bresc C., 2004. « Listes de la titulature des Ghaznavides et des Ghurides à travers les documents numismatiques et épigraphiques », *Eurasian Studies*, 3/2, 161-243.

Giuzalian L.T., 1968. « The Bronze Qalamdan (Pen-Case) 542/1148 from the Hermitage Collection (1936-1965) », *Ars Orientalis*, 7, 95-119.

Gladiss A.H. von, Kröger J., 1985. *Islamische Kunst, Loseblattkatalog unpublizierter Werke aus Deutschen Museen 2. Berlin, Staatliche Museen Preussischer Kulturbesitz, Museum für Islamische Kunst. Metall, Stein, Stuck, Holz, Elfenbein, Stoffe*, Mainz, Philipp von Zabern.

Glover I., Bennett A., 2012. « The High-Tin Bronzes of Thailand », in *Scientific Research on Ancient Asian Metallurgy. Proceedings of Fifth Forbes Symposium at the Freer Gallery of Art*, P. Jett, B. McCarthy and J.G. Douglas, eds., 28-29 October 2010, London, Archetype Publications Ltd / Smithsonian Institution, 101-14.

Grabar O., 1959. *Persian Art before and after the Mongol Conquest*, exhibition catalogue, The University of Michigan Museum of Art, 9 April-17 May 1959, Ann Arbor, The University of Michigan Museum of Art.

Grabar O., 1987. *La formation de l'art islamique*, Paris, Flammarion.

Graves M.S., 2008. « Ceramic House Models from Medieval Persia: Domestic Architecture and Concealed Activities », *Iran*, 46, 227-251.

Graves M.S., 2012. « The Aesthetics of Simulation: Architectural Mimicry on Medieval Ceramic Tabourets » in *Islamic Art, Architecture and Material Culture. New perspectives*, M.S. Graves, ed., « BAR International Series 2436 », Oxford, BAR Publishing, 63-79.

Graves M.S., 2018A. *Arts of Allusion: Object, Ornament and Architecture in Medieval Islam*, New York, Oxford University Press.

Graves M.S., 2018B. « Say Something Nice: Supplications on Medieval Objects, and Why They Matter », in *Studying the Near and Middle East at the Institute for Advanced Study, Princeton, 1935-2018*, S. Schmidtke, ed., Piscataway, NJ, Gorgias Press, 322-330.

Grigor T., 2005. « Of Aryan Origin(s), Western Canon(s), and Iranian Modernity », *Repenser les limites : l'architecture à travers l'espace, le temps et les disciplines*, conference proceedings, 31 August–4 September 2005, Paris, Publications de l'NHA, 1-6.

Grigor T., 2009. « Orientalism & Mimicry of Selfness: Archeology of the neo-Achaemenid Style », in *L'Orientalisme architectural entre imaginaires et savoirs*, N. Oulebsir and M. Volait, eds. Paris, Publications de l'INHA, 244-260.

Grohmann A., 1958. « Anthropomorphic and Zoomorphic Letters in the History of Arabic Writing », *Bulletin de l'institut d'Égypte*, 40, 117-122.

Gruber C., 2016. « From Prayer to Protection: Amulets and Talismans in the Islamic World », in *Power and Protection. Islamic Art and the Supernatural*, F. Leoni (ed.), Oxford, Ashmolean Museum, 33-51.

Hackin J., 1933. « Recherches archéologiques à Bamiyan en 1933 », in *Diverses recherches archéologiques en Afghanistan, 1933-1940*, J. Hackin, J. Carl and J. Meunié, « Mémoires de la DAFA, 8 », 1959, Paris, PUF, 1-6.

Hackin J., 1936. « Recherches archéologiques dans la partie afghane du Seistan », in *Diverses recherches archéologiques en Afghanistan, 1933-1940*, J. Hackin, J. Carl and J. Meunié, « Mémoires de la DAFA, 8 », 1959, Paris, PUF, 23-28.

Halevi L., 2004. « Wailing for the Dead: The Role of Women in Early Islamic Funerals », *Past & Present*, 183, 3-39.

Halevi L., 2007. *Muhammad's Grave. Death Rites and the Making of the Islamic Society*, New York, Columbia University Press, new edition 2011.

Halevi L., 2008. « Christian Impurity versus Economic Necessity: A Fifteenth-Century Fatwa on European Paper », *Speculum*, 83, 917-945.

Hameed A.A., 1967. « Étude d'objets en métal de période islamique », *Sumer*, 23, 154-160.

Hanaway W.L., 1988. « Blood and Wine: Sacrifice and Celebration in Manūchihri's Wine Poetry », *Iran*, 26, 69-80.

Harari, R. 1938, « Metalwork after the early Islamic period », *The Arts of Metalwork*, vol. XII/3, Survey of Persian Art, A.U. Pope, ed., 2466-2529.

Hartner W., 1938. « The Pseudoplanetary Nodes of the Moon's Orbit in Hindu and Islamic Iconographies », *Ars Islamica*, 5/2, 112-154.

Heidemann S., Laperouse J.-F. de, Parry V., 2014. « The Large Audience: Life-Sized Stucco Figures of Royal Princes from the Seljuq Period », *Muqarnas*, 31, 35-71.

Herzfeld E., 1936. « A Bronze Pen-Case », *Ars Islamica*, 3/1, 35-43.

Hill D.R., 1974. *The Book of Knowledge of Ingenious Mechanical Devices*, translation of al-Jazarī, Ibn al-Razzāz, *Kitāb fī ma'rifat al-ḥiyal al-handasiyya*, Dordrecht, D. Reidel.

Hook D.R., 1998. « Inductively Coupled Plasma Atomic Emission Spectrometry and its Role in Numismatic Studies », in *Metallurgy in Numismatics*, W.A. Oddy and M.R. Cowell, eds., vol. IV, London, Royal Numismatic Society, 237–252.

Hook D.R., Craddock P.T., 1996. « The Scientific Analysis of the Copper Alloy Lamps: Aspects of Classical Alloying Practices », in *A Catalogue of the Lamps in the British Museum*, vol. IV, *Lamps of Metal and Stone, and Lampstands*, D.M. Bailey, ed., London, British Museum Press, 144–164.

Inaba M., 2013. « Sedentary Rulers on the Move: the Travels of the Early Ghaznavid Sultans », in *Turko-*

Mongol Rulers, Cities and City Life, D. Durand-Guédy, ed., Leiden/Boston, Brill, 76-98.

Istanbul, 1983. *Avrupa sanat sergisi: Anadolu medeniyetleri, vol. 3.c.: Selçuklu/Osmanlı*, exhibition catalogue, Istanbul, 22 May-30 October 1983, Istanbul, T.C. Kültür ve Turizm Bakanlığı.

Ivanov A., 1983. « Abu Bakr Marvazi », *Encyclopædia Iranica*, vol. I, fasc. 3, 263.

Izzi Dien M., 1997. *The Theory and the Practice of Market Law in Medieval Islam*, Cambridge, E.J.W. Memorial Trust.

Jenkins M., ed., 1983. *The al-Sabah Collection. Islamic Art in the Kuwait National Museum*, London, Philip Wilson Publishers for Sotheby Publication.

Johnson H.V., 1960. *Metal Spinning, Techniques and Projects*, Milwaukee, Bruce Publishing.

Jones A., 1962. « The Mystical Letters of the Qurʾān », *Studia Islamica*, 16, 5-11.

Jones D., Michell G., eds., 1976. *The Arts of Islam*, exhibition catalogue, London, Hayward Gallery, 8 April–4 July 1976, London.

Kadoi Y., ed., 2016. *Arthur Upham Pope and a New Survey of Persian Art*, « Studies in Persian Cultural History, vol. 10 », Leiden / Boston, Brill.

Kalter J., Pavaloi M., 1987. *Linden-Museum Stuttgart: Abteilungsführer Islamischer Orient*, Stuttgart, Linden-Museum.

Kalter J., Pavaloi M., ed., 1997. *Heirs to the Silk Road*, Uzbekistan, New York, Thames & Hudson.

Kana'an R., 2009. « The de Jure "Artist" of the Bobrinski Bucket: Production and Patronage of Metalwork in pre-Mongol Khorasan and Transoxiana », *Islamic Law and Society*, 16, 175-201.

Karev Y., 2005. « Qarakhanid Wall Paintings in the Citadel of Samarqand: First Report and Preliminary Observations », *Muqarnas*, 22, 45-84.

Karev Y., 2013. « From Tents to City. The Royal Court of the Western Qarakhanids Between Bukhara and Samarqand », in *Turko-Mongol Rulers, Cities and City Life*, D. Durand-Guédy, ed., Leiden/Boston, Brill, 99-147.

Khakimov A., ed., 2004. *Masterpieces of the Samarkand Museum*, Tashkent, The State Museum of History of Culture of Uzbekistan.

Khamis E., 2013. *The Fatimid Metalwork Hoard from Tiberias: Excavations in the House of the Bronzes*, « Qedem, 55 », Jerusalem, Hebrew University of Jerusalem / Institute of Archaeology.

Kiani M.Y., 1978. *Iranian Pottery. A General Survey based on the Prime Ministry of Iran's Collections*, Tehran.

Kiani M.Y., ed., 1981. *Robat-e Sharaf*, Tehran.

Kiani M.Y., 1984. *The Islamic City of Gurgan*, Deutsches Archäologisches Institut Abteilung Tehran, Archäologisches Mitteilungen Aus Iran Ergänzungsband 11, Berlin.

Kiani M.Y., 2001. *Iranian Pottery with Particular Reference to the Islamic Period*, Tehran.

Kœchlin R., 1910. « Correspondance d'Allemagne. L'exposition d'art musulman à Munich », *Gazette des Beaux-Arts*, 5, September, 255-260.

Kœchlin R., Migeon G., 1928. *100 planches d'art musulman*, Paris, Albert Lévy ; reprint 1956.

Komaroff L., Carboni S., eds., 2002. *The Legacy of Genghis Khan, Courtly Art and Culture in Western Asia, 1256-1353*, exhibition catalogue, New York, Metropolitan Museum of Art, 5 November 2002-16 February 2003 and Los Angeles County Museum of Art, 13 April-27 July 2003, New Haven / London / New York, Yale University Press / The Metropolitan Museum of Art.

Konstantakos I.M., 2020. « The Flying King: The Novelistic Alexander (Pseudo-Callisthenes 2.41) and the Traditions of the Ancient Orient », *Classica*, 33/1, 105-138.

Krachkovskaya V.A., 1960. « O bronzovikh zerkalakh Donskovo Muzeya », *Issledovaniya po istorii Kul'turi Narodov Vostokas*.

Kröger J., 1995. *Nishapur, Glass of the Early Islamic Period*, New York, Metropolitan Museum of Art.

Labrusse R., ed. 2007. *Purs décors? Arts de l'Islam, regards du XIXᵉ siècle*, exhibition catalogue, Paris, Musée des Arts Décoratifs, 11 October 2007-13 January 2008, Paris, Les Arts Décoratifs / Musée du Louvre éditions.

La Niece S., 2003. « Medieval Islamic Metal Technology », in *Scientific Research in the Field of Asian Art. Proceedings of the First Forbes Symposium at the Freer Gallery of Art*, P. Jett, J.G. Douglas, B. McCarthy and J. Winter, eds., 27-29 September 2001, London, Archetype Publications.

La Niece S., Ward R., Hook D., Craddock P.T., 2012. « Medieval Islamic Copper Alloys », in *Scientific Research on Ancient Asian Metallurgy. Proceedings of the Fifth Forbes Symposium at the Freer Gallery of Art*, P. Jett, B. McCarty and J.G. Douglas, eds., 28-29 October 2010, London, Archetype Publications Ltd / Smithsonian Institution, 248-254.

Launert E., 1990. *Der Mörser. Geschichte und Erscheinungsbild eines Apothekengerätes. Materialen - Formen - Typen*, Munich, Callwey-Verlag.

Laviola V., 2016. *Metalli Islamici dai territori iranici orientali (IX-XIII sec.). La documentazione della Missione Archeologica Italiana in Afghanistan*, PhD thesis, Venice, Università Ce'Foscari.

Laviola V., 2017A. « Three Islamic Inkwells from Ghazni Excavation », *Vicino Oriente*, XXI, 111-126.

Laviola V., 2017B. « Artisans' Signatures from Pre-Mongol Iranian Metalwork. An Epigraphic and Palaeographic Analysis », *Eurasian Studies*, 15/1, 80-124.

Laviola V., 2017C. « Unpublished Islamic Bronze Cauldrons from Private Collections: Two Early and One Very Late Specimens », *Vicino Oriente*, XXI, 257-263.

Leoni F., ed., 2016. « Sacred Words, Sacred Power: Qur'anic and Pious Phrases as Sources of Healing and Protection », in *Power and Protection. Islamic Art and the Supernatural*, Oxford, Ashmolean Museum, 53-65.

Lermer A., Shalem A., eds., 2010. *After One Hundred Years. The 1910 Exhibition "Meisterwerke muhammedanischer Kunst" Reconsidered*, Leiden/ Boston, Brill.

Le Strange, 1905. *The Lands of the Eastern Caliphate*, London, Frank Cass, reprint, 1966.

London, 1931A. *Catalogue of the International Exhibition of Persian Art*, London, London Royal Academy of Arts.

London, 1931B. *Persian Art. An Illustrated Souvenir of the Exhibition of Persian Art at Burlington House*, London, Hudson and Keams.

Lory P., 2016. « Divination and Religion in Islamic Medieval Culture », in *Power and Protection*.

Islamic Art and the Supernatural, F. Leoni, ed., Oxford, Ashmolean Museum, 13-31.

Loukonine V., Ivanov A., 1995. *L'art persan*, Bournemouth, Parkstone, UK / Saint-Petersburg, Aurora.

Lucas L., 2007. «Charles Pascal Marie Piet-Lataudrie, collectionneur-donateur au musée de Niort», *Bulletin de la Société historique et scientifique des Deux-Sèvres*, XI, 35-62.

Maddison F., Savage-Smith E., 1997. *Science, Tools & Magic*, «The Nasser D. Khalili Collection of Islamic Art, XII», London / Oxford, The Nour Foundation / Azimuth Editions / Oxford University Press.

Maish J., Collinet A., 2023. «Inlay and overlay», in *Guidelines for the Technical Study of Cast Bronze Sculpture*, D. Bourgarit, J. Bassett, F.G. Bewer, A. Heginbotham and P. Motture, eds., vol. 1, Los Angeles, Getty Publication.

Makariou S., ed., 1998. *L'apparence des cieux, astronomie et astrologie en terre d'Islam*, exhibition catalogue, Paris, Musée du Louvre, 18 June-21 September 1998, Paris, Éditions de la Réunion des musées nationaux.

Makariou S., ed., 2002. *Nouvelles acquisitions, Arts de l'Islam, 1988-2001*, Paris, Éditions de la Réunion des musées nationaux.

Makariou S., ed., 2012. *Les Arts de l'Islam au musée du Louvre*, Paris, Hazan / musée du Louvre éditions.

Manteghi H., 2018. *Alexander the Great in the Persian Tradition: History, Myth and Legend in Medieval Iran*, London / New York, Bloomsbury / I.B. Tauris.

Marchal H., 1974. «L'art du bronze islamique d'Afghanistan dans les collections du Louvre», *Revue du Louvre*, 1, 7-18.

Marshak B.I., 1972. «Bronzovyï Khushin iz Samarkanda», *Srednaja Azija I Iran*, Leningrad, 61-90.

Matin, M., 2020, «Appendix. The Technology of Medieval Islamic Ceramics: A Study of Two Persian Manuscripts», O. Watson, Ceramics of Iran. Islamic Pottery from the Sarikhani Collection, Yale University Press, New Haven and London, 459–487.

Mattusch C., 1990. «A Trio of Griffins from Olympia», *Hesperia*, 59/3, 549-560.

Maury C., ed., 2019. *Le goût de l'Orient. Georges Marteau collectionneur*, exhibition catalogue, Paris, Musée du Louvre, departement des Arts de l'Islam, 26 June 2019-6 January 2020, Musée du Louvre éditions / In Fine.

Mayer L.A., 1959. *Islamic Metalworkers and their Works*, Geneva, Albert Kundig.

Melikian-Chirvani A.S., 1971. *Arts de l'Islam des origines à 1700 dans les collections publiques françaises*, exhibition catalogue, Paris, Orangerie des Tuileries, 22 June-30 August 1971, Paris, Éditions de la Réunion des musées nationaux.

Melikian-Chirvani A.S., 1973. *Le bronze iranien*, exhibition catalogue, Paris, Musée des Arts Décoratifs, July-September 1973, Paris, Musée des Arts Décoratifs.

Melikian-Chirvani A.S., 1974A. «The White Bronzes of Early Islamic Iran», *Metropolitan Museum Journal*, 9, 123-152.

Melikian-Chirvani A.S., 1974B. «Les bronzes du Khorāssān I», *Studia Iranica*, t. 3, fasc. 1, 29-50.

Melikian-Chirvani A.S., 1975A. «Les bronzes du Khorāssān II. Une école inconnue du XIIe siècle», *Studia Iranica*, t. 4, fasc. 1, 51-71.

Melikian-Chirvani A.S., 1975B. «Les bronzes du Khorāssān III. Bronzes inédits du Xe et du XIe siècles», *Studia Iranica*, 4/2, 187-205.

Melikian-Chirvani A.S., 1976. «Les bronzes du Khorāssān IV. Bronzes inédits du Khorassan oriental», *Studia Iranica*, 5/2, 203-212.

Melikian-Chirvani A.S., 1977. «Les bronzes du Khorāssān V. De quelques coupes inédites du Khorassān», *Studia Iranica*, 6/2, 185-210.

Melikian-Chirvani A.S., 1979. «Les bronzes du Khorāssān VII. Šāzī de Herat, ornemaniste», *Studia Iranica*, 8/2, 223-243.

Melikian-Chirvani A.S., 1982A. *Islamic Metalwork from the Iranian World, 8th–18th centuries*, London, Victoria & Albert Museum.

Melikian-Chirvani A.S., 1982B. «Essais sur la sociologie de l'art islamique. I. Argenterie et féodalité dans l'Iran médiéval», in *Art et Société dans le monde iranien*, C. Adle, ed., Paris, A.D.P.F.

Melikian-Chirvani A.S., 1982C. «Le rhyton selon les sources persanes. Essai sur la continuité culturelle iranienne de l'Antiquité à l'Islam», *Studia Iranica*, 11, 263-292.

Melikian-Chirvani A.S., 1986A. «State Inkwells in Islamic Iran», *The Journal of the Walters Art Gallery*, vol. 44, 70-94.

Melikian-Chirvani A.S., 1986B. «Silver in Islamic Iran: The Evidence from Literature and Epigraphy», in *Pots & Pans. A Colloquium on Precious Metals and Ceramics in the Muslim, Chinese and Graeco-Roman Worlds*. M. Vickers, ed., «Oxford Studies in Islamic Art, III», Oxford, Oxford University Press, 89-106.

Melikian-Chirvani A.S., 1991. «Les taureaux à vin et les cornes à boire de l'Iran islamique», in *Histoire et cultes de l'Asie centrale préislamique*, P. Bernard and F. Grenet, eds., Paris, Éditions du CNRS, 101-125.

Melikian-Chirvani A.S., 1992. «The Iranian Bazm in Early Persian Sources», in *Banquets d'Orient, Res Orientales*, vol. 4, 95-120.

Melikian-Chirvani A.S., 1995. «The Wine Birds of Iran from Pre-Achaemenid to Islamic Times», *Bulletin of the Asia Institute*, new series, 41-97.

Melikian-Chirvani A.S., 1996. «The Iranian Wine Horn from Pre-Achaemenid Antiquity to the Safavid Age», *Bulletin of the Asia Institute*, new series, vol. 10, *Studies in Honor of Vladimir A. Livshits*, 85-139.

Melikian-Chirvani A.S., Allan J.W., 1989. «Berenj, "brass"», *Encyclopædia Iranica*, vol. IV, fasc. 2, 145-147.

Menghini A., Contin D., eds., 2009. *Kitâb al-Diryâq (Thériaque de Paris)*, Sansepolcro, Italy, Aboca museum Edizioni.

Meyer J., 2015. *Sensual Delights. Incense Burners and Rosewater Sprinklers from the World of Islam*, exhibition catalogue, Copenhagen, The David Collection, 20 mars-6 September 2015, Copenhagen, The David Collection.

Meyers P., 2003. «Production of Silver in Antiquity: Ore Types Identified Based Upon Elemental Compositions of Ancient Silver Artifacts», in *Patterns and Process. A Festchrift in honor of Dr. Edward V. Sayre*, L. Van Zelst, ed., Maryland, Smithsonian Center for Materials Research and Education, 271-289.

Migeon G., 1899. «Les cuivres arabes. Le Vase Barberini au Louvre», *Gazette des Beaux-Arts*,

December, 462-474.

Migeon G., 1900. «Les cuivres arabes. Le Baptistère de Saint Louis au Louvre», *Gazette des Beaux-Arts*, February, 119-131.

Migeon G., 1903A. «L'exposition des arts musulmans au Musée des Arts Décoratifs», *Les Arts*, 16, 1-34.

Migeon G., 1903B. «L'exposition des arts musulmans à l'Union Centrale des Arts Décoratifs», *Gazette des Beaux-Arts*, May, 353-359.

Migeon G., 1905. «Notes d'archéologie musulmane, à propos de nouvelles acquisitions du Louvre», *Gazette des Beaux-Arts*, June, 441-455.

Migeon G., 1909. «La collection de M. Piet-Lataudrie», *Les Arts*, 92, 1-32.

Migeon G., 1910. «Exposition des arts musulmans à Munich», *Les Arts*, 108, 1-32.

Migeon G., 1922. *Musée du Louvre. L'Orient musulman*, vol. I, *Sculptures, bois sculptés, ivoires, bronzes, armes, cuivres, tapis et tissus, miniatures*, Paris, A. Morancé.

Migeon G., Van Berchem M., Huart M., eds., 1903. *Exposition des arts musulmans, catalogue descriptif*, Union Centrale des Arts Décoratifs, Pavillon de Marsan, Paris, Société française d'imprimerie et de librairie.

Migeon G., Marquet de Vasselot J.-J., Leprieur P., Michel A., 1917. *Musée du Louvre. Catalogue de la Collection Arconati Visconti*, Paris, Hachette.

Mille B., 2017. *D'une amulette en cuivre aux grandes statues de bronze. Évolution des techniques de fonte à la cire perdue, de l'Indus à La Méditerranée, du 5ᵉ millénaire au 5ᵉ siècle av. J.-C*, PhD thesis, Nanterre / Fribourg, université de Paris-Nanterre / université de Fribourg, http://www.theses.fr/2017PA100057

Milstein R., ed., 1994. *King Solomon's Seal*, Jerusalem Tower of David, Museum of the History of Jerusalem.

Milwright M., 2017. *Islamic Arts and Crafts, an Anthology*, Edinburgh, Edinburgh University Press.

Momenzadeh M., 2004. «Metallic Mineral Resources of Iran, Mined in Ancient Times. A Brief Review», in *Persiens Antike Pracht, Bergbau-Handwerk-Archäologie*, T. Stöllner, R. Slotta and A. Vatandoust, eds., vol. I, Bochum,

Deutsches Bergbau Museum, 8-21.

Muhly J.D., 1973. *Copper and Tin, The Distribution of Mineral Resources and the Nature of the Metals Trade in the Bronze Age*, New Haven, Connecticut Academy of Arts and Sciences.

Murakami R., Sawada M., Chase W.T., Jett P., 2003. «A Scientific Study of Twin Japanese Bronze Mirrors», in *Scientific Research in the Field of Asian Art. Proceedings of the First Forbes Symposium at the Freer Gallery of Art*, P. Jett, J.G. Douglas, B. McCarthy and J. Winter, eds., 27-29 September 2001, London, Archetype Publications.

Nabi Khan A., 1990. *Al-Mansurah, a Forgotten Arab Metropolis in Pakistan*, Karachi, Archaeology and Museum Department of the Government of Pakistan.

Necipoğlu G., 1995. *The Topkapi Scroll – Geometry and Ornament in Islamic Architecture*, Santa Monica, The Getty Center for the History of Art and the Humanities.

Necipoğlu G., 2007. «L'idée de décor dans les régimes de visualité islamiques», in *Purs décors ? Arts de l'Islam, regards du XIXᵉ siècle*, R. Labrusse ed., exhibition catalogue, Paris, Musée des Arts Décoratifs, 11 October 2007-13 January 2008, Les Arts Décoratifs / Musée du Louvre éditions, 10-23.

Necipoğlu G., 2016. «Early Modern Floral: the Agency of Ornament in Ottoman and Safavid Visual Cultures», in *Histories of Ornament from Global to Local*, G. Necipoğlu and A. Payne, eds., Princeton, Princeton University Press, 132-155.

Nezafati N., Pernicka E., Momenzadeh M., 2008. «Iranian Ore Deposits and Their Role in the Development of the Ancient Cultures», *Anatolian Metals*, IV, 77-90.

Ogden J., 1999. *Age & Authenticity: The materials and techniques of 18th and 19th century goldsmiths*, London, National Association of Goldsmiths.

O'Kane B., 2009. *The Appearance of Persian on Islamic Art*, Costa Mesa, California, Mazda Publishers.

O'Kane B., Abbas M., Abdulfattah I., 2012. *The Illustrated Guide to the Museum of Islamic Art in Cairo*, Cairo / New York, The American University in Cairo Press.

Omidsalar M., 2011. «Divination», *Encyclopædia Iranica*, vol. VII, fasc. 4, 440-443.

Orfanou V., Birch Th., Lichtenberger A., Raja R., Barford G.H., Lesher Ch.E., Eger Ch., 2020. «Copper-Based Metalwork in Roman to Early Islamic Jerash (Jordan): Insights Into Production And Recycling Through Alloy Compositions and Lead Isotopes», *Journal of Archaeological Science: Reports*, 33, 1-15.

Orfanou V., Collinet A., El Morr Z., Bourgarit D., 2018. «Archaeometallurgical Investigation of Metal Wares from the Medieval Iranian World (10ᵗʰ-15ᵗʰ centuries): The ISLAMETAL Project», *Journal of Archaeological Science*, 95, 16-32.

Oudbashi O., Hasanpour A., Jahanpoor A., Rahjoo Z., 2017. «Microscopic and Microanalytical Study on Sasanian Metal Objects from Western Iran: A Case Study», *Science and Technology of Archaeological Research*, 3/2, 194-205.

Pancaroğlu O., 2016. «Ornament, Form, and Vision in Ceramics from Medieval Iran: Reflections of the Human Image», in *Histories of Ornament from Global to Local*, G. Necipoğlu and A. Payne, eds., Princeton, Princeton University Press, 192-203.

Paris, 1996. *À l'ombre d'Avicenne. La médecine au temps des califes*, exhibition catalogue, Paris, Institut du Monde Arabe, 18 November 1996-2 March 1997, Paris / Ghent, Institut du Monde Arabe / Snoeck-Ducaju & Zoon.

Paul J., 2000. «The Histories of Herat», *Iranian Studies*, 33/1-2, 93-115.

Paul J., 2003. «Herat. V. Local Histories», *Encyclopædia Iranica*, vol. XII, fasc. 2, 217-219.

Pellat Ch., 1991. «ʿanḳā», *Encyclopedia of Islam*, second edition, vol. II, Leiden, Brill, 524.

Pernot M., 2015. «Études technologiques», in *Le dépôt d'Evans (Jura) et les dépôts de vaisselles de bronze en France, Bronze final*, J.F. Piningre, M. Pernot and V. Ganard, eds., «*Revue Archéologique de l'Est et du Centre-Est*, supplément 37», Dijon, Société archéologique de l'Est.

Piotrovsky M.B., Pitrula A.D., eds., 2006. *Beyond the Palace Walls, Islamic Art from the State Hermitage Museum*, Edinburgh, National Museums of Scotland.

Piotrovsky M.B., Vrieze J., eds., 1999. *Earthly Beauty, Heavenly Art, the Art of Islam*, exhibition catalogue, Amsterdam, De Nieuwe Kerk,

16 December 1999-24 April 2000, Amsterdam, De Nieuwe Kerk.

Pillai S.G.K., Pillai R.M., Damodaran A.D., Ramachandran T.R., 1994. « The Thermomechanical Processing of High-Tin Bronzes: An Old Practice in a South Indian Village », *Journal of Metals*, 46/3, 59-62.

Ploug G., Oldenburg E., Hammershaimb E., Thomsen R., Løkkegaard F., 1969. *Hama. Fouilles et recherches de la Fondation Calsberg 1931-1938. Les petits objets médiévaux sauf les verreries et poteries*, Copenhagen, Nationalmuseet.

Ponting M., 2003. « From Damascus to Denia: the Scientific Analysis of Three Groups of Fatimid Period Metalwork », *Historical Metallurgy*, 37/2, 85-105.

Ponting M., 2008. « The Scientific Analysis and Investigation of a Selection of the Copper Base Alloy Metalwork from Tiberias », in *Tiberias: the house of the bronzes 1*, Y. Hirschfeld and O. Gutfeld, eds., « Qedem, 48 », Jerusalem, Hebrew University of Jerusalem / Institute of Archaeology, 48, 35-61.

Ponting M., Levene D., 2015. « Recycling Economies, When Efficient, Are by Their Nature Invisible? A First Century Jewish Recycling Economy », in *The Archaeology and Material Culture of the Babylonian Talmud*, M.J. Geller, ed., « IJS Studies in Judaica 16 », Leiden, Boston, Brill, 39-65.

Pope A.U., 1935. « The Third International Congress and Exhibition for Iranian Art and Archaeology », *Bulletin of the American Institute for Persian Art and Archaeology*, IV, 2, 59-65.

Pope A.U., Ackerman Ph., 1939. *Survey of Persian Art*, vol. IX, Oxford, Oxford University Press.

Porter Y., 2002. « Les céramiques au lustre métallique dans le monde iranien, XIIᵉ-XIIIᵉ s. », *Le décor lustré dans la céramique*, conference proceedings, Geneva, Ariana Museum, 16 November 2001, Geneva, Fondation Amaverunt / musée Ariana, 3-12.

Porter Y., 2003. « Les techniques du lustre métallique d'après le Jowhar-nâme-ye Nezâmi (1196 AD) », *VIIᵉ congrès international de céramique médiévale en Méditerranée*, Ch. Bakirtzis, ed., Thessaloniki, 11–16

October 1999, Athens, Caisses des recettes archéologiques, 427-436.

Porter Y., 2004. « Le quatrième chapitre du Jawâhar-nâma-i Nizâmi: le plus ancien texte persan sur la céramique », in *Sciences, techniques et instruments dans le monde iranien (Xᵉ-XIXᵉ s.)*, N. Pourjavady and Z. Vesel, eds., conference proceedings, Tehran, University of Tehran, 7–9 June, 1998, Tehran, University Press of Iran, / Institut français de recherche en Iran, 341-360.

Porter Y., 2011. *Le prince, l'artiste et l'alchimiste. La céramique dans le monde iranien, Xᵉ-XVIIᵉ siècles*, with Richard Castinel, Paris, Hermann.

Pougatchenkova G., Khakimov A., 1988. *L'art de l'Asie centrale*, Leningrad, Aurora.

Rajput S.A., 2009. *History of Islamic art: based on al-Mansurah evidence*, Lahore, Sang-e-Meel Publications.

Rante R., ed., 2015. *Greater Khorasan. History, Geography, Archaeology and Material Culture*, Berlin / Munich / Boston, De Gruyter.

Rante R., Collinet A., 2013. *Nishapur Revisited. Stratigraphy and Ceramics of the Qohandez*, Paris / Oxford, Musée du Louvre éditions / Oxbow Books.

Rashidi K., 2011. *Historic Locks from Iran. Islamic bronzes in the Bumiller-Collection*, « Schriften zur Islamischen Kunst und Kulturgeschichte, 9 », Bamberg, University Museum Islamic Art.

Rice D.S., 1955. « Studies in Islamic Metalwork - V », *Bulletin of the School of Oriental and African Studies*, 17/2, 206-231.

Rice D.S., 1961. « A Seljuk Mirror », *First International Congress of Turkish Art*, Ankara, Institute of Turkish and Islamic Art, Ankara, University of Ankara, 19–24 October 1959, Ankara, Türk Tarih Kurumu Basimevi, 288-290.

Riefstahl R.M., 1931. « Persian Islamic Stucco Sculptures », *The Art Bulletin*, 13/4, 438-463.

Riyadh, 1985. *The Unity of Islamic Art*, O. Hoare, ed., exhibition catalogue, Riyadh, Islamic Art Gallery, 1985, Riyadh, King Faisal Center for Research and Islamic Studies.

Rizvi K., 2007. « Art History and the Nation: Arthur Upham Pope and the Discourse on "Persian Art"

in the Early Twentieth Century », *Muqarnas*, 24, 45-65.

Robinson B.W., 2000. « The Burlington House Exhibition of 1931. A Milestone in Islamic Art History », in *Discovering Islamic Art, Scholars, Collectors and Collections*, S. Vernoit, ed., London / New York, I.B. Tauris, 147-155.

Ross J.C., Allan J.W., 2001. « Gold », *Encyclopædia Iranica*, vol. XI, fasc. 1, 68-75.

Rowland B., Rice F.M., 1971. *Art in Afghanistan: Objects from the Kabul Museum*, London, Allen Lane.

Roxburgh D.J., 2000. « Au Bonheur des Amateurs: Collecting and Exhibiting Islamic Art, ca. 1880-1910 », *Ars Orientalis*, 30, 9-38.

Rugiadi M., 2007. *Decorazione architettonica in marmo da Ġaznī (Afghanistan)*, PhD thesis, Naples, Università degli Studi di Napoli « Oriental Studies Department ».

Rugiadi M., 2012. « As for Colours, Look at a Garden in Spring, Polychrome Marble in the Ghaznavid Architectural Decoration », in *Proceedings of the 7ᵗʰ International Congress on the Archaeology of the Ancient Near East, 12-16 April 2010, the British Museum and UCL, London*, vol. II, *Ancient & Modern Issues in Cultural Heritage, Colour & Light in Architecture, Art & Material Culture, Islamic Archaeology*, R. Matthews and J. Curtis, eds., Wiesbaden, Harrassowitz Verlag, 425-443.

Salibi N., 2004. « Les fouilles du Palais B 1950-1952 », in *Raqqa III, Baudenkmäler und Paläste 1*, V. Daiber and A. Becker, eds., Mainz Philipp von Zabern, 77-104.

Sarre F., 1906. *Erzeugnisse Islamischer Kunst*, vol. 1, *Metall*, Berlin / Leipzig, Druck von H.S. Hermann / Kommissionsverlag von K.W. Hiersemann.

Sarre F., Martin F.R., eds., 1912. *Die Ausstellung von Meisterwerken Muhammedanischer Kunst in München 1910*, 3 volumes, Munich, Bruckmann; reprint, London, Alexandria Press, 1985.

Sauer E.W., Rekavandi H.O., Wilkinson T.J., Nokandeh J., 2013. *Persia's Imperial Power in Late Antiquity. The Great Wall of Gorgān and Frontier Landscapes of Sasanian Iran*, « BIPS Archaeological Monograph Series 2 », Oxford, Oxbow Books.

Saussus L., 2019. *Travailler le cuivre à Douai au XIIIᵉ siècle: histoire et archéologie d'un atelier*

de proximité, « Collection Archaeologia Duacensis, 31 / Collection d'archéologie Joseph Mertens, 17 », Douai / Louvain-la-Neuve, Association Les amis d'Arkeos / Université Catholique de Louvain / Centre de Recherches d'Archéologie Nationale.

Savage-Smith E., 1997. « Magic-Medicinal Bowls », in *Science, Tools & Magic. Part One. Body and Spirit, Mapping the Universe*, F. Maddison and E. Savage-Smith, eds., « The Nasser D. Khalili Collection of Islamic Art, XII », London / Oxford, The Nour Foundation / Azimuth Editions / Oxford University Press, 72-100.

Scerrato U., 1959. « Oggetti metallici di età islamica in Afghanistan. I: Antiquario di Kandahar », *Annali dell'Istituto Orientale di Napoli*, 9, 73-714.

Scerrato U., 1964. « Oggetti metallici di età islamica in Afghanistan. II: Il ripostiglio di Maimana », *Annali dell'Istituto Orientale di Napoli*, 14/2, 673-714.

Scerrato U., 1980. « Specchi islamici con sfingi scorpioniche », *Arte Orientale in Italia*, 5, 61-94.

Schimmel A., Soucek P.P., 1992. « Color », in *Encyclopædia Iranica*, vol. VI, fasc. 1, 46-50; revised in 2011.

Schlumberger D., 1959. « Le Palais ghaznévide de Lashkari Bazar », *Syria*, 29/3-4, 251-270.

Schlumberger D., Sourdel-Thomine J., 1978. *Lashkari Bazar, une résidence royale ghaznévide et ghoride. Volume 1 A: l'architecture. Volume 1 B: le décor non figuratif et les inscriptions*, « Mémoires de la DAFA, 18 », Paris, Diffusion de Boccard.

Scott D.A., 1991. *Metallography and Microstructure of Ancient and Historic Metals*, The Getty Conservation Institute / Denbigh, Wales, The Getty Conservation Institute / J. Paul Getty Museum / Archetype Books.

Scott Meisami J., 1987. *Medieval Persian Court Poetry*, Princeton, Princeton University Press.

Scott Meisami J., 1999. *Persian Historiography: to the End of the Twelfth Century*, Edinburgh, Edinburgh University Press.

Scott Meisami J., 2001. « Palaces and Paradises: Palace Description in Medieval Persian Poetry », in *Islamic Art and Literature*, O. Grabar and C. Robinson, eds., Princeton, Marcus Wiener Publishers, 21-54.

Seyed-Gohrab A.A., ed., 2012. *Metaphor and Imagery in Persian Poetry*, Leiden / Boston, Brill.

Shalem A., 1994. « Fountains of Light: The Meaning of Medieval Islamic Rock Crystal Lamps », *Muqarnas*, 11, 1-11.

Shalem A., 2012. « Medieval Islamic Terms for Glassware Imitating Vessels of Carved Precious Stones », in *Sehrâyîn: Die Welt der Osmanen, die Osmanen in der Welt. Wahrnehmungen, Begegnungen und Abgrenzungen / Iluminating the Ottoman World. Perceptions, Encounters and Boundaries. Festschrift Hans Georg Majer*, Y. Köse and T. Völker, eds., Wiesbaden, Harrassowitz Verlag, 25-34.

Shalem A., 2017. « The Discovery and Rediscovery of the Medieval Islamic Object », in *A Companion to Islamic Art and Architecture. Volume I, From the Prophet to the Mongols*, F.B. Flood and G. Necipoğlu, eds., Hoboken, Wiley-Blackwell /John Wiley & Sons, 559-578.

Shalev S., Freund M., 2002. « The Archaeology of Islamic Metals and the Anthropology of Traditional Metal Casting in Cairo Today », in *Metals and Society: Papers from a Session Held at the European Association of Archaeologists Sixth Annual Meeting in Lisbon 2000*, B.S. Ottaway and E.C. Wager, eds., Oxford, BAR Publishing, 83-97.

Sheperd D., 1957. « A Lion Incense Burner of the Seljuk Period », *The Bulletin of the Cleveland Museum of Art*, 6/1, 115-118.

Shimkin D.B., 1953. *Minerals: A Key to Soviet Power*, Cambridge, MA, Harvard University Press.

Shishkina G.V., Pavchinskaja L.V., 1992. *Terres secrètes de Samarcande*, catalogue of a travelling exhibition, Paris / Caen / Toulouse, Institut du Monde Arabe / musée de Normandie / musée des Augustins.

Siméon P., 2012. « Hulbuk: Architecture and Material Culture of the Capital of the Banijurids in Central Asia (Ninth-Eleventh Centuries) », *Muqarnas*, 29, 385-421.

Sourdel-Thomine J., 2004. *Le minaret ghouride de Jam. Un chef-d'œuvre du XIIᵉ siècle*, Paris, Mémoire de l'Académie des Inscriptions et Belles-Lettres.

Spink M., 2015. « Silver », *Encyclopædia Iranica*, online edition.

Spink M., Behrens-Abouseif D., Gibson M., 2020. *Brasses, Bronze and Silver of the Islamic Lands*, « The Nasser D. Khalili Collection of Islamic Art », vol. XI, part. 1, The Nour Foundation.

Srinivasan S., Glover I., 1998. « High-Tin Bronze Mirrors of Kerala, South India », *IAMS*, 20, 15-17.

Stein A., 1936. « An Archaeological Tour in the Ancient Persis », *Iraq*, 3/2, 111-225.

Stöllner T., 2004. « Prehistoric and Ancient Ore-Mining in Iran », in *Persiens Antike Pracht, Bergbau-Handwerk-Archäologie*, T. Stöllner, R. Slotta and A. Vatandoust, eds., vol. I, Bochum, Deutsches Bergbau Museum, 44-64.

Szuppe M., 2003A. « Herat. III. History, Medieval Period », *Encyclopædia Iranica*, vol. XII, fasc. 2, 206-211.

Szuppe M., 2003B. « Herat. IV. Topography and Urbanism », *Encyclopædia Iranica*, vol. XII, fasc. 2, 211-217.

Tabbaa Y., 1987. « Bronze Shapes in Iranian Ceramics of the Twelfth and Thirteenth Centuries », *Muqarnas*, 4, 98-113.

Taragan H., 2005. « The "Speaking" Inkwell from Khorasan: Object as "World" in Iranian Medieval Metalwork », *Muqarnas*, 22, 29-44.

Tazzafoli A., 1974. « List of Trades and Crafts in the Sassanian Period », *Arcäeologische Mitteilungen aus Iran*, 7, 191-196.

Tehran, 1948. *Guide to the Archaeological Museum of Tehran*, Tehran, Mūzih-i Īrān-i Bāstān.

Thomas D.C., 2018. *The Ebb and Flow of the Ghūrid Empire*, « Adapa Monographs », Sydney, Sydney University Press.

Thomas N., Bourgarit D., 2014. « Les techniques de production des batteurs et fondeurs mosans au Moyen Âge (XIIᵉ-XVIᵉ siècles) », in *L'or des dinandiers. Fondeurs et batteurs mosans au Moyen Âge*, N. Thomas, I. Leroy and Plumier, eds., « Cahiers de la MPPM, n° 7 », Bouvignes-Dinant, Maison du patrimoine médiéval mosan, 43-63.

Tissot F., 2006. *Catalogue of the National Museum of Afghanistan, 1931-1985*, Paris, UNESCO Publishing.

Tokyo, 2008. *Brilliance of Persian Ceramics*, exhibition catalogue, Tokyo, the Museum of the Middle Eastern Culture Center in Japan.

Treptow T., 2007. *Daily Life Ornamented*.

The Medieval Persian City of Rayy, with the collaboration of Donald Whitcomb, Chicago, Oriental Institute Museum, Oriental Institute of the University of Chicago.

Tylecote R.F., 1970. « Early Metallurgy in the Near East », *Metals and Materials*, 4, 285-293.

Untracht O., 1982. *Jewelry, Concepts and Technology*, London, Robert Hale.

Van Berchem M., 1904. « Notes d'archéologie arabe, troisième article. Étude sur les cuivres damasquinés et les verres émaillés, inscriptions, marques, armoiries », *Journal Asiatique*, 10/3, January-February, 5-96.

Vesel Z., 1985. « Sur la terminologie des gemmes : *yâqut* et *la'l* chez les auteurs persans », *Studia Iranica*, 14/2, 147-155.

Vitry P., Dreyfus C., Leprieur P., Demonts L., Migeon G., 1922. *Catalogue de la collection Isaac de Camondo*, Paris, Gaston Braun.

Wannell B., 2002. « Echoes in a Landscape – Western Afghanistan in 1989 », in *Cairo to Kabul, Afghan and Islamic Studies Presented to Ralph Pinder-Wilson*, W. Ball and L. Harrow, eds., London, Melisende, 236-247.

Ward R., 1993. *Islamic Metalwork*, London, British Museum.

Ward R., ed., 2014. *Court and Craft. A Masterpiece from Northern Iraq*, London, The Courtauld Gallery / Paul Holberton Publishing.

Watson O., 1985. *Persian Lustre Ware*, London, Faber & Faber.

Watson O., 1986. « Pottery and Metal Shapes in Persia in the 12th and 13th Centuries », in *Pots & Pans. A Colloquium on Precious Metals and Ceramics in the Muslim, Chinese and Graeco-Roman Worlds. Oxford 1985*, M. Vickers, ed., « Oxford Studies in Islamic Art, III », Oxford, Oxford University Press, 205-212.

Wheatly P., 1961. *The Golden Khersonese*, Kuala Lumpur, University of Malaya Press.

Wheeler B., 2006. *Mecca and Eden. Ritual, Relics, and Territory in Islam*, Chicago / London, The University of Chicago Press.

Wiet G., 1931. « Un nouvel artiste de Mossoul », *Syria*,

12/2, 160-162.

Wiet G., 1933. *L'Exposition persane de 1931*, Cairo, IFAO.

Wilkinson C.K., 1973. *Nishapur: Pottery of the Early Islamic Period*, New York, Metropolitan Museum of Art.

Wood B.D., 2000. « A Great Symphony of Pure Form : the 1931 International Exhibition of Persian Art and its Influence », *Ars Orientalis*, 30, 113-130.

Wulff H.E., 1966. *The Traditional Crafts of Persia. Their Development, Technology and Influence on Eastern and Western Civilizations*, Cambridge / London, Massachusetts Institute of Technology, MIT Press.

Yarshater E., 1960. « The Theme of Wine-Drinking and the Concept of the Beloved in Early Persian Poetry », *Studia Islamica*, 13, 43-53.

Zakeri M., 2008. « Javānmardi », *Encyclopædia Iranica*, vol. XIV, fasc. 6, 594-601.

Ziffer I., 1996. *Islamic Metalwork*, exhibition catalogue, Tel-Aviv, Philatelic and Postal Pavilion, Eretz Israel Museum.

AUCTION CATALOGUES

London, 1992. *Islamic Art, Indian Miniatures, Rugs and Carpets*, Christie's London, 28-30 April 1992.

London, 1994. *Islamic and Indian Art*, Sotheby's London, 20 October 1994.

London, 2006. *Arts of the Islamic World*, Sotheby's London, 11 October 2006.

London, 2008. *Art of the Islamic and Indian Worlds*, Christie's London, 7 October 2008.

London, 2011A. *The Stuart Cary Welch Collection, Part One, Arts of the Islamic World*, Sotheby's London, 6 April 2011.

London, 2011B. *Arts of the Islamic World Evening Sale, Including the Harvey B. Plotnick Collection of Islamic Ceramics, Part One*, Sotheby's London, 4 October 2011.

London, 2013. *The Saeed Motamed Collection – Part One*, Christie's, South Kensington, 22 April 2013.

Paris, 1888. *Catalogue des objets d'art de l'Orient*

et de l'Occident, tableaux, dessins, composant la collection de feu M. Albert Goupil, Paris, Hôtel Drouot, 23, 24, 25, 26, 27 April 1888 (...) and at the house of M. Albert Goupil, 28 April 1888.

Paris, 1919. *Catalogue des objets d'art appartenant à M.J. Jeuniette*, Paris, Galerie Manzi, Joyant & Cie, 26-29 March 1919.

Paris, 1952. *Succession du colonel W. Ancienne collection Mutiaux, cinquième vente. Objets d'art orientaux (...)*, Paris, Hôtel Drouot, 14 March 1952.

Paris, 1960. *Art d'Iran, Bronzes du Louristan, Bronzes de Gourgan du XIIIe siècle, Céramique orientale*, Paris, Hôtel Drouot, 18-19 May 1960.

Paris, 1965. *Bijoux barbares et orfèvrerie antique (...) Objets d'art musulman*, Paris, Hôtel Drouot, 17-18 June 1965.

Paris, 1976. *Importants manuscrits persans des XVIe et XVIIe siècles*, Paris, Drouot Rive-Gauche, 10 March 1976.

Paris, 1978. *Art d'Orient, Antiques*, Paris, Drouot Rive-Gauche, 16-17 November 1978.

Paris, 1994. *Arts d'Orient*, Paris, Hôtel Drouot, 7 October 1994.

Paris, 2002. *Orientalisme, Arts d'Orient*, Paris, Drouot Richelieu, 28 November 2002.

Paris, 2010. *Arts d'Orient et d'Extrême Orient*, Paris, Pierre Bergé & associates, 15 November 2010.

Stuttgart, 2010. *Spezialauktion, Teppiche & Ethnologica. Rugs & Carpets, Islamic & Tribal Art*, Stuttgart, Nagel, 16 March 2010.

Index

A

Abbasids, 32, 109, 188, 198

ʿAbd al-Razzaq al-Nishapuri, 166

Abu Bakr ibn Ahmad Marwazi / Abu Bakr ibn Ahmad-e Marvazi, 287

Abu Bakr ibn Mahmud Saffar, 287, 290–91

Abu Dulaf, 54–55

Abu'l Munif ibn Mas'ud, 190

Abu'l Qasim Kashani, 53–57, 277

Abu Zayd, 55

Adle, Chahryar, 35

Afrasiab, 42, 198, 227

Ajīr (salaried contact), 47

Alborz, 55, 222

ʿAli ibn Abu Nasr, 241

ʿAli ibn Haidar, 287

ʿAli ibn Muhammad al-Tadji,, 241

ʿAli ibn ʿUmar (?) al-Isfaraʾini 134–35

Allan, James W., 15, 19–20, 24, 41, 42, 44, 47, 54–55, 57–58, 92, 115, 144, 158, 170, 180, 182, 190, 194, 196, 198, 240, 251, 254, 268–69, 276–78, 282

Anatolia, 55, 80, 94, 116, 139, 274, 278, 283

Antimony, 61, 65–66, 94, 328

Antinopolis, 64, 166

Arsenic, 61, 65–66, 92, 94, 97, 104 n.75, 189, 328

Astrology, 14, 39, 110, 127

Astrological decoration, 22, 39, 110, 119, 140–43, 218, 228

Astronomy, 20, 110, 119, 124, 127, 140–43, 180, 214

Azerbaijan, 55

B

Balkh, 32, 35, 42–43, 46, 144, 151, 178

Bamiyan, 18, 26, 34, 48 n.10, 54, 87, 96, 98, 151–52, 158, 178–81, 206, 251, 252

Batruy (Pers. leaded or high leaded copper), 56, 92, 277

Bayyāʿ / bayyaʾ (merchant), 44, 45

Bazaar, 41, 43, 44–47, 68, 70, 99, 109, 112, 116, 152, 180, 211–12, 250, 286, 297

Bazm (Pers. feast), 36–37, 124, 139, 164, 199, 205, 255, 269

Bazm o razm (Pers. feast and battle), 124, 214, 234

Beyhaqi, 46, 151–52, 198, 206 n.14, 214, 234

Birenj/berenj (Pers. brass), 47, 56, 92

al-Biruni, 35, 47, 48 n.25, 53–57, 63, 110, 189, 269, 277

Bismuth, 61, 65, 94–95, 96, 105 n.145, 189

Bukhara 43, 180, 182, 227, 278

Brass, 43, 44, 47, 56–57, 59, 62–63, 64, 66, 68, 70, 83, 92, 94, 96–98, 101, 103 n.62, 111, 199

Brass, inlaid, 44, 47

Brass, high leaded, 59–61, 63, 64, 67, 200

Brass, leaded, 59–61, 63, 64, 67, 200 ; see als *Birenj/berenj*

Bronze, 47, 54, 56–57, 60, 94, 104 n.72, 234

Bronze, high tin / white bronze, 25, 56–57, 59, 62, 63, 64, 68–69, 94, 105 n.131, 189, 269; see also *Khār ṣīnī, Safīdruy,*

Bronze makers, 286

Bu Bakr ibn Mahmud Saffar, 75 fig. 17, 287, 290–91

Bulliet, Richard, 31, 56

Burin, 86–87, 97

Bust (Lashkar Gah) / Lashkar-i Bazar, 37, 188–189

C

Caesarea, 58

Casting/cast, 42, 46, 45–47, 56, 62–70, 72–73, 75, 77–78, 80–83, 84, 86–92, 94–102, 104 n.116, 110, 126–32, 134–39, 153–55, 158, 161–73, 179–87, 189–96, 198–205, 213, 216–32, 235–50, 256–92, 295 n.11; see also *Rikhtan, Rikhteh-shodeh*

Casting, lost wax, 72–76, 82, 99–100, 227, 256, 269–70, 286, 296, 331

Casting, sand, 72, 226–27

Champlevé 33, 42, 62, 76, 78, 80–83, 86–88, 90, 97, 114, 333

Chasing 15, 26, 34, 62, 72, 77, 78–84, 87–90, 96–97, 101–102, 104 n.114, 330

Cobalt, 61, 93, 188, 200

Colour, 34–37, 44, 47, 48 n.17, n.23, 57, 63–64, 83, 90, 114, 241, 269

Contract, 99, 101–102

Copper, 22, 24–26, 31, 34–37, 38, 40, 42, 43–45, 53, 55, 56–62, 64–67, 68, 80, 85–88, 92–95, 96–98, 101–102, 126, 132, 161, 178, 188, 198–99, 211–12, 233, 277, 286, 296, 328, 329; see also *Batruy, Darāruy, Mis/mes, Tāl*

Copper mines, 54

Coppersmiths, 24, 46, 47, 68, 70, 101–102, 188, 295 n.248

Core pins, 72–73, 75, 184

Cursive (inscription, writing), 37–39, 110–111

D

Darāruy, (Pers. copper alloy) 56

Davāt, (Pers. inkwell) 127–27

Denia, 58, 64

E

Engraving, 62, 73, 77–78, 81, 84, 85, 90, 179, 332

Engraving, compass, 84–85

Expansion, biaxial (sinking), 70, 104 n.95

Expansion, uniaxial (raising), 70–71

F

Ferdowsi, 35, 222

Ferghana, 43, 49 n.81, 54, 259

File, 78, 96, 329

Foundry, 47, 80, 100, 287, 296; see also *Rikhteh-garī*

Futuwwa / javānmardi (Ar. and Pers. brotherhood, chivalry), 46

G

Gardin, Jean-Claude 178, 188

Gardizi, Abu Sa'id 'Abd al-Hayy, 36, 48 n.5, 151–52, 241, 269

Ghazna, 15, 18, 20, 25–26, 32, 36–38, 40, 41–42, 53, 58, 63, 66–67, 70 fig.9, 78, 82, 84, 87, 90, 94–98, 100–102, 111, 125, 127, 132, 144–45, 151–177, 178, 188–93, 196, 198–200, 218, 226, 234, 251, 277–78, 297

Ghaznavid, 32, 37–39, 41, 44, 46, 48 n.10, 151–53, 178, 188–89, 198, 207 n.106, 233–34, 241

Ghouchani, Abdullah, 283

Ghurid, 32–33, 37, 41, 44, 46, 109, 111, 121, 141, 152–53, 178, 188–89, 214

Gold, 65, 67, 88, 95, 104 n.89, 152, 160, 269

Gold, mine, 178

Goldsmith, 47, 68, 100–102, 151, 296

Gurgan, 248, 250

H

Hackin, Joseph, 17–18, 23, 70 fig.9, 96, 105 n.119, 153

Haddaddin (Ar, blacksmiths), 46

Hajaki Tusi / Khadjaki-e Tusi, 287

al-Hamdani, 53, 55

Hammering/hammered, 26, 34, 43, 44, 46–47, 56–57, 62, 64, 66–71, 82–83, 85–88, 90–91, 92, 94, 96–98,

100–102, 104 n.78, n.90, 110–11, 112–25, 141–45, 170, 174–75, 176, 200–202, 204–205, 256–58, 295 n.248, 332; see also *Zarb*

Hari Rud, 109

Hasan ibn 'Ali, 287

Herat, 15, 19, 20, 25–26, 31, 32, 37, 40–41, 43–44, 46, 53–54, 66–67, 78, 82, 84, 87, 94–95, 96–97, 100–101, 105 n. 151, n.152, 109–45, 151, 161, 168–69, 174–77, 178, 184–85, 188, 189, 199, 205, 226, 252, 278–87, 297

Himachal Pradesh, 34

Hindu Kush 54, 178

al-Husayn ibn al-Hasan al-Saffar, 287

I

Ibn al-Athir, 126

Ibn al-Balkhi, 45

Ibn Hawqal, 43, 54, 151, 188

Ibn Isfandiyar, 55

Ibn Khordadbeh, 55

Ibn Said, 55

Ibrahim ibn Ahmad Saffar, 288–89

Impurities, 24–25, 58–63, 65–67, 92–94, 97–98, 101, 103 n.63, n.64, 105 n.133, n.145, 133, 161,174, 176, 178–79, 188, 194, 200, 236, 245, 256, 296, 322, 335

Inlay, copper and silver, 24, 34 fig.2, 36, 42, 58, 64–67, 88 figs. 32 and 33, 89 fig. 35, 95–98, 103 n. 53, 115, 120 fig. 46, 124–25, 128–31, 140–43, 154–55, 161–62, 166, 168–69, 174, 176–177, 199, 231, 241, 250, 262, 333

Inlay, black material, 15, 34–36, 38, 77, 81, 83, 85–88, 90–91, 110, 112–25, 126, 130–32, 134–45, 154–57, 159– 60, 164–65, 170–75, 180–84, 190–91, 196–97, 199, 203–205, 213, 216–19, 222–25 230, 235–39, 242–43, 253, 257–59, 264–65, 268–69, 278–80, 283–85, 292

Inscriptions, animated, 88, 112–15, 122–25, 134–35, 141–43

Iron, 43, 46, 53, 61, 73, 92, 105 n.130, 146 n.3

al-Isfara'ini, 'Ali ibn 'Umar (?), 134–35

al-Istakhri, 54

J

Ja'far ibn Muhammad ibn'Ali, 241

Jam/Firuz-Koh, 37, 152, 178, 214

Jarbaya, 55

Jawzahr, 124, 141–42, 274

Juzjani, Minhaj Siraj, 31, 152, 178, 188

K

Kabul, 54

Kalah, 55

Kashmir, 34, 236

Kirman, 54, 55

khār ṣīnī (Ar. and Pers. high tin bronze), 53, 57, 269

Khurasan, 15, 19–21, 23, 26, 31–34, 36, 40–44, 48 n.9, n.32, 49 n. 67, n.82, 53–57, 71, 80, 88, 94–95, 101, 109–111, 114, 119, 125, 127, 133–34, 141, 144, 146, 151–52, 160, 170–72, 178–87, 188–197, 198–200, 211, 213, 216–25, 226–32, 233–50, 252–54, 259–92, 296–97

Khwarazm Shahs, 32, 33, 44, 109, 141, 144, 146 n.19, 152, 160, 178

Kohistan, 54

Kufic (inscriptions, writing), 37–40, 42, 111, 112–125, 128–145, 154–55, 158–59, 168, 173–77, 182, 183–87, 200, 202, 216, 224, 226, 237–38, 245, 252, 257–58, 260–63, 266–69, 271–74, 279–85, 288, 290

L

Lahore, 152

Lead, 53–55, 56, 59–67, 92–94, 126, 236, 245, 249, 266, 277, 295 n.209, 334; see also *Usrub*

M

al-Mafarrukhi, 54

Mahmud ibn Abi Bakr, 287, 290–91

Mahmud ibn Muhammad al-Haravi, 44, 110, 125

Mahmud of Ghazna, 36, 188, 190, 222, 251, 269

Maimana, 42, 226, 278, 282

Manuchihr, 234, 262

Marchal, Henri 23, 192, 196

Mashhad, 54

Masud ibn Ahmad al-naqqash al-Haravi, 44

al-Mas'udi, 55

Mawarannahr, 43, 200, 213, 226, 274

Melikian-Chirvani, Assadullah Souren, 15, 19–20, 23, 25, 37, 42–43, 44, 56, 93, 111, 114–115, 120, 127, 134, 142, 144, 146, 162, 170, 180, 184, 190, 199, 212, 254, 256, 259, 274, 278, 279, 286–287

Mercury, 35, 48 n.47, 54

Metal workshops, 36, 40, 65, 96–97, 99–102, 120, 125, 134, 142, 162, 199, 212, 260

Merv, 32, 43, 44, 49 n.67, n.82, 146 n.19

Muhammad ibn 'Abd al-Wahid, 45

Muhammad ibn Abu Sahl al-Haravi, 110, 127

Muhammad ibn al-Husayn al-Salar (*saffar*?), 287

Muhammad ibn Nasir ibn Muhammad al-Haravi, 44, 110

al-Muqaddasi, 53, 54, 151

Mis/mes (Pers. copper), 54, 56

N

Naḥās (Ar. copper), 54

Naqqāsh (Ar. and Pers. painter, inlayer, designer), 44, 45, 47, 99, 101, 110, 114

Nasir-e Khosraw, 45

Nasir al-din Tusi, 55–56, 110

Naskh (inscription, writing) 122, 128, 134, 155, 162, 192, 200–201, 242, 254, 283, 286, 288; see also Cursive

Nepal, 34

Nizami, 35, 222

Nickel, 61, 65, 66, 94, 189, 328

Niello, 34, 36, 39, 47, 86, 133

Nisba (Ar. place of origin used as name) 43–44, 110, 114, 126, 133, 134, 136, 189, 227, 283, 286

Nishapur, 20, 31–32, 35, 41–42, 43, 49 n.67, n.70, , 54, 127, 134, 151, 166, 186, 194, 198, 200, 206 n. 65, 207 n.166, 241, 269, 287

Nizam al-Mulk, 45

P

Panjhir, 55, 95

Paydar ibn Marzban al-Qayni, 227

Pearls, 34

Penjikent, 160

Peshawar 44, 141

Polychromy, 15, 33, 34–37, 38, 44

Punch, 78, 80, 84, 90, 101, 183, 190, 192, 202, 204, 228, 257, 258, 280, 282, 283, 332

Punch, domed dot, 78, 114 fig. 38, 115, 128, 162, 252, 280, 332

Punch, tracing, 78, 80, 82, 90, 96, 112–15, 116–21, 122–25, 134, 144–45, 162, 166, 174, 176, 258

Punjab, 33, 152

Q

Qa'en / Qayin, 44, 227

Qal'ī (Pers. and Ar. tin), 54

Qandahar, 54

Qarakhanid, 32, 42, 251

al-Qazwini 43, 146 n.3

R

Raṣāṣ (Pers. and Ar. tin), 55; see also *Qal'ī*, Tin

Razm (Pers. battle), 124

Rayy, 35, 216, 233, 234, 266, 283

Repoussé 23, 43, 47, 68, 70–71, 78, 83–84, 101, 104 n.90, 110–11, 116–25, 141–45, 160, 176–77

Rikhtan (Pers. pouring), 47

Rikhteh-gari (Pers. casting workshop), 49 n.113

Rikhteh-shodeh (Pers. cast by pouring), 47

Rubies, 34, 48 n.25, 178

Ibn Rustah, 54

S

Saffar, saffarin (coppersmith) 188, 286, 295 n.248

Saffarids, 32, 36, 49 n. 110, 109, 151

Safidruy, asfidhruy, isfidrū (Pers. white bronze), 56

Saljuq, 19, 22, 32, 33, 56, 109, 152

Samanids, 32, 33, 42, 55, 109, 151, 226, 259

Samarqand 42–43, 54, 95, 180, 192, 198, 200, 207, 227

Scerrato, Umberto, 19, 41, 274

Serçe Limanı, 58, 64, 104 n.82

Shabah, shabah mufragh (Pers. poured brass), 47, 56, 92, 93, 277

Shadiakh 41, 198

Shazi al-naqqash al-Haravi 38 fig.5, 44, 82, 97, 101, 110, 111, 112–115, 139, 140, 146 n.19

Sidon, 64

Silver, 22, 24, 25, 34–36, 38, 42, 43, 44, 46–47, 53–56, 58, 61, 65–67, 86, 88, 91, 94–95, 97, 101, 105 n.145, 110, 112–125, 126, 128–138, 140–45, 152–155, 160, 162, 164–65, 174–76, 178, 189, 196, 198, 199, 227, 234, 241, 250, 251, 256, 283, 328

Silver mines, 54–55, 95, 178

Silversmith, 46

Sindh, 33, 35, 151, 152

Siraf, 104 n.81, 269

Sistan, 17, 18, 23, 24, 31, 36, 48, 49 n.82, 54–57, 81, 82, 84, 94–96, 109, 133, 134, 147 n.61, 151, 188–97, 198, 206 n.95, 215, 253

al-Sufi, ʿAbd al-Rahman 110, 224

Sufr (Ar. copper), 54

Sulphur, 61, 66, 103, 105 n.151

Susa, 14, 18, 19, 25, 64, 94, 104, 265, 269, 293 n.9, 294 n.175

T

Tajikistan, 49 n.81, 55, 160, 172, 184, 200, 226, 241

Tāl (Pers. leaded or high leaded copper), 56, 277

Thuluth (inscription, writing), 112, 116, 120 fig. 45, 122, 130, 136–37, 144–45, 154–55, 156,164–65, 172, 174, 176, 180, 196, 204, 217, 230, 264–65, 266, 284–85

Tiberias, 40, 49 n.68, 58, 64, 104,166, 178,199–200, 212, 227

Tibet, 34

Tin, 53–55, 57, 59–61, 62, 63, 65, 92–93, 95, 98, 334; see also *Qalʿī*

Tombak, tombac, 104 n.75

Transoxiana, 32, 40, 43–44, 47, 54–55, 95, 198, 251, 287

Tus, 43, 53

al-Tusi, Nasir al-Din, 53, 56, 57, 110, 277

Tūtīyā (Pers. zinc oxide?), 56

U

Umayyads, 32, 58, 103 n.49

Umm Qays, 103 n.47

Umm al-Walid, 58

Usrub (Pers. lead), 55

W

Wax model, 72–77, 78–81, 84, 87, 90, 91, 96, 98, 99–102, 134, 136, 154–55, 164, 173, 182, 184, 187, 190, 194–95, 196, 201–203, 205, 217–220, 222–224, 228, 230, 232, 233, 240, 242, 246, 248, 252, 254, 258, 260, 262, 265, 268, 270–76, 279–80, 283–84, 290, 331

Y

al-Yaʾqubi, 54

Yazd, 55

Z

Zarang, 188

Zarb (Pers. to hammer/strike), 45–47

Zinc, 53–54, 56–64, 92–93, 97, 99, 103, n.11 and n.63, 104 n.69, n.72, n.75, 105 n.130, n.151 and n.152, 126, 334

Zodiac, 39, 110, 119, 122, 122–25, 156, 233, 256

Archeometallurgy

Cat no.	Inv. no.	Object type	Attribution and Date	Place of Discovery	Quality	Shaping (Casting or Hammering)	Inlay Material	Openwork decoration	Recessed decoration	Alloy	Type of Analysis	Cu	Zn	Pb	Sn	Class of Impurity	Ag	As	Bi	Co	Fe	Ni	S	Sb
1	MAO 900	Vase	Khurasan, before 900		2	H	-	-	-	PIXE	High tin bronze	72	0.04	0.1	26	2	< 0.01	0.13	< 0.01	0.03	0.1	0.07	0.14	< 0.43
2	MAO 2228	Pen box	Afghanistan, Herat, c. 1210		5	H	Cu+Ag	-	Chased, champlevé	PIXE	Brass	78	21	0.10	0.6	2	0.08	0.06	< 0.02	< 0.01	0.2	0.05	< 0.01	0.02
3	OA6315	Candlestick	Afghanistan, Herat, c. 1150-1200		5	H	Cu+Ag	-	Chased, champlevé	ICP	Brass	76	23	0.17	0.35	2	0.052	0.032	0.013	0.002	0.09	0.005	0.01	0.004
4	OA 5548	Ewer	Afghanistan, Herat, end of 12th C.		5	H	Cu+Ag	-	Chased, champlevé	PIXE	Brass	81	12	0.05	0.22	1	0.04	0.03	<0.03	< 0.01	0.03	0.02	0.3	< 0.02
5	OA 3354a	Inkwell (lid)	Afghanistan, Herat, 1150-1220		3	C	-	-	Incised, chased	PIXE	High leaded brass	69	12	17	3.7	2	0.12	0.62	< 0.16	< 0.02	0.3	0.11	< 0.2	0.42
	OA 3354b	Inkwell (base)	Afghanistan, Herat, 1150-1220		3	C	Cu+Ag	-	Chased	PIXE	Leaded brass	73	17	7.1	2.7	2	0.06	0.45	< 0.09	< 0.02	0.4	0.12	< 0.1	0.15
6	OA 3372a	Inkwell (lid)	Afghanistan, Herat, 1150-1220		3	C	Cu+Ag	-	Chased, champlevé	PIXE	High leaded brass	68	12	16	2.1	1	0.13	1.7	< 0.18	< 0.01	0.9	0.14	0.1	0.43
	OA 3372b	Inkwell (base)	Afghanistan, Herat, 1150-1220		3	C	Cu+Ag	-	Chased, champlevé	PIXE	Leaded brass	68	15	8.6	2.2	1	0.15	1.3	< 0.13	< 0.01	0.8	0.16	< 0.01	0.47
7	MAO 428	Ewer	Afghanistan, Herat, end of 12th C.		4	C	Cu+Ag	-	Chased, champlevé	PIXE	Leaded brass	71	17	6	2.6	2	0.07	0.56	< 0.09	< 0.01	0.3	0.09	0.13	0.18
8	OA 6314	Ewer	Afghanistan, Herat, 586 / 1190-1191		4	C	Cu+Ag	-	Chased, champlevé	PIXE	Leaded brass	67	21	8	1.6	1	0.08	0.32	< 0.10	< 0.01	0.7	0.11	0.04	0.23
9	AA 269	Feline carpet weight	Afghanistan, Herat, 1150-1220		3	C	Cu	-	Chased, champlevé	ICP	Leaded brass	81	7.6	8.6	1.6	2	0.043	0.29	0.016	0.009	0.23	0.042	0.03	0.20
10	OA 6479	Tabletop/tray	Afghanistan, Herat, 1150-1220		4	H	Ag	-	Chased, champlevé	PIXE	Brass	77	22	< 0.03	0.3	2	0.09	< 0.01	< 0.02	< 0.01	0.1	0.03	< 0.01	< 0.01
11	MAO 498	Tabletop/tray	Afghanistan, Herat, 1150-1220		4	H	Cu+Ag	-	Chased, champlevé	PIXE	Brass	84	16	0.07	0.4	2	0.1402	< 0.03	< 0.02	< 0.01	0.1	0.03	< 0.01	< 0.01
12	AA 65	Inkwell (lid)	Afghanistan, Ghazna, end of 12th-beginning of 13th C.	Ghazna	4	C	Cu+Ag	-	Champlevé, chased	PIXE	High leaded brass	63	11	16	3.2	1	0.11	0.70	< 0.17	< 0.02	0.7	0.14	0.16	0.40
13	AA 64	Plate from a set of scales	Afghanistan, Ghazna, c. 12th C.	Ghazna	3	H	-	-	Chased, champlevé	PIXE	Brass	81	18	< 0.03	0.2	2	0.16	0.04	< 0.02	< 0.01	0.1	0.03	< 0.05	< 0.01
14	AA 63	Small tray/incense burner	Afghanistan, Ghazna, c. 1150-1220	Ghazna	2	C	-	-	Chased, champlevé	ICP	Brass	83	15	1.0	0.29	2	0.016	0.11	< 0.003	0.026	0.10	0.084	0.06	0.005
15	AA 61	Tabletop/tray	Afghanistan, Ghazna, end of 12th-beginning of 13th C.	Ghazna	2	H	-	-	Chased, champlevé	PIXE	Brass	78	20	0.05	0.13	2	0.04	0.03	< 0.01	< 0.01	0.1	< 0.01	0.09	0.03
16	AD 26749	Bucket	Afghanistan, Ghazna, end of 12th-beginning of 13th C.		2	C	-	-	Chased	PIXE	High leaded brass	58	11	19	3.6	1	0.08	0.67	0.02	< 0.02	0.6	0.14	0.17	0.47
17	MAO 605	Inkwell (base)	Afghanistan, Ghazna, end of 12th-beginning of 13th C.		3	C	Cu+Ag	-	Chased, champlevé	PIXE	High leaded brass	56	7.4	31	3.7	1	0.16	0.73	< 0.25	< 0.01	0.7	0.07	< 0.02	0.31
18	MAO 2103	Sprinkler	Afghanistan, Ghazna, 12th C.		3	C	Cu	-	Chased, filed	PIXE	High leaded copper	61	6.4	23	3.8	1	0.08	1.0	< 0.16	0.02	0.5	0.10	1.3	0.29
19	MAO 855	Ewer	Afghanistan, Ghazna, end of 12th C.		3	C	Cu	-	Chased, engraved, champlevé	ICP	High leaded brass	63	8.5	22	3.8	1	0.11	0.78	0.044	0.015	0.37	0.14	0.12	0.62
20	MAO 761	Sprinkler	Afghanistan, Ghazna, 12th C.		3	C	-	-	Chased, champlevé	PIXE	High leaded brass	69	11	14	3.6	1	0.09	0.57	< 0.15	< 0.01	0.8	0.26	0.04	0.47
21	MAO 854	Lamp	Afghanistan, Ghazna, 12th C.		2	C	-	-	Chased	ICP	High leaded brass	62	10.5	21	4.2	1	0.12	0.81	0.047	0.014	0.28	0.15	0.13	0.74
22	MAO 2105	Mortar	Afghanistan, Ghazna, 12th C.		1	C	-	-	Worn	ICP	High leaded copper	67	5.8	21	4.0	1	0.11	0.73	0.065	0.028	0.28	0.16	0.33	0.77
23	MAO 499	Tabletop/tray	Afghanistan, Ghazna, c. 1150-1220		4	H	Cu+Ag	-	Chased	PIXE	Brass	80	19	0.23	0.4	2	0.03	< 0.03	< 0.04	< 0.01	0.1	0.03	< 0.01	< 0.02
24	AA 176	Ewer	Afghanistan, Ghazna, end of 12th C.	Afghanistan	3	H	Cu	-	Chased, champlevé	PIXE	Brass	80	20	0.15	0.07	2	0.07	0.05	< 0.02	< 0.01	0.1	0.02	0.09	< 0.01
25	AA 62	Small tray/incense burner	Afghanistan, Bamiyan? v. 1150-1220	Bamiyan	2	C	-	-	Chased, engraved, champlevé	PIXE	High leaded brass	67	9.2	16	2.5	2	0.3	1.9	< 0.24	< 0.01	0.8	0.20	< 0.01	1.9
26	MAO 2104	Mortar	Khurasan, 11th-12th C.		3	C	-	-	Engraved	ICP	High leaded copper	65	0.04	24	6.6	1	0.12	1.7	0.035	0.016	<0.005	0.40	0.5	1.7
27	MAO 2107	Mortar	Khurasan, 11th-12th C.		1	C	-	-	Engraved, chased, champlevé	ICP	High leaded copper	88	0.20	8.0	0.81	1	0.086	1.0	0.056	0.004	0.022	0.082	0.2	1.6
28	MAO 1255	Lamp/incense burner	Khurasan, 11th-12th C.		2	C	-	Yes	Chased, champlevé	PIXE	High leaded copper	65	4.6	25	3.0	1	0.13	1.0	< 0.13	< 0.01	0.3	0.09	0.13	1.1
29	MAO 908	Lamp	Khurasan, 11th-12th C.		2	C	-	Yes	Champlevé, chased, incised	PIXE	High leaded copper	76	7.7	9	5.0	1	0.13	0.93	< 0.14	< 0.01	0.6	0.25	< 0.01	0.50
31	OA 6160	Sprinkler	Khurasan or Sistan, 11th-12th C.	Sistan	2	C	-	-	Chased	ICP	High leaded brass	74	10.0	13	1.8	2	0.047	0.32	0.024	0.008	0.28	0.018	0.03	0.098
32	OA 6158	Lamp	Khurasan or Sistan, 11th-12th C.	Sistan	1	C	-	-	Chased, drilled	ICP	High leaded copper	77	3.2	15	4.0	2	0.054	0.37	0.020	0.018	0.23	0.074	0.19	0.16
33	OA 6159	Lamp	Khurasan or Sistan, 11th-12th C.	Sistan	1	C	-	-	Chased, drilled, filed	ICP	High leaded brass	71	9.4	16	2.4	2	0.072	0.51	0.020	0.010	0.29	0.14	0.02	0.18
34	OA 6157	Lamp	Khurasan or Sistan, 12th C.	Sistan	2	C	-	-	Chased	ICP	High leaded copper	79	5.2	12	3.0	2	0.079	0.37	0.020	0.010	0.28	0.059	0.22	0.23
35	AA 175	Large basin	Afghanistan, c. 1150-1220	Afghanistan	3	H	-	-	Chased, champlevé	ICP	Brass	75	25	0.18	0.12	2	0.035	0.018	< 0.0012	< 0.0001	0.06	0.004	< 0.01	0.008
36	AA 59	Ewer	Afghanistan, 11th-12th C.	Afghanistan	3	C	-	-	Chased, champlevé	ICP	High leaded copper	62	3.9	26	3.6	1	0.15	0.94	0.061	0.046	1.7	0.17	0.6	1.0
37	MAO 1256	Ewer	Afghanistan, c. 1150-1220		3	C	-	-	Chased, champlevé	PIXE	Leaded brass	71	18	7	3.5	2	0.05	0.09	< 0.10	0.03	0.2	0.07	0.10	0.02
38	OA 7871 / 34	Lamp	Khurasan, Afghanistan or Iran, Rayy? 12th C.	Rayy?	1	C	-	-	Engraved, chased, champlevé	ICP	High leaded brass	72	6.6	17	3.3	2	0.070	0.51	0.018	0.012	0.30	0.069	0.26	0.23
39	MAO 502	Lamp	Khurasan, Afghanistan, 12th C.		2	C	-	-	Chased, champlevé	ICP	High leaded brass	62	16.0	18	2.1	1	0.079	0.78	0.054	0.017	0.53	0.080	0.08	0.41
40	MAO 853	Lamp	Khurasan, Afghanistan, 12th C.		2	C	-	-	Chased, engraved	ICP	High leaded brass	62	13.0	20	3.1	1	0.098	0.65	0.029	0.008	0.26	0.10	0.05	0.45
41	OA 7958	Lamp	Khurasan, 12th C.		2	C	-	-	Filed	ICP	High leaded brass	65	7.9	22	3.7	2	0.087	0.64	0.019	0.016	0.34	0.089	0.09	0.28
42	MAO 760	Lamp	Khurasan, 11th-12th C.		2	C	-	-	-	ICP	High leaded copper	69	3.4	23	2.9	2	0.11	0.74	0.020	0.019	0.14	0.073	0.17	0.32
43	OA 7958 / 2	Lamp	Khurasan, 11th-12th C.		2	C	-	-	Chased, filed	ICP	High leaded brass	67	12.0	17	2.7	2	0.085	0.42	0.021	0.019	0.31	0.066	0.10	0.20

Cat. no.	Inventory no.	Object type	Attribution and Date	Place of Discovery	Quality	Shaping (Casting or Hammering)	Inlay Material	Openwork decoration	Recessed decoration	Type of Analysis	Alloy	Cu	Zn	Pb	Sn	Class of Impurity	Ag	As	Bi	Co	Fe	Ni	S	Sb
44	OA 7890	Lamp	Khurasan, 11th-12th C.		3	C	-	Yes	Chased	ICP	High leaded copper	78	3.5	15	2.2	2	0.062	0.53	0.021	0.007	0.10	0.080	0.19	0.28
45	OA 7957b	Lampstand (base)	Khurasan, 11th-12th C.		2	C	-	-	Chased	ICP	High leaded copper	76	5.1	15	2.9	2	0.057	0.45	0.019	0.012	0.23	0.041	0.15	0.14
	OA 7957a	Lampstand (shaft)	Khurasan, 12th-early 13th C.		2	C	-	Yes	Chased	ICP	High leaded copper	83	0.40	12	3.1	2	0.078	0.69	0.014	0.004	0.013	0.072	0.14	0.29
46	MAO 771	Lampstand base	Khurasan, Afghanistan, 12th-early 13th C.		2	C	-	Yes	Chased, engraved	ICP	High leaded brass	63	12.0	20	3.5	1	0.11	0.56	0.031	0.012	0.31	0.11	0.08	0.44
47	MAO 772	Lampstand base	Khurasan, Afghanistan, c. 1150-1220		2	C	Cu	-	Too corroded	ICP	High leaded copper	63	4.8	27	3.6	1	0.099	0.83	0.025	0.008	0.17	0.10	0.39	0.44
48	MAO 830	Lamp	Khurasan, 11th-early 12th C.		2	C	-	-	Incised	ICP	High leaded copper	65	2.2	27	4.2	1	0.11	0.77	0.030	0.013	0.19	0.12	0.30	0.44
49	OA7800-1	Front of a feline carpet weight	Khurasan, 11th-early 12th C.		2	C	-	-	Chased, champlevé	ICP	High leaded brass	74	8.9	13	2.6	2	0.065	0.43	0.018	0.016	0.23	0.13	0.09	0.23
50	OA 7800-2	Front of a feline carpet weight	Khurasan, 11th-early 12th C.		2	C	-	-	Chased, engraved?	PIXE	High leaded brass	57	8.5	28	3.9	1?	0.09	0.90	<0.24	0.03	0.5	0.12	<0.7	0.30
51	OA 7819	Partridge	Khurasan, Eastern Iran, 12th C.		2	C	-	-	Chased, champlevé	ICP	High leaded brass	71	9.8	14	3.2	2	0.093	0.79	0.026	0.010	0.25	0.11	0.01	0.55
52	OA 4044bis	Incense burner	Khurasan, Eastern Iran, c. 1180-1220		3	C	-	Yes	Chased, champlevé	ICP	High leaded brass	75	5.4	16	2.4	2	0.0665	0.49	0.020	0.013	0.20	0.050	0.16	0.21
53	AA 19	Incense burner	Khurasan, Eastern Iran, 12th C.		2	C	-	Yes	Incised	ICP	High leaded brass	59	10.5	26	3.6	2	0.09	0.67	0.046	0.032	0.32	0.12	0.17	0.38
54	MAO 357	Incense burner (support)	Khurasan, Eastern Iran, 12th C.		2	C	-	Yes	Chased	ICP	High leaded brass	61	8.8	24	3.8	1	0.088	0.60	0.038	0.015	0.41	0.14	0.32	0.32
55	MAO 486a	Fountain spout	Khurasan, Eastern Iran, 12th C.		2	C	-	-	Engraved	ICP	High leaded copper	68	7.4	18	5.3	2	0.12	0.28	0.017	0.005	0.29	0.076	0.09	0.10
	MAO 486b	Tap	Khurasan, Eastern Iran, 12th C.		2	C	-	-	Engraved	ICP	High leaded copper	78	6.3	7.5	7.0	2	0.089	0.52	0.038	0.012	0.19	0.11	0.08	0.22
56	MAO 415	Padlock	Khurasan, Eastern Iran, 12th-early 13th C.		1	C	-	-	Chased	ICP	High leaded copper	78	0.32	10	11	2	0.062	0.31	0.010	0.005	0.035	0.044	0.04	0.18
57	MAO 622	Incense burner	Khurasan, Afghanistan, 11th C.		2	C	-	Yes	Engraved, chased	ICP	High leaded brass	69	9.3	17	3.4	2	0.10	0.47	0.027	0.013	0.26	0.084	0.18	0.27
58	MAO 762	Incense burner	Khurasan, Afghanistan, 10th-11th C.		2	C	-	Yes	Worn surface	ICP	High leaded copper	81	3.3	13	1.9	2	0.04	0.31	0.023	0.007	0.12	0.058	0.03	0.18
59	OA 7187	Incense dish	Khurasan, late 12th-early 13th C.		2	C	-	-	Incised	ICP	High leaded brass	72	9.0	15	2.8	2	0.063	0.39	0.020	0.012	0.32	0.050	0.05	0.16
60	AA 60	Pouring vessel	Afghanistan, 10th-11th C.	Afghanistan	2	C	-	-	Chased, champlevé	PIXE	High leaded brass	69	9.0	12	4.1	1	0.09	0.76	< 0.13	< 0.02	0.4	0.15	0.9	0.62
61	OA 6101	Pouring vessel	Afghanistan, 10th-11th C.		2	C	-	-	Engraved, chased, champlevé	ICP	High leaded brass	74	7.4	15	2.4	2	0.069	0.53	0.028	0.013	0.34	0.087	0.09	0.37
62	MAO 615	Jug	Khurasan or Afghanistan, 11th C.		2	C	-	-	Chased, champlevé	PIXE	High leaded brass	68	11	17	3.0	2	0.06	0.50	< 0.49	< 0.01	0.3	0.14	0.1	0.17
63	MAO 614	Vase	Khurasan, 11th-12th C.		3	C	-	-	Chased, champlevé	PIXE	Leaded brass	73	12	9	3.3	1	0.10	0.94	< 0.17	< 0.01	0.5	0.16	0.01	0.86
64	OA 7485	Sprinkler	Khurasan, Eastern Iran, 12th-early 13th C.		3	C	-	-	Engraved, chased, champlevé	ICP	High leaded brass	74	8.4	14	2.2	2	0.082	0.42	0.017	0.015	0.49	0.063	0.02	0.29
65	OA 7083	Rice shovel	Iran, Khurasan, 12th-early 13th C.		2	C	-	-	Chased, champlevé	ICP	High leaded brass	73	6.7	16	3.0	1	0.088	0.62	0.043	0.013	0.24	0.12	0.19	0.58
66	MAO 437	Bowl	Iran or Khurasan, 12th-early 13th C.		2	C	-	-	Chased?	PIXE	High leaded brass	67	10	16	2.9	1	0.10	0.74	< 0.15	0.02	0.3	0.12	0.15	0.28
67	MAO 235	Flask	Khurasan, Eastern Iran, end of the 13th C.		1	C	-	-	Engraved	PIXE	High leaded brass	72	11	12	2.5	1	0.08	0.45	< 0.13	0.02	0.8	0.11	0.4	0.27
68	OA 6090	Mirror	Khurasan? 12th-early 13th C.		2	C	-	-		ICP	Brass	82	12	2.7	2.9	-	0.017	0.065	0.007	0.0002	0.11	0.040	< 0.01	0.014
69	AD 14919	Mirror	Khurasan? 12th-early 13th C.		2	C			Alloy not analysed															
70	OA 3945	Mirror	Khurasan or Anatolia, 12th-early 13th C.		2	C	-	-		PIXE	High tin bronze	75	3	8	13	2	0.09	0.31	< 0.10	< 0.01	0.2	0.09	0.3	0.26
71	OA 7871 / 72	Mirror	Khurasan or Anatolia, 12th-early 13th C.		2	C	-	-		PIXE	High tin bronze	80	0.2	3.2	14	2	0.06	0.63	< 0.06	0.04	0.05	0.10	0.7	0.25
72	AFI 1343	Mirror	Khurasan or Anatolia, 12th-early 13th C.		2	C	-	-		ICP	High tin bronze	77	0.58	4.8	17	2	0.061	0.29	0.014	0.018	0.036	0.043	0.06	0.11
73	AD 14918	Mirror	Khurasan or Anatolia, 12th-early 13th C.		2	C			Alloy not analysed															
74	OA 6020	Mirror	Iran or Anatolia? 12th-early 13th C.		2	C	-	-		ICP	High tin bronze	82	0.5	3.1	13	2	0.13	0.16	0.022	0.003	0.13	0.049	< 0.01	0.45
75	MAO 2218	Mortar	Khurasan, 12th C.		1	C	-	-	Chased	ICP	High leaded copper	82	0.1	13	3.6	2	0.039	0.37	0.016	0.016	0.023	0.13	0.23	0.19
76	AD 11287	Mortar	Khurasan, end of the 12th C.		3	C	-	-		PIXE	High leaded copper	70	7.6	15	3	1	0.07	1.2	0.06	< 0.01	0.3	0.20	< 0.4	1.3
77	MAO 2224	Mortar	Khurasan, 12th-early 13th C.		1	C	-	-	Engraved, chased	ICP	High leaded copper	63	1.8	30	3.6	2	0.11	0.82	0.020	0.009	0.10	0.087	0.21	0.34
78	MAO 2106	Mortar	Khurasan or Anatolia, 12th-early 13th C.		1	C	-	-		ICP	Leaded brass	87	6.0	5.2	0.9	-	0.040	0.28	0.005	0.027	0.20	0.033	0.2	0.11
79	OA 6438	Mortar	Khurasan or Afghanistan, 12th-early 13th C.		1	C	-	-	Chased	ICP	High leaded copper	74	2.6	19	3.1	2	0.090	0.66	0.033	0.009	0.14	0.088	0.18	0.50
80	OA 8181	Mortar	Iran or Anatolia, 13th C. ?		1	C	-	-	Chased, champlevé.	ICP	High leaded copper	72	5.2	15	6.0	2	0.10	0.59	0.018	0.043	0.30	0.081	0.20	0.22
81	MAO 316	Mortar	Iran or Anatolia, 13th C. ?		2	C	-	-	Chased, champlevé, engraved	ICP	High leaded copper	68	2.6	20	8.2	2	0.080	0.5	0.022	0.025	0.18	0.069	0.12	0.25
82	MAO 366	Cauldron	Khurasan, 12th-13th C. ?		2	C	-	-	Chased	ICP	High leaded copper	78	1.4	15	3.4	1	0.093	0.97	0.014	0.009	0.10	0.12	0.33	0.40
83	MAO 362	Cauldron	Khurasan, 12th-13th C. ?		2	C	-	-	Chased?	ICP	High leaded copper	72	4.7	18	3.5	2	0.092	0.73	0.017	0.017	0.21	0.082	0.20	0.28
84	MAO 436	Cauldron	Khurasan, 12th-13th C. ?		2	C	-	-	Chased	ICP	High leaded copper	76	0.04	22	1.7	2	0.043	0.20	0.008	0.001	<0.005	0.011	0.05	0.10

2

Appendix 1

Previous pages :
Corpus and synthesis of archaeometallurgical data
of DAI objects from the pre-Mongol Iranian world.
Elemental composition of the constituent metal of 81
objects (by 85 analyses). Results in % by mass.

Appendix 2

Map of copper deposits (red) in Iran
and Afghanistan, sampled for analysis
by Berthoud et al, 1982. A tin mine, of
cassiterite (yellow) was also sampled
at Sarkar in Afghanistan.

Cat. no.	Inv. no.	Type of analysis	Alloy	Cu	Zn	Pb	Sn	Class of Impurity	Ag	As	Bi	Co	Fe	Ni	S	Sb
6	OA 3372a	PIXE	High leaded brass	68	12	16	2.1	1	0.13	1.7	< 0.18	< 0.01	0.9	0.14	0.1	0.4
	OA 3372b	PIXE	Leaded brass	68	15	8.6	2.2	1	0.15	1.3	< 0.13	< 0.01	0.84	0.16	< 0.01	0.47
7	MAO 428	PIXE	Leaded brass	71	17	6	2.6	2	0.07	0.6	< 0.09	< 0.01	0.3	0.09	0.13	0.2
8	OA 6314	PIXE	Leaded brass	67	21	8	1.6	1	0.08	0.3	< 0.10	< 0.01	0.7	0.11	0.04	0.2
9	AA 269	ICP	Leaded brass	81	7.6	9	1.6	2	0.043	0.29	0.016	0.009	0.23	0.04	0.03	0.2
14	AA 63	ICP	Brass	83	15	1.0	0.3	2	0.02	0.11	< 0.003	0.03	0.10	0.08	0.06	0.005
16	AD 26749	PIXE	High leaded brass	58	11.1	19	3.6	1	0.08	0.7	0.02	< 0.02	0.6	0.14	0.17	0.5
18	MAO 2103	PIXE	High leaded copper	61	6.4	23	3.8	1	0.08	1.0	< 0.16	0.02	0.5	0.10	1.3	0.29
20	MAO 761	PIXE	High leaded brass	69	10.7	14	3.6	1	0.09	0.6	< 0.15	< 0.01	0.8	0.26	0.04	0.5
25	AA 62	PIXE	High leaded brass	67	9.2	16	2.5	2	0.3	1.9	< 0.24	< 0.01	0.8	0.20	< 0.01	1.9
26	MAO 2104	ICP	High leaded copper	65	0.04	24	7	1	0.12	1.7	0.04	0.016	<0.005	0.40	0.45	1.7
27	MAO 2107	ICP	High leaded copper	88	0.2	8	0.8	1	0.086	1	0.056	0.004	0.022	0.08	0.22	1.6
28	MAO 1255	PIXE	High leaded copper	65	4.6	25	3.0	1	0.13	1.0	< 0.13	< 0.01	0.3	0.09	0.13	1.1
29	MAO 908	PIXE	High leaded copper	76	7.7	9	5.0	1	0.13	0.9	< 0.14	< 0.01	0.6	0.25	< 0.01	0.5
36	AA 59	ICP	High leaded copper	62	3.9	26	3.6	1	0.15	0.9	0.06	0.05	1.7	0.17	0.6	1.0
37	MAO 1256	PIXE	Leaded brass	71	18	7	3.5	2	0.05	0.09	< 0.10	0.03	0.2	0.07	0.10	0.02
55	MAO 486a	ICP	High leaded copper	68	7.4	18	5.3	2	0.12	0.28	0.017	0.005	0.29	0.08	0.09	0.10
	MAO 486b	ICP	High leaded copper	78	6.3	7.5	7.0	2	0.089	0.52	0.038	0.012	0.19	0.11	0.08	0.22
56	MAO 415	ICP	High leaded copper	78	0.3	10	11	2	0.062	0.31	0.010	0.005	0.035	0.04	0.04	0.18
60	AA 60	PIXE	High leaded brass	69	9.0	12	4.1	1	0.09	0.8	< 0.13	< 0.02	0.4	0.15	0.9	0.6
68	OA 6090	ICP	Brass	82	12	2.7	2.9	-	0.02	0.07	0.007	0.0002	0.11	0.04	< 0.01	0.01
70	OA 3945	PIXE	High tin bronze	75	3	8	13	2	0.09	0.3	< 0.10	< 0.01	0.2	0.09	0.3	0.3
74	OA 6020	ICP	High tin bronze	82	0.5	3.1	13	2	0.13	0.2	0.022	0.003	0.13	0.05	< 0.01	0.45
78	MAO 2106	ICP	Leaded brass	87	6.0	5.2	0.9	-	0.04	0.3	0.005	0.027	0.20	0.03	0.22	0.11
80	OA 8181	ICP	High leaded copper	72	5.2	15	6.0	2	0.10	0.59	0.018	0.043	0.30	0.081	0.20	0.22
81	MAO 316	ICP	High leaded copper	68	3	20	8	2	0.080	0.5	0.022	0.025	0.18	0.07	0.12	0.25
84	MAO 436	ICP	High leaded copper	76	0.04	22	2	2	0.043	0.2	0.008	0.001	<0.005	0.01	0.05	0.10

4a

4b

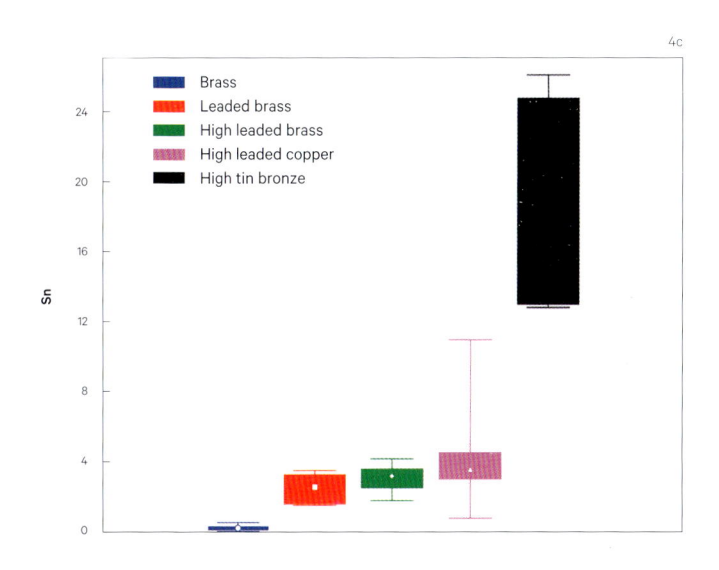

4c

Brass
Leaded brass
High leaded brass
High leaded copper
High tin bronze

Appendix 3

DAI objects from the pre-Mongol Iranian world with a typical compositions (elemental composition in % mass). The atypical appearance may be due to the content (grey), impurity content (yellow), and/or unusual correlations between chemical elements (green). The two totally atypical objects highlighted in red are not included in the statistical analysis.

Appendix 4

Graphs 4a to 4c show the zinc (Zn), lead (Pb) and tin (Sn) contents of the five alloys in different coloured boxes. The centre of the box shows the average; the dot in the box the median, the edges the quartiles, and the 'T' lines the extreme values (% by mass; PIXE or ICP-AES analyses; 85 analyses of 81 objects) The two objects with highly atypical compositions: cat. no. 68 and cat. no. 78, have been removed.

Appendix 5

The zinc (Zn), lead (Pb) and tin
(Sn) contents in the 81 DAI items
that were analysed (85 analyses),
according to the five types of
alloy, shown in two binary graphs.
The arrows represent dilution lines
of either lead (5a) or tin (5b). The
results are shown in % by mass.
Analysis by PIXE or ICP-AES. The
two highly atypical alloys, cat. nos.
68 and 78, have been removed.
From top to bottom and left to
right:
5a: cat. nos. 29, 9, 55, 27, 56, 80,
81, 84, 26
5b: cat. nos. 9, 27, 84, 55, 80, 81,
26, 56

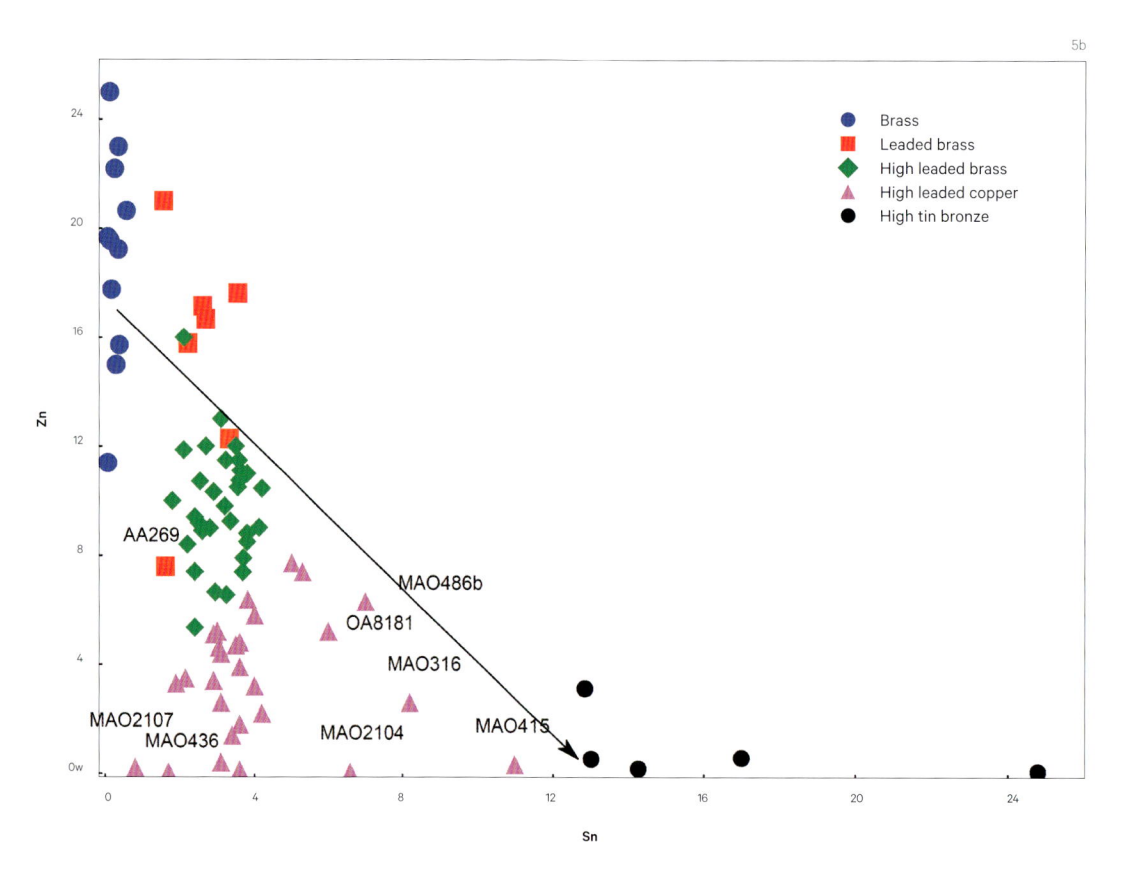

HIGH TIN BRONZE / HIGH LEADED COPPER / BRASS

Alloy	Cat. no.	Inv. no.	Type of analysis	Cu	Zn	Pb	Sn	Class of Impurity	Ag	As	Bi	Co	Fe	Ni	S	Sb
HIGH TIN BRONZE	1	MAO 900	PIXE	72	0.04	0.1	26	2	< 0.01	0.13	< 0.01	0.03	0.1	0.07	0.14	< 0.43
	70	OA 3945	PIXE	75	3	8	13	2	0.09	0.31	< 0.10	< 0.01	0.2	0.09	0.3	0.26
	71	OA 7871/72	PIXE	80	0.2	3.2	14	2	0.06	0.63	< 0.06	0.04	0.05	0.10	0.7	0.25
	72	AFI 1343	ICP	77	0.58	4.8	17	2	0.061	0.29	0.014	0.018	0.036	0.043	0.06	0.11
	74	OA 6020	ICP	82	0.5	3.1	13	2	0.13	0.16	0.022	0.003	0.13	0.049	< 0.01	0.45
HIGH LEADED COPPER	18	MAO 2103	PIXE	61	6.4	23	3.8	1	0.08	1.0	< 0.16	0.02	0.5	0.10	1.3	0.29
	22	MAO 2105	ICP	67	5.8	21	4.0	1	0.11	0.73	0.065	0.028	0.28	0.16	0.33	0.77
	26	MAO 2104	ICP	65	0.04	24	6.6	1	0.12	1.7	0.035	0.016	<0.005	0.40	0.5	1.7
	27	MAO 2107	ICP	88	0.20	8.0	0.81	1	0.086	1.0	0.056	0.004	0.022	0.082	0.2	1.6
	28	MAO 1255	PIXE	65	4.6	25	3.0	1	0.13	1.0	< 0.13	< 0.01	0.3	0.09	0.13	1.1
	29	MAO 908	PIXE	76	7.7	9	5.0	1	0.13	0.93	< 0.14	< 0.01	0.6	0.25	< 0.01	0.50
	30	OA 6156	ICP	71	4.4	20	3.1	1	0.093	0.58	0.033	0.015	0.32	0.13	0.13	0.42
	32	OA 6158	ICP	77	3.2	15	4.0	2	0.054	0.37	0.020	0.018	0.23	0.074	0.19	0.16
	34	OA 6157	ICP	79	5.2	12	3.0	2	0.079	0.37	0.020	0.010	0.28	0.059	0.22	0.23
	36	AA 59	ICP	62	3.9	26	3.6	1	0.15	0.94	0.061	0.046	1.7	0.17	0.6	1.0
	42	MAO 760	ICP	69	3.4	23	2.9	2	0.11	0.74	0.020	0.019	0.14	0.073	0.17	0.32
	44	OA 7890	ICP	78	3.5	15	2.2	2	0.062	0.53	0.021	0.007	0.10	0.080	0.19	0.28
	45	OA 7957A	ICP	83	0.40	12	3.1	2	0.078	0.69	0.014	0.004	0.013	0.072	0.14	0.29
	45	OA 7957B		76	5.1	15	2.9	2	0.057	0.45	0.019	0.012	0.23	0.041	0.15	0.14
	47	MAO 772	ICP	63	4.8	27	3.6	1	0.099	0.83	0.025	0.008	0.17	0.10	0.39	0.44
	48	MAO 830	ICP	65	2.2	27	4.2	1	0.11	0.77	0.030	0.013	0.19	0.12	0.30	0.44
	55	MAO 486a	ICP	68	7.4	18	5.3	2	0.12	0.28	0.017	0.005	0.29	0.076	0.09	0.10
	55	MAO 486b		78	6.3	7.5	7.0	2	0.089	0.52	0.038	0.012	0.19	0.11	0.08	0.22
	56	MAO 415	ICP	78	0.32	10	11	2	0.062	0.31	0.010	0.005	0.035	0.044	0.04	0.18
	58	MAO 762	ICP	81	3.3	13	1.9	2	0.04	0.31	0.023	0.007	0.12	0.058	0.03	0.18
	75	MAO 2218	ICP	82	0.1	13	3.6	2	0.039	0.37	0.016	0.016	0.023	0.13	0.23	0.19
	76	AD 11287	PIXE	70	7.6	15	3	1	0.07	1.2	0.06	< 0.01	0.3	0.20	< 0.4	1.3
	77	MAO 2224	ICP	63	1.8	30	3.6	2	0.11	0.82	0.020	0.009	0.10	0.087	0.21	0.34
	79	OA 6438	ICP	74	2.6	19	3.1	2	0.090	0.66	0.033	0.009	0.14	0.088	0.18	0.50
	80	OA 8181	ICP	72	5.2	15	6.0	2	0.10	0.59	0.018	0.043	0.30	0.081	0.20	0.22
	81	MAO 316	ICP	68	2.6	20	8.2	2	0.080	0.5	0.022	0.025	0.18	0.069	0.12	0.25
	82	MAO 366	ICP	78	1.4	15	3.4	1	0.093	0.97	0.014	0.009	0.10	0.12	0.33	0.40
	83	MAO 362	ICP	72	4.7	18	3.5	2	0.092	0.73	0.017	0.017	0.21	0.082	0.20	0.28
	84	MAO 436	ICP	76	0.04	22	1.7	2	0.043	0.20	0.008	0.001	<0.005	0.011	0.05	0.10
BRASS	2	MAO 2228	PIXE	78	21	0.10	0.6	2	0.08	0.06	< 0.02	< 0.01	0.2	0.05	< 0.01	0.02
	3	OA6315	ICP	76	23	0.17	0.35	2	0.052	0.032	0.013	0.002	0.09	0.005	0.01	0.004
	4	OA 5548	PIXE	81	12	0.05	0.22	1	0.04	0.03	<0.03	< 0.01	0.03	0.02	0.3	< 0.02
	10	OA 6479	PIXE	77	22	< 0.03	0.3	2	0.09	< 0.01	< 0.02	< 0.01	0.1	0.03	< 0.01	< 0.01
	11	MAO 498	PIXE	84	16	0.07	0.4	2	0.1402	< 0.03	< 0.02	< 0.01	0.1	0.03	< 0.01	< 0.01
	13	AA 64	PIXE	81	18	< 0.03	0.2	2	0.16	0.04	< 0.02	< 0.01	0.1	0.03	< 0.05	< 0.01
	14	AA 63	ICP	83	15	1.0	0.29	2	0.016	0.11	< 0.003	0.026	0.10	0.084	0.06	0.005
	15	AA 61	PIXE	78	20	0.05	0.13	2	0.04	0.03	< 0.01	< 0.01	0.1	< 0.01	0.09	0.03
	23	MAO 499	PIXE	80	19	0.23	0.4	2	0.03	< 0.03	< 0.04	< 0.01	0.1	0.03	< 0.01	< 0.02
	24	AA 176	PIXE	80	20	0.15	0.07	2	0.07	0.05	< 0.02	< 0.01	0.1	0.02	0.09	< 0.01
	35	AA 175	ICP	75	25	0.18	0.12	2	0.035	0.018	< 0.0012	< 0.0001	0.06	0.004	< 0.01	0.008
	68	OA 6090	ICP	82	12	2.7	2.9	-	0.017	0.065	0.007	0.0002	0.11	0.040	< 0.01	0.014

LEADED BRASS / HIGH LEADED BRASS

Alloy	Cat. no.	Inv. no.	Type of analysis	Cu	Zn	Pb	Sn	Class of Impurity	Ag	As	Bi	Co	Fe	Ni	S	Sb
LEADED BRASS	5	OA 3354b	PIXE	73	17	7.1	2.7	2	0.06	0.45	< 0.09	< 0.02	0.4	0.12	< 0.1	0.15
	6	OA 3372b	PIXE	68	15	8.6	2.2	1	0.15	1.3	< 0.13	< 0.01	0.8	0.16	< 0.01	0.47
	7	MAO 428	PIXE	71	17	6	2.6	2	0.07	0.56	< 0.09	< 0.01	0.3	0.09	0.13	0.18
	8	OA 6314	PIXE	67	21	8	1.6	1	0.08	0.32	< 0.10	< 0.01	0.7	0.11	0.04	0.23
	9	AA 269	ICP	81	7.6	8.6	1.6	2	0.043	0.29	0.016	0.009	0.23	0.042	0.03	0.20
	37	MAO 1256	PIXE	71	18	7	3.5	2	0.05	0.09	< 0.10	0.03	0.2	0.07	0.10	0.02
	63	MAO 614	PIXE	73	12	9	3.3	1	0.10	0.94	< 0.17	< 0.01	0.5	0.16	0.01	0.86
	78	MAO 2106	ICP	87	6.0	5.2	0.9	-	0.040	0.28	0.005	0.027	0.20	0.033	0.2	0.11
HIGH LEADED BRASS	5	OA 3354a	PIXE	69	12	17	3.7	2	0.12	0.62	< 0.16	< 0.02	0.3	0.11	< 0.2	0.42
	6	OA 3372a	PIXE	68	12	16	2.1	1	0.13	1.7	< 0.18	< 0.01	0.9	0.14	0.1	0.43
	12	AA 65	PIXE	63	11	16	3.2	1	0.11	0.70	< 0.17	< 0.02	0.7	0.14	0.16	0.40
	16	AD 26749	PIXE	58	11	19	3.6	1	0.08	0.67	0.02	< 0.02	0.6	0.14	0.17	0.47
	17	MAO 605	PIXE	56	7.4	31	3.7	1	0.16	0.73	< 0.25	< 0.01	0.7	0.07	< 0.02	0.31
	19	MAO 855	ICP	63	8.5	22	3.8	1	0.11	0.78	0.044	0.015	0.37	0.14	0.12	0.62
	20	MAO 761	PIXE	69	11	14	3.6	1	0.09	0.57	< 0.15	< 0.01	0.8	0.26	0.04	0.47
	21	MAO 854	ICP	62	10.5	21	4.2	1	0.12	0.81	0.047	0.014	0.28	0.15	0.13	0.74
	25	AA 62	PIXE	67	9.2	16	2.5	2	0.3	1.9	< 0.24	< 0.01	0.8	0.20	< 0.01	1.9
	31	OA 6160	ICP	74	10.0	13	1.8	2	0.047	0.32	0.024	0.008	0.28	0.018	0.03	0.098
	33	OA 6159	ICP	71	9.4	16	2.4	2	0.072	0.51	0.020	0.010	0.29	0.14	0.02	0.18
	38	OA 7871/34	ICP	72	6.6	17	3.3	2	0.070	0.51	0.018	0.012	0.30	0.069	0.26	0.23
	39	MAO 502	ICP	62	16.0	18	2.1	1	0.079	0.78	0.054	0.017	0.53	0.080	0.08	0.41
	40	MAO 853	ICP	62	13.0	20	3.1	1	0.098	0.65	0.029	0.008	0.26	0.10	0.05	0.45
	41	OA 7958	ICP	65	7.9	22	3.7	2	0.087	0.64	0.019	0.016	0.34	0.089	0.09	0.28
	43	OA 7958/2	ICP	67	12.0	17	2.7	2	0.085	0.42	0.021	0.019	0.31	0.066	0.10	0.20
	46	MAO 771	ICP	63	12.0	20	3.5	1	0.11	0.56	0.031	0.012	0.31	0.11	0.08	0.44
	49	OA7800-1	ICP	74	8.9	13	2.6	2	0.065	0.43	0.018	0.016	0.23	0.13	0.09	0.23
	50	OA 7800-2	PIXE	57	8.5	28	3.9	1?	0.09	0.90	<0.24	0.03	0.5	0.12	<0.7	0.30
	51	OA 7819	ICP	71	9.8	14	3.2	1	0.093	0.79	0.026	0.010	0.25	0.11	0.01	0.55
	52	OA 4044 bis	ICP	75	5.4	16	2.4	2	0.0665	0.49	0.020	0.013	0.20	0.050	0.16	0.21
	53	AA 19	ICP	59	10.5	26	3.6	1	0.09	0.67	0.046	0.032	0.32	0.12	0.17	0.38
	54	MAO 357	ICP	61	8.8	24	3.8	1	0.088	0.60	0.038	0.015	0.41	0.14	0.32	0.32
	57	MAO 622	ICP	69	9.3	17	3.4	2	0.10	0.47	0.027	0.013	0.26	0.084	0.18	0.27
	59	OA 7187	ICP	72	9.0	15	2.8	2	0.063	0.39	0.020	0.012	0.32	0.050	0.05	0.16
	60	AA 60	PIXE	69	9.0	12	4.1	1	0.09	0.76	< 0.13	< 0.02	0.4	0.15	0.9	0.62
	61	OA 6101	ICP	74	7.4	15	2.4	2	0.069	0.53	0.028	0.013	0.34	0.087	0.09	0.37
	62	MAO 615	PIXE	68	11	17	3.0	1	0.06	0.50	< 0.49	< 0.01	0.3	0.14	0.1	0.17
	64	OA 7485	ICP	74	8.4	14	2.2	2	0.082	0.42	0.017	0.015	0.49	0.063	0.02	0.29
	65	OA 7083	ICP	73	6.7	16	3.0	1	0.088	0.62	0.043	0.013	0.24	0.12	0.19	0.58
	66	MAO 437	PIXE	67	10	16	2.9	1	0.10	0.74	< 0.15	0.02	0.3	0.12	0.15	0.28
	67	MAO 235	PIXE	72	11	12	2.5	1	0.08	0.45	< 0.13	0.02	0.8	0.11	0.4	0.27

Appendix 6

The five families of alloys making up the 81 DAI objects from the pre-Mongol Iranian world. (85 analysed). Elemental composition of metal. Results in % by mass.

Appendix 7

Cumulative impurity content (% by mass) in the 81 DAI items (85 analysed), sorted by alloy type and arsenic content (results in % by mass; analysis by PIXE or ICP-AES). The two highly atypical alloys, cat. nos. 68 and 78, have been removed.

Appendix 8

Silver (Ag), lead (Pb), antimony (Sb), nickel (Ni), arsenic (As) and bismuth (Bi) (% by mass) in the cast DAI objects that were analysed, grouped by classes of impurity. Class 1 in blue, class 2 in red. It was noted that correlations between elements are the same from one class to another.

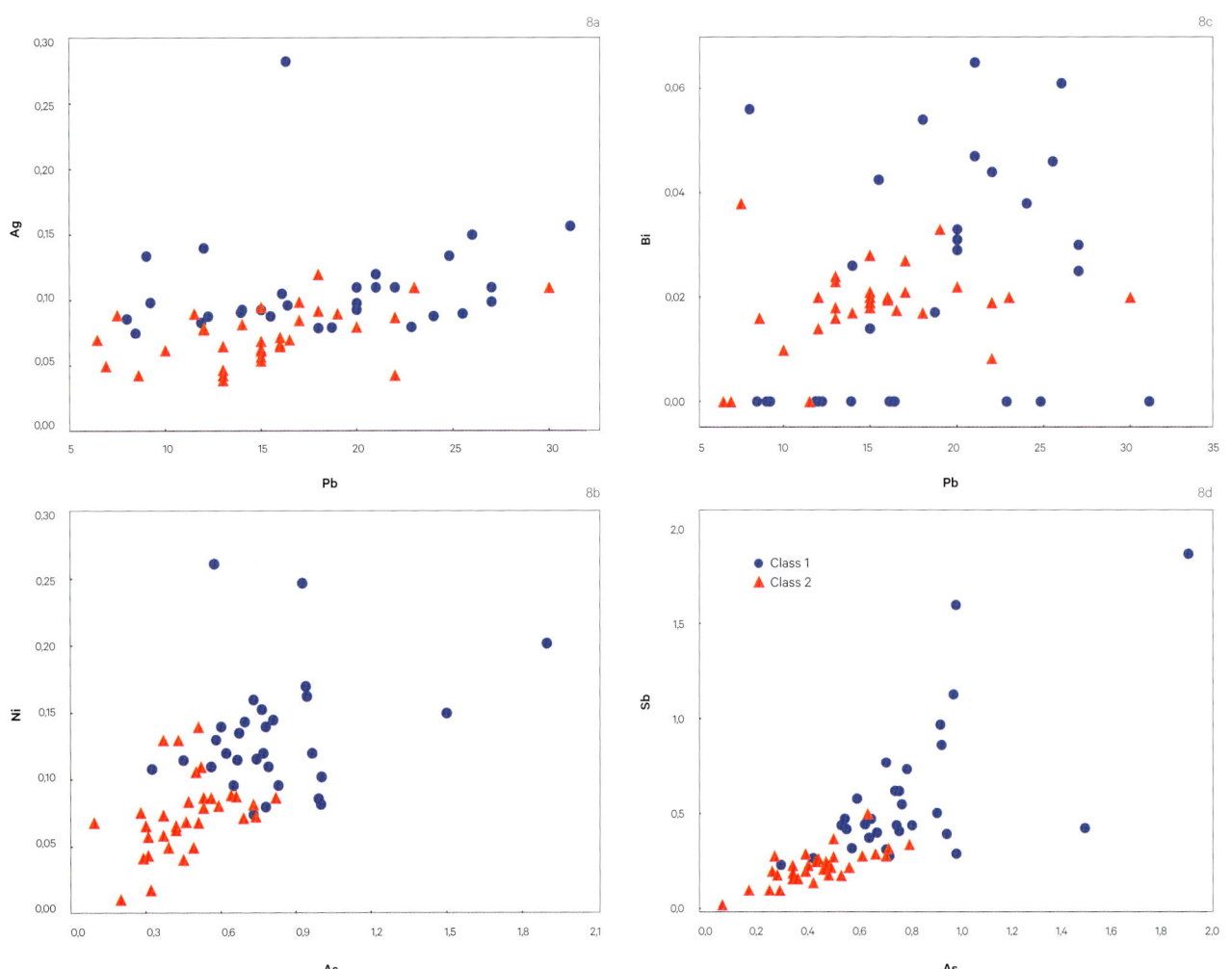

Elemental composition of metals in Iranian objects dating to the 10th-13th centuries in the Freer Gallery (surface XRF analysis), British Museum and the Ashmolean Museum (analysis of samples by AAS or ICP-AES). Content is as reported in publications (tr= trace, nd= not detected). For comparison with the DAI objects, a quality index based on the same criteria as those of the objects in the collection is also indicated.

Collection name	Publication ref.	Type	Inv.no.	Shaping (Casting or Hammering)	Quality	Alloy	Cu	Zn	Pb	Sn	Comparable objects in this catalogue
WASHINGTON DC, FREER GALLERY OF ART	Atil, Chase et Jett, 1985	Partridge	73.4	C	3	High leaded brass	64	13	19	4	cat. no. 51
		Incense burner	77.5	C	3	Leaded or high leaded brass	-	13-23	0-50	3-4	cat. nos. 30, 58
		Candlestick	51.17	H	5	Brass	77	23	tr	nd	cat. no. 3
		Pen box	36.7	H ?	5	Leaded or high leaded brass	70	9-17	10-20	1-2	cat. no. 2
LONDON, BRITISH MUSEUM	Craddock et al., 1998	Tray	1968,1224.1	H	4	Brass	78	20	0.5	0.7	cat. nos. 11, 23
		Tray	1878,1230.706	H	-	Brass	83	13	1	1	-
		Ewer*	1848,0805.1	H	5	Brass	79	22	0.1	0.3	cat. no. 4
		Ewer	1848,0805.2	H	5	Brass	80	20	0.5	1	cat. no. 4
		Vase	1885,0711.1.a	H	5	Brass	79	20	0.2	0.9	cat. no. 4
		Bucket	1959,0723.1	H ?	3	Copper	90	6	2	0.7	cat. no. 16
		Bucket	1959,0723.1	C	-	High leaded brass	69	7	22	1	
		Bucket	1885,1010.10	C	-	High leaded brass	69	15	12	2	
		Bottle	1964, 615.1	C	-	High leaded brass	63	9	22	4	
		Bottle	1883,1019.7	C	-	High leaded brass	69	12	15	2	
		Mortar	1939,1018.1	C	-	High leaded copper	74	2	19	3	
		Mortar	883,1020.7	C	-	High leaded brass	69	9	18	3	
		Cauldron	1958,1013.1	C	-	High leaded brass	64	13	21	2	
		Plate	1949,0217.2	C	-	High leaded copper	80	1	14	4	
		Box	1967,0724.1	C	4	High leaded brass	68	10	18	3	
		Inkwell	1939,0620.1	C	3	High leaded brass	74	9	14	3	cat. nos. 5, 6, 12, 17
		Pen box	1891,0623.5	C	-	Leaded brass	75	15	6	3	
		Lampstand	11905,1110.10	C	2	High leaded copper	68	5	22	3	cat. nos. 45, 46
		Lampstand	1969,0213.1	C	-	High leaded brass	66	13	16	3	
		Lampstand	1954,0216.1	C	-	High leaded brass	69	7	17	5	
		Lamp	1956,0726.10	C	-	High leaded brass	72	7	15	4	
		Lamp	1956,0726.9	C	-	High leaded brass	67	7	18	3	
		Incense burner	1966,0728.1	C	-	High leaded copper	69	5	19	4	
		Incense burner	1956,0726.8	C	-	High leaded brass	65	8	23	3	
		Incense burner	1953,0217.2	C	-	High leaded brass	67	8	20	4	
		Ewer	1956,0726.2	C	-	High leaded brass	71	7	18	3	
		Ewer	1969,0113.1	C	-	High leaded brass	71	9	15	2	
		Ewer	1848,0805.1	C	-	Brass	79	19	1	1	
		Mirror	1963,0718.1	C	2	High tin bronze	77	6	2	13	cat. nos. 68-73
		Mirror	1866,1229.75	C	2	High tin bronze	76	2	10	10	cat. nos. 70, 71, 73
		Mirror	1866,1229.76	C	2	High tin bronze	81	0.4	6	13	cat. nos. 70, 71, 73
OXFORD, ASHMOLEAN MUSEUM	Craddock et al., 1998	Ewer	EA 1969.8	C	-	High leaded brass	67	7	20	4	
		Incense burner	EA 1968.35	C	-	High leaded brass	67	8	19	3	

* The handle of this ewer is described as cast in Craddock et al. 1998, but according to Susan La Niece (oral communication, January 2020), is actually cast and hammered.

Quality	Cat. no.	Inv. no.	Shaping (Casting or Hammering)	Inlay	Openwork decoration	Recessed decoration	Type of analysis	Alloy	Cu	Zn	Pb	Sn	Class of Impurity	Ag	As	Bi	Co	Fe	Ni	S	Sb
5	2	MAO 2228	H	Cu+Ag	-	Chased, champlevé	PIXE	Brass	78	21	0.10	0.6	2	0.08	0.06	< 0.02	< 0.01	0.2	0.05	< 0.01	0.02
5	3	OA 6315	H	Cu+Ag	-	Chased, champlevé	ICP	Brass	76	23	0.17	0.35	2	0.052	0.032	0.013	0.002	0.09	0.005	0.01	0.004
5	4	OA 5548	H	Cu+Ag	-	Chased, champlevé	PIXE	Brass	81	12	0.05	0.22	1	0.04	0.03	<0.03	< 0.01	0.03	0.02	0.3	< 0.02
4	7	MAO 428	C	Cu+Ag	-	Engraved, chased, champlevé	PIXE	Leaded brass	71	17	6	2.6	2	0.07		< 0.09	< 0.01	0.3	0.09	0.13	0.18
4	8	OA 6314	C	Cu+Ag	-	Chased, champlevé	PIXE	Leaded brass	67	21	8	1.6	1	0.08	0.32	< 0.10	< 0.01	0.7	0.11	0.04	0.23
4	10	OA 6479	H	Ag	-	Chased, champlevé	PIXE	Brass	77	22	< 0.03	0.3	2	0.09	< 0.01	< 0.02	< 0.01	0.1	0.03	< 0.01	< 0.01
4	11	MAO 498	H	Cu+Ag	-	Chased, champlevé	PIXE	Brass	84	16	0.07	0.4	2	0.1402	< 0.03	< 0.02	< 0.01	0.1	0.03	< 0.01	< 0.01
4	12	AA 65	C	Cu+Ag	-	Chased, champlevé	PIXE	High leaded brass	63	11	16	3.2	1	0.11	0.70	< 0.17	< 0.02	0.7	0.14	0.16	0.40
4	23	MAO 499	H	Cu+Ag	-	Chased, champlevé	PIXE	Brass	80	19	0.23	0.4	2	0.03	< 0.03	< 0.04	< 0.01	0.1	0.03	< 0.01	< 0.02
3	5	OA 3354a	C	-	-	Incised, chased	PIXE	High leaded brass	69	12	17	3.7	2	0.12	0.62	< 0.16	< 0.02	0.3	0.11	< 0.2	0.42
3	5	OA 3354b	C	Cu+Ag	-	Incised, chased	PIXE	Leaded brass	73	17	7.1	2.7	2	0.06	0.45	< 0.09	< 0.02	0.4	0.12	< 0.1	0.15
3	6	OA 3372a	C	Cu+Ag	-	Chased, champlevé	PIXE	High leaded brass	68	12	16	2.1	1	0.13	1.7	< 0.18	< 0.01	0.9	0.14	0.1	0.43
3	6	OA 3372b	C	Cu+Ag	-	Chased, champlevé	PIXE	Leaded brass	68	15	8.6	2.2	1	0.15	1.3	< 0.13	< 0.01	0.8	0.16	< 0.01	0.47
3	9	AA 269	C	Cu	-	Chased, champlevé	ICP	Leaded brass	81	7.6	8.6	1.6	2	0.043	0.29	0.016	0.009	0.23	0.042	0.03	0.20
3	13	AA 64	H	-	-	Chased, champlevé	PIXE	Brass	81	18	< 0.03	0.2	2	0.16	0.04	< 0.02	< 0.01	0.1	0.03	< 0.05	< 0.01
3	17	MAO 605	C	Cu+Ag	-	Chased, champlevé	PIXE	High leaded brass	56	7.4	31	3.7	1	0.16	0.73	< 0.25	< 0.01	0.7	0.07	< 0.02	0.31
3	20	MAO 761	C	-	-	Chased, champlevé	PIXE	High leaded brass	69	11	14	3.6	1	0.09	0.57	< 0.15	< 0.01	0.8	0.26	0.04	0.47
3	18	MAO 2103	C	Cu	-	Engraved, chased, filed?	PIXE	High leaded copper	61	6.4	23	3.8	1	0.08	1.0	< 0.16	0.02	0.5	0.10	1.3	0.29
3	19	MAO 855	C	Cu	-	Engraved, chased, champlevé	ICP	High leaded brass	63	8.5	22	3.8	1	0.11	0.78	0.044	0.015	0.37	0.14	0.12	0.62
3	24	AA 176	H	Cu	-	Chased, champlevé	PIXE	Brass	80	20	0.15	0.07	2	0.07	0.05	< 0.02	< 0.01	0.1	0.02	0.09	< 0.01
3	26	MAO 2104	C	-	-	Engraved	ICP	High leaded copper	65	0.04	24	6.6	1	0.12	1.7	0.035	0.016	<0.005	0.40	0.5	1.7
3	35	AA 175	H	-	-	Chased, champlevé	ICP	Brass	75	25	0.18	0.12	2	0.035	0.018	< 0.0012	< 0.0001	0.06	0.004	< 0.01	0.008
3	36	AA 59	C	-	-	Chased, champlevé	ICP	High leaded copper	62	3.9	26	3.6	1	0.15	0.94	0.061	0.046	1.7	0.17	0.6	1.0
3	37	MAO 1256	C	-	-	Chased, champlevé	PIXE	Leaded brass	71	18	7	3.5	2	0.05	0.09	< 0.10	0.03	0.2	0.07	0.10	0.02
3	44	OA 7890	C	-	yes	Chased, incised	ICP	High leaded copper	78	3.5	15	2.2	2	0.062	0.53	0.021	0.007	0.10	0.080	0.19	0.28
3	47	MAO 772	C	Cu	-	Too corroded	ICP	High leaded copper	63	4.8	27	3.6	1	0.099	0.83	0.025	0.008	0.17	0.10	0.39	0.44
3	52	OA 4044bis	C	-	yes	Chased, champlevé	ICP	High leaded brass	75	5.4	16	2.4	2	0.0665	0.49	0.020	0.013	0.20	0.050	0.16	0.21
3	63	MAO 614	C	-	-	Chased, champlevé	PIXE	Leaded brass	73	12	9	3.3	1	0.10	0.94	< 0.17	< 0.01	0.5	0.16	0.01	0.86
3	64	OA 7485	C	-	-	Engraved, chased, champlevé	ICP	High leaded brass	74	8.4	14	2.2	2	0.082	0.42	0.017	0.015	0.49	0.063	0.02	0.29
3	76	AD 11287	C	-	-	-	PIXE	High leaded copper	70	7.6	15	3	1	0.07	1.2	0.06	< 0.01	0.3	0.20	< 0.4	1.3
2	1	MAO 900	C	-	-	-	PIXE	High tin bronze	72	0.04	0.1	26	2	< 0.01	0.13	< 0.01	0.03	0.1	0.07	0.14	< 0.43
2	14	AA 63	C	-	-	Chased, champlevé	ICP	Brass	83	15	1.0	0.29	2	0.016	0.11	< 0.003	0.026	0.10	0.084	0.06	0.005
2	15	AA 61	H	-	-	Chased, champlevé	PIXE	Brass	78	20	0.05	0.13	2	0.04	0.03	< 0.01	< 0.01	0.1	< 0.01	0.09	0.03
2	16	AD 26749	C	-	-	Chased	PIXE	High leaded brass	58	11	19	3.6	1	0.08	0.67	0.02	< 0.02	0.6	0.14	0.17	0.47
2	21	MAO 854	C	-	-	Chased	ICP	High leaded brass	62	10.5	21	4.2	1	0.12	0.81	0.047	0.014	0.28	0.15	0.13	0.74
2	25	AA 62	C	-	-	Engraved, chased, champlevé	PIXE	High leaded brass	67	9.2	16	2.5	2	0.3	1.9	< 0.24	< 0.01	0.8	0.20	< 0.01	1.9
2	28	MAO 1255	C	-	yes	Chased, champlevé	PIXE	High leaded copper	65	4.6	25	3.0	1	0.13	1.0	< 0.13	< 0.01	0.3	0.09	0.13	1.1
2	29	MAO 908	C	-	yes	Chased, champlevé, incised	PIXE	High leaded copper	76	7.7	9	5.0	1	0.13	0.93	< 0.14	< 0.01	0.6	0.25	< 0.01	0.50
2	30	OA 6156	C	-	yes	Chased, champlevé	ICP	High leaded copper	71	4.4	20	3.1	1	0.093	0.58	0.033	0.015	0.32	0.13	0.13	0.42
2	31	OA 6160	C	-	-	Chased	ICP	High leaded brass	74	10.0	13	1.8	2	0.047	0.32	0.024	0.008	0.28	0.018	0.03	0.098
2	34	OA 6157	C	-	-	Chased	ICP	High leaded copper	79	5.2	12	3.0	2	0.079	0.37	0.020	0.010	0.28	0.059	0.22	0.23
2	39	MAO 502	C	-	-	Chased, champlevé	ICP	High leaded brass	62	16.0	18	2.1	1	0.079	0.78	0.054	0.017	0.53	0.080	0.08	0.41
2	40	MAO 853	C	-	-	Chased, engraved	ICP	High leaded brass	62	13.0	20	3.1	1	0.098	0.65	0.029	0.008	0.26	0.10	0.05	0.45
2	41	OA 7958	C	-	-	Filed	ICP	High leaded brass	65	7.9	22	3.7	2	0.087	0.64	0.019	0.016	0.34	0.089	0.09	0.28
2	42	MAO 760	C	-	-	-	ICP	High leaded copper	69	3.4	23	2.9	2	0.11	0.74	0.020	0.019	0.14	0.073	0.17	0.32
2	43	OA 7958/2	C	-	-	Filed, incised	ICP	High leaded brass	67	12.0	17	2.7	2	0.085	0.42	0.021	0.019	0.31	0.066	0.10	0.20
2	45	OA 7957 B	C	-	-	Chased	ICP	High leaded copper	76	5.1	15	2.9	2	0.057	0.45	0.019	0.012	0.23	0.041	0.15	0.14
2	45	OA 7957A	C	-	yes	Chased	ICP	High leaded copper	83	0.40	12	3.1	2	0.078	0.69	0.014	0.004	0.013	0.072	0.14	0.29

Quality	Cat. no.	Inv. no.	Shaping (Casting or Hammering)	Inlay	Openwork decoration	Recessed decoration	Type of analysis	Alloy	Cu	Zn	Pb	Sn	Class of Impurity	Ag	As	Bi	Co	Fe	Ni	S	Sb
	46	MAO 771	C	-	yes	Engraved, chased	ICP	High leaded brass	63	12.0	20	3.5	1	0.11	0.56	0.031	0.012	0.31	0.11	0.08	0.44
	48	MAO 830	C	-	-	Incised	ICP	High leaded copper	65	2.2	27	4.2	1	0.11	0.77	0.030	0.013	0.19	0.12	0.30	0.44
	49	OA7800-1	C	-	-	Chased, champlevé	ICP	High leaded brass	74	8.9	13	2.6	2	0.065	0.43	0.018	0.016	0.23	0.13	0.09	0.23
	50	OA 7800-2	C	-	-	Chased, engraved?	PIXE	High leaded brass	57	8.5	28	3.9	1?	0.09	0.90	<0.24	0.03	0.5	0.12	<0.7	0.30
	51	OA 7819	C	-	-	Chased, champlevé	ICP	High leaded brass	71	9.8	14	3.2	1	0.093	0.79	0.026	0.010	0.25	0.11	0.01	0.55
	53	AA 19	C	-	yes	Incised	ICP	High leaded brass	59	10.5	26	3.6	1	0.09	0.67	0.046	0.032	0.32	0.12	0.17	0.38
	54	MAO 357	C	-	yes	Chased	ICP	High leaded brass	61	8.8	24	3.8	1	0.088	0.60	0.038	0.015	0.41	0.14	0.32	0.32
	55	MAO 486a	C	-	-	Engraved	ICP	High leaded copper	68	7.4	18	5.3	2	0.12	0.28	0.017	0.005	0.29	0.076	0.09	0.10
		MAO 486b	C	-	-	Engraved	ICP	High leaded copper	78	6.3	7.5	7.0	2	0.089	0.52	0.038	0.012	0.19	0.11	0.08	0.22
	57	MAO 622	C	-	yes	Engraved, chased	ICP	High leaded brass	69	9.3	17	3.4	2	0.10	0.47	0.027	0.013	0.26	0.084	0.18	0.27
	58	MAO 762	C	-	yes	Worn surface	ICP	High leaded copper	81	3.3	13	1.9	2	0.04	0.31	0.023	0.007	0.12	0.058	0.03	0.18
	59	OA 7187	C	-	-	Reworked with incisions?	ICP	High leaded brass	72	9.0	15	2.8	2	0.063	0.39	0.020	0.012	0.32	0.050	0.05	0.16
	60	AA 60	C	-	-	Chased, champlevé	PIXE	High leaded brass	69	9.0	12	4.1	1	0.09	0.76	< 0.13	< 0.02	0.4	0.15	0.9	0.62
2	61	OA 6101	C	-	-	Engraved, chased, champlevé	ICP	High leaded brass	74	7.4	15	2.4	2	0.069	0.53	0.028	0.013	0.34	0.087	0.09	0.37
	62	MAO 615	C	-	-	Chased, champlevé	PIXE	High leaded brass	68	11	17	3.0	2	0.06	0.50	< 0.49	< 0.01	0.3	0.14	0.1	0.17
	65	OA 7083	C	-	-	Chased, champlevé	ICP	High leaded brass	73	6.7	16	3.0	1	0.088	0.62	0.043	0.013	0.24	0.12	0.19	0.58
	66	MAO 437	C	-	-	Chased ?	PIXE	High leaded brass	67	10	16	2.9	1	0.10	0.74	< 0.15	0.02	0.3	0.12	0.15	0.28
	68	OA 6090	C	-	-		ICP	Brass	82	12	2.7	2.9	-	0.017	0.065	0.007	0.0002	0.11	0.040	< 0.01	0.014
	70	OA 3945	C	-	-		PIXE	High tin bronze	75	3	8	13	2	0.09	0.31	< 0.10	< 0.01	0.2	0.09	0.3	0.26
	71	OA 7871/72	C	-	-		PIXE	High tin bronze	80	0.2	3.2	14	2	0.06	0.63	< 0.06	0.04	0.05	0.10	0.7	0.25
	72	AFI 1343	C	-	-		ICP	High tin bronze	77	0.58	4.8	17	2	0.061	0.29	0.014	0.018	0.036	0.043	0.06	0.11
	74	OA 6020	C	-	-		ICP	High tin bronze	82	0.5	3.1	13	2	0.13	0.16	0.022	0.003	0.13	0.049	< 0.01	0.45
	81	MAO 316	C	-	-	Engraved, chased, champlevé	ICP	High leaded copper	68	2.6	20	8.2	2	0.080	0.5	0.022	0.025	0.18	0.069	0.12	0.25
	82	MAO 366	C	-	-	Chased	ICP	High leaded copper	78	1.4	15	3.4	1	0.093	0.97	0.014	0.009	0.10	0.12	0.33	0.40
	83	MAO 362	C	-	-	Chased ?	ICP	High leaded copper	72	4.7	18	3.5	2	0.092	0.73	0.017	0.017	0.21	0.082	0.20	0.28
	84	MAO 436	C	-	-	Chased	ICP	High leaded copper	76	0.04	22	1.7	2	0.043	0.20	0.008	0.001	<0.005	0.011	0.05	0.10
	22	MAO 2105	C	-	-	Worn	ICP	High leaded copper	67	5.8	21	4.0	1	0.11	0.73	0.065	0.028	0.28	0.16	0.33	0.77
	27	MAO 2107	C	-	-	Engraved, chased, champlevé	ICP	High leaded copper	88	0.20	8.0	0.81	1	0.086	1.0	0.056	0.004	0.022	0.082	0.2	1.6
	32	OA 6158	C	-	-	Drilled with a gimlet	ICP	High leaded copper	77	3.2	15	4.0	2	0.054	0.37	0.020	0.018	0.23	0.074	0.19	0.16
	33	OA 6159	C	-	-	Drilled with a gimlet, filed	ICP	High leaded brass	71	9.4	16	2.4	2	0.072	0.51	0.020	0.010	0.29	0.14	0.02	0.18
	38	OA 7871/34	C	-	-	Engraved, chased, champlevé	ICP	High leaded brass	72	6.6	17	3.3	2	0.070	0.51	0.018	0.012	0.30	0.069	0.26	0.23
1	56	MAO 415	C	-	-	Chased	ICP	High leaded copper	78	0.32	10	11	2	0.062	0.31	0.010	0.005	0.035	0.044	0.04	0.18
	67	MAO 235	C	-	-	Engraved	PIXE	High leaded brass	72	11	12	2.5	1	0.08	0.45	< 0.13	0.02	0.8	0.11	0.4	0.27
	75	MAO 2218	C	-	-	Chased	ICP	High leaded copper	82	0.1	13	3.6	2	0.039	0.37	0.016	0.016	0.023	0.13	0.23	0.19
	77	MAO 2224	C	-	-	Engraved, chased	ICP	High leaded copper	63	1.8	30	3.6	2	0.11	0.82	0.020	0.009	0.10	0.087	0.21	0.34
	78	MAO 2106	C	-	-		ICP	Leaded brass	87	6.0	5.2	0.9	-	0.040	0.28	0.005	0.027	0.20	0.033	0.2	0.11
	79	OA 6438	C	-	-	Chased	ICP	High leaded copper	74	2.6	19	3.1	2	0.090	0.66	0.033	0.009	0.14	0.088	0.18	0.50
	80	OA 8181	C	-	-	Chased, champlevé	ICP	High leaded copper	72	5.2	15	6.0	2	0.10	0.59	0.018	0.043	0.30	0.081	0.20	0.22

Classification into five groups of the DAI objects from the pre-Mongol Iranian world. The objects of a certain quality are classified according to the shaping and decorative techniques, and to the elemental composition of the metal (% by mass).

Quality 5
Unique or identified items made in a small series. Exceptionally well-executed decoration, rich in silver and copper inlays. Inscriptions with titles, dates and/or places of manufacture.

Quality 4
Mass-produced objects, well executed and richly decorated. Copper and silver inlays.

Quality 3
Mass-produced objects with elaborate, well-executed decoration. Little or no copper or silver inlay.

Quality 2
Mass-produced, utilitarian objects. More careful shaping and decoration than quality 1 but less precise than quality 3. Few manufacturing defects, relatively symmetrical shapes.

Quality 1
Utilitarian, mass-produced objects. Summary and relatively mediocre shaping and decoration. Significant manufacturing defects, imbalance in the symmetry of the object, of its parts or its decoration; poor casting of decoration (figurative, calligraphic, geometric).

Appendix 11

Indices and criteria of quality for the manufacture of the DAI metal objects from the pre-Mongol Iranian world.

Appendix 12

Analysis of 81 DAI objects (85 analysed) according to quality and alloy.

Inv. no.	Type	Place of discovery	Quality	Shaping (Casting or Hammering)	Recessed decoration	Alloy	Cu	Zn	Pb	Sn	Ag	As	Bi	Co	Fe	Ni	S	Sb
MAO S. 1753	Sprinkler	Iran, Susa	1	C	-	High leaded brass	66	15.0	16.0	2.4	0.053	0.21	0.007	0.017	0.35	0.11	0.07	0.13
MAO S. 401	Sprinkler	Iran, Susa	1	C	-	High leaded copper	50	5.6	29	3.9	0.094	0.10	0.04	0.02	0.9	0.02	0.5	0.18
AF 1199	Sprinkler	Egypt, Antinopolis	2	C	Chased	High leaded copper Atypical	56	3.1	31	9.2	0.12	0.61	< 0.23	< 0.01	0.3	0.09	0.8	0.23
MND 534	Lampstand	Lebanon, Sidon	2	C	-	Atypical brass	90	6.6	1.4	1.2	0.033	0.25	0.011	0.009	0.19	0.033	0.01	0.079
MND 330	Lampstand	Lebanon, near Sidon	3	C	-	High leaded copper	64	6.3	26	2.4	0.10	0.60	< 0.22	0.03	1.0	0.10	< 0.4	0.22
AA 100	Shield boss?	Afghanistan, Ghazna	3	H	Chased	Brass	80	17	0.2	< 0.2	not measured	< 0.06	< 0.06	0.00	1.5	< 0.04	0.02	< 0.03

Appendix 13

11th-12th century objects in the DAI, Musée du Louvre, analysed for comparison.

Inlay	Cat. no.	Inv. no.	Type	Attribution	Quality	Shaping (Casting or Hammering)	Type of analysis	Alloy	Cu	Zn	Pb	Sn	Class of Impurity	Ag	As	Bi	Co	Fe	Ni	S	Sb
Ag	10	OA 6479	Tray	Herat	4	C	PIXE	Brass	77	22	< 0.03	0.3	2	0.09	< 0.01	< 0.02	< 0.01	0.1	0.03	< 0.01	< 0.01
Cu	9	AA 269	Feline carpet weight	Herat	3	C	ICP	Leaded brass	81	7.6	8.6	1.6	2	0.043	0.29	0.016	0.009	0.23	0.042	0.03	0.20
	18	MAO 2103	Sprinkler	Ghazna	3	C	PIXE	High leaded copper	61	6.4	23	3.8	1	0.08	1.0	< 0.16	0.02	0.5	0.10	1.3	0.29
	19	MAO 855	Ewer	Ghazna	3	C	ICP	High leaded brass	63	8.5	22	3.8	1	0.11	0.78	0.044	0.015	0.37	0.14	0.12	0.62
	24	AA 176	Ewer	Ghazna	3	H	PIXE	Brass	80	20	0.15	0.07	2	0.07	0.05	< 0.02	< 0.01	0.1	0.02	0.09	< 0.01
Cu+Ag	2	MAO 2228	Pen box	Herat	5	H	PIXE	Brass	78	21	0.10	0.6	2	0.08	0.06	< 0.02	< 0.01	0.2	0.05	< 0.01	0.02
	3	OA6315	Candlestick	Herat	5	H	ICP	Brass	76	23	0.17	0.35	2	0.052	0.032	0.013	0.002	0.09	0.005	0.01	0.004
	4	OA 5548	Ewer	Herat	5	H	PIXE	Brass	81	12	0.05	0.22	1	0.04	0.03	<0.03	< 0.01	0.03	0.02	0.3	< 0.02
	5	OA 3354b	Inkwell (base)	Herat	3	C	PIXE	Leaded brass	73	17	7.1	2.7	2	0.06	0.45	< 0.09	< 0.02	0.4	0.12	< 0.1	0.15
	6	OA 3372a	Inkwell (lid)	Herat	3	C	PIXE	High leaded brass	68	12	16	2.1	1	0.13	1.7	< 0.18	< 0.01	0.9	0.14	0.1	0.43
	6	OA 3372b	Inkwell (base)	Herat	3	C	PIXE	Leaded brass	68	15	8.6	2.2	1	0.15	1.3	< 0.13	< 0.01	0.8	0.16	< 0.01	0.47
	7	MAO 428	Ewer	Herat	4	C	PIXE	Leaded brass	71	17	6	2.6	2	0.07	0.56	< 0.09	< 0.01	0.3	0.09	0.13	0.18
	8	OA 6314	Ewer	Herat	4	C	PIXE	Leaded brass	67	21	8	1.6	1	0.08	0.32	< 0.10	< 0.01	0.7	0.11	0.04	0.23
	11	MAO 498	Tabletop/tray	Herat	4	H	PIXE	Brass	84	16	0.07	0.4	2	0.1402	< 0.03	< 0.02	< 0.01	0.1	0.03	< 0.01	< 0.01
	12	AA 65	Inkwell (lid)	Ghazna	4	C	PIXE	High leaded brass	63	11	16	3.2	1	0.11	0.70	< 0.17	< 0.02	0.7	0.14	0.16	0.40
	17	MAO 605	Inkwell (base)	Ghazna	3	C	PIXE	High leaded brass	56	7.4	31	3.7	1	0.16	0.73	< 0.25	< 0.01	0.7	0.07	< 0.02	0.31
	23	MAO 499	Tabletop/tray	Ghazna	4	H	PIXE	Brass	80	19	0.23	0.4	2	0.03	< 0.03	< 0.04	< 0.01	0.1	0.03	< 0.01	< 0.02

Appendix 14

Analysis of the elemental composition of substrate metals in 16 inlaid objects from the pre-Mongol Iranian world in the DAI (% by mass).

Cat. no.	Inv. no.	Type	Attribution	Quality	Shaping (Casting or Hammering)	Inlay	Type of analysis	Alloy	Type of silver inlay	Ag	Au	Bi	Cu	Cu (recalculated with Zn)	Pb	Sn	Zn	Cu/Zn in the substrate
2	MAO 2228	Pen box	Herat	5	H	Cu+Ag	PIXE	Brass	Wire and sheet	95	1.1	0.03	2.7	1.9	0.5	0.2	0.2	3.8
3	OA6315	Candlestick	Herat	5	H	Cu+Ag	PIXE	Brass	Sheet	89	1.0	0.06	7.2	6.5	0.6	< 1.5	0.2	3.3
4	OA 5548	Ewer	Herat	5	H	Cu+Ag	PIXE	Brass	Wire and sheet	83	0.9	<0.05	13	11.2	0.4	1.5	0.3	6.7
4	OA 5548	Ewer	Herat	5	H	Cu+Ag	PIXE	Brass	Wire and sheet	88	1.2	0.04	6.5	5.8	0.6	2.7	0.10	6.7
5	OA 3354b	Inkwell (base)	Herat	3	C	Cu+Ag	PIXE	Leaded brass	Wire	81	0.6	<0.04	10	8.7	3.7	2.1	0.4	4.3
6	OA 3372	Inkwell	Herat	3	C	Cu+Ag	PIXE	High leaded brass	Wire	89	1.2	0.04	6.6	4.5	2.0	0.4	0.5	4.4
7	MAO 428	Ewer	Herat	4	C	Cu+Ag	PIXE	Leaded brass	Wire	96	2.6	<0.02	1.0	0.7	<0.02	0.4	0.14	4.1
8	OA 6314	Ewer	Herat	4	C	Cu+Ag	PIXE	Leaded brass	Wire	99	<0.006	<0.005	0.6	0.3	0.2	<0.5	0.07	3.2
10	OA 6479	Tray	Herat	4	H	Ag	PIXE	Brass	Wire and sheet	96	<0.01	<0.005	2.6	2.6	0.4	<0.5	<0.008	3.5
11	MAO 498	Tabletop/tray	Herat	4	H	Cu+Ag	PIXE	Brass	Wire and sheet	95	0.6	<0.01	2.5	2.4	1.0	<0.6	0.03	5.3
12	AA 65	Inkwell (lid)	Ghazna	4	C	Cu+Ag	PIXE	High leaded brass	Sheet	94	1.0	<0.003	1.6	1.1	0.5	<1.5	0.09	5.5
17	MAO 605	Inkwell (base)	Ghazna	3	C	Cu+Ag	PIXE	High leaded brass	Wire and sheet	90	0.2	0.04	3.9	2.7	3.0	0.3	0.3	8
23	MAO 499	Tabletop/tray	Ghazna	4	H	Cu+Ag	PIXE	Brass	Wire and sheet	94	1.2	0.22	3.9	3.2	0.6	<0.6	0.2	4.2

Appendix 15

DAI objects from the pre-Mongol Iranian world Silver inlays: elemental composition (% by mass). The copper content was recalculated to take into account the influence of the underlying substrate (correction of the Cu/Zn ratio of the substrate).

Appendix 16

Hierarchical classification of fifteen copper inlays according to their Ag, As, Ni, Pb, Sb content (reduced centred value, Ward method, Euclidean distance).
From top to bottom cat. nos.: 5, 4, 12, 17, 23, 19, 24, 18, 9, 11, 7, 6, 8, 2. 3

Appendix 17

Comparison of antimony (Sb), nickel (Ni), arsenic (As) and silver (Ag) content in the copper in the inlay and the substrate. The composition of the inlay is shown in the top section and of the substrate in the bottom section. Objects are arranged into three groups: at the top the objects with inlays that are purer than the substrate, and on the bottom those in which the inlay and substrate have a similar composition. From top to bottom: cat. nos. 5, 19, 6, 18, 3, 4, 23, 11, 24, 7, 2, 8, 17, 9, 12.

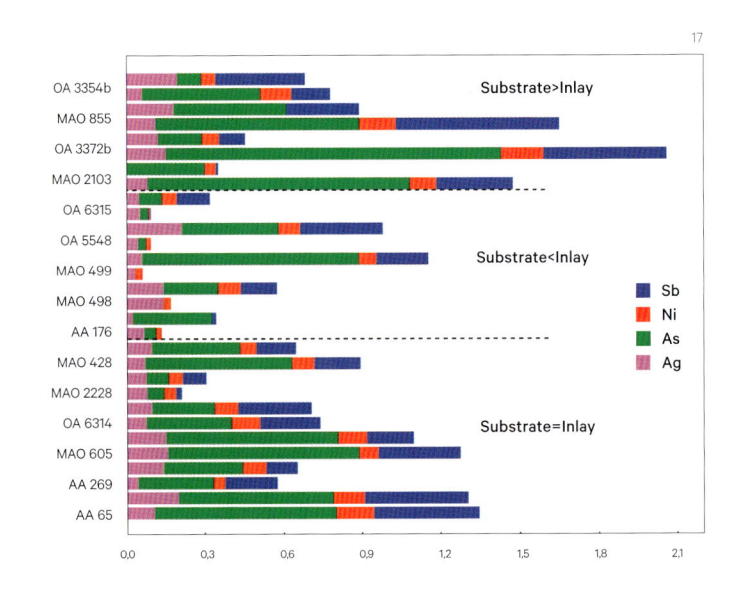

Cat.	Inv. no.	Type	Attribution	Quality	Shaping (casting or hammering)	Inlay	Substrate alloy	Substrate/inlay relationship	Type of analysed inlay	Classification in ascending order	Cu	Ag	As	Ni	Pb	Sb
2	MAO 2228	Pen box	Herat	5	H	Cu+Ag	Brass	S=I				0.08	0.06	0.05	0.10	0.02
									Sheet	4	97	0.08	0.08	0.05	1.4	0.09
3	OA 6315	Candlestick	Herat	5	H	Cu+Ag	Brass	S<I				0.05	0.03	0.005	0.17	0.004
									Wire and sheet	3	97	0.05	0.09	0.06	1.7	0.13
4	OA 5548	Ewer	Herat	5	H	Cu+Ag	Brass	S<I				0.04	0.03	0.02	0.05	<0.03
									Wire	1	98	0.21	0.37	0.08	0.57	0.32
5	OA 3354b	Inkwell (base)	Herat	3	C	Cu+Ag	Leaded brass	S<>I				0.06	0.45	0.12	7.1	0.15
									Wire	1	99	0.19	0.09	0.05	0.66	0.34
6	OA3372b	Inkwell (base)	Herat	3	C	Cu+Ag	Leaded brass	S>I				0.15	1.3	0.16	8.6	0.47
									Wire and sheet	3	97	0.12	0.17	0.07	1.9	0.10
7	MAO 428	Ewer	Herat	4	C	Cu+Ag	Leaded brass	S=I				0.07	0.56	0.09	6.5	0.18
									Wire and sheet	3	97	0.10	0.34	0.06	1.8	0.15
8	OA 6314	Ewer	Herat?	4	C	Cu+Ag	Leaded brass	S=I				0.08	0.32	0.11	8.4	0.23
									Wire	3	97	0.10	0.24	0.09	1.6	0.28
9	AA 269	Feline carpet weight	Herat	3	C	Cu	Leaded brass	S=I				0.04	0.29	0.042	8.6	0.20
									Wire	3	98	0.14	0.30	0.09	1.5	0.12
11	MAO 498	Tabletop/tray	Herat	4	H	Cu+Ag	Brass	S<I				0.14	<0.025	0.03	0.07	<0.01
									Sheet	3	97	0.14	0.21	0.08	1.2	0.14
12	AA 65	Inkwell (lid)	Ghazna	4	C	Cu+Ag	High leaded brass	S=I				0.11	0.70	0.14	16	0.40
									Wire	5	97	0.20	0.59	0.12	1.5	0.40
17	MAO 605	Inkwell (base)	Ghazna	3	C	Cu+Ag	High leaded brass	S=I				0.16	0.73	0.07	31	0.31
									Wire	5	97	0.15	0.66	0.11	2.0	0.18
18	MAO 2103	Sprinkler	Ghazna	3	C	Cu	High leaded copper	S>I				0.08	1.0	0.10	23	0.29
									Wire	2	98	<0.008	0.30	0.04	2.2	0.01
19	MAO 855	Ewer	Ghazna	3	C	Cu	High leaded brass	S>I				0.11	0.78	0.14	22	0.62
									Sheet	6	96	0.18	0.43	<0.019	2.4	0.28
23	MAO 499	Tabletop/tray	Ghazna	4	H	Cu+Ag	Brass	S<I				0.03	<0.028	0.03	0.23	<0.015
									Sheet	5	97	0.06	0.83	0.07	2.7	0.20
24	AA 176	Ewer	Ghazna	3	H	Cu	Brass	S<I				0.07	0.05	0.02	0.15	<0.06
									Wire	2	97	0.02	0.30	<0.013	2.2	0.02

Appendix 18

DAI objects from the pre-Mongol Iranian world Copper inlays: elemental composition (% by mass, PIXE analysis). The values indicated for each object show the average based on the analysis of several inlays. Forming part of one of the five compositional groups is indicated (classification by hierarchy). In each case, the alloy type of the substrate and the composition of its impurities, and the relative purity of the inlay and substrate (S<I, S=I or S>I) are indicated.

Appendix 19

DAI objects from pre-Mongol Iran
File marks on cast objects.

Cat. no.	Type	Attribution / Date	Width (mm)
18	Sprinkler	Afghanistan. Ghazna. c. 12th C.	2
32	Lamp	Khurasan or Sistan. 10th-11th C.	1.8
33	Lamp	Khurasan or Sistan. 10th-11th C.	1 and 3.5
39	Lamp	Khurasan. Afghanistan. 12th C.	1.2
41	Lamp	Khurasan. 12th C.	1.2
43	Lamp	Khurasan. 11th-12th C.	1-1.2
48	Lamp	Khurasan. 11th-12th C.	?
67	Flask	Khurasan. eastern Iran. 12th-13th C.	1.5-2

Cat. no.	Type	Attribution	Shape of the chasing on cast objects	Width	Length	Shape of the chasing on hammered objects	Width	Length
4	Ewer	Afghanistan, Herat				Rectangular?	0.4	1.1
8	Ewer	Afghanistan, Herat	Rectangular	0.5	1.3			
7	Ewer	Afghanistan, Herat	Triangular	0.45	0.9			
15	Tabletop/tray	Afghanistan, Ghazna				Triangular	0.6	1.9
24	Ewer	Afghanistan, Ghazna				Rectangular	0.9	1.9
18	Sprinkler	Afghanistan, Ghazna	Rectangular/ U bottomed	0.6	1.2			
31	Sprinkler	Khurasan or Sistan	Rectangular/ flat bottomed	0.3	1.5			
60	Pouring vessel	Afghanistan	Rectangular	0.55	0.85			
61	Pouring vessel	Afghanistan	Rectangular/ flat bottomed	0.8	1.25			
			Rectangular/ V bottomed	1	2			
79	Mortar	Khurasan or Afghanistan	Oblong or rectangular/ U bottomed	1	1.5			
37	Ewer	Afghanistan	Rectangular/ flat bottomed	0.6	1.9			
80	Mortar	Iran or Anatolia	Rectangular/ flat bottomed	1	2.75			

Appendix 20

DAI objects from the pre-Mongol Iranian world
Chasing on cast and hammered objects: tool marks.

Cat. no.	Type	Attribution / Dating	Shape of the chasing	Width	Length
31	Sprinkler	Khurasan or Sistan, 10th-11th C.	Rectangular/flat bottomed	0.3	1.5
30	Incense burner	Khurasan or Sistan, 10th-11th C.	Rectangular/flat bottomed	0.9	
61	Shape of the chasing	Khurasan or Sistan, 10th-11th C.	Rectangular/flat bottomed	0.8	1.25
			Triangular/V bottomed	1	2
62	Shape of the chasing	Khurasan or Sistan, 10th-11th C.	Rectangular	0.5	
36	Ewer	Khurasan or Afghanistan, 11th C.	Rectangular	0.4	
40	Lamp	Khurasan or Afghanistan, 11th C.	Rectangular/flat bottomed	0.6	
38	Lamp	Khurasan or Afghanistan, 11th C.	Rectangular/flat bottomed	0.5	
52	Incense burner	Khurasan or Afghanistan, 11th C.	Rectangular/flat bottomed	0.5	
37	Ewer	Khurasan or Afghanistan, 11th C.	Rectangular/flat bottomed	0.6	1.9
			Triangular? V bottomed?	?	?
27	Mortar	Khurasan, 11th-12th C.	Oblong or rectangular/ U bottomed	0.8-0.9	
77	Mortar	Khurasan, 12th-early 13th C.	Oblong or rectangular/ U bottomed	1.1	
64	Sprinkler	Khurasan, Eastern Iran 12th-early 13th C.	Oblong or rectangular/ U bottomed	?	
79	Mortar	Khurasan or Afghanistan, 12th-early 13th C.	Oblong or rectangular/ U bottomed	1	1.5
8	Ewer	Afghanistan, Herat, 586/1190-1191	Rectangular	0.5	1.3
6	Inkwell	Afghanistan, Herat, c. 1150-1220	Rectangular/ U bottomed	0.4	
7	Ewer	Afghanistan, Herat, end of 12th C.	Triangular	0.45	0.9
9	Feline carpet weight	Afghanistan, Herat, c. 1150-1220	Triangular	0.4	0.9
25	Small tray/incense burner	Afghanistan, Bamiyan? c. 1150-1220	Rectangular/flat bottomed	0.7	
19	Ewer	Afghanistan, Ghazna, end of 12th C.	Triangular	0.5	
13	Plate from a set of scales	Afghanistan, Ghazna, 12th C.	Triangular	0.5	
			Rectangular/flat bottomed	0.3-0.5	
20	Sprinkler	Afghanistan, Ghazna, 12th C.	Rectangular/ U bottomed	0.4	
18	Sprinkler	Afghanistan, Ghazna, 12th C.	Rectangular/ U bottomed	0.6	1.2
80	Mortar	Iran or Anatolia, 13th C.?	Rectangular/flat bottomed	1	2.75
81	Mortar	Iran or Anatolia, 13th C.?	Oblong or rectangular/ U bottomed	?	?

Appendix 21

DAI objects from the pre-Mongol Iranian world
Cold worked chasing on cast objects.

Appendix 22

DAI objects from the pre-Mongol Iranian world

Type and category of thickness of objects shaped with the lost wax process.

Type	Thickness < 2 mm	Thickness 2–4 mm	Thickness > 4 mm
Bucket	Cat. no. 16		
Sprinkler	Cat. nos. 18, 20, 31, 64		
Pouring vessel	Cat. nos. 60, 61		
Bowl	Cat. no. 66		
Feline carpet weight	Cat. nos. 9, 49, 50		
Jug	Cat. no. 62		
Mirror	Cat. nos. 68 à 74		
Ewer	Cat. no. 37	Cat. nos. 7, 8, 19, 36	
Lamp	Cat. nos. 21, 29, 32, 33, 40	Cat. nos. 34, 38, 39, 41, 42, 43, 44, 48	
Lampstand	Cat. no. 47	Cat. nos. 45, 46	
Incense burner	Cat. nos. 30, 52, 53, 54, 57, 58	Cat. no. 28	
Partridge		Cat. no. 51	
Inkwell		Cat. nos. 5, 6, 12, 17	
Small tray/incense burner		Cat. nos. 14, 25, 59	
Vase		Cat. nos. 1, 63	
Rice shovel		Cat. no. 65	
Flask		Cat. no. 67	
Mortar			Cat. nos. 22, 26, 27, 75–81
Cauldron			Cat. nos. 82, 83, 84
Fountain element			Cat. no. 55

Appendix 23

DAI objects from the pre-Mongol Iranian world

Chasing on objects shaped by casting transposed from the wax model and reworked cold:
(cat. nos. 82, 53, 58, 28, 59, 56, 67 have been too much altered to be described and measured).

Cat. no.	Type	Attribution / Dating	Chasing in the wax	Shape of the chasing	Length	Width
54	Incense burner (support)	Khurasan, Eastern Iran, 12th C.	l. 0,5-1,6 mm			
60	Pouring vessel	Afghanistan, 10th-11th C.		Rectangular	0.55	0.85
63	Vase	Khurasan, Eastern Iran, 12th C.		Rectangular	0.5	
45	Lamp support	Khurasan, 12th-early 13th C.		Rectangular/rectangular profile	0.5	
65	Rice shovel	Khurasan, 12th-early 13th C.		Rectangular/rectangular profile	0.5	
34	Lamp	Khurasan or Sistan, 12th C.		Rectangular/rectangular profile	0.6	
21	Lamp	Afghanistan, Ghazna, 12th C.		Rectangular profile	0.7	
14	Small tray/incense burner	Afghanistan, Ghazna, c. 1150-1220		?	0.7	
50	Feline carpet weight	Khurasan, 12th-13th C.		Rectangular/ V bottomed	0.9	
49	Feline carpet weight	Khurasan, 12th-13th C.		Rectangular/ V bottomed	1	
57	Incense burner	Khurasan, Afghanistan, 11th C.		Rectangular/ V bottomed		
44	Lamp	Khurasan, 11th-12th C.		Rectangular/ V bottomed		
29	Lamp	Khurasan, 11th-12th C.		V bottomed		
83	Cauldron	Khurasan, 11th-12th C.		V bottomed		
84	Cauldron	Khurasan, 12th-13th C.		Rectangular profile		
82	Cauldron	Khurasan, 12th-13th C.		?		
53	Incense burner	Khurasan, Eastern Iran, 12th C.		?		
58	Incense burner	Khurasan, Eastern Iran, 12th C.		?		
28	Incense burner or lamp	Khurasan, Eastern Iran, 12th C.		?		
59	Incense dish	Khurasan, end 12th-early 13th C.		?		
56	Padlock	Khurasan, Eastern Iran, 12th-early 13th C.		?		
67	Flask	Khurasan, Eastern Iran, 12th-13th C.		?		

Cat. no.	Type	Attribution / Dating	Chasing profile	Width	Length
2	Pen box	Afghanistan, Herat c. 1210	Rectangular?	0.25	
11	Tabletop/tray	Afghanistan, Herat, c. 1150-1220	Rectangular	0.3	
4	Ewer	Afghanistan, Herat, end of 12th C.	Rectangular?	0.4	1.1
10	Tray	Afghanistan, Herat, c. 1150-1220	?	0.6	
23	Tabletop/tray	Afghanistan, Ghazna, c. 1150-1220	Rectangular?	0.4-0.6	
15	Tabletop/tray	Afghanistan, Ghazna, end of 12th-beginning of 13th C.	Rectangular	0.6	1.9
24	Ewer	Afghanistan, Ghazna, end of 12th C.	Rectangular	0.9	1.9

Appendix 24

DAI objects from the pre-Mongol Iranian world
Profile of chasing on hammered objects.

Type	Attribution / Dating	Diameter of punch (mm)	
57	Incense burner	Khurasan, Afghanistan, 11th C.	1
76	Mortar	Khurasan, end of 12th C.	1
77	Mortar	Khurasan, 12th-early 13th C.	1
2	Pen box	Afghanistan, Herat, c. 1210	0.5
5	Inkwell	Afghanistan, Herat, c. 1150-1220	0.7
4	Ewer	Afghanistan, Herat, end of 12th C.	1.3
3	Candlestick	Afghanistan, Herat c. 1150-1200 C.	1.5
16	Bucket	Afghanistan, Ghazna, end of 12th-beginning of 13th C.	0.7
18	Sprinkler	Afghanistan, Ghazna, 12th C.	0.7
FIG. 9	Shield boss?	Afghanistan, Ghazna, 12th C.	1.5-1.7

Appendix 25

DAI objects from the pre-Mongol Iranian world
Cast and hammered objects with matte punching (domed-dot punch).

Cat. no.	Type	Attribution / Dating	Engraving profile	Width	Length	Compass engraving width (mm)
60	Pouring vessel	Afghanistan, 9th-10th C.				0.4
19	Ewer	Afghanistan, Ghazna, end 12th C.	Concave/U bottomed	0.4		
77	Mortar	Khurasan, 12th-early 13th C.	Concave/U bottomed	0.9		
79	Mortar	Khurasan or Afghanistan, 12th-early 13th C. ?	Concave/U bottomed	1		
41	Lamp	Khurasan, 12th C.	?/V bottomed	0.5		
7	Ewer	Afghanistan, Herat, end 12th C.	?/V bottomed	0.1		0.4
38	Lamp	Khurasan, Afghanistan or Rayy? 12th C.	?/V bottomed			0.5
37	Ewer	Afghanistan, c. 1150-1220	?/V bottomed	0.3		
8	Ewer	Afghanistan, Herat, 586/1190-1191	?/V bottomed	0.4		
27	Mortar	Khurasan, 12th-13th C.	Rectangular	0.5	1	
25	Small tray/incense burner	Afghanistan, Bamiyan? c. 1150-1220	Rectangular			0.5

Appendix 26

DAI objects from the pre-Mongol Iranian world
Engraving on cast objects.

Appendix 27

DAI objects from pre-Mongol Iran
Champlevé on cast and hammered objects.

Cat. no.	Type	Attribution / Dating	Cast objects			Hammered objects		
			Shape	Width	Length	Shape	Width	Lenth
27	Mortar	Khurasan, 12th-13th C.			2.2			
41	Lamp	Khurasan, 12th C.		1.6				
36	Ewer	Afghanistan, 11th-12th C.	Rectangular	1.3				
39	Lamp	Afghanistan, 12th C.		1.2				
25	Small tray/incense burner	Afghanistan, Bamiyan ? c. 1150-1220	Rectangular	1.3				
37	Ewer	Afghanistan, c. 1150-1220	Rectangular	1.9				
80	Mortar	Iran or Anatolia, 13th C.?			2.8			
35	Bowl	Afghanistan, c. 1150-1220				Rectangular	1.75	
4	Ewer	Afghanistan, Herat, end of 12th C.				Rectangular	1	
3	Candlestick	Afghanistan, Herat, c. 1150-1200					1.2	
10	Tray	Afghanistan, Herat, c. 1150-1220				Rectangular	0.9	
11	Tabletop/tray	Afghanistan, Herat, c. 1150-1220				Rectangular	0.9	
7	Ewer	Afghanistan, Herat, end of 12th C.	Rectangular	0.8				
8	Ewer	Afghanistan, Herat, 586/1190-1191	Rectangular	0.8				
23	Tabletop/tray	Afghanistan, Ghazna, c. 1150-1220				Rectangular	1	
15	Tabletop/tray	Afghanistan, Ghazna, end of 12th-beginning of 13th C.				Rectangular	1.5	
13	Plate from scales	Afghanistan, Ghazna, 12th C.					1.5	

Appendix 28

DAI objects from the pre-Mongol Iranian world
Inlays on cast objects: chasing and wire inlay.

Cat. no.	Type	Attribution/ Dating	Shape of the chasing	Width	Length	Silver inlay wire width (mm)	Copper inlay wire width (mm)
8	Ewer	Afghanistan, Herat, 586/1190-1191	Rectangular	0.25	0.8	0.6	0.8
7	Ewer	Afghanistan, Herat, end 12th C.	Rectangular	0.4	1.2	0.6	0.8
9	Feline carpet weight	Afghanistan, Herat, c. 1150-1220	Triangular	0.4	0.9		1
6	Inkwell	Afghanistan, Herat, c. 1150-1220	Rectangular/ U profile	0.4		0.4	0.5
5	Inkwell	Afghanistan, Herat, c. 1150-1220	Rectangular/ U profile				0.3
19	Ewer	Afghanistan, Ghazna, end 12th C.					1.3
18	Sprinkler	Afghanistan, Ghazna, 12th C.	Rectangular	0.5	1.2		1

Appendix 29

DAI objects from the pre-Mongol Iranian world
Inlays on hammered objects: chasing and wire inlay.

Cat.	Type	Attribution/ dating	Shape of the chasing	Width	Length	Silver inlay wire width (mm)	Copper inlay wire width (mm)
2	Pen box	Afghanistan, Herat, c. 1210	Rectangular	0.25	0.5-0.6	0.5	0.6
3	Candlestick	Afghanistan, Herat, c. 1150-1200	Rectangular	0.1-0.2	0.4-0.6	0.5	0.5
4	Ewer	Afghanistan, Herat, end of 12th C.	Rectangular	0.4	0.9	0.6	
10	Tray	Afghanistan, Herat, c. 1150-1220	Rectangular	0.75 max.	1.5 max.		
11	Tabletop/tray	Afghanistan, Herat, c. 1150-1220	Rectangular	0.3	1	0.4-0.5	0.4-0.5
23	Tabletop/tray	Afghanistan, Ghazna, c. 1150-1220	Triangular	1.3	0.3	1	0.4
				0.6	2	1	

30a

30b

31a

32

31b

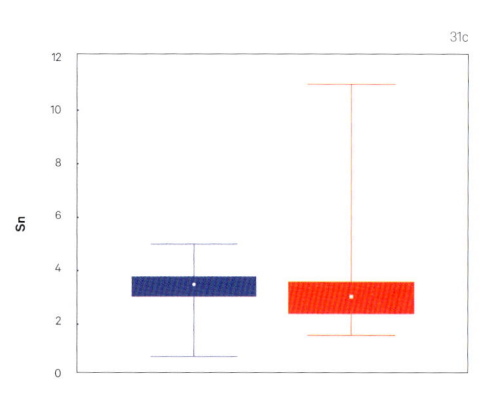

31c

Appendix 30

Zinc (Zn), lead (Pb) and tin (Sn) contents of the 81 DAI items that were analysed (85 analyses) according to 5 alloy types, shown in two binary graphs. The arrows show lines of dilution with either lead (30a) or tin (30b) (results in % by mass; analysed by PIXE or ICP-AES). The two objects with highly atypical compositions, cat. no. 68 and cat. no. 78, have been removed 30a). From left to right (indicated by inventory number): cat. nos. 29, 9, 55, 80, 27, 56, 81, 84, 26
30 b) From left to right (indicated by inventory number): cat. nos. 9, 27, 84, 55, 80, 81, 26, 56.

Appendix 31

Graphs 31a to 31c show the zinc (Zn), lead (Pb) and tin (Sn) contents of the DAI objects that were analysed, grouped by the impurity class to which they belong. Brass and high tin bronze are not represented. The graphs shows that the compositions of these three elements, in other words the contents of the alloy, are similar in every group. The centre of the box shows the average; the dot in the box the median; the edges the quartiles; and the 'T' lines the extreme values (% by mass; PIXE or ICP-AES analyses; 85 analyses of 81 objects) The two objects with highly atypical compositions, cat. no. 68 and cat. no. 78, have been removed.

Appendix 32

Zinc (Zn) and lead (Pb) contents (% by mass) of the cast lead alloy objects according to the class of impurity, showing that a majority of Class 1 objects (blue) are close to the lead dilution line, while those in class 2 (red) are mostly below it, due to recycling. A few exceptions are: cat. nos. 9 (AA 269), 52 (OA 4044 bis), (red arrows) 27 (MAO 2107) and 82 (MAO 366) (blue arrows).

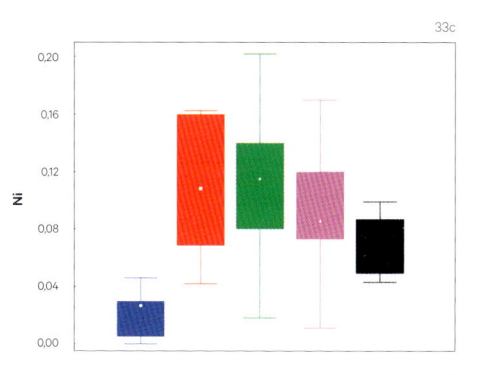

Appendix 33

Graphs 33a to 33h show the levels of impurities (sulphur, iron, nickel, cobalt, arsenic, silver, antimony and bismuth) in the five types of alloy. The centre of the box shows the average; the dot in the box the median, the edges the quartiles, and the 'T' lines the extreme values (% by mass; PIXE or ICP-AES analyses; 85 analyses of 81 objects) The two objects with highly atypical compositions, cat. no. 68 and cat. no. 78, have been removed.

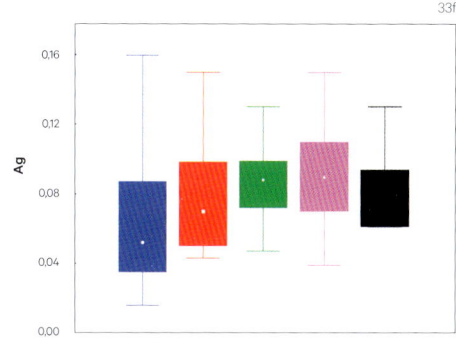

Appendix 34

Hierarchical classification of 81 analysed DAI objects (85 analysed; indicated by inv. nos.) according to their Ag, As, Ni, Pb, Sb content. The two highly atypical alloys, cat. nos. 68 and 78, have been removed. (reduced centered value, Ward method, Euclidean distance).
From top to bottom:
cat. nos. 35, 15. 3. 23. 4, 84, 24. 2. 10, 9, 58, 32, 37, 52, 45, 31, 72. 56. 14, 1, 53, 30. 66. 54. 46, 5, 77, 42, 82, 47, 48, 40, 79, 65, 51. 75, 71, 44, 45, 62, 33, 49, 5, 81, 34, 43, 7, 38, 61, 83, 41, 80, 55, 57, 70, 13, 11, 55, 74, 12, 16, 18, 50, 39, 17, 67, 8 (not in the cat. MAO 764) 64, 36. 20, 29, 6, 25, 26, 60, 19, 22. 21. 63, 76. 28. 27

335

Photographic Credits